Photographic Possibilities:

The Expressive Use of Equipment, Ideas, Materials, and Processes

THIRD EDITION

Robert Hirsch

ELSEVIER

AMSTERDAM • BOSTON • HEIDELBERG • LONDON • NEW YORK • OXFORD
PARIS • SAN DIEGO • SAN FRANCISCO • SINGAPORE • SYDNEY • TOKYO
Focal Press is an imprint of Elsevier

Focal
Press

Focal Press is an imprint of Elsevier
Linacre House, Jordan Hill, Oxford OX2 8DP, UK
30 Corporate Drive, Suite 400, Burlington, MA 01803, USA

First published 2009

British Library Cataloguing in Publication Data
Hirsch, Robert
 Photographic possibilities : the expressive use of equipment, ideas, materials, and processes. –
 3rd ed.
 1. Photography
 I. Title
 771

Library of Congress Control Number: 2008935936

ISBN: 978-0-240-81013-3

For information on all Focal Press publications
visit our website at www.focalpress.com

Printed and bound in China

09 10 11 12 12 11 10 9 8 7 6 5 4 3 2 1

Typeset by Charon Tec Ltd., A Macmillan Company.
(www.macmillansolutions.com)

771 . HIR

Photographic Possibilities

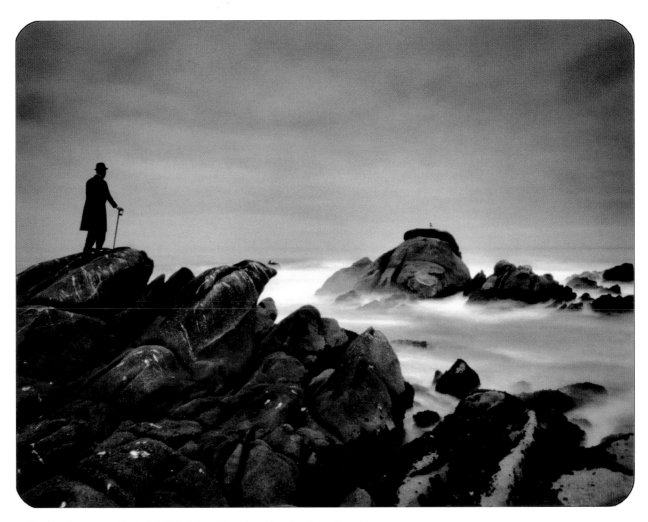

© Martha Casanave. *Untitled*, 2002. 14 × 18 inches. Toned gelatin silver print.

Dedication

To my mother, Muriel Hirsch, for teaching me to read, and my wife, Adele Henderson, for teaching me a few other things.

"We work in the dark, We do what we can, We give what we have, Our doubt is our passion, And our passion is our task, The rest is the madness of art." – Henry James

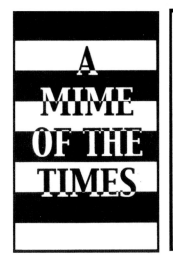

A MIME OF THE TIMES

Though mime is certainly one of our oldest forms of theater, having been introduced by the early Greeks and remaining a significant art form to this day, it's hard not to think that a few changes might be made to the classic repertoire. Confinement in invisible boxes and pulling non-existent loads with unseen ropes is all very fine, but how about something a little more 2007? Allow us to suggest a few additional effects that an ambitious mime might use to revitalize this ancient art.

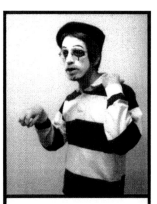

A man in an airport, holding his shoes, and wondering if the toothpaste in his carry-on bag is going to be confiscated.

A seventh-grade civics teacher, momentarily pausing before giving the same lecture on the three branches of government that he's used for the past 20 years.

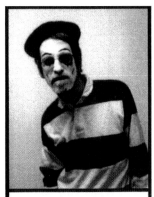

A Vice President describing the enormous success thus far of our efforts to create a vibrant new democracy in the Middle East.

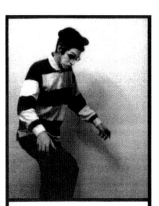

A nineteen-year-old veteran learning how to walk on his two new prosthetic limbs.

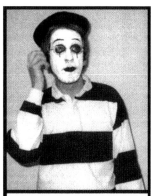

A worried young woman talking to her mother-in-law on her cell phone, moments before two military officers in dress uniform knock on her front door.

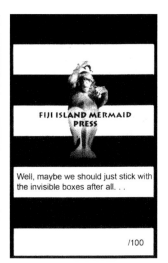

FIJI ISLAND MERMAID PRESS

Well, maybe we should just stick with the invisible boxes after all. . .

/100

Snyder's artists' book is one of over eighty that he has produced for Fiji Island Mermaid Press's artists' book of the month club (www.fimp. net). Snyder states, "The images were created to be seen as a sequence. They were not meant to stand alone, but are intended to be accompanied by a text explaining the action being portrayed. The sequence was designed to start with humorous images, as is a cliché when the subject is mime. The political content, evident from the first image, becomes progressively darker. The element of surprise, found in the contrast between the absurd face paint and outfit of the 'mime' and the actions he is portraying, hopefully makes the thorny content in the final two images more powerful."

© Marc Snyder. *A Mime of the Times*, 2007. 2-1/2 × 4 inches. Electrostatic print. Courtesy of Fiji Island Mermaid Press.

Table of Contents

Preface xi
Contributors to Photographic Possibilities xv

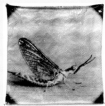

CHAPTER 1

Essential Moments in Photographic
 Printmaking 1

The Language of Photography 1

Concepts and Technology Affecting
 Photographic Printmaking 3

Extending Photographic Boundaries 21

Electronic Imaging: New Ways of Seeing 26

Possessing a Sense of History 27

CHAPTER 2

Predarkroom Actions: Imaginative
 Thinking and Personal Safety 29

Establishing a Personal Creation Process 29

Photographic Origins 29

Thinking within a System 30

Purposes of Photography 35

Essential Safety Guidelines 37

Contact Allergies, Chemical Sensitivities and
 Poison Control 39

Disposing of Chemistry 40

Darkroom Ventilation 41

Water for Photographic Processes 41

CHAPTER 3

Image Capture: Special-Use Films, Processing
 and Digital Negative Making 43

Film and the Photographer 43

General Film Processing Procedures 44

Infrared Black-and-White Film 46

Extended Red Sensitivity Film 49

High-Speed Black-and-White Films 50

Heightening Grain and Contrast 54

Ultra-Fine Grain Black-and-White Film:
 Ilford Pan F Plus 55

High-Contrast Litho Films 55

Orthochromatic Film 58

Paper Negatives and Positives: Contemporary
 Calotypes 58

Reversing Black-and-White Film 59

Instant Positive and Negative Film 61

Film for Classic Cameras 61

Processing Black-and-White Film for
 Permanence 61

Digital Negative Making: An Overview 62

Scanners 66

CHAPTER 4

Formulas of One's Own 71

Prepared Formulas or Mixing Your Own 71

Basic Equipment 71

Chemicals 73

Preparing Formulas 74

US Customary Weights and Metric
Equivalents 76

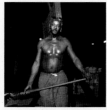

CHAPTER 5

Black-and-White Film Developers 79

What Happens to Silver-Based Films During
Exposure and Processing? 79

Image Characteristics of Film 79

Components and Characteristics of
Black-and-White Developers 81

Basic Developer Types 85

Postdevelopment Procedures 87

Film Developer Formulas and their
Applications 91

Is All this Necessary? 103

CHAPTER 6

Analog Fine Printmaking: Equipment,
Materials, and Processes 105

The Analog Fine Printmaking Process 105

Printing Equipment 108

Standard Printing Materials 116

Print Finishing 121

Special Printing Materials 123

Processing Prints for Permanence 127

CHAPTER 7

Black-and-White Paper Developers 129

Paper Developer and Developing-out
Paper 129

Components of Black-and-White Silver Print
Developers 129

Additional Processing Factors 131

Controlling Contrast During
Development 133

Matching Developer and Paper 134

Developer Applications and
Characteristics 135

Other Paper Developer Formulas 140

CHAPTER 8

Toning for Visual Effects 147

Processing Controls 147

Basic Types of Toners 147

Processing Prints to be Toned 148

General Working Procedures for Toners 150

Brown Toners 151

Blue Toners 158

Red Toners 158

Green Toners 159

Toning Variations 159

CHAPTER 9

Special Cameras and Equipment 165

What Is a Camera? 165

The Pinhole Camera 167

Custom Cameras 171

Plastic Cameras 171

Disposable Cameras 173

Changing the Angle of View 173

Panoramic Cameras 176

Sequence Cameras 178

Obsolete Special-use Cameras 179

Stereoscopic Photography 181

Stroboscopic Photography 184

Underwater Equipment and Protection 185

CHAPTER 10

Historic and Alternative Processes: Beauty, Imagination and Inventiveness 187

Paper and the Image Viewing Experience 189

Exposure 191

Salt Prints 192

Cyanotype Process 197

Ambrotype Process: Wet-plate Collodion Positives on Glass 202

Kallitype and Vandyke Brownprint Processes 207

Chrysotype Process 210

Platinum and Palladium Processes 211

Gum Bichromate Process 217

The Bromoil Process 221

Gumoil 222

Mordançage 223

Lith Printing 224

Electrostatic Processes: Copy Machines 226

CHAPTER 11

Transforming Photographic Concepts: Expanding the Lexicon 231

Hand-Altered Work 231

Photograms 232

Chemigram 235

Cliché-Verre 236

Extended Camera Exposures 238

Postcamera Techniques: in Search if Time 241

Multiple-Exposure Methods 243

Fabrication: Happenings for the Camera 248

Composite Variations 251

Processing Manipulation: Reticulation 255

Hand-Coloring 256

Airbrushing 259

Transfers and Stencils 262

Cross-Processing: Slides as Negatives 271

Pictures From a Screen 271

Index 275

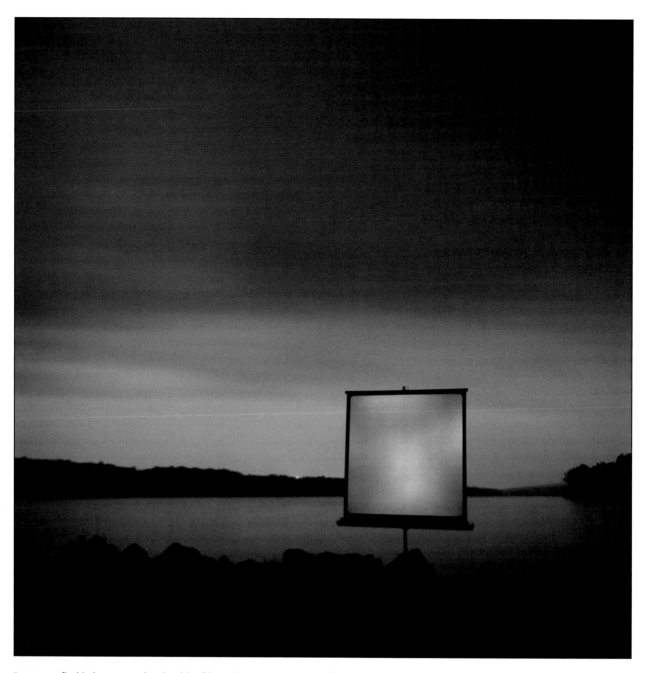

Pointing a flashlight equipped with a blue filter at the projection screen for a few seconds allowed Carr to capture dramatic light variations during this two-minute exposure. As the imagemaker succinctly states, "This is about the non-traditional potential the light possesses in forming photographic images."

© Christine Carr. *Screen*, 2002. 19 × 19 inches. Chromogenic color print.

Preface

"In any act, the primary intention of him who acts is to reveal his own image". – Dante

"Life for a photographer cannot be a matter of indifference and it is important to see what is invisible to others." – Robert Frank

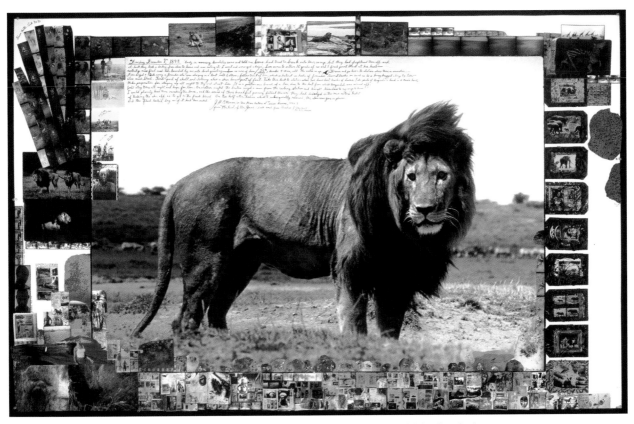

© Peter Beard. *Serengeti Lion*, 1984/2006. 50¼ × 69⅜ inches. Gelatin silver print with blood and ink.

Since first appearing in 1990, *Photographic Possibilities* has become a trusted gateway for those who want to experience and understand innovative ways of thinking about and working with the photographic medium. The book is designed for imagemakers who are familiar with the basics of black-and-white photography and are keen to learn about uncommon ways of expanding their visual practice.

Specifically, *Photographic Possibilities* is devised for those who find it vital to actively interact with the photographic process to thoughtfully interject their personal responses to the subject being portrayed. It is a book for expressive imagemakers whose photographs represent an essential component of how they observe, describe, define, remember, express, and communicate their response to life.

In a wide-ranging and open manner, *Photographic Possibilities* surveys what today's alternative imagemakers are actually doing in the field, something different from the ordinary, in terms of apparatus, materials, processes, representation concepts, and notions of creativity. Additionally, the text provides a historical background about the major processes it covers. Unfamiliar terms are defined upon their first use. Resource Guides of additional sources of information and supplies, including Websites, are included at the end of subject sections whenever appropriate.

The book's art program presents a stimulating survey of works by over 150 contemporary photographers from around the world, which *illuminate*, not illustrate, concepts and methods discussed in the book. Images were curated through an international work call and also by contacting specific artists. Each imagemaker was asked a series of question about the thinking and working methods they employed to realize their vision. This information was distilled into captions, which allows the makers to speak directly to the readers.

Photographic Possibilities examines and presents works by contemporary artists who utilize photo-based processes to picture an inner state of consciousness and grapple with a subject beyond its topographical structure and integrate a subject's external appearance with its interior makeup. The book is a resource for artists working with unconventional photographic forms. It posits that learning historic methods can lead to innovation and the best way to gain this understanding is by actually doing them.

The book champions "human images," those that possess their own idiosyncratic sense of essence, time, and wonder. Such work is often aesthetically demanding, but this challenging methodology is often what is necessary to get us to set aside the predetermined answers to the question: "What is a photograph?" and encourage us to appreciate photography's remarkable diversity of form, structure, representational content, and meaning.

The text advocates the notion of a "*Possibility Scale*," which proclaims: "If one can imagine it, there can be a way to make it happen." It invites artists to reach beyond the range of their known experiences and to push their limits of understanding. This way of thinking disrupts conventional assumptions and provides a pathway to supplying answers to the question "Why not?"

Photographic Possibilities is intrigued by how photography allows the manifestation of personal realities by means of light-sensitive materials to see beyond the fixed frame. Its philosophical stance is that there is no mandate of how an image should look. When two imagemakers independently photograph the same subject they will produce different results. This is because the bedrock of inventiveness and originality comes from autonomous actions, which generate different representations than previously recognized views of a similar subject. In this spirit, *Photographic Possibilities* says that history matters by acknowledging that fresh ideas come from recontextualizing existing knowledge and are links in a progression of knowledge. When we examine images of others, we draw in their memories and commingle them with our own experiences to expand our worldview. The more one understands how images are made, the more one grasps that imagemaking is an on-going derivative, collaborative, and interpretive process.

Photographic Possibilities inspires imagemakers to acquire applied experience in a wide range of photographic processes, expanding their visual lexicon and their range of outcomes. It puts forward the assertion that learning an array of representational models and photographic methods is vital to the act of translating an abstract idea into a specific physical reality. Only after a working knowledge of a process is obtained can precise control begin. To that end, this text offers proven working procedures and well-tested photographic methods, with examples of how and why other photographers have applied them. These are departure points rather than final destinations, encouraging one to freely navigate to fabricate one's own meaningful destination. In this setting process is always placed in the service of concept to construct evocative content. This is possible when the mind and the spirit unite an idea from the imagination and determine the most suitable technical means of bringing it into existence. Then individual vision is the most valuable resource, a result summarized up by former New York Yankee catcher Yogi Berra, whose whimsical "yogi-isms" include: "In theory there is no difference between theory and practice. In practice there is."

This book offers numerous alternative photographic approaches. This information allows an expressive printmaker to understand how photography has evolved and to be ready to explore future possibilities in imagemaking. Although the text stresses analog imagemaking, it recognizes all approaches and includes work that incorporates digital means. Such works reflect how photographers have been integrating classic and contemporary processes that zigzag through time and traditional media boundaries to achieve their visual ends.

The most dramatic changes for this edition include: the expansion of Chapter 1 to provide an historic overview of photographic printmaking; a revision of Chapter 2 to include a highly refined thinking model, which had been eliminated in the second edition; the inclusion of digital negative making and scanning in Chapter 3; the elimination of the two separate digital chapters; and an expansion of Chapter 10 to include new historic processes that are currently being practiced. In addition to expanded Resource Guides, all formulas, processes, and products have been rechecked, revised, and updated by working artists with expertise in specific areas.

Acknowledgements

I would like to acknowledge the assistance I have received in revising this book from the people at Focal Press who include my editor Valerie Geary, my copy editor Ray Loughlin, and Lisa Jones, Project Manager, Graham Smith, Editorial Assistant, my proofreader Marion Stockton, and Indexing Specialists (UK) Ltd for the index.

I wish to thank all the photographers who submitted their work and formulas for this project and engaged us in a running dialogue about the relationship between their ideas and their working methods. Without their cooperation this book would not exist.

Over the years many people have generously contributed their time, expertise, and work to make this book a reality. For this third edition I am especially indebted to the individuals listed below who have been exceedingly generous in sharing their photographic knowledge as contributors and readers.

Christina Z. Anderson, Montana State University
Jo Babcock
Jonathan Bailey
Michelle Bates
Michael Bosworth, Villa Maria College
Dan Burkholder
Pierre Cordier
Greg Drake, independent researcher and editor
Jill Enfield
Mark Jacobs, independent photographic historian and collector
Eric Joseph, Freestyle Photographic Supply
Blue Mitchell
Tom Persinger, f295
Mark Osterman
Ginger Owen-Murakami, Western Michigan University
Eric Renner, Pinhole Resource
Robert Schramm
France Scully Osterman
Jill Skupin Burkholder
Nancy Spencer, Pinhole Resource

Brian Taylor, San Jose State University
Mike Ware

Special thanks to my assistant Anna Kuehl for her outstanding job with research, permissions, image placement, captions, database, correspondence, and the numerous other tasks that went into preparing this edition.

Additional thanks to David McNamara of sunnyoutside, an independent press, for editing the page icons.

Finally, I pay tribute to all my teachers, students, and past authors who have provided me with the knowledge and the spirit to continue to convey it.

A note of caution: The techniques covered in this book require the use of a wide variety of chemicals. All chemicals pose a possible threat to your health, those around you, and to the environment. By using common sense and following standard working procedures, health and environmental problems can be avoided. Read the sections on safety in Chapter 2 before carrying out any of the processes described in this book.

Mark Twain once said, "The trouble with the world is not that people know too little, but that they know so many things that ain't so." *Photographic Possibilities* seeks to avoid this pitfall by stressing that learning is a cyclical process, with good students absorbing, and then instructing and surpassing their teacher's knowledge. It is my hope this book will encourage its readers to do the same by taking pleasure in the process of making engaging photographs.

Robert Hirsch
Buffalo, NY

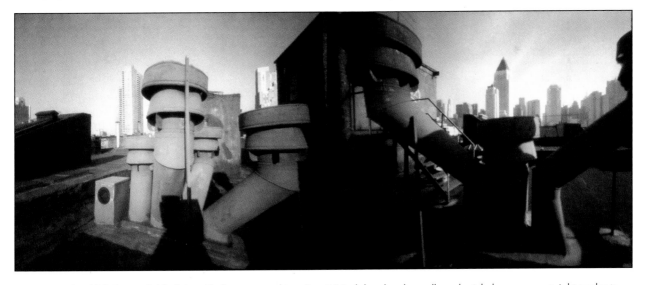

To compose this 180 degree field of view, Barber arranged two 8 × 10 inch handmade cardboard, pinhole cameras at right angles to each other, which also cast their own shadows. This method allowed the artist to explore "the chaos of city streets, which lies far below the order and function existing upon rooftops. Upon each building rest an environment of air conditioning ducts, ventilation shafts, elevator housings, pipes and wires all vital to the life of the entire structure. They are ignored by most inhabitants yet maintained by mechanics who have created sculptural objects where form follows function."

© Craig Barber. *West 48th*, from the series *City Above*, 1990. 8 × 20 inches. Toned Vandyke Brownprint. Courtesy of Benham Gallery, Seattle, WA.

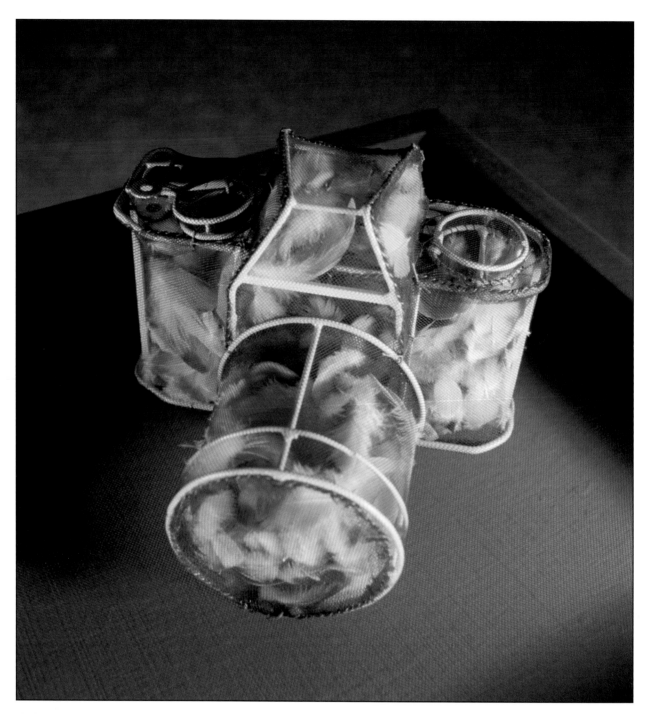

Abeles's artists' book, *Encyclopedia Persona A-Z* (1993), demonstrates the artist's dedication to the physical aspect of creation. *Camera Desiros* is an exact replica of Abeles's 35mm camera and is an ancillary piece to the series, *Mountain Wedge*, a 14-month attempt to photograph a clear view of the San Gabriel Mountains located 16 miles north of Los Angeles. "The piece is made of welded steel rod covered with sheer mosquito netting and filled with pigeon feathers. Abeles says, 'As its title and presence suggest, it speaks of a photograph's ethereal desire to capture images."

© Kim Abeles. *Camera Desiros*, 1987. 3-3/4 × 5-1/2 × 4-1/4 inches. Pigeon features, metal, and netting. Courtesy of Art Resources Transfer, New York.

Contributors to Photographic Possibilities

Kim Abeles, Christina Anderson, Catherine Angel, Bill Armstrong, Jo Babcock, Pat Bacon, Karl Baden, Jonathan Bailey, Craig Barber, Tom Barrow, Michelle Bates, Amanda Bauer, Peter Beard, Alyson Belcher, Wayne Martin Belger, Renee Billingslea, Michael Bosworth, Gloria DeFilipps Brush, Peter C. Bunnell, Jerry Burchfield, Dan Burkholder, Jill Skupin Burkholder, Diane Bush, Jeffery Byrd, Kathleen Campbell, Ellen Carey, Brigitte Carnochan, Christine Carr, Martha Casanave, Paula Chamlee, Carl Chiarenza, Fred Clatworthy, Linda Connor, Les Cookson, Pierre Cordier, Andrew Davidhazy, Robert Dawson, Sylvia de Swaan, Dennis DeHart, Greg Drake, Peter Eide, Jill Enfield, Greg Erf, Mark Eshbaugh, Dan Estabrook, Susan Evans, Marion Faller, S. W. Fallis, Dennis Farber.

Peter Feldstein, Peter Helmes Feresten, Jesseca Ferguson, Alida Fish, M. K. Foltz, Mary Frey, James Friedman, Ellen Garvens, Stan Gaz, Misha Gordin, Shelby Graham, Myra Greene, Elizabeth Raymer Griffin, Steve Harp, Robert Heinecken, Adele Henderson, Robert Hirsch, Rick McKee Hock, Ann Ginsburgh Hofkin, Frank Hunter, Joseph Jachna, Mark Jacobs, Molly Jarboe, Keith Johnson, Thomas Kellner,

Michael Kenna, Kay Kenny, Mark Klett, Nicolai Klimaszewski, Kevin Kline, Karl Koenig, Arunas Kulikauskas, Sally Grizzell Larson, William Larson, Dinh Lê, David Lebe, Stu Levy, Peter Liepke, Adriane Little, Martha Madigan, Mark Maio, Stephen Marc, Elaine McKay, Gerald Mead, Amanda Means, Joe Mills, Blue Mitchell, Andrea Modica, Osamu James Nakagawa, Harry Nankin, Bea Nettles.

Pipo Nguyen-duy, Michael Northrup, Ted Orland, Mark Osterman, France Scully Osterman, Ginger Owen-Murakami, Elizabeth Opalenik, Bill Owens, Scott Palmer, Robert and Shana ParkeHarrison, Tom Persinger, Thomas Porett, Beverly Rayner, June Redford-Range, Eric Renner, John Rickard, Holly Roberts, Joyce Roetter, Milton Rogovin, Martha Rosler, Norman Sarachek, Naomi Savage, Lincoln Schatz, Robert Schramm, J Seeley, John Sexton, Keith Sharp, Michael Smith, Marc Snyder, Jerry Spagnoli, Nancy Spencer, Doug and Mike Starn, Donna Hamil Talman, Brian Taylor, Keith Taylor, George Tice, Terry Towery, Timothy Tracz, Laurie Tümer, Jerry Uelsmann, John Valentino, Michael Ware, Heather Wetzel, Joel Peter Witkin, Ilan Wolff, John Wood, Melissa Zexter, Tricia Zigmund.

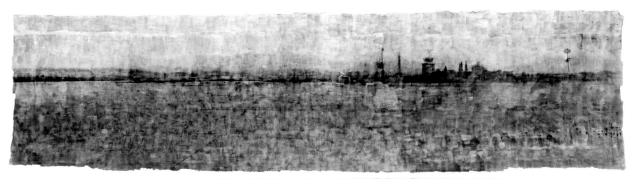

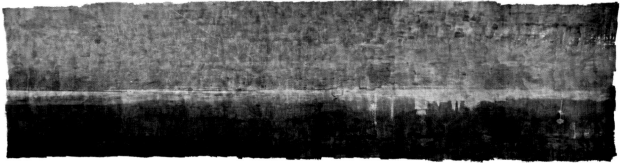

Burchfield constructed *The Great Picture* using the 44 × 79 × 161 foot pinhole camera that he built in Building #115, a plane hangar at the Marine Corps Air Station El Toro in Irvine, California. To create the negative image, he and hundreds of volunteers coated a sheet of unbleached muslin with 80 liters of Rockland liquid emulsion. After a 35 minute exposure, he developed the muslin with traditional black-and-white chemistry in a nontraditional 114 foot × 35 foot × 6 inch vinyl pool. Burchfield also used digital reproduction methods to create a positive image of The Great Picture on a 60 × 228 inch vinyl sheet.

© Jerry Burchfield. *The Great Picture* (negative and positive), 2006. 107 × 31 feet. Gelatin silver emulsion on canvas.

Chapter 1

ESSENTIAL MOMENTS IN
PHOTOGRAPHIC PRINTMAKING

An imaging system designed to record pictures by capturing light reflected by a subject onto a light-sensitive medium, such as film or electronic sensors, photography is built upon evolving artistic, cultural, scientific, and technical innovations. The motivating force behind its invention was the human desire to easily and accurately make visual representations directly from life.

Most people find user-friendly digital cameras adequate for their photographic record keeping needs. Others do not. For them, it is imperative to control, interact with, and manipulate the photographic process, and actively interject their responses to the subject. This book has been written for these expressive imagemakers whose photographs are an essential component of how they observe, describe, define, communicate, remember, celebrate, and express their relationship to the world.

Nowadays, people often take it for granted that all pictures are either quotes from visible reality or signs that stand for something else and possess their own innate structure and value. But sometimes pictures can defy our cultural expectations and predetermined narratives and simply represent circumstances that cannot be expressed in any other way. Pictures possess their own native structure that may defy explanation, regardless of how many words are wrapped around them. They remain a purely visual phenomenon that can elicit unique responses from both makers and viewers. Those who are compelled to make pictures understand that visual communication has its own vocabulary or language.

Reactions to a photograph are uniquely personal and should not be pigeonholed into tight-fitting, predetermined roles. Although many people have been conditioned by photojournalism to believe the purpose of a photograph is to quickly provide empirical commentary "about" a subject, it is possible that a photograph may not make a concrete statement or answer a specific question. A photograph is not necessarily about something; rather it is something in and of itself. It may be enigmatic or a work of the imagination, allowing viewers access to something that could not be perceived or understood in another medium. Open-ended photographic images can be eccentric, and their changeable nature, which can disturb conventional standards of correctness, often makes them uncomfortable to look at. Such challenging and consciousness raising images can be likened to dancer Isadora Duncan's statement: "If I could tell you what it meant, there would be no point in dancing it" or as Oscar Wilde stated tongue in cheek, "All art is quite useless."

Some people think of a photograph as a conversation between a photographer, a subject, and a viewer. Every conversation has a context, whose participants not only exchange words but formulate meaning based on how the words are spoken, to whom they are addressed, the body language of the participants, the personal history among the participants, and the environment in which the conversation takes place. When the participants think about a particular subject or image, a distillation of meaning becomes possible. Thinking involves the creative interaction among the participants in the visual conversation and can lead to definition. Definition allows people to acknowledge and take responsibility for solving a problem or reaching a conclusion about what an imagemaker deemed significant.

During the early part of the twentieth century Albert Einstein's Theory of Relativity (1905–1916) collapsed the Newtonian notion that space and time are fixed by representing examples of how space and time are relative.[1] Einstein's Theory provided a variable interaction between the observer and the observed, shattering the notion of Renaissance illusionism, the convincing depiction of nature. This open process acknowledged an active interaction among the artist, the object, and the viewer in the formation of meaning and greatly affected how artists of the time, from Picasso to Alvin Langdon Coburn, depicted their world. As the artist/photographer Man Ray mused, "Perhaps the final goal desired by the artist is a confusion of merging of all the arts, as things merge in real life."

THE LANGUAGE OF PHOTOGRAPHY

Photography is seeing double, a stand-in for the original subject. All photographs are manipulated representations of something else; it is all a matter of degree because photographs are directly derived from other sources of external reality. When knowledgeable viewers look at a photograph they can usually trace it back to its technical origins, such as type of camera or whether the capture was film or digital. The final image is the culmination of

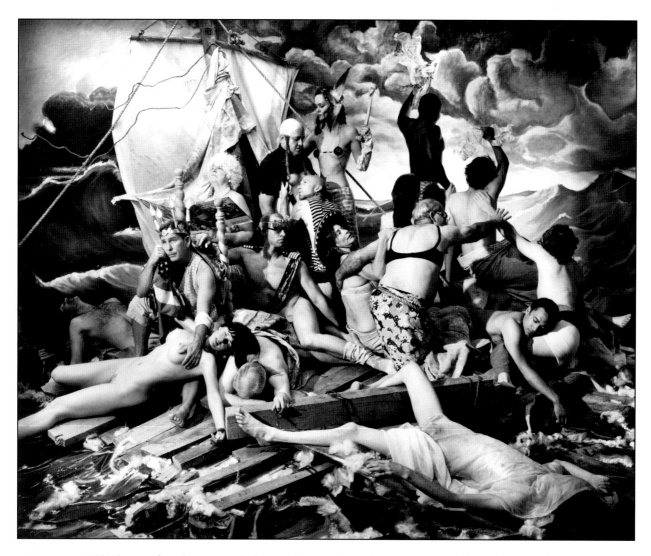

FIGURE 1.1 Witkin borrows from the past to rethink recent American history by constructing truth through fantasy. "There are many parallels to the *Raft of the Medusa* [painted by Théodore Géricault, 1818–1819 as a political statement about the incompetent French leadership] and the presidency of George W. Bush. When the French frigate *Medusa* sank, the captain and many of his senior officers brutally commandeered the seaworthy lifeboats, leaving the passengers and sailors to try and survive on a raft. The people on the *Medusa* were the victims of a class struggle. The people on the *Raft of George W. Bush* – his party and regime – are the victims of their own rationale, their conservative elitism, their hunger for political and social power, and their unilateral military ambitions. I want to show the leaders of this regime as royalty without clothes. As the fools they really are."
© Joel-Peter Witkin. *The Raft of George W. Bush*, 2006. 16 × 20 and 38 × 24 inches. Toned gelatin silver print.

the properties of the original subject, the specific materials used in the creation, the process of production, the artistic vision of the photographer, and the presentation method. When people disagree about whether or not a picture is "photographic," what they are really arguing about is the amount of image management, the degree to which deviation from the original image capture is tolerated for a work to still be considered photographic in character.

The old expression notwithstanding, photography is not nature's mirror. Rather, the nature of photography permits the manifestation of personal realities through the action of light through photographically light-sensitive materials (film, paper, sensor). Simply put, but difficult for many to accept, there is no mandate of how an image should look. When two first-rate photographers independently photograph the same subject they produce different results. This is because the underpinnings of creativity and originality are formulated on learning to think and act autonomously based on life experiences and in turn expressing these ideas in a fashion different from previously recognized views of a similar subject.

Fresh ideas come from recontextualizing the past. When we look at other images, we draw in memories of things we never directly experienced, expanding to our world-view. The more one knows about how images are made, the more one realizes that imagemaking is a both a derivative and interpretive process.

Notions of what constitutes creativity and originality have always swirled around photographic practice, thus making it imperative to realize that Western society's intellectual heritage, including photography, is founded on a culture of transformation, one of borrowing, sharing, reborrowing, and then amending, expanding, and improving – the full range of ways in which new art builds on and emerges from the old. Consider one of America's cultural icons: *Steamboat Willie*, the 1928 Walt Disney cartoon that introduced Mickey Mouse. *Steamboat Willie* borrowed from, and played off of, Buster Keaton's 1928 silent film *Steamboat Bill, Jr.*, which itself had borrowed from a 1910 song, *Steamboat Bill*. Disney's creative act was to snatch material from the ethos around him, mix it with his own talent, and then imprint that union into the character of our culture. Select an art form and you will find this 1–2–3 combination of snatch, mix, and imprint. As Pablo Picasso quipped, "Bad artists copy; great artists steal."

It is worth noting that in the early history of photography a series of judicial decisions could have changed the course of the medium: courts were asked to decide whether a photographer needed permission before capturing an image. Was a photographer *stealing* from an architect or building owner when photographing a structure or from an individual whose photograph he or she took, pirating something of private and certifiable value? Those early decisions went in favor of those accused of thievery. Just as Disney took inspiration from Keaton's *Steamboat Bill, Jr.* and the existence of real mice, imagemakers need the freedom to interpret the archive of human knowledge without the bonds of restrictive and expensive copyright laws to expand our fund of collective information.

What photography can do is provide us with the physical means to create or invent images from our imaginations. By gaining a working, hands-on understanding of a wide range of photographic processes, imagemakers can expand their visual vocabulary and be in a better position to obtain the desired outcome.

Learning to control a process is the first step an imagemaker must master to transform an abstract idea into a specific physical reality. Only after a basic working knowledge of a process is obtained can precise control begin. To that end, this text provides basic working procedures and introduces a variety of well-tested photographic methods, with examples of how and why other photographers have applied them. It promotes a position of inclusive thinking in terms of concept, content, and process, with the ability to freely navigate among them, to fabricate one's own meaningful destination. In this setting process is placed in the service of concept to construct evocative content. This is possible when the heart and the mind combine an idea from the imagination and determine the most suitable technical means of bringing it

into existence. Then individual vision is the trump card, an outcome superbly summed up by former New York Yankee catcher and pop philosopher Yogi Berra who said: "In theory there is no difference between theory and practice. In practice there is."

CONCEPTS AND TECHNOLOGY AFFECTING PHOTOGRAPHIC PRINTMAKING

Ever since Louis-Jacques-Mandé Daguerre made public his daguerreotype process in 1839, people have been discovering new photographic materials and methods to represent the way they see the world. Initially people considered photography an automatic mechanical method for transferring what was seen in nature into the familiar two-dimensional form of Renaissance perspective. Unsurprisingly, within a short period of time photographs were confused with, and substituted for, reality. Photography proved so able at reality substitution that many people came to see this as photography's raison d'être. The photographer was presumed to act as a neutral observer who operated a piece of machinery that automatically performed (supposedly without human intervention) to truthfully record a subject, capturing it as a visual specimen in Time. Such thinking bound photography to representation, while liberating painting to explore new avenues of color, form, and space, giving rise to the development of abstract modern art.

Photography's ability to preserve a moment of reality led to the early subgenre of postmortem photography, the practice of photographing the recently departed as a keepsake to remember the deceased became part of the mourning process. This was especially common with infants and young children, as this was likely the family's only image of the child. This practice of "cheating death" peaked in popularity around the end of the nineteenth century and faded as the family snapshot gained popularity.

Although Photoshop has become a verb, people still want to believe their own eyes, even when they are aware they are only seeing pixels, thus validating Grouch Marx's observational wisecrack, "Who you going believe – me – or your lyin' eyes?" During the mid-twentieth century Henri Cartier-Bresson's concept of "The Decisive Moment," that fraction of a second when the essence of a subject is revealed, defined full-frame 35 mm photographic truth. Now we can have countless, dynamic, digital moments. Just because something is in flux or has been constructed from many different pieces of time and space doesn't mean it isn't true. What we refer to as "The Truth," is where our legends commingle with fact to form an accepted cultural reality, which is why allegory remains a favorite method for expressing moral, political, and spiritual messages. Artists have long recognized this phenomenon, leading Pablo Picasso, known for his ability to dissect and reassemble his subjects, to observe: "Art is a lie that reveals the truth."

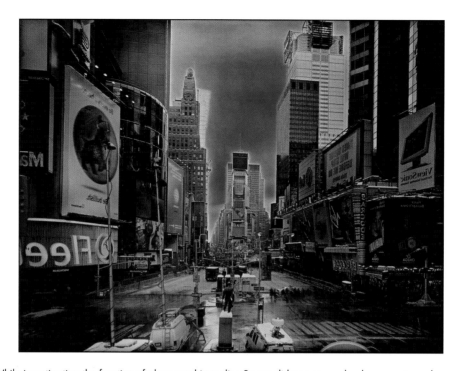

FIGURE 1.2 While investigating the function of photographic reality, Spagnoli began to make daguerreotypes because of their illusion of depth. This illusion, Spagnoli states, "Allows viewers to feel as if they are seeing the 'thing itself,' as was said in the nineteenth century, but combined with this veracity is the obvious artifice of the image." To create this image, the artist used an 8 × 10 inch Deardorff view camera to produce a direct positive view of Times Square on New Year's Eve from atop scaffolding erected for the celebrations. © Jerry Spagnoli. *Untitled*, from the series *Last Great Daguerreian Survey of the Twentieth Century*, 2001. 6½ × 8½ inches. Daguerreotype.

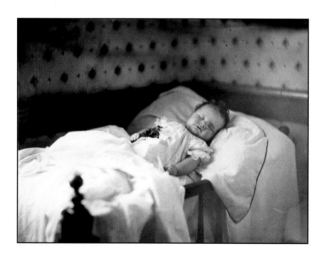

FIGURE 1.3 In 1856 Hamilton L. Smith of Ohio patented a photographic method called the melainotype, previously described as ferrotypes. These one-of-a-kind images are made directly on a thin iron plate that has been coated with chemicals, exposed in a camera while still wet, and developed on the spot. Although now faded, the flower appears to have been hand-colored. Even though the plates are iron, not tin, these images were popularly known as tintypes. The process, less expensive than daguerreotype and more durable than other earlier methods of photographic portraiture, became popular during the Civil War and remained so with itinerant and street photographers, especially in overseas tourist locations, until the Polaroid process replaced it in the 1950s. Unknown photographer. *Unidentified Baby, post-mortem*, circa 1870s. 4¼ × 5½ inches. Tintype. © Collection of Mark Jacobs.

We should bear in mind there are no neutral photographs. All photographic depictions have an inherent bias. Photography has four distinct kinds of bias. The first bias originates with the people who create and manufacture the commonly used photographic systems, which include the cameras, lenses, films, papers, chemicals, and darkroom equipment as well as digital equipment, materials, and software relied on by most people to physically produce a photographic image. Historically, these companies set the physical boundaries and the general framework that came to be considered standard practice and within which most photographers must operate. Additionally, market forces, including competition, are prime factors in determining product availability. The second bias comes

from each photographer's internal predilections and how they use these systems to create specific images. Every photograph reveals the photographer's point of view – a combination of the subject, the photographer, and the process. The third bias is in the personal experiences viewers bring to determine what a photograph means to them. The fourth bias consists of external cultural forces, including academic social/economic/political/media trends, which steer public perception in particular directions at any given time.

Initial Modifications to Photographic Images

Even before the advent of photography the technical exploitation of new inventions, such as dioramas,[2] were made possible by compositing many images. Just past the dawn of photography, methods that could alter the photographic reality were widely practiced and accepted. Practitioners of photography had no qualms about modifying a process to improve and/or fit their aesthetic and technical requirements. For instance, people noticed color was not present so miniature painters began applying the missing ingredient directly on daguerreotypes and paper prints to meet the demand to reproduce color, setting the precedent of hand-applied synthetic color.

Extensive manipulation of the daguerreotype demanded more resourcefulness. By the early 1850s John A. Whipple of Boston patented a vignetting method to produce what he called "crayon daguerreotypes." In this method a hole is cut in a piece of white card stock and attached to a wire frame, which is placed between the camera and the sitter so that light reflects on the surface. During the exposure it is kept in motion, in a manner similar to burning in a print under the enlarger, to produce a blurry white vignette that allows the image of the sitter to fade to white on the outer edges. The result is the subject's head visually projects itself forward, while the shoulders softly "dissolve" into the white background.

As early as 1858, the photography manual *The American Handbook of the Daguerreotype* provided instructions for using masking and double exposures to make one person appear twice in a single photograph. In the 1840s Henry Fox Talbot sometimes chose to wax his paper calotypes (the first negative/positive process) after development to make them more transparent. Also during this time, the first photographic studios added backdrops to provide the illusion the subject was somewhere else, such as beside a window that looked out onto a local landmark or natural scenery. This increased their visual detail and contrast, making them easier and faster to print. In 1848 Gustave Le Gray introduced a waxed paper process in which the wax was incorporated into the paper fibers before the paper was sensitized. This chemically and physically altered the speed and tonal range of the paper negatives and produced a result different from the waxed calotype. Photographers such as Charles Nègre, David Octavius Hill, and Robert Adamson used a pencil on calotype negatives to alter tonal relationships, increase separation of a figure from the background, accent highlights,

FIGURE 1.4 The presence of the artist's hand is evident in Mitchell's work. He refers to this body of images as "blanketscapes," artificial landscapes made by substituting blankets for geographical elements. He then combines these images with those of actual landscapes to make a collage that bears the indexical markings of the fragmentation and reconstruction steps of his method. After creating the collage, Mitchell transfers the image to a tintype plate using AG-Plus liquid emulsion. Though each tintype is unique, Mitchell relies on previsualization throughout the creation process to control the outcome.
© Blue Mitchell. *The Calling*, 2005. 8 × 10 inches. Tintype.

add details or objects not included in the original exposure, and remove unwanted items.

One might think that such practices would have revealed the malleability of photography from its beginnings, but this does not seem to have been an issue. Perhaps people were bedazzled by the process itself or considered such effects as hand-coloring to be positive enhancements, making for a truer picture. Whatever their thoughts, for the most part people ignored how the human hand so frequently revised the so-called mechanical objectivity of photographs both before and after the moment of exposure.

Combination Printing

Combination printing from multiple negatives became fairly common in the mid-to-late 1800s. The collodion, or wet-plate, process, which became the major commercial photographic method of the 1850s, possessed a low sensitivity to light that hampered the making of group portraits. The wet plate's limited sensitivity to blue and ultraviolet (UV) light made it impossible to record naturalistic, full tonal range landscapes. If the exposure for the subject or landscape was correct, the sky would be grossly overexposed, and when printed would appear, at best, as a mottled, unpicturesque white. Combination printing was developed to overcome these inherent technical problems. For instance, Gustave Le Gray made separate exposures

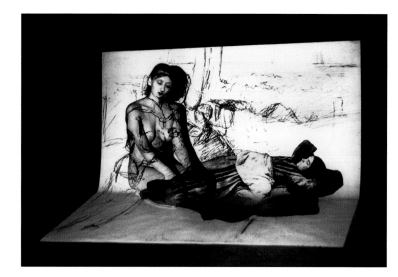

FIGURE 1.5 Throughout Tracz's *Renude* series, the artist reinterprets and reconsiders iconic photographic nudes. To create this image, he projected photographs of nudes, originally taken by Henry Peach Robinson in the 1850s, onto contemporary nude models. The resulting image serves as both a depiction of and a deconstruction of the role of the nude in photographic history. Tracz elaborates, "My purpose is to demystify and bring to social reality the practice of (mostly female) depictions of nudity."
© Timothy Tracz. *Robinson Renude #185*, from the series *The History of Art Renude*, 2002. 12 × 18 inches. Gelatin silver print.

for his landscapes – one of the ground and another for the clouds and sky that then, through the use of masking, were printed on a single piece of paper. This technique received a great deal of attention with the unveiling of Oscar Gustav Rejlander's *Two Ways of Life* (1857), an image made from 30 negatives. Through the photographs and writing of Henry Peach Robinson in *Pictorial Effect in Photography* (1869), combination printing became the method of choice for serious photographers of artistic intent.

Amateurs Push the Boundaries of Accepted Practice

As paper prints became the most popular method for making photographic images, amateurs formed camera clubs that began issuing their images in limited edition albums. Following the example of the daguerreotype, Alfred H. Wall, a former miniature and portrait painter, promoted the practice of applying color in his *A Manual of Artistic Colouring as Applied to Photographs* (1861). Writing that painting over a photograph was no less acceptable than painters such as Leonardo and Titian painting over the *abbozzo*,[3] Wall complained that artists repudiated colored photographs because they were not paintings while photographers rejected them because they were not true photographs. He saw no reason for censuring work that combined "the truth of the one with the loveliness of the other." Composite and hand-colored images took time and deft handwork. The additional time was seen as a way to make photography less mechanical and more artistic. This in turn increased a photograph's value and encouraged photographers to portray subjects previously reserved for painters.

Amateurs pushed the boundaries of accepted practice and explored a more personal style of expression than the commercial studios. Rejecting the genteel and preordained poses of the commercial studio in favor of a more active image, they pictured a wider range of facial expressions

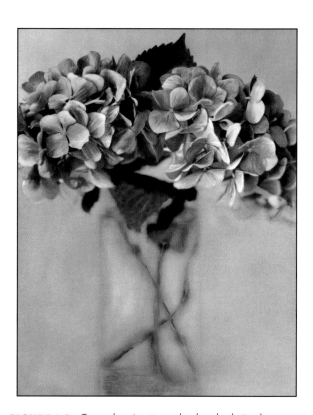

FIGURE 1.6 Carnochan is attracted to hand-coloring because she is "moved by the ways in which the imagination colors everyday life and creates private views of experience, whether revealed in words or in images." After printing this floral study on a warm-tone, semi-matte paper, she used cotton swabs to paint the work with oils. Erasers allowed the artist to hand-alter the work further, creating highlights and manipulating the painted areas, until the image on the paper matched the image in her mind's eye.
© Brigitte Carnochan. *Hydrangea*, 1999. 11½ × 9 inches. Hand-colored gelatin silver print. Courtesy of Modernbook Gallery, Palo Alto, CA.

FIGURE 1.7 For his *Portrait Collages* series, Tracz created a "fictitious family album of surreal snapshots," influenced by nineteenth century travel photographs. He collaged found portrait photographs with his own landscape photographs, giving new rationale to extant images. Whether the collages appear logical or uncanny, they highlight the disruption that Tracz has purposely created by altering the scale of the original images as he sees fit, making elements of human involvement and uncertainty decidedly visible.
© Timothy Tracz. *07_00_01*, from the series *Portrait Collages*, 2000. 9½ × 13 inches. Inkjet print.

and postures. In the 1860s, one such amateur, Lady Filmer, made early collages that combined carte-de-visite portraits (2½ × 4 inch prints attached to a paper card) with watercolor designs of butterflies and floral arrangements. These pieces, with their occasional sexual allusions, reveal a pre-Freudian spirit of unconscious association, aspects of mental life not subject to recall at will. At the time, such expressions could only be made with pictures, as the terminology to discuss them did not exist yet. Photographic montage allowed people of various levels of artistic skill to take everyday events and re-orient them in time and space. This positioned photography as a medium that invited artists to delve in the free association, cut and paste world of dreams, enabling the unconscious, repressed residue of socially unacceptable desires and experiences to come to conscious recognition.

Cartes were commonly collected into albums of friends and family, a practice that thrives today in digital imaging in the form of photosharing websites such as Flickr and Snapfish. This impulse is also very active on social-centric Internet sites such as Facebook and MySpace.

Postcards

An off-shoot of the carte, the postcard format, about 3½ × 5½ inches, was patented in the US in 1861 and spread to Europe around the end of the decade. It became a popular folk art genre with fantastic photomontaged cards becoming popular in the Victorian and Edwardian

periods. At the turn of twentieth century America, free rural delivery; reduced rates for cards; small, folding, handheld cameras; and the new postcard-size printing papers contributed to making the postcard immensely popular. The postcard's form and style threw the sacred rules of picture making to the winds. Proverbial joke cards, such as the Jackalope (a jack rabbit with antlers) and enormous fruits and vegetables, played with visual veracity and sense of scale to startle viewers and express an irreverent sense of good humor in how the subject is depicted. Others served as documents, from the exotic and bizarre to the commonplace and mundane, commemorating people, places, and events from the World's Columbian Exposition (the Chicago World Fair of 1893) to Dallas's Dealey Plaza where President John F. Kennedy was assassinated.

The Stereoscope

During the Great Exhibition of 1851 Queen Victoria became captivated by Sir David Brewster's refracting stereoscope. After a special one was made for her, within 3 months a quarter million stereoscopes and millions of stereo cards sold in London and Paris, touching off a Stereo Craze. By 1856, the London Stereoscopic Company, whose motto was "No home without a stereoscope," had sold an estimated 500 000 inexpensive stereo viewers. The ease of reproducing wet-plate collodion images insured cheap paper stereo cards. Mass production allowed the "optical wonder of the age" to find its way into middle and upper economic level homes, and made the stereo craze photography's biggest nineteenth century bonanza, remaining popular as a educational tool up to World War II.

Not only was the viewing experience of the stereoscope radical, stereo cards also dramatically democratized the subject matter of picture making in a manner people recognized and understood. Although too small for many general artistic effects, cards did portray a scene both during daylight and at night and featured numerous optical special effects, such as double exposures that were utilized to produce spirit cards. The serial aspects of certain cards that were sold in sets can also be considered precinematic in how they represented time and space.

The strength of stereo cards was to provide a plenitude of representations, and people clamored to see anything they could not see for themselves. Oliver Wendell Holmes proposed creating a comprehensive stereographic library. In this context, the stereo card was the forerunner of Wikipedia – a home encyclopedia for the eye, providing a visual reference of outer reality that was a consummate manifestation of the empiricism of the Enlightenment. In the Age of Reason, the empirical mindset depended on direct experience and/or observation. The camera, with its seemingly neutral recording, could represent the naive, ideal, and rational. If an encyclopedia is a source where data is collected, then anyone with a camera could collect evidence. The concept that one could be educated through the use of photographs and that history could be recorded and learned by means of photography got a boost from the stereo card. Additionally, everyday activities, such as

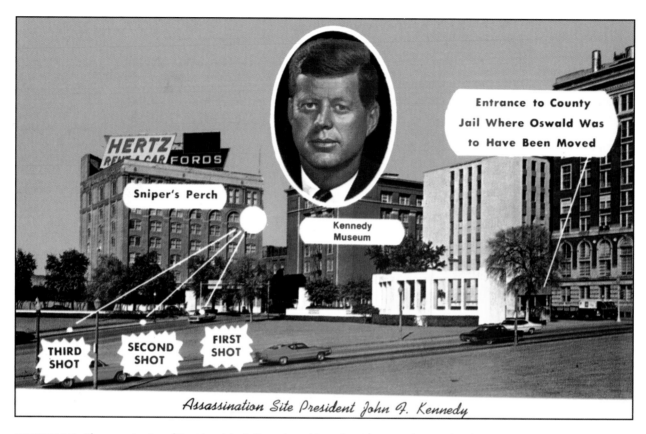

FIGURE 1.8 The assassination of President John F. Kennedy on November 22, 1963 distressed and saddened the US. Postcards marking the event were an unpretentious, low-cost form of manipulated, photographic-based commemoration, which provided a way for people to try and comprehend the part of human nature that leads people to believe murder will solve their problems. The Warren Commission concluded Lee Harvey Oswald was the lone gunman, but others had their doubts, spawning numerous conspiracy theories, none of which has ever been proven.
Assassination Site President John F. Kennedy, circa 1970s. 3½ × 5½ inches. Curteichcolor® 3-D Natural Color Reproduction. Courtesy of Robert Hirsch Collection.

men drinking beer, families having dinner, a hometown band playing, appeared as a presnapshot innovation. The popularity of stereo cards, made possible by the collodion process, demonstrated that people not only wanted images of themselves and their loved ones but also of their world. This desire for visual information, and the potential profits that could be made by supplying it, led photographers into situations not yet visually recorded.

Spirit Photography

Spirit photography, stereoscopic ghost images generally made through extended and/or multiple exposure, were originally intended as mass-market amusements. However in 1861, a Boston engraver named William H. Mumler claimed to photograph actual ghosts. This extension of photographic time touched off an international wave of spirit photography and a scientific controversy that lasted well into the twentieth century, eventually including all types of paranormal photography.

The Hand-Held Camera and the Snapshot

In the late 1880s, the advent of flexible roll film and affordable, simple-to-use hand-held cameras, such as the Kodak, kick-started the process of allowing ordinary people to make photographs of their own daily existence. The Kodak initiated a new dialogue among the maker, subject, and viewer, continuing photography's ability to create a broader sense of visual democracy. George Eastman astutely marketed the camera to people who had never taken a photograph and, in doing so, reformed the boundaries of photographic practice. In providing an industrial support system capable of producing standardized materials to maintain the new practice, Eastman and his Kodak transformed a decentralized practice into a mass retail market of goods and services. With the introduction of daylight loading film and his inclusive motto, "You Press the Button, We Do the Rest," Eastman launched the photo-finishing industry that ultimately made the camera

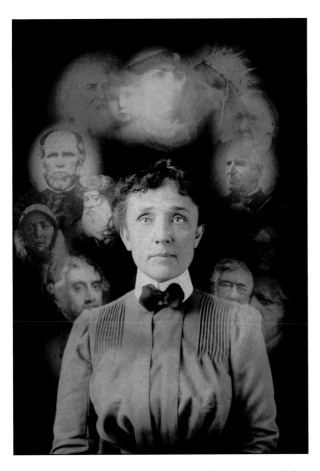

FIGURE 1.9 Using multiple exposure, Fallis superimposed the faces of several deceased figures over the figure of a living woman supposedly in the midst of a séance. Though spirit photography originated as an amusement, it raised important questions of the level of trickery and truth in photography. The experimentation with time and the construction of meaning through numerous exposures with which Fallis and other spirit photographers became involved continue to influence the methodology and thinking of contemporary photographers. © S. W. Fallis. *[Spirit Photograph Supposedly Taken During a Séance]*, circa 1901. Courtesy of Library of Congress, Washington, DC.

an integral part of middle-class American life. By enabling a wide-ranging cross-section of the population to actively join the imagemaking process without any special training, the Kodak contradicted the proclamations of artists and scientists that special equipment and training were needed, marking the start of photography as a popular pastime.

The snapshot shooter's interest was generally personal, often picturing family members and activities. This unpretentious outlook had a deceptively simple freshness capable of changing the attitude of an observer toward a subject. The snapshot genre was not the invention of an individual, but rather an extended collaborative process of exploring the prosaic that relied on consensus to establish meaning. The will of the individual was set aside in favor of community consent, with a partiality for familiar moments positioned in the center of the frame with little thought to what was occurring in the rest of the scene. The snapshot's proliferation after World War I signaled professionals were no longer necessary to make basic record pictures, forcing them to become proficient in highly specialized applications, such as studio lighting, which was beyond the scope of hobbyists. The hand-held cameras renewed interest in making prints that were larger than the original negative, encouraging enlarging and its accompanying aesthetics to become universal practice.

The ease of producing a snapshot encouraged people to take chances just to see what would "come out." The sheer number of photographs being taken increased the impact of chance, leading George Bernard Shaw to say: "The photographer is like the cod which produces a million eggs in order that one may reach maturity."[4] Through its million incarnations, the snapshot altered the visual arts. While meeting certain basic pictorial expectations, the snapshot also invited chance and the unexpected. This element of surprise could reveal a subject without adornment, covering another or a different kind of truth. The snapshot attitude became provocative when gaffes, previously eliminated by professionals, were adopted as working methods by serious imagemakers. What were initially accidents, such as informal framing, unexpected cropping, unbalanced compositions, skewed horizon lines, unusual angles, weird perspectives, banal subject matter, extremes in lighting, out-of-focus subjects, blurring, double exposures, extended time exposures, and poor quality optics, grew into conscious design. These ideas and ways of seeing began to transform pictorial conventions, influencing modern art movements, from surrealism to Dadaism. This reached a high point in the late 1960s with the so-called snapshot aesthetic being practiced by highly trained professionals, which set themselves in opposition to the ideals of the classical photographic customs.

Picturing Time

The technical innovations of the nineteenth century altered and expanded the perimeters of human vision in art and science. As early as 1834, Sir Charles Wheatstone observed that an object painted on a revolving disk appeared to be stationary when illuminated by intense electric light. He also noticed that flying insects seemed to be fixed in mid-air by the same means. In 1851, Henry Fox Talbot attached a page of *The London Times* to a swiftly revolving wheel in a darkened room, uncapped the lens of his camera, and made an exposure of about 1/100 000 of a second by means of an electric spark, sharply freezing the action of the moving paper. Talbot concluded that pictures of moving objects could be made by illuminating them with a sudden electric flash. By the 1860s, as previously mentioned, photographers were making instantaneous stereoscopic views that arrested the action of people walking on the street. In 1887 Ernst Mach, an Austrian scientist, used an electric spark (the

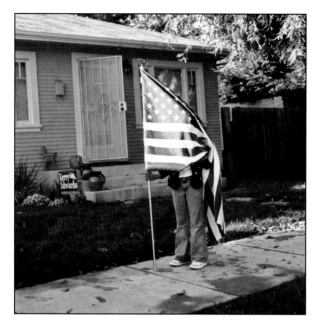

FIGURE 1.10 In the manner of an archetypal snapshot, Billingslea quickly "grab shot" this portrait. Though her act of composition and capture was almost instantaneous, Billingslea's processing was very deliberate. After developing her T-MAX film in T-MAX developer, she printed this image on fiber base paper and processed it using Lauder chemistry, one of many small companies making black-and-white chemistry. She later increased the print's highlight detail and permanence through selenium toning. © Renee Billingslea. *American Flag, Santa Clara, CA,* 2004. 15 × 15 inches. Gelatin silver print. Courtesy of Michael Rosenthal Contemporary Art Gallery, Redwood City, CA.

precursor of flash) as a lighting source to make postage-sized, stop-action images of projectiles moving at over 750 miles per hour. By the mid-1890s, spark exposures of one-millionth of a second were being made by scientists such as Lord Rayleigh and Théodore Lullin (who photographed dripping tap water) and A. M. Worthington (who photographed splashing milk), providing the first images of previously unseeable occurrences. What these photographs depicted was often startlingly different from earlier visual depictions, making it obvious that human vision was unreliable for detecting events that unfolded in fractions of a second.

Up until the 1880s, most people considered photography to consist of single images that depicted and made a subject known to the viewer. The work of Muybridge, Marey, and others opened the possibility of learning more about a subject through a series of photographs that occurred over time. These new ways of conceptualizing time and motion shifted society's understanding of the present moment as a singular instant to that of a temporally extended continuum. This profound transformation in understanding and experiencing time encouraged photographers like Nadar to experiment in the portrait studio with extending the amount of visual time a viewer had to know a subject by presenting an extended collection of

moments. In 1886, Nadar published a photo-interview, *The Art of Living a Hundred Years,* based on a series of 21 exposures made by his son Paul as Nadar conversed with the French scientist Michel-Eugene Chevreul on his 100th birthday. Chevreul's commentary formed the captions to the photographs, which were reproduced via the new *halftone process* that allowed photographs and text to be simultaneously printed together. The serial use of sequential photographs combined with an interview resulted in a new format: the photo-essay. These newly developed methods affected the look and content of photographs and further altered society's sense of how time and space were visually represented.

Photography into Ink: The Halftone Process

In 1842 the search for a process that would bring photography into the arena of publishing led Hippolyte Fizeau to devise a method for making prints from etched daguerreotypes, but it was impractical. The breakthrough came in the work Talbot did for what would come to be known as the *halftone process.* The halftone process permits a continuous tone image, such as a photograph, to be printed simultaneously with text. The halftone principle utilizes an optical illusion in which tones are represented by numerous small dots of different sizes having equal optical density and equal spacing between their centers. In printing, the halftone screen divides an image into tiny dots that deposit ink on paper in proportion to the density of the original image tones in the areas they represent. By the 1890s, refinements in the halftone process made it economically feasible to print text and monochromatic images together, ending the era during which early photographers acted as small independent publishers of their own images. As photomechanical reproduction improved during the first decades of the twentieth century, picture magazines used more photographs for illustration and in advertising and found that their sales rose, which propelled their use.

The Photo Magazine

Improvements in the halftone process made it a crucial component of the twentieth-century newspaper's dynamic graphic system of type, drawing, and photographs, Attaching text to a photograph, generally by an editor, editorial committee, or paying client, was a way to stabilize its free-floating meaning and deliver a message in an instructive mode with a distinct point of view. In a technologically based culture that is dependant on precise definitions, a multiple reading of a news photograph was not considered desirable. The control of meaning for commercial, editorial, and political purposes was refined by German illustrated magazines, such as *Berliner Illustrierte Zeitung* (Berlin Illustrated Newspaper, founded in 1890), the *Münchner Illustrierte Press* (*Munich Illustrated Press,* 1923), and *AIZ* [*Arbeiter Illustrierte Zeitung* (Workers' Illustrated Newspaper), started in 1921]. Their illustrated lessons about how to influence viewer reaction to visual media were quickly

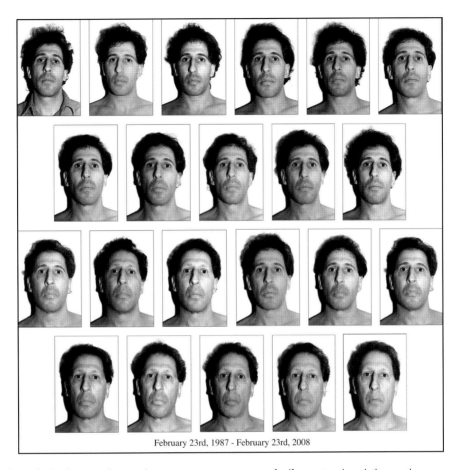

February 23rd, 1987 – February 23rd, 2008

FIGURE 1.11 Baden rethinks photographic time by constructing a sequence of self-portraits taken daily over the course of 20 years. Keeping things simple, he uses as a Pentax K1000, a tripod, and a white backdrop, and processes the film and resulting prints following ordinary, by the book procedures. Baden explains, "It is vital that each day's image be no more and no less than a visual record, a facsimile of its subject. I consciously avoid beauty. I standardize the technical and logistic aspects of this procedure to the extent that only one variable remains: whatever change may occur in my face, measured obsessively and incrementally, day after day, for the rest of my life." © Karl Baden. *Twenty-Two Faces*, from the series *Every Day*, 1987–2008. Dimensions variable. Inkjet print. Courtesy of Howard Yezerski Gallery, Boston and Robert Mann Gallery, New York.

absorbed and conveyed throughout the world, especially in American publications including *The Saturday Evening Post* (1821–1969), *Colliers* (1888–1957) and *The Ladies Home Journal* (circa 1883 to present).

By the 1930s, the expansion of the audience for photographs changed the subject matter depicted. Previously, photographers could make a living selling postcards of local scenes and people. Now, to reap the economic advantages of the new technology, publishers, such as Henry Luce, founder of *Time*, *Fortune*, and *Life*, needed subjects that interested large audiences, leading to the glamorization of places and people from the Fork Peck Dam to Greta Garbo.

Photomechanical Reproduction and Meaning

Photomechanical reproduction made pictures ubiquitous and altered concepts of art while raising issues of control and censorship. In "The Work of Art in the Age of Mechanical Reproduction" (1936),[5] Walter Benjamin stated that even the best reproduction has an imperfect presence, therefore it lacks a unique existence, an authenticity, a state of being and authority he called *aura*. Benjamin wrote that reproduction eliminates aura, shatters tradition, and emancipates a work of art from its dependence on ritual, reducing the distance between artists and viewers and making the work more accessible. The breakdown of aura and its replacement of reality with reproduction altered conventions, but the loss of contact with the authentic (original) left a spiritual vacuum of "second-hand" experiences. As photography-based reproduction became routine during the twentieth century, the authentic individuality of an art work and, in turn, the personal self suffered from a mounting sense of alienation due to a loss of belief in the power of nature and its replacement by technology. This is a great irony in light of the fact that such technology was first welcomed by many

in the art world as a cost effective way to increase the circulation of their images. By the close of World War II, American artists who previously portrayed the beauty of the natural world joined their European counterparts in turning inward to find subjective responses to their existential woes. Ironically, as inky reproductions age they become "antique images" with a patina of nostalgia and our culture then reassigns an aura, based on the romantic sentiments about the passage of time. This liberates the reproductions from their primary function, converting them into new ways of seeing the past based on the present. Also, Benjamin does not take into account works, such as John James Audubon's prephotographic (engraved in aquatint) catalog *The Birds of America* (1827–1838), regarded as one of the most superlative picture books ever produced, designed to be seen as reproductions.

The Pictorialists

As market forces experimented with the mass distribution of photographic images during the 1890s, individual explorations into the artistic application of photography experienced a heyday as manipulative methods, especially gum printing, were investigated. This type of printing was favored by the Pictorialists and championed through the work and writing of Alfred Maskell and Robert Demachy in *Photo Aquatint*, or *The Gum Bichromate Process* (1897). The Pictorialists stressed the atmospheric and formal effects of the image over those of the subject matter. Composition and tonal values were of paramount concern. Soft-focus lenses were used to emphasize surface pattern rather than detail. Pictorialists did not want to be bound by the tyranny of exactitude. These expressive printmakers favored elaborate processes to show that photography was not a mere mechanical process, but could be controlled by the hand of the maker and therefore be a legitimate visual art form. The Pictorialists' attitudes and procedures dominated much commercial portrait and illustrative work throughout the first part of the twentieth century, with an emphasis on how beauty could be constructed as opposed to found in nature.

The Secession Movement and the Rise of Photography Clubs

The early 1890s saw the commercial and scientific values of earlier photographic and art societies challenged by supporters of the new aesthetics. The *Secession movement* reflected the disenchantment of younger artists with the practices and exhibition policies of established Western art societies and led to the formation of alternative institutions in Berlin, Munich, and Vienna, among other places. In photography it led to the creation of the Wiener Kamera Klub in 1891, the Brotherhood of Linked Ring in London in 1892, the Photo-Club de Paris in 1894, and the Photo-Secession in New York in 1902.

The Linked Ring

The Linked Ring, a loose group of photographers disenchanted with the Photographic Society of London's exhibition policies, was one of the most influential secession groups. The "Links" found alternative venues to display and promote photography as an independent medium whose works could be evaluated in their own context and terms rather than by their ability to imitate other media. This privileged club (membership by invitation only) was founded by educated men including Emerson, Robinson, Alfred Maskell, George Davis, and Alfred Horsley Hinton, editor of *The Amateur Photographer*, begun in 1884 as the first magazine to cater to nonprofessionals. Their first exhibition of some 300 prints, in 1893, generated a stir for being mindfully hung, asymmetrically, breaking with the Photographic Society's Victorian tradition of cramming pictures of different sizes and subject matter frame to frame from the floor to the ceiling. The Links wanted more stringent exhibition standards: they were fed up with how all types of photographs were massed together on a gallery wall, the awarding medals to mediocre formula pictures, and the use of nonphotographers to jury show entries. They adopted a motto: "no medals and rigid selection." The Links wanted to separate utilitarian work, whose goal was to record facts, from aesthetic photographs, whose goal was to express beauty. They sought "complete emancipation of pictorial photography...from the retarding...bondage of that which was purely scientific or technical [so it could pursue] its development as an independent art."[6] Their annual Salon of Pictorial Photography continued to be an important exhibition site until the group dissolved in 1910.

The Photo-Secessionists

In the US, the Pictorialists were followed by the Photo-Secessionists, under the leadership of Alfred Stieglitz. The active group included Joseph Keiley, Gertrude Käsebier, Frank Eugene, Edward Steichen, Alvin Langdon Coburn, and Clarence White. In their quest to have photography recognized as an art form, they experimented with a wide variety of printmaking methods. The Photo-Secessionists' ideals culminated in the International Exhibition of Pictorial Photography (1910), at the Albright Art Gallery in Buffalo, NY. But by this time, a number of the group's members, including Stieglitz, had abandoned the ideas and working concepts of the manipulated image. The Pictorialists did not update their working concepts, and faded as an innovative art movement by the mid-1920s.

Autochrome

The Photo-Secessionists were also the first to artistically experiment with Autochrome, the first widely available color process (1907) to become commercially successful. Autochrome could be used in any regular plate camera, giving photographers access to direct color image capture, albeit in a soft, suggestive pastel color scheme. Although expensive and technically limited, which greatly limited its use, Autochrome cracked a major aesthetic barrier, and publications such as *National Geographic* began using it as the basis for color reproductions. The Pictorialists found the early color processes foreign to their visual vocabulary and were frustrated by the limited amount of

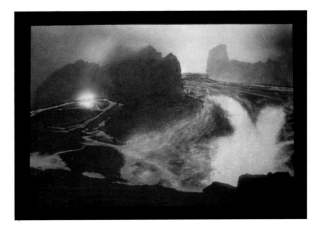

FIGURE 1.13 Clatworthy, a self-taught imagemaker, made his living photographing scenic wonders. Though he worked primarily in the Rocky Mountains, Clatworthy also traveled widely, often while freelancing for *National Geographic*, which reproduced over a hundred of his autochromes. He made this autochrome in 1928 while traveling in New Zealand and Hawaii. Clatworthy hand-colored the plate to vivify the glowing lava. His manipulation serves to convey the emotional reaction prompted by the volcano's eruption, intensifying the violence and explosiveness of this scene.
© Fred Clatworthy. *Lava Flow*, 1928. 5 × 7 inches. Autochrome. Courtesy of Mark Jacobs Collection.

FIGURE 1.12 Wetzel's series *without the elephants* explores death, memory, and introspection. She utilizes the ambrotype for the brilliance and clarity the process lends to pictorial images. Additionally, she can easily combine twenty-first century darkroom techniques with this nineteenth century process. For this image, Wetzel produced a wet-plate collodion positive transparency from a quarter plate collodion negative. She made a 2 minute exposure to produce the negative and later a 45 second exposure in the enlarger to generate the positive transparency.
© Heather Wetzel. *November and April*, from the series *without the elephants*, 2004. 10 × 8 inches. Collodion positive transparency.

the photographer was to discover the camera's own visual code. He stated that through one's selection of framing, lighting, and selective focusing, good images could be made. Emerson emphasized photographing subjects in their natural surroundings without any of the artificial manipulations of the combination printers. He came under heavy criticism for these ideas and recanted with "The Death of Naturalistic Photography" (1890), but the seeds of what would become the "straight" photography movement had been sown.

technical control they could exercise over the materials. They therefore continued to favor processes such as platinum/palladium in which they could manage the tone of the final image, adding colors as they saw fit.

Naturalistic Photography

Major objections to the concepts and methods of the combination printers and pictorialists were raised in Peter Henry Emerson's *Naturalistic Photography* (1889), which attacked the concepts of combination printing. Emerson called for simplified working procedures and "selective naturalistic focusing." This visual approach was supposed to allow the photograph to more closely replicate human vision, in which not everything is seen clearly and sharply. Emerson thought the obligation of

The Straight Photographic Aesthetic

After his work in Pictorialism came to a close, Stieglitz began to promote a straight photographic aesthetic in the US at his 291 Gallery and in the final issues of his publication, *Camera Work*, as exemplified in Paul Strand's photographs made around 1916. Strand had successfully incorporated the concepts of painterly abstraction directly into the idea of straight, sharp-focus, minimally manipulated photography. He believed that photography's raison d'être was its "absolute unqualified objectivity," which could be found by investigating the medium's own inherent characteristics. The emphasis of the art of photography switched from postexposure methods to creating the image in the camera at the moment of exposure and maintaining a narrow range of simplified printmaking techniques that relied mainly on burning and dodging of dark and light tonal values.

FIGURE 1.14 Dawson's work echoes the ideas put forth in Peter Henry Emerson's *Naturalistic Photography* (1889). Photographers, such as Alfred Stieglitz and Paul Strand, later expanded this position into straight, sharp-focus, minimally manipulated photography. The credo of straight photography is based on the premise of previsualization – that a work is fundamentally created at the moment of exposure rather than after the exposure through postvisualization techniques. © Robert Dawson. *Japanese Bridge and Geothermal Plant, Iceland*, from the *Global Water Project*, 2004. 16 × 20 inches. Gelatin silver print.

FIGURE 1.15 Tice purposely utilized a wide-angle lens on his 8 × 10 inch Deardorff camera to exaggerate the diner's angularity. The 30 second exposure provided adequate shadow detail in the milk crates piled up at the back of the diner. He anticipated the pattern of lights produced by the cars rounding the curve of the highway, making it a central compositional device that leads the viewer's eye through and around the picture space.
© George Tice. *White Castle, Route #1, Rahway, New Jersey*, 1973. 8 × 10 inches. Gelatin silver print.

Previsualization

Edward Weston's work, from the late 1920s on, represents the idea of straight photography through the use of what has been referred to as previsualization. Weston claimed that he knew what the final print would look like before he released the camera's shutter. This notion of seeing the final image ahead of time would bring serious printmaking full circle, back to the straightforward approach of the 1850s, when work was directly contact printed onto glossy albumen paper. Weston simplified the photographer's working approach by generally using natural light and a view camera with its lens set at a small aperture. He produced a large-format negative that was contact printed (no enlarging) with a bare light bulb. Photographic detail and extended tonal range were celebrated in a precise black-and-white translation of the original subject on glossy, commercially prepared paper. By eliminating all that he considered unnecessary, Weston wanted to get beyond the subject and its form and uncover the essence or life force of "the thing itself" – an unknowable, inexpressible reality that lies "behind" or beyond what we can observe with our five senses.

Group f/64 and the Zone System

In 1932, a band of California-based photographers, including Weston, Ansel Adams, Imogen Cunningham,

Sonya Noskowiak, and Willard Van Dyke, founded Group f/64. Their primary goal was to create photographs of precise realism without any signs of pictorial handwork. The name of the group reflects the fact that the members favored a small lens aperture that enabled them to achieve images with maximum detail, sharpness, and depth of field. They concentrated on natural forms and found objects that became synonymous with the naturalistic West Coast style.

The ideas from Group f/64 were refined and expanded by Ansel Adams in his Zone System method. The Zone System is a technical method for controlling exposure, development, and printing to give an incisive translation of detail, scale, texture, and tone in the final photographic print. Adam's codification of sensitometry continues to set the standards for pristine wilderness landscape photography. The Zone System, as taught by Minor White and others, was so popular and successful that it dominated serious photographic printmaking throughout the 1960s and 1970s.

Photographic Collage/Montage and Modernity

Although its roots can be traced back to photo albums of the 1860s, photomontage became the pre-eminent symbol of Modernity during the 1920s and 1930s, defining the relationship between individual artists and the growing mass. A photographic collage is created when cut and/or torn pieces of one or more photographic images are attached to a common support. A photographic montage is produced when a collage is photographed to convert it back into a photographic image. Utilizing advertising, books, magazines, and newspapers, European artists began cutting and pasting to forge a form that helped explain the crumbling of Europe's great empires and the new society that was evolving after the ghastly devastation of World War I.

The passionate, political photomontages of John Heartfield were specially constructed for reproduction on the printed page. According to fellow Dadaist George Grosz, he and Heartfield "[re]invented the photomontage in his studio at five o'clock on a May morning in 1916."[7] Both were likely familiar with the cutting and pasting of images done by soldiers on the Western front to get reports of the absurd slaughter of World War I past the censors. They called their approach montage, meaning "assembly line," and termed the maker a "monteur," or "engineer/mechanic," indicating that the picture was "engineered," not "created."

Heartfield most often appropriated images that he then metaphorically reassembled, especially pictures dealing with the racist Nazis, dramatically subverting their original intent to make scathing social commentary. The photographic nature of montage lends it credibility. Its photographic exactness makes printed advertisements successful and observers are convinced of its message before they have time to analyze how they have been persuaded.

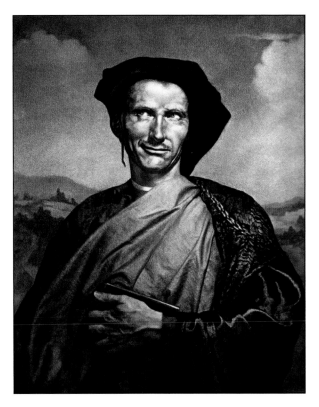

FIGURE 1.16 In his essay "Fallacies of 'Pure Photography,'" Mortensen challenged the hypothesis of Group f/64 by stating, "Purists and puritans alike have been marked by a crusading devotion to self-defined fundamentals, by a tendency to sweeping condemnation of all who over-step the boundaries they have set up, and by grim disapproval of the more pleasing and graceful things in life".[8] Mortensen etched the original negative to remove unwanted detail. He then elongated the image during the enlargement process and made the projection through a texture screen. For details about his printmaking methods, including the Abrasion-Tone Process he used to make this image, see William Mortensen, *Print Finishing*, San Francisco: Camera Craft Publishing, 1938.
© William Mortensen. *Machiavelli*, from the book *Monsters and Madonnas*, 1936. 10¼ × 8¼ inches. Abrasion-tone gelatin silver print. Courtesy of Robert Hirsch Collection.

Hannah Höch's montage work offered insight into the *new woman*, the official redefinition of women's roles going on in German society. The increase in mass print media, Höch's raw material, supplied her with fresh images of women's changing identity – working, using appliances, and modeling in advertisements. Höch explored the intersection of avant-garde photomontage and the splintered experience of daily life in Weimar Germany. Her work deployed allegory, caricature, the grotesque, and irony, reflecting the Dadaist concern with alienation (*Verfremdung*) and estrangement, taking the familiar and making it unfamiliar, and refashioning photo-based images into photomontages.

Bauhaus

The 1920s was a period of great artistic experimentation, and at the forefront, dealing with the "realm of the fantastic," was the innovative Bauhaus master László Moholy-Nagy, who sought a purely photographic approach independent of all previous forms of representation. Moholy urged investigation into "the new culture of light" so that "the strongest visual experiences that could be granted to man" could be made available through its

understanding and use. He wanted to use photography to show what the human eye alone could not see, and wrote: "This century belongs to light. Photography is the first means of giving tangible shape to light, though in a transposed and – perhaps just for that reason – almost abstract form."[9] In "Production–Reproduction,"[10] Moholy took the position that mediums primarily used for reproduction, such as photography and film, could be reduced to their most elemental level and then extended on a new, innovative course. For Moholy, "reproduction" stood for imitative or repetitive relationships. "Production" signified the new forms, such as his photograms, appropriate to the world of technology, that make "new, previously unknown relationships ... between the known and as yet unknown optical."

Moholy's practice of montage, which he called *fotoplastik*,[11] was based on the surrealist method of recording the unconscious, but without the movement's

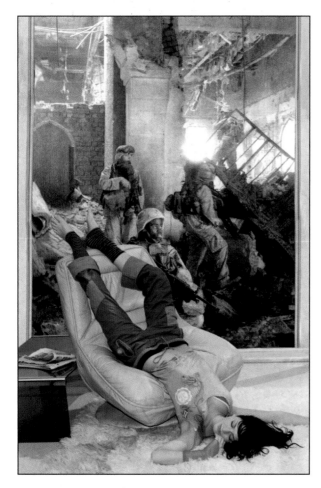

FIGURE 1.17 Inspired by her own Vietnam War era photomontage series, 30 years later Rosler rethought and reinterpreted this work in the context of the Iraq War. Instead of embracing twenty-first century digital montage techniques, she used the same manual cut-and-paste technique she employed in the original work, drawing a further parallel between the two conflicts. The issues of protest and activism Rosler raises in this work links her with early montage artists, such as John Heartfield and Hannah Höch, whose photomontages also protested and satirized politics and war.
© Martha Rosler. *Lounging Woman*, from the series *Bringing the War Home: House Beautiful*. 24 × 20 inches. Photomontage.

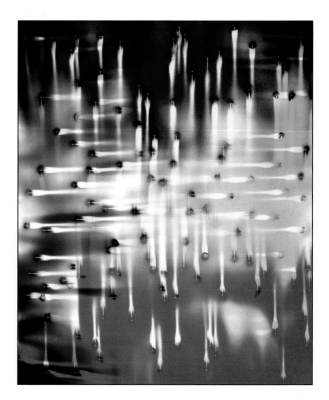

FIGURE 1.18 Carey's cameraless image revisits the photogram, exploring light and four-color photographic theory. To construct this photogram, "the pins are placed directly and at random into the paper's surface in the color darkroom and the paper is exposed multiple times using a color enlarger." Carey values the positive and negative elements as well as the aspects of shadow and light at work in the photogram process, concepts she looks into throughout her experimentation with light to create undefined, abstract expressions.
© Ellen Carey. *Push Pin Photogram (B/Y/R/G)*, 2002. 24 × 20 inches. Chromogenic color print.

attachment to the irrational. Moholy saw his approach as an experimentally disciplined and judicious strategy to achieve an art form that struck a balance between reason and spirit, and between people and their culture. His photomontages relied on the graphic suprematist forms of the circle, cone, and spiral to create multi-perspective compositions. This scheme disturbed Renaissance perspective and its companion formulas for acquiring knowledge through images. Moholy's photomontages juxtaposed contrasting imagery in open compositions, with much of the surrounding space left intentionally blank. The resulting interplay of movement between the fragmented images and the stillness of the unused space applied both optical and psychological pressure on viewers to recreate the same commotion and unstableness they experienced in modern daily life.

Postvisualization

The antithesis of Group f/64 can be found in the images and writings of William Mortensen, as in his essay "Fallacies of 'Pure Photography'" (1934), which rejected the notion of previsualization and the so-called "straight" print and the doctrine of singular aperture as being mechanistic. A sterling craftsman, Mortensen urged imagemakers to manipulate their negatives and prints in any manner to achieve their vision goals. However, despite his expressive ideas on photography, Ansel Adams

FIGURE 1.19 Wood's collage work is based on postvisualization, experimenting with how varying image placement affects meaning. He says, "I started working with photo collages at the Institute of Design in Chicago in the early 1950s. My work in the 1960s was process oriented. I used images from newspapers, magazines, television, and my own resources. Generally, the collages were carefully dry mounted to archival board and invariably had a political commentary. This activity continues up to the present time."
© John Wood. *Nixon and Agnew (Pop Goes the Weasel)*, circa 1960s. 7¾ × 9¾ inches. Gelatin silver print with mixed media.

and key tastemakers, such as Beaumont and Nancy Newhall, shunned Mortensen's work and the concepts that informed it. Additionally, his work featuring nude women in sadomasochistic situations being dominated by men has been labeled politically incorrect, which has had the unintended side effect of throwing the message out with the messenger. During the 1940s and 1950s, the small mainline photographic community ignored non-straight-forward approaches, with a few exceptions such as work done by Henry Holmes Smith, Richard Hamilton, and Wallace Berman.

The 1960s was a time of experimentation in Western society: questioning how and why things were done, trying new procedures, and eliciting fresh outcomes. A rising interest in countercultural ideas sparked a renewal of interest in numerous forgotten photographic printmaking processes and sent many photographers back into photographic history to rediscover alternative techniques and encouraged new directions in imagemaking. This revival of historical methods surfaced with the national recognition Jerry Uelsmann received for his surrealistic use of combination printing that visualized the unconscious working of his mind by the seeming irrational juxtaposition of images, which spread to nonsilver approaches such as cyanotypes and gum printing.

During an era that emphasized a sense of mind-expanding possibilities, the concept of *postvisualization*, in which a photographer could continue to interact with the image at any stage of the process, was reintroduced into the repertoire of acceptable practices. Imagemakers such as Robert Heinecken, Ray Metzker, Bea Nettles, and John Wood began to reject the notion of a single fixed perspective and actively sought alternative viewpoints. Such artists shared a desire for subjective expression, a confidence in the untamed imagination, and an aversion to dogma and fixity in order to question conventional photography, to convey internal realities, and to critique history and the concepts of truth and self. In addition to opening up an avenue to inner experience, artists find handwork attractive because it promotes inventiveness, allows for the free play of intuition beyond the control of the intellect, extends the time of interaction with an image (on the part of both the maker and the viewer), and allows for the inclusion of a wide range of materials and processes within the boundaries of photography.

In the late 1960s, experimental imagemakers began to cut and paste and make use of quick-copy centers, rubber stamps, and old, unwanted printing equipment as they rediscovered the artist-made book as a vehicle to express diaristic and narrative themes as well as those of dreams, friendship, love, sequential time, and social-political issues.

Starting in the 1960s, art departments began adding photography to their curriculum, which encouraged cross-pollination with other media – mixing photography with drawing, painting, and printmaking. This reflected the growing influence of young innovative artists, such as Robert Rauschenberg and Andy Warhol, whose experiments using photography in combination with other media, had a profound impact on the visual arts.

FIGURE 1.20 Nettles' work reflects the concepts of the investigational spirit of postvisualization, with her multiple methods of hand-altering and ongoing interaction with the image throughout the picture making process. Working with the defunct Kwik Print process, she contact printed large ortho negatives multiple times onto the light-sensitive pigment of the Kwik Print process that she had applied onto a sheet of white vinyl serving as the image support base. Nettles further altered the image by scrubbing areas of the pigment after exposure.
© Bea Nettles. *Three Deer*, from the book *Flamingo in the Dark*, 1978. 20 × 26 inches. Kwik Print. Courtesy of Ilene Shane Collection.

FIGURE 1.21 Beard is known for his collage diaries, which he started compiling in 1949 at the age of 11. After discovering photography, he used photographs to extend and enhance them, constructing collages that bear connections to museum dioramas. After reading Karen Blixen's *Out of Africa* (1937), Beard traveled to Africa to photograph wildlife, later combining these photographs with animal blood, remains, and ephemera. Beard says, "I like to think of photography as life-thickening. At the end of the year you've got a fat book that you never would have had if you weren't keeping a diary. You wouldn't have thought so much could happen in a year. I was always marking time, waiting for something to happen to me."

© Peter Beard. *Reflections in Natural History*, 1965/2004. 165 × 65 inches. Gelatin silver print and color collage with found objects mounted to board.

Photographist

Robert Heinecken, a printmaker at UCLA, promoted new ways one could be a photographer. In a 1969 "debate" with Ansel Adams at Occidental College in Los Angeles, Heinecken announced that he and other up-and-coming artists with maverick and rebellious natures had every intention of upending the dominant modernist, objective concepts of photography in their broad desire to challenge conventional systems of thought.[12] A gadfly who provoked by example, Heinecken used the elements of play and wonder to question everyday assumptions and seek out associations among presumably divergent subjects. His work combined various mediums to fashion witty, sardonic, and unexpected cultural connections among food, the media, sex, and violence. Heinecken referred to himself as a "paraphotographer – one who uses "found" photographs rather than going out and making them. Art critic Arthur Danto later used the term *Photographist* to describe the distinction between photographers who make "photography as art" and those concerned with "photography in art."[13]

Heinecken's subject matter, his appropriation of existing images, and the constructed appearance of his finished work – which can be 3-D – all make his approach the antithesis of the straight photography that was dominant in the 1960s and that Ansel Adams, with his transcendental landscapes, quintessentially represented. But even Adams came to acknowledge alternative ways of circulating images by allowing one of his Yosemite photographs to be reproduced on a coffee can (1969), which effectively conveyed his environmental concerns by recycling disposable consumer trash into a collectable object (see Figure 9.5 of a Hills Brothers coffee can featuring a archetypal Ansel Adam's image of Yosemite Valley, CA, which Jo Babcock made into a pinhole camera).

FIGURE 1.22 In his *Are You Rea* series, Heinecken contact printed magazine pages with sexually suggestive photographs of women so both sides of each page could be seen simultaneously as a single blended image. This methodology reveals unexpected visual and textual interactions, in turn generating new ways of seeing and thinking about images. The fragmentation of the text is particularly provocative and is indicative of an anti-illustrative impulse toward evocative and unhindered interpretation. Could "Rea" stand for real, ready, or reasonable? The intuitiveness and openness of Heinecken's technique exemplifies a nondoctrinaire approach to the sexually charged material, suggesting that social truth is variable and unstable.
© Robert Heinecken. *Are You Rea #1*, from the series *Are You Rea*, 1966. 11 × 8½ inches. Gelatin silver print. Courtesy of Pace MacGill Gallery, New York.

EXTENDING PHOTOGRAPHIC BOUNDARIES

Peter C. Bunnell was a groundbreaking promoter of handmade photography in his role as a curator. The year before the Heinecken/Adams debate, Bunnell mounted *Photography as Printmaking* at the Museum of Modern Art (MoMA) in New York City, an exhibit that featured 72 works by 55 artists. One of the artists was Naomi Savage whom Bunnell credited with having "extended the photographic medium by her presentation of the photo-etched plate itself. A simple act, but in its generosity she has brought to the medium a kind of topographic photograph, which modulates forms in three dimension with a variety of metallic surfaces and tones."[14] The three-dimensionality and varied texture Savage utilized to

FIGURE 1.23 Savage's efforts prompted a reconsideration of the limits and definitions of photography. This work, which exists only in photographic plate form, demands the inclusion of unprinted photographic objects to the conceptual boundaries of the field. Her extension of the medium by broadening of the techniques and roles associated with photo-based imagery expands visual horizons and connotations.
© Naomi Savage. *Enmeshed Man*, 1966. 9⅞ × 7¾ inches. Photographic plate. Courtesy of Peter C. Bunnell Collection, Princeton, NJ.

explore the complex relationship between internal and external experience and the indefinite boundaries between the two was so unusual that viewers could not always accept her work as photography. Savage's prominence in *Photography as Printmaking* demonstrated a parallel between the technical liberation that this new generation of artists practiced and social emancipation that heralded a widening role for women in art world.

In 1970 Bunnell followed *Photography as Printmaking* with *Photography Into Sculpture*, a MoMA exhibition that featured works by 52 artists. This exhibit showed how artists were carrying the three-dimensionality of work like Savage's to even greater lengths and embracing "a new kind of photography in which many of the imaginary qualities of the picture, particularly spatial complexity, have been transformed into actual space and dimension."[15] This embrace of three-dimensionality in photography broke emphatically from the modernist dictum that no artistic medium should take on attributes of any other medium.

Bunnell's innovative exhibitions showed a larger audience that photography's essence is nothing more than light sensitive material on a surface. The exhibitions also recognized that the way a photograph is perceived and interpreted is established by artistic and societal preconceptions about how a photographic subject is supposed to look and what is accepted as truthful. The work Bunnell presented was indicative of a larger zeitgeist of the late 1960s that involved leaving the safety net of custom, exploring how to be more aware of and physically connected to the world, and critically examining expectations with regard to lifestyles.[16] For the artists in these exhibitions the camera-defined image was only a beginning that inspired a "postvisualized" image, brought about by their direct physical involvement in its creation.

Unfortunately, during his rein as the director of MoMA's photography department, John Szarkowski showed little interest in experimentation while actively promoting straight photography as exemplified by Diane Arbus, Lee Friedlander, Garry Winogrand, and William Eggleston.

Revisualization

In 1966 Jerry Uelsmann, who taught at the University of Florida, Gainesville, articulated the concept of postvisualization in a paper he delivered at a Society for Photographic Education (SPE) conference in Chicago. Urging photographers to consider the darkroom to be "a visual research lab; a place for discovery, observation and mediation." He went on to say, "Let us not be afraid to allow for 'postvisualization.' By post-visualization I refer to the willingness on the part of the photographer to revisualize the final image at any point in the entire photographic process."[17] Uelsmann's remarks focused on the darkroom as the place of photographic creation. He and other photographers respond intensely to the solitariness of the darkroom experience. The dimly glowing light, the sound of trickling water, and the acrid smells of acetic acid and fixer rising from the sink create an otherworldly environment that alters customary space and time, spurring the senses

to privately circumvent the confines of familiarity and predictability. This manual, measured dreamworld of picturemaking is widely divergent from the high tech, bright glowing screens of a digital workspace where one is likely to be multi-tasking as a mechanized printer noisily translates pixels into minuscule rows of sprayed ink to form an image.

Uelsmann's darkroom creations revived the art of combination printing. With consummate skill, he exposed his light sensitive paper through a series of enlargers, each holding a different negative. The results disturbed the conventions of the photographic time/space continuum.

Uelsmann enhanced the provocativeness of his imagery with poetic titles, such as *Small Woods Where I Met Myself* (1967).

Such images did not provide the concise photographic message that people had grown to expect from their experiences with mass media, such as *Life* magazine, in which editorial committees embedded photographs in highly tendentious text that was designed to insure that the viewers were getting the "right" message. Uelsmann's sense of fantasy defied these expectations by opening a private window into a reality that grasps the inwardness of a subject that lies beyond its external form.

FIGURE 1.24 In the predigital 1960s, Uelsmann revived the manual process of combination printing. With magician-like craftsmanship, he utilizes numerous negatives to create surreal juxtapositions that viewers know cannot reflect outer reality. Yet his pictures remain believable because of the general belief in the truth of the photographic image. Uelsmann writes: "For me the darkroom (containing eight enlargers) functions as a visual research laboratory.... I believe that almost anything you can think of is worth trying. It is difficult to make a qualitative judgment in the initial stages of the creative process."
© Jerry Uelsmann. *Small Woods Where I Met Myself*, 1967. 16 × 20 inches. Gelatin silver print.

FIGURE 1.25 According to Mike Starn, the sun controls this species of butterflies. When it shines they fly and when there are clouds they fall to the ground. "Up and down all day long, they seem to create an idiotic poetry of puppets, creating an embarrassing metaphor for ourselves. Enlarging our perspective, we see the dominance of the sun over the earth and humanity, revealing that we are nothing more than a meaningless silhouette, a shadow, and shadows have control." The butterfly was illuminated with a ring flash and photographed with extension tubes to get sufficient enlargement onto Polaroid Positive/Negative film, which was used to print onto a hand-coated silver emulsion, and toned in Kodak Brown Toner.
© Doug and Mike Starn. *Attracted to Light*, 1997–99. 20 × 20 inches. Toned silver emulsion. Courtesy of Artists' Rights Society, New York.

This approach can be linked to the Japanese concept of "*shashin*," which states that something is only true when it integrates both the external appearance with the inner makeup of a subject. Uelsmann's art fosters an open, dynamic relationship between artist, subject, and viewer. *Small Woods Where I Met Myself* can be interpreted as a reflection of American society's growing sense of doubt about everything from abortion, to the Vietnam War, to the possibility of assigning meaning to art or life. The work signals the growing awareness that meaning is unfixed and changes according to the interplay between the maker's intentions and the viewer's understanding. Where there had once been a sense of assurance, ambiguity now prevailed.

Revisualizing Time

In the 1970s and 1980s other artists began revisualizing ways of representing time on a more personal than historic scale, as in the manner of Marcel Proust. In attempting to regain his personal past, Proust was acutely aware of both the instability of memory and its importance in defining one's position in the world. Proust comprehended the volatility of time and our tentative grasp of it. Many artists who have worked with handmade photography,

such as Mike and Doug Starn, have a similar understanding. The Starns reject the notion that a moment in time can be grasped or that time is neatly linear. They construct work in a way that embraces the fluidity of time. This can be seen in *Double Rembrandt with Steps*, 1987, which hints that the past can easily invade the present. The Starns also comment on the force of time on photographs themselves. Photographs may resurrect the past, but as the Starns so emphatically demonstrate with their splash-toned, Scotch-taped images mounted with push pins, photographs themselves are fragile objects with limited life spans.

Handmade Photography and Alternative Spaces

Rather than breaking new curatorial ground that defines contemporary practice, major museums continue to be dominated by the art market's structure of pricing and marketing to determine who and what is important. An ongoing modernist critique sees handmade photography as a mongrel of doubtful pedigree because it mixes "pure" photography with techniques attributed to other

media. But for handmade practitioners, this is precisely the point. Their purpose is to reveal the other self, not the one we present in daily life, but the one that passionately represents our *phantasmagoria* – images like those seen in dreams. Their methods suit their purpose. If they are to challenge and expand the standards that define visual reality, then they cannot be expected to stop at the boundaries of a medium out of consideration for its purity. They have no qualms about implementing Man Ray's adage: "A certain amount of contempt for the material employed to express an idea is indispensable to the purest realization of this idea".[18]

In their eagerness, indeed delight, in mixing media, handmade photographers embrace the postmodern view that purity is not possible or desirable and that to pursue it is misguided dogma. During the 1970s such thinking gave rise to the workshop movement and alternative spaces, including CEPA Gallery, Buffalo, NY; Light

FIGURE 1.26 Rayner's work involves *phantasmagoria* with its reappropriation of memory-addled vintage photographs. She states, "I look at the volatile places in our brains where memory plays with reality, deception and misconception tangle with truth, emotions arouse the intellect, critical thinking grapples with intuition, and the logical and the inexplicable tease each other." Rayner's mixed media process begins by recapturing found photographs, which she prints at two different sizes. She then places the two photographs opposite each other in an open cigar mold, casts beeswax over both photographs, and removes different amounts of the beeswax from the two images in order to suggest shifting and fading of memory.
© Beverly Rayner. *Memory Experiment #1: Diminishing Returns* (detail), 1999. 22 × 13 × 4 inches. Chromogenic color prints with mixed media. Courtesy of Maylee Noah Collection.

FIGURE 1.27 Born in Vietnam, the Khmer Rouge invasion of his village forced the artist's family to immigrate to the US when he was a child. While a young boy in Vietnam, he learned grass-mat weaving from his aunt, a skill which decades later influenced the development of his handmade photographic weaving. Lê utilizes his weaving method to visualize the intermingling of the identities that emerge from those living in two different cultures. Now Lê spends much of his time in Ho Chi Minh City, formerly known as Saigon, where he founded a not-for-profit artists' space devoted to contemporary Vietnamese art.
© Dinh Lê. *Untitled*, 2007. 76½ × 53 inches. Woven chromogenic color prints and linen tape. Courtesy of PPOW Gallery, New York.

Factory, Charlotte, NC; Light Work, Syracuse, NY; Photo Resource Center, Boston, MA and Visual Studies Workshop, Rochester, NY, which provided gathering places to exchange ideas, training, exhibition, and publishing opportunities for experimental approaches for underrepresented artists and their work.

ELECTRONIC IMAGING: NEW WAYS OF SEEING

Digital imaging started to surface in the scientific community during the mid-1950s, when Russell A. Kirsch made one of the first digital images. Along with other scientists working at the National Bureau of Standards, Kirsch created one of the first digital scanners. By the 1960s, the National Aeronautics and Space Administration (NASA) was using digitized images produced from its Surveyor landing craft in 1966 and 1968 to formulate never-before-seen composite photographs of the moon's surface, which were of great interest to artists and the public. Yet it was not until the late 1980s, with the advent of affordable home computer graphics workstations, that digital image manipulation became a viable means for creating photographs. Digital image manipulation has removed the burden of absolute truth from photography. By doing so it has revolutionized how images are created and caused a conceptual shift from photography as a medium that records reality to one that can transform it. In the late 1960s, Sonia Landy Sheridan incubated the notion of a Generative Systems Department at the School of the Art Institute of Chicago. It was conceived as a way to provide artists and scientists the opportunity to investigate new means of image production, which included electrostatic photocopy machines, video, and computer-generated images, and it offered its first course in 1970. What followed has been an explosive new set of technical possibilities that have enabled a vast extension of new and diverse voices to be seen.

Effects of Digital Aesthetic

During the first decade of the twenty-first century, digital imaging, originally considered an alternative process, has come to dominate professional photographic practice. Its rise has produced hybrid works, known as *New Media*, a mixture of approaches and technologies utilizing computing power that often feature interactivity between the work and its audience.

At first the seeming ease with which computers allow imagemakers to realize their aims brought about a decrease in the use of handmade techniques. However, an unintended side effect of digital imagery has been wider acceptance of the fundamental premises of handmade photography and how it may legitimately be manipulated to express a range of ideas. Additionally, a reaction to digital image making has resulted in a revitalized interest in handmade techniques. One of the values of handmade

techniques over digital algorithms is that when one manually engages in the making of art, one may allow the physical doing itself to guide the appearance and meaning of the creative endeavor. This disparity between handmade and digital methods has led some to suggest that they are so different that they should be considered as entirely separate ways of working, even if they can produce similar results. Be that as it may, more artists appear to be experimenting with hand processes now than in any time since the late 1980s (see "Resource Guide" at end of chapter).

In spite of postmodernism's assault on the myth of authorship, sense of cultural exhaustion, and sardonic outlook regarding the human spirit, artists who produce handmade photography continue to believe that individuals can make a difference, that originality matters, and that we learn and understand by doing. Embracing imperfection, they find a physically crafted image to be a human image, a flexible one that possesses its own idiosyncratic sense of essence, time, and wonder. Their work can be aesthetically difficult, as it may not provide the audience-friendly narratives and well-mannered compositions some people expect. But sometimes this is necessary to get us to set aside the ordained answers to the question: "What is a photograph?" and allow us to recognize photography's remarkable diversity in form, structure,

FIGURE 1.28 Eide explores photographic time by manually interrupting his film's printing process. To create this image, he sent a digital photograph of a Dutch landscape to his film recorder. At first, he used the recorder according to normal operation, but before printing the photograph to 35 mm film, Eide disrupted the process by freezing and crashing his computer. The resulting image exacts a reconsideration of human involvement in the natural world, which Eide further re-examines through his "reconstruction of a post-apocalyptic natural world by building plots of ground from both real and re-imagined dust. This landscape in particular is the byproduct of computer malfunctions. In its new composition, time and context are suspended, providing a meditative emptiness and a window onto a roguish world of warning."
© Peter Eide. *Dutch Landscape #12*, 2006. 30 × 40 inches. Chromogenic color print.

representational content, and meaning. This acknowledgment grants artists the freedom and respect to explore the full photographic terrain, to engage the medium's broad power of inquiry, and to present the wide-ranging complexity of our experiences, beliefs, and feelings for others to see and contemplate.

POSSESSING A SENSE OF HISTORY

There is much to be learned from studying extraordinary photographers of the past. They utilized the range of materials that the medium had to offer. The possibilities of photography excited them, and the complexity of the process fired their imaginations. The care that remarkable work reveals suggests the mastery of tasks needed to perform visual feats. Accomplished practitioners are not afraid to experiment or to fail. Their images are produced out of knowledge and commitment. This enables them to create complex works with the power to endure because they do not hold anything back. Going forward from a foundation of knowledge, the imagemaker is in a position to carry out the Irish writer Oscar Wilde's aphorism: "The duty we owe to history is to rewrite it," or in the photographic sense, to re-image history.

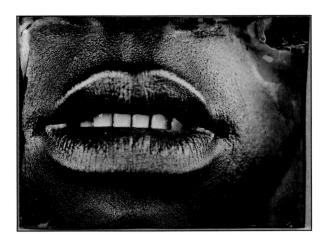

FIGURE 1.29 Greene's acts of documenting the body reference late nineteenth century ethnography processes. Employing her own body as subject, Greene's documentation process functions as a reconsideration of how her identity is perceived by outsiders and how of her own history is intertwined with social history. She questions, "Am I nothing but black? Do my strong teeth make me a strong worker? Does my character resonate louder than my skin tone?" Her use of the nineteenth century ambrotype process allows her to create images that are simultaneously modern and historic. Her process is informed by Mark and France Scully Osterman's text *The Wet-Plate Process: A Working Guide* (2002). See Chapter 10 for process details. © Myra Greene. *Untitled*, from the series *Character Recognition*, 2006. 3 × 4 inches. Ambrotype on black glass.

RESOURCE GUIDE

Blacklow, Laura. *New Dimensions in Photo Processes: A Step by Step Manual for Alternative Techniques, Fourth Edition*, Boston, MA: Focal Press, 2007.

Barnier, John. *Coming into Focus: A Step-by-Step Guide to Alternative Photographic Printing Processes*. San Francisco, CA: Chronicle Books, 2000.

Bunnell, Peter C. "*Photography As Printmaking*," in Bunnell, Peter C., *Degrees of Guidance: Essays on Twentieth-Century American Photography*. Cambridge & New York: Cambridge University Press, 1993.

Bunnell, Peter C. "Photography Into Sculpture," in Bunnell, Peter C., *Degrees of Guidance: Essays on Twentieth-Century American Photography*. Cambridge & New York: Cambridge University Press, 1993.

Crawford, William. *The Keepers of Light: A History & Working Guide to Early Photographic Processes*. Dobbs Ferry, NY: Morgan & Morgan, 1979.

Davis, Keith F. *An American Century of Photography: From Dry-Plate to Digital*. The Hallmark Photographic Collection. Second Edition, revised and enlarged. Kansas City, MO: Hallmark Cards in Association with Harry N. Abrams, 1999.

Eisinger, Joel. *Trace & Transformation: American Criticism of Photography in the Modernist Period*. Albuquerque, NM: University of New Mexico Press, 1995.

Frizot, Michel (Ed.). *A New History of Photography*. English version. Cologne: Könemann, 1998.

Green, Jonathan. *American Photography: A Critical History 1945 to the Present*. New York: Harry N. Abrams, 1984.

Henisch, Heinz K., and Bridget A. Henisch. *The Photographic Experience 1839–1914: Images and Attitudes*. University Park, PA: The Pennsylvania State University Press, 1994.

Hirsch, Robert. "Flexible Images: Handmade American Photography, 1969–2002." *exposure*, vol. 36, no. 1, cover and pp. 23–42, 2003.

Hirsch, Robert. *Seizing the Light: A Social History of Photography*, Second Edition, New York: McGraw-Hill, 2009.

James, Christopher. *The Book of Alternative Photographic Processes*, Second Edition, Clifton Park, NY: Delmar/Cengage Learning, 2008.

Marien, Mary Warner. *Photography: A Cultural History*, Second Edition, Upper Saddle River, NJ: Prentice Hall, 2006.

Newhall, Beaumont. *The History of Photography*, Revised Edition, New York: The Museum of Modern Art, 1982.

Rosenblum, Naomi. *A World History of Photography*, Third Edition, New York: Abbeville Press, 1997.

Stone, Jim (Ed.). *Darkroom Dynamics: A Guide to Creative Darkroom Techniques*. Marblehead, MA: Curtin & London, 1979.

Taft, Robert. *Photography and the American Scene: A Social History, 1839–1889*. New York: Dover Publications, 1964.

Uelsmann, Jerry N. "Post-Visualization," www.uelsmann.net, 1967.

Out-of-print photographic literature contact: Andrew Cahan Bookseller, Ltd: www.cahanbooks.com.

END NOTES

1. Einstein theorized that time must change according to the speed of a moving object relative to the frame of reference of an observer. Scientists have tested this theory through experimentation – proving, for example, that an atomic clock ticks more slowly when traveling at a high speed than it does when it is at a standstill.

2. In 1822, Daguerre opened his first 350 seat *diorama*. The diorama consisted of a dark circular chamber in which large painted scenes were represented on translucent linen. Each picture was seen through a 2800 square foot calico "window" that was painted half opaque. The opaque portion was frontally lit and the translucent part was illuminated from behind, producing an illusion that the picture emitted a radiant light and was not on a flat surface. The color, brightness, and direction of the light was controlled through a system of cords, pulleys, shutters, and slides, and its pictorial effects soon included real animals, stage props, and sound effects. The diorama was an immediate success and Daguerre later built an elaborate 200 seat amphitheater in London, capable of pivoting viewers from scene to scene.

3. *Abbozzo* is Italian for sketch. In painting, it refers to the first outline or drawing on the canvas; also to the first underpainting.

4. Shaw, George Bernard, *Preface, Photographs By Mr. Alvin Langdon Coburn, 1906*, in Jay, Bill, and Margaret Moore (Eds), *Bernard Shaw on Photography*, Salt Lake City, UT: Gibbs Smith Publisher, 1989, p. 103.

5. Walter Benjamin, "The Work of Art in the Age of Mechanical Reproduction," in Arendt, Hannah (Ed.), Walter Benjamin, *Illuminations*. English translation. New York: Harcourt, Brace, and World, 1968, pp. 219–253. Although published in 1936, this essay did not widely enter into academic discussions of photography until the late 1980s and early 1990s.

6. Keiley, Joseph T. "The Linked Ring," *Camera Notes*, vol. 5, no. 2, October 1901, p. 113.

7. Grosz, George. "Randzeichnungen zum Thema," Blätter der Piscatorbühne (Berlin, 1928); trans. in Selz, Peter. "John Heartfield's Photomontages," *The Massachusetts Review*, vol. 4, no. 2, Winter 1963, unp.

8. Mortensen, William. "Fallacies of 'Pure Photography'". *Camera Craft*, 41, 1934, pp. 260–261.

9. All quotes in this paragraph from Moholy-Nagy, László. "Unprecedented Photography," 1927; reprinted in Phillips, Christopher. *Photography in the Modern Era: European Documents and Critical Writings, 1913–1940*. New York: The Metropolitan Museum of Art and Aperture, 1989, pp. 83–85.

10. Moholy-Nagy, László. "Produktion–Reproduktion," *De Stijl (Leiden)*, vol. 5, no. 7, July 1922, as in Phillips, Christopher. *Photography in the Modern Era: European Documents and Critical Writings, 1913–1940*. New York: The Metropolitan Museum of Art and Aperture, 1989, pp. 79–82.

11. Fotoplastik was the term Moholy used to separate his photomontages from the montages of the Dadaists. A completed fotoplastik was a finished collage that was photographed by Lucia Moholy and altered in the printing to produce a series of variant images, such as a negative print. The titles, also done with Lucia Moholy, were not intended to be descriptive and were often colloquialisms or made-up words that defy translation.

12. See Eisinger, Joel. *Trace & Transformation: American Criticism of Photography in the Modernist Period*. Albuquerque, NM: University of New Mexico Press, 1995, particularly Chapter 2, "Straight Photography," pp. 52–78.

13. See Coleman, A. D., and Lynne Warren (Eds), *Robert Heinecken: Photographist*. Chicago, IL: Museum of Contemporary Photography, 1999, p. 4.

14. The Museum of Modern Art did not publish a catalogue for this show. However, Bunnell's comments are available in Bunnell, Peter C. "Photography As Printmaking," in Bunnell, Peter C., *Degrees of Guidance: Essays on Twentieth-Century American Photography*. Cambridge & New York: Cambridge University Press, 1993, pp. 153–154.

15. Bunnell, Peter C. "Photography Into Sculpture," in Bunnell, Peter C., *Degrees of Guidance: Essays on Twentieth-Century American Photography*. Cambridge & New York: Cambridge University Press, 1993, p. 164.

16. This could be seen in the large numbers of young people experimenting with mind-altering drugs, practicing transcendental meditation, yoga, and Zen, pursuing alternative life-styles in communes as part of the "back to the land" movement, resisting the draft, and forming radical groups such as the Black Panthers and Students for a Democratic Society.

17. Uelsmann, Jerry N. "Post-Visualization," 1967, www.uelsmann.net, 10/17/02.

18. *Ray, Man*. "The Age of Light" [1934], *Photographs by Man Ray: 105 Works, 1920–1934*. Mineola, NY: Dover Publications, 1980, unp. Baldwin, Neil. *Man Ray: American Artist*. New York: Da Capo Press, 1988.

PREDARKROOM ACTIONS: IMAGINATIVE THINKING AND PERSONAL SAFETY

efore beginning your explorations into the equipment, materials and processes discussed in this book, it is highly advantageous to first contemplate what you desire to visually accomplish and how to safely realize your objective.

ESTABLISHING A PERSONAL CREATION PROCESS

There are countless ways of defining the creation process, but fundamentally it comes about through creative thinking, which involves the imaginative interaction between the photographer and the subject. Definition is a vital component because it takes you into the thinking process by acknowledging and taking responsibility for a problem. A problem is a situation for consideration. It is a question for open discussion and should not be a cause of anxiety. Defining the genuine nature of a problem paves the way for a deeper understanding, which can lead to accomplishing your resolution of the problem. To obtain the maximum benefit from this book, one should begin reflecting about how photography can be utilized to arrive at your specific destinations. This can occur when intelligence and passion coalesce in taking a mental picture and finding the most effective technical means of bringing it into existence.

PHOTOGRAPHIC ORIGINS

As discussed in the opening chapter, photography is an evolutionary process in the sense one can usually trace the progression of a photograph back to its technical origin. The final image depends on the properties of the specific materials involved in the creation. Photography does not imitate nature, as it is often said to do, but it manifests personal realities in both its making and interpretation. Photography can provide the means to transfer internal thoughts into the physical world. Knowing a wide range of photographic processes positions one to be in control of the final results.

Learning to control a process is the first step a photographer must master to transform an abstract idea into a concrete physical reality. To facilitate the transformation

Box 2.1 Points of Embarkation

Before embarking on a photographic project, ask yourself the questions in the following sections.

- *Interest.* Am I really interested in this project? Am I willing to spend energy, time, and resources on it? Am I willing to make an internal pact with myself to see the idea through to completion?

- *Selection.* Am I familiar with this subject? Narrow down your choices and be specific about what you are going to include. Once you have begun, do not be afraid to change or expand the project according to the situation.

- *Audience.* Will other people be interested in this subject? Can I engage and retain the audience's attention without violating my personal integrity or that of the subject?

- *Visualization.* Does the subject lend itself to a strong visual interpretation? Subjects and themes that portray action or strong emotions are generally easier to visualize than intellectual concepts. Think of films you appreciate and stand-up to multiple viewings. Generally their message and story are delivered primarily through the use of images, with sparingly used dialogue.

- *Accessibility.* Is this a practical project? Can I photograph at times that are accessible to the subject and me?

- *Research.* How can I increase the breadth and depth of my knowledge about the subject? Look at the work of other artists who have covered similar areas. What did they do right and wrong? What would you do differently? Discuss the subject with people directly involved. See what they are thinking and feeling. Research what others have discovered. Write out and/or diagram your thoughts to help expand and clarify your understanding of the project. Think about all these different ideas and approaches and how they tie in together. Use these bits of information to generate ideas of your own that can be visually expressed.

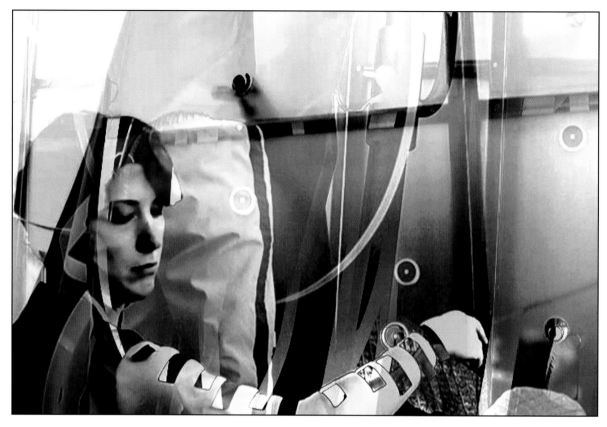

FIGURE 2.1 To create this "generative portrait," Schatz set up 24 camcorders in a specially designed 10 × 10 × 8 foot cube. The information captured by the cameras, which recorded the subject inside the cube for 1 hour, was sent to a single computer that merged and recombined the images to form a single portrait. In this series, Schatz uses new technology to invite chance into the outcome to reassess and expand the ideas of posing and immortality that are traditionally associated with portraiture. The artist says, "I love the fact that these portraits continually evolve. I don't control what gets kept, what gets discarded, what gets put onscreen. It's completely random. I'm simply creating a framework, a hole through which things take place."
© Lincoln Schatz. *Sabrina Raaf, Cube Portrait*, 2007. Dimensions variable. Inkjet print. Courtesy of bitforms gallery, New York and Catharine Clark Gallery, San Francisco, CA.

from mind to medium, one needs to discover how to direct their energy effectively through the technical means at hand. This text introduces a variety of these photographic methods, gives examples of how other photographers have applied them, provides proven basic working procedures, and encourages readers to make future inquiries. Once a person obtains a basic understanding of a process, taking command of it can begin.

Box 2.1 provides a pathway to assist one in producing meaningful images.

THINKING WITHIN A SYSTEM

The following section offers a basic model for a process of thinking (creative interaction between the artist and the subject) with photography. Try using it as a starting point. Feel free to expand it or contract it. Analyze it. Criticize it. Throw it away and replace it with your own model. The important thing is to start thinking and uncover what works best for you in understanding and conveying your ideas by photographic means. This type of critical thinking not only involves the acquisition of information, but also requires one to examine a multitude of viewpoints and hold conflicting ideas simultaneously in the mind for discerning comparison.

Most people perform better if they begin with a point of departure and a specific destination. The use of a system or thinking model can be very helpful in instigating, clarifying, and speeding up the creative process. Such a structure can reveal errors and inconsistencies and can help to substantiate the accuracy of a working method. Look for a scheme that expands your thought process and opens new vistas and working premises to solve problems. A successful problem solver must become a fearless questioner and build a keen internal bullshit

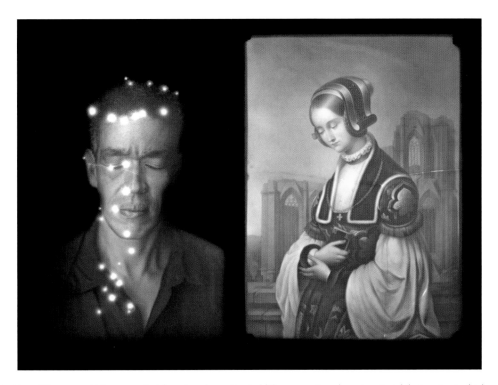

FIGURE 2.2 Here Klimaszewski incorporated found and constructed lithopanes (translucent material that varies in thickness, creating light and dark areas that correspond to the thickness). To construct this Andes Serrano portrait, the artist employed the Woodburytype process, which allowed him to make a photographic image on a porcelain plate. First, he took Serrano's portrait on film, digitized the negative, then he had the image digitally carved (i.e. made a mold of the relief surface) and finally used the mold to print onto the porcelain plate. When he first made the portrait, Klimaszewski considered the plate's cracks and pinholes to be unfortunate accidents, but when he placed the work on a light table next to the portrait of Sister Agnes, he realized this chance occurrence was a breakthrough. The pinholes are reminiscent of the ubiquitous bubbles that appear in Serrano's works that involve the submersion of religious objects in bodily fluids, and this religious element creates a clear link with the portrait of Sister Agnes. Klimaszewski elaborates, "Sister Agnes appears to be genuinely concerned for Serrano, who of course has had a complex relationship with the church, which he seems to be acknowledging. This image speaks to me of relationships and reckoning."
© Nicolai Klimaszewski. *Andres Serrano & Sister Agnes*, 2006. 11 × 14 inches. Woodbury-process lithopane with mixed media.

detector so as not to be misled or deceived into making poor decisions (see next section, "A Thinking Model: Phase 2").

A system may be used as a tool of the experimental. Work with a model that encourages experiments, taking chances, which may take you outside the system. A well functioning sense of orderliness can inspire self-confidence, but it can never tell you exactly what to do. A true thinking model acts as only a guide. It provides a channel for the free flow of creative energies without diverting their strength by demanding rigid adherence to arbitrary procedures or set of ideas.

If your personal authenticity is going to be discovered, there must be freedom to ask uninhibited questions. Keep in mind that experimental work disrupts assumptions and conventions of traditional modes of working. Ideas about originality, subject matter, print quality, process, and treatment should be open to inquiry during the creative process. An ideal thinking process entitles you to uninhibited questioning as determining an apt artistic solution often involves finding the core questions at the heart of the most indubitable answers and pushing past them into new territory.

Although systems provide the reassurance of starting out on a known road, you must remember that there are many routes to a destination. For this reason, attempting to use the same paradigm in every situation can be a recipe for failure. If there is too much framework work, a problem solver can get confused or lost or can develop a mindset that provides solutions without studying the problem. If everything is spelled out exactly, creativity ceases, boredom sets in, and a set of programmed responses results. There is nothing creative about regurgitating preconditioned responses to a situation. Unfortunately, the seeming coherence of a known scheme is not a guarantee of ingenious results. The purpose of a thinking model is to open the possibilities of new visions and provide an exciting means of realizing what has been envisioned.

TABLE 2.1 Thinking Model

Step	Summary
1. Thinking time	Discovering and holding on to key ideas. Using a source notebook for idea generation.
2. Searching for form	Self-declaration accepting the situation and the challenge to give the idea concrete form by visualizing the possibilities.
3. Picking an approach	Selecting the equipment, materials, methods, and techniques that provide the best avenue for visual development of the idea.
4. Putting it together	Photographically pulling your knowledge and resources together into a concrete form of an image or images.
5. Appraisal	Reviewing what has been done by formulating questions to reflect your concerns, expectations, needs, and wants. Discovering what did and did not work and why.

A Thinking Model

This thinking model is offered, despite the warning, as a structural device to help you contemplate, organize, and evaluate the approaches put forth in this book. Try it on for size, make alterations, and come up with a consistent method on which to base your explorations (see Table 2.1). A flexible system for visual creation does not set boundaries, but opens up horizons, which change every time one moves towards it.

Phase 1: Thinking Time

This is when you experience the conscious awareness that you have an idea to visualize. Where did this idea come from? Sometimes you can trace it back to an external stimulus, such as talking with friends, seeing something online, watching a film or video clip, reading a book, or observing a situation. Other times it may come from within. It may be produced by anxiety or pleasure based on your experiences and knowledge. It may be brought about through conscious thought directed at a particular subject. Or it may strike without warning, seemingly out of nowhere. It can be of an intellectual or emotional nature. It can arrive while you are riding to work or in the middle of the night in the form of a dream.

Holding on to Ideas What should you do when an idea first makes itself known? Hold on to it! Many ideas emerge only to be lost in the routine of everyday life. An idea can be the spark that will ignite the act of creation. It does no good to think of marvelous ideas if you cannot retain them for development. If you ignore it, the spark will die out. Whenever possible, immediately act on an idea by recording it. If it is a thought, write it down. If it is a visual stimulation, get a camera and record it. If you do not have a

camera, make a quick sketch on whatever is handy. This is not the time to be concerned about creating a masterpiece. Start recording what has piqued your interest; worry about analyzing and evaluating it later. The important thing is to break inertia and generate raw source material.

Many of the processes offered in this book enable a photographer to have continued interaction with these initial situations over a period of time. This provides an opportunity for you to rethink your initial response and build the concept of extended time into the image.

Keep a Source Notebook There are times when you cannot immediately act on your idea. In these situations, record it in some sort of analog or digital notebook or combination of both. Keep it handy. Take the time to transfer your notes into it so your ideas will be preserved in one place. The analog and/or digital notebook should include your own written ideas; other written and visual material from books, magazines, and newspapers; sketches, snapshots, work prints; online resources, plus any other items that stimulate your thought processes.

The notebook can help you define and develop ideas. Do not worry about following up on every idea. The notebook will help you sort out your ideas and decide which are worth pursuing. It can act as a compass pointing out the direction in which you want to travel. The notebook can serve the future by providing you with a personal history of ideas to which you can refer back, which is a reason to date your entries. As your needs and interests change, an idea that did not seem worth pursuing in the past may provide the direction you are now seeking.

Getting Ideas

- Stick to what you know. Photograph something familiar.
- Discover something new. Photograph something unfamiliar that you would like to learn more about.
- Look at lots of images in different mediums. When one makes an impression, ask yourself what it is that either appeals to you or disturbs you. Incorporate these concepts as active ingredients into your way of seeing and working.
- Inform yourself by studying the development of the photographic medium. It is difficult to understand the present or the future without knowing the past. Look for practitioners, concepts, ideas, and processes that appeal to your personal needs and artistic direction as they can provide a springboard for your experiments. Learn about the philosophies as well as the economic/political/social values that informed their work.
- Collect materials that you may use in making future photographs and then look for ways to generate new ideas from these materials. Create your own visual resource center that offers a site for self-renewal.

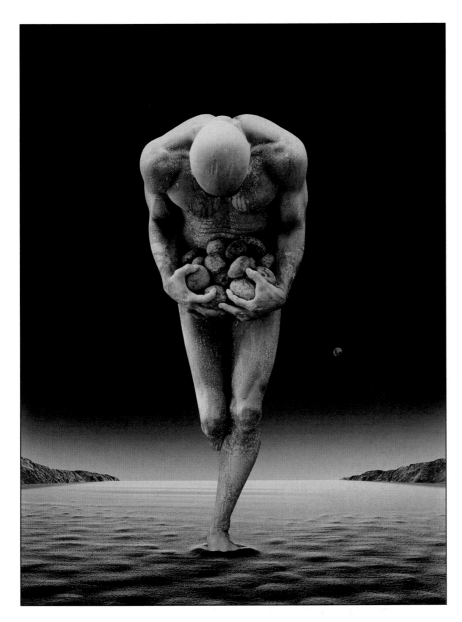

FIGURE 2.3 Before beginning the photographic process, Gordin makes sketches that serve as guides during his lengthy creation process. He then photographs the various image components, assessing and adjusting as he goes, keeping detailed tables of the correct exposure and sequence for each negative. After processing his film, Gordin projects each subsequent negative in his given order, meticulously making masks that only permit a specific part of the paper to be exposed at any given time. Upon competing image, "the tension disappears. It feels like returning safely home after a long, long drive."
© Misha Gordin. *Doubt 15*, 1994. 24 × 20 inches. Gelatin silver print.

Phase 2: Searching for Form: Visualization

In the search for concrete representations of an idea, both the problem and the challenge need to be acknowledged. The problem is how to present the idea visually in a form that communicates your thoughts and feelings to the intended audience. The challenge is to create visual impact and feel satisfied with the outcome. This is the growth stage of the idea. You have acknowledged the problem and taken responsibility for its resolution. Now make a declaration to uncover promising possibilities.

This is the time to consider your previous experiences and knowledge. Visualize the idea in many different forms and then analyze the strong and weak points of each of the visualizations. Imagine how the choice of camera format, lens, point of view, quality of light, film developer combinations, and paper and its processing procedures will affect the final outcome of the visualization. Let these internal pictures run inside the projection room of your brain. Do not limit any of your visualizations but look for elements that will provide continuity and unity to your vision.

The Possibility Scale The power to visualize is vital because it lets you consider different approaches without making a concrete representation. Practice using the *"Possibility Scale"* that postulates: "If I can imagine it,

there could be a way to make it happen." It is transcendent artistic thinking – one that seeks to reach beyond the range of known experiences – encouraging one to adventurously visit regions once deemed out of bounds or inhabited by demons to push the limits of our understanding. Consider Leonardo da Vinci, Jules Vern, H. G. Wells, and now William Gibson, the father of the cyberpunk science fiction, all whose fantastic works, created outside the margins of their times, anticipated future inventions and societal transformations.

Opening Up Your Mind and Heart You can do things to stimulate the problem solving process. Try breaking your normal routine and working habits. Turn off the bombardment of external stimuli and listen to what is happening inside you. Sit down and chart out your ideas on a big piece of paper. Get beyond surface scanning and start seeing more deeply before making any final decisions. The act of perception provides the visual awareness that can reveal the actual problem and as opposed to its symptoms.

Avoiding Fear Steer clear of the roadblock of fear. Fear kills more ideas than anything else. Do not worry about being right or thinking that you have to know everything there is to know about any given subject or process. The deeper one goes into any subject, the more one understands how much we can never know about it. We accept this paradox of scholarship: the need to try and comprehend while realizing the ridiculousness of ever being able to completely do so. This is what learning is about and mistakes are part of the process. We often learn more from our failures than from our successes. This is the time to let ideas evolve, to alter them, or to throw them away and begin anew. Question everything and consider all the options to discover what you want to say and how you want to express it. Once you know this, it is easier to go about the business of imagemaking.

Asking "What If" Questions Keep pursuing the "what if" questions. What if I use this type of light? What if I use this type of recording device? What if I use this developer formula? What if I use this brand of paper? What if I tone the image? What if …. The work will only be as strong as the questions it asks of itself. Consider the possibilities while maintaining your sense of wonderment and curiosity about your interests.

Bullshit Defection In *Beyond Bullsh*t: Straight-Talk at Work* (2008) UCLA Professor Samuel Culbert defines BS as telling others what you think they need to hear for self-servicing ends. It encourages people to hide their mistakes, which is a prescription for artistic disaster. Good work demands candid thinking, based on having a working environment of trust that encourages an honest response to one's ideas and efforts.

Chance and Getting Unstuck Are you drawing a blank in the studio? Invite the unexpected into your thinking by downloading an online version of Brian Eno's

and Peter Schmidt's *Oblique Strategies: Over One Hundred Worthwhile Dilemmas* card decks (www.rtqe. net/ObliqueStrategies/OSintro.html). Each card features a phrase or cryptic remark that can be used to break a deadlock or dilemma situation. The introduction of the 2001 edition states: "These cards evolved from separate observations of the principles underlying what we were doing. Sometimes they were recognized in retrospect (intellect catching up with intuition), sometimes they were identified as they were happening, sometimes they were formulated. They can be used as a pack, or by drawing a single card from the shuffled pack when a dilemma occurs in a working situation. In this case the card is trusted even if its appropriateness is quite unclear..." Eno tells us: "The Oblique Strategies evolved from me being in a number of working situations when the panic of the situation – particularly in studios – tended to make me quickly forget that there were other ways of working and that there were tangential ways of attacking problems that were in many senses more interesting than the direct head-on approach. If you're in a panic, you tend to take the head-on approach because it seems to be the one that's going to yield the best results Of course, that often isn't the case – it's just the most obvious and – apparently – reliable method. The function of the *Oblique Strategies* was, initially, to serve as a series of prompts which said, "Don't forget that you could adopt *this* attitude," or "Don't forget you could adopt *that* attitude."

Phase 3: Picking an Approach

Picking an approach means you have considered the strengths and limitations of the possibilities you have generated. This is the time to be judgmental, narrow down your choices and decide which will best suit the visual development of your ideas and feelings. The key to a successful approach is being able to select the equipment, materials, methods, and techniques that will enable you to present your concept in the strongest visual terms. Give thought to both previsualization (before an exposure is made) and postvisualization (after an exposure has been made) methods. Mastering the techniques will not guarantee artistic results, but it will provide a means to overcome the limitations inherent in the mechanics of photography. Try not fall in love with one idea or approach. Stay loose and keep alternatives available.

Phase 4: Putting It Together

This is the time to muster your resources and put them into photographic action. You are no longer thinking or talking about photography; you are actually involved in making images. Try out your visualizations. Enjoy the process; it too can be as rewarding.

A possible working scenario first involves the pre-exposure considerations of subject, quality of light, angle of view, camera format, capture method, and exposure determination. Next consider what combination of film and developer are best suited for what you are going to photography. Ask yourself, "Am I going to get the results

I want from the printing of a straight negative, or should I consider altering the negative by means such as retouching or hand alteration?" Once the final look of the capture means has been determined, decide which paper processing materials and methods you will use. These decisions include type of paper developer, paper grade and surface, use of archival or nonarchival methods, and type of toner, if any.

Examine the completed print. Where do your eyes come to rest? The most important decision you make is where you direct the viewer's vision. Does it look like, and say what you had in mind? If not, why not? Will postdarkroom work solve the problem or is a reshoot in order? When the image is satisfying, it is time to think about presentation. Will the image be stronger individually or in a group? Should it be mounted, matted, floated, framed, or shown in book format? How will it look on a website? Maintain a mode of inquiry to help maintain an open mind. Take that extra exposure. Make one more print. Cut one more mat. Do not get discouraged, for this is a time of discovery, growing, and learning.

Phase 5: Appraisal

This is the phase to review your labors. Appraisal can be carried out during any stage of the process after the initial exposure, film processing, or printmaking or when the work is completed and/or presented. Formulate questions that reflect your concerns, expectations, needs, and wants. Get specific and give detailed answers. Consider these questions: Am I satisfied with the outcome? Why or why not? Did I do my research? Was I well informed? Take into account photographer and educator Tod Papageorge rethinking of Robert Capa's axiom, "If your pictures are not good enough, you aren't close enough," to, "If your pictures are not good enough, you aren't reading enough."[1] Did I accomplish what I set out to do? Have I deviated from my original approach? What methods did I use to accomplish my objective? If I were to do this again, what would I do differently? Locate, define, and discuss sources of satisfaction and dissatisfaction. Have someone else look at the work and listen to what they have to say. Now ask the big questions: Does this image meet my goals? Is the final work aesthetically, spiritually, and technically satisfying? If the answers are yes, note the things you did that were helpful and apply them to future efforts. If the answers are no, it is time to start the process over and reshoot. Respect the late philosopher Richard Rorty's common sense reminder "some ideas are just no damn good" and no amount of phony tolerance or foolish excuses will make them better. Learn from both your successes and failures. Do not get scared away. The key is to keep on working and making images.

Knowing Good Image Creation The triumph or failure of an image is the result of the intensity by which it was imagined and rendered into visual language. Personal satisfaction and significant viewer interaction are clues to knowing when is has happened. Other points to consider include: How well were you able to define your internal thoughts?

Did your technical response deliver the desired results? What insight and understanding into the nature of the challenge and the process of making has been gained? Has this knowledge been translated through the medium to the intended audience? When the image fits the problem and the problem solver, a successful resolution has been achieved.

***Shashin* or Thing in Itself** Engaging work carries the watermark that identifies a well-formed thinking process (Table 2.1). Engaging photographers incorporate such attitudes and work ethics into their photographic life. Look for that joyful moment in the process of photography that defies words when there is nothing else, just you and the subject. A first-rate photograph is capable of evoking an interior state of consciousness that can grapple with a subject beyond its external physical structure. As mentioned in Chapter 1, this approach can be compared to the Japanese theory of *shashin*, which posits a representation can only be truly accurate when it incorporates the outer appearance with the inner structure of a subject. American writer Herman Melville referred to the purely surface view of reality as "a pasteboard mask." Such a multi-sheeted mask conceals the intuitive world of the *thing in itself* – a deep structure of cultural, political, and psychological models that inform the realities "behind" or beyond what we can observe with our five physical senses – an idea dating back to Plato's concept of delving into the multi-faceted, interior panorama of the world. If we could fully express ourselves with written symbols there would be no need for the visual arts. When united with the mind and the heart, the processes of photography allow us to express things that would otherwise be impossible. When this amalgamation occurs, superior photographs come into being.

PURPOSES OF PHOTOGRAPHY

The material covered in this text can take you away from the old notion that photography's purpose is to recreate outer reality. The truth is that all images are make-believe – impressions that point to an original experience, and once let loose in the world generate their own meanings. The majority of information is designed to let you discover both your own and the medium's potentials. This data can help you to bring into existence that which never was. It starts to supply answers to the question "Why not?" It disrupts assumptions and conventions by asking: How can I go beyond recording surface reflections?

You can meet a challenge and use it to your advantage if you have done your exploratory thinking, are making images you care about, and control your technique so that it becomes a vital part of the visual statement. Such work can elicit resistant because there are no prescribed responses. If the situation permits, take on the role of teacher – plainly and respectfully explaining unconventional work to your audience. It is likely you will learn more about the subject by trying to teach someone about something you understand and believe in. Nobody learns more about the subject than a well-prepared teacher. It is

FIGURE 2.4 Armstrong set the focusing ring of his 645 camera at infinity as he rephotographed magazine images to produce this photo-collage. This act of "defocusing" causes a re-examination of the role of color in photography and "conjures a mysterious tromp l'oeil world that hovers between the real and the fantastic. The nature of visual perception intrigues me: the idea that the eye continually tries to resolve these images, but is unable to do so, and how that is unsettling continues to interest me. I am drawn to the idea that we can believe something is real, while at the same time knowing it is illusory; the experience of visual confusion, when the psyche is momentarily derailed, is what frees us to respond emotionally."
© Bill Armstrong. *Figure 6*, 1999. 20 × 21 inches. Chromogenic color print. Courtesy of Clamp Art, New York.

FIGURE 2.5 In this sequence Porett rethinks the dynamics of urban life and creates a space and time tension by weaving together multiple film exposures using digital technology that was not available when the images were first recorded. Originally working with an Olympus Pen half-frame camera in 1967, Porett made these images by partially advancing and exposing the film multiple times. In 2000 he revisited the images, scanning and reversing the original transparency film, which he had developed as a negative. Next he digitally manipulated the film by inserting a black-and-white overlay atop the image and then erased areas of the overlay to allow the vivid color to show through.
© Thomas Porett. *Time Warp – Philadelphia*, 1967/2000. 9⅛ × 43 inches. Inkjet print.

FIGURE 2.6 *Chemistry Equipment,* from Robert Brent's *The Golden Books of Chemistry Experiments: How to Set up a Home Laboratory – Over 200 Simple Experiments.* Illustrated by Harry Lazarus. New York: Golden Press, 1960. Courtesy of Gary Nickard Collection.

also possible that the explanation will help viewers to see something new and unlock their doors of perception too.

RESOURCE GUIDE

Davis, Philip J., and David Park (Eds). *No Way, The Nature of the Impossible.* New York: W. H. Freeman, 1987.

ESSENTIAL SAFETY GUIDELINES

Photographers must be aware of certain health and environmental concerns to ensure a safe and creative working atmosphere. Before beginning to work with any of the

processes mentioned in this text, it is essential to follow the basic precautions and procedures outlined in the next section. Only you can be responsible for your safety, those living creatures around you, and our environment.

Safety Guidelines

1. Read and follow all instructions and safety recommendations on Material Safety Data Sheets (MSDS) and product literature, which are provided with each product by its manufacturer and in this text, *before* carrying out any process (see Addendum 1.1 and Addendum 1.2). This includes mixing, handling, disposal, and storage. Also, obtain any special safety equipment *before* using the materials you have purchased. MSDS are available from the manufacturers of each product, often online. The Occupational Safety and Health Administration (OSHA) has a standard MSDS form that is reproduced in this section to give you an idea of the type of information provided. Each manufacturer prepares its own MSDS. Typically they provide additional ecological, disposal, transport, and regulatory information, and are available to download from their website.

2. Become familiar with all the inherent dangers associated with any chemicals used. When acquiring any chemicals or when working with a new process, ask about proper handling and safety procedures. Obtain MSDS for all chemicals used, which can usually be found on the manufacturer's website. Keep them available in a notebook for easy reference. Learn how to interpret the MSDS. Right-to-know laws in the US and Canada require all employers to formally train workers to read MSDS.

3. Know the first aid and emergency treatment for the chemicals with which you are working. Keep the telephone numbers for poison control and emergency treatment prominently displayed in your working area and near the telephone. Each MSDS has the manufacturer's emergency number on it. Add these numbers to your personal electronic phone directories.

4. Many chemicals may be flammable. Keep them away from any source of heat or open flame to avoid possible explosion or fire. Keep an ABC-type fire extinguisher in the darkroom, which can be used for ordinary combustibles (wood and paper), solvent, grease, and electrical fires in the work area.

5. Protect chemicals from low temperatures (lower than 40°F/4.4°C). They may freeze, burst in their containers, and contaminate your working environment. Chemicals that have been frozen may also be damaged and deliver unexpected and faulty results.

6. Work in a well-ventilated space (see "Darkroom Ventilation" section of this chapter). Hazardous chemicals should be mixed under a vented hood or outside.

7. Protect yourself. Wear disposable, chemical-resistant gloves, safety glasses, and plastic aprons. Find a glove maker who gives information that indicates how long the glove material can be in contact with a chemical before it becomes degraded or permeated. Degradation happens when the glove deteriorates from being in contact with the chemical. Permeation occurs when molecules of the chemical penetrate through the glove material. Permeated gloves often appear unchanged and wearers may be unaware they are being exposed to the chemical. Some chemicals can penetrate chemical gloves in minutes and begin to penetrate the skin. Barrier creams, which can protect the skin from light exposure to specific chemicals, can be applied to your skin. Choose the right cream to block acids, oils, or solvents, and use it exactly as directed. Do not use harsh soaps or solvents to wash your hands. After washing, apply a high-quality hand lotion to replace lost skin oils.

8. Precisely follow mixing instructions. Label each solution container to reduce the chance of contamination and/or using the wrong solution. Avoid contamination problems by keeping all working surfaces clean, dry, and free of chemicals. Use polystyrene mixing rods, funnels, graduates, and pails. Use separate mixing containers for each chemical, and do not interchange them. Label them with a permanent marker. Thoroughly wash all equipment used in chemical mixing. Keep floors dry to prevent slips and falls.

9. When mixing chemicals, wear a disposable facemask or respirator especially if you have had a previous allergic reaction. If you have any type of reaction, immediately suspend work with all photographic processes and consult a physician. In addition to disposable plastic gloves, wear safety glasses and a plastic apron.

10. Consult the MSDS for the proper type of protection required with each chemical or process. When mixing powered materials, use a NIOSH (National Institute of Occupational Safety and Health)-approved mask for toxic dusts. When diluting concentrated liquid chemicals containing solvents, acetic acid, and sulfites, wear a combination organic vapor/acid gas cartridge. Ideally all mixing should be done in a local exhaust system. If you have any type of reaction, immediately suspend work with all

photographic processes and consult with a knowledgeable physician. Once an allergic reaction has occurred, you should avoid the chemicals unless your physician approves the use of a respirator. Employers of workers who wear respirators, including dust masks, are required by OSHA to have a written respirator program, formal fit testing, and worker training. People with certain diseases and some pregnant women should not wear them. Check with your doctor.

11. Always pour acids slowly into water; never pour water into acids. Do not mix or pour any chemical at eye level, as a splash could easily hit your eyes. Wear protective eyewear, especially when mixing acids.

12. Avoid touching any electrical equipment with wet hands. Install shockproof outlets (ground fault interrupters) in your own darkroom. Make certain all equipment is grounded. Keep the floor dry. When designing a darkroom, plan to separate wet and dry areas.

13. Follow instructions for proper disposal of all chemicals. Wash yourself and any equipment that has come into contact with any chemicals. Launder darkroom towels after each session. Dispose of gloves and masks to avoid future contamination. Keep your workspace clean and uncontaminated.

14. Store all chemicals properly. Use safety caps or lock up chemicals to prevent other people, children, and pets from being exposed to their potential dangers. Store chemicals in a cool, dry area away from direct sunlight.

15. Do not eat, drink, or smoke while handling chemicals. Wash your hands thoroughly after handling any chemicals. OSHA forbids the consumption or storage of food or drink wherever toxic chemicals are in use or stored. Food should not be stored in the refrigerator next to chemicals and paper.

16. If you are pregnant or have any pre-existing health problems, read the pertinent materials under "Additional Information" at the end of this chapter before carrying out any process described in this book.

17. People have varying sensitivities to chemicals. If you have had allergic reactions to any chemicals, pay close attention to the effects that darkroom chemicals have on you, and be ardently careful about following all safety procedures (see following section on "Contact Allergies, Chemical Sensitivities and Poison Control"). Specific safety measures and reminders are provided in the chapters on each process. These guidelines are not designed to produce paranoia but to ensure that you have a

long and safe adventure in uncovering the many possibilities of photography. Your eyes, lungs, and skin are porous membranes and can absorb chemical vapors. It is your job to protect yourself.

18. Follow the manufacturer's instructions for proper disposal of all chemicals (see section "Disposing of Chemistry").

CONTACT ALLERGIES, CHEMICAL SENSITIVITIES AND POISON CONTROL

Although most people work with photographic chemicals and materials with no adverse effects, some individuals have a high sensitivity to certain substances. This group of people may have a reaction to substances like household cleaners, latex, matches, paints, rubber, wool, and even some types of jewelry. All chemicals used in photography should always be treated with care.

The symptoms of chemical sensitivity vary from one person to another. These symptoms can include redness, itching, or swelling when skin comes in contact with a chemical. The skin may form blisters that later break. A chemical sensitivity reaction does not require contact with the substance. Inhalation or skin contact with fumes may be enough to trigger the reaction. Note that an individual chemical may not be particularly toxic in liquid form but may be highly toxic if inhaled while in powder form.

Chemical sensitivities are not allergies but they often cause many of the same symptoms, such as light-headedness, fatigue, headaches, and recurrent illnesses that seem to have no explanation. Reactions may vary widely, but the treatment is the same – avoidance of the substance causing the reaction.

Chemicals used in photography that commonly cause chemical sensitivity reactions include: Metol, paraphenylene diamine, potassium aluminum sulfate, gold and platinum salts, selenium salts, potassium persulfate, potassium dichromate, and potassium chlorochromate.

This is only a partial list. Generally, the chemical formulations listed in this book can be safely used with only a few precautions such as a pair of gloves and good ventilation.

Local Poison Control

The telephone number for your local poison control hotline is often listed in the first few pages of your telephone directory or can be found via your Web search engine. Keep this number close to the telephone in case of an emergency. Add it to your cell phone directory as well.

FIGURE 2.7 Dawson's series *Water in the West* addresses the looming ecological and societal controversies surrounding how water is diverted, stored, and used in the desert environments of the American West. Here the artist used the classical pictorial device of "mirroring to elegantly" frame the vital role water plays in shaping our environment, recreation, and urban growth.
© Robert Dawson. *Flooded Salt Air Pavilion, Great Salt Lake, Utah*, from the *Water in the West Project*, 1985. 16 × 20 inches. Gelatin silver print.

DISPOSING OF CHEMISTRY

As environmental regulations are made stronger, what may have been disposable by pouring down the drain ten years ago may require careful disposal today. As the beneficiaries of cleaner air and water, photographers are responsible for following local regulations.

Municipal waste treatment plants can handle most photochemical solutions under a certain volume and concentration. Local sewer authorities regulate the concentrations and the volume of chemicals released per day into sewer systems. Most individual home photographic processing will not exceed these regulations.

Before setting up a darkroom, check with your local sewer authority for information about how to properly dispose of your photographic solutions.

Disposing of Fixer

Fixing baths can contain high concentrations of silver thiocyanate. It is usually acceptable to pour small amounts of fixer down the drain with running water. The US Clean Water Act allows no more than 5 parts per million (p.p.m.) of silver ion to be deposited in municipal wastewater treatment plants. This concentration can easily be reached during a single printing session. Large amounts of used fixer (more than a few gallons per day) should therefore be treated with a silver recovery system. These systems come

in a variety of styles, sizes, and prices and can be found online. The precipitated silver must be sent to a company that will recover the silver.

Septic Systems

Because household septic systems use bacteria to break down waste they can easily be damaged by photographic chemistry disposal. Most septic systems can handle a few pints of chemistry at any one time. Some municipalities now require a permit to dump photographic wastes into septic systems.

DARKROOM VENTILATION

Good ventilation, consisting of a light-tight exhaust fan and an intake vent for fresh air along with temperature control, is recommended for health and comfort. Exhaust fans are rated by their ability to remove air in cubic feet per minute (c.f.m.). A 10×20 foot darkroom with a 10 foot ceiling would require an exhaust fan rated at 500 c.f.m. (against $1/4$–$1/2$ inch static pressure) to do 15 air exchanges per hour. Fans that do 500 c.f.m. just sitting on the floor will not provide proper ventilation. The amount of ventilation needed varies depending on what chemicals are used, room size, and conditions. Read the MSDSs or contact the manufacturer for suggested ventilation guidelines for chemicals. This type of ventilation, known as general or dilution, is designed to dilute the contaminated air with large volumes of clean air to lower the amounts of contaminants to acceptable levels and then exhaust the diluted mixture from the work area. Dilution ventilation does not work with highly toxic materials or any particle materials that form dusts, fumes, or mists. These materials require what is referred to as local exhaust ventilation, such as a table slot or fume hood, to capture the contaminants at the source before they escape into the room air. Refer to the reference section at the end of this chapter to carefully research this area before constructing a system.

WATER FOR PHOTOGRAPHIC PROCESSES

Water makes up almost two-thirds of the human body, three-quarters of our planet's surface, and is the key ingredient in most predigital photographic processes. Although water itself does not create a safety issue, it is included here because its purity can affect your processing results. The following information applies whenever water is called for in any process discussed in this book.

Use a source of "pure" water. The chemical and mineral composition and pH of your local water source can affect processing results. Color developers are most sensitive to these factors. You can eliminate this variable beforehand by making certain your water source is pure or by using water processed by reverse osmosis. Distilled water often has had certain components (calcium) removed that are required for proper chemical reactions to take place. Water that has gone through a softening process is not recommended for any photographic chemical mixing. This is because water is commonly softened by passing it through a treatment tank containing high amounts of salts. This process alters the chemical composition of the water and can lead to processing irregularities.

RESOURCE GUIDE

McCann, Michael. *Artist Beware: The Hazards in Working with All Art and Craft Materials and the Precautions Every Artist and Craftsperson Should Take*, Third Edition, Guilford, CT: The Lyons Press, 2005.

Rempel, Siegfried, and Wolfgang Rempel. *Health Hazards for Photographers* Guilford, CT: The Lyons Press, 2005.

Rossol, Monona. *The Artist's Complete Health and Safety Guide*, Third Edition, New York: Allworth Press, 2001.

Shaw, Susan, and Monona Rossol. *Overexposure: Health Hazards in Photography*, Second Edition, San Francisco, CA: The Friends of Photography, 1991.

Spandorfer, Merle, Jack Snyder and Deborah Curtiss. *Making Art Safely: Alternative Methods and Materials in Drawing, Painting, Printmaking, Graphic Design, and Photography* New York: John Wiley & Sons, 1995.

Tell, Judy. *Making Darkrooms Saferooms*, Durham, NC: National Press Photographers Association, 1989, (www. nppa.org).

Thompson, Robert Bruce. *Illustrated Guide to Home Chemistry Experiments: All Lab, No Lecture* Sebastopol, CA: O'Reilly Media, 2008.

Utilize your favorite search engine with key words, such as "photographic safety," to find latest sites.

END NOTES

1. "Collapsing Images" A talk hosted by *Blind Spot* at The New York Public Library on November 3, 2007. Part III of the series "Truth and Authenticity in Photography".

FIGURE 2.8 Jarboe alludes to analog printmaking and documentary photography by choosing to print this series in black-and-white. These digitally-captured images "document imagined scenes and memory fragments that have been rescued from dreams or pulled from fading personal histories" instead of found *Decisive Moments*.

© Molly Jarboe. *Bee*, from the series *Things I May Have Lost*, 2008. 20 × 24 inches. Inkjet print.

IMAGE CAPTURE: SPECIAL-USE FILMS, PROCESSING AND DIGITAL NEGATIVE MAKING

FILM AND THE PHOTOGRAPHER

Being a photographer involves learning how to make the camera and photographic materials function to fulfill your purposes and learning to see in the manner of various camera formats and lenses. Analog cameras use a light-sensitive substance on a support base called film to record an image. Digital cameras capture an image electronically and in combination with imaging software can perform or replicate the functions of convention cameras. But because they record images differently than film does, the effect and overall character of the image may differ. Although electronic imaging can deliver film-like quality and mimic the look of particular products, film remains the measuring gauge many photographers rely on to when evaluating their image capture results.

As this chapter covers special-use films, one should be confident in camera handling, exposure, and in processing a wide variety of general-purpose black-and-white films before proceeding. If you are uncertain about your abilities in any of these areas, a review of working procedures is in order. The films discussed can also be scanned, allowing for additional manipulation with imaging software.

FIGURE 3.1 De Swaan captured the two images in this diptych 10 years apart. She made the photograph on the right in 1992 with T-MAX P3200 film and the one on the left in 2002. Using various high-speed films permits her to capture images in the available light conditions, while scanning and digitally montaging the photographs allows her to generate a sequential flow. Here de Swaan purposefully constructed a cinematic koan "about the scenes of violence and terror emanating at us from our televisions, contrasted with the eerily ordinary lives we continue to lead. I combine documentary and staged photos, incorporating signage and images from the media, to examine the changing social panorama and show how politics and world events increasingly impinge on our domestic sphere." © Sylvia de Swaan. *On the News*, from the series *Sub-version*, 1992/2003/2007. 30 × 40 inches. Inkjet print.

Film Selection

Film is the fundamental material for recording an analog image, and its basic characteristics are crucial in determining the look of the final image. Brands and types of film differ in contrast, grain structure, sensitivity, sharpness, and speed. For these reasons, it is important for imagemakers to base their film selection on the aesthetic and technical requirements of the given situation.

Manufacturers regularly alter existing films, discontinue old favorites, and introduce new ones. Digital imaging has also resulted in numerous old favorites being dropped from production. Additionally, the life span of technical information has been greatly reduced, almost becoming obsolete as soon as it is printed. The Internet makes it easy to get up-to-date information, but beware, as there is often no way to ascertain the veracity of information from nonmanufacturers' websites. Such data can be a treasure trove of valuable data or fool's gold of inaccurate blather. To deal with this situation, a photographer needs a sound conceptual understanding in a wide array of photographic processes. A process or product may change, but the underlying principles remain the same. Many photographers find that refining their working methods with one film–developer combination can be effective for most general situations. More-than-ever, as new products take the place of once familiar materials, a photographer needs to be willing to test new films in noncritical situations and make a judgment based on personal experience.

Selecting a film is an individualistic decision in that many subjective aesthetic concerns take precedence over technical matters. Moreover, film image quality is also affected by the method of development. The same roll of film can produce a wide range of characteristics depending on how it is treated before, during, and after exposure and processing. It can be helpful to talk with other photographers and read widely. Remember, you can discuss and read about photography all you want, but this is not photography. Being a photographer means making images. The only way to know what is going to work in photography is to do it for yourself. The multiplicity of human experience shows that what makes up reality is dynamic and complex issue. Let your selection of film reflect what actually works for you in a particular situation.

Compiling a Resource Guide

The information provided in this chapter is designed to offer aesthetic and technical possibilities that cannot be achieved through the use of conventional films. The data has been compiled through the personal working experiences of professionals, teachers, and students. Make these working procedures your own by changing them to suit your personal requirements. This can be done by keeping a detailed resource guide of procedures, ideas, and sources based on personal practice, which can save time and act as a springboard for new directions in your work. It is advisable to check processing recommendations against the manufacturer's data sheet and website before beginning to work with the film, and note changes in your guide.

GENERAL FILM PROCESSING PROCEDURES

Certain general working procedures can be followed in film processing to ensure consistent high-quality results. These include the following:

- Read, follow, and understand all technical and safety data before processing the film.
- Ascertain your equipment and working area are clean, dry, and properly functioning.
- Seal any light leaks in film-loading and film-processing areas.
- Lay out your equipment in a manner so you can find it in the dark.
- Utilize durable, plastic funnels, graduates, mixing pails, stirring rods, and bottles, which are easy to clean, inexpensive, and applicable to most processes. Avoid possible contamination by using separate graduates and containers for developer and fixer. Rinse all mixing equipment before and after each use.
- Once a developer is mixed into a working solution, store it in a clean brown plastic container, removing as much air as possible from the container, to ensure maximum life.

- Do not exceed the working capacities (the amount of film that may be processed) of the solutions.
- Mix the developer with distilled water to ensure consistency, especially in areas with problematic water.
- Employ the same, accurate thermometer to ensure all solutions are at their proper operating temperatures and for processing consistency.
- Presoaking film removes the antihalation backing incorporated into the emulsion, increasing the potential for streaking. As the developer has to displace the water absorbed by the emulsion during the presoak, you may have to extend the developing time. Some people think that presoaking the film for 1–2 minutes *before* beginning to process prepares the film for developer and eliminates air bubbles, thus helping deliver superior quality. Try it and decide for yourself.

- Follow recommended agitation patterns for each step of processing. With small single- or double-reel tanks, drop the loaded film reel into the developer and attach the top to the tank. Firmly tap the tank on a flat surface at 30 degrees to dislodge any air bubbles. Provide initial agitation of five to seven inversion cycles in 5 seconds, i.e. extend your arm and vigorously twist your wrist 180 degrees. Then repeat this agitation procedure at 30 second intervals for the rest of the development time.

- Include drain time in each processing step.

- Stop bath rapidly changes the pH of film, causing the action of the developer to cease and also extending the life of the fixer. Prepare an acid stop bath by mixing it from a 28 per cent stock solution of acetic acid to avoid the problems that can occur when working with the highly concentrated 99 per cent glacial acetic acid. Dilute the 28 per cent stock solution to its recommended working strength. Use it one time (one shot) and dispose of it. If you want to reuse the stop bath, get one that contains an indicator dye that changes color to inform you when the solution is becoming exhausted. Discard the indicator stop after its orange color disappears. If you wait for it to turn purple, it may already be exhausted. Indicator stop bath may be used to make all film and paper stop baths. If you choose not to use a stop bath, rinse the film twice in the processing tank, with water.

- Fixer or hypo comes in two forms: regular, which consists mainly of sodium thiosulfate powder, and rapid, which is usually ammonium thiosulfate in a liquid form. Either may be used for most processes. Check to make sure the dilution is correct for the process being carried out. Both types may be reused. Keep a record of the number of rolls processed or perform a hypo test to see when the fixer has become exhausted due to silver saturation. The general rule of thumb is to fix for twice as long as it takes the film to clear.

- Hypo check is necessary to ensure the fixer is not exhausted due to use, age (oxidation) or other contamination. The most accurate method to determine the fixer's efficiency is to take a small piece of exposed film and fix it. The film should clear in about 30 seconds. If it takes more than a minute to clear dump the fixer. Some films, such as T-MAX, will have a pinkish cast after being properly fixed and will not completely clear until they have been treated in a hypo clearing agent. Although not as accurate, a hypo test solution can provide a visual guide to check the fixer for exhaustion. This test solution can be purchased commercially or made by following the formula at the end of this chart.

- Using a film washer will facilitate the washing process. The constant turbulence created by introducing water and air into the bottom of the washing chamber helps remove hypo and debris. However, film may be washed in the processing tank. Make certain that the water is changed often, at least 12 complete changes of water, or get a film washer that does this automatically.

- Use a hypo clearing agent to help remove fixer residue and reduce washing time.

- Place the film in a wetting agent for about 2 minutes with light agitation before hanging it to dry in a dust-free area. Always mix the wetting agent with distilled water. Dispose of the used solution after each use. Do not use heat or forced air to speed film drying.

- If the water you are using is extremely hard or if you are experiencing problems with particles drying on the film, try this procedure even though it violates the general rule not to touch film. On removing the film from the wetting agent, shake off excess solution in the sink. Hang film up and clip it on the bottom. Make sure your fingers are clean and smooth, put your index and middle fingers in the wetting solution and shake them off. Now use these two fingers to gently squeegee both sides of the film. With a lint-free disposable towel, such as a Photo-Wipe, carefully wipe the nonemulsion (shiny) side of the film from top to bottom. Do *not* wipe the emulsion side, as it is still soft and can be damaged easily. Hold the film at a slight angle with one hand. Using the other hand, slowly bring the disposable towel down the full length of the film. Keep your eye on the film just behind where the towel has passed to check for any spots, streaks, or particles. If any are visible, go back and remove them. A rainbow effect on the film surface indicates that you are carrying out the procedure correctly. Allow to air dry.

- After the film is dry, place it in archival plastic sleeves or acid-free paper envelopes. Store it in a cool, dry place. Do not use glassine, kraft paper, or polyvinyl chloride (PVC) materials for storage, as they contain substances that can damage film over time.

- Record all yours procedures in your Resource Guide. List the date, type of film, developer, time, and temperature; any procedures that are different from normal; the outcome; and the changes to be made in working methods if a similar situation is encountered in the future.

- Refrigerate or freeze the film in a zip-lock plastic bag before and after exposure for maximum quality. Let the film reach its operating temperature before loading, exposing, or processing it.

- Problems may be remedied by scanning the film and then using imaging software to make adjustments or corrections.

Hypo Check Formula

Potassium iodide	2 g
Distilled water (68°F/20°C)	100 ml

This solution can be stored in a dropper bottle, available at most drugstores. It should keep indefinitely. For the most accurate results, pour a small amount of the fixer into a clear bleaker and then add a few drops of the solution. Wait a few seconds. If any cloudiness is visible within about 10 seconds, replace the fixer.

INFRARED BLACK-AND-WHITE FILM

Black-and-white infrared (IR) films are sensitive to all wavelengths of the visible spectrum of light but also extend into the IR region. IR film is sensitive to radiation that the human eye cannot detect. Conventional panchromatic film, sensitive to the visible spectrum, is designed to record a subject in tones that approximate those of human perception. IR film sees and records beyond human parameters but also has a reduced sensitivity to green wavelengths of light. These two factors combine to render objects differently than panchromatic film does and can cause dramatic shifts in tone, producing images that appear unworldly, and sometimes almost phantasmagoric, providing the apparent perception of being able to capture something that is not present in our normal vision.

To understand IR film, it is necessary to experiment with and test it as the roster of selections changes and each brand as its own unique characteristics and responses differently to filtration and processing. Such experiments will show you a variety of pictorial responses that IR film can generate by altering a subject's tonal relationships, distorting the conventional sense of photographic time and space.

Although the roster of black-and-white IR films continues to change, there are some general characteristics that can be gleaned.

Handling

IR film is sensitive to IR radiation, so should be handled in total darkness when loading or unloading either the camera

FIGURE 3.2 Ginsburgh Hofkin used 120 black-and-white IR film to accentuate the sharp contrast of the flowers and the lava fields. She explains, "The elements of the invisible and immeasurable are added to the image area to prod surprises that may be frightening or exhilarating. My method of working is reflective of this tension between knowing and uncertainty." She processed the film in Ilford Microphen 1:1 and printed on glossy Ilford Multigrade paper. The image was toned in Kodak Rapid Selenium Toner (6 ounces per gallon for 10 minutes).
© Ann Ginsburgh Hofkin. *Sicily_05_2*, 2005. 18 × 23 inches. Gelatin silver print. Courtesy of FLATFILEgalleries, Chicago, IL; Sande Webster Gallery, Philadelphia, PA; Nina Bliese Gallery, Minneapolis, MN.

or the developing tank. The felt strips of the film cassette can permit IR radiation leaks. Check the darkroom to make certain it is light-tight. When a darkroom is not available, use a high-quality changing bag. Keep the bag in an area shaded from direct sunlight. Be aware that changing bags can leak IR radiation; check the bag with a test roll. IR film can also be fogged by high temperature and/or high humidity. Whenever possible, keep it refrigerated before and after exposure. IR films are susceptible to static markings at low relative humidity. If static problems occur, especially when rewinding the film, it may be necessary to ground the camera to avoid a static electricity buildup. For most consistent results, process film as soon as possible after exposure.

Many IR films have no antihalation backing, which makes the film thinner and trickier to load on to developing reels. However, many users favor the lack of antihalation because it can produce flare that adds to IR's mysterious look.

Focusing

Regular camera lenses are not designed to focus IR wavelengths. This is because IR radiation has longer wavelengths than those of the visible spectrum, making the focus point further from the camera lens. Therefore, the lens must be moved slightly farther from the film to focus an IR image. This focus difference is critical when using filters to block all visible radiation from the film. To correct this problem,

most lenses have an auxiliary IR focusing index marker engraved on the lens barrel. It is often a red dot or the letter R located close to the normal focusing mark on the lens. Check the camera manual to ascertain the location of the IR marking.

To obtain correct IR image definition, focus the camera in the normal manual mode. Note the distance indicated by the regular focusing index mark, then manually rotate the focusing ring to place that distance opposite the IR focusing index mark. The image may be fuzzy in the viewfinder, but the IR film will record it sharply. It is not necessary to make this adjustment when using a wide-angle lens or a small lens aperture (f-8, f-11, f-16), as the increase in depth of field will compensate. It is necessary to do this at distances of 5 feet or less and with all telephoto lenses. If your lens does not have an IR focusing index marker, adding about 0.25 per cent of the focal length to the lens–film distance can make the correction. For instance, a 200 mm lens would need a 0.50 mm extension as $200\,mm \times 0.0025 = 0.50\,mm$.

Filters

Because IR film is sensitive to visible and IR spectra, filters can be used to alter and control the amount of spectrum that the film records. Note that each film will respond differently to filtration. The following describes filters commonly used with IR film.

FIGURE 3.3 Bosworth's *Vivaria* series consists of black-and-white IR images he scanned and then digitally combined with digital color photographs to formulate a dialogue between a constructed reality and security in Washington, DC. His diptychs make these connections by "suggesting parallel narratives and causing us to feel the lure of the potential veracity and to want to believe in the photograph. Interpretation is a product of experience, fear, and desire and aligns the audience with the defenders of the gates."
© Michael Bosworth. *White House, East Gate*, from the series *Vivaria*, 2006. 16 × 32 inches. Chromogenic color print.

The Wratten No. 87 filter absorbs all visible light, allowing only IR radiation to pass through and be recorded. With a single lens reflex (SLR) camera, it is necessary to remove this filter to focus, as it appears opaque to the human eye. Subjects will be recorded in tones proportional to the amount of IR radiation they reflect. Those reflecting the most IR radiation will appear in the lightest tones. Objects that appear to be the brightest to the human eye are not necessarily those that reflect the most IR radiation. For this reason, the tonal arrangement of the scene recorded by the IR film will often seem unreal when compared with the same scene recorded on a panchromatic film that is sensitive to the visible spectrum. Other filters that block UV and most or all visible radiation are Wratten No. 89B, No. 88A, and No. 87C. Each of these filters removes different wavelengths of light, creating different effects.

The Wratten No. 25 filter (red) is commonly used with IR film. It prevents blue and green light from passing through but transmits red and IR radiation. It enables the photographer to focus through the SLR viewfinder. This filter can produce bold visual effects. The sky may appear black, with clouds seeming to pop out into the third dimension. Caucasian skin can lose detail and take on an unworldly glow. Surface veins in the skin can become extremely noticeable.

The Wratten No. 29 (deep red) filter can produce an even greater effect, but requires one f-stop more exposure than the Wratten No. 25.

IR film is excellent for use in penetrating haze and can be used with a polarizer in conjunction with a No. 87 or No. 25 filter.

Almost any colored filter will block certain wavelengths of visible light and permit IR radiation to pass through. A polarizer and the Wratten No. 12 (yellow), Wratten No. 58 (green), and Wratten No. 15 (orange) filters offer varying effects by removing part of the blue wavelengths of light. Try different filters and see how the film responses. Keep notes so that you can replicate the results.

Without filtration, IR film reacts more strongly to the visible spectrum. This produces less dramatic images than those produced with filters and generally results in a noticeable increase in graininess.

Exposure

Determining the correct exposure for IR film requires experience. It is impossible to determine the precise film speed needed to set the exposure meter. This is because the ratio of IR to visible light is variable and most metering systems do not respond to IR radiation.

Table 3.1 offers ISO/film speed starting points. When possible, determine exposure with a hand-held meter in incident light mode. Note: that with through-the-lens (TTL) metering systems, make your readings before mounting the filter over the lens. Then ignore the meter reading/readout after attaching the filter. Bracket in one-half f-stops and when in doubt, overexpose.

Changes in exposure cause noticeable differences in how IR film records the image. A correct exposure delivers

TABLE 3.1 Starting ISO Settings for Black-and-White IR Film

Wratten Filters	Type of Illumination	
	ISO for Daylight*	ISO for Tungsten*
No filter	80	200
25, 29, 70, and 89B	50**	125
87 and 88A	25	64
87C	10	25

*Film processed in Kodak D-76 or Ilford ID-11 stock solution.
**When in doubt, use this ISO rating as a starting place.

a scene with a wide contrast range that is easy to print. Underexposure causes the scene to lose depth and appear flat. Details in the shadow areas are lost. Overexposure produces a soft, grainy image often possessing a sense of visual weightlessness when compared to the original scene.

The amount of IR radiation will vary depending on the time of day, season, altitude, latitude, and distance of the camera from the subject. As a general rule, the lower the sun is on the horizon, the greater the amount of IR light. Faraway scenes such as a landscape often require less exposure than a close-up such as a portrait. This is due to the increased amount of IR radiation that is reflected and scattered by the atmosphere over greater distances. Various subjects will also respond in different ways. As variations are likely and unpredictable, it is initially advisable to bracket exposures by at least two f-stops in each direction to ensure the desired aesthetic and technical results with IR film.

Processing

Manage IR film with care, as it can be more prone to damage from handling than conventional film. Handle IR film only by its edges when loading it onto a processing reel, as it has a remarkable ability to capture and incorporate fingerprints into the processed image.

Process the film in closed stainless steel tanks with stainless steel lids. Some plastic tanks can leak IR radiation and fog the film. Test them to be safe.

Table 3.2 lists suggested beginning processing times for the most commonly used developers with IR film. D-76 produces a tonal range similar to that of a panchromatic film. D-19 greatly increases contrast and graininess. After development, follow standard processing procedures. Do not hesitate to modify these recommendations.

Flash

IR film can be used with an electronic flash in a variety of ways, including the following:

- Use a Wratten No. 25 filter and normal flash methods.
- Cover the flash tube with Wratten No. 87 gel. This will make the flash almost invisible to the human eye,

TABLE 3.2 Starting Development Times for IR Film*

Developer	65°F/18°C (minutes)	68°F/20°C (minutes)	70°F/21°C (minutes)	72°F/22°C (minutes)	75°F/24°C (minutes)
D-76 (for pictorial effect)	13	11	10	9½	8
HC-110 (Dilution B)	6	5	5	4½	4
D-19 (for high contrast)	7	6	5½	5	4
XTOL	6½	5½	5	4½	4

*Check manufacturers' guidelines for latest recommendations.
Development time in minutes for small tanks. Initial constant 30 second agitation; 5 second agitation every 30 seconds thereafter.

FIGURE 3.4 Abeles merged an IR satellite image with sculptural trees, combining a clean, seamless, 2-D digital print with messy, tactile, 3-D found objects. The combination of these elements explores the function of landscape in an urban area, "focusing on the Newport Coast region of Southern California where palm trees are a common luxury that leaves an engraved impression on the minds of residents and visitors." © Kim Abeles. *Infrared Coast*, 2007. 18 × 18 × 6 inches. Ultrachrome print with mixed media. Courtesy of a private collection.

enabling the flash to be used without people being aware of it.

■ Get an IR flash unit designed to emit light at the wavelengths to which IR film is most sensitive. Some flash units have detachable heads that can be replaced with the IR type.

IR Exercise: Gaining Experience

Obtain three rolls of IR film, such as Efke IR820. Use the first two rolls to photograph a variety subjects – people, buildings, plant life, and landscapes – at different distances and at different times of the day. Keep a record of your bracketed exposures. Process one roll in D-76 and another roll in D-19 and note your procedures. Make contact sheets of each roll. Now take the third roll and apply what you have learned.

IR Films and their Characteristics

IR film is known for the textural, dreamlike images it can generate. When used with filters that are deep to opaque red, IR film can generate scenes where foliage and clouds are glowing-white, while water and blue sky look coal black and the overall contrast is slightly soft. Warm skin tones and lips will appear white. When used without filtration IR film behaves much like a conventional panchromatic black-and-white film. Depending on its IR sensitivity, each film will deliver different results and therefore should be tested before undertaking any important work.

EXTENDED RED SENSITIVITY FILM

Films, such as Ilford's SFX 200, are not true black-and-white IR films; rather they have an extended red range that can give similar effects. SFX 200 has a panchromatic black-and-white emulsion that is sensitive beyond the visible spectrum into the IR (about 740 nanometers) as opposed to a true IR film, which goes farther (about 900 nanometers). SFX has a useful speed rating of ISO 200 and can be processed in a wide range of conventional developers.

Filters

An R72 IR filter is recommended for IR effects. With a Wratten No. 25 (red) or No. 89B (very deep red) filter you can get image effects similar to IR film. The extended red sensitization allows the film to record the IR fluorescence of chlorophyll, the effect that turns foliage bright white

TABLE 3.3 Development Times for Ilford SFX Film (Meter Setting ISO 200)

Developer	65°F/18°C (minutes)	68°F/20°C (minutes)	70°F/21°C (minutes)	72°F/22°C (minutes)	75°F/24°C (minutes)
D-76 or ID-11 (stock)	11½	10	9	8	7
T-MAX (1:4)	9	8½	7¾	7	6
ILFOTEC HC (1:15)	5½	5	4½	4	3¼
HC-110 (Dilution B)	10	9	8	7¼	6¼

and darkens skies. With these filters the film relies on the extended red sensitivity for exposure, so testing and experience are helpful. Without filters, its full panchromatic sensitivity allows it to be used as a normal black-and-white film.

Focus

No focusing correction is needed as the film is not sensitive much beyond the visible spectrum and therefore does not record the wavelengths that are out of the designed operating range of the lens. As a result, Ilford SFX generally produces sharper images, with less flare, than IR film. The film also does not need to be loaded in complete darkness, although it is still recommended.

HIGH-SPEED BLACK-AND-WHITE FILMS

General Characteristics

High-speed panchromatic stock, often with extended red sensitivity, is designed for low-level light situations or any time when a flash cannot be used. Such films are useful for capturing very fast action; in dimly lit situations where you can not use flash; for subjects requiring good depth of field combined with fast shutter speeds; and for handholding telephoto lenses for fast action or in dim light. It is an excellent choice for indoor or nighttime sports events and available-light press photography, as well as law-enforcement and general surveillance applications that require exposure indexes of 1600–25 000, thus allowing photography in situations where it was previously impossible.

High-speed films are designed to be used at multi-speeds and possess excellent push processing capability; allowing it to be effectively processed at an ISO greater than it is normally rated at. The speed depends on your application; and testing is recommended to determine the appropriate speed and processing details.

High-speed panchromatic film is very sensitive to environmental radiation; and should be exposed and processed as soon as possible.

Load and unload your camera in subdued light, and rewind the film completely before unloading the camera. Store processed film in a cool, dry place.

In the darkroom, unprocessed high-speed panchromatic film must be handled in absolute darkness and cannot be developed by inspection. Timers and watches with fluorescent faces should be turned away from the unprocessed film. Even the afterglow of certain white lights (incandescent bulbs) can fog these films. Double-check to be sure the darkroom is totally dark before handling unprocessed film.

Store unexposed film in its original sealed package at 75°F (24°C) or below. For protection from heat in areas with temperatures consistently higher than 75°F (24°C), you can store the film in a refrigerator. If film has been refrigerated, allow the package to warm up to room temperature for 1–1½ hours before opening it.

Request visual inspection of high-speed films at airport X-ray inspection stations.

Some older cameras have ISO settings that go up to only 1600. If your camera does not have ISO settings above 1600 but has an exposure compensation dial, set it at minus 1 to get a speed of 3200 or minus 2 to achieve an ISO of 6400.

To expose film at speed settings that are higher than the maximum setting on your camera or meter, set the meter at a lower speed; then reduce the aperture or increase the shutter speed to compensate.

To use high-speed film in conventional lighting situations, it is helpful to have a camera with high-speed shutter capabilities. The shutter speed should at least be able to equal the film's speed rating. If it is not possible to use such a camera, neutral density (ND) filters can be used to reduce the amount of light reaching the film.

Kodak T-MAX P3200 and Ilford Delta 3200 High-Speed Films

When extremely fast black-and-white film speeds are required without sacrificing image quality and tonality, Kodak T-MAX P3200 and Ilford Delta 3200 are multi-speed negative films to consider. T-MAX P3200 is capable of delivering high to ultrahigh film speeds with a fine grain and broad tonal range, good shadow detail, and open highlights. It is the fastest of any of the films in the

T-MAX group. Delta 3200's grain structure is slightly different than T-MAX P3200, with the grains being slightly smaller but with a greater overall surface area. The result is a film that shows more grain but is both faster and slightly sharper than T-MAX P3200.

The fast speeds of T-MAX P3200 are possible through the T-grain technology, which improves the silver halide sensitivity by the use of tabular (T) silver grains. These grains provide a larger surface, enabling the emulsion to capture more light than was possible using the conventional pebble-shaped silver crystals. Delta 3200 Professional is based on Ilford's proprietary core-shell crystal technology, a complex four-part emulsion package. This emulsion gives the film heightened tonal rendition and wide exposure flexibility. The technology of these two films allows exposure at very high ISO ratings while still retaining a fine grain structure and a great amount of sharpness that permits the retention of detail in large-scale enlargements. The larger grain size does cause higher contrast but offers good tonal separation, wide exposure latitude, and minimal reciprocity failure.

Exposure

As T-MAX P3200 and Delta 3200 are multi-speed films, their rating depends on their application. T-MAX P3200 has a nominal speed of 1000 when processed in Kodak T-MAX Developer and 800 with other black-and-white developers. Its amazing latitude permits exposure at 1600, which results in high-quality negatives with little apparent change in grain size and only a slight loss of detail in the shadow areas. P3200 film can easily be exposed at speeds of 3200 or 6400 by increasing the development time. This will produce a slight increase in contrast and grain size, as well as a loss of detail in shadow areas.

Test Roll

Testing is necessary to determine the correct speed for your equipment and circumstances. When exposing your first roll, begin bracketing/rating the film at 3200 and bracket two f-stops over (1600 and 800) and four f-stops under (6400, 12 500, 25 000 and 50 000). When exposing your first roll, start with ISO 1600 and bracket, in one-half f-stops, two full f-stops in the minus direction (underexpose). Based on this visual test, select the exposure that best represents the subject. Continue to bracket and analyze the results until confidence and experience are gained. There is a big increase in contrast and graininess, with a distinct loss of shadow detail at speeds above 6400, but image sharpness remains surprisingly good.

Note: With both long and short exposures, T-MAX P3200 requires less compensation than traditional films. There is no correction at speeds between 1 and 1/10 000 second. At 10 seconds, the lens aperture needs to be opened an additional two-thirds f-stop, or the time must be increased by 5 seconds to provide a total exposure of 15 seconds.

T-MAX P3200 Development

T-MAX P3200 was designed to be processed in T-MAX Developer or T-MAX RS Developer and Replenisher to provide improved shadow detail in both normally and push-processed T-MAX films. Both T-MAX developers are all-liquid formulas that can be used to process and push process other black-and-white films that are not in the T-MAX group. T-MAX films also may be processed in other developers.

Processing

Table 3.4 lists starting points for developing T-MAX P3200 at a variety of ISOs with T-MAX Developer to produce a normal contrast negative for use in printing with a diffusion enlarger. With a condenser enlarger, a lower contrast negative may be desirable. This is accomplished by using a development time for a film speed rating of one f-stop lower than the speed used to expose the T-MAX P3200 in the normal fashion with the film. For instance, if the film was exposed at 6400, develop it at the time indicated for 3200. Expect to modify these time based on your situations.

After development is complete, process T-MAX P3200 in the normal fashion with the exception of the fixing step. P3200 requires careful fixing using a rapid fixer for 3–5 minutes with vigorous agitation. This film will exhaust the fixer more quickly than conventional films. If the film shows a pinkish magenta stain or is blotched or streaked with an intense purple, the fixing time is too short or the fix is nearing exhaustion. These problems can be corrected by refixing the film in fresh fixer. If the stain is still present after proper fixing, it is often eliminated through the use of a hypo clearing agent. A slight stain, caused by the increased amount of residual sensitizing dyes used to make the film panchromatic, should not affect the film or its printing characteristics even with variable-contrast paper. This slight stain tends to fade with time and exposure to light. However, if the stain is pronounced and/or irregular over the film's surface, refixing the film in fresh fixer is in order. For more information see: Kodak Publication No. F-4016 (www.kodak.com/global/en/professional/support/techPubs/f4016/f4016.pdf).

Ilford Delta 3200 Development

Delta 3200 Professional does not require any special development steps. The film can be processed in all types of processing equipment including spiral tanks, rotary processors, dishes or trays, deep tanks, and automatic processors. Standard capacity figures and replenishment rates can be maintained. Like P3200, Delta 3200 requires careful fixing using a rapid fixer (1:4) without a hardener for 3–5 minutes at 68°F (20°C) with vigorous agitation. This film will also exhaust the fixer more quickly than conventional films. Ilford recommends a hardener only when processing at high temperatures (above 86°F/30°C). Table 3.5 provides temperatures and times in a variety of developers.

TABLE 3.4 Development Temperatures and Times for T-MAX P3200 Film

Developer	Film Speed	70°F/21°C (minutes)	75°F/24°C (minutes)	80°F/27°C (minutes)	85°F/29°C (minutes)
T-MAX	400	7	6	5	4
	800	7½	6½	5½	4½
	1600	8	7	6	5
	3200	11	9½	8	6½
	6400	13	11	9½	8
	12500	15½	12½	10½	9
	25000	17½	14	12	10
	50000	20	NR	NR	NR
T-MAX RS	400	7	6	5½	5
	800	8½	6½	6	5½
	1600	9½	7½	7	6
	3200	12	10	9	8
	6400	14	11	10	9
	12000	16	12	11	10
	25000	NR	14	13	11
D-76	400	9½	7½	6	4½
	800	10	8	6½	5
	1600	10½	8½	7	5½
	3200	13½	11	8½	7½
	6400	16	12½	10½	9
HC-110	400	6½	5	4½	3½
(Dilution B)	800	7	5½	4¾	4
	1600	7½	6	5	4½
	3200	10	7½	7	5¾
	6400	12	9½	8	6¾
XTOL	400	7½	6¾	6	5¼
	800	8¼	7½	6¾	5¾
	1600	9¼	8¼	7½	6¾
	3200	11	10	9	7½
	6400	12½	11¼	10	8¾
	12500	15¼	13¾	12½	10½
	25000	18½	16¾	15	12¾

NR = not recommended.

TABLE 3.5 Development Temperatures and Times for Ilford Delta 3200 Film

Developer	Film Speed	68°F/21°C (minutes)	70°F/24°C (minutes)	75°F/27°C (minutes)	80°F/29°C (minutes)
Ilfotec DD-X (1:4)	400	6	5½	4	
	800	7			
	1600	8			
	32000	9½			
	6400	12½			
	12500	17			
T-MAX (1:4)	400	5½	5	3½	NR
	800	6½	6	4½	3½
	1600	7½	6¾	5¼	4
	3200	8½	7¾	6	4¾
	6400	11	10	7½	6
	12500	14	12½	9¾	7¾
T-MAX RS	400	NR	5½	4	NR
	800	NR	6	4½	NR

(Continued)

TABLE 3.5 Contd.

Developer	Film Speed	68°F/21°C (minutes)	70°F/24°C (minutes)	75°F/27°C (minutes)	80°F/29°C (minutes)
	1600	NR	6½	5	3¾
	3200	NR	8½	6½	5¼
	6400	NR	10	8½	6¾
	12500	NR	13½	10½	8
D-76&ID-11	400	7	6½	5	3¾
	800	8	7¼	5½	4¼
	1600	9½	8½	6½	5¼
	3200	10½	9½	7¼	5¾
	6400	13	11¾	9	7
	12500	17	15¼	11¾	9
HC-110 (Dilution A)	400	NR	NR	NR	NR
	800	NR	NR	NR	NR
	1600	5	4½	NR	NR
	3200	8	7¼	5½	4¼
	6400	13	11¾	9	7
HC-110 (Dilution B)	400	6	5½	4	NR
	800	7½	6¾	5¼	4
	1600	9	8	6¼	5
	3200	14½	13	10	7¾
	6400	NR	NR	NR	NR
XTOL	400	5	4½	NR	NR
	800	6	5½	4	NR
	1600	6½	6	4½	3½
	3200	7½	6¾	5¼	4
	6400	10	9	7	5½
	12500	12½	11¼	8¾	7

NR = not recommended.

General Characteristics of T-MAX P3200 and Delta 3200 at Various ISOs

400 This produces an extremely solid, not quite opaque (bulletproof) negative, resulting in a mushy print lacking in sharpness and having blocked highlights. It is not recommended for general pictorial use.

800 One f-stop faster delivers much better results, but still lacks good tonal range and sharpness.

1600 This speed produces gorgeous quality. Shadows are fully separated and highlights are open and unblocked. Tonal range is excellent, with grain and sharpness compatible with conventional ISO 400 films. A slight increase in contrast results in a snappy print and is useful with low-contrast subjects.

3200 The negative has a full tonal range with a small loss of detail in the shadow areas. Grain and sharpness are outstanding. These 3200-speed films dispense with the technique of "cooking" film in exotic developers, which often produces chalky and extremely grainy images at this ISO.

6400 This speed still produces a highly acceptable negative, but the loss of shadow detail is more apparent. Contrast and grain size start to increase, but highlight retention and tonal range remain good.

12500 Tonal range is compressed, contrast starts to become excessive, and granularity is much more visible. Pictorial print quality begins to degrade, but good press or Internet quality prints can be made.

25000 This is the outer limit for a printable negative. Highlights begin to become chalky, and shadows lack detail. Subtleties disappear as the tonal range becomes greatly compressed. Image quality remains sharp but very grainy. Prints are still useable for newspapers, some magazines, and the Internet.

50000 This astronomical speed pushes the film's capability to the edge. Try it when a picture is a "must" and traditional print quality is not a factor. Contrast and grain are way up, but the image is still sharp. Shadow detail is almost nonexistent. Printing requires expert care and patience, with dodging needed to make shadow areas recognizable.

HEIGHTENING GRAIN AND CONTRAST

Kodak TRI-X in Dektol

Generally, the faster the film, the more grain it will produce. Using a conventional, moderately fast film such as Kodak TRI-X, you can increase the amount of grain by altering the standard processing method. Developing TRI-X in fresh Dektol produces much coarser grain than normal, with an increase in contrast. This combination works well in both flat and average contrast situations, but there is a noticeable reduction in the tonal range.

Exposure

Rate TRI-X at 1600 for daylight and 800 for tungsten. Bracket your exposures – one f-stop under and two f-stops over. Note: Developing TRI-X in Dektol reduces the film's exposure latitude so meter carefully.

Development

Table 3.6 gives a starting point for development. After development is completed, continue to process normally.

Kodak TRI-X and Sodium Carbonate

Another way to increase the grain pattern in films like TRI-X is to use sodium carbonate. Expose the film normally, then soak the film in a 10 per cent solution of sodium carbonate for 2–5 minutes before putting it in its normal development. The amount of soaking time determines the increase in the grain pattern. The sodium carbonate is a moderate alkali that increases the pH of the film, causing the action of the developer to accelerate.

TABLE 3.6 Development Times for Kodak TRI-X in Fresh Dektol*

Temperature	Time (minutes)
68°F (20°C)	4
72°F (22°C)	3½

*Use continuous agitation for the first 15 seconds and then agitate for 5 seconds every 15 seconds to avoid potential streaking, that may be caused by the high activity and strength of the developer.

FIGURE 3.5 "The act of remembering combines fact and fiction. These pictures utilize diverse materials to simulate how the mind intermingles and blurs the boundaries of reality. They fabricate depictions that reflect the authenticity of the original memory. This visual strategy allows events and thoughts to be rearranged out of their original context and progression." To achieve these ends, the original scene was photographed with TRI-X and a red filter and developed in Dektol for 4 minutes to heighten the contrast. With the enlarger light on and a red filter in place under the enlarging lens, square masks were overlaid on a grade #4 photographic paper. The enlarger light was then turned off, the red filter removed, and the exposure was made. During the enlarging exposure the image was painted with light using fiber optics and small flashlights. Light painting also continued while the print was in the developer to achieve different tonal effects. © Robert Hirsch. *Tucson*, from the series *Remembering and Forgetting*, 1983. 16 × 20 inches. Toned gelatin silver print.

If the film carbonic absorbs too much sodium carbonate, gas bubbles can form in the emulsion when an acid stop bath is used. These gas bubbles will create pinholes in the emulsion; for this reason it is advisable to avoid using an acid stop bath with this procedure.

ULTRA-FINE GRAIN BLACK-AND-WHITE FILM: ILFORD PAN F PLUS

Ilford PAN F PLUS is an extremely fine-grain film that can be used to produce incredibly sharp normal-contrast pictorial images and/or mural-size enlargements with minimal grain. The film has an outstanding range of tone and detail as well as excellent resolution, sharpness and edge contrast. With a rated ISO of 50 and normal film-processing techniques, it is a good choice where fine detail and lack of grain are more important than film speed, especially when exposed at ISO 25. The film has minimum exposure latitude, lacking the leeway of higher-speed films and therefore requires accurate exposure.

Processing

Ilford PAN F PLUS is a moderate-contrast film and can be processed with a variety of different developers to achieve outstanding pictorial results at ISO 25. Table 3.7 shows how a variety of developers can be used to produce finer grain or maximum sharpness (greater contrast).

HIGH-CONTRAST LITHO FILMS

High-contrast litho films are orthochromatic (not sensitive to red light) and can be handled under a red safelight. They are designed primarily for the production of halftones (they create a dot pattern, based on tonal graduations, that allows a photograph to be reproduced using printer's inks) and line negatives and positives for use in photomechanical reproduction. Conversely, they can be used for dramatic pictorial effects because of their ability to drop out most of the midrange tonal gradations of a subject. This creates a composition that relies on graphic black-and-white shapes for visual impact.

High contrast can be produced in the darkroom through the use of a graphic arts litho film in conjunction with high-contrast litho developers. Most commonly used by the offset and screen printing industry, litho films are manufactured by a number of firms and are available in rolls and sheets. A variety of sizes and brands of litho films can be found at photography dealers and offset printing suppliers.

Applications

Litho films offer an extensive visual array of effects that cannot be achieved with conventional films. Litho films also offer a quick and convenient method for producing many generations, in different forms, from an image on a negative or transparency. A normal negative can be used to make a high-contrast positive that can be used to form a new high-contrast negative, which in turn can be reversed back to a positive. This film can be drawn or painted on, sandwiched together with other film images, scraped, scratched, cut up, collaged, or used directly as a final image itself. Litho film can also be presented in a light box. Small-format images can be enlarged to be contact printed in a variety of other processes.

Images from other sources also can be incorporated into the process. For instance, a magazine picture can be contact printed, ink side down, on litho film. Both sides of the image will be visible. If this is not acceptable, try one of the transfer methods discussed in Chapter 11. Litho films may be exposed directly in a camera. Photograms can be made by placing objects on top of the film and exposing it. A bas-relief print can be produced by combining a contact-size positive, slightly out of register, with the original continuous-tone negative. For instance, a high-contrast bas-relief can be produced if a litho negative and positive of the same size are sandwiched slightly out of registration. A high-contrast black-and-white positive can be used to make a high-contrast positive print. The original negative and the contact litho positive and negative can all be sandwiched together and printed. Posterizations are possible by making a series of positives and negatives to be combined and printed.

Unfortunately, some people abuse litho films' ability to transform a subject; trying to make a boring and trite image magically daring by converting it to a high-contrast print. An image that is dull to begin with will not become new and exciting by transferring it to a litho film.

Do not force the process on an image. Work with an image that will be enhanced by the process. Do feel free to experiment with this type of film, however, for it offers the thinking photographer an abundant source of possibilities.

TABLE 3.7 Ilford Developers and Pan F Plus at ISO 25 with Standard Agitation

Desired Outcome	Developer	65°F/18°C (minutes)	68°F/20°C (minutes)	70°F/21°C (minutes)
Normal results	ID-11 (stock)	7½	6½	6.0
Fine grain	Perceptol (stock)	10½	9	8
Maximum sharpness	ID-11 (1:3)	16	14	12½

FIGURE 3.6 To initially fashion this image Seeley used an office copier as a camera; placing a drawing template, an eye chart, and assorted military patches directly on the copier glass. The paste-up was then exposed to a large sheet of ortho litho film, which in turn was exposed to an aluminum waterless lithographic plate. After processing, the plate was "rolled up" in adhesive rather than ink. Carbon powder was brushed into the tacky areas, and then blown off the dry areas of the print. Seeley says that he likes "this method of printing because it creates the densest, flattest black possible. The construction of the image from copies is inexpensive and allows for a looseness of form that is not always possible in other forms of printing. I like the crude effect of the copy process and often make copies of copies to exaggerate the effect. I retouch the paper positive with fine and broad-tipped marking pens and the litho film with liquid opaque." © J. Seeley. *Chart*, a 21 Steps Edition, 1994. 22 × 30 inches. Carbon-dusted photographic litho.

Litho Production and Materials

One can make litho negatives and positives by contact or projection methods starting with a negative or a positive (transparency). You need these basic materials:

- Original continuous-tone negative or slide (black-and-white or color).
- Contact printing frame or clear glass.
- Litho film.
- Litho film developer.
- Orthochromatic safelight filter, such as Wratten Series 1A (red).

The darkroom setup, with the exception of the litho developer and 1A safelight, is the same as for processing a regular black-and-white print. Follow the manufacturer's instructions for mixing the litho developer.

Mix all chemicals in advance and allow them to reach a processing temperature of 68–72°F (20–22°C). Due to its rapid oxidation, a working solution of litho developer is generally prepared by combining equal amounts of mixed stock solutions at the time of processing. Use trays that are slightly larger than the size of the film being processed. Have enough solution to cover the film completely during each step. One quart of working litho developer solution will process about 15 8 × 10 inch sheets before exhaustion.

Making an Enlarged Litho Positive

1. Place a clean original continuous-tone negative in the enlarger.

2. Project the image onto a clean opaque surface like a paper easel that has been painted with a black matte finish or attach black paper to the easel instead to ensure there is no reflectance. Adjust for the desired enlargement size. Focus on a piece of white paper.

3. Position the litho film on the opaque surface, emulsion side up. The emulsion side is lighter colored and more reflective than the base side. Cover it with a clean piece of glass.

4. Litho film, like any type of film, will attract dust more than photographic paper. Use air or a soft brush to clean off any dust that may be clinging to the surface of the film. The use of a static brush on unexposed litho film is not recommended as it may cause fogging.

5. Set the lens to about f-11 and make a test strip at 3 second intervals. The times should be similar to those used for making test strips with black-and-white paper of the same size.

6. Develop the film by sliding it, emulsion side up, into the developer solution. Agitate by lifting one corner of the tray slightly and setting it down. Repeat by lifting the opposite corner. Standard development time is between 2¼ and 2¾ minutes. Development time can be altered to change the contrast and tone.
 - Development can be carried out by visual inspection. To duplicate the results, use the same developing time. Normal development is complete when the dark areas are completely opaque. Not enough development time can produce pinholes and streaks. If the image appears too quickly, reduce the exposure time. If it looks too light after 2 minutes, increase the time.

7. After development is complete, follow normal processing procedures. Fixing time should be twice the time required for the film to clear.

8. Based on the test, determine the correct exposure and make a new high-contrast positive.

This process can also be carried out by contact printing the original negative, emulsion to emulsion, with the litho film.

Making a Litho Negative

To make a litho negative, take the dried positive and contact print it, emulsion to emulsion, with an unexposed piece of litho film. Follow the same processing procedures as in making a litho positive. Starting with a positive (transparency film) will enable you to make a direct litho negative, thus eliminating the need to make a litho positive. Bear in mind that litho film is orthochromatic and may not properly record the red and orange hues from the transparency.

Continuous Tones from Litho Film

Although litho films were designed to produce high contrast negatives, they can be processed to give continuous tones, from light to dark, like a normal black-and-white camera made negative. Professor Brian Taylor and his students at San Jose State University have successfully used the following method.

Two-Step Enlarged Negatives Place a clean black-and-white negative in the enlarger. Under red safelight conditions, identify the emulsion side of the litho film by gently folding one side over on itself until you can discern the lighter side. This lighter side is the emulsion, and should face up when printing. Treat the litho film just as you would conventional photographic paper in terms of cutting test strips (overexposure may be in order), establishing correct exposure times, using your easel, and tray developing (see "Making an Enlarged Litho Positive" box). As litho film is contrasty it is necessary to use a diluted developer mix of 1:6 to 1:15, which is processed for between 1½ and 3 minutes, to generate continuous tones.

Processing Litho Film for Continuous Tone Negatives

1. For *normal* contrast, start with Kodak Dektol Paper Developer at a dilution of 1:10. Develop for 2 minutes at 68°F (20°C). For *less* contrast, dilute the developer by adding more water to make a dilution of 1:12. For *more* contrast, add more developer to make a dilution of 1:8. Use constant tray agitation, just like photo paper, with all processing steps.

2. Weak acid stop bath (one-half paper strength) for about 15 seconds.

3. Fix in regular rapid film fixer for about 3 minutes. Paper fixer can be used, but is not recommended unless it has a hardener to guard against scratches later in handling.

4. Wash as you would other film: hypo neutralize, wash, and finish with Photo-Flo to reduce water spots. Hang to air dry in a dust-free environment.

What you will now have is a continuous tone positive, which will require contact printing with another piece of film, like making a contact sheet, to reverse it back to a negative.

Enlarged Negatives Alternatives One can produce a negative in a single step by putting a film positive, such as a color transparency, in an enlarger and carrying out the previous steps.

A second method involves first contact printing your original camera black-and-white negative onto a special continuous tone orthochromatic film, such as Efke Print Film, which is designed to hold highlight and shadow detail as opposed to having to coax it out of a standard litho film. In either case, after exposure, process, and place these black-and-white positives in an enlarger to produce your enlarged negatives.

A third solution is to make an enlarged negative by contact printing a resin-coated (RC) print on top of a piece

of ortho film. This procedure allows you to do your burning and dodging when making the original print, then contact print it with litho film to convert it into a same-sized negative.

Retouching Litho film is highly susceptible to pinholes, which can be blocked out by opaquing the base side of the film. Opaque also conceals scratches or unwanted details. Place the litho film, emulsion side down, on a clean light table. Apply the opaque with a small, pointed sable brush (size 0–000). Opaque is water soluble, so mistakes can be corrected with a damp Photo-Wipe.

Brian Taylor recommends simply using a red magic marker, which can opaque areas more easily than conventional opaque fluid applied with a brush. However, opaque and a brush are still best for spotting out pinholes. Even if light passes through the red color of the magic marker, it will be a "safelight" red and not expose the emulsion. Professional red opaque pens are available for graphic artists, but most permanent red markers work quite successfully.

ORTHOCHROMATIC FILM

Orthochromatic films were once widely used to produce dramatic portraits. By eliminating the red sensitivity of the film, flesh tones take on a rich gray hue and lips become very dark. Now the only continuous-tone orthochromatic films available are Ilford Ortho Plus, ADOX Ortho 25, and Efke Ortho 25. Check with manufacturers websites as to format availability. An effect similar to ortho film can be achieved by using a general use panchromatic film with a No. 80A filter.

PAPER NEGATIVES AND POSITIVES: CONTEMPORARY CALOTYPES

Today most photographers use clear-base flexible film to record images in the camera. This was not always the case. Photographic pioneer William Henry Fox Talbot invented a process called photogenic drawing (see Chapter 1). This process used high-quality writing paper sensitized with salt and silver nitrate to make photograms and contact-print copies of drawings and objects. By 1835, Talbot was using this paper process to record images in a camera obscura. The process relied on a printing-out exposure (light made the complete image) for camera negatives and prints. In 1841, Talbot patented an improved process called the calotype. It was much faster because the light was used to create a latent image that was completed during the development process. This process has served as the model for all current analog negative/positive imagemaking systems.

Compared with clear film negatives, paper negatives are less sensitive to light, do not record as much of the

visible spectrum, capture less detail, and have a reduced tonal range and higher contrast. Since the final image is printed through the fibers of the paper, the completed photograph has a soft, highly textured, impressionistic appearance.

Applications

Any paper may be treated with a light-sensitive emulsion and exposed (see Chapter 6). Regular photographic paper is usually used. Paper can be exposed directly in a view or pinhole camera. The processed paper negative can be contact printed with an unexposed piece of photographic paper to make a positive print. An image from a normal negative can be used by enlarging it on a piece of photographic paper at the desired size. This paper positive is contact printed onto another piece of photographic paper to form a paper negative. The paper negative is now contact printed onto another piece of photographic paper to create the final print.

A transparency image can be used to make an enlargement on a piece of photographic paper. Since the transparency image is a positive, it can be used to produce a paper negative that is in turn used to produce a paper contact print. Images on any type of translucent surface, such as the paper used in magazines, newspapers, and posters, can be contact printed and used in this process. Paper negatives can be combined with normal negatives to make a multi-image composition. Paper negatives and positives are easy to retouch. The photographer can make additions such as clouds or remove unwanted items.

Paper Negative and Positive Process

1. Place a continuous-tone negative in the enlarger and make a print at the exact size of the final image. The print should be flatter in contrast and darker than normal, having discernible detail in both crucial highlight and shadow areas. If possible, use a low-contrast single-weight paper. Variable-contrast papers are handy for this process. Avoid papers that have the manufacturer's name imprinted on the back. RC paper can be used because the plastic diffuses the trademark so it is not visible in the final print. RC paper makes good contact when two pieces are placed together for contact printing.

2. Tape the corners of the completed print, image side down, to a light table for retouching. Dark areas can be intensified by adding density on the back of the print, thereby giving the printmaker control over the shadow areas. Soft pencils, pastels, ink, or even a ballpoint pen can be used. If retouching materials do not adhere properly, coat them with a clear Retouching Spray such as McDonalds Professional Photo Lacquer, which is formulated with a non-nitrocellulose resin system that provides archival qualities in clarity and color transmittance, and neutral pH.

3. Contact print the retouched print onto a piece of unexposed photographic paper to make a paper negative. Remove the enlarger's lens board to reduce exposure time. Make sure the two pieces of paper are in as close contact as possible. If you are having trouble making good contact, try soaking the paper positive and the unexposed paper in water and pressing them together with a squeegee or roller.

4. After processing and drying the paper negative, tape it, image side down, to the light table for retouching. During this stage, added density from retouching will block out and intensify the highlight areas.

5. Contact print the retouched negative onto unexposed paper. The choice of paper will determine the amount of control the printmaker has over contrast and surface texture. Coating the back of the paper negative with a very thin layer of oil can increase the contact, making the negative more transparent and reducing exposure time.

Control of Detail and Texture

For maximum texture in the final print, expose the paper normally, emulsion side up. For minimum texture and maximum detail, briefly (about 1 second) flash light from the enlarger through the paper's base side (emulsion side down). Turn it over (emulsion side up) and contact print it with the paper negative. For minimum detail and texture, expose the paper through its base side with no flash exposure.

Paper Digital Negatives

Paper negatives can also be created using a digital process. Desktop printers connected to a computer offer a variety of quick, print attributes. Although the quality of a desktop printer may not be suitable to create a negative for enlargement printing, outstanding results can be achieved through contact printing (see section on "Digital Negative Making"). Check with the manufacturer for details about the weight and consistency of paper put through the printer. Also, negatives from an inkjet, color, or black-and-white electrostatic printer (photocopier) can also be used as negatives (see Chapter 12).

REVERSING BLACK-AND-WHITE FILM

Today most photographers present prints as their finished product. This has not always been the case. At the turn of

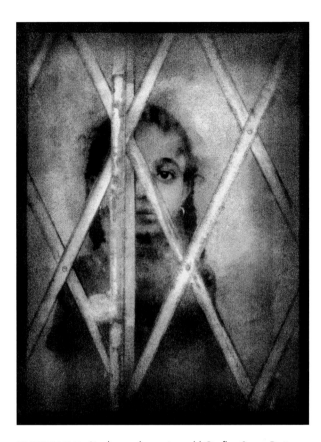

FIGURE 3.7 Liepke used a century-old Graflex Super D view camera to capture this image. He developed the 4 × 5 inch TRI-X film in Agfa Rodinal 1:25 and scanned the negative into Photoshop. After producing an enlarged paper negative, he coated it in wax, ultimately using the waxed paper negative to create the print. Liepke's work, which encompasses technology ranging from a late nineteenth century to early twenty-first century, "is a constant process of mixing the old with the new." © Peter Liepke. *Spanish Harlem Girl*, 2003. 10 × 8 inches. Bromoil print.

the nineteenth century, lantern slides were most popular in photographic clubs and salons. A lantern slide is a positive transparency, named after the nineteenth century projectors called magic lanterns, made or mounted on glass for projection. With slides, what you see is what you get. There is no second step needed to arrive at the final image as in the negative/positive process. This enables the slide to depict a greater amount of detail and a wider range of tones than can be expressed by a traditional print. This is because film (the lantern slide) has a wider tonal range than paper. Lantern slides were fragile, heavy, thick, and larger than their 35 mm heirs. The glass ensured image flatness during projection, giving the scene incredible sharpness. The bigger formats added to the retention of detail and the luminosity of the original subject.

A present-day photographer could still choose to work with black-and-white positives when making photographs expressly for the following purposes: reproduction

in the print media, when images are needed for analog projection, for copying any continuous tone material, when a complete darkroom with a printing facility is not available, or simply for the sheer beauty the slide image is capable of bestowing on the subject.

Kodak Direct Positive Film Developing Outfit

The Kodak Direct Positive Film Developing Outfit is an all-liquid kit that delivers black-and-white slides from Kodak T-MAX 100 Professional Film. With T-MAX 100, this outfit provides continuous-tone slides of the original subject. This film is recommended for making copy negatives from black-and-white or color negatives, for duplicating black-and-white slides, for making black-and-white slides from color slides, or for general pictorial purposes.

Exposure/ISO

For normal contrast use, such as producing slides from continuous-tone photographs or artwork, and for general pictorial work, set the ISO for T-MAX 100 at 50. For high-contrast use, such as making slides from line art, set the ISO at 64. For lower contrast, set the ISO at 25. For initial use, make a series of exposures in which you bracket, in small increments of one-third f-stop, one full f-stop over and under the indicated exposure to determine the correct speed for your situation. When doing copy work, meter off of an 18 per cent gray card to ensure accuracy as metering off of the copy material can produce inconsistent results.

Processing

Film must be handled in total darkness until bleaching is completed, after which the film can be examined under a Kodak OA safelight filter. Do not use white light until the film has been fixed.

Table 3.8 lists the starting small tank processing steps for the Direct Positive Film Developing Outfit. Read the instructions supplied with the developing kit before mixing and processing. Wash, hypo clear, final wash, Photo-Flo, and dry following normal procedures.

Contrast Control

Contrast is controlled most effectively at the time of initial camera exposure by bracketing, in one-third f-stops, within an effective range of about one f-stop in the plus or minus direction.

Slight changes in contrast can be achieved with T-MAX 100 by modifying the first developer solution. Lower contrast can be achieved by adding 40 milliliters of KODAK T-MAX Developer concentrate while adding 50 grams of sodium sulfite will increase contrast. These alternations will produce an effect similar to the result of printing a black-and-white negative on the next higher or lower contrast grade of paper (see outfit for details).

TABLE 3.8 Processing with Kodak Direct Positive Film Developing Outfit at 68°F (20°C)

Step	Time (minutes)
First developer	8*
Rinse	2
Bleach	2
Rinse	2
Clearing bath	2
Redeveloper	6*
Rinse	½
Fixer**	5

* This time is for fresh solutions. For partially used solutions, you must adjust the times in both the first developer and the redeveloper, using the tables provided in the kit, to compensate for the number of rolls already processed. Using this method, each 1 quart outfit allows up to 12 rolls of 35 mm film (36 exposures), 12 rolls of 120 film, or 12 8 × 10 inch sheets to be processed. Follow suggested agitation patterns.

** The processing outfit does not include fixer. Rapid or regular fixer may be used.

It is not possible to alter the contrast of the final positive image to a large extent by changing the temperature or time of the first developer. An increase in time or temperature in the first developer will produce an effect similar to overexposure of slide film. There is a general loss of density, as the entire image is lightened, with highlight detail becoming washed out. A decrease in the time or temperature of the first developer produces a result similar to underexposure. The overall density is increased and the highlights begin to darken.

The film's dark values can be intensified by combining 20 milliliters of Rapid Selenium Toner with 1 liter of hypo clear solution. A more neutral image tone is possible by treating the film with Kodak Brown Toner (see outfit for details).

One-Step Enlarged Negatives

One-step enlarged negatives can be produced with T-MAX 100 film with the Kodak Direct Positive kit by following these guidelines:

1. Expose film in the same way you would to make a print. As the film is panchromatic it must be handled in total darkness.
2. Place the original negative, emulsion side up, in the enlarger.
3. Use a black easel surface or cover it with an opaque paper to reduce fog and flare.
4. Use brief exposure times. Set the enlarging lens to f-22 or f-32 (a ND filter may be needed to reduce the amount of light). Set the timer for ½ second intervals (a digital timer is recommended for repeatable results).

5. Make a series of eight $^1/_2$ second exposures (from $^1/_2$ to 4 seconds).

6. Process normally following the instructions supplied with the kit.

Reversing Other Black-and-White Films

It is possible to perform reversal processing on other black-and-white films. Other reversal films, kits, and formulas are available from a variety of source. Also, some conventional films also can be reversed. Check the reversal kit you are using before processing, as certain films and film sizes do not yield good results.

RESOURCE GUIDE

Kodak T-MAX 100 Direct Positive Film Developing Outfit, Kodak Publication No. J-87 (www.kodak.com/global/en/professional/support/techPubs/j87/j87.pdf). www.dr5.com (specializing in film processing, especially reversal methods).

INSTANT POSITIVE AND NEGATIVE FILM

There are advantages to working with "instant" materials from the predigital age. These include: no need for a darkroom; rapid feedback, allowing corrections and changes to be made while still shooting; a reliable way to test equipment, lighting, and subject poses; and a good icebreaker that can help establish a rapport between photographer and subject.

Polaroid Positive/Negative film (Type 55) is a black-and-white material with an ISO of 50 and a standard development time of 20 seconds at 75°F (24°C). The negative must be cleared in a sodium sulfite solution (chemical provided with the film), then washed and dried before printing. The sodium sulfite removes the processing gel and makes the image visible.

Polaroid Positive/Negative film can be archivally processed. After the sodium sulfite bath, fix the negative for 2 minutes in a rapid acid-hardening fixer and then continues to process following regular black-and-white archival film processing procedures. One problem with this material is that the ideal exposure may be slightly different for the negative and the print, with the negative sometimes requiring more time. The negative is more fragile than a conventional film negative and must be handled carefully. These negatives can produce beautiful prints and may be used in nonsilver processes.

FILM FOR CLASSIC CAMERAS

Manufacturers stopped making film for most classic cameras years ago. If you want to make pictures with these older machines contact Film for Classics, who purchases large rolls black-and-white and color films from manufacturers,

FIGURE 3.8 Chiarenza likens his studio and darkroom to a scientific laboratory, in which he endeavors to make new realities visible. He embarks on this process without previsualizing the result, beginning by setting up a light in his studio and arranging pieces of paper and mixed media on his worktable. He manually manipulates, wrinkles, and damages the materials until they absorb and reflect the light in a visually striking manner. As he works, he makes innumerable Positive/Negative Polaroids, which effectively function as sketches of the collages. He makes maquettes out of the Polaroid contact prints before entering the darkroom to determine the extent of the manipulation that he needs to perform in to control the light in the final image through burning, dodging, and masking. Chiarenza states, "In the end, it is primarily about light. Light can be energy, symbol, metaphor, source; it can reveal, absorb, hide, reflect, modulate, modify, or transform an object's substance as well as its tone. Creating with light is, for me, as close to making music as the visual arts can get." © Carl Chiarenza. *Untitled 253*, 1994. 16 × 20 inches. Gelatin silver print. Courtesy of Stephen Cohen Gallery, Los Angeles, CA; Robert Klein Gallery, Boston, MA; and Alan Klotz Gallery, New York.

such as Kodak. They cut, and when necessary, spool the film with backing paper. They also offer a variety of cut sheet film and processing services for many film sizes. Also, Freestyle Photographic Supplies carries the once-common 127 film format in black-and-white ISO 100 stock.

RESOURCE GUIDE

Film for Classics: www.filmforclassics.com.
Freestyle Photographic Supplies: www.freestylephoto.biz.

PROCESSING BLACK-AND-WHITE FILM FOR PERMANENCE

Most serious photographers want their efforts to last as long as possible. To accomplish this goal, it is necessary

TABLE 3.9 Processing Black-and-White Film for Permanence*

Procedure	Time (minutes)
Presoak (optional)	1
Developer	As required
Acid stop bath (28 per cent)	½
Fixer (one or two baths)	Twice clearing time
Selenium toner (1:20) (optional)**	Until a slight change in color occurs (about 6 minutes)
First Wash	2–5
Washing aid	2
Final wash	10 (minimum)
Wetting agent in distilled water	1–2
Air-dry	As needed

*Use fresh solutions at 68°F (20°C).
**Film is immersed in toning solution directly from the fixer with no water rinse. Toner is used only once and then discarded.

TABLE 3.10 Sources of Archival Equipment and Supplies

Calumet Photographic	www.calumetphoto.com
Conservation Resources International	www.conservationresources.com
Freestyle Photographic	www.freestylephoto.biz
Light Impressions	www.lightimpressionsdirect.com
Century Photo Products	www.centuryphoto.com
University Products	www.universityproducts.com

TABLE 3.11 Sources of Alternative Photographic Chemicals, Lab Equipment, and Processing Kits

Artcraft Chemicals	www.artcraftchemicals.com
Bostick & Sullivan	www.bostick-sullivan.com
Fisher Scientific	www.fishersci.com
Photographers' Formulary	www.photoformulary.com

FIGURE 3.9 Burkholder made this hand-coated platinum/palladium print from a digital negative. One benefit of working from a digital negative is that every print gets the same exposure time without having to manually burn or dodge the print, as all the corrections are made in Photoshop before exposing the paper. This allows one to make the desired print with a higher rate of success and saves on consumable resources, such as expensive light sensitizers.
© Dan Burkholder. *Windmills, Spain*, 2002. 6 × 9 inches. Platinum/palladium print.

to follow working procedures that deliver maximum permanence. With archival methods, it is possible for contemporary black-and-white film well into the future. Table 3.9 lists the basic working procedures to process black-and-white film for maximum permanence.

DIGITAL NEGATIVE MAKING: AN OVERVIEW

This hand-coated platinum/palladium print (see Figure 3.9) was made from a digital negative. One benefit of working from a digital negative is that every print gets the same exposure time without having to manually burn or dodge the print as all the corrections are made in Photoshop before exposing the paper. This allows one to make the desired print with a higher rate of success and saves on consumable resources, such as expensive light sensitizers.

At a time when large format film and duplicating films are becoming more difficult to obtain, digital negatives combine classic chemical based photography with the latest digital capture and control to offer a precise way to generate the larger negatives needed for contact printing processes. This mix of analog and electronic methods allows one maximum leeway to experiment with numerous processes requiring a large negative.

Box 3.1 Basic Steps for Making a Digital Negative

1. Editing your image in Photoshop to make it look *exactly* like you want it to print as a final wet-process contact print. An image resolution of 240–360 pixels per inch (p.p.i.) works for most printers.

2. Including a step tablet with your image until your negatives are printing exactly as you want them.

3. Preparing your image with the proper contrast via Curves.

4. Inverting the image so it prints as a negative instead of a positive.

5. Printing the negative on clear transparency material using specific print dialog box settings.

The simplest way to make digital negatives is using Photoshop and a desktop inkjet printer. The resulting inkjet negatives can be used to print on classic photosensitive silver gelatin materials or with nineteenth century cyanotype or platinum/palladium methods. When properly done, you can make contact prints rivaling the quality of those made from camera-original negatives. The following procedure for making a basic digital negative has been provided by photographer and digital negative expert Dan Burkholder.

How to Make a Digital Negative

The following are the five fundamental steps for making a digital negative (see Box 3.1).

Step 1: Making your Image Look Just Right

Using your Photoshop image adjustment tools, such as Levels, Brightness, and Image Size, correct your image so it looks just the way you want it to print (other imaging programs can also be utilized). Factors like the quality of your initial camera capture or scan, Photoshop skills, and monitor calibration will all affect the speed and ease of preparing your images.

Step 2: Including a Step Tablet

Our goal is to make beautiful prints, *not* beautiful step tablets. But as in any scientific testing procedure it is useful to have a *control* that allows us to clearly judge the visual results. The step tablet performs this function by providing a set of densities – from black to white – that you print simultaneously with your image, making it easier to visually evaluate contrast problems. For beginners not wanting to make their own step tablets, a few basic examples can be downloaded for free at: www.DanBurkholder.com/steptablets. It is a good idea to include the step tablet

on its own Photoshop layer so it can be turned on and off as needed during testing and printing.

Step 3: Preparing your Image with the Proper Contrast for Making a Negative

Since inkjet printers are not designed to make negatives, images need to be specifically prepared, which necessitates changing the image's contrast before printing. Using a Photoshop Curve is an ideal way to achieve this end. Figure 3.10 shows a typical Epson printer curve used to make a negative to print on hand-coated platinum/palladium sensitizer. Notice the steepness of the curve, especially in the shadow region towards the bottom of the graph. This is typical of the how most of the curves for our purposes will be shaped, regardless of the final printing process for which they are intended. For comparison, Figure 3.11 shows the curve used for making a negative for gelatin silver printing.

Notice subtle differences between the two curves. The silver gelatin curve (Figure 3.11) is not quite as steep and therefore will not create as much density in the final digital negative in the highlight part of the curve. This is because most platinum/palladium printmakers prefer a negative with more contrast than is typically used to make a full-scale gelatin silver print. Other processes, such as cyanotype and Vandyke or even pure palladium, will have slightly different curve shapes to prepare the image with the proper contrast for that specific printing medium.

The curve will not make your image look better on your computer monitor. In fact, it will make your image look too light. This is normal; bear in mind the finished negative will have the proper contrast required/necessary for printing on photosensitive materials. Just as a glob of clay does not represent a finished piece of pottery, your contrast-adjusted image on your monitor is one of the raw materials you shape to obtain the desired results.

One other thing to pay attention to in these illustrations is that the curve grid is showing 10 per cent increments instead of the default 25 per cent. This detailed grid only changes the cosmetics of the curves dialog box; the functionality remains the same. The advantage to having your grid in the detailed mode (10 per cent increments) is you can easily place points on your curve corresponding to the densities in the step tablet. Figure 3.13 shows the icon to click to change your curve increments from 25 to 10 per cent.

The myriad variables of printer type, ink formulations (dye and pigment) and printing processes mean you may have to adjust your image contrast (via Curves in Photoshop) before you get your desired contact print (see "Troubleshooting" section). Keeping careful notes of your experiments can be helpful to ensure consistency and repeatability.

Step 4: Inverting your Image to Create Negative Densities

After applying the curve to the image, it needs to be inverted (Photoshop: Edit > Adjustments > Invert) otherwise you will produce a positive on the transparency material.

FIGURE 3.10 A typical curve used to prepare a digital negative for platinum/palladium printing with an Epson printer. *Typical Platinum Curve*. Courtesy of Dan Burkholder Collection.

FIGURE 3.12 The platinum and silver curves are superimposed to show how similar – yet different – they are. Note that this is for illustrative purposes only; you will never have two separate curve shapes in a Photoshop Curves dialog box. *Comparing Curves*. Courtesy of Dan Burkholder Collection.

FIGURE 3.11 A typical curve used to prepare a digital negative for gelatin silver printing with an Epson printer. *2400 Silver Curve*. Courtesy of Dan Burkholder Collection.

FIGURE 3.13 A curve indicating the process to change the grid to 10 per cent increments. *Curve with Grid*. Courtesy of Dan Burkholder Collection.

FIGURE 3.14 *Printer Setup A.* Courtesy of Dan Burkholder Collection.

FIGURE 3.16 *Printer Setup C.* Courtesy of Dan Burkholder Collection.

FIGURE 3.15 *Printer Setup B.* Courtesy of Dan Burkholder Collection.

FIGURE 3.17 *Printer Setup D.* Courtesy of Dan Burkholder Collection.

Step 5: Printing the Negative on Clear Transparency Material using Specific Print Dialog Box Settings

Every inkjet printer has it's own method of depositing ink onto a surface. This lack of uniformity means there is no one set of print dialog box settings that will work for every printer. Figures 3.18 and 3.19 show the settings for an Epson printer using Epson's Advanced Black and White Mode to create a slight reddish/brown color cast in the negative. This color helps block UV light, which is especially useful for making cyanotype and platinum/palladium prints. Overhead projection (OHP) films from Pictorico (www.pictorico.com) have been consistent and reliably hold ink.

Troubleshooting

Before printing your image on transparency film, it is a good idea to make a normal print (positive image) on ink-jet paper. This *proof* will let help you notice flaws in retouching and tonality that you might otherwise miss on your computer monitor.

If your negative does not print with the desired tonality, the most common cause is improper image-editing that can produce shadows that are too dark or highlights that are too gray. This can be corrected by revisiting your image in Photoshop and making the appropriate adjustments.

If your negative is properly prepared and it still prints unsatisfactorily, the problem is likely due to your digital

FIGURE 3.18 *Printer Setup E.* Courtesy of Dan Burkholder Collection.

FIGURE 3.19 *Printer Setup F.* Courtesy of Dan Burkholder Collection.

negative's contrast. If this occurs, carefully examine your step tablet and learn how to judge the tones so you can move curve points to alter the negative's contrast. You can easily change tonality in shadows, midtones and highlights by moving the corresponding curve points up or down in the Curves dialog box. The skills you acquire in

FIGURE 3.20 *Printer Setup G.* Courtesy of Dan Burkholder Collection.

learning how to tweak curves will serve you well in all of your digital photography work.

It is common to have to alter your first curve adjustment and it may take a number of curve point changes to produce a negative that prints flawlessly. Of course, if you change any variables, such as printer, developer temperature, or even humidity, it may be necessary to readjust the curve shape to match the new set of conditions.

Your Color Management settings can induce problems and you may have to temporarily turn off Color Management to get consistent results. For instance, you will know Color Management is working against you if your step tablet densities have strayed from their stated values (5, 10, 20 per cent, etc.).

Most printers deliver better results with the Photo Black (PK) ink rather than with the Matte Black (MK) ink. If your digital negative does not seem to be holding enough ink you should swap black inks when making digital negatives.

RESOURCE GUIDE

Burkholder, Dan. *Making Digital Negatives for Contact Printing.* Second edition, available at www.DanBurkholder. com. Burkholder also offers other publications, such as the Inkjet Negative Companion, Inkjet Negative Template, and tutorials, which can be downloaded from his website.

SCANNERS

Scanners are input devices that digitize information directly from flat printed or photographic materials in a method similar to photocopiers. It is also possible to scan 3-D items. Aside from a digital camera, scanners are the most widespread means of making images digital. Scanners provide a convenient pathway for accessing analog material and bringing it into ones' working procedures, such as making negatives for contact printing.

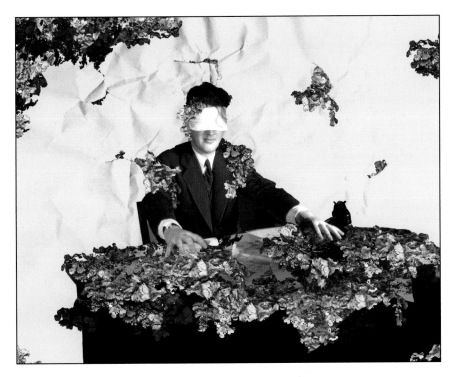

FIGURE 3.21 This series is digitally produced by "borrowing" old glass plate negatives from an early twentieth century stock photographic agency and then combining them with scanned plant forms. Campbell reflects, "The content has to do with the interdependent relationship between man and nature. It is ironic because both the original photographs and the natural forms are 'real' in the sense of being 'taken' from nature. Combining them digitally, however, changes the original 'truth' of the parts into a fictional whole. It creates a sense of dissonance. The idea of photographic 'truth' is challenged. Scale is distorted and people float in a groundless, eternal space. The new context allows new possibilities for meaning."
© Kathleen Campbell. *Man with Blindfold*, from the series *Relics from the Garden*, 2007. 19 × 24 inches. Inkjet print.

The most common scanners use a line of charge-coupled device (CCD) cells to record one row of the image at a time, which the scanner then assembles into a grid that digitally reconstructs your original image. Light is reflected off or through an image or object and interpreted by light sensors. Color scanners use red, green, and blue (RGB) filters to read an image in single or multiple passes. After the scan is complete, software is typically used to make color and contrast corrections and to crop and adjust image size. Scanners also have optical scanning recognition (OSR) programs that allow text to be scanned and converted into digital data, which gives one the ability to combine text and pictures with imaging software. Although manufacturers use their own software drivers, there are some basic scanning features and procedures (see section on "Scanning Steps") that are useful to know.

Flatbed and Film Scanners

Flatbed scanners, capable of digitizing images in a variety of resolutions, are frequently utilized to digitize a document and can be thought of as large, flat cameras. These devices allow the user to preview an image and make minor corrections before scanning. Although designed to digitize prints, some flatbed scanners can do a good job of handling transparencies (slides) or negatives, especially when coupled with quality software, which may be optional.

Film scanners are specifically designed to capture the minute details of small negatives and transparencies by transmitting light through an image. They are more expensive than flatbed scanners.

Drum Scanners

Drum scanners are generally the most accurate way to digitize flat media. An image is read on a glass drum while being spun at several thousand revolutions per minute. Scans of both prints and transparencies made on these more expensive devices are more precise and translate images with greater detail than with traditional flatbed scanners. Some high-end flatbed scanners are capable of scanning prints, 8 × 10 inch transparencies, or film at a quality that can rival drum scans.

Scanning Guidelines

Although there are numerous types of scanners, some basic principles can be applied in most scanning situations. Scaling and resolution must be set at the time the

image is scanned. The input settings draw reference from the original image, producing the best-quality scans. A common mistake is to allow the scanner's photo-imaging software to automatically set the final size (scaling) and resolution, which may force interpolation/resampling to occur (creating new pixels that did not exist in the original capture) and degrade the final image. Select the appropriate resolution based on the intended use (see Table 3.12).

The best resolution for continuous tone prints is dependent on the maximum dots per inch (d.p.i.) of the printer being used. Good scanning software will allow a user to input a scaling factor into a dialog box and then will automatically do the file size math. If your software does not do this, use the simple formula in Table 3.12 to calculate input resolution based on printer resolution and the scaling of the image.

Scanning Steps

1. Open the scanning software. Often this can be done through imaging software, under File > Import > name of the scanning software. Many scanners use an independent software application to drive the scanner. In this case, open the independent application and proceed to the next step.
2. Set the scanner for positive or negative. Many scanners are dual use, with the ability to scan photographic positives (reflective) and negatives or slides (transparent). Make sure the scanner is properly physically configured for reflective or transparent materials and set to the proper media before scanning.
3. Select grayscale or color. Even though scanning in grayscale is possible, scanning in color often provides superior results because the scan is occurring in three channels (RGB) instead of one. If a black-and-white image is desired, simply change the saturation levels to remove all color with the saturation adjustment tool and print in RGB to maintain quality.

TABLE 3.12 Scanning Resolutions for Printing

Application	Scan Resolution (d.p.i.)
Internet	72
Newspaper	150
Glossy magazine	300
Photo-quality print	300
Large fine art print	4000+

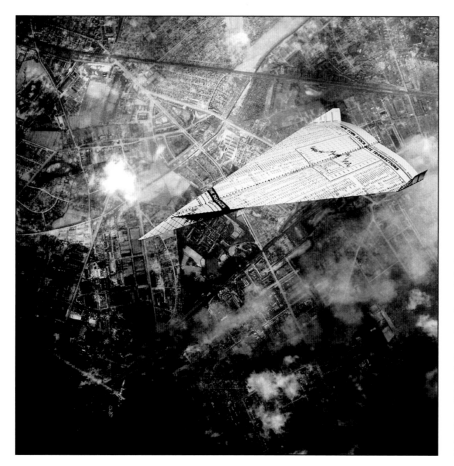

FIGURE 3.22 To construct this collage, Larson scanned and digitally combined work prints of paper airplanes and landscape images. Using a shallow depth of field, she created the effect of photographing a moving object. Establishing a point of view in the air, Larson aimed to "simulate a documentary quality compatible with the idea of aerial combat photographs from World War II." With this case, she created the possibility for a new look at flight and its contradictory contexts of heroics, innocence, and evil.
© Sally Grizzell Larson. *No. 1 (43°N, 3°S)*, from the series *Flight*, 1999. 24 × 24 inches. Inkjet print.

4. Place the image/negative or object on the scanning bed. For flat artwork, be sure to place the image squarely on the scanning bed, as this will reduce the amount of postscanning scaling and rotating.

5. Preview the scan of the entire scanning bed. This will allow you to see the entire scanning area and the image to be scanned. Use the marquee tool to select the target area as closely as possible.

6. Make tonal adjustments. Most good scanning software will create a preview of the image based on the area you selected with the marquee tool. All scanning software has settings to control the contrast, brightness, and color balance of images. Change these settings to get the previewed image color-balanced as closely as possible before scanning. The most important adjustment to make is contrast. An image that has excessive contrast contains less information about tonal values. Slightly flat-contrast images contain more information in the highlight and shadows and generally provide better results in postscan processing. After scanning, use your photo-editing software to make final color and contrast adjustments to an image.

7. Set the file size. Before scanning, decide what size your final print is going to be. Scanners display and define size in two ways: image size and resolution. Most scanning software will display the size of the area being scanned, multiplied by a scaling factor.

Increasing the scale of the image increases the dimensions of the final scanned image. Increasing the resolution of the scan increases the potential quality of the image. Both operations increase the file size. As a general rule, the larger the file size, the more options you have in working with the finished scanned image. Know the limitations of your scanner and select the appropriate file size. There is no need to scan at a greater resolution than you need, as larger files are slower to work with and take up more storage space.

8. Scan the image.

9. Save the file. Once your image is scanned, immediately save the file. If you regularly work in Photoshop, save it as a PSD file. Keep these original scans protected and work only with copies of these scans.

Frame Grabber

A frame grabber is another form of input that enables one to capture an individual analog video frame and digitize it as a still image. The resulting image file can be handled just like one made by a still digital camera. Frame grabbers can be either stand-alone devices that plug into a computer port or a program function built into a video capture board or display adapter. Software can also be used with digital camcorders to grab an already digitized image.

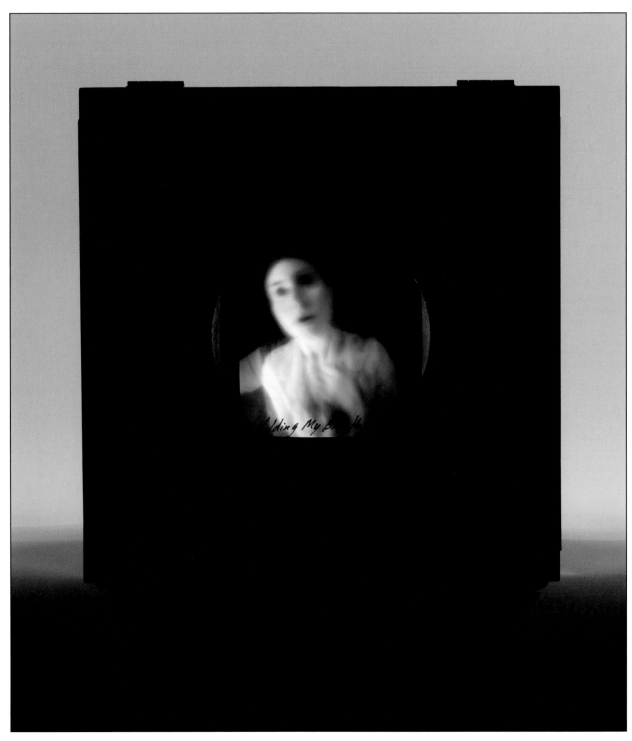

FIGURE 3.23 Capturing this image on Kodak E100 Ektachrome with a handmade 4 × 5 pinhole camera equipped with a Zone Plate allowed the artist to create a photograph that simultaneously juxtapositions the vivid saturation of the transparency film with the indistinctness of the Zone Plate produced image. She elaborates, "This series is influenced by my figure modeling work. I convey the act of holding a pose—the performance aspect of capturing the extended moment—and have chosen particularly unpleasant poses, such as biting my tongue, pulling my hair, and holding my breath, to convey this experience. These self-portraits reveal the tension between my mind and body and act as evidence of my private exercises in strength and patience."

© Elizabeth Raymer Griffin. *Holding My Breath: 1:27*, 2003. 4 × 5 inches. Chromogenic color transparency.

chapter 4

FORMULAS OF ONE'S OWN

PREPARED FORMULAS OR MIXING YOUR OWN

A wide variety of commercially prepared formulas are available for use in photographic processes. These prepared formulas are accurately compounded and easy to mix, and they provide reliable purity and uniformity that ensures consistent high-quality results.

Conversely, there are numerous reasons to prepare your own photographic formulas. It can be valuable for a photographer to know how to prepare a formula from scratch. Mixing your own formulas can provide a clear, concrete cause-and-effect demonstration of how various photographic processes work. This understanding can be applied to achieving more precise control of the medium. Mixing your own formulas also can be less expensive than buying packaged preparations and allows you to utilize formulas that are no longer commercially available. This process offers further visual adventures, and is enjoyable and gratifying.

This chapter provides the fundamental background in terms of equipment and methodology necessary to begin experimenting with nonprepared photographic formulas.

Specific tried and true formulas and process details are included in the appropriate chapter sections dealing with specific processes. Although no previous expertise is required, one needs to read and follow all handling, mixing, and safety instructions included with the chemicals being used before preparing any formula. Also read and follow all the general safety guidelines outlined in Chapter 2. Protect yourself by wearing protective equipment such as safety glasses, a plastic apron, rubber gloves, and a mask to avoid allergic reactions, burns, and irritation to the skin or lungs.

BASIC EQUIPMENT

Many photographers already have most of the items needed to prepare their own formulas. These include graduates, mixing containers, stirring rods or paddles, a funnel, an accurate thermometer, opaque storage bottles, protective gear, and a well-ventilated area that is not used for preparing food and is free from children and animals. The items that may be lacking are a scale and a mortar and pestle. All equipment must be made of nonporous and easy to wash materials.

FIGURE 4.1 *Boy and Girl Chemists*, from Robert Brent's *The Golden Books of Chemistry Experiments: How to Set up a Home Laboratory – Over 200 Simple Experiments.* Illustrated by Harry Lazarus. New York: Golden Press, 1960.
Courtesy of Gary Nickard Collection.

Scales: Mechanical and Electronic

A small, accurate scale is essential for weighing chemicals. Scales are available in a variety of sizes, styles, and price ranges. Balance scales are recommended because they are reliable, affordable, long-lived, easy to use, and do not require batteries or electricity. When purchasing a balance scale, be sure the sliding scale is easy to read and that the scale has removable pans for convenience of use and cleaning. The Ohaus Scale Corporation makes a mechanical triple-beam balance scale that is superb for photographic purposes. The scale is sensitive to 0.1 gram and its standard capacity range is suitable for most individual needs and can be extended with attachment weights. If you plan on doing a good deal of your own mixing, this durable scale is a good investment.

Electronic digital scales have replaced many of the lower priced triple-beam balance scales. These scales, often battery powered, are available for those who want a simple LCD readout. Most digital scales will calculate Tare weights with a push of a button. Tare weight is the mass of the container that holds what is being weighed. The Tare weight button automatically subtracts the weight of the container so that only the actual substance (chemical) is weighed. Acculab makes different sized digital scales, some the size of a credit card. Their ECON series portable electronic scales are simple to use, have multiple weighing modes, and are a good value.

Scales and other mixing equipment mentioned in this chapter can be ordered over the Internet, through mail-order photo and scientific houses, from chemical supply houses, or directly from the manufacturer (see Table 4.1).

Mortar and Pestle

A mortar and pestle made out of glass or porcelain is useful for crushing, grinding, and mixing dry chemicals that are not in powder or grain form. Do not use marble or wooden sets, as they will absorb chemicals and could contaminate other formulas.

Spoons

A set of plastic or stainless steel spoons for transferring chemicals from the bottle to the scale can prevent messy spills that are wasteful and can cause contamination.

Mixing Equipment

Accurate, easy-to-read graduates in small and large sizes, clearly marked in both milliliters (ml) and ounces (oz), are

TABLE 4.1 Laboratory Equipment Suppliers

Acculab Company	www.acculab.com
Edmund Scientific	www.scientificsonline.com
Lab Safety Supply Inc.	www.labsafety.com
Ward's Natural Science	www.wardsci.com
Ohaus Scale Corporation	www.ohaus.com

FIGURE 4.2 To get the visual results he wanted from printing-out paper, Hunter needed a negative with much greater than normal contrast. He achieved this by rating 8 × 10 inch TRI-X film at 100 and developing it in modified Pyro ABC developer. The printed-out image was treated with Gold Chloride Toner, producing a lavender tone.
© Frank Hunter. *Frank Ross's Barber Shop, Lebanon Jct., Kentucky*, 1985. 8 × 10 inches. Toned printing-out paper. Courtesy of Thomas Deans Fine Art, Atlanta, GA.

essential. Plastic containers of various sizes make good mixing pails and stirring paddles are helpful for mixing.

Storage Containers

Different sized brown or opaque bottles made of glass or plastic make excellent storage containers for mixed solutions. Opaque containers prevent deterioration caused by light. Plastic is more durable than glass and can be squeezed to eliminate most of the air to lessen the effects of oxidation. Bear in mind all plastic containers absorb chemistry over time. Keep similar chemistry in the same containers and replace plastic containers periodically. Medicine-dropper bottles, available at drugstores, are excellent for keeping small amounts of expensive solutions.

Certain chemicals are hygroscopic (absorbing water from the air) and can form a hard crust upon exposure to air. Others are efflorescent, losing their normal water content when exposed to air. Either of these conditions can make accurate weighing impossible. Still other chemicals can evaporate or fume. Avoid these problems by tightening the lids on all bottles. Clearly label every bottle with its contents and the date it was mixed.

CHEMICALS

Obtaining Chemicals

One can obtain many of the chemicals used in contemporary processes from large photography stores. When working with some of the more unusual or older processes, obtaining the required chemicals can be more problematic. Check with a chemical supply company (see Table 4.2). Some companies may not sell chemicals in small quantities for individual use. If possible, purchase through a business or educational facility. A few companies specialize in stocking photographic chemicals. Check the ads in photography publications or online for information on suppliers.

The prices of chemicals can vary dramatically, so shop around. In addition, manufacturers often give different trade names to the same chemical. For example, the developing agent methylaminophenol sulfate is known as Kodak Elon, Agfa Metol, Pictol, and Rhodol. Spelling also can vary. For instance, the British spelling of sodium sulfite is sodium sulphite and the British spelling of sodium sulfate is sodium sulphate. Chemicals come in three different classifications or grades that reflect their purity (see Box 4.1). Be sure the price obtained is for the exact grade of the chemical required.

TABLE 4.2 Sources of Photographic Chemicals

Artcraft Chemicals	www.artcraftchemicals.com
Bostick & Sullivan	www.bostick-sullivan.com
Photographers' Formulary	www.photoformulary.com
Rockland Colloid	www.rockaloid.com
VWR Scientific	www.vwrsp.com

FIGURE 4.3 Eshbaugh piggybacked two rolls of 120 film and exposed them simultaneously using his handmade pinhole camera. After developing the film in Sprint chemistry, he montaged images from the two rolls of film and printed that image on Ilford Warmtone fiber base paper. The artist then lightly selenium toned the photograph (1:10 dilution), which was followed by selectively applying a copper toner and finally selectively applying Kodak Poly-Toner (5:100 dilution). Eshbaugh tells us, "The fractured imagery reminds us of the limitations of the medium and the limitations of our own memories. We cannot capture a complete moment of time with a photograph, just as we can never remember a complete moment of time accurately. Each split pane exists in a paradox of harmony and conflict." © Mark Eshbaugh. *Untitled #276*, 2000. 14 × 18 inches. Toned gelatin silver print.

Box 4.1 Chemical Classifications/ Grades

1. Analytical Reagent (AR) is the highest standard for purity and uniformity. This grade is the most expensive and is not needed for most photographic purposes. It is usually labeled ACS (American Chemical Specification). In the UK, it is labeled ANALAR.

2. Pharmaceutical or Practical is about 97 per cent pure and can be used for almost all-photographic work. It is labeled USP (US Pharmacopoeia) or NF (National Formulary). In the UK, it is labeled either BP (British Pharmacopoeia) or BPC (British Pharmaceutical Codex).

3. Technical or Commercial is approximately 95 per cent pure and is subject to variations that could alter the visual outcome. It is not recommended for important work.

Chemical Storage

Keep all chemicals away from all living creatures. If necessary, lock them up. Label and date all bottles of mixed solutions. Be sure storage bottles are securely capped. Protect all chemicals from air, heat, light, moisture, and contamination from other chemicals.

Chemical Disposal and Safety

When working with any chemical, you assume the responsibility for its safe use and disposal. Follow any special instructions included with each chemical or process being used as well as the safety recommendations in

Chapter 2. Laws concerning disposal of chemicals vary widely. Check with your local health department to get guidelines. Hazardous liquids can be poured onto kitty litter and placed in a plastic bag. Dry chemicals or contaminated materials can be disposed of by sealing them in a plastic bag. Both should be put in a closed outside dumpster. Do not mix liquid and solid wastes together, as dangerous reactions might occur.

PREPARING FORMULAS

Weighing Chemicals

Place your scale on a level surface, protected from spills with newspaper or plastic, and zero it. Put a piece of filter paper, any clean paper, or a paper cup in the middle of the balance pan. For critical measurements with a triple-beam scale, weigh the paper or cup first and include its weight plus that of the chemical. On electronic scales this procedure can be done automatically by pressing the Tare button after the paper or cup is placed on the scale and before the chemical is added. When using a double-pan scale, place the same size paper in both pans so their weights will cancel each other out. Line up the needed chemicals in an orderly fashion. Put the chemical to be measured in the center of the pan to avoid any leverage errors. Use fresh paper for each chemical to prevent contamination and facilitate cleanup. Immediately recap the bottles to avoid confusion, spills, or contaminating one chemical with another.

Temperature

Closely follow the temperature recommendations given with each formula. If the chemicals need to be heated, carry out this procedure in a double boiler, not in a pan directly over the heat source. Direct heat can alter or damage a chemical. The solubility of many chemicals is increased

FIGURE 4.4 Anderson made this photograph by combining digital and analog methods. She captured the image with a digital Nikon and used Photoshop to soften and blur it slightly. She then created a digital color separation negative, producing a palladium (warm) negative and a cyanotype (cool) negative, and printed it using the Precision Digital Negative System. To make the final image, she mixed her own chemistry. For the palladium print, she followed the Na_2 method, in which the salt form of platinum serves to adjust the contrast, and for the cyanotype print she combined 2 parts 20 per cent ferric ammonium citrate solution A to 2 part 8 per cent potassium ferricyanide solution B. Exploring this personal method helped serve as Anderson's coping mechanism while she photographed aftermath of Hurricane Katrina in New Orleans. © Christina Anderson. *Abundance*, 2006. 11 × 15 inches. Cyanotype over palladium.

Box 4.2 Chemical Mixing Guidelines

- Protect your eyes with safety glasses and your hands with disposable chemical barrier gloves, which are available at medical supply stores.
- When mixing an acid, always pour the acid into water. Do not pour water into an acid, as splattering can cause dangerous burns. Wear eye protection.
- Use a funnel when pouring mixed solutions into bottles. Tightly secure the top and label the bottle with the name of the solution and the date. Most developers are good only for a few months after they have been mixed.
- Keep a written record of what you do so that you can judge the results, which permits easy adjustment and customization of the formulas.

FIGURE 4.5 Wetzel's interest in mixing her own formulas and in the tactile aspects of photography led her to explore the nineteenth century wet-plate process (see Chapter 10), which gave her more personal involvement and control in the photographic process. The portable darkroom in the trunk of her car allowed the artist to process the plate on location. For Wetzel, "this work focuses on the random thoughts and memories – real or constructed – that we bury in our mind, tuck away in boxes, forgetting about them until we stumble upon the sealed container and open the door thereby shedding light on the contents." © Heather Wetzel. *Collective Bargaining*, 2007. 3½ × 4½ inches. Ruby ambrotype on black glass.

with heat. For this reason, the mixing temperature of the water may vary from the solution's working temperature. Other chemicals may release heat when dissolved, creating an exothermic reaction, and need to be mixed in cool water. Endothermic chemicals absorb heat when mixed and may require hotter water for complete mixing.

Mixing Chemicals

Always follow the prescribed order of chemicals given in the formula, as any changes may prevent the solution from being properly mixed. Follow specific recommendations provided with the formula and guidelines in Box 4.2. In general, start with two-thirds to three-quarters of the total amount of water at the correct mixing temperature. While stirring vigorously, slowly pour the first properly measured chemical into the water, not allowing any chemical to settle at the bottom of the container. Wait until each chemical has been completely dissolved before adding the next one. When the correct sequence has been followed and all the chemicals are thoroughly mixed, cold water can be added to bring the solution to room temperature. If you are not confident of the purity of the water being used, mix all developers with distilled water.

Percentage Solutions

In some formulas the amount of a chemical may be too small to be weighed accurately, so the amount is given as a percentage solution, or in terms of weight per volume. For photographic purposes, this can be simply stated as how many grams of a chemical are dissolved in 100 milliliters of water. For instance, a 5 per cent solution has 5 grams of a chemical dissolved in 100 milliliters of water. Regardless of the amount needed, the percentage (how many parts of the chemical to be mixed into 100 parts of water) is always the same.

When making a percentage solution, mix the chemical in less than the total volume of water required. After the chemical is dissolved, add the remaining water. For example, in preparing a 7 per cent solution, dissolve 7 grams of the chemical in about 75 milliliters of water. After mixing is complete, add more water so that the final volume is exactly 100 milliliters.

Formulas in Parts

Older photographic formulas were often given in parts. Parts can be converted into the equivalent number of grams and milliliters or ounces and fluid ounces. For instance, a formula calling for 10 parts of a chemical and 80 parts of water can be translated as calling for 10 grams of the chemical and 80 milliliters of water or 10 ounces of the chemical and 80 fluid ounces of water.

pH Scale

Most photographic solutions have a definite pH (potential of hydrogen), which is a way to measure the acidity or alkalinity of a chemical. Acidity is measured by the number of hydrogen ions present while alkalinity is measured by the concentration of hydroxide ions in a solution. The scale runs from 1 to 14, with 7 being neutral. Pure distilled water has a pH of 7. Chemicals with a pH

below 7 are considered to be acids. Chemicals with a pH above 7 are alkalis. The change of one whole increment in the pH scale indicates a tenfold change (plus or minus) in the intensity of the acid or alkaline reaction.

All photographic processing solutions perform best within a specific pH range. For example, developers must be alkaline to work, stop baths must be acid, and fixers are normally neutral to slightly acid. The pH of most of the commonly used working solutions in today's photographic processes is between 5 and 9. The pH can be measured with pH test paper or with a pH meter. The paper is inexpensive but not very reliable. A pH meter, which is expensive, is required for accuracy. Fortunately, most black-and-white formulas do not require strict pH monitoring. Small changes produced by variations in pH usually do not cause irreparable visual defects. Most of these changes can be corrected during the printing of a negative. The use of distilled water will eliminate most difficulties in controlling pH as long as the chemicals are reliable and all procedures are correctly carried out.

Chemicals possessing either a high or low pH should be handled with care. Acids on the low end of the pH scale get progressively stronger. Acids can dehydrate the skin and, in high concentrations, produce burns. Highly alkaline substances, such as calcium hydroxide, can degrease the skin and cause burns.

Acetic acid is the most commonly used acid in photography. It is a relatively weak acid in its standard 28 per cent photographic dilution and does not react as vigorously as other acids, but it can cause tissue damage in a concentrated form.

Prolonged exposure to photographic chemicals can cause allergic reactions, cracking, dehydration, or discoloration of the skin. Allergic reactions tend to be cumulative. Therefore, when mixing or working with any concentrated chemicals, wear full protective gear.

US CUSTOMARY WEIGHTS AND METRIC EQUIVALENTS

When preparing your own chemicals, you will probably encounter formulas given in both the US customary and metric systems. The scientific world has adopted the metric system, but the US at large has not followed suit. Older formulas in British publications use still another system called British Imperial Liquid Measurement. These systems are not compatible. Many older formulas may be written in only one system, so it is often necessary to translate from one system to the other. This can be accomplished quickly and accuracy by using one of the online conversion sites, such as www.worldwidemetric.com/metcal.htm, which gives calculations of the metric system into the US customary system and vice-a-versa in for length, weight, pressure, and volume, and temperature. Tables 4.3 and 4.4 provide commonly used equivalents.

Equivalent Imperial and Metric Measurements

TABLE 4.3 Solid Measures

US and Imperial Measures		Metric Measures
Ounces	Pounds	Grams
1		28
2		28
3½		100
4	¼	112
5		140
6		168
8	½	225
9		250
12	¾	340
16	1	450
18		500
20	1¼	560
24	1½	675
27		750
28	1¾	780
32	2	900
36	2¼	1000
40	2½	1100

TABLE 4.4 Liquid Measures

Fluid ounces	US	Imperial	Milliliters
¼	1 teaspoon	1 teaspoon	5
¼	2 teaspoons	1 dessertspoon	10
1	1 tablespoon	1 tablespoon	14
1	2 tablespoons	2 tablespoons	28
2	¼ cup	4 tablespoons	56
4	½ cup		110
5		¼ pint or 1 gill	140
6	¾ cup		170
8	1 cup		225
9			250
10	1¼ cups	½ pint	280
12	1½ cups		340
15		¾ pint	420
16	2 cups		450
18	2¼ cups		500
20	2½ cups	1 pint	560
24	3 cups		675
25		1¼ pints	700
27	3½ cups		750
30	3¾ cups	1½ pints	840
32	4 cups or 1 quart		900
35		1¾ pints	980
36	4½ cups		1000

FIGURE 4.6 Sarachek's chemigram process (see Chapter 11) is cameraless: his main tools include photo paper, chemicals, photosensitive resist, and light. To create this image, Sarachek first applied the resist coating to the photo paper with nonstandard objects such as sticks or socks and then treated the photo paper with chemicals that affect the unprotected silver. The resulting image, which is reminiscent of calligraphy, is largely previsualized. Sarachek states, "As with an abstract painter making a gestural brush stroke, an element of chance is coupled with my control of the media. I believe this combination of control and chance energizes the final image." © Norman Sarachek. *Kokoro*, 2004. 7 × 6 inches. Chemigram.

RESOURCE GUIDE

Anchell, Stephen.G. *The Darkroom Cookbook*, Third Edition, Boston, MA: Focal Press, 2008.

Donofrio, Diane (Ed.). *Photo Lab Index, Lifetime Edition*. Dobbs Ferry, NY: Morgan & Morgan, 2001.

Stroebel, Leslie, Richard.D, Zakia, Ira Current, John Compton. *Basic Photographic Materials and Processes*, Second Edition, Boston, MA: Focal Press, 2000.

FIGURE 4.7 Ferguson relates, "While some might consider me a photographer, I feel I am more of an assembler of images and tableaux, which then come to exist as pinhole photographs of an interior landscape. Usually I work in my studio, setting up arrangements of images and objects culled from my 'museum of memory,' my personal collection of oddments, books, and artifacts. My work is slow, hand-built, and cumulative, rather like the layering of dust or memories over time. Books have long served as models, as raw material, and as sources for my pinhole images. When I work with books, I find myself taking pinhole photographs in a multi-layered 'museum within a museum.'"

© Jesseca Ferguson. *Two Horses/Book*, 1998. 5 × 4 inches. Toned printing-out paper.

BLACK-AND-WHITE FILM DEVELOPERS

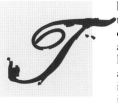

There are a wide range of possibilities to choose from in selecting a developer that is appropriate for the film and its intended application. A developer plays a vital role in determining a number of key factors in the making of the final negative. These include acutance (sharpness), contrast, useful density range (the difference between the brightest highlight and the darkest shadow areas from which detail is wanted in the final print), fog level, grain size, and the progression, separation, and smoothness of the tonal values. The developer formula selected – its dilution; degree of exhaustion; temperature of use; frequency, duration, and degree of agitation; and time the film is in the solution – are all adjustable controls each photographer can use to get the desired results from any developer.

WHAT HAPPENS TO SILVER-BASED FILMS DURING EXPOSURE AND PROCESSING?

Upon exposure, the light-sensitive emulsion produces an electrochemical effect on the silver halide crystals of the film emulsion. This changes the electrical charge of the silver halide crystals, making them responsive to the developer. The exposure produces an invisible latent image made up of these altered crystals. The developer reduces these exposed crystals to particles of metallic silver, forming the visible image on black-and-white film. The extent of this reaction is determined by the amount of light received by each part of the film. The more light striking an area, the more reduced silver there will be, resulting in a higher density.

After being developed, the negative has tiny particles of metallic silver and residual silver halide that were not exposed and therefore not developed. This halide must be removed, or it will discolor the negative when it comes in contact with light.

To complete the developing process, plain water or a mild acid stop bath (sometimes called a short-stop) is used to neutralize the alkaline developer still in the emulsion. The film is then transferred into an acidic fixing bath to remove any of the unreduced silver halide in the emulsion. Fixer or hypo (once known as sodium hyposulfite) is usually made up of sodium thiosulfate. Rapid fixer generally contains ammonium thiosulfate as its fixing agent. After fixing, the remaining thiosulfate compounds must be eliminated. The film is rinsed and treated with a hypo clearing solution, which changes the thiosulfate into a compound that washes off the film more easily. Any residual fixer will discolor, stain, and ultimately destroy the image. Finally, the film is thoroughly washed and dried.

Chromogenic Black-and-White Film

In chromogenic black-and-white film, as in most color films, the developing process creates both silver particles and dyes. During processing, carried out in the standard C-41 color negative process, the silver is removed in a bleaching process, leaving a negative image formed only by the dyes. This delivers a very fine grain negative, which can be printed in the same manner as conventional black-and-white negatives.

IMAGE CHARACTERISTICS OF FILM

Grain

The silver particles that make up the image structure are called grain. The grain size is determined by two major factors. The first is the inherent natural characteristics of the film. Generally, the faster the film is, the coarser the grain. Fast films have a thicker emulsion, permitting more vertical clumping of the grain. The second factor determining grain size is development. During development the individual silver grains tend to gather together and overlap, creating larger groups that form a pattern. This is not very noticeable in the negative but becomes visible in an enlarged print. The grain we see in the print is not the individual grains but the spaces between the grains on the negative. These grains hold back the light during printing, so they appear white in the print.

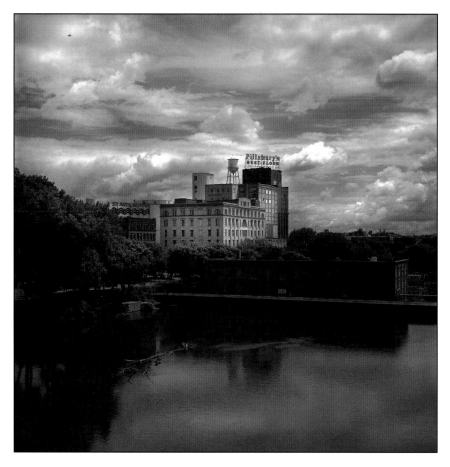

FIGURE 5.1 Taylor shot *Pillsbury 'A' Mill* with his 6 × 6 cm Rolleiflex, using a red filter and Ilford Delta 400 film. After processing the film in PMK Pyro developer, to produce maximum shadow detail, he scanned the film and then digitally increased the contrast to add a higher level of drama to the scene. Next, Taylor inverted the image file and then outputted it onto Pictorio OHP film to produce a large negative suitable for platinum/palladium contact printing. "Believing that the simplest method is usually the best, Taylor doesn't use a densitometer or let his life be run by numbers. He trusts his experience and his heart when it comes to printing."
© Keith Taylor. *Pillsbury 'A' Mill,* 2005. 12 × 12 inches. Platinum/palladium print.

The number and size of the grains in any part of the negative give it density. Graininess is increased by excessive density, which can be produced by overexposure or overdevelopment. Improper film processing, including rough agitation, temperature shock, excessive fixing, and lengthy wet time, increases the size of the grain. Visible grain also increases as the contrast of the print increases.

Acutance

Acutance describes the ability of film to record the edges of objects. The standard test measures film's ability to form a sharply defined image of a knife edge when exposed to a point light source. The nature of the grain and how it is distributed affect the film's acutance. Fine-grain films with a thin emulsion have a high acutance value. They produce less spreading of the light because there is not as much emulsion through which light must travel.

Developers do play a role in how we perceive a film's acutance. An acutance developer develops less of the faintly exposed portions of the knife line, reducing the gradient width and giving the impression of increased edge sharpness, even though the film may not measure out as having a higher acutance. The sharper the grain is, the greater the appearance of acutance. Softer grain produces a diffused edge, giving the impression of less acutance.

Resolution

The film's ability to reproduce fine detail is called resolution. The camera equipment, film, and printing equipment determine resolving power. These factors include lens sharpness and freedom from aberrations, the graininess of the emulsion, the contrast of the subject, the contrast characteristics of the film, and the degree of light scattering throughout the system. Slow, fine-grain films have a greater resolving power than faster films containing larger grains. Fine-grain films have a greater acutance, producing sharper outlines and higher contrast. The thinner emulsion yields less irradiation (internal light scattering), which can blur distinctions between details. Excess density produced by overexposure or overdevelopment increases light scattering in the emulsion. This reduces edge sharpness and contrast, which results in less overall resolving power.

The sharpness of the grain produced by the developer influences resolution. Grain that is not very sharp can reduce the resolution of an image made through a

first-rate optical system. The guiding rule is – the sharper the grain, the higher the degree of apparent resolution.

Fog

Fog is any tone or density in the developed image that is produced by stray, nonimage-forming light or by an unwanted chemical action. Fog adds density and is first noticeable in less dense areas. In a negative, it results in a loss of contrast and detail in the shadow areas. Light fogging is caused by lens flare, camera light leaks, improper handling, loading or unloading of film, darkroom light leaks, inappropriate safelight conditions, or exposure to X-rays. The latter most commonly occurs in the baggage check-in systems used in airports.

Chemical fog results from the development of unexposed halides. This happens all the time in small amounts, causing what is known as the base-plus-fog density of film. Fog amounts greater than base-plus-fog degrade the image. A restrainer, often potassium bromide, is added to the developer to reduce fog. Improper storage or outdated film often produces higher fog levels because the silver halides become more developable with age. High development temperature, excessive agitation, or chemical activity increases the fog level. Fog and other visible stains can result from fine-grain developers used with fast films or from using nearly exhausted chemicals. Letting the emulsion come in contact with an excessive amount of air during development produces an oxidation effect called aerial fog. Chemical dust, from the mixing of chemicals, also is a source of fog.

To prevent fog, make sure both camera and darkroom are light-tight, use fresh films and solutions, follow proper operating procedures and temperatures, maintain clean working conditions, and avoid airport X-ray machines. Request a hand inspection of your photographic equipment and do not put exposed film in your luggage.

COMPONENTS AND CHARACTERISTICS OF BLACK-AND-WHITE DEVELOPERS

Developer formulas contain a number of different chemicals required to perform specific functions in the development of the film. Getting to know the basic ingredients and the roles they perform enables each photographer to make adjustments to meet individual requirements in different situations.

Developing Agents

The role of a developing agent is to reduce the silver halide salts in the emulsion to metallic silver. The developing agent is oxidized during this process. Since the advent of photography, countless chemicals have been

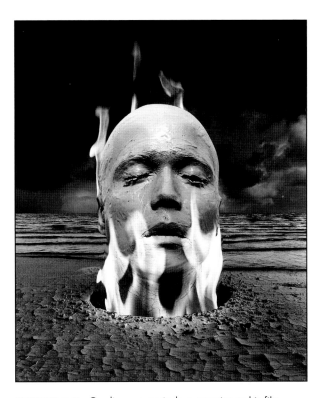

FIGURE 5.2 Gordin pays meticulous attention to his film processing to achieve highly consistent results that facilitate assembling numerous negatives under a single enlarger to create a final image using a masking technique he perfected over time. © Misha Gordin. *Shout 30*, 1985. 24 × 20 inches. Gelatin silver print.

tried in hopes of producing a developing agent with improved properties. The majority of the developing agents currently in use were discovered before the start of the twentieth century, although new developing agents might be in proprietary formulas that manufacturers have not yet made public.

MQ and PQ Developers

The most common contemporary developing agents are Metol (Kodak's Elon), hydroquinone, Phenidone, and ascorbic acid (vitamin C). Older formulas are amidol, glycin, and pyrogallol (pyro). Most general-purpose developers are compounded pairs of developing agents that complement each other's action during the development process. The most popular combinations are Metol and hydroquinone, known as an MQ developer, and Phenidone and hydroquinone, sometimes called a PQ developer. The M stands for Metol, the Q comes from Quinol, the old Kodak trade name for hydroquinone, and the P represents Phenidone. The characteristics of these developing agents are discussed later in this chapter.

Metol and Phenidone provide good low-contrast shadow detail in the negative but produce very little

density in the highlights. Hydroquinone acts more intensely in the highlight areas, adding density and contrast. The combination of the two developing agents results in greater development of the entire negative than the sum of the development given by equal amounts of the individual developing agents. In effect, when MQ or PQ combinations are used, $1 + 1 = 3$. This effect is called *superaddivity* and is used in the majority of contemporary formulas. The MQ and PQ combinations yield good shadow and mid-range detail, while still retaining easily printable density in the highlights.

Metol should be handled with care, as it can cause skin irritation that resembles poison ivy. If you have a reaction to Metol, use a Phenidone-based developer. Note that most of Kodak's developers have Elon (Metol) in them.

Phenidone behaves much like Metol. It is more expensive, but it is used in smaller quantities. Phenidone has a low oral toxicity and is considered nontoxic. With normal use, it is unlikely to cause dermatitis. In combination with hydroquinone, it can produce higher useful contrast. It is not as sensitive to bromide, giving the solution more constant and longer keeping properties. Phenidone can be more difficult to dissolve and can require very hot water (175°F/80°C) to go into solution easily. Check the formulas carefully before mixing. Many people use a percentage solution when mixing their own Phenidone-based formulas, since only a small amount is required.

Some popular commercial developers that claim to be Metol free include Edwal's FG-7, Acufine, Ilford's Microphen, and Kodak's HC-110.

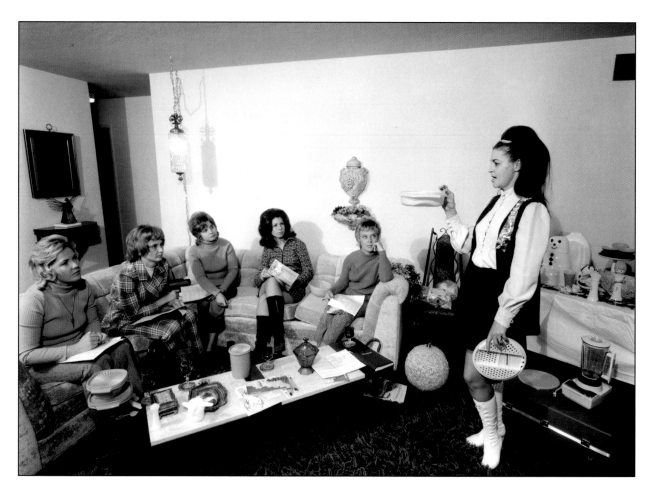

FIGURE 5.3 When photographing for his now classic book *Suburbia* (1973), Owens used a Brooks Veriwide 2¼ × 3¼ inch camera with a bare bulb flash that produces a very soft, even, natural looking light effect. Owens used TRI-X 220 film rated at ISO 800, which he processed in Edwal FG-7 for about 10 minutes, depending on the situation. The people portrayed in the book report to enjoy their suburban lifestyle and state they have achieved the American Dream of homeownership and material success. The caption accompanying this photograph in the text reads: "I enjoy giving a Tupperware party in my home. It gives me a chance to talk to my friends. But really, Tupperware is a homemaker's dream, you save time and money because your food keeps longer."
© Bill Owens. *Tupperware Party*, from the book *Suburbia*, 1970. 8 × 10 inches. Gelatin silver print. Courtesy Bill Owens Archive.

Accelerator

Developing agents used alone can take hours to produce useful density, are quickly oxidized by air, and yield a high level of fog. An alkaline accelerator creates an environment that greatly increases the developing agent's activity, dropping processing times from hours to minutes. The amount of alkalinity in the accelerator determines how much of an increase takes place in the developer. Alkalinity is measured on the pH scale: the higher the pH, the greater the alkalinity. Some commonly used alkaline chemicals are borax or balanced alkali (sodium metaborate, formerly known as Kodalk), with a pH value of about 9.9; sodium carbonate, with a pH of 10; and sodium hydroxide, also known as caustic soda, with a pH of 12.

A developer containing sodium hydroxide, which has a high pH, greatly accelerates the action of the developer. It increases contrast and is often used for high-contrast applications such as graphic arts films. The higher the pH value, the more quickly the alkalinity drops off when used in a solution. Developers with a high pH accelerator oxidize extremely rapidly and have a very brief life span. To combat these difficulties, the developer and alkaline (accelerator) are stored as separate A and B solutions that are mixed immediately before use.

A developer with a low-pH accelerator such as borax produces less contrast and takes longer to work, but it remains stable for a longer period of time in a working solution.

Preservative

When a developing agent is dissolved in water, especially with an alkaline chemical present, it oxidizes rapidly, causing the solution to turn brown, lose its developing ability, and produce stains on the emulsion. To prevent the

FIGURE 5.4 Connor holds to Robert Bly's maxim: "Whoever wants to see the invisible has to penetrate more deeply into the visible." Connor likes to keep her technical operations very simple. Her 8 × 10 inch Ektapan film is processed in Kodak HC-110, a convenient, one-shot liquid developer. This image was contact printed using the sun on printing-out paper toned with gold chloride.
© Linda Connor. *Death, Hemis Monastery, Ladakh*, 2006. 10 × 8 inches. Toned gelatin silver print. Courtesy of Cheryl Haines Gallery, San Francisco, CA.

developing agent from oxidizing, a preservative is added, usually sodium sulfite. This increases the working capacity of the developer. It also can act as a silver solvent during the long developing time, and in large quantities, as in D-23, it produces the mild alkalinity needed to make the developer work. In the A solution of the Pyro ABC formula, sodium bisulfite prevents the oxidation of the pyro developing agent. Potassium metabisulfite is sometimes used in two-solution formulas instead of sodium sulfite.

Restrainer

During the development process, some unexposed silver halides are reduced to black metallic silver before development is complete, producing unwanted overall fog. A restrainer is added to the developer to reduce the fog level. Bromide, with derivatives of either potassium or sodium, is the primary restrainer found in most developers. Potassium bromide is more commonly used. The restrainer increases contrast by preventing the reduction of the silver halides; hence, the production of metallic silver, in the slightly exposed areas, giving a lower overall density to the shadow areas. This inhibiting of silver halide reduction also tends to produce a fine-grain pattern. A potassium bromide restrainer is used only in small amounts, as it holds back the overall developing action, reduces the speed of the film, and has a greater effect on the low-density areas, diminishing the amount of useful density created in the shadow areas. Some low-alkaline developers do not produce much fog and therefore do not require a restrainer.

As the emulsion is developed, soluble bromide is discharged into the developer, increasing the proportion of restrainer in the solution and thereby slowing the action of the developer. If these soluble bromides are not removed through proper agitation of the solution, they can inhibit the developing process.

Some developer solutions use benzotriazole instead of potassium bromide. These two restrainers cannot always be interchanged, as the benzotriazole does not have the same effect with all developing agents.

Other Ingredients

Alcohol solvents can be found in certain concentrated liquid developers to increase the solubility of specific chemicals and to prevent freezing. Sulfates are sometimes added to a developer to reduce emulsion swelling, which keeps the grain size down.

Basic Factors in Selecting a Developer

Each photographer should bear in mind the nature of the subject, the light source of the enlarger, and the size of the final print. For a subject calling for maximum retention of detail, as in architectural work, traditional landscapes, or photographs for reproduction, a normal developer with maximum acutance is preferred, even at the expense of increased grain size. For a subject requiring a softer look with less sharply defined grain and a flowing progression of tones, as in some portrait work, a fine-grain developer that gives the grain a more rounded look might be appropriate.

Developer Keeping Qualities

The keeping qualities of any developer will be affected by the following factors:

1. *Purity of water.* Use distilled water and avoid water that has been softened.

2. *Chemical makeup.* Developers will oxidize when left unprotected from the air. Most normal developers containing sodium sulfite are slow to oxidize. High-energy and pyro developers oxidize quickly after a working solution has been prepared and should be used immediately.

3. *Storage containers.* Use dark brown or opaque containers. Glass or stainless steel is best for long-term storage because they will not interact with film developers. However, the breakability of glass does not make it safe or suitable for all situations. Plastic can be used, but be aware that some plastic containers allow oxygen to pass through their walls and interact with the developer. This speeds up the oxidation process and leaves brownish stains inside the container. Plastic is not recommended for long-term storage.

4. *Contamination.* Follow the preparation instructions and mixing order carefully. Do not allow the developer to come into contact with other chemicals. Wash all equipment completely after use. Do not store other chemicals in containers used for developer.

Photographers using condenser enlargers, which emphasize contrast and crispness, may wish to use a softer negative with lower grain acutance. Those using a diffusion enlarger generally prefer maximum sharpness, since the diffused light softens the image slightly. Many photographers who use diffusion enlargers extend the development time to create a slightly denser negative than they would use with a condenser enlarger. This is done to retain some of the contrast that is lost in diffusion systems (see the section in Chapter 6 on "Illumination: Condenser and Diffusion Systems").

The development time of most developers can be varied to compensate for high-contrast or flatly lit scenes. For example, if the entire roll of film was exposed in brighter than normal lighting conditions, one may wish to decrease the normal development time by 10–25 per cent to reduce the overall contrast. This narrows the distance between the key highlights and shadows, giving the negative a tonal range that will be easier to match with the paper to make a normal print. If a roll of film is exposed in flatter than normal light, one can increase the normal development time by about 25 per cent to produce added contrast in the image.

Liquid or Powder Chemistry

Developers are available in liquid and powder form. Neither is better than the other, as both are valuable in different situations. Photographers often work with both types, although extra safety precautions should be taken when mixing chemistry in powder form due to chemical dust. It is a good idea to experiment with both in noncritical situations to see the visual results they can deliver.

Liquid Developers

Many liquid developers are proprietary formulas (i.e. not published for use by the public) and cannot be obtained in any form other than those the manufacturer provides. Some proprietary formulas include Kodak's HC-110 and T-MAX developers, and Edwal's FG-7. These formulas are convenient, consistent in quality, and high in price. Many of the liquids are extremely concentrated and can be difficult to measure out in small quantities, accurately may require using a hypodermic needle.

HC-110 is too syrupy for this technique and can be measured in small amounts in a 1-ounce graduate. With this method, always measure on a level surface. Pour the developer into a mixing container filled with half the water required for the proper dilution. Add the remaining water by pouring it, an ounce at a time, into the small graduate and then into the working solution. This ensures that none of the developer will remain in the graduate. Other people prefer to make a stock solution from these concentrated liquids that is later diluted to make a working solution. Most of these developers are designed for one-time use (one-shot) and then discarded.

Powder Developers

Powders can be more difficult to mix and their dust can contaminate the darkroom. Prepare the solutions where the chemical dust will not land on surfaces where film is handled. When mixing powders, wear a mask to avoid breathing in the dust. Clean the mixing area with a damp paper towel. Ideally, powders should be mixed 24 hours before use to ensure that all the chemicals are dissolved and stable. This lack of convenience is offset by the fact that the formulas for many contemporary and older powder developers are available. A photographer who takes the time to mix a formula from scratch can save money and customize the formula for individual needs. He or she is not restricted to what is available commercially, will gain a cleaner understanding of what happens in the process, will learn how to influence the development process, and thus increase visual possibilities.

BASIC DEVELOPER TYPES

Categorizing developers can be problematic. The visual results one photographer considers normal might be unacceptable to another. This chapter offers basic characteristics of commonly used developers, how they are typically applied, and their formulas, if they are available. This

FIGURE 5.5 Rogovin made this heroic portrait with a 2¼ inch Rolleiflex, Kodak TRI-X, and bare bulb flash. Using Edwal FG-7 developer, with additional sodium sulfite, he achieved both maximum sharpness and rich tonality in his negatives that made printing easier. Rogovin prefers to explore the world in black-and-white; as he explains, "If I photographed a woman in a pink dress, all people saw was the pink dress. Color got in the way of what I thought was important, so I got rid of it."
© Milton Rogovin. *Joe Kemp*, from the series *Working People*, 1976. 7 × 7 inches. Gelatin silver print. Courtesy of Center for Creative Photography, Tucson, AZ.

information, based on the experiences of numerous photographers, is intended as a starting point from which photographers can conduct experiments to see which film–developer combinations offer visual satisfaction.

Generally, developers can be divided into four categories: normal, fine-grain, high-energy, and special-purpose. Formulas for the nonproprietary developers (i.e. formulas available for public use) mentioned in this section are presented at the end of this chapter.

Normal

The normal developer is one that provides high acutance, a moderate grain pattern, and a good range of clearly separated tones; maintains the film's regular speed; and is simple to use. These developers can be used with roll or sheet film in a tank or tray. Common examples include Kodak HC-110 and D-76, Ilford ID-11 and Ilfotech HC, plus Edwal FG-7. The key difference between a normal developer and a fine-grain developer is how the grain looks. A normal developer yields a sharp, toothy grain, similar to the shape of a pyramid. A fine-grain developer produces a softer grain, similar to a rounded dome.

Many developers can be classified as either normal or fine-grain. D-23 is one such classic formula. D-23 is a

Metol developer yielding a moderately fine grain due to the solvent action produced by its higher than normal content of sodium sulfite. In the case of D-23, the sodium sulfite's main purpose is not to create a finer grain but to produce the alkalinity needed for development to take place. The finer than normal grain is a byproduct of this action. D-76 contains the same amount of sodium sulfite as D-23, but its MQ formula of Elon and hydroquinone gives it more energy. This reduces the developing time, so there is less silver reduction and the grain remains better defined. HC-110, D-76, and FG-7 are available from the manufacturer in packaged form. D-23 must be mixed from scratch (see formula later in this chapter).

Fine-Grain Developers

Fine-grain developers increase their silver halide solvent power by chemical means, usually with a higher level of sodium sulfite. This increased solvency yields a reduction in graininess. Unfortunately, this is accompanied by a reduction in film speed and acutance, producing a negative in which the grain is actually softer than that of a normal developer. Instead of the grains looking like the well-sharpened point of a pencil, they appear to have been rounded off. The negative will actually deliver a less well-defined grain pattern. This is neither good or bad, it is simply different from the results obtained with a normal developer. It is a matter of how a photographer wants the final print to look. Prints made from such fine-grain negatives are softer and smoother looking than those made from film processed in a normal developer.

D-25 is a model of such a fine-grain developer. Its basic formula is the same as that for D-23, but sodium bisulfate is added as a buffer to reduce the developer's pH value (alkalinity). This buffering effect increases the development time, resulting in increased solvent action of

FIGURE 5.6 *Against the Grain* was a 16 year visual sociology project started in 1989 and centered around Buffalo, NY's harbor, the Irish Old First Ward neighborhood, and the men from there who worked unloading grain shipped across the Great Lakes using technology from the 1840s. Working in difficult conditions with only available light 50–60 feet below the deck of a 725 foot long grain boat, Maio kept things simple by working with a Leica M4-P camera and a 90 mm lens. He used Ilford HP5 Plus film, which he developed in Ilford ID-11 (1:1) for 9½ minutes at 68°F. Using a variable contrast cold light head on his enlarger, he made prints on variable contrast paper that were processed in separate trays of Dektol and Selectol Soft for 3 minutes for maximum contrast control. Maio informs us the title pays homage to Paul Strand's 1915 image with that name.
© Mark Maio. *Wall Street*, from the series *Against the Grain* 1990. 8¼ × 12¾ inches. Toned gelatin silver print.

the sulfite on the silver, giving it a fine-grain effect. D-25 must be mixed from scratch.

Kodak's Microdol-X, available in liquid and powder form, is a fine-grain, Metol only, high-sulfite developer that is similar to D-25.

Some commercial, fine-grain, one-shot developers, such as Ilfosol 3, are designed to deliver fine grain and optical sharpness in films having an ISO of 125 or less.

Ultra fine-grain commercially prepared developers, such as Acufine and ACU-I, are designed to increase the standard film ISO rating of many films.

High-Energy Developers

High-energy developers are often used for graphic arts work or rapid processing. They tend to produce high contrast, eliminating the middle tones and giving areas either a black or clear density. They are generally not intended for normal pictorial use, but they can be diluted and the exposure time manipulated to produce continuous-tone results. In many of these formulas, such as liquid lith developer, the developing agent (Part A) and the alkali (Part B) are stored separately and mixed only at the time of use. Once they are combined into a working solution, they rapidly oxidize. The level of bromide in these formulas is generally increased to keep the fog level down. This also helps to produce the completely clear areas on the film for high-contrast effects. Other widely used high-energy developers include Kodak's D-8, D-11, and D-19, and Ilford's ID-13.

Special-Purpose Developers

Special-purpose developers are designed for specific uses such as direct-positive, high- or low-temperature, and low-contrast/low-energy processing; reproduction work; X-ray development; nonstandard visual effects; and monobath or two-solution development methods.

Two-Solution and Water-Bath Development

Both these procedures can be effective in reducing overall contrast while maintaining useful density in the key shadow areas. They permit the developer to soak into the emulsion before the film is placed in a bath of mild alkali or water. When the film is taken out of the developer and placed in the second solution, the developer in the highlight areas rapidly exhausts itself, while the developer in the shadow areas continues to act. The cycle may be repeated to achieve the desired range of contrast. Either method works well with fast, thick-emulsion films such as TRI-X and HP5 Plus. The alkaline solution method is more effective with a broader range of films, including slower, thin-emulsion films. When working with either method, one may have to give about one f-stop more exposure than normal.

Diafine is a commercially available two-bath formula designed to produce the highest effective film speed, ultrafine grain, maximum acutance, and high resolution.

It is usable over a wide temperature range (68–85°F/20–29°C) with a single developing time for all films. Diafine permits wide exposure latitude without having to adjust the time or temperature of the developer.

D-23 Processing

The Single-Cycle Method

Film is developed in D-23 for 3–7 minutes at 68°F (20°C) and then allowed to soak, without agitation, in a 1 per cent solution (10 grams per liter) of sodium metaborate, a balanced alkali formerly marketed as Kodak Balanced Alkali. The process raises the film's base-plus-fog level, but this fog can usually be printed through without difficulty. The fog level can be combated by adding a 10 per cent potassium bromide solution to the sodium metaborate or by adding benzotriazole at the rate of 30 grains per liter of sodium metaborate. The resulting negative will appear to be soft but will contain fully developed shadow area detail. Other developers such as Microdol-X may also be used.

The Multi-Cycle Method

The multi-cycle method can produce a more completely developed negative, with additional compensating effects, than the single-cycle procedure. In this process, the film is developed in D-23 for 30–60 seconds, and then put into the 1 per cent sodium metaborate solution for 1–3 minutes with no agitation. The film is then put into a weak acid stop bath and completely rinsed in water. After these procedures, the film is returned to the D-23 for the second cycle. This entire procedure may be repeated three to five times to achieve the desired contrast range.

POSTDEVELOPMENT PROCEDURES

Developer Replenishment

A developer loses its potency as it carries out the task of reducing the exposed silver halides. During this process, contaminants, mainly soluble bromides, which are a byproduct of the chemical reaction, build up in the solution. A replenisher is a chemical solution added to the original developer to restore it back to its original strength, allowing it to be reused numerous times. Not all developers can be replenished. Check with individual manufacturers to find out whether a specific developer can be replenished.

Generally, for replenishment to be economical and effective, the developer must be used in at least 1 gallon tanks. Also, the solution must have film run through it regularly (preferably daily) to keep the developer at working strength. Careful records of the amount of film processed must be maintained to determine the amount of replenishment required. For these reasons, large-volume users primarily use replenishment.

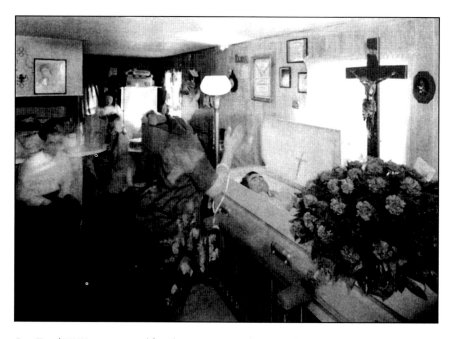

FIGURE 5.7 Here 5 × 7 inch TRI-X was exposed for about 1 minute at f-22. Two flashbulbs were fired during the exposure to paint the subjects at appropriate and unpredictable points in time. To compensate for the long, imprecise exposure with mixed lighting, Feresten used a double-bath development of exhausted Kodak Microdol-X followed by a solution Kodak Balanced Alkali. This reduced the overall contrast while maintaining detail in the key shadow areas. Feresten likened his method to casting a net into unknown waters. The results contain a collection of nonsimultaneous truths connected by time.
© Peter Helms Feresten. *Javier Garcia Wake, Fort Worth, Texas,* 1987.12 ⅝ × 18 inches. Gelatin silver print. Courtesy of the Feresten Estate and The Afterimage Gallery, Dallas, TX.

Most photographers prefer one-shot (nonreplenishable) developers because of their consistency and ease of use. If the volume of work is great enough, however, replenishing is more economical. Some photographers like the look of a negative processed in a replenished solution. This preference derives from the fact that during long development times, some of the residue silver in the solution attaches itself to the developed emulsion in a process called *plating*, which adds a slight amount of contrast and density. Kodak T-MAX RS Developer and Replenisher combination makes replenishing viable for people processing small amounts of film.

T-MAX RS Developer and Replenisher

The T-MAX RS Developer and Replenisher is an all-liquid system designed to provide a number of advantages over traditional replenisher methods. The mixed T-MAX RS acts both as a working solution and as a replenisher. No starter solution or separate replenisher solution is required. At its recommended temperature of 75°F (29°C), RS gives better shadow detail than regular T-MAX Developer. This makes it an excellent choice for both normal and push processing. It is suitable for low-volume, small-tank processing because it can be mixed in quantities as small as one gallon, does not require a daily

run of film, and has a good storage life. A working-strength solution will keep for 6 months in a full, tightly closed bottle and a half-filled bottle will last for 2 months. T-MAX RS can be used to process any T-MAX or conventional black-and-white film, such as TRI-X. It also may be used in an unreplenished system, one shotted, and dumped. Kodak says not to use RS to replenish regular T-MAX Developer.

T-MAX RS Developer is easy to replenish. You simply mix one gallon of RS and pour the required amount of solution into the developing container. After the film is developed, save the used developer in a separate bottle. For each 135-36, 120 roll, or 8 × 10 inch sheet processed, 1½ ounces (45 milliliters) of fresh RS Developer is added to the used solution. For example, if four rolls of 135-36 film were processed, you would add 6 ounces (180 milliliters) of fresh RS Developer to the used solution. All future development is done in the used solution after it has been replenished with fresh RS Developer. Check the RS Developer instructions for detailed processing information, or get Kodak T-MAX Developers, Kodak Publication No. J-86.

Reticulation

Excessive swelling of the emulsion during processing causes reticulation. It wrinkles the emulsion into a

FIGURE 5.8 After processing the Kodak Ektachrome 100 in the standard E-6 process, Towery performed the extreme opposite of recommended film handling procedures. He melted the original slides, alternately boiling and freezing them, and manipulated the emulsion with sandpaper and razor blades. These acts of deconstruction contribute to Towery's exploration of the processes of decline and aging. "I am interested in the decay of the body and find the dolls to be simultaneously human and non-human; suggestive without being specific."
© Terry Towery. *Untitled (6), from The Figurative Decay Series: Destroying the Image,* 2001. 60 × 40 inches. Inkjet print.

random web-like pattern that is more visible than the grain itself. The major cause of reticulation is temperature fluctuations between the different processing steps. Traditionally, reticulation has been considered a mistake that destroys the detail and uniformity of a negative. However, reticulation can be purposely induced for a graphic, textured effect. Improvements in contemporary emulsions have reduced the likelihood of accidental reticulation. In fact, it can be very difficult to induce reticulation with most modern films. Induced reticulation methods are covered in Chapter 11.

Intensification

Intensifiers are used to increase the density and contrast of an already processed underexposed or underdeveloped negative or positive. An intensifier cannot create something from nothing. Some density must be present for the intensifier to have any effect. An intensifier will not save a grossly underexposed negative. When using any intensifier, read and follow all safety and handling instructions.

The safest, simplest, and most permanent intensifier is selenium. It is called a proportional intensifier and it has a greater effect in the high-density areas than in the low-density ones. Selenium can add up to the equivalent of one f-stop of density to the upper highlight regions, which also increases contrast. This added density drops off through the mid-tone areas and falls drastically as the shadow areas deepen. Selenium intensification is an excellent choice with roll film because it does not increase grain size.

Selenium Intensification Process

1. Soak the processed and completely washed film for a few minutes in distilled water.

2. Refix with plain hypo (no hardener) for 2 minutes. This is easy to do with liquid fix by not mixing any of the hardener into the solution.

3. Place the film in the selenium toner solution diluted 1:2 or 1:3 with Kodak Hypo Clearing Agent or Perma-Wash for 2–10 minutes at 68°F (20°C) with constant light agitation. Dilution and time are determined by visual inspection and will vary depending on the amount of intensification required. Some hypo clearing baths may produce discoloration when mixed with selenium toner. Test your hypo clear with some unwanted film before using it with important work.

4. Put the film in a plain hypo clearing bath, at normal working strength, for 2 minutes with constant agitation.

5. Wash the film for a minimum of 5 minutes.

6. Dry the film.

Chromium and Silver Intensification

Photographers' Formulary makes a prepared chromium intensifier that increases the density of black-and-white negatives. Like selenium, it is a proportional intensifier, somewhat proportional to the amount of silver originally present in the negative. Negatives intensified with chromium are stable, but not archival. The process is done in room light with the chemicals being used once and discarded. Additional intensification may be obtained by repeating the process. This method is not suitable for use with T-grain films, which require a silver intensifier.

Chromium Intensifier at 70°F (21°C)

1. Fix the film in an acid hardening fixer and wash well. If the film is dry, soak it for 10 minutes in distilled water before carrying out the next step.

2. Immerse only one piece of film at a time in the bleach for 8–10 minutes with agitation. Chemicals are used once and discarded.

3. Rinse the film in running water for 5 minutes.

4. Redevelop the film in a low-sulfite developer such as Dektol or D-72 (1:3) until the image is totally black (about 5 minutes). Do not use a high-sulfite fine-grain developer such as D-76 or Microdol-X.

5. Rinse the film in running water for 1 minute.

6. Fix for 3–4 minutes.

7. Wash the film for 10–20 minutes.

8. Repeat the process if desired for greater effect.

9. Dry the film. Negatives intensified with this process are not considered to be permanent.

Photographers' Formulary also makes a silver intensifier, which acts by depositing additional silver on an underdeveloped negative. The results are permanent, but the new grain is predictably not as fine as the original image. The chemicals in the kit make four stock solutions that are mixed together just prior to use to make a single working solution. The stock solutions are stable for several months, but the working solution is usable for only ½ hour after mixing. The negative is intensified in room light to the desired degree and then washed. This intensifier contains both Metol and silver nitrate in a solid form and should be handled with care while wearing protective gloves. Silver nitrate will stain anything it touches.

The Silver Intensification Process

1. Mix the four stock solutions according to the manufacturer's instructions. The solutions are mixed 1 part solution A to 1 part solution B to 1 part solution C to 3 parts of solution D. Exercise safety precautions as silver nitrate is an oxidizer and is caustic and in solid form can cause a chemical burn.

2. If the film is dry, soak it for 10 minutes in distilled water. Immerse only one piece of film at a time in the intensifier. Intensification is done by visual inspection. You will see a slow darkening as the intensification occurs. The longer the film is in the solution the darker it will get. Chemicals are used once and discarded.

3. Remove the negative and rinse in running water.

4. The film will have excess silver nitrate that must be removed by fixing in a 30 per cent sodium thiosulfate solution for 2–3 minutes.

5. Put the film in a plain hypo clearing bath, at normal working strength, for 2 minutes with constant agitation.

6. Wash the film for a minimum of 5 minutes.

7. Dry the film.

Reduction

Reducers are used to subtract density from completely processed film that has been overexposed or overdeveloped. Reduction can be tricky and inconsistent. Before attempting this process on an important piece of film, make some dupes and run tests to determine the correct procedures before undertaking a reduction of the original. A negative can undergo the reduction process more than once but over-reduction cannot be undone. A negative can be reduced slightly, a test print can be made, and if it is not satisfactory the negative can be reduced again. Reducers are classified into three general types:

1. Cutting or subtractive reducers act first on the shadow areas and then on the midrange and highlights. They are excellent for clearing film fog. The net effect is to increase the overall contrast. Kodak R-4a (also known as Farmer's Reducer) is the most widely used and easiest to control cutting reducer. It is recommended for film that has been overexposed.

2. Proportional reducers decrease the image density throughout the film in proportion to the amount of silver already deposited. The effect is similar to that achieved by giving the film less development. Kodak R-4b is an example of a proportional reducer. It is suggested for use with overdeveloped film.

3. Super-proportional reducers have a considerable effect on the highlight areas but hardly act on the shadow densities. They are the trickiest and most unpredictable reducers and are not often used.

Photographers' Formulary sells a variety of prepared reducers, each designed for a specific purpose such as increasing or decreasing negative contrast or diminishing the overall density of the negative.

FILM DEVELOPER FORMULAS AND THEIR APPLICATIONS

This section provides a number of highly useful and thoroughly tested formulas and their general applications. They are listed by their major developing agent and are offered as initial points of departure. Photographers should feel free to experiment and modify these formulas

Farmer's Reducer (Kodak R-4a) Formula

Prepare stock solution A

Water	250 ml
Potassium ferricyanide	37.5 g (anhydrous)

Cold water to make ½ liters (500 ml)

Prepare stock solution B

Water	1500 ml
Sodium thiosulfate (hypo)	480 g

Cold water to make 2 liters

To use, take 30 ml of solution A, add 120 ml of solution B, and add water to make 1 liter. Immediately put the film in this working solution. Watch the reducing action very carefully. After about 1 minute, remove and wash the film. Examine it. If it needs more reduction, return it to the solution. Repeat the examination steps every 30 seconds or so thereafter. Transfer the film to a water wash before the desired amount of reduction has taken place. (To slow the activity of the reducer, making it easier to control, cut the amount of solution A by 50 per cent.) When the reduction is complete, wash the film for 5 minutes. Fix the film with an acid hardening fixer and give it a final wash before drying. Any residue left on the film can be removed during the final wash with a Photo-Wipe or cotton ball.

Farmer's Reducer (Kodak R-4b) Formula

Prepare solution A

Water	750 ml
Potassium ferricyanide	7.5 g (anhydrous)

Cold water to make 1 liter

Prepare solution B

Water	750 ml
Sodium thiosulfate (hypo)	200 g

Cold water to make 1 liter

Place the film in solution A for 1–5 minutes at 68°F (20°C) with constant agitation. Transfer it to solution B for 5 minutes, then wash it. This process may be repeated if necessary. After the desired degree of reduction has been achieved, place the film in an acid fixer for about 4 minutes. Follow with a hypo clearing bath and a final wash.

to reach their full visual potential. Although these formulas consistently provide "never fail results," testing is still recommended before using any one for critical work. Read and follow the information in Chapters 2 and 4 before using any of the formulas presented here. Many of the chemicals used are dangerous if not properly handled. Mix all formulas in the order they are given. Formulas are presented in both US customary units and metric (when available).

Amidol Developer

Amidol (2,4-diaminophenol hydrochloride) was a popular developing agent in the first half of the twentieth century because of its high reduction potential. It was often used in a water-bath combination, since a small amount of amidol is capable of efficiently converting the silver halides into metallic silver. It contains no alkali, so there is minimum softening of the emulsion. Amidol does have a tendency to produce stains. It is used more today as a paper developer noted for its beautiful blue-black tones. Wear gloves at all times when working with amidol to avoid absorption of this substance through the skin. Ilford ID-9 is an easy-to-use amidol developer.

Ilford ID-9 Formula

Water (125°F/52°C)	24 oz (750 ml)
Sodium sulfite (desiccated)	3 oz (100 g)
Amidol	½ oz (20 g)
Potassium bromide	88 grains (6 g)

Cold water to make 32 oz (1 liter)

This developer should be used as soon as possible after being mixed. Starting development time with a medium-speed film is 8 minutes at 68°F (20°C). Its standard useful range is 6–10 minutes.

Glycin Developer

Alfred Stieglitz and Joseph T. Keiley used glycin at the height of the pictorial movement in the early part of the twentieth century as a contrast control for a developing technique used in making platinum prints. Glycin has since been used in modern fine-grain developers such as Ilford ID-60.

FIGURE 5.9 Using his 35 pound, 12 × 20 inch Deardorff with an 8 × 20 inch back, Smith set out "to photograph 'decisive moments' to demonstrate that a large camera is not a limiting factor when it comes to selecting subject matter." He tray developed the Super XX film in ABC Pyro, relying on visual inspection. He printed the image on Azo contact paper developed in Amidol, which allowed him to "photograph scenes of extreme contrast – scenes with far more than the proverbial nine or ten tonal zones."
© Michael Smith. *Princeton, New Jersey*, 1985. 8 × 20 inches. Gelatin silver chloride print.

Ilford ID-60 Formula

Water (125°F/52°C)	24 oz (750 ml)
Sodium sulfite (desiccated)	291 grains (20 g)
Potassium carbonate	2 oz (60 g)
Glycin	1 oz (30 g)

Cold water to make 32 oz (1 liter)

Dilute this formula at a ratio of 1:7. Starting development time with a medium-speed film is 15 minutes in a tank and 12 minutes in a tray at 68°F (20°C).

Hydroquinone Developer

Hydroquinone is usually used as a developing agent in combination with Metol (MQ formula) or Phenidone (PQ formula). It can be used as the sole developing agent in conjunction with an alkali, found in a B solution, to produce extremely high-contrast images. It loses much of its activity at a temperature of 55°F (12°C) or lower. It is used for line and screen negatives or for special high-contrast visual effects. Ilford ID-13 and Kodak D-85 are hydroquinone developers.

Ilford ID-13 Formula

Stock solution A

Water (125°F/52°C)	24 oz (750 ml)
Hydroquinone	365 grains (25 g)
Potassium metabisulfite	365 grains (25 g)
Potassium bromide	365 grains (25 g)

Cold water to make 32 oz (1 liter)

Stock solution B

| Sodium hydroxide | 1¾ oz (50 g) |

Cold water to make 32 oz (1 liter)

Caution: Sodium hydroxide generates heat when mixed and should be mixed only in cold water. If mixed in warm water, it can boil up explosively. Do not handle this chemical without full safety protection.

Equal parts of stock solutions A and B are combined immediately before use. This solution should be discarded after each use. Normal development time is 2½–3 minutes at 68°F (20°C).

Kodak D-85 (litho developer)

Water (not over 90°F/32°C)	1500 cm^3
Sodium sulfite (desiccated)	90 g
Paraformaldehyde	22.5 g
Sodium bisulfite	6.6 g
Boric acid crystals	22.5 g
Hydroquinone	67.5 g
Potassium bromide	9 g

Water to make 3 liters

Due to its rapid oxidation, mix the developer immediately before use and discard after each use. Normal development time is 2½–3 minutes at 68°F (20°C).

Metol Developers

Metol, also known as Elon and Pictol, is most often used in combination with a contrast-producing developing agent such as hydroquinone in an MQ formula. By itself it is used as a fine-grain, low-contrast, soft-working developer yielding excellent highlight density. Agfa 14, Kodak D-23, and Kodak D-25 are classic Metol developers. If you have any allergic reactions to Metol, try switching to a Phenidone-based developer.

Agfa 14

Agfa 14 Formula

Water (125°F/52°C)	24 oz (750 ml)
Elon	65 grains (4.5 g)
Sodium sulfite (desiccated)	3 oz (85 g)
Sodium carbonate (monohydrate)	18 grains (1.2 g)
Potassium bromide	7½ grains (0.5 g)

Cold water to make 32 oz (1 liter)

Development time at 68°F (20°C) is 10–20 minutes, depending on the contrast desired. During development use a 15 second water rinse instead of an acid stop. An acid stop may cause the sodium carbonate to release carbon dioxide (CO_2) bubbles within the emulsion.

Kodak D-23

This Elon-sulfite developer is suitable for low- and medium-contrast applications. It produces negatives with grain and speed comparable to those developed with Kodak D-76.

Kodak D-23 Formula

Water (125°F/52°C)	24 oz (750 ml)
Elon	¼ oz (7.5 g)
Sodium sulfite (desiccated)	3 oz (100 g)

Cold water to make 32 oz (1 liter)

Average development time for a medium-speed film is 12 minutes in a tank or 10 minutes in a tray at 68°F (20°C).

Kodak D-25

This is a fine-grain developer for low- and medium-contrast uses. The grain is softer than that produced with D-23.

Kodak D-25 Formula

Water (125°F/52°C)	24 oz (750 ml)
Elon	¼ oz (7.5 g)
Sodium sulfite (desiccated)	3 oz (100 g)
Sodium bisulfate	½ oz (15 g)

Cold water to make 32 oz (1 liter)

With a medium-speed film, an average starting development time in a tank is about 20 minutes at 68°F (20°C).

MQ Developers

These MQ agents make up one of the most popular combinations for normal developers. The soft-working Metol (Elon) and the density-providing hydroquinone act together to create *superadditivity* (i.e. the energy of the combination of the two is greater than the sum of the energies of the individual parts). This combination can deliver a good balance between the shadow and the highlight areas while maintaining the film's speed, a tight grain pattern, and good tonal separation. Kodak D-19, DK-50, D-76, and D-82 plus Ilford ID-11 are all MQ developers.

Kodak D-19

When mixed in the correct proportions, Metol and hydroquinone can produce a high-contrast, high-energy

developer. Kodak D-19 was originally designed to process X-ray film, but is now used for continuous-tone scientific and technical work requiring higher than normal contrast, as well as for special effects, including infrared processing.

Kodak D-19 Formula

Water (125°F/52°C)	16 oz (500 ml)
Elon	30 grains (2 g)
Sodium sulfite (desiccated)	3 oz (90 g)
Hydroquinone	115 grains (8 g)
Sodium carbonate (monohydrate)	1¾ oz (52.5 g)
Potassium bromide	75 grains (5 g)

Cold water to make 32 oz (1 liter)

Average starting development time is 6 minutes in a tank or 5 minutes in a tray at 68°F (20°C).

Kodak DK-50

DK-50 is widely used in commercial and portrait work to produce a crisp negative with a good range of tones.

Kodak DK-50 Formula

Water (125°F/52°C)	16 oz (500 ml)
Elon	37 grains (2.5 g)
Sodium sulfite (desiccated)	1 oz (30 g)
Hydroquinone	27 grains (2.5 g)
Sodium metaborate	145 grains (10 g)
Potassium bromide	7½ grains (0.5 g)

Cold water to make 32 oz (1 liter)

For commercial work, DK-50 is generally used without dilution. An average starting time is about 6 minutes in a tank or about 4½ minutes in a tray at 68°F (20°C). For portrait work using tank development, DK-50 is often diluted 1:1 and used for about 10 minutes at 68°F (20°C). In a tray, it is used undiluted for approximately 6 minutes at 68°F (20°C).

Kodak D-76

Formula D-76, was introduced in 1927 as a fine-grain developer for motion picture and still-camera films. This classic developer has remained so popular that most film manufacturers optimized their products for development with it. Pictorial photographers use D-76 for its ability to

deliver full emulsion speed, its handling of low-contrast scenes, good sharpness, and its ability to deliver maximum detail in shadow areas. Ilford's ID-11 is almost an identical formula (see D-76 formula).

Kodak D-76 Formula

Water (125°F/52°C)	24 oz (750 ml)
Elon (Metol)	29 grains (2 g)
Sodium sulfite (desiccated)	3 oz (100 g)
Hydroquinone	73 grains (5 g)
Borax (decahydrate)	29 grains (2 g)

Cold water to make 32 oz (1 liter)

Average development time with D-76 undiluted in a tank is 8–10 minutes and in a tray is 6–9 minutes at 68°F (20°C). With certain films, D-76 may be diluted 1:1 for greater sharpness and increased grain. Development time will be about 1 minute longer than normal.

Ilford's ID-11 formula is the same except it uses 30 grains of Metol, 75 grains of hydroquinone, and 30 grains of borax.

Kodak D-82

Formula D-82, is a high-energy formula for underexposed negatives. It provides the utmost density with a minimum of exposure.

Kodak D-82 Formula

Water (125°F/52°C)	24 oz (750 ml)
Wood alcohol	1½ oz (48 g)
Elon	200 grains (14 g)
Sodium sulfite (desiccated)	1¾ oz (52.5 g)
Hydroquinone	200 grains (14 g)
Sodium hydroxide (caustic soda)	125 grains (8.8 g)
Potassium bromide	125 grains (8.8 g)

Cold water to make 32 oz (1 liter)

Caution: Dissolve sodium hydroxide only in cold water, as a great deal of heat is created when it is mixed. It is best to dissolve sodium hydroxide in a separate container of water and then add it to the solution after the hydroquinone. Stir vigorously.

Starting development time in a tank is 6 minutes and in a tray 5 minutes at 68°F (20°C).

FIGURE 5.10 "It is my intention to create mythic images that combine a sense of implied narrative with the presence of ritual. The montages address cultural coding and private enigma. They usually contain elements that reflect an African American identity and refer to the complex relationships with mainstream society. Self-portraiture remains an important element in the work, which I recognize as a romantic search of my ancestral roots and cultural heritage. The montages are meant to function as a visual crossroads. They are made using a film recorder to produce 4 × 5 inch negatives of photographs taken of my work, my family's archives, and found antique photos, which are processed in D-76. Some montages include objects placed directly on the scanner. I created the patterns using sections of photos, scanned objects, and drawings on paper and directly on the computer."
© Stephen Marc. *Untitled*, from the series *Soul Searching*, 1997. 12 × 18 and 24 × 36 inches. Gelatin silver print.

Phenidone Developers

People who are allergic to Metol (Elon) should use Phenidone developers, which deliver very similar results to those produced by Metol developers. In combination with hydroquinone, a Phenidone developer becomes a super-additive PQ formula. Unlike Metol, Phenidone is actively regenerated by the hydroquinone, resulting in a developer that retains its activity longer.

The activity of Phenidone is about 10 times that of Metol. Phenidone developers produce a denser fog than Metol developers. Since the type of fog created cannot be eliminated with potassium bromide, an organic restrainer such as benzotriazole is used. The purpose of the potassium bromide in Phenidone formulas is to stabilize the developer against the changes produced by the release of bromide during the development process.

Ilford Microphen

Microphen is a fine-grain Phenidone developer that can also produce an effective increase in film speed without yielding a corresponding increase in grain size. Its high speed/grain ratio permits an increase of one-half f-stop without a change in the grain pattern. For example, HP5 Plus can be rated at ISO 650 instead of 400. (See page 96 for the formula).

Ilford Microphen Formula

Water (125°F/52°C)	24 oz (750 ml)
Sodium sulfite (anhydrous)	3 oz (100 g)
Hydroquinone	77 grains (5 g)
Borax	46 grains (3 g)
Boric acid (granular)	54 grains (3.5 g)
Potassium bromide	15 grains (1 g)
Phenidone	3 grains (0.2 g)

Cold water to make 32 oz (1 liter)

Starting development times range from about 4½–6 minutes at 68°F (20°C). Microphen can be diluted 1:1 for a developing time range of 8–11 minutes or 1:3 for developing times of 14–21 minutes. The greater the dilution, the greater the acutance. Diluted developer works well for retaining key shadow and highlight details in subjects possessing a wide tonal range.

Ilford ID-62

Formula ID-62 is a good general-purpose Phenidone (Metol free) developer that can also be used as a neutral tone paper developer, which is similar to Dektol.

Ilford ID-62 Formula (Stock Solution)

Water (125°F/52°C)	24 oz (750 ml)
Sodium sulfite (anhydrous)	1¾ oz (50 g)
Hydroquinone	175 grains (12 g)
Sodium carbonate (desiccated)	2 oz (60 g)
Phenidone	7½ grains (0.5 g)
Potassium bromide	30 grains (2 g)
Benzotriazole	3 grains (0.2 g)

Cold water to make 32 oz (1 liter)

For tank development, dilute 1:7 and develop 4–8 minutes at 68°F (20°C). For tray development, dilute 1:3 and process 2–4 minutes at 68°F (20°C).

Ilford ID-68

Formula ID-68 is a low-contrast, fine-grain Phenidone developer, which is similar to Microphen. Compared to D-76, it can deliver an increase in film speed of a half to two thirds of an f-stop compared to D-76, changing the rating of a ISO 125 film to 200.

Ilford ID-68 Formula

Water (125°F/52°C)	24 oz (750 ml)
Sodium sulfite (anhydrous)	3 oz (85 g)
Hydroquinone	75 grains (5 g)
Borax	92 grains (7 g)
Boric acid	29 grains (2 g)
Potassium bromide	15 grains (1 g)
Phenidone	1.9 grains (0.13 g)*

Cold water to make 32 oz (1 liter)

*For ease of measurement, 13 ml of 1 per cent Phenidon solution is 0.13 g of Phenidone.

Use undiluted at full strength. Starting times for tank development are 7–11 minutes and for tray development 4–7 minutes at 68°F (20°C).

Ilford ID-72

Formula ID-72 is a high-contrast Phenidone developer, which is similar to Kodak's MQ Kodak D-19 developer.

Ilford ID-72 Formula

Water (125°F/52°C)	750 ml
Sodium sulfite (anhydrous)	72 g
Hydroquinone	8.8 g
Sodium carbonate (monohydrate)	57 g
or	
Sodium carbonate (anhydrous)	48 g
Phenidone	0.22 g
Potassium bromide	4 g
Benzotriazole	0.1 g
or	
Benzotriazole 1 per cent solution	10 ml

Cold water to make 1 liter

Use undiluted at full strength. Starting development time is 4–5 minutes at 68°F (20°C).

POTA Developer

POTA is a super compensating, very low-contrast developer originally designed to develop images of nuclear blasts, where the light ranged over 20 f-stops. Capable of producing extremely sharp fine-grain negatives possible, it is useful in harsh lighting situations, such as in astronomy, where the retention of density is needed over an extensive brightness range.

POTA Formula

Water (100°F/38°C)	750 ml
Sodium sulfite	30 g
Phenidone A	1.5 g

Cold water to make 1 liter

Use immediately, as the solution deteriorates very quickly after it has been mixed. Starting development times range between 12 and 15 minutes in a tank and between 6½ and 8 minutes in a tray at 68°F (20°C).

Pyro Developers

Pyrogallol, known as pyro and pyrogallic acid, has been used as a developing agent since it was introduced in 1851. Pyro was the most popular nineteenth century developer and was used by the major wet plate photographers of the American West, including Carlton E. Watkins, William Henry Jackson, and Timothy O'Sullivan. In the twentieth century it was favored by West Coast photographers, such as Edward Weston and Morley Baer, for its ability to produce firmer edge effects, increased separation of highlight and shadow detail, higher image resolution, and finer grain structure than conventional developers.

Pyro is a staining developer that creates a yellow stain in proportion to the metallic silver formed in the negative. This yellow stain will block some of the blue light during the printing process. Although the negative may look flat, it will print with good contrast. When printing with variable contrast papers, pyro stain, which is always proportional to silver density, functions as a continuous variable color mask that reduces printing contrast, particularly in the high values. This allows shadow and mid-tones to be printed without compressing or blocking the highlights, reducing time spent burning and dodging.

Pyro can be a good solution for photographers wanting dual-purpose negatives, i.e. negatives that print well with both silver papers and with alternative processes such as platinum or palladium. This is because a stained negative has in effect two printing density ranges, one for the bluish/green light used in printing silver papers, and another for the UV light used with alternative processes.

Pyro also has been useful in developing underexposed film because the stain reinforces the silver image enough to make a thin negative more printable. It is even possible to bleach the silver away and print only from the stain, yielding a very fine-grain image. Pyro also has a *tanning effect* on the emulsion, hardening it during development. This reduces the lateral movement of the silver, producing a high degree of acutance. The tanning effect is more pronounced in fast, thick-emulsion films.

Pyro oxidizes swiftly. This can make it unpredictable when using the standard time/temperature method of

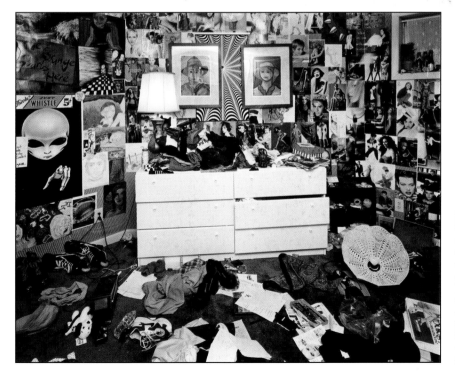

FIGURE 5.11 Chamlee recorded this image in a darkly lit basement, using a 500 watt Tota light to give the appearance of natural light. She tray developed the Kodak Super XX film in ABC Pyro by relying on visual inspection. She then printed the image on Azo contact paper developed in Amidol and finally selenium toned the print for a warm-neutral effect.
© Paula Chamlee. *Mia's Room, Mason, Ohio*, 1998. 8 × 10 inches. Gelatin silver chloride contact print.

development, as the amount of image stain depends on the degree of oxidation. For this reason, photographers, such as Edward Weston, developed the film by visual inspection under a faint green safelight. Presently pyro is rarely used. With fast, highly sensitive modern films, this process of visual inspection is not recommended, as the fog level might become too high. Wear protective gloves, as pyro will also stain your fingers and nails.

Photographers' Formulary offers a contemporary formula specifically designed and test for rotary processing tubes, such a Jobo.

Pyrocatechin (catechol), introduced in 1880, can be utilized with contemporary films to create a staining and tanning effect similar to that produced by pyro. It works well with fast, thick-emulsion films, especially when dealing with high-contrast scenes. It provides excellent separation in the highlight areas, but reduces the speed of the film by about 50 per cent. To make up for this speed loss, Metol is sometimes added to the formula. The addition of Metol will not change the character of the developer.

Kodak D-1/Pyro ABC Formula

Stock solution A
Water (65°F/18°C)	24 oz (750 ml)
Sodium bisulfite	140 grains (9.8 g)
Pyrogallol	2 oz (60 g)
Potassium bromide	16 grains (1.1 g)

Water to make 32 oz (1 liter)

Stock solution B
Water (65°F/18°C)	24 oz (750 ml)
Sodium sulfite (desiccated)	3½ oz (105 g)

Water to make 32 oz (1 liter)

Stock solution C
Water (65°F/18°C)	24 oz (750 ml)
Sodium carbonate (monohydrate)	2½ oz (90 g)

Water to make 32 oz (1 liter)

Mix and use fresh developer immediately. For tray development, the normal dilutions are 1 part each of stock solutions A, B, and C with 7 parts water. Develop for 6 minutes at 65°F (18°C). With a tank, take 9 oz (285 ml) of solutions A, B, and C and add water to make 1 gallon (about 4 liters). Develop for about 12 minutes at 65°F (18°C). To minimize oxidation, mix solution B, solution C, and the water, and then add solution A immediately before using. If there is any scum on the surface of the developer, remove it with blotting paper before developing or unwanted stains may result.

The PMK (Pyro-Metol-Kodak Balanced Alkali, also known as sodium metaborate) formula solves two of pyro developer's problems: reduction in speed and rapid oxidization. Adding Metol to the formula combines the high degree of acutance and image stain of traditional pyro and adds stability and repeatability. PMK developers have an extremely long shelf-life.

PMK Formula

Solution A
Water (68°F/20°C)	24 oz (750 ml)

Add a few crystals of sodium bisulfite, then add the following:
Metol	145 grains (10 g)
Sodium bisulfite	291 grains (20 g)
Pyrogallol	3 oz (100 g)

Water to make 32 oz (1 liter)

Solution B
Distilled water (68°F/20°C)	48 oz (1.4 liters)
Sodium metaborate	21 oz (600 g)

Water to make 64 oz (2 liters)

Mix solutions A and B in the following proportions: 1 part A and 2 parts B to 100 parts water. While mixing parts A and B the solution will change color from green to a pale yellow.

Pyrocatechin Compensating Developer Formula

Solution A
Water (68°F/18°C)	100 ml
Sodium sulfite (desiccated)	1.25 g
Catechol (pyrocatechin)	8 g

Solution B
Sodium hydroxide	1 g
Cold water to make	100 ml

Caution: Mix sodium hydroxide only in cold water.

Immediately before use, mix solutions A and B in the following proportions: 20 parts A and 50 parts B to 500 parts water. Starting development times are 10–15 minutes at 68°F (20°C).

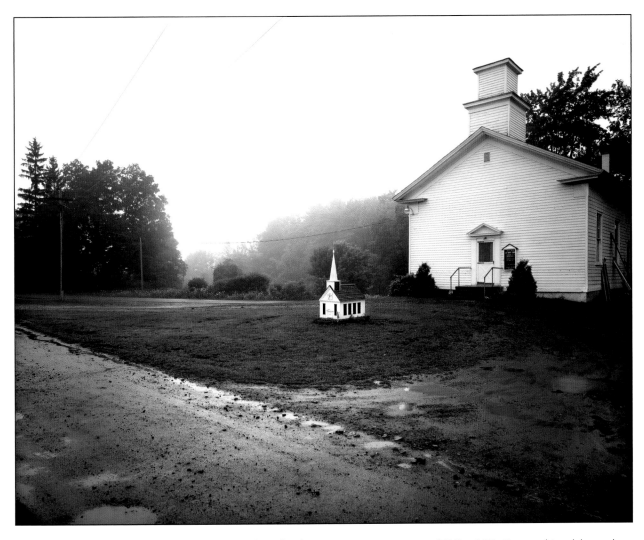

FIGURE 5.12 Using printing-out paper, which works well with a strong, contrasty negative (TRI-X at 100), Hunter achieved the results he wanted by using a modified Pyro ABC developer. This developer was a favorite when printing-out paper was most popular (1850–1920). The paper was exposed in sunlight until the highlights were slightly degraded and then fixed in two baths of rapid fix. The image was toned with gold chloride until the darkest shadows lost their green cast and took on a lavender color.
© Frank Hunter. *Methodist Church, Mexico, New York*, 1985. 8 × 10 inches. Printing-out paper. Courtesy of Thomas Deans Fine Art, Atlanta, GA.

The Photographers' Formulary makes both a powdered and liquid PMK formula consisting of stock A (developer agents) and stock B (alkali or accelerator) solutions.

An alkaline fixer solution, such as Photographers' Formulary TF-4, is necessary to achieve maximum pyro stain. An acid rapid fix may diminish staining effects of both pyro and PMK formulas. You can increase the yellowish stain by putting the processed and fixed negatives back into the developer.

Paraminophenol (Rodinal) Developers

Paraminophenol, better known by its trade name, Rodinal (Agfa), has been used as a developing agent since the 1890s. It is a classic *compensating developer*, designed to compress the overall contrast range in a negative without altering the gradation of tonal values in the shadow and highlight areas. The compensation happens when bromide is released in areas of intense exposure,

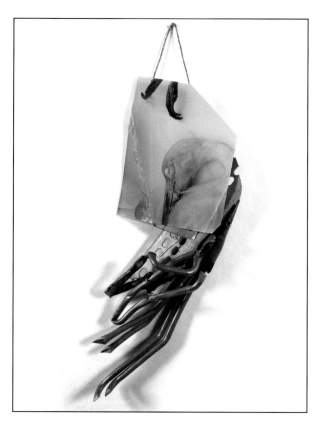

FIGURE 5.13 The potential for focus and intimacy that the telephoto 480mm Rodenstock Sironar-N presented was compromised by the lens's weight and limited depth of field. Palmer solved this problem by building a suction cup apparatus that attached the Wisner 8 × 10 inch camera to a nearby wall, ensuring the lens and camera's stability, and also constructing a brace for the subject's head, minimizing his movement. Palmer captured this tremendously sharp portrait on TRI-X, which he processed with PMK. He printed the photograph on Kodak AZO, which he processed for 1½ minutes in Kodak Dektol and toned with a selenium solution.
© Scott Palmer. *Saloonatics – R-74*, 2003. 10 × 8 inches. Gelatin silver print.

FIGURE 5.14 Garvens made this photograph with her 4 × 5 inch Sinar Swiss Alpina. She exposed the TRI-X for about 10 seconds and developed it in Rodinal. She printed the image on Agfa Portriga Rapid paper, which she developed in Dektol, and toned in a copper toner. Garvens attached found objects, such as shards of copper tubing and galvanized steel, which both extended the image in the photograph and contrasted with the relatively delicate paper photograph. With this image she combines "disparate materials, creating the dual relationship of harmony and discord."
© Ellen Garvens. *Bosque*, 1992. 24 × 12 × 3 inches. Mixed media. Courtesy of Museum of Fine Arts, Houston, TX.

where development is rapid and continuous. The bromide slows the development of the highlight values, preventing them from becoming too dense to print. Rodinal can be prepared in a very concentrated solution, enhancing the compensating effect. The concentrate lasts for a long time and when diluted with water its produces an excellent general-purpose developer. When used with fast film having an ISO of 400 or higher, Rodinal

produces a visible but very tight, sharp-edged grain pattern.

Rodinal for Maximum Highlight Detail

This is a modified formula based on commercially prepared Rodinal, which can deliver better performance in the highlight areas of contemporary films.

Paraminophenol Formula

Stock solution A

Boil 10 oz (625 ml) of water, then allow it to cool for 5 minutes.

Add a few crystals of potassium metabisulfite, then add the following:

Paraminophenol hydrochloride	384 grains (50 g)
Potassium metabisulfite	2 oz (150 g)

Stir until dissolved.

Stock solution B

Sodium hydroxide (caustic soda)	3 oz (215 g)
Cold water	8 oz (500 ml)

Caution: Use cold water only.

Add 6 oz (350 ml) of the B solution to the A solution, stirring constantly. A precipitate of the paraminophenol solution will form but will dissolve as more sodium hydroxide is added. Put in enough sodium hydroxide to almost dissolve this precipitate.

Add cold water to make 16 oz (½ liter). Place in a tightly closed opaque bottle and allow to cool. If any of the paraminophenol crystallizes, add more sodium hydroxide to nearly dissolve it. It is necessary to leave some of the paraminophenol undissolved to make the developer work properly.

Mix 1 part of the bottled solution with 10 parts of water for use with negatives. Starting development times are about 6–10 minutes at 68°F (20°C).

Rodinal Highlight Formula

Water (70°F/21°C)	350 ml
Rodinal	7 ml
Hydroquinone	1.3 g

Water to make 500 ml

This formula is designed for developing only one roll of film in a two-reel tank. For two rolls, double the amount of Rodinal and water and process in a four-reel tank.

Starting development times at 70°F (21°C) are as follows: one roll of Plus-X or FP4, 11 minutes; two rolls, 12 minutes; one roll of TRI-X or HP5 Plus, 15 minutes.

Agitate the film for the first complete minute, then 10 seconds for each minute after, allowing the tank to stand still between agitations.

XTOL

One of the newest developers is based on a vitamin C derivative (sodium isoascorbate) and a modified form of Phenidone. It also contains no hydroquinone. For decades it was known that ascorbic acid (vitamin C) acts as a reducing agent and can be used as a developing agent in a high-alkalinity solution. As early as the 1940s, Kodak chemists worked with an ascorbic acid-based developer. Ascorbic acid made its commercial debut in 1996 as Kodak XTOL. XTOL has been hailed as the replacement for D-76 because of its low toxicity, superior speed, finer grain, excellent sharpness, and ease of use and replenishment.

XTOL Approximation Formula

This formula provides a close approximation to Kodak's patented process (US Patent 5,756,271, 1998), which Kodak has published.

Part A

Sodium sulfite anhydrous	10 g
Diethylene-triamine-penta acetic acid, pentasodium salt (40 per cent)	1 g
Sodium metaborate (8 mol)	4 g
4-Hydroxymethyl-4-methyl-1phenyl-3-pyrazolidone (Phenidone)	0.2 g

Part B

Sodium sulfite anhydrous	75 g
Sodium metabisulfite	3.5 g
Sodium isoascorbate	12 g

Add part A to 750 ml of water at room temperature; follow with part B and water to make 1 liter. Depending on the dilution, starting development time is 6–9 minutes at 68°F (20°C). For detailed information see Kodak Professional XTOL Developer Publication J109.

MYTOL: XTOL Substitute

Paul Lewis developed another formula using ascorbic acid and Phenidone as developing agents. The Phenidone provides good low-contrast shadow detail and is *superadditive* with ascorbic acid. Called MYTOL, the developer can be used straight, but a 1:2 dilution is recommended. Increasing the dilution increases the relative speed of the developer but dilutions of 1:1 or 1:2 are recommended. Average starting development time is 9 minutes in a tank or 8 minutes in a tray at 68°F (20°C).

Lewis says MYTOL can be used in the same manner as packaged Kodak XTOL. The negatives developed with this formula are comparable to those developed in XTOL, with no discernable difference.

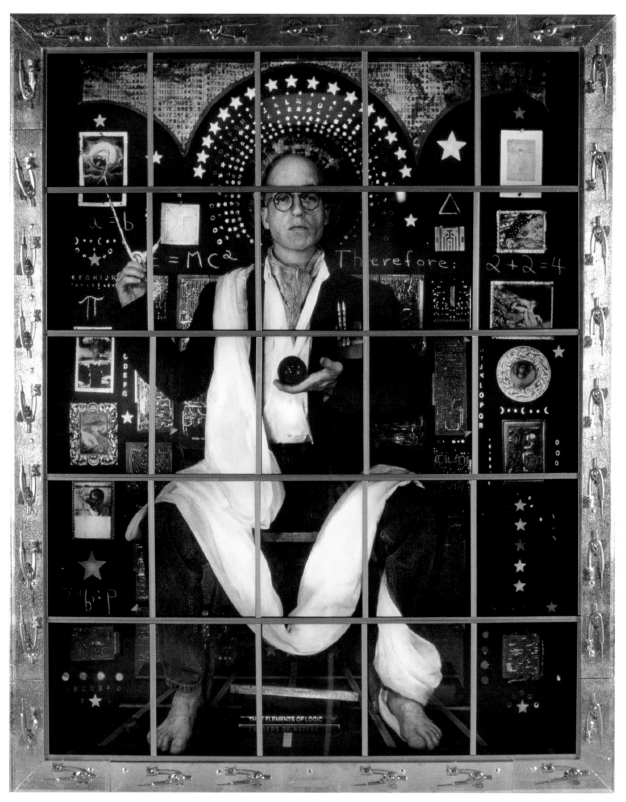

FIGURE 5.15 Campbell's work refers to the sacred artistic tradition of the West to examine contemporary beliefs. Here, she creates a "chapel" in the form of an artificial universe dedicated, tongue-in-cheek, to Western rationalism, ironically critiquing its effects on nature and ourselves. The light boxes connote the stained glass windows of medieval cathedrals. The portraits are photographed with a 6 × 7 cm format camera on TRI-X film and processed in Rodinal to achieve a sharply defined grain pattern. She hand-painted the black-and-white prints and rephotographed them using color negative film. The final images are on color Duratrans, a positive transparency material.

© Kathleen Campbell. *Rational Being*, from the series *Modern Theology or a Universe of Our Own Creation*, 1996. 5 × 4 feet. Color Duratrans with mixed media; light box installation.

FIGURE 5.16 "While the original full-frame 35 mm black-and-white depicts the Holocaust survivors in an objective manner, the cropped version is a grim, claustrophobic, and confrontational picture." Processing in Edwal FG-7 with extra sodium sulfite gave Friedman the acutance to enlarge a small portion of the negative. Today commercial developers like Kodak XTOL provide a more convenient and environmentally friendly way of achieving similar results.
© James Friedman. *Survivors' Reunion, Majdanek Concentration Camp Near Lublin, Poland, #42, from the series 12 Nazi Concentration Camps*, 1983. 20 × 24 inches. Toned gelatin silver print.

MYTOL Formula

Distilled water (80°F/27°C)	750 ml
Sodium sulfite anhydrous	60 g
Sodium metaborate	4 g
Sodium ascorbate	13 g
Phenidone	0.15 g
Sodium metabisulfite	3 g
Water to make 1 liter	

IS ALL THIS NECESSARY?

You may ask yourself, "Is all this really necessary? What difference does it make whether I know the components of a developer and how they work?" The information provided in this chapter increases your visual options. In many photographic situations, you cannot control the circumstances under which you make the picture. On the contrary, you are forced to work with conditions as you find them. These additional resources add to your tool kit that can help you make the most out of what has been dealt you. Mixing your own formulas is another way for you to educate yourself. This knowledge can give you the flexibility and power to move beyond conventional solutions and assist you in realizing the full potential of your vision. Strong feeling and passion are not enough to make the complete statement. In addition to a solid conceptual base, photographers also need craftsmanship and exactness to manage their desire outcome. The blending of these empirical and spiritual ingredients can help to organize the chaos of life, enabling one to deliver the photographs of what they see inside their minds eye.

RESOURCE GUIDE

Adams, Ansel, and Robert, Baker. *The Negative*. Boston, MA: Little Brown, 1995.

Anchell, Stephen G. *The Darkroom Cookbook*, Third Edition, Boston, MA: Focal Press, 2008.

Anchell, Stephen G., and Bill Troop Bill. *The Film Developing Cookbook*. Boston, MA: Focal Press, 1998.

Donofrio, Diane. (Ed.). *Photo Lab Index, The Lifetime Edition*. Dobbs Ferry, NY: Morgan & Morgan, 2001.

Wall, Edward J., and Franklin I. Jordan; revised and enlarged by John S. Carroll. *Photographic Facts and Formulas*. Englewood Cliffs, NJ: Prentice Hall, 1976.

Brandess-Kalt-Aetna Group (BKA) supply Acufine, Diafine, Edwal, Ethol, Heico: www.bkaphoto.com.

FIGURE 5.17 Images for this montage were photographed with a macro lens and recorded onto Ilford HP5 Plus film, which was processed in Ilfotec HC at dilution B. The resulting negatives were scanned, adjusted, and composed in Photoshop. *World in a Jar* (See Figure 11.25) evolved out of Hirsch's response to the events of 911 and the appalling consequences and injustices of war, ethnic violence, genocide, and religious intolerance. The project offers a visual atlas examining the principles of social justice and the nature of evil. With its open storytelling format, the images engage diverse audiences, us to ponder, "Who we are."
© Robert Hirsch. *World in a Jar: World & Trauma Montage*, 2005. Dimensions vary. Ink jet print. Courtesy of Burchfield-Penney Art Center, Buffalo, NY

CHAPTER 6

ANALOG FINE PRINTMAKING: EQUIPMENT, MATERIALS, AND PROCESSES

THE ANALOG FINE PRINTMAKING PROCESS

The analog printing process offers photographers countless ways of thoughtfully interpreting what they have captured on film. It is not a rote process of automatically translating a negative into a print. The negative is a departure point that provides the raw construction information to craft the final vision. Although printing offers a photographer a second chance to correct for technical errors in exposure and processing, serious defects such as poor lighting or unsharp focus cannot be corrected. More importantly, however, printing gives photographers the opportunity to further express themselves by defining their relationship to a subject. If nine different photographers were given the same negative to print, you will get nine different renditions of the same subject. Once a print is made, it takes on its own existence as an object, especially as others interact with it. As Ansel Adams stated, "the negative is like a musical score and the print is the performance."

To make a good negative one must understand that the human eye has a realistic range of only about 10 f-stops and photographic paper has a limit of about three f-stops. In practice, a photographer must decide how to expose the film to obtain the desired range of tones within these physical limits. The Zone System (see Chapter 1) applied sensitometry to the nineteenth century maxim, "Expose for the shadows and develop for the highlights" to help deal with this situation.

Generally, a properly exposed negative contains enough shadow and highlight detail to provide the information needed to successfully visualize an entire subject. Continued difficulties with weak, underexposed negatives indicate the need to (1) make sure all equipment is functioning properly, (2) review exposure methods, and (3) review of film processing procedures. A good negative makes the printmaking experience forthright and rewarding.

The fine printmaking process brings together a photographer's ideas, knowledge, equipment, and technique to express in a concrete form what was personally seen, felt, and understood. A fine print demonstrates both the objective and subjective experience, conveying a sense of the physical reality and a photographer's response to it. Fine printing reflects a combination of the underlying concepts behind the image, technical knowledge and control, practice, and patience and is constantly open to reevaluation.

Styles in Printmaking

Since the 1930s the "straight" aesthetic has dominated fine black-and-white printmaking. The straight classical style is reflected in the work of photographers such as Paul Strand and Edward Weston. Generally, their prints are made on a silver-based glossy paper from a negative that is not altered except to correct for technical shortcomings. Their prints express a complete range of clearly separated tones that reveal form and texture in the key highlight and shadow areas that were visualized at the time the negative was exposed and is still considered to the standard to be mastered.

In the 1960s an alternative movement expanded the printmaking practice. The alternative printmakers revived old processes and experimented with new ones, often blurring the distinction between media boundary lines. They used different types of papers and emulsions, manipulated the negative for subjective reasons, combined photography with other media, integrated new and old images, appropriated images from other sources, and in general dispensed with the rules of what was previously considered acceptable. This chapter deals with the printing of traditional silver-based materials. The other styles of printmaking are discussed in later chapters.

Learning What Is Available

It is vital for photographers to become acquainted with the numerous avenues available to express their vision. Imagine how tedious it would be if all photographs were required to be printed according to the same set of guidelines. Tremendous visual possibilities lie in producing quiet, soft, subtle prints with a limited range of tones. In other cases, snappy renditions with strong contrast, stressing deep blacks and solid whites, may be the destination. Each photographer needs to decide which mode best expresses a particular situation.

FIGURE 6.1 Sexton says of the traditional darkroom printmaking process, "Exhilaration is still a part of the photographic process for me. That's why I love the traditional darkroom. I find my darkroom to be a place of solitude and, in a way, almost a sanctuary – not unlike climbing underneath the focusing cloth of my old-fashioned 4 × 5 inch view camera. I'm separated from the rest of the world. Watching an image appear under the dim glow of safelights is still an intoxicating part of the process: the anticipation, waiting for the time to pass in the fixer before turning on the white light; the ultimate excitement when that light illuminates a print which meets your expectations. When that happens it makes the entire photographic ritual utterly addictive. The process, for me, is still magical and alive."
© 1982 John Sexton. All rights reserved. *Trees, Blowing Snow, Yosemite Valley, California.* 11 × 14 inches. Gelatin silver print.

There is no right or wrong style of printmaking. Photographers should consider making prints in a variety of ways to expand their personal expression. Fine printmaking is a highly personal and subjective response to the factual and emotional experience of the subject. The temporal relationship between the negative and the print is in flux, altering the aesthetic response each time a print is made. In the past there were those who advocated that negatives and prints should be made as quickly as possible to elicit the "purest" response to the subject. But other expressive printers like Josef Sudek had a different approach in which the negative has to be put "to one side" and time is allowed to pass before one knows the appropriate way to make the print. Sudek stated: "It takes me some time to realize if a photograph is any good or not If you do the positives right away you'll probably be disappointed; my memory still retains too vivid an image of the real landscape, with which you cannot compare a photographic image, because it is impossible to photograph things as they are. Only when the memory fades am I capable of finding out how someone who has not seen the reality with me may see the photograph. I think that for photographs like mine haste is a poor counselor."[1]

What Makes a Good Printmaker?

One becomes a good printer by printing and discovering what methods and techniques allow your personal vision to be realized. This involves making many prints to see what actually happens. The best way to see visual possibilities is to make one more print and compare it with the previous ones. This means following through with additional ideas and not worrying that everything you do turns out to be a "success." Part of the course of discovery and learning is coming to terms with "failure," for without these experiences knowledge would be static. Becoming a good printer means overcoming expectations, fears, and prejudices, temporarily suspending judgment, and trying different approaches to see what occurs. In fine black-and-white printing, the amount of sensitivity displayed in rendering the scale of tones in relation to the aesthetic and emotive concerns of the subject determines how well the print succeeds.

The best printmakers learn all they can about their craft and then set it aside so as to remain receptive to new prospects. They can control the process but are not bound to a set of established rules. Good printers use their knowledge as a point of departure to travel into the

Analog Fine Printmaking: Equipment, Materials, and Processes

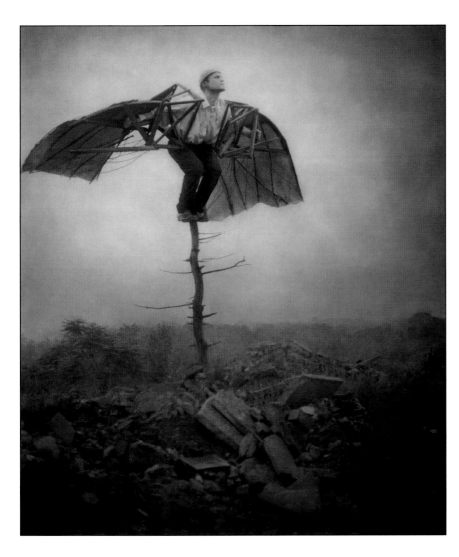

FIGURE 6.2 The ParkeHarrisons create photographs that tell stories of loss, human struggle, and personal exploration within landscapes scarred by technology and overuse. Robert ParkeHarrison says, "The scenes we depict display futile attempts to save or rejuvenate nature. We portray these attempts within our work by inventing machines and contraptions from junk and obsolete equipment. These contraptions are intended to help the character in the black suit I portray to jump-start a dying planet. I patch holes in the sky, create rain machines, chase storms to create electricity, communicate with the earth to learn its needs. Within these scenes, we create less refined, less scientific, more ritualistic, and poetic possibilities to work with nature rather than destroying it. We attempt to represent the archetype of the modern man and draw the viewer into the scene without dictating a message or the outcome of the myth presented." To produce large-scale prints, the ParkeHarrisons use an enlarger mounted to a wheeled cart to project the image onto mural paper pinned to the wall. The paper is processed in troughs made from cutting PVC pipe long-ways and then capping the ends with a piece of Plexiglas sealed with fiberglass. The prints are manipulated with darkroom techniques, paints, and varnishes. © Robert and Shana ParkeHarrison. *da Vinci's Wings*, 1998. 45 × 36 inches. Gelatin silver print with mixed media. Courtesy of Jack Shainman Gallery, New York.

unknown. The German philosopher Friedrich Nietzsche said, "The powerful man is the creative man, but the creator is not likely to abide by the previously established laws." A good printmaker is like a magician who is able to amuse, amaze, astonish, enchant, and reveal.

To help ensure that you do not overlook possibilities, closely inspect your negatives on a light table and make contact sheets. In the darkroom, through visual trial and error, make test prints to determine the correct exposure time for the grade of paper that will yield the desired amount of contrast.

Do not hesitate to crop or enlarge portions of your negatives. There is nothing written in stone stating a negative must be printed full frame. Alfred Stieglitz had no qualms about cropping when it would deliver the visual results he desired, as in *Winter on Fifth Avenue*, 1892. It is also permissible to return to old negatives and give them a new interpretation. Ansel Adams printed *Moonrise, Hernandez, NM*, 1941, for decades, even altering the

original negative through intensification to achieve more dramatic renditions. A good print visually articulates a particular set of circumstances at a given time and place. Later it is possible to discover significant things we did not originally recognize and see how each negative can hold numerous interpretations, recollections, and identities. William Henry Fox Talbot's Cambridge tutor, philosopher William Whewell said, "Of all the visits of old friends the most agreeable and the most affecting is the visit form a man's former self." Ultimately the goal should be to let photography be photography and not overburden the process with unnecessary dogmas or rules. Nor should one sanctify the moment of taking over the moment of making. The journey that a photographer makes to find a satisfactory pictorial representation should be given the same credence as the origin of the photograph.

Fine printmaking is both an art and a craft that blends concrete technical processes with personal interpretation. Soulful printmakers make their images resonate

FIGURE 6.3 Friedman recorded this scene with a Leitz 21 mm Super Angulon lens on his Leica, which delivers tremendous depth of field, and then enlarged a small section of the 35 mm negative. Friedman states that "by radically isolating and drastically enlarging a segment of the full frame photograph, I transformed a picture about a memorial sculpture created to honor those who were murdered at Majdanek concentration camp into a photograph about tourists who visit the site."
© James Friedman. *Tourists at Monument Designed by Sculptor Wiktor Tolkin That Includes Three Tons of Human Ashes from Majdanek's Crematoria, Majdanek Concentration Camp, Near Lublin, Poland, #7*, from the series *12 Nazi Concentration Camps*, 1983. 20 × 24 inches. Toned gelatin silver print.

by sustaining their sense of wonder. They preserve their ability to be astonished and continue to get excited every time an image emerges in the developer tray. For them fine printmaking is more than completing the process of transforming negative tones into positive ones. It is an expressive, flexible, and physical act that requires thought, feeling, and control. The camera provides the appearance of the subject, and the intelligent printmaker supplies meaning and emotion. Good printers are dreamers and risk takers who find ways to breathe life into the image so a viewer can interact with it and discover meaning.

Fine printmaking techniques are not difficult to learn and can be mastered with practice, patience, and discipline. Finding a photographic voice to express yourself is a much more complex matter. It means listening to internal guide and then pursuing that direction by exposing film and making prints. The key is to devote the time needed to explore these inner processes. It has been estimated to become a master of a craft one can expect to devote about 10 000 hours to it. Ultimately one may ask if being an artist is an innate ability or one that can be learned, and wonder if following these suggestions will make a difference. The answer is maybe and maybe not, but how will you know unless you try? These pathways should help you organize and more thoughtfully present your ideas in visual form.

PRINTING EQUIPMENT

As you gain printing experience, you will acquire tools of personal preference. There is no need to rush out and buy everything at once. Find out exactly what you need before making any purchases. Do not get carried away. More

equipment will not necessarily make you a better printer or produce more powerful images. If lack of specific equipment is preventing you from making photographs you desire, then acquire what is necessary to make the image. The printmaker's job is to find a convincing way to give tangible form to the dream that is encapsulated in the negative.

The Analog Enlarger

The enlarger is the fundamental instrument in most photographers' darkrooms. Considerable thought should be given to the following items when choosing an enlarger.

Size

The size of an enlarger refers to the maximum negative size it can handle. Enlargers are widely available in sizes from 35 mm (24 × 36 mm) up to 8 × 10 inches (20.3 × 25.4 cm). When purchasing an enlarger, choose a machine capable of handling the largest negative that you anticipate using. A 4 × 5 inch enlarger is generally a good investment because it is versatile and allows you room to work with all the widely used negative sizes. Even if you plan to work only with roll film, a larger format enlarger can ensure uniform light coverage of the negative. Some enlargers experience a falloff of light in the corners (vignetting) when used with their maximum negative size.

Illumination: Condenser and Diffusion Systems

Any size enlarger can distribute light evenly across the negative in a number of different ways. The two major

FIGURE 6.4 Means converted an 8 × 10 inch camera into a nontraditional enlarger, placing the water glass directly inside the apparatus. Behind the water glass, she positioned a cold light enlarging head, which the glass transmitted, exposing the photographic paper that Means positioned on a nearby wall. The water glass thus effectively functioned as the negative, and a high contrast printing filter intensified the scratches on the empty, well-worn glass, creating increased detail in the image. Means contact printed the 20 × 24 inch master print, which reversed the print's tones to positive, and then produced a high-quality negative from the print by photographing it with an 8 × 10 inch copy camera. Means used this negative to produce the final photographic print.
© Amanda Means. *Water Glass #10*, 2004. 46 × 38 inches. Gelatin silver print. Courtesy of Gallery 339, Philadelphia, PA.

methods are the condenser and the diffusion systems with both offering specific advantages and disadvantages. Ideally, it is beneficial to have access to both types. When the opportunity arises, try out both systems and see if your aesthetic and technical considerations are more fulfilled by one system than the other.

In a *condenser system*, the illumination generally comes from one very bright tungsten bulb, which is often frosted to reduce contrast. In the better systems, the light is focused through plano-convex lenses, with the convex sides facing each other. The lenses focus the light into straight parallel lines known as a collimated beam. A condenser enlarger provides greater image sharpness and contrast than a diffusion enlarger. Many 35 mm photographers prefer this system because of its ability to retain image sharpness at high levels of magnification. Condenser enlargers generally form brighter images and thus provide the fastest exposure times.

The disadvantages of condenser systems include the fact that any defects in the negative, as well as grain and dust, are emphasized in the print. There also can be a loss in tonal separation in the highlight areas due to the Callier effect.

The *Callier effect* refers to the way the light is scattered by the silver grains that form the image. In a condenser system, the highlights of the negative, which have the greatest deposits of silver, scatter and lose the most light. The shadow areas, having the least amount of density, scatter the least amount of light. The net effect is that the upper highlight values can become blocked and detail is lost. The Callier effect also accentuates the differences between the shadow and highlight areas, delivering a print with greater contrast.

The degree to which this effect is revealed in the print varies widely due to differences in the design of the various enlargers. The Callier effect is not as noticeable in films with a thin (slow) emulsion. It is barely perceptible in chromogenic films, in which the final images are formed with colored dyes instead of silver.

To compensate for the Callier effect when printing with a condenser system, some photographers slightly reduce their development time. This produces more separation in the highlight areas. If the development time is reduced too much, there will be a loss of separation in the lower shadow tones.

In a *diffusion system*, the illumination is diffused. The most popular diffused-light source is the cold light. It consists of a fluorescent grid or tube that is situated behind a diffusing screen. The cold light produces very smooth, uncollimated light, which is not affected much by the Callier effect. This enables the upper highlight areas to be printed without blocking up. Also, since the cold light does not produce much heat, there is no problem with negatives buckling. The cold light tends to minimize the effects of dust and other minor imperfections in the negative, thereby reducing the amount of spotting required in making the print.

Cold lights require their own transformers and are extremely sensitive to voltage fluctuations and temperature changes. A voltage stabilizer or a light-output stabilizer, which monitors the intensity of the tube and automatically adjusts it, is highly recommended to make printing more consistent. Certain solid-state digital timers cannot be used with cold lights because the surges of current produced by the tube can damage the timers. Diffusion systems that operate with tungsten bulbs help you avoid these difficulties, but they can produce enough heat to cause buckling with larger negatives.

Diffusion systems are generally slower than condenser systems, and require longer exposure times. Prints made with a diffusion enlarger also tend to appear less sharp. Diffusion models work best with larger negatives, which require less magnification, making sharpness less critical. Compared to a condenser, a diffusion enlarger will reduce overall contrast. A cold light tends to lower contrast in the

shadow areas. This effect is not as noticeable with diffusion systems using incandescent bulbs.

Negative Carriers

The negative carrier is made to hold the negative flat and parallel to the enlarging lens. There are two basic types of carriers: glass and glassless. A glassless carrier is most often used with negative sizes up to 4 × 5 inches. A glass carrier is usually suggested with negative sizes of 4 × 5 inches or larger to make sure that the film remains flat. However, two advantages of glassless carriers are that you only have to worry about keeping the two sides of the negative (rather than the four additional surfaces of the two pieces of glass) from collecting dust and also that there are no Newton rings to be concerned with.

Negative Carrier Troubles: Newton Rings, and Negative Curl and Pop Newton rings are the iridescent concentric circles that occur when the film and glass are pressed together with an uneven amount of pressure. They are caused by the interference effect of light reflecting within the tiny space between the glass and the base side of the negative. They do not occur between the glass and the emulsion side of the film. Changing the amount of pressure between the glass and the negative should cause the Newton rings to disappear. Some photographers solve this problem by gently rubbing the glass surface of the negative carrier with jeweler's rouge to roughen the glass. Also, an unexposed sheet of film can be fixed, washed, cut to size, and placed between the glass and the negative to eliminate this problem.

Most negatives will curl slightly toward the emulsion side. This can cause the image to be slightly less than

FIGURE 6.5 For the camera exposure, Bauer set her shutter to B (bulb) to capture movement, but not excessive blur in each image. After developing the Kodak T-MAX 100 film, she painted each piece with nontoxic silver metallic paint to enhance the highlights and shadows. She then assembled several pieces of photo paper on the wall and, with a Besler 23C II enlarger, exposed all pieces of paper simultaneously. After reassembling the collage on plywood, Bauer selectively hand-colored the collage and added text onto the acetate that topped the entire work. Bauer views "accidental, unplanned, or unanticipated events as an integral part of the process and incorporates them into the work whenever possible."
© Amanda Bauer. *Fire in the Nest I* (left panel of triptych), 1997. 26 × 21 inches each. Toned gelatin silver prints with mixed media.

sharp. You can correct this by stopping the lens down to a smaller aperture to increase the depth of focus.

If the enlarger light is left on for a long time during composing and focusing, the negative can overheat and pop up, changing its position. If this happens, let the negative cool down and refocus.

The Digital Enlarger

Digital enlargers, such as the De Vere 504DS, bridges the gap between analog and digital darkroom by merging analog and electronic technology. Using a LCD output device to make virtual negatives from digital files, images are prepared in Photoshop, and then tungsten light projects the digital image on to black-and-white or color photographic paper. The De Vere digital enlarging system can be retro-fitted to an existing enlarger chassis such as Omega and Durst.

How It Operates A digital enlarger replaces the negative stage of an analog enlarger with a digital imaging system that utilizes a high-resolution LCD to simulate a conventional negative. The enlarger's computer system converts digital files into virtual negatives that appear on a display panel through which light can be projected. When the panel is active and the enlarger's shutter is opened, the enlarger projects the file onto the base board in the same way a film enlarger projects a negative. The image can be cropped, focused, sized, and in the same way as an analog enlarger. Contrast can be adjusted using both Photoshop or, if available, with your enlarger's dichroic filters (typically used in color printing).

Enlarging Lenses

Enlarging lenses need to be sharper than camera lenses to resolve the grain or dye pattern in the film during printing. A typical 35 mm camera lens may record 100 line pairs per millimeter (lp/mm) of information on the film, but a good enlarging lens is capable of resolving 300 lp/mm. This translates into better grain definition, delivering sharper prints and clearer separation of tonal values. The higher resolving power of an enlarging lens also enables it to outperform most camera lenses when doing flat copy or macro photography. Adapter rings are available to mount enlarging lenses on cameras for such purposes.

Field Flatness The characteristics that make a good enlarging lens are not the same as those that determine a good camera lens. Since the negative and paper are flat during the exposure of the print, a good enlarging lens needs to have a flat field of focus. The problem is that the field curvature of a lens changes with distance, meaning a lens can have a truly flat field at only one distance.

Most camera lenses can tolerate some field curvature, but enlarging lenses cannot. A camera lens typically has a flat field of focus at about 30 feet. The average enlarging lens has a flat field at a magnification of about ×4, with an acceptable flatness range from about ×2 to ×6.

If the lens does not produce a flat field of focus, it will not be possible to get both the center and edges of the image sharp. Stopping down the lens to a small f-stop, thus increasing the depth of field, can help correct focusing problems caused by a lack of field flatness.

Focal Length It is important to have an enlarging lens of the proper focal length to match the format size of the negative. The general rule is to have the focal length of the lens about equal to the diagonal measurement of the negative to make a conventional looking print.

A wide-angle lens has a focal length 20–25 per cent shorter than that of a normal lens. This means the wide-angle lens is capable of increasing the image size by about 30 per cent at the same enlarger height as a normal lens.

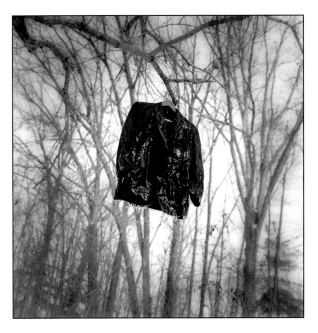

FIGURE 6.6 Nakagawa tells us that this series revolves around a time when, "I found out my father was dying of cancer and my wife was giving birth to our daughter. Photographing became a way for me to 'slow down' and question things that were happening to me as change brought a different rhythm to my life. I became fascinated with preserving and creating memories by constructing visual connections and relationships between my family members. Through this cycle of age, I began to recognize time as being circular, where the beginning and end can occur simultaneously." Nakagawa wanted to maintain a critical narrative of death and birth without being overtly emotional or nostalgic. He did this by using a Zone VI variable-contrast cold light enlarger head and a cold-tone paper (Ilford Multigrade IV FB, Glossy) with warm-tone developer (Agfa Neutol WA) and very weak selenium toning solution to create subtle tonality changes.
© Osamu James Nakagawa. *Frozen Jacket, Bloomington, Indiana, Winter 1999*, from the series *Kai*, 1998–2001. 14 × 14 inches. Toned gelatin silver print. Courtesy of SEPIA International Gallery, New York.

The biggest problem with wide-angle lenses is that they have more image falloff in the corners than an enlarging lens with a normal focal length.

Table 6.1 lists the starting points for various types of normal enlarging lenses that are compatible with given negative formats to deliver customary pictorial results. Variation from these rules can produce other types of visual effects. For instance, using a 105 mm enlarging lens with a 35 mm negative will compress the visual space.

All lenses make a somewhat brighter image in the center than they do at the edges. Just as with a camera lens, an enlarging lens generally provides optimum image sharpness if it is stopped down two to three f-stops from its widest aperture.

TABLE 6.1 Normal Enlarging Lenses Compatible with a Given Format Size

Format	Normal Focal Length	Wide-Angle Focal Length
35 mm	50 mm	40 mm
6 × 6 cm	75–80 mm	60 mm
6 × 7 cm	100–105 mm	80 mm
6 × 9 cm	100–105 mm	80 mm
4 × 5 inch	150–160 mm	135 mm
5 × 7 inch	210 mm (8½ inch)	not recommended
8 × 10 inch	300–360 mm (12–14 inch)	not recommended

Longer than Normal Focal Length Lenses Some printers prefer a longer focal length enlarging lens than normal, such as an 80 mm lens with a 35 mm negative, because it relies more on the center of the lens's field of view. This means that resolution is at its peak, making for better definition at any given f-stop, and avoids the problem of illumination falling off at the edges. The disadvantage is the need for a greater distance from the lens to the easel, which requires the enlarger to be raised to a higher level. This increases the exposure time and can surpass the capacity of the enlarger's bellows to focus the image.

Focus Shift An enlarging lens should be color corrected and free from major aberrations. Poorly corrected lenses can create spherical aberrations, which lower image definition and produce focus shift. When a lens is at its maximum f-stop (wide open), the image is created by the center and edges of the lens. When the lens opening is stopped down to a small f-stop to make the print, only the center of the lens is used to form the image. If the lens is poorly corrected, using only this tiny central portion can cause the point of focus to shift, which results in a loss of image sharpness.

Dirt and Flare Make sure the enlarging lens is always clean and there is no light flare from leaks around the enlarger. Both these conditions will produce a loss of contrast in the print.

Inexpensive enlarging lenses usually have four elements. Lenses having fewer than four elements are not recommended. Better quality lenses normally have six or more elements. They are better corrected for color and may be labeled APO (apochromatic). They probably will deliver better definition in black-and-white printing as well.

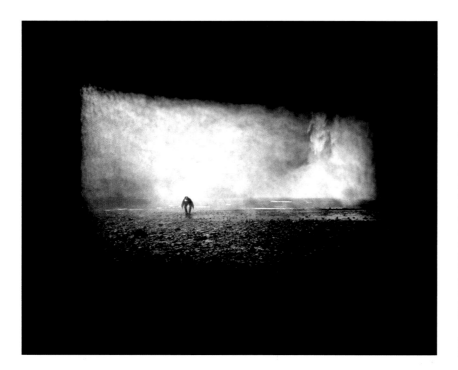

FIGURE 6.7 The choice of enlarging lens can greatly affect the look and hence the interpretation of the final print. The 35 mm negative for this image was made with an 18 mm Nikkor lens, but rather than use a standard 50 mm enlarging lens, Hirsch chose a 105 mm Componar lens. This combination purposefully alters the viewers' sense of pictorial space by taking the distortion of a very wide-angle camera lens (100 degree view) and then condensing it with a slightly telephoto enlarging lens. This fabrication of a new compacted pictorial space reminds us how much artifice there is in the creation of a photographic print.
© Robert Hirsch. *The Fall*, 1999. 16 × 20 inches. Toned gelatin silver print. Courtesy of CEPA Gallery, Buffalo, New York.

Safelights

Most conventional black-and-white papers are only sensitive to particular wavelengths of light, allowing them to be conveniently used under specific safelight conditions. Normal-graded papers are generally sensitive only to blue light and can be handled under a fairly bright yellow safelight. Variable-contrast papers are sensitive to a wider band of the spectrum and may require a different safelight filter. A light amber filter, such as Kodak's OC, is a good general choice when working with both graded and variable-contrast papers. Check the specific manufacturer's instructions before use. Table 6.2 provides general safelight guidelines.

For use with contact papers, a No. OA filter (greenish yellow) is recommended. Panchromatic papers (sensitive to the full visible spectrum) are designed to produce an accurate tonal translation of a color negative into a black-and-white print. They are sensitive to a much broader range of the spectrum and should be handled under a No. 13 safelight filter (amber) or in total darkness. Orthochromatic (not sensitive to red) materials, e.g. litho films, need to be handled under a red safelight such as a Kodak No. 1A, No. 1, or No. 2. These filters are safe for most papers except the panchromatic types.

Safelights come in a variety of styles and price ranges, from inexpensive models that screw into a light fixture to powerful ceiling-mounted sodium-vapor units. Some lamps offer the versatility to switch filters to match whatever paper is being used. Ruby lamps, with the filter built into the glass, are a very inexpensive alternative to safelights, although some workers claim that some of these bulbs are not safe and will fog the paper. It is best to test all safelights periodically with the specific materials being handled under them. In addition, the distance of the safelight from the paper, the brightness of the bulb, the age of the filter, and the number of safelights used all factor into paper fogging.

If a safelight fogs the paper before it is exposed, this process is called *hypersensitization*. The most frequent cause of safelight fog is *latensification*, which occurs if the safelight fogs the paper after it has been exposed. Minimum amounts of safelight fog are noticeable as a loss of contrast in the upper highlight values. This causes the tones to become more compressed and lowers the overall contrast of the image. As the fog level increases, the print becomes denser (darker), most noticeably in the highlight areas. Table 6.3 provides a list of common safelight filters and their general applications.

Safelight Testing

The safelight's bulb size and distance from the print should permit safe handling of the material for about 5 minutes. You can perform several different tests to ensure selection of the proper safelight.

Quick Test Under operating safelight conditions, place an opaque object, such as a coin, on a piece of printing material. Leave it there for 5 minutes and then process the paper. If a white area is visible, safelight correction is required.

Pre-Exposure Test Using the enlarger, pre-expose the paper to make a very faint gray tone. Pre-exposed paper is more sensitive to small amounts of light than unexposed paper and so pre-exposing the paper makes the test more accurate. After pre-exposing the paper, place an opaque object in the center of it and position the paper at the normal distance it will be from the safelight. Leave it there for 2 minutes. After processing, the outline of the object should not be visible. To find the maximum safelight time, repeat the test, adding 1–2 minutes of safelight exposure until the outline of the object becomes visible.

Real-Thing Test In total darkness, make an exposure that will produce a full tonal range print. After making the exposure, cover half the paper with an opaque piece of paper, turn on the safelight, and put the paper under the safelight, at its normal distance, for 2 minutes. Turn the safelight off and process the paper. After processing, visually compare the two halves. If a careful examination

TABLE 6.2 General Safelight Guidelines

- Match the safelight designation with the type of paper being used.
- Minimum distance with a single direct safelight and normal graded paper is about 4 feet with a 15 watt bulb.
- A 25 watt bulb can be used in a single indirect safelight hung from the ceiling in an 8 × 10 foot darkroom.
- Avoid having a direct safelight too close to the enlarger or processing sink. Follow the manufacturer's guidelines as a starting point for correct distance placement.
- Check the condition of the filters periodically as they can deteriorate over time without any visible change in color. A safelight that shows any signs of deterioration or uneven density should be replaced.
- For additional protection, prints can be processed facedown during most of their development time.
- Test safelights regularly and whenever you are using a new printing material.

TABLE 6.3 Safelight Filters and Their General Applications

Color	Safelight Filter	Application
Yellow	OO	Black-and-white contact and duplicating material
Greenish yellow	OA	Black-and-white contact and duplicating material
Light amber	OC	Contact and enlarging papers
Red	1	Blue sensitive materials
Light red	1A	Slow orthochromatic materials
Dark red	2	Faster orthochromatic materials
Dark green	3	Panchromatic materials
Brown	6B	Blue-sensitive X-ray films

of the two, especially in the highlight areas, does not reveal any loss of contrast or increase in density, the safelight can be considered safe with that particular paper under those conditions.

Easels

In addition to providing a stable surface for composing and focusing the image, an easel must be able to hold the printing material flat and parallel to the negative. It also provides a stable surface for composing and focusing the image. Easels with independently adjustable blades are recommended because they allow you to change the paper size and the size of the print borders. Easels with a white focusing surface can reflect enough light back through certain single-weight papers to produce a change in the overall print values. This can be corrected by painting the easel yellow or by taping a thin sheet of opaque paper to it. This is not usually a problem with double-weight papers.

Focusing Devices

The image must be critically focused on your easel to ensure the maximum benefit of the camera and enlarging lenses. When making enlargements, optimum focus occurs when the grain of the negative is sharp over the entire image. You can achieve this through the use of a grain focuser or magnifier. These devices generally have a mirror that diverts part of the projected image to an eyepiece for viewing. Adjust the fine-focus control of the enlarger until the grain appears sharp in the eyepiece.

With large-format negatives and some fine-grain films focusing on the grain can be difficult. In cases such as these, use a focusing device that simply magnifies a small part of the image in the eyepiece for viewing. These devices are also useful for checking the corner sharpness of the image. Many people use both types of focusing aids to ensure optimum focus.

Whenever you are using filters, such as those used with variable-contrast papers, you will obtain the best results if you place the filters between the light source and the negative. Filters used below the negative can affect the optical quality of the image and the focus. If you are using filters below the negative, recheck the focus with the filter in place. Table 6.4 provides guidelines for producing sharply focused enlargements.

Timers

Accurate and repeatable results are required ingredients in the timing of all photographic procedures. Timers are

FIGURE 6.8 When making a series of images to be used in sequence, as in Klett's five-panel panoramic Western landscape, it is usually important to match the tonality of all the prints as closely as possible for the sake of visual continuity. To obtain these results, especially when making large images, a printmaker must be consistent in all procedures such as focusing the image and processing times. All mechanical equipment, including safelights, must be checked to make sure it is in top working order to deliver accurate and repeatable results.
© Mark Klett. *Around Toroweap Point, Just Before and After Sundown, Beginning and Ending with Views Used by J. K. Hillers, Over 100 Years Ago, Grand Canyon,* 1986. 20 × 80 inches. Gelatin silver print. Courtesy of Pace MacGill Gallery, New York.

available with electronic or mechanical operating gear, having both a visible display and audible signal to indicate when the timing operation is complete.

Electronic timers are extremely accurate, especially for short times, and give highly consistent results. They can be set to give repeatable results in units as small as a fraction of a second, which can be useful for fine-tuning a print or making a sequential series of prints. Some can be set to run an entire processing program. Digital electronic timers are generally the most expensive and may not work with cold-light enlarging heads.

Mechanical timers are less expensive and are compatible with any standard photographic equipment. They are not as accurate as electronic timers at brief exposures and cannot be set to run a processing program.

Trays

Good-quality photographic trays that are impervious to chemical contamination are available in heavy plastic or stainless steel. To facilitate agitation of the solutions, the trays should be slightly bigger than the print being processed. For example, an 8 × 10 inch print should be processed in an 11 × 14 inch tray.

Trays are available with flat or ribbed bottoms. Some workers prefer the ribbed bottom because they say it is easier to pick the print out of the tray. Others say the ribbed bottom can damage the print by scratching it against the ribs or causing the print to bend or fold more easily. Generally, having several of both types is useful. Try each type to determine personal preference.

TABLE 6.4 Producing Sharply Focused Enlargements

1 Adjust the enlarger to get the desired print size.
2 Open the lens to its maximum aperture, to produce the brightest possible image.
3 Place a scrap sheet of photographic paper, emulsion side down, the same type of paper as you will use for the final print, in the easel as a focusing target.
4 Adjust the fine-focus control on the enlarger until the image is sharply focused.
5 Stop the lens down to a working aperture of between f-8 to f-16 to improve image sharpness.
6 Recheck for possible focus shift. Make any final adjustments after the working lens aperture is set.
7 Remove the focusing paper, insert the printing paper, and make the exposure.

When the printing session is complete, discard the developer and pour the stop bath into the developer tray. This will neutralize the residual alkaline developer solution. Thoroughly wash all trays with warm water.

Many printers label or color coordinate their trays so that they always use the same tray for each solution to avoid chemical contamination. Commercial preparations compatible with environmental concerns are available to clean stubborn stains.

Enlarging Meters

Enlarging meters tell one how many seconds to expose the paper and are designed to deliver acceptable results in mass-production situations. They are rarely useful in the making of a fine print, when the artist is actively involved in appraising the tonal range of the print rather than programming a meter for repeatable results. The expressive print is a unique and highly subjective item and does not lend itself to a programmed process of analysis.

Print Washer

An archival print washer is highly recommended to ensure proper washing with minimum water usage. Washing procedures should be validated as archival by running a residual hypo test. These tests will factor all the variables such as water hardness or softness and your own prewash procedures. Test kits are available from Photographers' Formulary.

Miscellaneous Darkroom Equipment

Negative Cleaning Devices and Materials

A clean negative ensures maximum quality and reduces the headache of later spotting the print. Antistatic devices can help you achieve this goal by neutralizing static charges. Antistatic brushes, such as the StaticMaster, do a good job but contain small amounts of radioactive polonium (not to be confused with plutonium). The manufacturer claims the alpha-energy released by polonium-210 is so low in that it cannot penetrate the outermost dead layer of skin or even a plain sheet of paper. However, if this is a concern, use an antistatic device such as the hand-held Zerostat Antistatic Gun. Just point the Zerostat at the film and squeeze the trigger, showering positive ions onto the film. When you release the trigger, the film is struck by a stream of negatively charged ions, which neutralize both the positive and negative charges. The Zerostat also works well on any plastic-based surface, such as a disk. It requires no batteries and does not use any radioactive materials.

In conjunction with the Zerostat, you can use a good sable brush to clean the negative. Other products, such as Edwal Anti-Stat Film Cleaner, can also be used in conjunction with lint-free, nonabrasive towels such as Photo-Wipes or PEC*PADs. Canned air, another cleaning device, is not recommended, as it simply blows the dust around. Some products spit their propellant out of the can along with the air, which can stain the negative.

Hiding Scratches

Products such as Edwal No-Scratch can be used with small-format negatives to conceal scratches that do not go completely through the emulsion. Clean the negative before painting on No-Scratch with the brush that comes inside the bottle cap. After printing the negative, remove the No-Scratch completely with film cleaner and lint-free, highly absorbent towels such as Photo-Wipes or PEC*PADs, as No-Scratch leaves a sticky residue and this and other defect-hiding products will diffuse and soften the image.

Additional Tools and Paraphernalia

Other important printing gear are a reliable thermometer, burning and dodging tools (which can be homemade from an opaque board and thin, hard wire or a bicycle spoke), print tongs to avoid getting chemical solutions on your skin, thin, disposable surgical gloves for handling prints during processing (especially while toning), and a collection of graduates and storage bottles.

A Notebook

Keep a notebook to record the details of how each print was made. Typical information should include negative identification; type and grade of paper; type, dilution, and temperature of developer; f-stop; exposure time; and burning and dodging instructions. Such record keeping can save you time if you have to reprint a negative and can refresh your memory about your methodology when creating new prints in the future.

Darkroom Comfort and Ambiance

Good ventilation, especially a high-quality exhaust fan, along with temperature control is recommended for health and comfort (see section in Chapter 2 on "Essential Safety Guidelines"). Rubber mats can help reduce the fatigue of standing for long periods of time.

Often silence is what is needed for one to find the "appropriate" psychological frame of mind for fine printmaking. Other times a radio with a CD and MP3 functions can provide a supportive printing atmosphere. Some workers even have a television with a red filter over the screen.

STANDARD PRINTING MATERIALS

All black-and-white photographic printing materials consist of a base or support, generally paper, coated with a light-sensitive emulsion. The emulsion is made of silver halide crystals suspended in gelatin. Silver chloride, silver bromide, and silver iodide are the most widely used silver halide salts in contemporary photographic emulsions. The individual characteristics of an emulsion, such as contrast, image tone, and speed, are determined by the type of silver salt or salts, how they are combined in coating the base, and any other ingredients added to the emulsion.

FIGURE 6.9 Frey created this photograph while working out of the janitor's closet of a science museum, which allowed her access to numerous taxidermy objects. She explores links between nature and civilization by making a color digital file, which she converts to black-and-white and prints on 4 × 5 inch Fuji Provia transparency film. She then makes the final image using the ambrotype process, exposing the film in an enlarger onto a sensitized, black glass substrate, and controlling the exposure with burning and dodging. Frey says, "One thing I have learned to do is 'embrace the flaws' of the ambrotype process. The resultant markings created by the imprecise mechanics of the human hand in coating and developing the plates are, for me, an apt metaphor for the vagaries of life itself. That the imagery depicts aging biological specimens speaks to our own human dilemma as we struggle to find constancy and meaning in an overly technological world."
© Mary Frey. *Varying Hare*, from the series *Imagining Fauna*, 2007–8. 15 × 12 inches. Ambrotype.

Contact Paper: Silver Chloride Emulsion

Silver chloride papers are generally very slow and are used for high-quality contact printing with large format negatives. They have excellent scale and tonal values, characterized by deep, rich blacks, and are easy to tone. Edward Weston's intense contact prints were made on silver chloride paper, as were Ansel Adams's contact prints of the late 1930s and early 1940s. A contact paper, similar to Kodak's classic Azo, is available directly from www.michaelandpaula.com.

Enlarging Paper: Bromide Emulsion

Bromide emulsions are much faster than silver chloride emulsions and are commonly used for enlarging, but may also be used for general contact printing. They are the most widely used exhibition paper and usually have a cool or neutral tone. Bromide and chloride are often combined to make warm-tone papers.

The speed of the emulsion is determined by its ANSI (American National Standards Institute) number and is comparable to the ISO rating system for films. These numbers are not of any particular use in the making of an expressive print, except as an indicator for comparing relative increases or decreases in exposure times when changing papers.

Although Kodak stopped making black-and-white photographic papers in 2005, other manufacturers continue to produce a variety of products. Papers are available in a range of surface textures and sheens, different weights, and various base tints. There are no industry standards in these areas. Each manufacturer creates its own set of guidelines, and the makers are known to alter its characteristics over time. It can be helpful to read each paper's general description on the manufacturer's website, but the only surefire way to find out what these papers will or will not do for your work is to try them out.

Paper Types

Currently there are two basic commercially prepared paper types used in the fine print darkroom: traditional fiber-based papers and RC papers.

Fiber-Based Papers

Fiber-based papers are the overwhelming choice of fine printmakers for their processing versatility and their ability to be processed to archival standards. Fiber-based papers are coated with barium sulfate, a clay substance known more commonly as baryta, beneath the emulsion. This provides a smooth, clean, white background that covers the inherent texture of the paper and provides a reflective surface for the emulsion. Cool or warm coloring is often added to the baryta, since it covers the paper base and provides the white that you see in a print.

Photographic papers are predominantly three different emulsions: chloride, bromide, and chlorobromide. Most papers are the chlorobromide combination with a small amount of silver iodide. The proportion of silver chloride to silver bromide determines the speed and tone of the paper. Papers with a higher proportion of silver chloride are generally slower and produce warmer tones than predominantly silver bromide papers, which are faster and produce a colder image. Beware of papers that have "optical brighteners" added to increase the reflectance in the highlight areas of the print, as they can lose their effect over time.

Resin-Coated Papers

RC papers have a polyethylene coating on both sides of the paper base, making them water-resistant so that

chemicals cannot soak into the paper fibers. This allows RC papers to be processed and washed very quickly, as all the chemicals are easier to remove.

RC papers can be marked with a pen or pencil, dry fast, have a minimum amount of curl, and hold up well in physically stressful situations that would destroy a conventional gelatin silver print. RC prints are desirable for their convenience and immediacy. These papers are not intended for work requiring long-term keeping capabilities and cannot be processed to archival standards.

The Double-Density Effect

Why does a transparency provide more detail and subtlety than a print of the identical scene? Transparencies are viewed by transmitted light, i.e. the light passes through the transparency one time before being seen by our eyes. With a print, light passes through the clear gelatin emulsion and strikes the base support of the paper, resulting in a reflection rate of about 90 per cent. Light that is not pure white (which is almost always the case) has to pass through the silver densities of the print twice, once when it strikes the paper and again when it is reflected back, and creates what is known as the double-density effect.

For example, imagine that the silver density in the emulsion of one part of a print allows 60 per cent of the light to reach the base of the paper. Since only 90 per cent of this light is reflected back from the base, only 54 per cent of the light remains. Now this 54 per cent has to pass through the same silver density again as it is reflected back, subtracting another 50 per cent. Thus only 27 per cent of the original light strikes the eye from this part of the print. The silver deposits in the print screen the light twice, creating the double-density effect. This results in a loss of detail, limiting the amount of separation between tones.

Paper Colors

Manufacturers make the base of their papers in a variety of colors. The color variations include brown-black, bluish black, and neutral black through a slightly warm to a very warm buff or ivory. There is no one standard for comparison. To get an idea of what the paper looks like, carefully examine and compare paper samples from each manufacturer. Some camera stores have these samples, or the company will often send you a set upon request.

The image color will be affected by the choice of developer and can be further altered through toning. For instance, processing a warm-tone paper in a warm-tone developer can produce a print so warm it will have olive green values (which can be neutralized by toning).

Selection of paper color should be given serious thought, but it remains a highly subjective and personal matter. It should reflect each photographer's overall concerns and the mood he or she wants to convey.

Paper Surface and Texture

Papers are available with a number of different surfaces. Smooth, glossy papers have the greatest reflectance range.

They present the most brilliant images with the widest range of tonal separation and good detail in key highlight and shadow areas. Matte surfaces have a reduced reflection-density range, with the amount depending on the degree of texture. They produce a print with much less brilliance. The matte surface is a good choice when extensive retouching or hand-altering of the print is planned. Matte paper takes airbrush, regular brush, and pencil retouching extremely well. Once again, there are no industry standards that permit direct comparison. Each manufacturer has its own system for designating the surface and texture characteristics.

Graded Paper

Matching the density range of a negative to the exposure range of a paper is necessary for a print to reveal the complete tonal range of the negative. To accomplish this, photographic papers are made in various degrees of contrast. Papers are given a number, called a paper grade, to indicate their relative degree of contrast. The higher the number is, the harder or more contrasty the paper. There is no industry standard, as each company uses its own grading system. Table 6.5 lists some paper grades and their general contrast characteristics. A normal negative, with a complete range of values, should produce a full range print on Grade 2 or 3 paper. A normal negative can be printed on a lower grade of paper for a softer, less contrasty look or on a higher grade to achieve a harder, contrastier appearance. If you want to make a long tonal range print from a contrasty negative, you should use a low-contrast paper. A high-contrast paper can be used to extend the tonal range of a low-contrast or flat negative. Soft, low-contrast papers are fast and have a long tonal scale. Hard, high-contrast papers are slower and have a shorter scale.

Even though a Grade 2 paper is considered to be industry normal, there is really no standard for normal in printmaking. You should never feel locked into trying to print on only one grade of paper. Expressive printing means that each negative must be evaluated in terms of how the final print should read and feel, and the grade of paper should be selected accordingly. If you think a print lacks contrast, make another print on a Grade 3 or 4 paper and visually decide what works for you.

Variable- or Multi-Contrast Papers

Variable-contrast papers have a blend of two emulsions. Usually the high-contrast emulsion is blue sensitive and the low-contrast emulsion is orthochromatic, which is sensitive to blue and green. By exposing the paper through special variable-contrast filters or a variable-color light source, the different proportions of the two emulsions are exposed. Different manufacturer's multi-contrast filter sets produce different results in exposure and contrast with various papers and thus require experimentation. Since variable-contrast papers are sensitive to a broader band of the spectrum than regular graded papers, you should read and follow the specific manufacturer's

FIGURE 6.10 Here Nettles explores her longstanding interest in "recording a sense of place and the selective, multi-layered nature of memory." This image, a landscape reconstructed from memory, looks at the function of travel in the process of recollection. To create the image, Nettles scans film negatives and places them into a grid format using Photoshop. Linotronic film negatives are then produced from which contact prints are made in the darkroom on photographic paper with charcoal surface.
© Bea Nettles. *Hole*, from the series *Return Trips*, 2005. 9 × 6¾ inches. Gelatin silver print.

TABLE 6.5 Paper Grades and Their Characteristics

Paper Grade	General Contrast Characteristics
0	Very soft, extremely low contrast
1	Soft, low contrast
2	Normal, average contrast
3	Slightly above normal contrast
4	Hard, above normal contrast
5	Very hard, very contrasty

instructions for proper safelight conditions. Variable-contrast papers are designed to be exposed with tungsten or tungsten-halogen light bulbs. Their use with other sources, such as cold lights, may necessitate testing.

Advantages

Only one box of variable-contrast paper is needed to produce a wide range of contrast. Filters are available in half-grade steps such as 1½, 2½, and 3½. Also, various sections of the paper can be exposed with different filters to alter the contrast locally within the print. For instance, imagine a landscape having a dark, flatly lit foreground and a bright, contrasty sky. A higher than normal filter could be used to expose for the shadow areas of the foreground and increase contrast. Then a lower than normal contrast filter could be used to make a second exposure to capture the highlight detail in the sky.

Disadvantages

Variable-contrast papers tend to print flatter than graded papers at any given level of contrast. They do not deliver

FIGURE 6.11 A 17 mm fish-eye lens and a mirror allowed Jachna to play with our established sense of perspective and space. A high-contrast print was achieved by exposing variable-contrast paper through a color enlarger with 40 points of magenta filtration. Many variable-paper manufacturers supply a guide that tells how their paper can be exposed by using the filters in a dichroic color enlarger. @ Joseph D. Jachna. *Door County, Wisconsin*, 1970. 8 × 12 inches. Gelatin silver print.

as deep a cold-tone black as do graded papers, and the exposure time can increase with higher filter numbers. Also, using variable-contrast filters below the lens, as is most commonly done, can result in a loss of image contrast, cause distortion of the image, and reduce overall sharpness. It also may be necessary to refocus the image after the filter is placed in front of the lens. This may be a problem, depending on the intensity of the filter, as it might be difficult to see the image clearly enough to check the focus accurately. This problem can be eliminated by printing with a dichroic color head enlarger. When working with a color enlarger, most manufacturers provide magenta and yellow filtration that is equal to the filter numbers.

Variable-contrast papers can be compared to a zoom lens. Generally, a fixed focal length lens delivers a sharper image than a zoom lens set at the same focal length. This does not mean you should not use a zoom lens, but it does mean that the lens has certain limitations. Likewise, variable-contrast papers can be used with great success in a wide variety of photographic applications. When the

opportunity presents itself, try some of the variable-contrast papers and see if they meet your needs.

Mural and Postcard Paper

Photographers who want to make prints larger than 20 × 24 inches will probably have to obtain mural paper. Typically, mural paper is sold in rolls of various widths and lengths that start at about 40 inches wide and 100 feet long. They are often available in a variety of surfaces as well as in different grades, including variable contrast.

Mural paper can be processed in homemade plastic troughs to save chemicals and space. One technique is to cut PVC pipe down the middle, cap the ends with a piece of Plexiglas, and seal them with fiberglass cement. Another way is to simply cap the ends of PVC pipe so that they become their own rotary processing tubes. Make certain the diameter of the PVC pipe is large enough to allow the chemicals to freely circulate around the paper in the tube to avoid processing marks. Mural paper can also be placed in a large, clean sink and the chemicals can be applied with

FIGURE 6.12 Billingslea's portrait serves as a study of contrasts. To counteract the high contrast of the sun, she exposed the ISO 100 T-MAX film at f-8 for 1/125 second, and then she slightly underdeveloped the negative. Billingslea printed the photograph on Ilford Pearl Finish Fiberbase paper, a multi-contrast paper, and then used a selenium toner to further manipulate the image contrast and tone.
© Renee Billingslea. *Boy with Bull, Santa Clara, CA*, 2006. 15 × 15 inches. Gelatin silver print. Courtesy of Michael Rosenthal Contemporary Art Gallery, Redwood City, CA.

sponges. A small amount of chemistry can be placed on the bottom of a clean sink. The sponge is constantly, yet gently, moved throughout the process while the paper is rotated to ensure even development. Different sponges should be used for each chemical to avoid possible contamination.

Photographers wishing to make their own official-looking postcards can use RC Post Card paper, approximately 4 × 6 inches (10 × 15 cm), which has the typical postcard markings preprinted on the reverse, nonemulsion side of the paper.

PRINT FINISHING

Air Drying

Generally, photographers making high-quality fine art prints prefer air drying because there is less dry-down effect than when heat is used. Typically, prints are squeezed on a piece of Plexiglas or heavy glass with beveled and sanded edges. They are then placed face down on a drying frame, which can be homemade or commercially purchased, that consists of a wooden or metal frame with new plastic screen material pulled tightly across it (window

screen frames can also be used). Prints are allowed to dry naturally in a dust-free environment. The cleanliness of the screening material must be checked and maintained before and after each use. Prints may be weighted later under a heavy piece of glass to lessen the curling effect.

Ferrotyping

If a high-gloss finish is desired, it is possible to dry a glossy paper on a special metal ferrotype plate. However, ferrotype prints can produce a tremendous amount of glare, which makes viewing difficult. Also, the heat required during the ferrotype process may also darken print tonal values, necessitating adjustments to your printing time. An excellent alternative to ferrotyping is to print on a glossy paper and air dry it, which will deliver a smooth, semi-gloss finish with much less glare.

Spotting

Once prints have been dried they are ready to be spotted with a clean, fine #0 sable brush and spotting dyes like Marshalls, Nicholson's Peerless, or Dr. Ph. Martin's, which are available in a variety of colors.

FIGURE 6.13 Talman fashioned this cameraless image by coating human bodies with printer's ink and then producing paper negatives from the impressions the bodies made on Kitikata paper. In Photoshop, she integrated the images of bodies with images of human cells that she obtained from electron microscope slides. She then used these printed images as paper negatives for contact printing on photographic paper. After Talman processed the life-size prints in homemade 45 inch trays, she selectively bleached the prints with potassium ferracyanide and applied Sprint fixer to the bleached areas. In constructing this series, Talman was inspired by ideas surrounding the function of autoimmune disease and the dependence of the body on its cells, desiring to "retain a sense of movement in the image while integrating it with the cellular imagery in a way that would address the issues of identity and origins that have been the focus of many of my series."
© Donna Hamil Talman. *Danse Ardente #11*, 2003–06. 51 × 34 inches. Toned gelatin silver print.

Waxing the Print

Gelatin silver prints can be treated with a wax medium such as Dorland's Wax Medium or Gamblin Cold Wax. Waxing can be done to protect the print surface, enhance luminosity, create a surface similar to that of a painting, build up a 3-D effect, or make a 3-D object. Often wax mediums contain mineral spirits along with several types of waxes plus other components and are very flammable. Read the manufacturers list of ingredients and MSDS (see Chapter 2) to make sure it is compatible with your needs and long-term expectations.

Wax can be heated to its melting point to make it easier to work with, but care must be taken to avoid its flash point (the temperature at which the vapor of a combustible liquid can be made to ignite), which for wax mediums is between 107 and 145°F. Do not expose the wax to direct flame. Melt the wax in a double-boiler pan.

Wax medium may be thinned with turpentine or mineral spirits. Wax also comes "soft" and can be directly applied with either a buffing cloth or a small piece of cheesecloth to the surface of the photograph without thinning.

For protection, a small amount of wax the size of a dime will cover an 11 × 14 inch print. Afterwards the wax can be buffed to a sheen finish. Several coats of wax can be applied to simulate the surface of a painting, but you should allow several days or even a week between coats. A brush can be used to spread the wax and induce the brush-stroke effects of a painting. A hair dryer can be used to keep the wax soft while spreading it on the print surface.

The wax can be applied even more thickly to achieve a tactile 3-D look. Prints can also be imbedded into blocks of paraffin wax to create a transparent 3-D presence. Wax mediums are generally available at professional art supply stores or online.

FIGURE 6.14 This work was part of a 3 week mail art project that consisted of mailing postcard collages from major cities in Europe to Buffalo, NY. This collage, which represents Day 16, Mead's visit to the National Portrait Gallery in London, merges two postcard images purchased from the museum store: a photograph of Andy Warhol and the artist's silkscreen portrait of Queen Elizabeth. In addition to montaging images of artist and subject, Mead draws further connections between the two with his inclusion of the text "Queen," which refers to both Warhol and Queen Elizabeth.
© Gerald Mead. *Day #16 – National Portrait Gallery*, from the series *European Travellages*, 1995. 6 × 4 inches. Mixed media.

SPECIAL PRINTING MATERIALS

Panchromatic Papers

Panchromatic means sensitive to the full range of the visible spectrum. Panchromatic papers are designed to produce an accurate black-and-white tonal rendition from a color negative. Regular printing paper is not panchromatic. It is sensitive mainly to the blue portion of the visible spectrum and distorts the tonal range of the original color negative (especially in the red part of the spectrum) when a black-and-white translation is created. Panchromatic papers should be handled under a color safelight filter, such as Kodak No. 13, or in total darkness.

Printing-Out Paper

Introduced in 1850 by Louis-Désiré Blanquart-Evrard on an albumen paper, modern printing-out paper was first marketed in 1885 and has a gelatine silver chloride emulsion, manufactured with extra silver nitrate. The image on a printing-out paper appears during exposure, so no

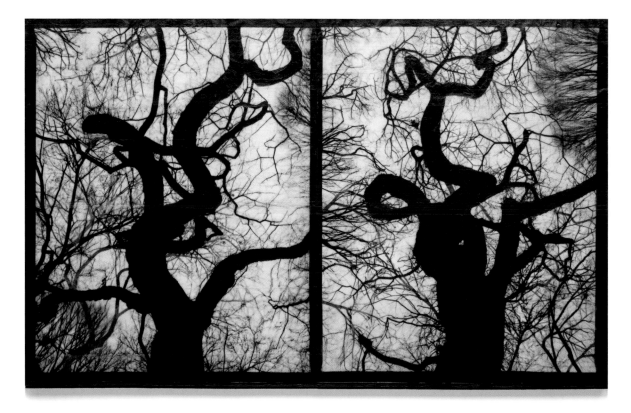

FIGURE 6.15 Doug and Mike Starn turned to digital printmaking to achieve an *effect* they could not realize in the darkroom, the appearance of real light in the sky and a black void in the trees that appears to reach for the light. The team scanned the negative and used Photoshop to create two slightly different files of the same negative, printing one on paper and then hand-coating it several times with wax. They printed the other file onto tissue paper, registered it exactly with the hand-waxed paper print, and coated it with encaustic. They carved and manipulated the encaustic surface to produce the final image.
© Doug and Mike Starn. *Blot Out the Sun 1*, 1998–2000. 84 × 132 inches. Inkjet print with mixed media. Courtesy of Artists' Rights Society, New York.

developer is required. Processing determines the tone of the final image (through a simple gold-toning formula) and stops the light sensitivity of the paper (through fixing in a plain hypo bath). These two solutions produce fine quality permanent prints which may range in color from ruddy brown to purple-black and which have a long tonal scale. Printing-out paper is very slow, requiring contact exposures of a minute or more in direct sunlight or from a strong ultraviolet light source. Due to its slow speed, all processing can take place in subdued, artificial light, dispensing with the need for a conventional safe-lit darkroom.

RESOURCE GUIDE

The Chicago Albumen Works: www.albumenworks.com

Liquid Emulsions

Liquid emulsions give the photographer the freedom to go beyond 2-D paper-based printing. Liquid emulsions can be applied to almost any inanimate surface, including paper, canvas, china, glass, leather, metal, plastic, rock, and wood. Liquid emulsions allow the photographer to consider the possibilities of extending the photographic medium into the third dimension.

Liquid Light

Rockland Liquid Light is a commercially prepared direct silver nitrate emulsion. After it is applied to a surface, it is handled and processed in the same manner as the emulsion on normal photographic paper. Refrigerated, Liquid

FIGURE 6.16 This homage to Bruce Nauman's *Self-Portrait as a Fountain* (circa 1966) comprises part of DeHart's series of historical rephotographs. He made the portrait with a 4 × 5 inch view camera on Polaroid Type 55 Positive/Negative material. He contact printed the resulting negative on printing-out paper in direct sunlight, as this allowed him to work outside of the darkroom. DeHart then put the print into a gold toner, complementing and augmenting the print's ruddy brown hue.
© Dennis DeHart. *Homage to Bruce Nauman*, 2005. 4 × 5 inches. Toned printing-out paper.

FIGURE 6.17 With its incorporation of rocks, Tümer's work addresses how it is possible to integrate photography into the third dimension. She first coated dozens of rocks with Liquid Light and let them dry for 1 week. She then exposed the same image of her own face onto the rocks and developed them using conventional black-and-white methods. For Tümer, rocks refer to archaic art, thereby raising ideas of personal and collective memory. As she says, "Like current chromosomal technologies that trace ancestry, I sensed the rock carried a memory of my earliest primordial and more recent ancestral history that merged races and geographies."
© Laurie Tümer. *Rock Faces*, from the series *Works on Rock*, 1995–2004. 3 × 2 inches. Silver emulsion on rock. Courtesy of photo-eye Gallery, Santa Fe, NM.

TABLE 6.6 Liquid Light Processing Guidelines

1. Place the bottle of solid emulsion in a pan of hot water until its contents become liquid (usually a couple of minutes). Open the bottle only under normal paper safelight conditions.

2. In the darkroom, under a paper safelight, pour some emulsion into a glass or plastic bowl. Do not use a metal bowl, as silver nitrate reacts with metal. Rapidly apply the emulsion with a soft, clean brush. Coat a piece of paper at the same time to serve as a test strip for determining the correct exposure. Mark the back of any paper that is coated because the emulsion can be hard to see once it dries.

3. Allow the coated material to dry in total darkness until it is at least tacky. After it is dry, it can be stored and handled like normal photographic paper. Best results are usually obtained if the coated material is used as soon as possible after drying.

4. The emulsion is slow and not very sensitive to light. When making an exposure, open the enlarging lens to about f-4 and make a series of about six exposures in 5 second increments on the test strip.

5. All processing solutions must remain between 60°F (16°C) and 68°F (20°C), as the emulsion will soften at temperatures above 70°F (21°C) and will release from the paper. Process following normal paper procedures, making sure not to let tongs touch the emulsion in the chemistry or wash baths. The emulsion is extremely delicate when wet. If the emulsion peels up at any time during processing, dispose of the print and start again. It may dry flat but in time will peel off of the paper.

6. Determine the correct time from the test strip, make that exposure on the coated material, and process. Liquid Light will produce a warm black image with soft contrast. The contrast can be controlled, to some degree, by using a normal paper developer such as Dektol or Selectol-Soft and varying the rate of dilution. A good starting point is 1 part developer to 10 parts Liquid Light.

FIGURE 6.18 To craft this tintype, Rickard relied on Rockloid Ag-Plus liquid emulsion. After coating the tintype plate, a 20 × 24 inch masonite sheet, he exposed it for 45 minutes with a 6 × 7 inch transparency in an enlarger. He then developed the plate with Rockloid tintype developer for longer than recommended, until the fog surrounding the image lifted, revealing the detail in the image. As Rickard explains, when working with tintypes, he appreciates the process during which "the image loses its ghostly appearance in the fixer and can put a beautiful leathery texture on the plate."

© John Rickard. *McCloud River Elephant Ear*, 2007. 20 × 24 inches. Tintype. Courtesy of The Rostel Gallery, Dunsmuir, CA.

TABLE 6.7 Archival Processing for Silver-Based Fiber Papers at 68°F (20°C) with Fresh Chemistry

Processing Step with Proper Agitation	Approximate Time (minutes)
Developer	1½–3
Acid stop bath	½
First fixing bath	3
Second fixing bath	3
Quick water rinse	As needed
First wash	5–10
Washing aid or hypo eliminator*	2–6
Express method: Perma-Wash and Rapid Selenium Toner**	1–10
Toning*	1–10
Final wash	60 (minimum)
Air-dry	As needed

 * Exact times are determined by the needs of the photographer through testing.

 ** The express method combines the washing and toning steps but may not deliver suitable results with all papers so testing is in order.

Light has a shelf-life of up to 2 years. See Table 6.6 for Liquid Light processing guidelines.

Paper-based images can be colored with Rockland Print Tint or regular photographic toners. Rockland also makes a contact-speed emulsion designed to be used on fabric called Rockland Fabric Emulsion Sensitizer FA-1. The iron-silver emulsion gives an antique Vandyke iron-silver image with a full range of warm brown-black tones.

Ag-Plus

Rockland also makes Ag-Plus, a liquid emulsion with a higher concentration of silver halide that has an ISO of 160, but otherwise is similar to the original Liquid Light. Its faster speed makes it the more practical choice when making larger prints at a greater distance from the enlarger. It also requires thinner coatings of emulsion to produce an image, and may be used in coating, ambrotypes, tintypes, and other alternative processes (see Chapter 10).

RESOURCE GUIDE

For more information on Liquid Light and other Rockland products, see: www.rockaloid.com.

Variable Contrast Liquid Emulsion

Variable contrast liquid chlorobromide silver emulsion, such as Kentmere VC, can be applied to various surfaces such as cardboard, ceramics, fabrics, glass, and plastics. The variable contrast emulsion gives you the flexibility to expose with standard variable contrast filters. The emulsion works well on both watercolor and printing paper and can be handled and processed like Liquid Light.

RESOURCE GUIDE

Kentmere Photographic: www.kentmere.co.uk. (Part of Harman Technology Ltd. See: www.harmantechnology.com/dotnetnuke).

PROCESSING PRINTS FOR PERMANENCE

"Eternal duration is promised no more to men's work than to men," said French writer Marcel Proust. The processing of prints to archival standards ensures the work will have the opportunity to communicate with others in the future. A properly processed and stored black-and-white print can last hundreds of years. Table 6.7 summarizes the guidelines for achieving maximum life for black-and-white gelatin silver fiber papers.

Although it may not be necessary to be a darkroom master to produce thought-provoking work, lack of technical skill can result in a loss of communicative ability. Deficiency of craft can be construed as intentional and part of the meaning, but it may also be interpreted as laziness and a basic misunderstanding of the power of photographic images to affect and converse with viewers. Being in the position to control the visual outcome gives ones work the best opportunity of a thoughtful engagement with others.

RESOURCE GUIDE

For a list of information sources, see "Resource Guide" at the end of Chapter 3.

END NOTE

1. Chaloupka, Otakar. "The artist Josef Sudek speaks." *Čs. fotografie* vol. 11, p. 373, 1963.

FIGURE 6.19 Johnson relates: "This sequence was made from 15 negatives I photographed of the grave markings at the Yuma Prison in Yuma, AZ. I used a Hasselblad SWC camera and Kodak 160VC film, which I changed into continuous tone in Photoshop. I chose black-and-white, as opposed to color, to emphasize form of the piles. The square format and very wide lens of the SWC lends itself to grid making and also the replicates the look of aerial photographs. The grid typology echoes the layout of the cemetery, allows viewers to compare the similarities and differences between piles, and expresses a sense of the place that would not be possible in single image." © Keith Johnson. *Yuma Rocks*, 2008. 24x20 inches. Ink jet print.

BLACK-AND-WHITE PAPER DEVELOPERS

PAPER DEVELOPER AND DEVELOPING-OUT PAPER

Learning to become a good printer requires inquisitiveness about all aspects of making an expressive print. The more experience you have with a range of developers, the more command you can exercise over how the final image will appear. As your knowledge and competence increase, so do the visual possibilities.

All silver-based developers, whether they are for paper or film, are quite similar in their chemical composition (see Chapter 5). The major difference between paper and film developers is that paper developers are generally more alkaline, which makes them more energetic and fast acting. If a film developer is used to process a print, the image will appear gray with no maximum black (the deepest black the paper is capable of producing) and will lack contrast.

It is helpful to know what chemicals make up a typical paper developer and the functions they perform in printmaking. The choice of developer influences the tonal range, contrast, and image color of the print, but it cannot make up for a poorly exposed negative. The most effective way to get the type of print you desire is to work from a properly exposed negative.

The commonly used developing-out silver-based papers, which require a chemical developer to bring out the image, have a thin emulsion that is designed to be chemically developed to completeness. Developing time varies depending on the type of developer, its dilution, the temperature, and the type of paper. All these factors will affect the outcome of the final print.

COMPONENTS OF BLACK-AND-WHITE SILVER PRINT DEVELOPERS

Major Developing Agents

Metol and Hydroquinone

Metol and hydroquinone are used in various combinations to form the majority of black-and-white print developers. Metol (Kodak Elon) produces a delicate, soft, neutral gray image with low contrast. With prolonged development, both contrast and density increase. Metol is energetic, has a long shelf-life, and is commonly blended with hydroquinone to increase contrast.

Hydroquinone makes a high-contrast image with a brownish tint. It works best in the low and middle range of tonal values and is rarely used by itself because it requires lengthy development times. Combining hydroquinone with another developing agent, such as Metol, activates it. Hydroquinone has a short life span and starts to become ineffective at temperatures below 60°F (15°C).

The frequently used MQ (see Chapter 5) developers are convenient, economical, extremely versatile, and have a long life span. By varying the proportions of Metol and hydroquinone, a photographer can alter the color and contrast of a continuous tone print.

As Metol has been used for photographic purposes for over 100 years, often by amateur photographers, there is a wide body of evidence about potential health problems that contact with Metol can cause. The most widely reported problem is local dermatitis of the hands and forearms. Additionally there is some data of sensitization dermatitis in which subsequent exposure triggers of a chronic condition that is resistant to treatment. Following the safety guidelines in Chapter 2 can minimize potential problems.

Phenidone

Phenidone is the proprietary name of Ilford's developing agent that behaves like Metol. Used alone, Phenidone produces a low-contrast image with a gray color. It is more expensive than Metol, but it also is more potent and can be used in much smaller amounts. Phenidone is recommended for people who are allergic to Metol. It acts as a superadditive agent (see Chapter 5) when combined with other developers such as hydroquinone. Phenidone has a long storage and tray life. It can often be exchanged for Metol in formulas by substituting 10 per cent of the amount of Phenidone for the amount of Metol.

Amidol

This longtime favorite of classic printmakers such as Edward and Brett Weston is used to produce rich images with cold, blue-black tones. Amidol is often used at high dilutions such as 1:20 (1 part amidol to 20 parts water)

with an extended development time of 10 minutes to produce soft images. This also can be effective when working with a very contrasty negative. Using amidol at reduced rates of dilution and at higher than normal temperatures can produce brilliant high-key prints. These have excellent highlight detail and retain subtlety without dulling the high tonal values.

Amidol is expensive and can stain the print, your skin, and clothes. Since amidol is poisonous, you must wear thin rubber gloves and/or use print tongs when working with it. Amidol is another alternative for those suffering from Metol poisoning.

Amidol must be mixed just before use, as it will keep only a couple of hours in solution. The addition of citric acid (60 grams per quart) as a buffer will help prolong amidol's useful life and will minimize the stain it produces.

Glycin

When used with bromide papers, glycin produces a straightforward black tone. With chloride or chlorobromide papers, it delivers soft brown or sepia tones. Glycin is often used with Metol and hydroquinone in developers such as Ansco 130, which favors the highlight areas of the print. With some papers, it produces a very slight stain in the upper highlight tonal range, often resulting in a soft glowing quality.

Reduction Potential

The strength of a developer's activity is known as its *reduction potential*, which how rapidly the developer converts the silver halides to metallic silver. The relative reducing energy of a developer is measured against hydroquinone, which has been assigned an arbitrary reduction potential

of 1. The reduction potentials of other commonly used developing agents are as follows: glycin 1.6, Metol 20, and amidol 30–40.

Other Paper Developer Ingredients

Accelerator

The energy and stability of a developer depend on the alkalinity (pH) of the solution. Most developers have an alkali added to serve as an accelerator. A greater concentration of alkali will produce a more energetic but short-lived solution.

The most commonly used accelerator is sodium carbonate, which is favored because its buffering action helps the developer maintain the correct pH level, thus prolonging its usefulness. Sometimes borax is used as the accelerator. On rare occasions, sodium hydroxide (caustic soda) is used for extremely active formulas or for high-contrast effects. It has a high pH and should be handled with full safety measures.

Certain developers, such as amidol, do not use an accelerator. In amidol, the reaction of the sodium sulfite with the water produces the needed pH for the developing action to take place.

Preservative

A preservative usually sodium sulfite, absorbs the free oxygen molecules in the developer. This retards oxidation and extends the working life of the solution.

Restrainer

The restrainer (also known as antifog) slows down the reduction of the silver halides to metallic silver, slightly

FIGURE 7.1 Smith processed his 8 × 20 inch Super XX film in Pyro ABC. The resulting negative was contact printed on Azo paper, which was developed in amidol and then selenium toned. This combination delivers a luxuriously detailed print that retains subtlety in both the high and low values, and invites viewers to linger and intimately engage with the image.
© Michael Smith. *Near San Quirico D'Orcia, Tuscany,* 2000. 8 × 20 inches. Gelatin silver chloride contact print.

reducing the speed of the paper and increasing the development time. This is important in preventing fog caused by high-energy developers, extended development times and/or temperature, by touching the emulsion surface during development, or out-of-date papers. A developer without a restrainer will reduce some of the unexposed silver halides to metallic silver, producing an overall fog. You can print through a light fog, but as the fog becomes denser, it also becomes visible in the finished print. The fog is most noticeable in the highlight areas. The upper range of tones will appear veiled and lacking in separation. The restrainer will keep the highlights clear and increase the apparent visual contrast of the print.

The most widely used restrainer is potassium bromide. If used in a high concentration, it will cause many papers to take on a greenish cast. Selenium toning (see Chapter 8) can neutralize this side effect.

Benzotriazole is a popular organic restrainer that can be used to help clear fog, produce cleaner-looking highlights, and reduce greenish cast. It tends to produce colder tones than potassium bromide, shifting the image color to blue-black. Benzotriazole is available in powder form and as Edwal Orthazite (liquid).

Water

The key, and often overlooked, ingredient in any developer is water. Generally, if the water supply is safe for human consumption, it is fine for photographic purposes. The amount of chlorine added to many water supplies is too small to have any effect. The same applies to copper sulfate, which is often added to kill bacteria and vegetable growth. The most important consideration is to be sure that the water is close to neutral on the pH scale (pH 7). If the water is more alkaline (having a pH greater than 7), it will cause the developer to be more active, thus reducing the total amount of time for development.

If the water contains a large number of impurities, boil it and let it stand until the precipitate settles. Then gently pour it, without disturbing the sediment, through prewashed cheesecloth or a paper filter. Distilled water may also be used.

If you suspect there is a problem with the water, do a comparison test by mixing two solutions of developer, one with tap water and the other with boiled or distilled water. Process and compare the results. Film is generally more susceptible to variations in water quality than prints. The most common problems are foreign particles, which can damage the emulsion, and changes in the pH, which can affect the speed of the materials. This is be corrected by adding replaceable cartridge filters to the water lines.

The amount of calcium, iron salts, and magnesium found in water determines its hardness. The greater the concentration of these minerals, the harder the water will be. Very hard water produces nonsoluble precipitates that collect on equipment and materials. The use of a water softener is not recommended because the softening process can remove too many of the minerals, especially calcium carbonate, and affect processing. Water softeners can drop the calcium content to below 20 parts per million (p.p.m.).

If the calcium carbonate level is too low, it can affect the activity and stability of the developer.

Many taps contain an aerating filter, a small screen screwed into the end of the faucet that adds oxygen to the water to improve its taste. This filter should be removed because added oxygen can increase the oxidation rate of many solutions, thus reducing their life span.

The ideal water supply for photographic purposes has a pH of about 7, contains 150–250 p.p.m. of calcium carbonate, and is free of most particle matter.

Remaining Processing Steps

After development is complete, the regular processing steps can be followed (see as Table 6.7 "Archival Processing for Silver-Based Fiber Papers").

ADDITIONAL PROCESSING FACTORS

Temperature

The rate of development depends on the reducing potential of the developing agent and its dilution, the characteristics of the emulsion, the amount of time in the developer, and the temperature of the solution. All developers work more quickly as their temperature rises. Just as with film development, 68°F (20°C) is the standard processing temperature for most silver-based papers. All processing solutions, including the wash, should be kept as close to the temperature of the developer as possible.

Changes in the temperature affect not only the processing time but also the characteristics of the developing agents themselves. Metol performs consistently over a wide range of temperatures, but hydroquinone does not. It becomes extremely active above 75°F (24°C) and loses much of its effect below 55°F (13°C). For example, as the temperature drops below 68°F (20°C), a MQ developer will produce a softer, less contrasty print than normal. As the temperature rises above 68°F (20°C), the print will become harder and contrastier. Changes in temperature also will change the image color of various papers from their normal appearance.

Time

Chloride papers are the fastest, having a developing time of about 1 minute. Bromide papers are the slowest, requiring times of 3 minutes or longer. Chlorobromide papers (widely used for enlarging) have the widest time latitude. Exposure and development times can be varied to produce different image colors. Chlorobromide papers have a normal developing range of 1½–3 minutes. Generally, more exposure and less development will result in a warmer image tone than normal. Depending on the paper, less exposure and more development time will result in a colder image. A developing time that is too short will not allow the developer to permeate the emulsion evenly.

This can result in flat, uneven, and muddy-looking prints. Too long a developing time can fog or stain the paper.

Agitation

To avoid uneven processing and streaking, prints should be agitated constantly by rocking the developer tray in different directions. First slide the paper, with a quick fluid motion, into the developer. Then lift up the front of the tray so that it is at 10–30 degrees and set it back down. Do the same thing on the right side of the tray. Repeat the procedure at the front of the tray and on the left side. Return again to the front and repeat this pattern of agitation until the development time is complete.

Prints should be kept under the developer during the entire processing time. Do not remove them from the developer for inspection, as exposure to the air can fog the developer-saturated emulsion.

Edge Burning

Although edge burning is not a development technique per se, you should take it into consideration when deciding on the correct exposure. Many prints can benefit from additional exposure at the edges (5–10 per cent of the total exposure is a good starting point). Making the edges darker can help keep the viewer's eye from wandering out of the corners of the print. This method is effective when there are bright highlights in a corner. Edge burning creates a definite separation between the print and its matte or mount board, keeping the two from visually blending together.

Edge Burning Method 1

The simplest method is to hold an opaque piece of cardboard that is larger than the print over the print, revealing the edge and about 25 per cent of the image into the print. Then make an exposure equal to about 5–10 per cent of the total print time. During the exposure, move the card away from the center of the print out to its edges. Each corner will receive two edge exposures, making them darker than the center portion of the entire edge. This can be visually effective, allowing the light to act as a visual proscenium arch that contains and frames the image.

Edge Burning Method 2

This technique permits all four edges to be burned in at the same time, thus giving all the edges and corners an equal increase in density. This is done by using an opaque board cut in the shape of a rectangle or oval in proportion to the image size and format. Center the board above the print so that it reveals the image area about 25 percent of the distance into the print. Set the timer for the desired amount of additional exposure, then using a smooth, steady motion, move the opaque board toward and away from the paper.

Dry-Down Effect

Determining the correct exposure for an expressive print can be accomplished only through visual inspection. A number of factors need to be considered. Under safelight illumination, prints tend to appear darker than they do under white light. Prints always have a richer, more luminous look when they are glistening wet than they do after they have

FIGURE 7.2 The *Shampoo Room* series documents the early 1990s New York nightclub scene where the worst sin was to be boring. In a world of ecstasy, VIP rooms, guest lists, drag queens, and alcohol, Klub Kids competed to see who was the most fabulous and fierce. Just as the subjects of these nightclub portraits wear costumes to draw attention to themselves, Valentino darkens the edges of his prints to keep the viewer's eye from wandering outside the print's borders and on his subjects.
© John Valentino. *Miss Channel, Limelight,* from the series *The Shampoo Room,* 1992. 16 × 20 inches. Gelatin silver print.

dried. All papers darken, losing some of their reflective power, as they dry. This dry-down effect can cause subtle shadow areas to become blocked. The highlight areas appear brighter in a wet print because the swelling of the emulsion causes the silver to spread apart slightly. This permits more light to be reflected back from the base of the paper. After the print is dry, the silver becomes more tightly grouped, so the density appears greater, reducing some of the brilliance of the highlight areas.

You can compensate for the dry-down effect by reducing the exposure time by 5–10 per cent, depending on the paper. Some photographers dry a test print or strip with a hair dryer or in a microwave oven to obtain an accurate exposure. They can then compare the dried print with a wet one to get an idea of what changes will occur. This is important when working with an unfamiliar paper.

CONTROLLING CONTRAST DURING DEVELOPMENT

After you have selected the developer and grade of paper, you can alter the contrast of the final image in a variety of simple, straightforward ways.

Two-Solution Development

You can reduce contrast and bring out shadow detail by transferring the paper from the developer to a tray containing a 10 per cent sodium carbonate solution or plain water and then transferring it back to the developer. You may repeat this process until you obtain the desired results. The following guidelines are a starting point for this procedure, but you will probably want to modify them as you go along.

1. Immerse the print in the developer for about 30 seconds.
2. Place the print in a 10 per cent sodium carbonate solution without agitation for about 90 seconds. You can use plain water, but it will increase the chances of your getting a mottled effect, which can be very noticeable in textureless highlight areas such as a cloudless sky. The carbonate results in a more uniform density.
3. Return the print to the developer for an additional 30 seconds.
4. Place the print in the stop bath and continue to process normally.

Local Development Controls

- Glycerin can be applied directly to the print to hold back (lighten) specific areas.
- Hot water can be used to increase the developer's activity in selected areas. Begin processing the print in a developer that is weaker than normal. After about 30 seconds, remove the print, place it on a flat surface, and brush very hot water on areas requiring more development. Give the print a number of brief applications, for about 10–15

seconds, and then return it to the developer. This process may be repeated.

- Straight, undiluted stock developer can be applied to specific areas for increased development and contrast. Begin by processing the print normally for 30 seconds. Remove the print from the developer, place it on a smooth, flat surface, wipe off all the developer with a squeegee or chamois cloth, and apply the stock developer, which has been heated to about 100°F (38°C). Let the print sit for 10–30 seconds, then return it to the regular developer. This process may be repeated as needed.
- Alkali may be applied to heighten the developer's effect. Prepare an accelerator such as sodium carbonate in a saturated solution, dissolving as much accelerator as possible in about 6 ounces of water. Follow the same application procedure as in the hot water method. This technique often produces the most noticeable visual effect.
- A small pocket flashlight with the bulb wrapped in opaque paper to form an aperture from which the light source can be controlled may be used to darken small portions of the print. This is accomplished by removing the print from the developer after about 30–45 seconds and completely wiping off the chemical with a squeegee or chamois cloth. The selected area is given extra exposure, and the print is returned to the developer tray for completion of the process.
- Print flashing is another effective way to reduce contrast and improve highlight detail. In traditional print flashing, the negative is removed from the enlarger and the paper is given a brief (1 second or less) exposure with white light. These short exposures can be difficult to control without an accurate digital timer.
- An alternative method that uses a longer flash time can be carried out with a mechanical timer. Before or after the print is exposed, hold a piece of tracing vellum, such as Clearprint 1000H, under the enlarging lens. Give the print a flash exposure of 10–20 per cent of that required for the normal exposure. For instance, if the total exposure time were 15 seconds, the flash time would be 1½–3 seconds. There is no need to remove the negative from the enlarger, as the tracing vellum acts as a light mixer. The time will be determined by the effect desired and the light transmission qualities of the vellum.
- Finally, altering the formula of the developer will alter the contrast of the print. Adding more hydroquinone and/or potassium bromide to the formula can increase contrast. Increasing the amount of Metol (Elon) in the formula can decrease contrast. Blacks can be deepened through the addition of carbonate. The increase in Metol depends on the desired outcome, but a range of about 10–25 per cent is suggested.

Local Development Controls

In situations where it is not practical to burn or dodge, you can apply various solutions to change the print's tonal value. These operations can be carried out in a flat-bottom tray. Care must be taken to avoid getting the solution in areas where it is not wanted, as a dark or light halo effect might be created in the treated area. Use a brush or cotton ball to precisely apply the solution. The type of paper being treated greatly affects the degree to which these controls can be applied without fogging or staining the print.

MATCHING DEVELOPER AND PAPER

Factors Affecting Paper Tone

Photographic paper, like film, has a grain structure. Fast paper emulsions, like their film cousins, have larger grain and produce a blacker image than slower, fine grain emulsions. Therefore fast emulsions deliver a cold-tone black image while a slow emulsion produces a warm-tone image. The paper emulsion grains expand during processing, thus a fast emulsion will generate a more visible grain pattern than a slow emulsion. During the early stage of development the silver grain is yellow in color, then it turns reddish, then brown, and finally, upon full development, it achieves its maximum black. Thus short development time tends to result in a warm-tone print while longer times produce cold-tone print.

During the development process, the three components that have the greatest influence on tone are the developing agent, bromide restrainer, and restrainer (antifog). Developing agents such as glycin or pyrocatechin give a warm image tone in the absence of a restrainer (i.e. benzotriazole). Additionally, as the bromide content is increased the image tends to become warmer in tone. Restrainers, such as benzotriazole, tend to produce a cold or bluish image.

FIGURE 7.3 *Real Estate History* juxtaposes two images, one of Native American architecture in Colorado and the other of modern American architecture in Arizona, to form a "social commentary portraying the history of land ownership in the American West." Taylor developed the T-MAX 100 film in Kodak T-MAX developer and printed the images on Agfa 118 fiber-based gelatin silver photo paper. He then used a 4 × 5 inch Omega D2V enlarger and developed the prints in Ilford paper developer and fixer. Taylor flashed the image on the right during development "to lend an ominous, oppressive light." To emphasize the divergence of the two scenes, Taylor selectively applied hand-mixed variable Thiourea sepia toner, creating a contrast between warm-toned areas and cooler untoned areas.
© Brian Taylor. *Real Estate History*, 2006. 15 × 22 inches. Toned gelatin silver prints bound in handmade book.

Cold-Tone Papers

Fast, coarse-grain chlorobromide papers generally produce cold black through blue-black image tone. The normal developer for these papers is a MQ combination containing a large amount of accelerator (alkali) and a minimum of restrainer (bromide) to prevent fog. Complete development in a full-strength developer should deliver a print with rich, deep, luminous tones and full detail in key highlight and shadow areas. Shortened development times produce less than a maximum black, preventing details in the upper range of highlights from becoming fully visible. This also permits mottling in clear areas, producing uneven effects with streaks, and giving the image an overall greenish tone.

Warm-Tone Papers

Slower, fine-grain papers have a higher proportion of silver chloride than cold-tone papers. These papers work best when processed in MQ developers that contain less accelerator (sodium carbonate) and more restrainer (potassium bromide) than those used with cold-tone papers. Increasing the exposure time and reducing the development time can create even warmer tones. This can be accomplished by diluting the developer with 2–3 parts of water and/or increasing the amount of potassium bromide in the solution. Less active developers, such as glycin, tend to produce warmer tones than the MQ combinations. For maximum effect, use these methods with warm toned papers, as they tend to have almost no effect on cold-tone papers.

DEVELOPER APPLICATIONS AND CHARACTERISTICS

Kodak Dektol Developer (D-72)

The most commonly used paper developer is Kodak Dektol, which is a MQ formula. Dektol is a cold-tone developer that produces a neutral to blue-black image on cold-tone papers. It is available as a prepared powder or can be made from the D-72 formula, which is very similar. Dektol's standard dilution is 1:2 (1 part developer to 2 parts water) with a recommended developing range of 45 seconds to 3 minutes at 68°F (20°C). It can be used straight to increase contrast or diluted 1:3 or 1:4 to cut contrast and produce warmer tones on certain papers. If you do this, add a 10 per cent solution of potassium bromide for each 32 ounces of working solution. Almost every manufacturer makes a developer that is very similar to Dektol. People who are allergic to Metol developers can use Phenidone-based prepared formulas such as Ilford Bromophen and Ilford ID-36.

Kodak D-72 (Dektol) Formula

Water (125°F/52°C)	16 oz (500 ml)
Metol (Elon)	45 grains (3 g)
Sodium sulfite (desiccated)	1½ oz (45 g)
Hydroquinone	175 grains (12 g)
Sodium carbonate (monohydrate)	2¾ oz (80 g)
Potassium bromide	30 grains (2 g)
Cold water to make 32 oz (1 liter)	

Processing procedures for this cold-tone paper developer are the same as those for Dektol. For even colder, blue-black tones, reduce the amount of bromide (start by reducing it by one-half).

Kodak Polymax T

Polymax T is a liquid developer designed to produce a neutral to cold-black image on cold-tone papers. It has a standard dilution of 1:9 (1 part developer to 9 parts water) with a useful range of processing times from 1–3 minutes at 68°F (20°C). At higher temperatures, the times are proportionately shorter.

Ilford Bromophen

Bromophen is a PQ-based cold-tone developer that is available in prepared powder form. It is normally diluted 1:3 (1 part developer to 3 parts water) and has a developing time of 1½–2 minutes at 68°F (20°C). Developments times can be extended a few minutes to bring out highlight details without fogging. Other manufacturers produce a similar PQ developer, such as Fotospeed PD5 B&W Paper Developer, in a liquid form.

Ethol LPD

LPD is a PQ developer available in both liquid and powder form. LPD can be used with both cold- and warm-tone papers. Varying the dilution of the stock solution can alter the tone of either warm- or cold-tone papers. LPD is designed to maintain uniform contrast and tonal range even if the dilution of the stock solution is changed. For example, with a cold-tone paper it may be diluted 1:8 (1 part developer to 8 parts water) to produce a very light to warm silver tone, or 1:2 for a cold to blue-black tone. Dilutions of 1:6 and 1:4 deliver light silver and neutral silver tones, while a dilution of 1:1 or even full strength produces the coldest, most brilliant blacks. Ethol LPD has a standard development time of 1½ to 3 minutes at 70°F (21°C). LPD offers long shelf-life, great print capacity and may be replenished.

Sprint Quicksilver

Quicksilver is a pyrazolidone-hydroquinone developer (no Metol) that develops all image tones at a constant rate. This means that overall print density increases with development, and contrast remains fairly stable. It has a standard dilution of 1:9 (1 part developer to 9 parts water) with a useful range of 1 to 4 minutes at 65–77°F (18–25°C). At the standard dilution, it produces a neutral tone on cold-tone papers. It gives warm-tone papers a more neutral color than other developers and is not recommended for certain cold-tone chloride papers (contact papers). Overall density may be controlled by exposure and/or development. Color and contrast are determined only by the type of paper and grade or filtration. For more information, see: www.sprintsystems.com

Kodak Selectol (D-52) Developer

Selectol, also known as D-52, is designed to produce a warm black to a brown-black image with normal contrast on warm-tone papers. D-52 is generally mixed 1:1 (1 part

developer to 1 part water) and is developed for 2 minutes at 68°F (20°C). Increasing the exposure and reducing the development time to 1½ minutes can produce a slightly warmer image color. Increasing the development time and reducing the exposure can result in colder tones and a slight increase in contrast. The effectiveness of either technique depends on the paper being used. For warmer tones, increase the amount of bromide (start by doubling it).

Kodak D-52 (Selectol) Formula

Water (125°F/52°C)	16 oz (500 ml)
Metol (Elon)	22 grains (1.5 g)
Sodium sulfite (desiccated)	¾ oz (21.2 g)
Hydroquinone	90 grains (6 g)
Sodium carbonate (monohydrate)	250 grains (17 g)
Potassium bromide	22 grains (1.5 g)
Cold water to make 32 oz (1 liter)	

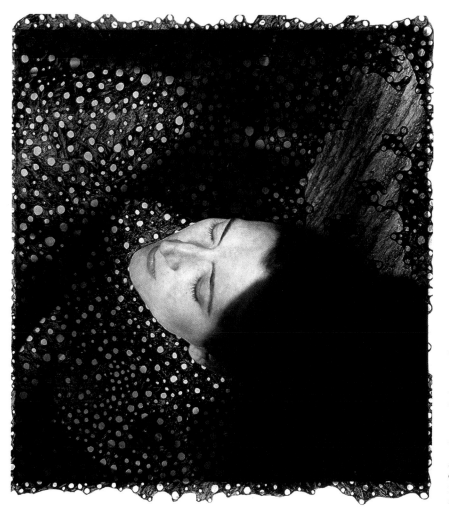

FIGURE 7.4 After making this portrait, Zexter developed the TRI-X 120 film in Rodinal and later produced the print with Sprint Quicksilver chemistry. She hand-colored the resulting print by applying a wash of blue oil paint and mapped out the image by drawing on it with black ink. The act of hand-coloring adds an additional dimension to the photograph, creating a different filter through which one views the image. Combining the immediacy of photography with the meditative practice of hand-coloring, Zexter constructs an image that embodies "both fragmentation and focused concentration."
© Melissa Zexter. *Blue Dream*, 2007. 20 × 24 inches. Hand-colored gelatin silver print.

Kodak Ektaflo, Type 2

Ektaflo, Type 2, is a liquid developer for warm-tone papers. At a dilution of 1:9 (1 part developer to 9 parts water), it has a development time of 1½–4 minutes. The warmest tones are produced by the lowest development times. An increase in time will produce colder tones.

Kodak Selectol-Soft Developer

Selectol-Soft is a packaged powder proprietary formula similar to D-52, but provides softer contrast and increased shadow detail. Selectol-Soft is known as a surface developer. It penetrates the emulsion slowly, acting on the highlights first and then on the middle and lower tonal areas. It gets stronger as the development time increases. Selectol-Soft acts like a low-contrast, Metol-only developer such as Ansco 120 (see formula). It has a regular development time of 2 minutes at 68°F (20°C) and a standard dilution of 1:1 (1 part developer to 1 part water). Changes in the dilution and development time affect the image color on warm-tone papers. Extending the development time to 8–10 minutes deepens the blacks, creating a rich print with a fairly neutral tone.

Selectol-Soft can be used in conjunction with a cold-tone developer such as Dektol for additional contrast control (see the next section on "Variable-Contrast Development"). Its warm-tone characteristics are not noticeable on cold-tone papers, but it will develop a cold-tone grade to a lower level of contrast.

Ansco 120 Developer

Ansco 120 is a low-contrast Metol developer that is usually diluted 1:2 (1 part developer to 2 parts water), but it may be used at full strength or at a higher dilution. Its normal developing time ranges from 1½ to 3 minutes at 68°F (20°C).

Ansco 120 Formula

Water (125°F/52°C)	24 oz (750 ml)
Metol	¼ oz (12.3 g)
Sodium sulfite (desiccated)	1 oz (36 g)
Sodium carbonate (monohydrate)	1 oz (36 g)
Potassium bromide	27 grains (1.8 g)
Cold water to make 32 oz (1 liter)	

FIGURE 7.5 Nankin created this shadowgram – a cameraless image that captures on photographic paper the light refracted by differences in air temperature – in a Tasmanian rainforest at night after careful planning and setup during daylight. He exposed the Bergger VCCB warm-tone variable-contrast fiber base photo paper to a flash pulse emanating from his Sunpak flash unit. He developed the exposed paper in Ansco 120 with benzotriozole to create a blue-black print, which he later gold toned. "This project was partly a poetic response to the phenomenon of global climate change. It is ironic that the project fieldwork was hampered because it took place in the midst of Australia's worst-ever drought, a situation some attribute to climate change."
© Harry Nankin. *The Rain/Quadrat 5*, 2005. 41¾ × 41¾ inches. Toned gelatin silver print. Courtesy of Dianne Tanzer Gallery, Melbourne, Australia.

Variable-Contrast Development

Variable-contrast developers are useful for making small adjustments (less than a full paper grade) that permit precision adjustments of the tonal range of the print. Three separate approaches to working with variable-contrast developers are offered:

1. Use a combination of the standard Kodak developers Dektol and Selectol-Soft.
2. Work with a two-part developer like Edwal TST (Twelve-Sixteen-Twenty).
3. Employ the classic Dr. Roland Beers formula that must be mixed from scratch. (see "Other Paper Developer Formulas" at the end of this chapter.)

Dektol and Selectol-Soft Developer

Stock solutions of Dektol and Selectol-Soft can be combined to provide almost as much contrast control as the Dr. Beers developer. They have the advantage of being mixable from widely available commercial formulas. Two methods have been successful in varying the contrast with Dektol and Selectol-Soft.

In the first method, you can add contrast to a long tonal range print and build up a good solid maximum black by adding 50 milliliters of straight stock Dektol per liter of Selectol-Soft stock solution (1½ ounces per quart). Increase the amount of Dektol in 50 milliliter increments until you achieve the desired contrast. The maximum that can be added is about 350 milliliters of Dektol per liter of Selectol-Soft stock solution (10 ounces per quart). Beyond this limit, the outcome resembles that achieved with Dektol alone. Do not add any additional water to this solution.

In the second method, begin print development in Selectol-Soft until good highlight separation is evident. Then transfer the print into Dektol to complete its development. Different times in each solution and different amounts of dilution permit a good deal of variation in contrast. As a starting point, placing a print in Selectol-Soft for about 90 seconds and then in Dektol for 90 seconds will produce results that are about halfway between those of developing the print in either solution by itself. Prints not receiving full development will lack a rich maximum black.

Edwal TST Developer

Edwal TST is a liquid two-part developer capable of controlling both the contrast and tone of an image. TST is

FIGURE 7.6 Combining six negatives shot in different locations throughout eastern New Mexico, Erf generates innovative realities. Alignment of these images is critical to unify the composition and is made possible with the use of a 1924, 11 × 14 inch Kodak Empire State View with a 12 inch Dagor lens. Erf begins with a single picture and then proceeds to construct his montage manually. His use of two-step contact print development, using Selectol Soft 1:1 for 1–2 minutes and then Dektol 1:2 for 2–3 minutes on an Ilford Multigrade fiber-based paper gives him the ability to fine-tune and control contrast to make the six different prints match up.
© Greg Erf. *Andromeda*, 2005. 28 × 48 inches. Toned gelatin silver print. Courtesy of Linda Durham Contemporary Art, Santa Fe, NM.

very convenient and versatile, and can deliver distinct visible results on a wide range of papers. TST can be diluted from 1:7 (1 part developer to 7 parts water) up to 1:39 to achieve varying effects. At 1:7, TST produces the coldest tones and the deepest blacks. At 1:15, it produces a neutral black. Warm tones on warm-tone paper begin to occur at a 1:19 dilution. The softest warm tones occur at a dilution of 1:39. TST will not produce a brown-tone image on cold-tone paper. For normal contrast and image tone, Edwal recommends using 1 ounce of solution B for every 8 ounces of solution A, regardless of the dilution used. Development times for normal contrast prints are 2–2½ minutes at 70°F (21°C).

Reducing the amount of solution B will proportionally increase the contrast. Solution B can be eliminated entirely for maximum effect. Reducing solution B also increases the developer's activity, and it may be necessary to reduce the standard development time or slightly reduce the paper's exposure time.

If you want maximum contrast, you can add Edwal Liquid Orthazite, a restrainer containing benzotriazole, to TST to prevent fog. Use ½–1 ounce of Orthazite per quart of TST at the 1:7 dilution to maintain clean, clear highlight detail.

You can decrease print contrast by increasing the amount of solution B up to double the normal amount. When you increase the amount of solution B, you can extend the development time up to 4 minutes.

Solarizing Developers

Solarol Developer

The Sabattier effect, commonly called solarization, is achieved by re-exposing the print (it may be done on film)

FIGURE 7.7 Expressive printmaking involves working through a process to arrive at a desired cerebral and emotional response of a subject. This series explores this dynamic environmental relationship between people and the landscape through its dichotomies, myths, and symbols of our natural and built environment. For psychological effect, Hirsch wanted to produce the cold tones and the deep blacks while maintaining clear highlight detail. He achieved this by printing on a Grade 3 paper that was developed in Edwal TST (1:7) with no solution B and 1 ounce of Orthazite.
© Robert Hirsch. *Ships at Sea*, from the series *The Southwest Space Project*, 1975. 16 × 20 inches. Toned gelatin silver print.

to white light while it is being developed. The problem with this procedure is one of control. The print tends to get dark and muddy very rapidly. Solarol is a prepared powder developer that has been designed to provide image control by maintaining print contrast during this procedure.

Solarol Working Guidelines

1. Prepare a stock solution of Solarol and dilute it 1:1 (1 part developer to 1 part water) for use at 68°F (20°C).

2. Make a normal print on high-contrast paper to determine the correct exposure and development time. This information is vital because the ideal time for re-exposure is at about one-third the time needed for total development. High-contrast paper tends to deliver a more pronounced effect. Simple scenes emphasizing strong graphic form are usually good subjects for initial experiments.

3. Place a 40 watt light bulb with a shockproof switch about 3 feet above the area where the developer tray with the print will be placed for re-exposure.

4. To achieve the Sabattier effect expose a piece of paper at one-third less time than the normal test print in Step 2. For example, if the exposure time for the test print was 12 seconds, the correct exposure for the Sabattier effect would be 8 seconds.

5. Develop the paper face up in Solarol for one-third the established developing time. For instance, if the developing time for the test print was 120 seconds, the ideal time for re-exposure would be at about 40 seconds. At this point, turn on the 40 watt bulb, without removing the paper from the developer, for 1 second.

6. Continue the developing process for the total established time.

7. After development is complete, finish processing the print following normal procedures.

The intensity of the Sabattier effect can be altered, from strong to gentle, by the following: (1) varying the distance of the white re-exposure light from the developer tray, (2) using different-strength light bulbs (10–200 watts), (3) increasing or decreasing the amount of re-exposure time, or (4) printing on different grades of paper. Practice, patience, and experimentation are needed to discover the full range of possibilities with the Sabattier effect.

The following formula is for a solarizing developer similar to Solarol that can be used by following the Solarol guidelines.

Solarizing Developer Formula (Stock Solution)

Water (68°F/20°C)	24 oz (750 ml)
Metol (Elon)	180 grains (12.0 g)
Sodium sulfite (anhydrous)	1¼ oz (37.5 g)
Sodium carbonate (monohydrate)	615 grains (41.0 g)
Sodium bromide	72 grains (4.8 g)
Cold water to make 32 oz (1 liter)	

Nontraditional Developer Applications

Brush and Spray Bottle Application

Developers can also be applied in nontraditional ways such as with a paintbrush or a spray bottle. It is possible to warm a stock solution of developer and paint it into the highlight areas with a brush to bring out more detail. Brush and/or spray bottle application of developer can also be used to create a fractured effect, visually separating a subject from its original context. Developers can also be combined with other unintended ingredients to achieve uneven print densities, partial image development, unusual print colors, and brush-like visual effects.

Lith Developer

It is possible to achieve unusual effects by processing paper in developers that the manufacturers did not intend. Normal silver-based paper can be processed in a litho developer, with the rest of the process steps remaining the same, to produce different tonal and color effects than those produced with a normal paper developer. (See the section on "Lith Printing" in Chapter 10.)

OTHER PAPER DEVELOPER FORMULAS

The following well-tested formulas provide an excellent starting place for controlling the contrast and image tone of silver-based black-and-white photographic papers.

High-Contrast Developer

Agfa 108 Developer

Agfa 108 paper developer will produce higher than normal contrast on many cold-tone papers with a hard, cool blue-black tone. It is generally used at full strength with a development time of 1–2 minutes at 68°F (20°C).

FIGURE 7.8 Lebe's photogram was printed on high-contrast paper processed in Solarol. The image was then very slightly bleached with potassium ferricyanide, with specific areas being bleached with a brush or Q-Tip. Finally, the print was painted with liquid watercolors. To make application easier, Photo-Flo was added to the mixing water to help the watercolors penetrate the print surface. © David Lebe. *Garden Series #2*, 1979. 16 × 20 inches. Gelatin silver print with paint.

Agfa 108 Formula

Water (125°F/52°C)	24 oz (750 ml)
Metol	75 grains (5 g)
Sodium sulfite (desiccated)	1½ oz (40 g)
Hydroquinone	88 grains (6 g)
Potassium carbonate	1½ oz (40 g)
Potassium bromide	30 grains (2 g)
Cold water to make 32 oz (1 liter)	

Warm-Tone Developers

It is possible to produce tones through warm black, luminous brown, and sepia by varying the type of developer. The type of paper used determines the effects generated. Fast neutral-tone papers yield warm blacks and brown-blacks, and slower warm-tone papers produce brown-black through very warm brown in the same developer. Experimentation is required to find the combination that will produce the desired image tone.

It is also possible to enhance warm tones by giving a print more than the usual exposure and developing it for less than the normal time. Using a warm-tone paper and developer combination will heighten this effect. As previously mentioned, when a developer nears exhaustion it cannot fully reduce the silver halides in the emulsion. As a result, the print may appear to be red or brown, as it unable to fully develop to black.

Warm tones can be heightened by combining a proportion, up to 1:1, of used developer with fresh developer. The used developer prevents the silver halides from being fully developed, while the fresh developer ensures that development takes place. This technique is especially effective with a glycin developer such as Ansco 130 (see formula that follows in the section on "Glycin Developers").

Agfa 120 Developer

Standard starting procedure for this is a warm-tone hydroquinone developer is to dilute it 1:1 (1 part developer to 1 part water) at 68°F (20°C) and process 1½–3 minutes. On a warm-tone paper this combination produces a warm black tone. Agfa 120 can deliver a variety of warm black to brown tones depending on the paper, dilution, and exposure time. For instance, a brown-black tone can be produced by increasing the exposure time by up to about 50 per cent, diluting the developer 1:5, and processing 4–5 minutes.

Agfa 120 Formula

Water (125°F/52°C)	24 oz (750 ml)
Sodium sulfite (desiccated)	2 oz (60 g)
Hydroquinone	350 grains (24 g)
Potassium carbonate	2½ oz (80 g)
Water to make 32 oz (1 liter)	

Agfa 123 Developer

Agfa 123 is designed to produce brown-black through olive-brown tones on warm-tone papers. For example, you can get a neutral to sepia brown by doubling the normal exposure, using a dilution of 1:4 (1 part developer to 4 parts water), and processing for about 2 minutes. If you increase the exposure time to 2½ times normal, use a dilution of 1:1, and extend the processing time to 5–6 minutes, it is possible to produce a brown-black tone on a warm-tone paper.

Agfa 123 Formula

Water (125°F/52°C)	24 oz (750 ml)
Sodium sulfite (desiccated)	2 oz (60 g)
Hydroquinone	350 grains (24 g)
Potassium carbonate	2 oz (60 g)
Potassium bromide	365 grains (25 g)
Cold water to make 32 oz (1 liter)	

Amidol Developer

Amidol is designed to be used full strength and developed for 2 minutes at 68°F (20°C) to get blue-black tones. It may be diluted and have the developing time lengthened to obtain softer, high-key prints. Amidol must be mixed fresh before each use because it will keep for only a few hours in stock solution. Since amidol has no carbonate, it does not require exact mixing. Variations in the amount of amidol affect the developing time. Variations in the amount of sodium sulfite affect the keeping qualities of the solution. Amidol is not very sensitive to bromide, so the amount of potassium bromide may be adjusted to ensure clear highlights. Contact papers often need only about half as much bromide as enlarging papers.

Amidol Formula

Water (125°F/52°C)	20 oz (800 ml)
Amidol	120 grains (10 g)
Sodium sulfite (desiccated)	365 grains (30 g)
Citric acid (crystal)	60 grains (5 g)
Potassium bromide (10 percent solution)	¾ oz (30 ml)
Benzotriazole* (1 per cent solution)	½ oz (20 ml)
Cold water to make 32 oz (1 liter)	

*Edwal Liquid Orthazite can also be used.

Glycin Developers

Glycin is a versatile paper developer that produces a strong, deep black on bromide papers and brown to sepia tones on warm-tone chloride and chlorobromide papers. With bromide papers the normal dilution is 1:4 (1 part developer to 4 parts water), and with chloride and chlorobromide papers the dilution is 1:3. Normal developing time is 2–3 minutes at 68°F (20°C). A wide range of tonal effects can be achieved by altering the exposure, dilution, and processing time.

Glycin Formula

Water (125°F/52°C)	24 oz (750 ml)
Sodium sulfite	3⅓ oz (100 g)
Trisodium phosphate (monohydrate)	4⅙ oz (125 g)
Glycin	375 grains (25 g)
Potassium bromide	45 grains (3 g)
Water to make 32 oz (1 liter)	

Ansco 130 Developer

Ansco 130 is an all-purpose MQ glycin developer that produces smooth, deep, well-separated black tones while retaining highlight detail and brilliance with a wide range of processing times. It is normal for this developer to appear to be slightly colored. For normal results, dilute 1:1 (1 part developer to 1 part water) at 68°F (20°C). Cold-tone papers can be developed for 2–6 minutes, while warm-tone papers have a range of 1½–3 minutes. Higher contrast can be achieved by using Ansco 130 straight (undiluted). Increasing the dilution to 1:2 can create softer prints.

Ansco 130 Formula

Water (125°F/52°C)	24 oz (750 ml)
Metol	32 grains (2.2 g)
Sodium sulfite (desiccated)	1¾ grains (50 g)
Hydroquinone	50 grains (11 g)
Sodium carbonate (monohydrate)	2½ oz (78 g)
Potassium bromide	80 grains (5.5 g)
Glycin	50 grains (11 g)
Cold water to make 32 oz (1 liter)	

Ilford ID-78 Developer

ID-78 is a PQ warm-tone developer that is often diluted 1:1 (1 part developer to 1 part water) at 68°F (20°C) and processed for 1 minute. To extend the developing time, increase the dilution to 1:3 and process for 2 minutes.

FIGURE 7.9 Fish's manipulated photographs question Western concepts of beauty by combining classical sculpture with nude figure studies. Her 6 × 7 cm negatives are scanned and reworked with Photoshop and outputted to 4 × 5 inch film by a service bureau. To achieve her unique tones, Fish begins processing her print in Dektol (1:1), but during the development process, she sprays the paper with nonrecommended developers: a mixture of Ilford Multigrade developer and Kodak activator and stabilizer. A starting mixture might consist of 30 per cent developer, 40 per cent activator, and 30 per cent stabilizer. The resulting images provoke awareness of the shortcomings of our "unclassically" proportioned bodies and our less-than-ideal corporeal states.
© Alida Fish. *Walking with Pygmalion #8*, 1998. 10 × 8 inches. Toned gelatin silver print. Courtesy of Schmidt-Dean Gallery, Philadelphia, PA.

Ilford ID-78 Formula

Water (125°F/52°C)	24 oz (750 ml)
Sodium sulfite (desiccated)	1¾ oz (50 g)
Hydroquinone	175 grains (12 g)
Sodium carbonate (desiccated)	2 oz (62 g)
Phenidone	7½ grains (0.5 g)
Potassium bromide	6 grains (0.4 g)

Cold water to make 32 oz (1 liter)

Catechol (Pyrocatechin) Developer

Catechol (pyrocatechin) yields exceedingly rich brown tones on bromide papers. It works best at about 100°F

(38°C) with exposure times greatly reduced from those used with normal cold-tone developers. After development, the print is cooled in a water bath and then processed following normal procedures.

Catechol (Pyrocatechin) Formula

Water (110°F/43°C)	22 oz (700 ml)
Catechol (pyrocatechin)	60 grains (4 g)
Potassium carbonate	1½ oz (45 g)
Potassium bromide	6 grains (0.4 g)

Water to make 30 oz (900 ml)

TABLE 7.1 Dr. Beers Variable-Contrast Developer Dilutions

	Contrast							
	Low			Normal			High	
	Sol. 1	Sol. 2	Sol. 3	Sol. 4	Sol. 5	Sol. 6	Sol. 7	Sol. 8
Parts of A	8	7	6	5	4	3	2	1
Parts of B	0	1	2	3	4	5	14	15
Parts of water	8	8	8	8	8	8	0	0

Sol. = solution.

FIGURE 7.10 Redford-Range finds Dr. Beers two-solution developer to be effective in refining the contrast of her final print. To retain the subtle nuances of the texture of this image, Beers solution 3 (slightly lower contrast than normal) was used with Grade 2 Agfa paper. The Metol developing agent in solution A acts on the high tonal values while the hydroquinone develops the middle and lower tonal values.
© June Redford-Range. *Retired Farmer and His Wife*, 1988. 11 × 14 inches. Gelatin silver print. Courtesy of The Afterimage Gallery, Dallas, TX.

Dr. Beers Variable-Contrast Developer

Dr. Roland Beers variable-contrast developer is a classic two-stock solution paper developer. Stock solution A contains Metol (a soft developer) and stock solution B contains hydroquinone (a contrast developer). Varying the proportions of the stock solutions A and B allows one to alter contrast by between ½ and 1½ grades, depending on the paper. The resulting prints typically have good blacks and neutral tones with excellent tonal separation. Stock solutions A and B are mixed at the time of use in varying proportions to yield a progressive range of contrasts, as listed in Table 7.1. Dr. Beers has a developing range of 1½–5 minutes at 68°F (20°C). The low-number solutions can be diluted even further with water for extremely soft effects.

A similar effect can be achieved by using a two developer processing method. See previous section Dektol and Selectol-Soft.

Dr. Beers Variable-Contrast Formula

Dr. Beers stock solution A

Water (125°F/52°C)	24 oz (750 ml)
Metol	120 grains (8 g)
Sodium sulfite (desiccated)	350 grains (23 g)
Sodium carbonate (desiccated)*	300 grains (20 g)
Potassium bromide	16 grains (1.1 g)

Cold water to make 32 oz (1 liter)

Dr. Beers stock solution B

Water (125°F/52°C)	24 oz (750 ml)
Hydroquinone	120 grains (8 g)
Sodium sulfite (desiccated)	350 grains (23 g)
Sodium carbonate (desiccated)*	400 grains (27 g)
Potassium bromide	32 grains (2.2 g)

Cold water to make 32 oz (1 liter)

*The original Dr. Beers used potassium carbonate. Sodium carbonate may be substituted, as it is less expensive and more widely available, and should not produce any observable differences.

RESOURCE GUIDE

Adams, Ansel. *The Print* Boston, MA: Little, Brown, 1995.

Anchell, Stephen G. *The Darkroom Cookbook*, Third Edition. Boston, MA: Focal Press, 2008.

FIGURE 7.11 After arranging her subjects on printing-out paper, Madigan exposes it to the sun for five minutes. She then makes the print permanent by processing it with gold chloride toner. The sun figures importantly throughout her work, which examines cycles, rhythms, and human nature. She explains, "The process of my work reflects the passages of life, seeking not an understanding of time, but rather an experience of the sacred presence within it. The radiance of the sun as the essence of creation becomes a direct experience within the work. The sun reveals the truth of human nature – that what we seek dwells quietly within the core of our beings. The exquisite form of a newborn baby embodies this teaching with the sweetness of absolute trust."

© Martha Madigan. *Embodied #14*, 1996-1997. 24 × 20 inches. Toned printing-out-paper. Courtesy of Jeffrey Fuller Fine Art, Ltd., Philadelphia, Pennsylvania and Michael Rosenfeld Gallery, NY.

TONING FOR VISUAL EFFECTS

Toning plays a vital role in translating each photographer's visual intent into a concrete reality. Alterations in the color and contrast relationships of a print can dramatically change the aesthetic and emotional responses to the work.

PROCESSING CONTROLS

When working with black-and-white materials, the following four factors play key roles in determining the final color of the photograph:

1. Paper type and grade.
2. Developer type, dilution, and temperature and length of development.
3. Processing and washing.
4. Chemical toner type, dilution, and temperature and length of toning.

The developer–paper combination plays a key role in determining the look of the print, regardless of which type of toner is selected. Similarly, toner that delivers the desired visual effect with one developer–paper combination can be ineffective or produce undesirable effects with another. Most manufacturers provide charts that list widely used and recommended paper–toner combinations. For example, if the printmaker wanted to achieve the maximum warm brown color from a toner, a paper such as Ilford Multigrade Fiber Base Warmtone developed in Kodak D-52 might be recommended. Almost all papers respond to some degree to most toners. Generally, warm-tone silver chloride papers (contact papers) show a more pronounced toning effect than cold-tone silver bromide papers (enlarging papers).

Extended development times tend to limit the effect of a toner. A warm-tone developer, such as Kodak D-52 or Kodak Selectol-Soft, used in place of a cold-tone developer, such as Kodak Dektol, will produce even warmer images. Thorough washing is important to avoid print staining. Experience, testing, and careful observations are necessary for consistent and repeatable results. Keeping a written record of procedures can help you build a storehouse of toning knowledge. Experimentation is the only way to see what works best in your situation.

BASIC TYPES OF TONERS

Many toners are available in prepared liquid or powder form, and by mixing from formulas one may derive even more variations. Chemical toners can be divided into three major types: replacement, mordant dye, and straight dye.

Replacement Toners

The use of inorganic compounds (salts) to replace or partially replace the silver in a fully processed photograph makes for a wide variety of image colors. In this process, the silver is chemically converted with toners such as gold, iron, selenium, sulfur, and other metallic compounds. Some of these toners act directly on the silver image, while others rely on bleaching the image and then redeveloping it in a toning solution. It is possible to achieve muted and subtle visual effects with replacement toners, which are also permanent and stable. When using any bleach/redeveloper process it is usually necessary make prints slightly darker than normal to compensate for some loss of density during the toning process.

Mordant Dye Toners

A mordant is a compound that combines with a dye so the color cannot bleed or migrate within the dyed medium. In mordant dye toning, the image is converted to silver ferrocyanide through the use of a mordant such as potassium ferricyanide. A mordant acts as a catalyst, permitting the use of dyes that would not normally combine with silver. The dye is deposited in direct proportion to the density of the ferrocyanide (mordant) image. This process allows dye toners to be used to produce a wide variety of vivid colors. Image color can be further altered by immersing the photograph in a bath containing different colored dyes or by combining dyes. Some of the problems with mordant dye toners are:

1. They are not as stable as replacement toners.
2. They are more likely to fade upon prolonged exposure to UV light.
3. Some of their initial intensity is often lost during the washing process.
4. Traces of the toner are often left in the white base areas of the paper even after a complete wash.

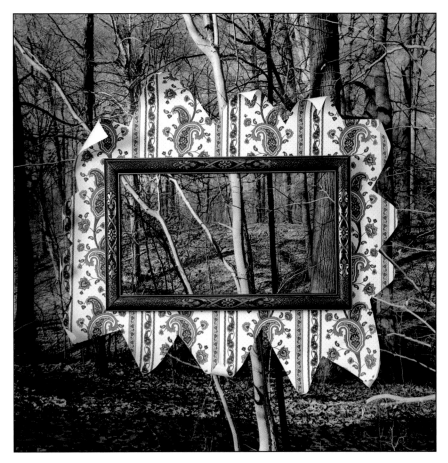

FIGURE 8.1 Sharp fabricated this selenium-toned image by collaging a photograph with found objects. He first made the landscape negative on film, which he then developed, scanned, and printed. After adhering this large print to a wall, he placed a fragment of wallpaper on it, positioned a frame atop the wallpaper, and cut away the wallpaper inside to reveal the original forest scene. To produce the final print, Sharp lit the fabricated image with Lowell Tota tungsten lights and rephotographed the work. "By blurring the boundaries between interior and exterior spaces, I create mysterious images that cause the viewer to do a double take. Within these real and fictional spaces, nothing is grounded." © Keith Sharp. *Picture and Wallpaper*, 2006. 20 × 16 inches. Toned gelatin silver print. Courtesy of Museum of Fine Arts, Houston, TX.

Straight Dye Toners

With these toners, the silver is not converted and the dye affects all areas equally. These toners are widely available and very easy to use. Although they can produce vivid colors, the lack of difference in toner intensity between the highlight and shadow areas tends to create a flat color field effect. This can unify a composition or it can create a sense of sameness that can be visually monotonous.

Prepared or Mixed from Scratch

Manufacturers, such as Kodak, Berg, and Edwal, offer ready to use toners. The Photographers' Formulary makes numerous toners packaged that may be very similar to those that must be prepared from scratch.

PROCESSING PRINTS TO BE TONED

The following procedures are recommended starting points for all toning procedures discussed in this chapter, unless otherwise noted. Table 8.1 summarizes the processing steps in toning for visual effects.

Printing and Development

To a certain degree, almost all toners affect the contrast and/or density of a print, so it is a good idea to experiment before toning any final prints. Some toners lighten the final print and others darken it. Changes in exposure and/or development time may be needed to adjust for these effects. Many toners' instructions tell you whether to expect such changes. When first working with a toner, it is helpful to make extra prints, including duplicates of what is believed to be the proper exposure and prints having more and less exposure than normal. The making of additional prints also permits variation in toning times, thus increasing your selection of color effects.

Stop Bath

After development is complete, prints should be drained and then immersed in a 28 per cent acetic acid stop bath for 30 seconds with constant agitation at 68°F (20°C). Indicator stop bath that changes color when the stop bath

TABLE 8.1 Processing Steps in Toning for Visual Effects at 68°F (20°C)

Step	Summary	Time (minutes)
1. Developer	Select a developer/paper combination to match the toner	1½–5
2. Stop bath	Use a regular 28 per cent acetic acid stop bath	½
3. First fix	Utilize only fresh fix; check to see if hardener is needed; do not overfix	3–5
4. Second fix	Same as Step 3	3–5
5. Rinse	Remove excess fix with water	5 (minimum)
6. First wash*	Begin the removal of chemicals	2–5
7. Washing aid	Use a hypo eliminator, such as Perma-Wash or Kodak Hypo Clearing Agent	2–5
8. Second wash	Remove fixer residuals to prevent staining	10
9. Toning	Make use of the following trays to avoid staining:	
	tray 1 – water holding	
	tray 2 – toner	
	tray 3 – collection tray	
	tray 4 – running water (print washer)	
10. Washing aid	Same as Step 7	2–3
11. Final wash*	Remove all chemicals from the paper	60
12. Drying	Air-dry, face down, on plastic screens; do not use heat	As needed

*All washing times must be established for specific conditions. The times given should be adequate to prevent print staining in most applications.

is exhausted and needs to be discarded is recommended to ensure repeatable results.

Fixer

Proper fixing, with fresh fix, is a must to ensure high-quality toning results. Either a single rapid fixing bath or a two-bath method can be used. Incomplete fixing will fail to remove residual stop bath and silver thiosulfate compounds, resulting in an overall yellow stain on prints toned with selenium or sulfide. These stains are most visible in the border and highlight areas of the print. Purplish circular stains are often due to improper agitation during fixing. Excessive fixing can bleach the highlight areas and produce an unexpected change in the color of the toned image.

Hardener

Most papers tone more easily if they are fixed *without* hardener. Some toners specifically require the use of fix without hardener. Check the directions before processing.

Prints toned with nonselenium brown toners can be treated with a hardener to increase surface durability. This is done right before the final wash. A hardening bath such as Kodak Liquid Hardener is diluted 1:3 (1 part hardener to 3 parts water) and the prints are immersed in it with constant agitation for 2–5 minutes. The print is then given a final wash.

Washing before Toning

After proper fixing, rinse excess fixer off the print and begin the first wash of at least 5 minutes at 68°F (20°C). Photographs can be stored in a water holding bath until the printing session is complete. This allows the remaining washing and toning steps to be carried out at the same time.

After the first wash, prints are immersed in a washing aid or hypo eliminator for recommended times, usually about 2–5 minutes. The print is then washed for a minimum of 10 minutes, after which it is ready to be toned.

Previously processed and dried prints can be toned, but first they must be allowed to soak in a water bath and become saturated. If you do not do this, the toner might be unevenly absorbed, resulting in a mottled finish.

Washing after Toning

After the print has been toned, it must be washed. The washing time will vary depending on the combination of paper, toner, and washing technique. Check the manufacturer's recommendations for suggested starting washing times. A general guideline is to rinse the print immediately after it comes out of the toner, immerse it in a washing aid, with constant agitation, for 2–3 minutes, and then give it a final wash of 1 hour in an archival print washer.

The wash and washing aids can affect certain toner–paper combinations. For instance, mordant dye toners tend to lose intensity during the final wash. You can compensate for this loss by extending the toning time. When the print is immersed in a washing aid, sepia toners may be intensified or a shift in tonality may occur, while blue toners may lose intensity.

Drying

Toned prints should be allowed to air-dry, facedown, on plastic screens. Heat-drying can produce noticeable shifts in color.

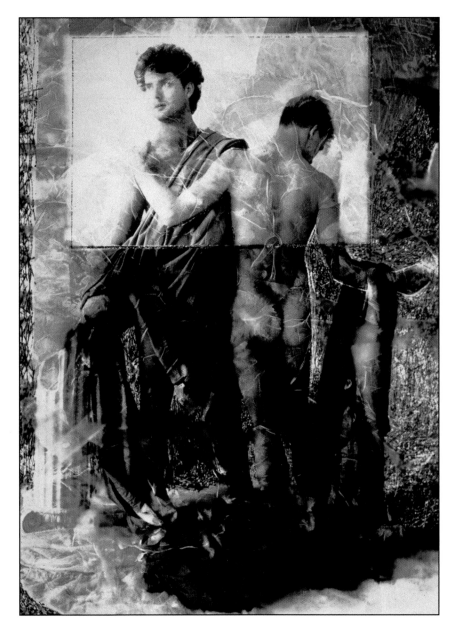

FIGURE 8.2 Toning permits a photographer to reenter the photograph and continue to make visual statements about the nature of the subject. One's knowledge of materials and expressionistic drive can come together in this process. Byrd used an etching needle on his 6 × 7 cm negative (emulsion side for black lines and base side for white lines). He made the print by exposing the negative through wet tissue paper on the paper's surface for 50 per cent longer than the normal exposure time. Then the interior rectangle was masked, and the print was given additional exposure. The paper was processed in Ethol LPD (1:1) for 3 minutes. After the final wash, the print was immersed in copper toner for 10 minutes, redeveloped in LPD (1:9) for 20 seconds, treated with a silver toner for 5 minutes, washed in a hypo clearing bath, and re-immersed in the copper toner for 5 minutes.
© Jeffery Byrd. *Life Is Splendid and Obscure and Broken and Long Enough*, 1989. 20 × 16 inches. Toned gelatin silver print. Courtesy of a private collection.

GENERAL WORKING PROCEDURES FOR TONERS

Safety

Review and follow all safety rules outlined in Chapter 2 before beginning any toning operation. Always wear thin, disposable rubber gloves and work in a well-ventilated area. Certain sepia toners release sulfur dioxide (rotten-egg smell) and should be properly ventilated with an exhaust fan. Have no other photographic materials in the toning area. Certain toners can release hydrogen sulfide gas, which can fog unexposed film and paper and oxidize unprotected silver images on film and prints.

Equipment

When working with a single-bath toner, a minimum of three, clean trays, slightly larger than the print, are required. The first tray is used to hold the prints waiting to be toned. The second contains the toner. The third contains a water bath to hold the prints after they have been toned. A fourth tray or print washer with a running water bath is desirable to rinse off excess toner. The action of the toner will continue as long as there is any

FIGURE 8.3 Taylor shot the three photographs that make up this collage with a Fuji 645 camera. He developed the T-MAX 120 in Kodak T-MAX developer and printed with Agfa 118 semi-matte fiber base developed in Ilford paper developer, using an Omega D2V enlarger. Taylor's home-mixed variable Thiourea sepia toner allowed him to blend the ideal hue for this work. He selectively brushed on ferricyanide part A to bleach and part B to tone areas of the collage's central image, which depicts an image of a freeway. The other images, which portray a freeway overpass and an amusement park, were heavily flashed during development to tone down the contrast and create a foreboding light. The three photographs were presented as an open handmade book, creating commentary on society's problematic reliance on automobiles, while juxtaposing images that generate an eerie reality. Taylor states, "I am interested in how daily life in the early twenty-first century presents us with incredible experiences in such regularity that we no longer differentiate between what is natural and what is colored with implausibility, humor, and irony."
© Brian Taylor. *Roller Coasters*, 2006. 15 × 22 inches. Toned gelatin silver prints bound in handmade book.

toner remaining on the paper. Different tonal effects can be achieved by varying the dilution rates of the single-bath toners.

Reuse of Toners

Once toners have been diluted and used, they cannot be reliably stored or reused. An exception is hypo alum sepia toner, which actually improves with use and can be kept for years. Generally, the correct amount of toner solution for the number of prints being toned should be mixed for each toning session and properly discarded after use.

Use of a Comparison Print

Keep a wet, untoned print next to the print being toned as a visual guide to the toner's action. This is the only accurate way to measure how much effect has taken place. A disposable work print can be placed on the back-side of a flat-bottom tray and propped up next to the toning tray for easy viewing.

BROWN TONERS

Brown toners are the most widely used and diverse group of toners. They are generally considered to have a warm, intimate, and engaging effect. They are divided into three major groups. Selenium toners such as Kodak Rapid Selenium Toner deliver purplish to reddish brown tones. Cool chocolate browns are created from single-solution, sulfur-reacting toners such as Kodak Hypo Alum Sepia Toner T-1a, Kodak Polysulfide Toner T-8, and Kodak Brown Toner. Very warm browns are produced by bleach and redevelopment sulfide toners, such as Kodak Sulfide Sepia Toner T-7a.

Any Kodak toner with a "T" in the name is a formula toner and must be prepared by you. Other manufacturers, such as Berg, Edwal, and the Photographers' Formulary, make packaged brown toners that may be every similar to those that must be prepared from scratch.

Some toners, such as Kodak Gold Toner T-21, are capable of producing a wide range of colors and cannot be put into a single category.

Brown Tones on Warm-Tone Papers

Many warm-tone papers, such as Ilford Multigrade Fiber Base Warmtone, lose contrast and density in polysulfide brown toners such as Kodak Brown Toner and Kodak Polysulfide Toner T-8. These toners also bleach the image slightly, producing a yellow-brown color that may not be visually acceptable. You can compensate for these effects by modifying the development time. For example, if the

normal development time is 2 minutes at 68°F (20°C), then use the same exposure time to make another print, but increase the development time to 3½ minutes. The extra development time increases both the contrast and the density, offsetting the bleaching effect of the toner. Warm-tone papers can deliver even richer browns when processed in a cold-tone developer such as Dektol (1:3) for 3½ minutes at 68°F (20°C).

Brown Tones on Neutral- and Cool-Tone Papers

Neutral- and cool-tone papers do not produce a yellow cast. You can maintain contrast and density by increasing the developing time by about 25 per cent and leaving the exposure time the same.

Kodak Rapid Selenium Toner

Kodak Rapid Selenium Toner is a prepared single-solution toner that can be used to make purplish brown to reddish brown colors on neutral- and warm-tone papers. Rapid Selenium Toner converts the silver image into brown silver selenide and causes a slight increase in print density and contrast. The increased density is more noticeable in the highlight areas, while the increased contrast is more noticeable in the shadow areas. To compensate for these characteristics, a slight reduction (often less than 10 per cent) in development time may be necessary.

The starting dilution rate for Rapid Selenium Toner is 1:3 (1 part toner to 3 parts water). The normal toning time range is 2–8 minutes. Diluting the toner 1:9, 1:20, or 1:30 slows the toning action, producing a variety of intermediate effects, and is easier to control. Very subtle effects and protective benefits against atmospheric gases can be achieved by diluting 1 ounce of Rapid Selenium Toner to a gallon of water and toning for 8–15 minutes. Allow for the fact that toning will continue for a brief time in the wash. A faint smell of sulfur dioxide may be noticeable when you are working with this toner. After toning is complete, treat the print with a washing aid and then wash for 1 hour.

Kodak Brown Toner

Kodak Brown Toner is a packaged single-solution toner that produces sepia tones on most papers. This is accompanied by a loss in contrast that can be offset by increasing the development time. Brown Toner changes the silver image into brown silver sulfide. This toner does contain potassium sulfide and should be used only in a well-ventilated area.

Kodak Brown Toner has a normal toning range of 15–20 minutes at 68°F (20°C) with agitation. When

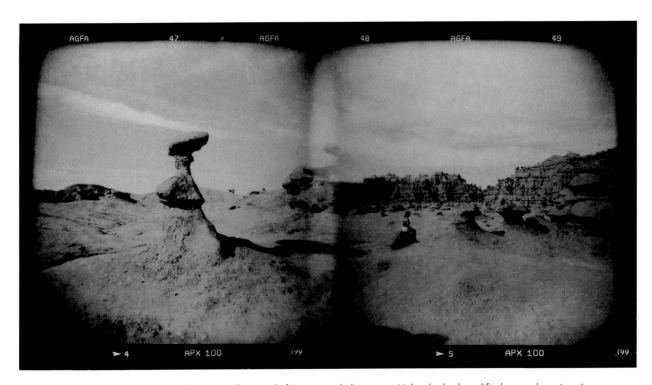

FIGURE 8.4 DeHart made this landscape in direct mid-afternoon sunlight using a Holga he had modified to produce 6 × 6 cm negatives. He contact printed this negative on Ilford Multigrade paper, which he then experimentally toned with selenium and brown toners. DeHart says that he often produces sequential images with this camera, both purposely and accidentally, as the unpredictability of the Holga and its film causes him to embrace the elements of chance and luck in photography.
© Dennis DeHart. *Goblin Valley, Utah*, 2002. 6 × 12 inches. Toned gelatin silver print.

toning is finished, treat the print with a washing aid and then wash for at least 1 hour. Increasing the temperature will increase the toner's activity and reduce the toning time. Kodak Polysulfide Toner T-8, whose formula is provided later in this section, can produce results very similar to those produced by Kodak Brown Toner.

Kodak Sepia Toner

Kodak Sepia Toner is a prepared two-solution toner that can provide good sepia tones on cold-tone papers such as Ilford Multigrade IV FB, or yellow-brown tones on warm-tone papers. Varying the toning time to alter the color is ineffective with Kodak Sepia Toner and is not recommended. This toner changes the silver image into brown silver sulfide. It results in some loss of print density, which can be corrected by increasing the exposure time.

With Kodak Sepia Toner, the print is bleached in solution A for approximately 1 minute, until the blacks in the shadow areas disappear. A light brown image in the shadows, with the lighter tones becoming invisible, indicates that the bleaching is complete. If the print is not totally bleached before being put in the sulfide toner, irregular tones are likely to occur. After bleaching, the print is thoroughly rinsed for a minimum of 2 minutes in

running water, then immersed in solution B for about 30 seconds, until the original density returns. Following the completion of the toning operation, the print is placed in a washing aid and then washed for a minimum of 1 hour. Kodak Sulfide Sepia Toner T-7a, whose formula is provided in this chapter, delivers similar results to those achieved with Kodak Sepia Toner.

For noticeably warmer tones on most black-and-white papers, use Kodak's prepared two solution Sepia II Warm Toner.

Kodak Sepia Toner Retoning Process

It is possible to retone prints in Kodak Sepia Toner to achieve a subtler, but nevertheless more striking, effect than can be produced from a fully toned sepia image. The gray areas are the most affected with this method, turning slightly golden brown rather than reddish brown. The black portions of the print change little or not at all.

For this retoning process, make a number of prints that are slightly darker than normal (start with a range of 10–25 per cent darker). Papers such as Ilford Multigrade Fiber Base Warmtone and Ilfobrom Gallerie FB deliver good results. Begin experimentation with test prints, as it may be necessary to adjust the processing times depending

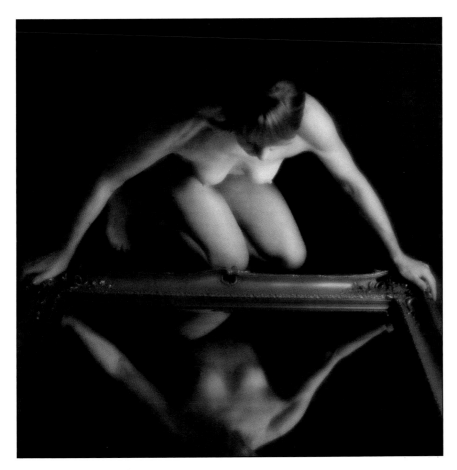

FIGURE 8.5 Carnochan recorded this portrait on infrared film with her Hasselblad 500 CW. After using a T-MAX developer in a Jobo processor, she printed the image on a warm-tone, semi-matte paper, and toned it with a soft sepia toner. The imagemaker endeavors to make the classic nude study both new and personal with her usage of infrared film, amateur models, and subtle hand-coloring. © Brigitte Carnochan. *Narcissa*, 2003. 9½ × 9½ inches. Hand-colored gelatin silver print. Courtesy of Modernbook Gallery, Palo Alto, CA.

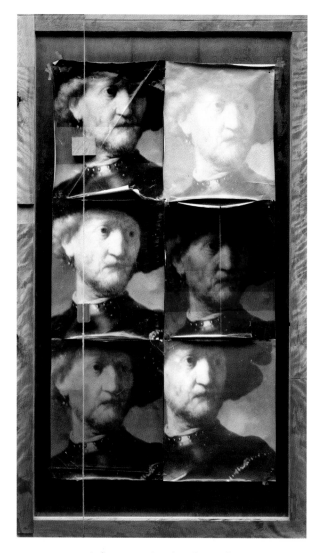

FIGURE 8.6 Reflecting on the idea of more than one, Doug and Mike Starn challenge many basic concepts of fine art photography. They are known for crumpled, scratched, torn, and taped-together images that have been thumbtacked to the wall. The Starns make large-scale photographs and installation pieces designed to hold the viewer's attention in big gallery spaces alongside painting and sculpture. *Rembrandt Heads* is composed of six prints of the same negative, which were given six different exposure times. These prints were then copper-toned for different lengths of time, resulting in a variety of copper hues, from salmon to deep copper.
© Doug & Mike Starn. *Rembrandt Heads* (detail), 1989. 88 × 51 inches. Toned gelatin silver prints with tape. Courtesy of Artists' Rights Society, New York.

on the type of paper and its contrast. To achieve the subtlest effects, begin with a dry print that has been fixed and completely washed. Use the regular Kodak Sepia Toner mixture at about 68°F (20°C) and follow the steps in Table 8.2.

TABLE 8.2 Kodak Sepia Toner Retoning Process (68°F/20°C)

1 Place the print in solution A (bleach) for about 30 seconds
2 Wash in running water for 2 minutes
3 Place the print in solution B (toner) for approximately 1 minute
4 Wash in running water for 2 minutes
5 Reblouch the print in solution A for about 15 seconds
6 Wash in running water for 2 minutes
7 Retone in solution B for approximately 1 minute
8 Wash for 1 minute
9 *Optional:* Place the print in a 1:13 solution of Kodak Liquid Hardener (1 part hardener to 13 parts water) for about 3 minutes with occasional agitation
10 Final wash in running water for a minimum of 30 minutes

Kodak Hypo Alum Sepia Toner T-1a

Kodak Hypo Alum Sepia Toner T-1a is designed to deliver sepia tones on warm-tone papers. Hypo Alum Sepia Toner T-1a results in a loss of contrast and density, which can be offset by increasing the exposure time by up to 15 per cent or increasing the development time by up to 50 per cent. This toner is designed to be used at a high temperature, 120°F (49°C), for 12–25 minutes. Toning at above 120°F for longer than 25 minutes may cause blisters or stains on the print. Toner temperatures can be maintained by floating the toner tray in another tray of hot water. The toner may be used at room temperature, but toning will take several hours. The solution should be agitated occasionally during this process. After completion, it may be necessary to place the print on a piece of glass under hot running water and wipe the print with a soft sponge or cotton wool and warm water to remove any scum or sediment. The print is then treated with a washing aid, followed by a final wash of at least 1 hour. Although it is time consuming to make and use, this toner maybe utilized for many years and improves with age.

Kodak Hypo Alum Sepia Toner T-1a Formula

Prepare this formula carefully following these instructions:

Water (68°F/20°C)	90 oz (2,800 ml)
Sodium thiosulfate (pentahydrate)	16 oz (80 g)

Dissolve completely and then add the following solution:

Water (160°F/70°C)	20 oz (640 ml)
Potassium alum (fine granular)	4 oz (120 g)

Now add the following solution, including the precipitate, slowly to the hypo alum solution while stirring rapidly:

Water (68°F/20°C)	2 oz (64 ml)
Silver nitrate crystals*	60 grains (4 g)
Sodium chloride	60 grains (4 g)

*Dissolve the silver nitrate completely, and then dissolve the sodium chloride. Immediately add the solution along with the milky-white precipitate to the hypo alum solution. The formation of any black precipitate should not impair the action of the toner if it is properly handled. Wear protective gloves because silver nitrate will stain anything it touches black.

After combining these two solutions, add water to make 1 gallon (3.8 liters). When you are ready to use the toner, heat it in a water bath to 120°F (49°C).

Kodak Sulfide Sepia Toner T-7a

Kodak Sulfide Sepia Toner T-7a is a two-solution bleach and redevelopment toner. It is capable of delivering warm brown tones on many types of paper, including cold-tone papers. Its results and general characteristics are similar to those achieved with the packaged Kodak Sepia Toner.

The print to be toned is placed in solution A (bleach) until only a faint yellowish brown image remains. This takes 5–8 minutes. The print is then rinsed completely in running water for a minimum of 2 minutes. Next it is immersed in solution B (toner) until the original details return, about 1 minute. After this procedure, the print is given a thorough rinse and treated in a hardening bath for 2–5 minutes. The hardening bath can be prepared by mixing 1 part prepared Kodak Liquid Hardener with 13 parts water or using 2 parts Kodak Hardener F-5a stock and 16 parts water (see formula). The hardening bath should not affect the color or tonality of the print. After toning (and hardening), place the print in a washing aid and then wash for a minimum of 1 hour.

Kodak Sulfide Sepia Toner T-7a Formula

Stock bleaching solution A

Water (68°F/20°C)	32 oz (1 liter)
Potassium ferricyanide (anhydrous)	2½ oz (75 g)
Potassium bromide (anhydrous)	2½ oz (75 g)
Potassium oxalate	6½ oz (195 g)
28 per cent acetic acid*	1¼ oz (40 g)
	Water to make 64 oz (2 liters)

*To make 28 per cent acetic acid from glacial acetic acid, combine 3 parts glacial acetic acid with

8 parts water. However, it is highly recommended that you purchase prepared 28 per cent acetic acid. Highly concentrated acid should only be handled in proper laboratory conditions as it can pose serious health and safety issues.

Stock toning solution B

Sodium sulfide (not sulfite; anhydrous)	1½ oz (45 g)
Water (68°F/20°C)	16 oz (500 ml)

Prepare the bleaching solution as follows:

Stock solution A	16 oz (500 ml)
Water	16 oz (500 ml)

Prepare the toner as follows:

Stock solution B	4 oz (125 ml)
Water to make 32 oz (1 liter)	

Mix the solutions directly before use and dispose of them after each session.

Kodak Hardener F-5a Formula

Water (125°F/50°C)	20 oz (600 ml)
Sodium sulfite (anhydrous)	2½ oz (75 g)
28 per cent acetic acid*	7½ oz (235 ml)
Boric acid crystals**	1¼ oz (37.5 g)
Potassium alum (fine granular, dodecahydrate)	2½ oz (75 g)
Cold water to make 32 oz (1 liter)	

*To make 28 per cent acetic acid from glacial acetic acid, combine 3 parts glacial acetic acid with 8 parts water.
**Crystalline boric acid is suggested because it is difficult to dissolve boric acid in powder form.

The standard dilution for Kodak Hardener F-5a is 1:13 (1 part hardener to 13 parts water). Process for 2–5 minutes at 68°F (20°C).

Kodak Polysulfide Toner T-8

Kodak Polysulfide Toner T-8 is a single-solution toner delivering slightly darker brown tones than Kodak Sulfide Sepia Toner T-7a on warm-tone papers. Unlike Kodak Hypo Alum Toner T-1a, it has the big advantage of not having to be heated. However, this toner is not recommended for use with cold-tone papers. A substitute formula for Kodak's Poly-Toner can be downloaded at: www.kodak.com/global/plugins/acrobat/en/service/chemicals/CIS268.pdf.

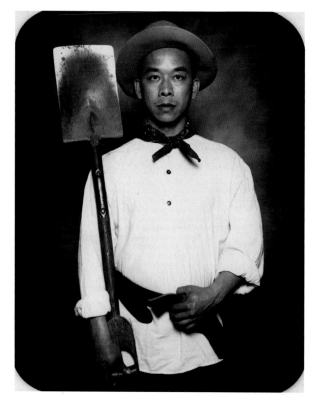

FIGURE 8.7 Pipo uses the nineteenth century photographic syntax to re-interpret and simulate tintype portraits made in the American West. Using himself as an Asian model for all the characters, he takes on and gives new twists of meaning to gunslingers, musicians, miners, and gentlemen. "By consciously assuming culturally powerful icons, and not the assumed stereotypical representations of Asians as the submissive other (opium addicts, domestic servants), my goal is to humorously and ironically question and challenge the legitimacy and authority of the Western myth." Pipo first used Kodak Poly-Toner to warm the image to mimic the feel of an old photograph, and then future toned with a combination of coffee and chicory from the Café du Monde in New Orleans.
© Pipo Nguyen-duy. *AnOther Western*, 1998. 5 × 4 inches. Toned gelatin silver print. Courtesy of Sam Lee Gallery, Los Angeles, CA.

Kodak Polysulfide Toner T-8 Formula

Water	96 oz (750 ml)
Sulfurated potash	1 oz (7.5 g)
Sodium carbonate (monohydrated)	145 grains (2.5 g)
Water to make 32 oz (1 liter)	

Prints are immersed in Polysulfide Toner T-8 for 15–20 minutes, with agitation, at 68°F (20°C). Raising the temperature increases T-8's activity and reduces the toning time to as low as 3–4 minutes at 100°F (38°C). After toning, the print is rinsed in running water for at least 2 minutes and can then be treated in a hardening bath, as mentioned in the Kodak Sulfide Sepia Toner T-7a section, for 2–5 minutes. If sediment forms on the print during the toning process, it should be removed with a soft sponge and warm water before the final wash. When these operations are complete, treat the print in a washing aid and give it a final wash of at least 1 hour.

Kodak Gold Toner T-21

Kodak Gold Toner T-21, also known as Nelson Gold Toner, is a single-solution toner that yields an excellent range of brown tones on most warm-tone papers but has little effect on most cold-tone papers. Final images considered highly permanent as they are formed by a combination of silver sulfide and gold, which in essence gold-plates the silver. T-21 is unique in the fact that it tones the highlight and shadow areas at the same rate. This allows the toning action to be stopped any time the desired effect has been achieved without having to worry whether the highlight and shadow areas have received equal effects. It also makes possible a variety of even-toned effects that can be created by simply changing the time in the toning bath. T-21 has a normal toning time range of 5–20 minutes.

Kodak Gold Toner T-21 Formula
Stock Solution A

Water (125°F/50°C)	1 gallon (4 liters)
Sodium thiosulfate (pentahydrate)	2 pounds (960 g)
Ammonium persulfate	4 oz (120 g)

The sodium thiosulfate must be totally dissolved before adding the ammonium persulfate. Vigorously stir the solution when adding the ammonium persulfate.
The solution should turn milky. If it does not, increase the temperature until it does.

Cool the solution to about 80°F (27°C), then add the following solution, including the precipitate, slowly, stirring constantly. If predictable results are desired, the first bath must be cool when these two solutions are combined.

Cold distilled water	2 oz (4 ml)
Silver nitrate	75 grains (5 g) crystals*
Sodium chloride	75 grains (5 g)

FIGURE 8.8 Barrow wondered how much he could alter the photographic image and yet retain its native qualities. In putting together this work, he used gold toner at an elevated temperature of 135°F (57°C) to create extreme blue-blacks on a cold-tone paper. Barrow tore the print apart and then reconstructed it with staples and silicon caulking. He intensified its distressed appearance by fogging various areas of the image with spray lacquer paint.
© Thomas Barrow. *Reconstructed, Caulked, Interstice*, 1977–79. 15 × 19 inches. Gelatin silver print with automobile lacquers, staples, and silicon caulk.

*The silver nitrate crystals must be completely dissolved before adding the sodium chloride. Wear protective gloves, as the silver nitrate will stain anything it comes in contact with black.

Stock Solution B

Distilled water (68°F/20°C)	8 oz (250 ml)
Gold chloride	15 grains (1 g)

Slowly combine 125 ml of stock solution B with all of stock solution A, stirring rapidly. Allow the bath to stand until it is cold and sediment has formed at the bottom. Pour off only the clear liquid for use, leaving the sediment behind.

Pour this clear solution into a tray and heat it with a water bath to 110°F (43°C). During toning, maintain a temperature of 100–110°F (38–43°C). When toning is complete, treat the print in a washing aid and give it a final wash of at least 1 hour.

Adding stock solution B may revive this bath. The quantity needed depends on the number of prints toned, intensity of the tone desired, and time of toning. For instance, when toning to a warm brown, add 4 ml of stock solution B after about 50 8 × 10 inch prints or the equivalent have been toned.

The toner keeps almost indefinitely and its capacity is extended by adding small amounts of gold chloride solution. Although it may initially appear to be expensive, 1 liter of solution has the capacity to tone hundreds of 8 × 10 inch prints (with replenishment).

This toner requires careful preparation to achieve the expected results. Photographers' Formulary has a prepared Nelson Gold Toner that is similar to Kodak T-21.

Kodak Gold Protective Solution GP-1

For years Kodak Gold Protective Solution GP-1 was the standard treatment to protect a silver-based photograph from atmospheric gases. Recent scientific evidence indicates that selenium toning can be more effective and a great deal less costly for protective measures. GP-1 is an extremely stable toner that is capable of yielding very pleasing brown tones. The high cost of gold has limited its widespread use. Gold toner protects all fiber-based papers and creates at least a slight visual effect in almost all cold-tone papers.

It can also be used to protect negatives.

For protective toning, the print is immersed in the gold toner for about 10 minutes, with agitation, at 68°F (20°C), or until a barely perceptible change in image tone (a slight blue-black) occurs. The toning time can be increased up to 20 minutes for visual effect. Following the toning operation, treat the print with a washing aid and give it a final wash of at least 1 hour.

Photographers' Formulary has a prepared gold protective toner that is similar to Kodak GP-1.

Kodak Gold Protective Solution GP-1 Formula

Distilled Water 68°F/20°C	24 oz (750 ml)
Gold chloride (1 per cent stock solution)	2½ drams (10 ml)
Sodium thiocyanate	145 grains (10 g)
Distilled water to make 32 oz (1 liter)	

Mixing 1 g of gold chloride in 100 ml of distilled water can make a 1 per cent stock solution of gold chloride. Add the stock solution of gold chloride to the amount of water indicated (24 oz). Mix the sodium thiocyanate separately in 4 oz (125 ml) of water. While stirring rapidly, slowly add the thiocyanate solution to the gold chloride solution. GP-1 deteriorates quickly and should be mixed right before use. It has a capacity of about 30 8 × 10 inch prints per gallon. Work in a well-ventilated area and wear protective gloves when mixing this formula.

BLUE TONERS

Kodak Blue Toner T-26

Kodak Blue Toner T-26 delivers solid, deep blue tones on warm-tone papers and soft blue-black tones on neutral-tone papers. It has no effect on cold-tone papers. T-26 increases the contrast and density of the print slightly. This can be corrected by reducing the normal exposure time (a 10 per cent reduction is a good starting place).

This toner deteriorates rapidly and should be mixed immediately before use. Toning starts in the highlight areas and then slowly moves into the shadows. Careful observation is necessary to avoid getting a partially toned print with blue highlights and untoned shadow areas. Berg, Edwal, and Photographers' Formulary also make blue toners.

The range of toning times is 8–45 minutes at 68°F (20°C). Increasing the temperature of the bath to 100–105°F (38–40°C) speeds up the toning action, thus decreasing the toning times to 2–15 minutes. Since toning is slow, only occasional agitation is needed to avoid streaking. For consistent results with a number of prints, slide them rapidly into the toner one after the other. T-26 exhausts itself very quickly. It has a capacity of only five to 15 8 × 10 inch prints or the equivalent per quart. When toning is finished, immerse the print in a washing aid and follow with a final wash of at least 1 hour.

Kodak Blue Toner T-26 Formula

Part A solution

Water (68°F/20°C)	31 ml
Gold chloride*	0.4 g

*A 1 per cent gold chloride solution can be used (available from chemical supply sources). Use 40 ml of this solution as part A and add 937 ml of water to make a total of 977 ml of solution.

Part B solution

Powder thiourea (thiocarbamide)	1 g
Tartaric acid	1 g
Sodium sulfate (anhydrous)	15 g

Dissolve the gold chloride in the water to make part A. Add part A to 946 ml (1 quart) of water at 125°F (52°C). Stirring, add part B. Continue to stir until all the chemicals are totally dissolved.

RED TONERS

Red toners can be intense and spectacular, but they require more work than brown or blue toners to achieve good results. Generally, the best and most varied results require toning the print in two separate toners. For example, a print is first toned in Kodak Sepia Toner or Kodak Brown Toner and thoroughly washed. Then it is immersed in Kodak Blue Toner T-26 for 15–30 minutes at 90°F (32°C) with occasional agitation. Cold-tone papers produce solid reds, while warm-tone papers yield orange-red hues.

Start with a print having more density and contrast than normal, as there is a loss of these qualities, especially in the shadow areas, with most papers. Red tones can be produced in a single bath of Red Toner GT-15 (see formula). Regardless of which method you use, treat the completed toned print with a washing aid and give it a final wash of at least 1 hour. Berg and Edwal also make red and copper toners, which may be mixed to produce intermediate hues and intensities.

Red Toner GT-15 Formula

Stock solution A

Potassium citrate	1½ oz (100 g)
Water (68°F/20°C) to make 16 oz (500 ml)	

Stock solution B

Copper sulfate	115 grains (7.5 g)
Water to make 8 oz (250 ml)	

Stock solution C

Potassium ferricyanide 100 grains (6.5 g)
Water to make 8 oz (250 ml)

Mix stock solution B into stock solution A. While stirring, slowly add stock solution C.

Red Toner GT-15 bleaches the print. Compensate by extending the printing time well beyond normal, up to 50 percent.

FIGURE 8.9 Gaz used sodium ferricyanide to form this image on an undeveloped Polaroid Type 55 negative. Essentially making a chemical drawing, he then exposed the negative to a composition of ash. The artist completed the print by applying gold toner, green toner, red toner, yellow toner, silver toner, and bleach with various tools, including brushes and sponges. Gaz explains, "The work enables me to explore issues of permanence and fragility while paying homage to the ephemeral composition that we live in and with."
© Stan Gaz. *Stan*, from the *Ash Series*, 2006. 50 × 40 inches. Toned gelatin silver print.

GREEN TONERS

Green tones are possible with a toner such as Green Toner GT-16. This toner is most effective on warm-tone papers.

As it bleaches the image, more exposure time than normal (10–25 per cent) is necessary. Berg, Edwal, and Photographers' Formulary make green toners.

Green Toner GT-16 Formula

Stock solution A

Oxalic acid	120 grains (7.8 g)
Ferric chloride	16 grains (1 g)
Ferric oxalate	16 grains (1 g)
Water (68°F/20°C) to make 10 oz (285 ml)	

Stock solution B

Potassium ferricyanide 32 grains (2 g)
Water to make 10 oz (285 ml)

Stock solution C*

Hydrochloric acid	1 oz (28.4 ml)
Vanadium chloride	32 grains (2 g)
Water to make 10 oz (285 ml)	

*First add the acid to the water. Then heat the solution to just below the boiling point and add the vanadium chloride.

Mix stock solution B into stock solution A. Then, stirring vigorously, add stock solution C.

Tone in the mixed solution until the print appears deep blue. Then remove and wash until the tone changes to green. After the green tone appears, continue to wash for an additional 10 minutes. Treat the print with a washing aid and give it a final wash of at least 1 hour.

Removing Yellow Stain

If a yellowish stain appears, you can remove it by placing the print in the following solution:

Ammonium thiocyanate	25 oz (1.6 g)
Water (68°F/20°C) to make 10 oz (285 ml)	

This operation should be carried out before treating the print with a washing aid and giving the final wash.

TONING VARIATIONS

Selective Toning: Using Frisket

One can tone only selected areas of a print by brushing on a mask that prevents the toner from affecting the covered area.

FIGURE 8.10 Addressing issues of the body, including sexual preference and AIDS, Byrd began this piece with medium-format studio shots that were printed on matte surface paper. To add texture, Byrd scratched the negatives by putting them under his shoe and spinning on them. The prints were made about 30 per cent too dark and toned for about 20 minutes in copper toner. The dry prints were torn and glued together and painted with a mixture of glue, sand, and tar. The photographs of the roses, which were done on 4 × 5 inch fiber paper, stand off the larger image about 3–4 inches, and are in gold frames. When installed, a charcoal frame is directly drawn onto the gallery wall around the entire piece.
© Jeffery Byrd. *Listening for Falling Debris*, 1991. 75 × 137 × 3 inches. Toned gelatin silver print with mixed media.

Begin with a frisket material such as Fotomask made by Fotospeed, Grumbacher Miskit, Incredible White Mask liquid frisket, or rubber cement and thinner plus different sizes of brushes. Fotomask is handy because it is a bright red liquid plastic, making it easy to see where it has been applied. Rubber cement, thinned 1:1 (1 part rubber cement to 1 part rubber cement thinner), may also be used. Another option is transparent self-adhesive frisket, such as Photo/Frisket Film made by Badger Airbrush.

Frisket Working Technique

Working on a dry print, brush the frisket or rubber cement onto the areas *not* to be toned. When using rubber cement, apply several thin coats, allowing one to dry before applying the next. This ensures complete coverage and reduces the likelihood of the toner's seeping into areas that are not fully protected.

To avoid leakage into protected areas, some print-makers place the dry print directly in the toner without any presoak. If you do this, you must constantly agitate the print to avoid streaks. The print may buckle and curl due to uneven wetting because of the mask, but this should not harm the print. If this method does not work, presoak the print for 3–5 minutes.

After toning is complete, follow the normal post-toning procedures. Remove the frisket after the print has been washed for about 30 minutes. You can remove Fotomask by picking it up with adhesive tape or by rubbing your fingers across the covered area after the print has gone through about half of its final wash. After you remove the mask, wash the print for a minimum of 1 hour to get rid of any residue from the mask.

Multi-Toned Prints

Different toners can be selectively applied to various areas of the photograph. If you are doing this, you must repeat the entire process each time, with the exception of the extra wash, which is given after all the toning is done. If you do not wish to combine toners, be certain to protect the previously toned areas with frisket.

Areas of a print can be selectively toned while it is still wet. Exact control and evenness of toning are extremely difficult to achieve, but interesting and unexpected possibilities exist with this technique.

FIGURE 8.11 Casanave appreciates pinhole cameras because "their near infinite depth of field allows me to play with visual elements of near and far. The time dilations – long, long exposures – allow water to become cloud, person to become ghost." To produce this image, she made a 10–15 second exposure with her Leonardo pinhole camera. She then developed the TRI-X film in an HC-110 dilution B and processed the print in Lauder Chemical Concentrate (1:7). Casanave first toned the print with selenium toner (1:9), which she then lightly toned for a second time in a natural toner made from Lipton tea. © Martha Casanave. *Untitled*, 2003. 14 × 18 inches. Toned gelatin silver print.

To wet-tone a well-washed print, place it on a clean, flat surface and squeegee the back and then the front so it is completely free of water. Then apply the toner with a brush or cotton swab. You can add a couple of drops of a wetting agent such as Kodak Photo-Flo to the toner to prevent it from beading up on the print surface. For more intensity, rinse the print with water, squeegee, and apply a second coat of toner. Apply only one color toner at a time. You can repeat this process as many times as you wish to obtain the desired results.

Toning with Colored Dyes

Prints can be toned with almost any substance. Natural organic dyes made from beets, coffee, grapes, or tea are possibilities. Commercial dyes, such as RIT, are more commonly used. These are inexpensive, come in a wide range of colors, and are available at most supermarkets.

RIT dyes come in powder form and are prepared by mixing the dye with a gallon of water at 125°F (52°C). Mix the dye thoroughly, as undissolved crystals will stain the print.

Selective and Mixed Dyeing

Dyes, like toners, can be used to make multi-colored compositions. First apply the frisket to any areas you do not want dyed. After the first areas have been dyed, washed, and dried, remove the frisket or rubber cement from the next area that you want to dye. You can protect the previously dyed area with frisket or rubber cement. Then place the print in another tray containing a different color dye. You may repeat this process as many times as needed.

A mixed-colored effect can be achieved by treating the print with different dyes without using any masking materials.

Color Dye Process

1. Presoak the print in water for about 2 minutes.

2. Immerse the print, emulsion side down, in a tray of prepared dye at 100°F (38°C).

3. There is no standard dyeing time. The dye begins to work after about 1 minute, depending on the type of paper used and the color desired. Agitate the print constantly. You can view it anytime, as the dye will continue to work until the print is removed from the solution.

4. When the desired color is achieved, remove the print and wash it for 15–60 minutes, or until all the excess dye is removed.

5. Air-dry the print, face down, on a plastic screen.

Bleaching Dyed Prints

You can use plain household bleach or Farmer's Reducer, applied with a number 0 or smaller brush, to remove small areas of dye from the image. Bleaching can provide accents in highlight areas or be used to create white areas within the composition. Household bleach can also be used to erase or distress a portion of the print surface for emotional and/or visual effect.

Split-Toning

Split-toning can visually expand the sense of color and space within a photograph by intensifying the differences between the cool white highlight areas and the warm brown shadow areas. This can create an unexpected and subtle sense of spatial ambiguity. Some photographers claim that split-toning can unify objects within a composition and give it added depth and separation. Others do not care for it, saying it fractures the continuity of the photograph by making it seem disjointed and out of kilter. Within any split-process, the specific colors are always related to a specific print density or amount of silver present. Photographer Jonathan Bailey "thinks of it as a

FIGURE 8.12 Talman made this photograph with her Holga 120S under the available light in a natural history museum. After processing the T-MAX film with a mixture of Kodak Selectol and Photo-Flo, Talman manipulated and distressed the negatives. She crumpled, scratched, and marked on them to imitate the passage of thousands of years endured by her fossil subjects. She slightly overexposed the image during the printing process to allow for selective bleaching with potassium ferricyanide and toning with two Berg toners, further distressing the print.
© Donna Hamil Talman. *Ancestor Portrait #15*, 2001–2004. 20 × 24 inches. Toned gelatin silver print.

topographical readout of the silver density, rendered in color" (see Figure 8.13). These colors can consistently repeated as long as separations of the densities are maintained. However, minor and often visually undetectable differences will commonly show up as variations from one print to the next. The only way to evaluate the effect of split-toning is to apply the technique to an image and decide whether it creates the desired visual effect. Chlorobromide papers, such as Ilford Warmtone, have two different sizes of silver particles in the emulsion which tone at different rates, making them advantageous for split-toning.

Paper and Developer Selection

As in all toning operations, the choice of paper and developer plays a key role in determining the visual outcome. Silver chloride contact papers deliver a noticeable split-toning effect. The use of a warm-tone developer, such as Kodak D-52 or Kodak Selectol-Soft, with such papers yields an even more vivid effect. Warm-tone chlorobromide enlarging papers also work well, while cold-tone bromide papers show almost no effect. If your negatives are not big enough to contact print, you can enlarge them (see Chapter 3). Photograms (cameraless images made by placing objects directly on the paper) also can be split-toned (see Chapter 11).

A more pronounced split-toning effect seems to take place with the developer temperature slightly above normal. A temperature of 77°F (25°C) with contact paper in Kodak D-52 is a suggested starting point. Keep the temperature constant, as variations of even 1 degree can alter the results.

Processing Procedures

Generally split-toning processes requires a print that is at least slightly higher in contrast than normal. The key is making sure there is a clear separation of tonal values. Experience will determine the required printing fine-tuning. Adjust the exposure time so that contact paper can be developed in Kodak D-52 for 1 minute at 77°F (25°C) with constant agitation. Developing for more than 1½ minutes tends to reduce the split-toning effect. Developing for less than 45 seconds can produce an image with streaks or without the proper density. Split-tone specialist Jonathan Bailey recommends using a 100 per cent hydroquinone developer, such as Zonal-Pro's HQ Warm Tone, which can also aid any paper in accepting toners After development is complete, continue to process following normal print processing procedures, using a non-hardening fixer, up through the first wash. Then you are ready to tone. Keep complete notes, either in a darkroom logbook or in pencil on the back of each print, so you can achieve repeatable results, and make extra prints for experimentation.

Split-Toning Formula

Water (68°F/20°C)	750 ml
Rapid Selenium Toner	70 ml
Perma-Wash	30 ml
Sodium metaborate	20 g
Water to make 1 liter	

Immerse the prints in the toner bath and agitate by continuously interleafing the prints (taking the bottom one and moving it to the top). Observe the prints carefully. Keep an untoned print available for visual reference. First the blacks will intensify. Next the print will exhibit an overall dullness. Finally the shadow areas will start to warm up, and the split between the highlights and shadows will begin to become evident. This should happen within about 4–5 minutes.

Continue toning until you like the color and effect. At this point, put the print in a water bath. If the print tones too long, the split will lose its intensity and eventually disappear, taking on a uniform brown color. When split-toning is complete, treat the print with a washing aid for 2 minutes, then wash for at least 1 hour. Air-dry the print, face down, on a plastic screen.

GP-1 Split Toning Process

Photographer Jonathan Bailey has developed the following process.

Always fix prints to be toned with a nonhardening fixer. Stay with one brand of fixer for consistent results. Sprint nonhardening fixer works very well for split-toning. It is essential to remove the fixer. Test for hypo residual to avoid staining.

1. Tone prints in a working solution of Kodak Rapid Selenium toner (1:10–1:15) until the tones in the print split. Treat the print with a washing aid for 2 minutes, then wash for at least 1 hour.
2. Place selenium toned prints in GP-1 stock solution. With constant agitation, tone prints by inspection until the desired result is reached (usually 3–10 minutes), but times of 30 minutes at not uncommon. The gold tone will strengthen blues in the highlights and will add a dark green to the shadow areas. Tones will continue to shift and finalize after prints are pulled from the toner. Hand wash for 15 minutes. Let prints sit in a water bath and change water every 15 minutes. Air-dry the print, face down, on a plastic screen.

Toning Black-and-White Film

It is possible to tone black-and-white film for color effects. Kodak T-20 is a versatile, single-solution dye toner that can be used to produce many different color effects. Be certain to mix and use this formula only in a well-ventilated area.

GP-1 Split-Tone Formula (Stock Solution)

Part A

Gold chloride	1 g
Distilled water to make 100 ml	

Part B

Sodium thiocyanate	100 g
Distilled water to make 1250 ml	

For a working solution, mix 10 ml Part A to 500 ml water. Add 125 ml Part B, and then water to make 1000 ml. Stock solutions will keep for months in brown glass containers. Use working solution immediately after mixing as it has a limited tray life and discard after use. Working solution tones about 12 8 × 10 inch prints.

Kodak T-20 Dye Toner Formula

Dye*	3–6 grains (0.2–0.4 g)
Wood alcohol or acetone	3¼ oz (100 ml)
Potassium ferricyanide	15 grains (1 g)
Glacial acetic acid	1¼ drams (5 ml)
Water (68°F/20°C) to make 32 oz (1 liter)	

*The amount of dye needed depends on the type of dye being used, as follows:

Nabor Yellow 6G	3 grains (0.2 g)
Auramine 0 (yellow)	6 grains (0.4 g)
Methyl violet	1¼ grains (0.1 g)
Methylene blue BB	3 grains (0.2 g)
Rhodamine B (red)	6 grains (0.4 g)
Nabor Orange G	3 grains (0.2 g)
Nabor Brilliant Pink	3 grains (0.2 g)
Nabor Blue 2G	3 grains (0.2 g)
Bismark Brown	3 grains (0.2 g)
Victoria Green	6 grains (0.4 g)
Fuchsin (red)	3 grains (0.2 g)

Average toning time is 3–9 minutes at 68°F (20°C). The tone will vary depending on the film and length of toning time. Beyond about 9 minutes, there is a danger that the image will begin to bleach out. One should experiment on unwanted or duped film before attempting to tone a finished piece. After toning is complete, wash the film until the highlights are clear, and then continue to give the film a final wash of about 15 minutes. These dyes are not considered archival and will fade over time.

FIGURE 8.13 Bailey made this image with both equipment and processes involving chance and unpredictability. He made the photograph with a Diana camera, developed the TRI-X film in PMK Pyro, and printed it on a warm-tone paper developed in Zonal Pro HQ. He split-toned the image first with selenium toner (1:10), and after washing, applied GP-1 gold toner. Bailey encourages experimentation with split-toning, which he says "is a result of nothing more complicated than a toner's specific response to the density of the silver present on the print surface. I think of it as a topographical readout of the silver density, rendered in color."
© Jonathan Bailey. *Iceberg #11, Change Islands, Newfoundland,* 2004. 20 × 20 inches. Toned gelatin silver print.

FIGURE 8.14 Angel tells us, "These photographs elicit memories and thoughts rather than the specific reality of the observed world. I use a plastic Diana camera that eliminates the detail often found in a traditionally made photograph. Through the camera's distortion, I engage viewers in a dialogue between their own experiences or associations and the photograph itself. After selective bleaching, the print was split-toned in sepia toner. The print was removed from the toner bath Part A before the entire image was affected, quickly rinsed, and put into toner bath Part B immediately. Thus the highlights are warm and the shadows cool."
© Catherine Angel. *Going Home,* from the series *Enchanted Landscapes,* 1994. 16 × 20 inches. Toned gelatin silver print. Courtesy of Catherine Edelman Gallery, Chicago, IL.

RESOURCE GUIDE

Donofrio, Diane (Ed.). *Photo Lab Index, Lifetime Edition.* Dobbs Ferry, NY: Morgan & Morgan, 2001.

Stone, Jim. *Darkroom Dynamics: A Guide to Creative Darkroom Techniques.* Boston, MA: Focal Press, 1979.

OTHER SOURCES

Art Craft Chemicals: www.artcraftchemicals.com.
Edwal: www.bkaphoto.com.

Freestyle Photographic: www.freestylephoto.biz.

Photographers' Formulary: www.photoformulary.com (bulk chemicals and prepared versions of many formulas that are no longer commercially manufactured).

Sprint Systems of Photography: www.sprintsystems.com.

Toning Kodak Black-and-White Materials (Kodak Publication No. G-23): www.kodak.com/global/en/professional/support/techPubs/g23/g23.pdf.

SPECIAL CAMERAS AND EQUIPMENT

WHAT IS A CAMERA?

A traditional camera, from a room-size camera obscura to the latest hand-held automatic, is essentially a light-tight box. A hole (aperture) is made at one end to admit light and light-sensitive material (film, paper, or sensor) is placed inside the box opposite the hole. The camera's purpose is to enable the light to form an image on the light-sensitive material. This can be accomplished in a variety of ways, but most modern cameras have the same basic components (see Box 9.1).

The Camera as a Way of Seeing

The camera remains the primary tool that photographers use to initially define and shape an image. The selection of camera and lens can determine image characteristics such as sharpness, tonal range, field of view, and graininess of the final print. As a result of this, it is often possible to identify the type of camera used in the creation of a particular image. Consequently, the type of camera chosen should support each photographer's way of seeing and working, since it plays an integral role in determining the final outcome of the image. Suffering a creative block? Try switching to an unfamiliar camera format to reinvigorate your vision. Limiting the choices of cameras is to reduce the possibilities of what one can express about the nature of a subject and photography itself.

A superb example of how equipment can influence artistic output can be seen in the work of German philosopher Friedrich Nietzsche, whose failing eyesight forced him to curtail his writing. In 1882 Nietzsche bought a typewriter, learned touch-typing, and was writing once again with his eyes closed, using just his fingertips. But the machine affected his output. A composer friend observed his curt prose becoming even tighter, more succinct. "Perhaps you will through this instrument even take to a new idiom," his friend wrote in a letter, noting that, in his own work, his "'thoughts' in music and language often depend on the quality of pen and paper." "You are right," Nietzsche replied, "our writing equipment takes part in the forming of our thoughts." According to German media scholar Friedrich A. Kittler, switching from a pen to a typewriter caused Nietzsche's prose to change "from arguments to aphorisms, from thoughts to puns, from rhetoric to telegram style."[1]

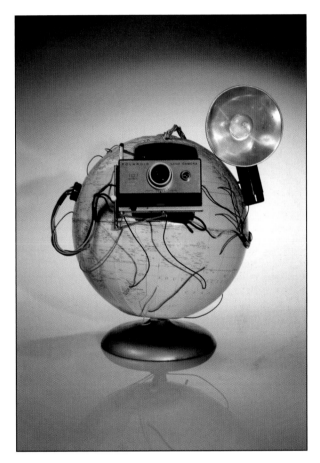

FIGURE 9.1 Kline constructed this handmade pinhole camera from a globe and the bellows and lens of a Polaroid camera to perform a particular task: taking images of maps. In building this purpose-specific camera, Kline examines highly specialized modern technology. He says, "My intent is to recontextualize and subvert the authority-bearing visual culture as a means of disturbing the narrative. The object interventions contained in the installation analyze the conventions and authority of their source material and detour their nostalgic simulacra. The entire body of work that this is connected to is intended to question the use and place of not only images since the advent of these technologies, but also the implantation of these technologies in the formulation of both reality and controlled myth delivered through various forms of mediated information."
© Kevin Kline. *Map Camera*, from the series *Camera Construction*, 2007. 18 × 14 × 17 inches. Mixed-media assemblage.

Box 9.1 What Is a Camera?

- Viewing system that allows accurate image composition.

- Lens, instead of a hole, which focuses the rays of light to form a sharp image at the back of the camera. This image is upside down and backward. The lens also determines the angle of view and influences the depth of field.

- Adjustable diaphragm, usually an overlapping circle of metal leaves that creates an adjustable hole called an aperture. The aperture controls the intensity of the light that passes through the lens. When it is widened (opened), it permits more light to pass through the lens. When it is closed (stopped down), it reduces the amount of light passing through the lens.

- Shutter mechanism that prevents light from reaching the film until the shutter is released. The shutter opens for a measured amount of time, allowing the light to strike the light sensitive recording material (film or sensor). When the time has elapsed, the shutter closes, preventing any additional light from reaching the light sensitive material.

- Focusing control that changes the lens-to-film distance, thus allowing a sharp image of the subject to be formed at various distances.

- Light-sensitive material that records the image created by the light. Most analog cameras record images on film in rolls, cassettes, or individual sheets. Digital cameras capture images magnetically on memory cards.

- Holder for the light-sensitive material. This is a system or device designed to maintain the correct position of the film or sensor in relationship to the lens.

- A film-advance mechanism, in roll and cassette cameras, that advances the film after an exposure is made to the next available unexposed portion of the roll or cassette. Sheet film is loaded into film holders that are put in the back of the camera. Digital cameras automatically go to the next free space on the memory card.

- Light meter, usually built into the camera body, measures the intensity of the light and runs automatic exposure programs.

Throughout the history of photography, the changing needs of photographers, as well as the expanding applications of the medium and technical innovations, have led to the development of many specialized camera designs. Cameras are the result of centuries of evolutionary change. This can be seen in designs from the past, such as Etienne-Jules Marley's photographic gun (capable of capturing a

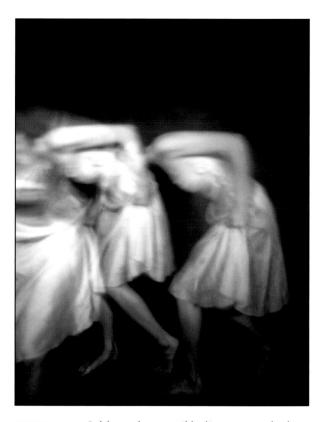

FIGURE 9.2 Belcher embraces a "blind" process involved in making a self-portrait with a pinhole camera. To make this image, she exposed the Polaroid Type 55 sheet film for 1–2 minutes, holding each separate pose for about 30 seconds. With this photograph, Belcher examines the origins of movement, which she says, "Is one way to access and give visual form to what lies beneath the surface of the skin. The making of these photographs is an exploration of the nature of each movement and where it originates internally."
© Alyson Belcher. *Self-Portrait #2B*, 2002. 5 × 4 inches. Gelatin silver print. Courtesy of Robert Tat Gallery, San Francisco, CA.

sequence of images on a single round photographic plate), to those of the present, as in cell phone cameras.

The camera's design is a basic part of a photographer's visual language. It is up to each photographer to understand and apply a camera's capabilities, to learn its strengths and limitations, and to know when to use different cameras to achieve the desired results. Regardless of camera type being used, most photographers want to acquire some basic accessories as included in Box 9.2.

We assume each reader has a fundamental knowledge of the basic cameras currently in widespread use, including the SLR, digital single lens reflex camera (DSLR), the range finder, the twin lens reflex, and the view camera. If you are not familiar with how these cameras operate, a review is in order before continuing with this chapter. This chapter introduces cameras and techniques that photographers have used to explore nontraditional, inventive photographic visions.

Box 9.2 Basic Camera Accessories

1. Sturdy, lightweight tripod.
2. Gray card plus white-and-black paper for light meter readings and color balancing.
3. Digital light meter (especially with strobe lights).
4. Filter set of red, blue, yellow, and polarizing filters.
5. Lighting equipment such as camera flash, flood and/or mono lights.
6. Hot shoe to PC adapter (preferably voltage stabilized) and PC cord, which will allow the use any PC sync-cord flash unit if your camera does not have a PC socket.
7. Camera case (hard or soft).
8. Lens cleaning kit.

RESOURCE GUIDE

Adams, Ansel. *The Camera*. Boston, MA: Little, Brown, 1983.

THE PINHOLE CAMERA

Enter into a dark room and make a small round hole in the window shade that looks out onto a bright outside scene. Hold a piece of translucent paper 6–12 inches from the hole and you will see what is outside. This optical phenomenon, which dates back to the ancient Greeks, provides the basis for making pinhole (camera) photographs. Note that the image will be upside down, the same as in our eyes – our brain turns it right side up.

Birth of the Camera

This optical observation lead to the invention of the camera obscura (Latin for "dark room"), which is a drawing device used to project an image onto a flat surface where it can be traced. By the sixteenth century the camera obscura was in common use by artists, such as Leonardo da Vinci. In 1658 Daniello Barbaro placed a lens on the camera obscura. It was this device that helped to work out the understandings and uses of perspective, which had been baffling artists, scientists, and scholars for centuries. Daguerre's camera was an uncomplicated camera obscura with a lens.

How the Camera Works: Circles of Confusion

An optical image is made up by what is known as tiny circles of confusion. Technically, the circle of confusion is the size of the largest circle with an open center, which the eye cannot distinguish from a dot, a circle with a filled-in center. It is the major factor that determines the sharpness of an image and the limiting factor of depth of field. When these circles are small enough to form an image they are called "points" and the image is considered to be in focus. The pinhole camera has infinite or universal depth of field, because it creates circles of confusion that are about the same size as the pinhole all over the inside of the camera. These tiny circles of confusion are small enough to be considered points of focus that have enough resolution to form a coherent image. This means that everything from the foreground to the background appears to have the same degree of sharpness. This uniformly soft, impressionistic image is characteristic of pinhole photographs. Adding a lens makes smaller points of focus and thus creates a much sharper and more detailed, coherent image.

Building a Pinhole Camera

For a couple of dollars and a few hours of time, you can build a simple pinhole camera. Many photographers find it gratifying to use their hands to build a camera that in turn forms the basis of their photographic vision. The pinhole camera removes you from the expensive high-tech environment of the standard formats of automatic cameras and returns you to the basic function of vision.

You can make a pinhole camera out of any structurally sound light-tight container (avoid shoeboxes). A 4 × 5 inch film box (100 sheet size) makes a good first pinhole camera with a wide angle of view, because the closer the light-sensitive material is to the pinhole, the wider the field of view and the shorter the exposure. Oatmeal boxes and coffee cans are also commonly used. One can also be built from scratch. See the materials list in Box 9.3.

Making the Pinhole

Get a thin (0.002) piece of brass or aluminum about 2 inches square from an automotive or hardware store. Also obtain a sharp, unused sewing needle (see Table 9.1). A #13 needle is ideal for a 4 × 5 inch film box (the smaller the pinhole, the sharper the image and the longer the exposure time). Since the distance between the front and back of the box is short, a larger needle hole could result in exposure times that are too short.

Hold the needle between your thumb and index finger and gently drill a hole in one side of the metal. Then turn the metal over and drill the other side. Do not stab a hole into the metal. Use very fine sandpaper to remove any burrs around the hole. Repeat this procedure until the opening is the same size as the diameter of the needle. By drilling, sanding, and slowly expanding the hole, you should end up with an almost perfectly round aperture without any burrs. The more perfectly round and burr-free the pinhole, the sharper the image will be.

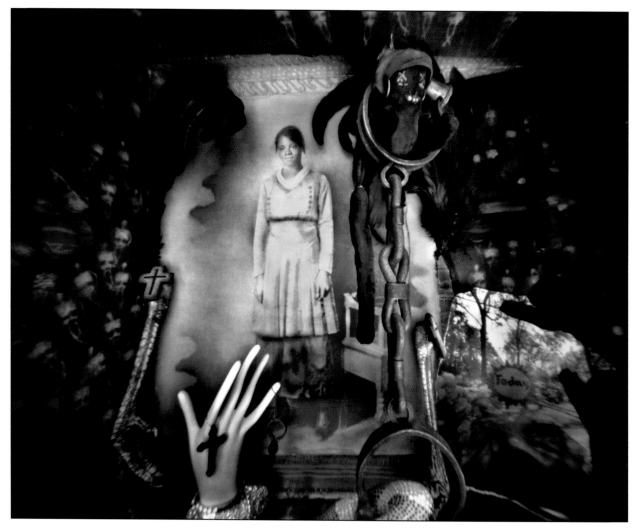

FIGURE 9.3 Using 4 × 5 inch Fuji NPS film in their 3 inch Leonardo 4 × 5 inch pinhole camera allowed Spencer and Renner to avoid the color imbalance that pinhole cameras often create. Exposing this film for 6–8 minutes produced more intensely saturated colors and the illusion of additional lighting. The final photograph, printed on Fuji Crystal Archive paper, created for the duo a new perspective on the assemblage, which they had originally constructed 15 years earlier as social commentary.
© Nancy Spencer and Eric Renner. *White Hand*, from the series *on deaf ears*, 2001. 29 × 23½ inches. Chromogenic color print.

Box 9.3 Pinhole Camera Building Materials

1. Sheet of stiff matt board or illustration board at least ¹⁄₁₆ inch thick. One side of the board should be black. This will be the inside of the camera. The black helps to reduce internal reflection.

2. Sharp X-Acto (number 11 blade is good) or mat knife.

3. A 2 × 2 inch piece of brass shim or aluminum. An offset plate, obtained from a printer, is ideal. You can also use an aluminum pie pan or TV dinner tray.

4. Glue. Any household white or clear glue is fine.

5. Steel-edged or plain straight-edged ruler will deliver a far more accurate and close cut than a cheap plastic or wooden ruler.

6. #10 or #12 sewing needle.

7. Small fine file or number 0000 sandpaper.

8. Ballpoint pen.

9. Black photographic pressure tape or black electrician's tape.

TABLE 9.1 Diameters of Common Sewing Needles

Needle Number	Hole Diameter (inches)
#4	0.036
#5	0.031
#6	0.029
#7	0.036
#8	0.023
#9	0.020
#10	0.018
#12	0.016
#13	0.013

Shutter

After completing the drilling operation, find the center of the front of the camera box. At this center point, cut a square opening equal to half the diameter of the metal pinhole material (1 inch square). Save this cutout for use as a shutter. Center the pinhole metal inside the box and secure it with black tape.

Darken the cutout on all sides with a black marker. If necessary, put black tape around the sides so it fits snugly back into the camera front, over the pinhole. Let a piece of tape stick out to act as a tab-type handle. This handle will allow the cutout to form a trapdoor-style shutter that can be removed and replaced to control the

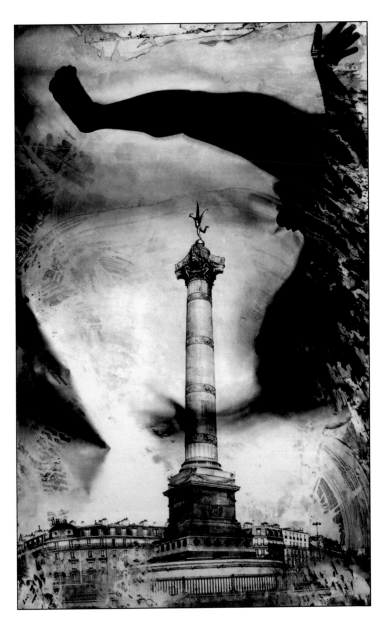

FIGURE 9.4 Wolff combines pinhole and photogram processes to craft his "stenograms." He uses his van as a large-scale pinhole camera and during the exposure he places figures or objects against the photographic paper, integrating them into the photogram. Wolff tells us, "This physical contact blends with the image of the outside external world to create a new meaning and reality. The large size of the paper offers the possibility to develop the photograph using sponges, brushes or even my hands for better control of the process. The photographic image is a drawing made by light, but by painting it with chemicals, I can create a new image filled with color and texture."
© Ilan Wolff. *Place de la Bastille*, 1997. 76¾ × 49½ inches. Gelatin silver print. Courtesy of Charles Nes, New York and Grünberg, Zurich.

FIGURE 9.5 Babcock drilled a hole in the center of this specially produced Hills Brothers coffee can, bearing a quintessential Ansel Adams photograph of Yosemite Valley, to construct his homage pinhole camera. Babcock uses the camera to capture scenes similar to those Adams was known for making, yet Babcock gravitates toward slightly less unspoiled settings. He explains that he aims to "honor the history of Ansel Adams but also to find my own direction irrelevant of all those Yosemite Valley photos taken by tourists."
© Jo Babcock. *Ansel Adams Coffee Can*, 1994. 9 × 6 × 6 inches. Mixed media assemblage with pinhole. Courtesy of Visual Studies Workshop Gallery, Rochester, NY.

exposure time. Another option is to simply use the black plastic top from a film container and hold it in place with your hand or tape. Aluminum foil and tape also work.

The Aperture Formula

To determine the f-stop of your pinhole camera, simply measure the distance from the pinhole to the film plane and divide by the diameter of the pinhole. The formula for calculating the f-stop is: $f = v/d$ where f equals aperture, v equals distance from pinhole to film or paper, and d equals pinhole diameter. For example, a 0.018 inch pinhole at a distance of 2 inches from the paper (focal length) produces an f-stop of 111.

Starting Paper Exposure Times

Begin by exposing black-and-white photographic enlarging paper outside in daylight. Single-weight fiber paper without any printing on the back works best. This paper is readily available, inexpensive, easy to process, and you can see exactly what is happening under the safelight. Typical daylight exposures with a film-box camera can run from 1 to 15 seconds, depending on the time of day, the season, the size of the pinhole, and the focal length (the distance from the pinhole to the paper).

After making the exposure, process the paper using normal black-and-white methods. If the paper negative is too dark, give it less exposure time. If it is too light, give it more exposure time. Trial and error should establish a paper negative with proper density within three exposures. When you get a good negative, dry it and then contact print it (emulsion to emulsion) with a piece of unexposed paper. Light will penetrate the paper negative. Process and then evaluate the paper positive. Make exposure adjustments and reprint until you are satisfied. After experience is gained it is possible to expose any type of photographic material in the pinhole camera.

After you have mastered the camera and the black-and-white enlarging paper, you are ready to expose any type of photographic material in the pinhole camera. Materials may include black-and-white or color film, regular RA-4 color paper, Ilfochrome (which gives a direct positive), and even Polaroid materials such as SX-70, which can be processed in an SX-70 camera.

Converting a 35 mm Camera to a Pinhole Camera

You can convert a 35 mm camera to a pinhole camera by covering a UV filter with opaque paper in the center of which you have made a good pinhole. Attach the pinhole filter to the camera's lens and it becomes a pinhole camera. You also can convert an old snapshot-type or disposable camera to a pinhole camera by removing its lens and replacing it with a pinhole aperture. Zero Image Company (www.zeroimage.com) makes a modified body cap, called a Zone Plate, for various film and digital cameras that has a laser-cut pinhole. They also make wooden pinhole cameras.

RESOURCE GUIDE

Renner, Eric. *Pinhole Photography: From Historic Technique to Digital Application*. Fourth Edition. Boston, MA: Focal Press, 2009.

Shull, Jim. *The Beginner's Guide to Pinhole Photography*. Buffalo, NY: Amherst Media, 1999.

For all things pinhole, including the *Pinhole Journal*, contact Pinhole Resource: www.pinholeresource.com.

Pinhole cameras: www.pinholeblender.com

General pinhole information: www.pinhole.org

FIGURE 9.6 To make this photograph of the Eastman House, Babcock drove to the site in his pinhole camera, a Volkswagen van with a lens-mirror built into its roof. Once parked in front of the Eastman House, Babcock blacked out the windows and adjusted the pinhole as necessary to capture the image. He used chromogenic paper as a paper negative original and processed test prints in tubes while on site in the van. Babcock effectively emphasizes the historic process of which he is a part by using this hand-built camera van to take a picture of the well-known photography museum in negative. © Jo Babcock. *Eastman House, Rochester, NY,* 1989. 20 × 37 inches. Chromogenic paper negative. Courtesy of Visual Studies Workshop Gallery, Rochester, NY.

CUSTOM CAMERAS

A small group of photographers build their own cameras or modify existing models for some of the reasons:

- Aesthetic pleasure and craftsmanship of creating one's own photographic instrument.
- Conceptually relating the camera to the images it produces.
- Carrying out a specific function for which there is no commercial equivalent.
- Economic reasons, to make equipment for less than it would cost to buy it commercially.

RESOURCE GUIDE

Here are also numerous individual who modify cameras and make modern camera obscuras and camera lucidas.

CameraObscura/LucidaShop:stores.ebay.com/Camera-Obscura-Lucida-Shop.

Abelson Scope Works: www.abelsonscopeworks.com.

PLASTIC CAMERAS

The Diana

If you are feeling alienated by the latest high-tech camera equipment, try the simplicity of a plastic toy camera. Beginning in the early 1960s, the Diana (120 film size camera) was made by the Great Wall Plastic Factory of Kowloon, Hong Kong. A number of different Diana models were produced. The original has only a single shutter speed (the shutter speed varies tremendously from camera to camera, from about 1/30 to 1/200 second). Some models have a B (bulb) setting for time exposures. The Diana F had flash attachment, but the synchronization often does not work properly. The shutter on these cameras can be fired repeatedly, making multiple exposures easy to produce (often unintentionally). All these models have three aperture settings: sunny (f-16), cloudy (f-6.3), and dull (f-4.5). The cameras also have adjustable zone focusing areas, which can be set at 4–6, 6–12, and 12 feet to infinity. The Diana uses 120 roll film to make 16 2 × 2 inch exposures per roll. There were also numerous clones marketed under other names such as Arrow and Banner.

Diana+

The main sources for these cameras are secondhand stores, yard sales, flea markets, camera shows, and online auctions. However, a new Diana+ has been produced by the Lomographic Society International (www.lomography.com). This homage version has innovative features including: two shutter settings (daylight and bulb), three aperture settings, and manual focus. Additionally, the Diana+ offers a removable lens and super-small aperture for pinhole images; two image formats (12 or 16 square shots on a standard 120 roll); an endless panorama feature that allows for unlimited and nearly seamless panoramic shots; a standard tripod thread and shutter lock for shake-free long exposures; and a removable flash unit.

The Holga

The Holga, made in the tradition of the Diana, is currently being manufactured. It uses 120 film, and produces

FIGURE 9.7 Bates made this image with her Holga 120S, which, as she says, required a combination of skill, experience, and luck. She processed the TRI-X 120 film in HC 110 developer longer than recommended to make more contrasty negatives. To produce an image with deep blacks and good tonal separation, she mixed her own Dr Beers Developer for "greater control over mid-tone contrast." Bates also constructed her own negative carrier so the entire negative could be printed for the shape and framing distinctive to Holga negatives.
© Michelle Bates. *Wild Horses: Grandfather Cuts Loose the Ponies, Vantage, WA,* 1994. 15 × 16 inches framed. Gelatin silver print.

6 × 4.5 and 6 × 6 cm negatives. It has a 60 mm, f-8 plastic lens and focuses from 3 feet to infinity. The Holga's shutter speed is about 1/100 second and has two f-stops: f-8 (normal) and f-11 (sunny). The Holga 120N has a standard tripod mount, a hot shoe for flash, a bulb (B) setting, and a 6 × 6 cm plastic mask that yields tighter, sharper images. No two Holga cameras are the same; some have slow shutters, others have peculiar lens distortions, while others have light leaks. There are a number of models with various features such as a glass lens and a color wheel to tint your flash with yellow, red, blue, or clear gels, plus accessories including a Polaroid film back.

While the optics of the two cameras are not exactly alike, the basic Holga is so inexpensive (usually under $25) that you can purchase additional cameras and feel free to alter the plastic lens for individual visual effects.

Plastic Camera Characteristics

Light Leaks

Almost all the classic cameras have light leaks. The Dianas tend to have many more leaks, especially around the lens barrel while the Holgas have some inherent leaks, which can usually be fixed. Some photographers wrap black tape around the camera body, after the film is loaded, to prevent stray light exposure of the film. The red transparent frame-counter window and the inside seams of the camera also can be taped. Some people paint the camera's interior flat black. The area where the lens is attached to the camera has been known to leak light, requiring additional taping.

You can take multiple images on one frame or overlap images by partially winding to the next frame. The film-advance mechanism does not always completely tighten the exposed film, resulting in a light fog when the film is removed from the camera. Many Diana and Holga users combat this by unloading the film in a darkroom or changing bag and then placing the film in an opaque container or wrapping it in aluminum foil. Others just go with the flow and take whatever surprises the camera may provide.

The Lens

Plastic lenses create a soft-focus image. Theses lenses tend to be sharpest in the middle, with the focus falling off rather rapidly toward the edges. They are not color corrected, so unusual color effects and shifts are normal.

The Viewfinder

The plastic camera's viewfinders are not corrected for parallax, so what you see in the viewfinder is not exactly the same as what the lens sees. This produces an image with a somewhat haphazard look because you have to figure out the composition by intuition and guesswork. Often what you see is higher than what the lens sees; raising the camera slightly can compensate for this. For instance, the Holga often records about 25–30 per cent more than the viewfinder indicates.

Film Selection

Black-and-white or color films may be used. Negative films having an ISO of 400 are often favored to compensate for the limited range of camera adjustments. These fast films provide a greater tolerance for exposures that are less than perfect (a likely situation with the cameras). The faster films tend to emphasize grain and texture, adding to the lack of traditional image clarity for which Diana and Holga photographs are known.

Why Choose a Plastic Camera?

The plastic cameras question photographic axioms such as "a photograph must be sharp," "a photograph must have maximum detail," and "a photograph must possess a complete range of tones to be considered good." These cameras challenge photographers to see beyond the equipment and into what makes up the essential elements of an image.

The plastic cameras also are easy to use. Since extensive adjustments are not possible, there is no need to use a light meter or to calculate shutter speeds and f-stops. Finally, these cameras summon up the Dadaist traditions of chance, surprise, and a willingness to see what can happen.

FIGURE 9.8 Foltz worked with a Diana camera instead of a more technologically sophisticated camera and lens to "yield an image that maintains the foreground/background relation present in actual human vision and refuses to create the illusion of a world of complete clarity. Such an instrument is remarkably well suited to capture the translucent and opaque gradations of water as well as bather and water." After shooting the photograph with her toy camera, Foltz developed her TRI-X 400 film and printed the image on Ilford warm-tone fiber-based paper developed in Dektol (1:3). © M.K. Foltz. *Three*, from the series *Bathers and Waters*, 1983 to 1986. 9 × 9 inches. Gelatin silver print. Courtesy of The Afterimage Gallery, Dallas, TX.

This lack of control can free you from worrying about doing the "right" thing and always being "correct." Since these cameras are toys, they allow you to look at and react to the world with the simplicity and playfulness of a child or use their distinctive look for your own vision.

RESOURCE GUIDE

Bates, Michelle. *Plastic Cameras: Toying with Creativity.* Boston, MA & Oxford: Focal Press, 2007.

Holga Manual. Third Edition. Hollywood, CA: Freestyle Photographic Supplies, 2008 (http://www.freestyle-photo.biz/pdf/HolgaManual3.pdf).

Lomographic Society International: www.lomography.com (specializing in selling and promoting nonmainstream cameras).

DISPOSABLE CAMERAS

A contribution to our throwaway culture is the disposable camera. It was conceived as a way to sell film and prints to people who do not own a camera, are caught without one at a special moment they wish to capture, or just have the urge to shoot some snapshots. Typically these use 35 mm cameras have a cardboard or plastic body containing a fixed-focus plastic lens with simplified internal workings.

These disposables offer photographers an inexpensive way to expand their image-capturing abilities. One unusual model is the Kodak MAX Water & Sport, which has a shock-proof rubber shell and is waterproof up to 50 feet (15 meters). This makes it an ideal camera for use during inclement conditions. It features a fixed-focus, single-element 35 mm plastic lens with one exposure setting of f-11 at 1/110 second. The camera comes loaded with 27 exposures of ISO 800 film and has oversize controls for ease of use while underwater. A camera like this enables the photographer to take pictures without the fear of damaging expensive equipment. Other cameras come with black-and-white film and even a different focal length lens.

Re-Using Disposable Cameras

You do not have to dispose of a disposable camera after a single use. Many disposables can be carefully opened, reloaded with whatever type of 35 mm film is desired, resealed, and reused. The plastic lens tends to produce a rather soft image similar to that produced with the Diana or Holga camera. As long as relatively fine-grain film is used and small prints are produced, the image quality should be acceptable. This soft effect can be exaggerated by making big enlargements. Using higher speed films is a way to achieve a heightened grain effect. It is also possible to remove the plastic lens and replace it with a pinhole aperture, thus creating a store-bought pinhole camera.

RESOURCE GUIDE

The Kodak Website offers downloaded opening instructions for all its disposable cameras: www.kodak.com/eknec/PageQuerier.jhtml?pq-path=2879/4191/4196/4213&pq-locale=en_US.

eCameraFilms: www.ecamerafilms.com (offers an array of single-use cameras, including custom event cameras that have printed announcements on the camera body).

CHANGING THE ANGLE OF VIEW

Many photographers find that the so-called "normal" lens that comes with their camera limits their vision. These imagemakers want their work to reveal a larger sense of visual space. Dealing with broader expanses of space poses a number of problems. Aesthetically, there never seems to be enough visual information in this type of photographic image, prohibiting the image from successfully conveying the sense of physical space at the site where the photograph was made.

Technically, due to distortion problems with cameras and lenses, it is problematic to achieve a realistic rendition

FIGURE 9.9 To record this expansive storefront from a very narrow road, Palmer used a 210 mm Schneider Apo-Symmar-S wide-angle lens on his 8 × 20 inch Wisner camera. He underexposed the TRI-X film (−1, based on the Zone System method), underprocessed it (−1, based on the Zone System method) with PMK, and stained it with Pyro developer in an effort to retain the detail of the highly illustrated storefront. Palmer contact printed the image on Kodak AZO processed in a combination of Kodak Selectol Soft and Dektol.
© Scott Palmer. *Saloonatics – B-16*, 2003. 8 × 10 inches. Gelatin silver print.

of sweeping expanses of space. Traditionally, there are two approaches to solving this problem: the use of ultra-wide-angle lenses and the use of special-purpose panoramic cameras. Some contemporary imagemakers have abandoned both these methods in search of a new aesthetic answer. They have come up with alternatives such as combining many individual images to create a single nontraditional representation of the scene. See the section on panoramic mosaics later in this chapter and Chapter 11 for discussions of some of these methods.

Rectilinear Wide-Angle Lenses

The first method most photographers think of when they want to portray an expanded sense of space is the ultra-wide-angle lens.

The latest lenses are rectilinear, meaning that they are designed to reproduce straight lines without bending or distorting them. An example of such a lens is the 14 mm Nikkor f-2.8 that produces a 114 degree sweep, giving a broad sense of open visual space. The amount of distortion is minimal, providing the subject has been vertically aligned with the camera back on a leveled tripod. The slightest tilt will cause straight parallel vertical lines to converge. Circular spaces and rounded objects tend to reveal more distortion than those with straight horizontal planes. Many of these lenses have built-in filters or a rear filter holder that accepts gelatin filters, thus encouraging the photographer to interact with and further interpret the scene.

The cosine law dictates that there is always some light falloff with a rectilinear lens. This loss of illumination is noticeable in the corners of the frame (vignetting), making the center of the image appear brighter. The amount of falloff depends on the quality of the lens.

Wide-angle lenses have more depth of field at any given aperture than their normal or telephoto cousins. This can be used to advantage when a photographer wants to maintain image sharpness from the foreground through the background. Wide-angle lenses also allow imagemakers to get very close to a subject and manipulate the depth of field to control what parts of the image will remain in focus.

Full-Frame Fish-Eyes

A typical full-frame fish-eye provides 180 degree diagonal coverage and about 150 degree coverage across the 36 mm side of 35 mm film. Unlike a rectilinear lens, a high-quality full-frame fish-eye should not produce any vignetting. However, these lenses do suffer from heavy barrel distortion. The center portion of the lens (about 5–10 degrees) usually has the least distortion, which becomes more pronounced toward the edges of the frame. As a result of this, strong vertical lines on both sides of the frame will bend toward each other. Visually, this can result in a sense of closed space, which defeats one of the main reasons for using a full-frame fish-eye. If bending lines are not acceptable, you should not consider using these lenses. Some photographers like this barrel distortion and incorporate it in their imagery. When evenness of illumination is of prime importance, the full-frame fish-eye is preferable to a wide-angle rectilinear lens.

FIGURE 9.10 Orland attached a 47 mm Super Angulon lens onto a Veriwide 100 camera to produce an almost 90 degree angle of view. When he originally printed this photograph in 1976, Orland split-toned the image to generate sepia tones in the background mountain peaks and cold tones in the foreground and then hand-colored the foreground sign with artist's oils. When he returned to this image 25 years later, he scanned the negative and digitally toned and colored it to produce a similar effect. Both versions examine the history of photography in Yosemite National Park. As Orland states, "The natural landscape in the distance is rendered in sepia tones reminiscent of the nineteenth century photographs of Carleton E. Watkins and Eadweard Muybridge, while the foreground gives way to the cold selenium tones favored by Ansel Adams. And lastly, manmade artifacts appear and the sign breaks out into lurid color, creating a Yosemite more vivid than reality."
© Ted Orland. *One-and-a-Half Domes, Yosemite National Park*, 1976. 13 × 20 inches. Inkjet print. Courtesy of Ansel Adams Gallery, Yosemite, CA.

FIGURE 9.11 Attaching a 17 mm fisheye lens to her Nikon F engagingly distorted and exaggerated Bauer's subject, a found rock sculpture. Tilting the enlarging head on her Besler 23C II, she exposed this image to several pieces of photographic paper she collaged and adhered to a nearby wall. Then she processed each sheet separately, using a standard process, and toned the prints in Agfa brown toner. To construct the final work, Bauer reassembled the collage and stitched the pieces together with an upholstery needle and double thread. For Bauer, "combining various media accomplishes more than the mere sum of the parts. Each medium is like its own language that comes with its own set of associations."
© Amanda Bauer. *Spiral of Rocks*, 1998. 18½ × 25 inches framed. Toned gelatin silver prints with thread.

Macro Lens

There are other times when imagemakers need to concentrate on only a very small area of a subject. A macro lens is designed for used in extreme close-up photography, focusing on subjects from a close distance, often allowing subjects to be photographed 1:1. Most digital cameras have a macro mode, which facilitates close-up or copy work. A normal focal-length macro lens is an ideal choice for most film cameras. The characteristics of a true macro lens consist of a flat picture field, high edge-to-edge definition, and maximum color correction. This combination delivers uniform sharpness and color rendition, regardless of focus distance, from the center and the edge of the lens.

Zoom lenses with a macro mode can also be used, but may produce slightly soft (not sharp) results. Bellows attachments, extension tubes, or auxiliary lenses, often referred to as *diopters*, usually supplied in sets of varying degrees of magnification, can convert a normal focal length lens into a very versatile copy lens.

A macro lens or macro mode can also serve as a postmodern imaging tool. For example, one can rephotograph small sections of an a subject, utilizing photography intrinsic elements such as angle, cropping, focus, and directional light, to alter the subject's original context and meaning.

Lensbaby

Special accessory equipment, such as a Lensbaby, can be very useful in controlling depth of field. Used in conjunction with a SLR or DSLR camera, a Lensbaby allows you to bring one area of your image into sharp focus while the remainder is surrounded by graduated blur. You can adjust this spot to any part of your composition by bending the flexible lens tubing. The high-end model allows you to lock the lens in place by pressing a button on the focusing collar. The f-stops are controlled by means of changeable aperture disks. Macro, wide-angle, and telephoto lens kits are also available (see www.lensbabies.com).

PANORAMIC CAMERAS

Why will an ultrawide-angle lens on a 35mm camera not produce a panoramic photograph? Regardless of how short (wide) the focal length of the lens happens to be, the aspect ratio remains unchanged. The aspect ratio is the height-to-width relationship of any film format. The 24 × 36mm format of a 35mm image has an aspect ratio of 1.5:1, making it 50 per cent wider than it is high. A panoramic camera achieves its effect by altering the aspect ratio, making its horizontal plane two to five times wider than its vertical plane, thus increasing the sense of space.

Types of Panoramic Cameras

Panoramic cameras can be divided into three basic designs:

1. A swing-lens camera having a curved film plane.
2. A specially built roll film or digital camera capable of recording a horizontal slice of an image. This is achieved by using a longer-than-normal focal length lens designed for use on a larger format (view) camera.
3. A 360 degree camera whose entire body rotates while the film is pulled past a stationary slit that acts as the shutter. These cameras are actually "any angle" cameras. The amount of visual coverage is determined by setting the camera to rotate for a prescribed number of degrees. Many can be reprogrammed to go past a complete 360 degree circle until they run out of film to expose.

Swing-Lens Cameras

The Russian-made Horizon 202 is the least expensive swing-lens camera that produces a 120 degree horizontal and 45 degree vertical view on a 24 × 58mm frame. It has a built-in bubble spirit level that is visible from the top of the camera and can also be seen in the viewfinder for use in hand-held shots. When the camera is level, the camera produces an image with a straight horizon. When the image is taken with the camera tilted up or down, the horizon looks bent. The Horizon 202 comes with a 28mm f-2.8 lens and an aperture range from f-2.8 to f-16. It has a shutter with two speed ranges; the first is 1/2, 1/4, and 1/8 of a second and the other is 1/60, 1/125, and 1/250 of a second. These exposure times are achieved by varying the slit width of the shutter from 6 to 1.5mm in combination with the rotation speed of the lens. A 4 × 5 inch enlarger is needed to make prints larger than contact size.

The medium priced Noblex cameras use the principle of a lens rotating 360° for one exposure. The film, resting on the curved film plane, is exposed through the constant shutter slit. During the first half of the rotation the lens drum is accelerated to a constant speed ensuring absolutely even exposure of the film during the second half of the rotation. This results in distortion free photographs with an angle of view of 146° when using a Noblex Pro 6/150 and 138° when taking pictures with a Noblex Pro 175.

The much higher priced Round-Shot 28-220 is a swing-lens camera manufactured by SEITZ Phototechnik in Switzerland and takes 120/220 film. The Round-Shot has reflex viewing, so the photographer can preview the scene to see what the lens will take in at any given angle setting. It is run by a hand-held control unit and features a push-button microprocessor panel that includes a LCD that allows you to set all functions of the camera: shutter speed, angle of the camera, timer and film type. The camera operates in 90 degree increments, allowing for up to eight shots equaling 720 degree views on 35mm film.

The swing-lens cameras all possess similar characteristics. They have limited shutter speeds, as the speed indicated applies only to the vertical section of the film being exposed by the focal plane slit at any given moment. The overall length of time it takes to make the exposure is longer than the indicated shutter speed. The actual exposure time is how long it takes the swinging lens to make its full sweep. For this reason, the sharpest results are obtained when the camera is on a tripod. Hand-held swing-lens cameras are sharp only at high shutter speeds. These cameras must be held on the top and bottom, not on the front and back, or your fingers might be included

in the picture. Holding these cameras by hand can require some practice to produce a decent image. Most of these cameras work best on a precisely leveled tripod, as camera tilt results in either concave or convex horizons.

Since the lens is closer to the center of the subject than to either of its ends, the "cigar effect," which visually expands the center portion of the image, comes into play. It is most noticeable with straight parallel lines. Objects moving in the same direction as the lens rotation may be stretched, and those moving against the lens rotation may be compressed. By learning how this effect works, you can either use it to your advantage or compensate for it. A conventional flash will not provide adequate coverage with this type of camera.

A good used swing-lens camera to consider is the 35 mm Widelux, whose 26 mm fixed-focus lens provides a 24 × 56 mm frame, produces a 140 degree view, and is the best-known and most widely used of the swing-lens cameras. It gives a wide field of view and offers good image size, and the image can be printed on a 2¼ inch enlarger. The Widelux image is made by a lens that swings left to right and has a curved film plane to compensate for the angle of the swinging lens. The camera does not have a conventional shutter but a focal-plane drum-slit mechanism to make and record the exposure. The Widelux 1500 works on the same principles but uses 120 roll film to give a 150 degree view on a 50 × 122 mm frame.

Roll Cameras

Roll cameras equipped with a view camera-type lens produce a more limited panoramic effect but do not have the exaggerated perspective of an ultrawide-angle lens on a normal camera. This design alters the aspect ratio by providing an elongated frame. The Horseman SW617 Pro that produces an ultrawide 6 × 17 cm image is an example of such a camera. It also has rise and fall movements camera movements, achieved by moving the lens up and down, which enables more accurate perspective control that is effective in architectural and interior photography. Along with six types of dedicated lens units, it takes roll film holders in two formats, 6 × 17 cm (120 roll film/four exposures) and 6 × 12 cm (120 roll film/six exposures), which can be attached to the back of the camera unit. It also has an optional ground glass back that allows for critical focusing and compositioning.

Another choice is the Linhof Technorama 617 S III, a 6 × 17 cm format camera that has interchangeable 72, 90, 180 or 250 mm lens that exposes four frames on 120 or eight frames on 220 roll film. The Linhof Technorama 612 PC is a 6 × 16 cm format which has 58 and 135 mm interchangeable lenses, an 8 mm rise that gives the effect of a shift lens, and takes 120 or 220 roll film.

Many discontinued models can be purchased at much lower prices. Examples of these cameras include the Fuji GX 617, a 6 × 17 cm format, which has four interchangeable lenses: a 90 mm f-5.6, a 105 mm f-8, a 180 mm f-6.7, and a 300 mm f-8 lens. The GX 617 camera can use either 120 or 220 roll film.

One of the most versatile out of production roll film cameras is the Hasselblad XPan Dual Format Panoramic camera with interchangeable lenses. The XPan can make 24 × 65 or 24 × 36 format sizes on the same roll of film. The 24 × 65 format has an aspect ratio of 1:2.7, but since the film lies flat, distortion is minimal. Three medium-format lenses were made for the camera: a 90 mm (with angle of view of 23 or 39 degrees and the approximate equivalent of a 50 mm lens on a 35 mm camera when in panoramic mode), a 45 mm (with angle of view of 44 or 71 degrees, with the approximate equivalent of a 25 mm lens on a 35 mm camera when in panoramic mode), and a 30 mm lens (with angle of view of 62 or 94 degrees with an approximate equivalent of a 17 mm lens on a 35 mm camera when in panoramic mode). The XPan utilizes DX coding, aperture priority, TTL automatic metering, and auto-bracketing. Focusing is done through a range finder that is lens and format coupled and provides parallax correction.

360 Degree Camera

The Hulcherama 120S is a 360 degree camera that uses 120 or 220 film with a 35 mm lens to create views up to and beyond 360 degrees. It can use Mamiya, Hasselblad, or Pentax lenses, and has an up and down lens shift and through the lens viewing. Out of production 360 degree cameras to consider include the Globuscope, which has a 25 mm lens capable of producing a complete circular image of 157 mm on 35 mm film; and the Alpa Roto 60/70, which uses either 120, 220, or 70 mm film, has a 75 mm lens to deliver 360 degree views.

Panoramic Effects Without a Panoramic Camera

It is possible to simulate the look of a panoramic camera image with a normal single-frame camera by capturing a series of overlapping views. This is called the panoramic mosaic working technique.

With a 35 mm camera, you would use a lens having a focal length of 35–55 mm. Lenses with wider or narrower focal length tend to create more distortion when you attempt to put the images together. To make the matching of the single frames easier, begin by photographing an outside scene that is evenly illuminated by daylight. Load the camera with a slow film (ISO 25–100) for maximum detail. Kodak T-MAX 100 is a good film to start with. Place the camera on a precisely leveled tripod with a panoramic head calibrated to show 360 degrees. Use a midrange to small lens opening (f-8 or smaller) to ensure that you get enough depth of field. Using a cable release or self-timer, make a series of exposures covering the entire scene. Overlap each successive frame by about 25–33 per cent.

After printing is complete, overlap the prints. For the most naturalistic look, carefully match the prints' tonality. (Extra care must be taken during the printing of the images to make sure the tonality is constant.) Trim and butt them together where the seam is least obvious. For the most accurate perspective, trim and butt together only at the center 10–15 degree portion of each image. Prints may be attached to a board using dry-mount tissue or an acid free PVA adhesive such as Jade No. 403 distributed

by Talas (www.talasonline.com). If you plan to dry-mount the print, be sure to tack the dry-mount tissue to the back of the print before trimming.

Instead of butting the images exactly together, you can mount them separately with space in between. This style of presentation is known as a floating panorama.

Some cameras are equipped with a so-called panorama mode, which is a film mask that alters the aspect ratio but does not produce a true panoramic view.

Numerous digital cameras come with software programs that will combine, "stitch" together, separate frames to form a constructed panorama.

SEQUENCE CAMERAS

Specially designed sequence cameras such as the Hulcher 35 mm Model 112 and the Hulcher 70 (70 mm) Model 123 can expose a prescribed number of frames during a specified period of time. You can load these cameras with magazines holding 100–400 feet of film, and they can make exposures as rapidly as 65 frames per second

(f.p.s.). The limited hand-production of the Hulcher cameras makes them very expensive. Detailed information is available from the Charles A. Hulcher Company (www.hulchercamera.com).

Power Winders and Motor Drives

Many film and digital cameras come with a built-in power winder or frame advance that can make exposures at the rate of 2–6 f.p.s. Most 35 mm SLRs have optional motor drives that are capable of exposing film at a similar rate. Either type is usually more than adequate for most sequential uses. Some professional cameras have special film backs that increase the number of exposures (up to 250) that can be made without reloading.

Single-Image Sequences/16 mm Movie Cameras

Even without a sequence camera, power winder, or motor drive, you can achieve a sense of sequential time by

FIGURE 9.12 The artists photographed their set-up scenes with a 16 mm Bolex movie camera. After processing, they edited, sequenced, enlarged, and stripped the negatives for the final series of images that was contact printed. Hollis Frampton (1936–1984) and Marion Faller satirize the images of Eadweard Muybridge, whose exhaustive study of *Animals in Motion* (1899) and *The Human Figure in Motion* (1901) included over 20 000 photographs of men, women, children, and animals in common and occasionally unusual types of movement. Faller and Frampton employed the visual devices of Muybridge's nineteenth century study, including the scientific grid, while creating humorous scenarios like Mature Radishes Bathing and Zucchini Squash Encountering a Sawhorse.
© Marion Faller and Hollis Frampton. *782.Apple Advancing [var. "Northern Spy"]*, from the series *Sixteen Studies from VEGETABLE LOCOMOTION*, 1975. 11 × 14 inches. Gelatin silver print.

stringing together a series of individual images into a single composition. If grainy enlargements are not a problem, you might consider using a 16 mm movie camera to make sequential images. Using a movie camera is ideal because it is designed to make a sequence of single-image exposures (typical speeds are 8, 16, 24, 32, and 64 f.p.s.). The digital video camera revolution has caused the prices of 16 mm equipment to drop drastically, making them an affordable option. Black-and-white 16 mm negative film, such as Eastman Double-X (ISO 200 tungsten or ISO 250 daylight) is available in 100 foot rolls. These films have to be processed by a commercial lab with 16 mm capability.

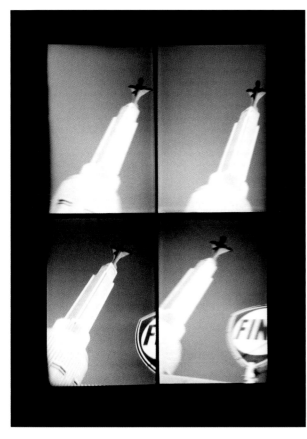

FIGURE 9.13 A toy four-shot sequence camera provides a simple and inexpensive technique of creating unusual spatial juxtapositions, exaggerating proportions, altering scale, and disrupting space and time. By purposely moving the camera while it was making its exposures, Hirsch plays off of the Renaissance system of one-point perspective by fragmenting the subject and redefining it from various viewpoints. Each frame offers new information, implying meaning is a continuous process of visual change that is relative to the viewer's mental and physical position, thereby making doubt a major subject of the image. This four-frame compression also allows the audience to comprehend, in a single view, the multiplicity of a subject.
© Robert Hirsch. *FIN*, 1989. 20 × 16 inches. Toned gelatin silver print.

Archaic and Toy Cameras

Over the years, various manufacturers have produced cameras capable of making sequential exposures. Examples include the Graph-Check, which has eight separate lenses that are fired sequentially in a controlled time span of $^1/_{10}$–4 seconds onto 4 × 5 inch film. The Yashica Samurai, with automatic focusing and a 25–75 mm zoom lens, can expose a roll of 35 mm film continuously, like a movie camera, or one frame at a time as quickly as you can press the shutter-release button. Such cameras can now be located via online auctions and used camera sources. A good source of used equipment is eBay.com or the monthly publication *Shutterbug* (www.shutterbug.net).

Another possibility is inexpensive, plastic point-and-shoot sequence cameras marketed and distributed under various names like Action Sampler. These cameras feature four single-element lenses that make four separate exposures about $^1/_8$ second apart on a single frame of 35 mm film. Currently a model can be ordered from www.lomography.com.

Digital Sequential Images

Although not covered, digital imaging hardware and software offers numerous potentials for capturing and editing sequential images.

OBSOLETE SPECIAL-USE CAMERAS

Scale Model Camera

There been numerous specialized cameras manufactured to accomplish particular tasks. One such camera is the Photech Scale Model Camera, which was built to meet the needs of architects, designers, engineers, and others who work with tabletop models. It allows them to see how the model will look at full size. The Scale Model Camera is small and lightweight, and it has an inverted periscope snorkel design that enables the photographer to position it within the model rather than outside it. This greatly increases the number of vantage points from which images of the interior of the model can be made, while maintaining the correct perspective. The camera comes equipped with an f-90 lens, giving it an almost infinite depth of field from about 2½ inches to infinity. It has an optical viewfinder that allows you to preview the image without distortion. Exposures are made on Polaroid 3¼ × 4¼ inch film by using a remote-control device. This ensures sharp pictures by eliminating camera shake, one of the biggest problems in scale model photography.

Half-Frame Cameras

A 35 mm half-frame camera exposes one-half of a standard 35 mm frame, doubling the number of exposures that can be made on a roll of film. Originally designed to be compact cameras, Olympus made 19 "Pen" models

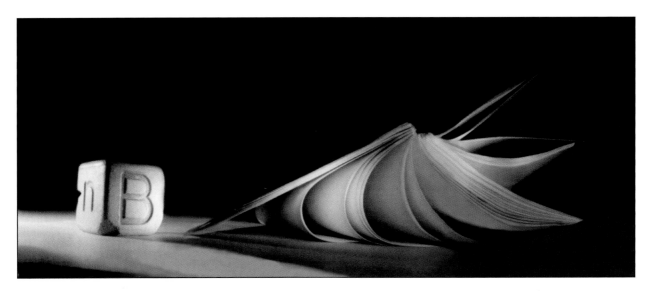

FIGURE 9.14 A Charette MC-150 Scale Model Architectural Camera allowed DeFillips Brush to make this eye-level photograph. In addition to using the light from two nearby 40 watt bulbs, the photographer gleaned additional light throughout the image by aiming two small, moving flashlights during the 2 minute exposure. She rephotographed the Polaroid 665 originals using a Mamiya 645 camera and processed her Kodak PLUS-X with Kodak D-76. DeFillips Brush then scanned the negatives and combined several digital images, each of which demonstrated the best lighting of the different objects, to make the final composite image, which she further altered by digitally dodging and burning. This photograph exhibits DeFillips Brush's "interest in the mutable condition of language. Words seek a secure syntactic position, but meaning constantly is devised, revised, relocated, transfigured. After considering the letters on the block, I chose to make the planes with the 'n' and the 'b' visible, the abbreviation for the Latin 'nota bene,' used to alert readers to 'note well.'"
© Gloria DeFilipps Brush. *Untitled (7450)*, from the series *Language/Text*, 2000. 13 × 36 inches. Inkjet print.

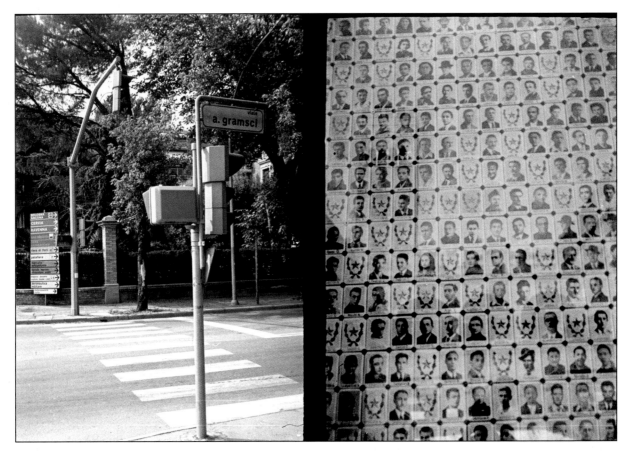

FIGURE 9.15 Photographer and video and installation artist Steve Harp used a Canon Demi half-frame camera, which makes 72 (rather than 36) exposures on a roll of 35 mm film, to produce diptych images about travel, place, and history. The camera makes vertical rather than horizontal images, allowing two adjacent frames to be put together in the negative carrier and printed as one image. Using his camera quickly as a sketchbook, Harp produced a series of diptychs in which juxtapositions are created and where each individual image is seen or considered in terms of the other.
© Steve Harp. *Diptych – Forli*, 1998. 16 × 20 inches. Gelatin silver print.

and four "F" series reflex models from 1959 to 1983, virtually creating the half-frame market. The name Pen derives from the concept that a camera could be carried and used as easily as a writing instrument. Photographers have intentionally used a variety of half-frame cameras to create diptychs. They deliberately expose the film knowing that they will print the subjects of the two half-frames as a single image to form a visual juxtaposition.

110 Format and APS Cameras

In the past, serious photographers have used other amateur style cameras such as the Pentax Auto 110 (1979–1983), a bantam SLR that used 110 film cartridges and featured interchangeable lenses. The tiny negative was an excellent way to produce exaggerated grain and soft focus effects. Today similar results can be achieved with high-speed film and the Advanced Photo System (APS), which was introduced in 1996 but is now only supported by a small number of manufacturers. The APS cameras use a film cartridge about a third smaller than a conventional 35 mm cassette.

RESOURCE GUIDE

A good reference to learn about such cameras is *McKeown's Price Guide to Antique & Classic Cameras*. The latest edition lists and describes over 40 000 cameras, lenses, and accessories. It also provides technical and historical information as well as current market values. For details, see: www.camera-net.com.

STEREOSCOPIC PHOTOGRAPHY

The fusing of photography with Sir Charles Wheatstone's discovery of the stereoscopic effect – the illusion of the third dimension on a flat field of view – set off two waves of stereo mania in Europe (1854–1880) and the US (1890–1920). Stereo cards became immensely popular because of the illusion of depth, space, and solidity that they were able to produce. The stereo phenomenon, like television and computers of today, found its way into millions of homes, bringing entertainment, education, and propaganda in a manner deemed aesthetically pleasing by the public at large. It is still occasionally used commercially for special promotions, which featured a 3-D section and viewing glasses.

Producing the Stereo Effect Photographically

Taking separate photographs of a subject from two different viewpoints creates the 3-D effect. These viewpoints are 2½ inches apart, which is the average distance between the pupils of the human eyes. The easiest way to do this is with a stereo camera. The typical stereo camera has two lenses, 2½ inches apart, and an interlocking double shutter that simultaneously exposes the two images side by side on the film. A print from each image is properly mounted on a standard 3½ × 7½ inch stereo card. The right image is on the right side of the card and the left image is on the left side, with 2½ inches between the centers of the images. The card is then placed in a stereo viewer, whose main purpose is to present the right image only to the right eye and the left image only to the left eye. The brain combines the two images, creating the visual sensation of the third dimension.

Stereo Cameras

The last big boom in stereo followed World War II and lasted until the late 1950s. Many cameras, viewers, and projectors were made during this time, and they constitute the majority of stereo equipment still used today. The most common cameras were manufactured by Kodak, Revere, Sawyer, Stereo Realist, and Wollensak. The Nimslo, which uses the lenticular screen (described in the next section), was manufactured in the 1980s. The Loreo Stereo Camera is the only stereo camera currently being made and is marketed under a number of different names. The Loreo stereo 3-D camera kit has twin 28 mm fixed-focus lenses and uses 35 mm film. The kit comes with its own viewer, which holds 4 × 6 inch prints. The Polaroid passport cameras, which make two exposures at the same time on a single piece of Polaroid film, also can be used to make stereo portraits.

Lenticular Screen Cameras

Some stereo cameras produce 3-D effects by interlacing the images through the use of a lenticular screen. The lenticular screen is made up of a transparent pattern of tiny lens elements called lenticules. The lenticules recreate an image on the emulsion as a series of lines or points from which a completed image is formed. When viewed, the lenticules allow only the right eye to see the right lens image and the left eye to see the left lens image. This permits the human brain to blend the images, thus producing a 3-D effect. Stereo cameras such as the Nimslo, Nishika, and Trilogy use the lenticular system. Special processing of the prints is required to produce the stereo effect. The lenticular screen is used to make stereo postcards, posters, and magazine illustrations.

Stereo with a 35 mm Camera

Draw a light pencil line down the center of a 3½ × 7 inch, two-ply matte board (the stereo card). Attach the right image to the right of this line and the left image to the left of the line. For viewing, put the card on a flat, evenly illuminated surface. Cut a piece of matte board to about 3½ × 5 inches and place the 3½ inch side on the centerline between the two images. Look down the 5 inch side. The board will act as a divider, keeping the right eye focused on the right image and the left eye focused on the left image. Inexpensive twin plastic lenses are available for easier viewing.

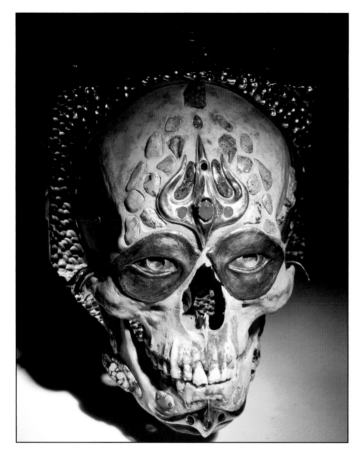

FIGURE 9.16 Belger built this camera using a 500-year-old Tibetan human skull and named it after Yama, the Tibetan god of death. He inlaid several precious gems on the exterior of the skull, and created a brass pinhole in each eye, which he cast from bronze and silver. Belger placed a divider inside the skull, effectively creating two cameras that mimic strereoscopic vision, and inserting a contact print into the back of the camera showed Belger what Yama "saw." Because the camera's small aperture did not allow for a viewer, he put a 4 × 5 inch Polaroid back in the camera's film slot, allowing him to check the composition and exposure of his photographs. For Belger, this camera functions as the bridge between the subject and himself. "With pinhole photography, the same air that touches my subject can pass through the pinhole and touch the photo emulsion on the film. There's no barrier between the two."
© Wayne Martin Belger. *Yama*, 2006. 16 × 10 × 19 inches. Skull with aluminum, titanium, copper, brass, steel, silver, gold, turquoise, sapphires, rubies, and opals.

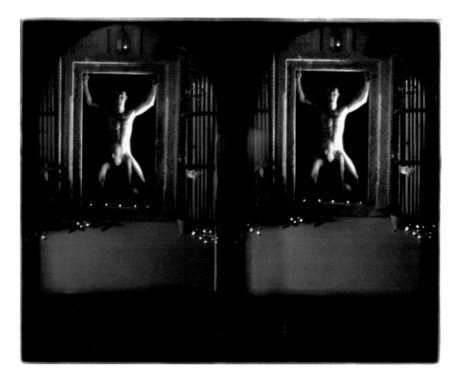

FIGURE 9.17 Belger made this stereoscopic photograph with his handmade Yama camera, essentially capturing what the 500-year-old skull "saw." For the first half of the 3 minute exposure, his subject knelt, and for the second half, the subject stood and raised his arms, creating the illusion of two figures. Belger printed the photograph on Forte Polywarmtone, which he developed with Ilford Harman warm-tone developer that he had mixed weaker than suggested with half water and half Fotospeed LITH printing developer. The effects of this mixture, which created harsh darks on the edges of the image and soft tones in the center, were intensified with the application of Kodak Brown Toner. Belger produced further contrast by hand-painting the figure with prickly pear cactus black tea.
© Wayne Martin Belger. *Brahma*, 2006. 16 × 20 inches. Toned gelatin silver print.

The simplest way to experiment with stereo photography is with a 35 mm camera. Just make two exposures of a static (nonmoving) scene. After you make the first exposure, shift the camera to the left 2½ inches and make the second exposure. This can be accomplished by making the first exposure with the camera up to the right eye and the second exposure with the camera up to the left eye. Binocular stereo attachments that consist of mirrors and prisms, which split a 35 mm frame into a narrow vertical pair, are marketed for 35 mm cameras.

Make prints no larger than 3½ × 3½ inches of the right and left images, making certain that the density of both is the same. Mark the back of the right image with an "R" and the back of the left with an "L" to avoid confusing the two.

Auxiliary Matched Focusing Lenses

An auxiliary pair of matched focusing lenses, which mount directly into a SLR or DSLR body with allow the camera to make stereo exposures. One such device is the Loreo 3D Lens in a Cap, which has a matched pair of focusing f-11 lenses with a focal length of 38 mm and have a focusing range from one meter to infinity.

Digital Stereo

Artist Michael Bosworth makes 3-D images by means of digitally printing overlapping stereo images with red/blue or red/cyan ink, which are then viewed with special colored glasses. When seen through a red filter, red ink and white paper appear much the same. A red filter will block all blue color causing an image printed with cyan ink to appear black. This is similar to exposing the sky on black-and-white film with a red filter that will reproduce the blue sky as black while clouds remain white. Overlapping red and cyan images will be seen by each eye independently and when viewed with cyan and red filters creates the illusion of depth.

In his *Niagara Falls* images (Figure 9.18), Bosworth used a single camera to make two exposures from different perspectives. A camera was placed on a tripod with a device allowing the camera to be moved side to side, between exposures, to create images from two perspectives. Stereo illusion works if the subjects of two images occupy nearly the same space in both images. If the subject changes position between exposures, the illusion will not work. Usually, a stereo camera uses two lenses to make two simultaneous exposures of the same scene. Although the water pouring over the falls was continually moving, a shutter speed lasting several seconds caused the water to take on a constant form. The smooth blur of the water occupied the same position in each exposure taken minutes apart.

After developing the black-and-white film, Bosworth selected and digitally scanned two negatives producing a pair of grayscale images. Using Photoshop, a new CMYK file of the same resolution and proportions as the grayscale images was created. One of the grayscale images was copied and pasted into the cyan channel of the new file, while the other grayscale image was pasted into the magenta and yellow channels. The resulting image, when printed in ink and viewed with cyan/red glasses, provides the illusion of depth.

FIGURE 9.18 Bosworth made two 5 second exposures with his Mamiya RB 67, which he attached to a tripod that shifted the camera six inches to the side during the exposures. After exposing and developing the black-and-white film following standard procedures, he scanned the two images. He then pasted one into the cyan channel and the other into the magenta and yellow channels. After making adjustments, Bosworth printed the images together on Ilfotrans paper, providing red/blue glasses for the viewer to see the stereoscopic photograph properly. Bosworth appreciates the possibilities that the Niagara River provides for this kind of imagemaking. "The Niagara has a sublime consistency allowing it to be photographed in stereo with a single camera. Water flowing over the cataracts offers a landscape that is fluid in movement but largely constant in form." © Michael Bosworth. *Niagara Winter No. 1,* from the series *Blue Water,* 2004. 22 × 30 inches. Digital chromogenic color print with light box.

3D Software

Digital software is available that allows one load your left and right eye images and then automatically mixes them into a single color or black-and-white 3D image.

RESOURCE GUIDE

Berezin Stereo Photography Products: www.berezin. com/3D.

Loreo 3D: www.loreo.com.

National Stereoscopic Association: www.stereoview.org.

Stereoscopy.com: www.stereoscopy.com (all around 3D resource).

Stereo 3D Web Ring Unlimited: www.ringsurf.com/netring? action=info&ring=2eyesR.

STROBOSCOPIC PHOTOGRAPHY

High-speed photography can be traced back to 1851 when William Henry Fox Talbot attached a page of the *London Times* to a wheel, which was rotated in front of his wet-plate camera in a darkened room. As the wheel rotated, Talbot used spark illumination from Leyden jars to expose a few square inches of the newspaper page for about $^1/_{2000}$ second to produce a readable image. In 1887 Ernst Mach achieved the first successful images of bullets in flight by the light of a single flash from a spark gap. In the early 1930s, Dr. Harold Edgerton of the Massachusetts Institute of Technology (MIT) perfected the modern electronic flash, ushering in the modern era of stroboscopy. Today photographs of moving subjects made by the use of repeated flashes or a pulsing light source are known as stroboscopic photographs.

Stroboscopic Effects

There are two ways that stroboscopic effects are generally used to make photographic images. The first method of stationary film stroboscopy takes place in a darkened room, where the shutter of the camera is opened for a very brief time. During this time, the successive flashes of light from a stroboscope stop and capture a subject in motion. The result shows the subject at different points during its course of travel on a single piece of film. Dr. Edgerton's widely known images are examples of this process. The limitations of this method include the number of exposures that can be made on a single piece of film before the event becomes chaotic, and the actual length of time (determined by the speed of the subject's motion) that is available to record the path of the subject's travel.

The second method, moving film stroboscopy, permits a clear and detailed visual record of a subject's motion to be made over a longer period of time. This method is discussed in the following section.

Moving Film Stroboscopy

The following items are needed to carry out moving film stroboscopy:

1. A 35 mm camera with a T (time) or B (bulb) setting that permits the film to be rewound with the shutter open. Some cameras automatically close the shutter when the film is rewound.
2. A strobe that can be operated at a fractional power setting, such as $^1/_{32}$ or $^1/_{64}$, and can be fired in quick succession. Flash units with a stroboscope mode designed for use with motor drives are ideal because of their rapid recycling time. For those who want to purchase a true stroboscope, Radio Shack stores sell the least expensive stroboscopes.
3. Thirty-six exposures of black-and-white or color film. Find a shooting area with a dark background (black is best) and enough room for the subject to carry out its intended path of motion. It must be possible to darken this area so that the stroboscope becomes the sole light source. Set up the stroboscope so it illuminates only the subject and not the background.

Load the camera with your film of choice and advance the film until the next to last frame appears on the film counter. To avoid exposing any of the film, it is

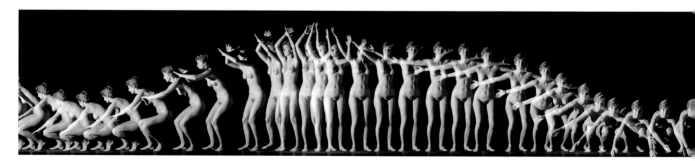

FIGURE 9.19 To overcome some of the limitations of using a strobe to stop action, Davidhazy has done extensive work with moving-film stroboscopy. These methods enable him to analyze motion in detail over an extended period of time while producing motion-analysis images suitable for publication.
© Andrew Davidhazy. *Untitled*, circa 1995. 1 × 9 inches. 35 mm transparency film.

best to do this in a darkroom or changing bag with the lens cap on, the aperture closed, and the shutter set to the highest speed. Make certain that the shutter is completely wound before going on to the next step. If the last wind leaves the shutter half-cocked, push in the rewind button and finish the cycle without forcing the camera's mechanism.

Place the camera on a tripod. Set the camera's aperture to what it would be for a normal single-flash exposure based on the subject-to-flash distance or a flash meter.

Focus on the subject. Push the rewind release button to enable the film-advance sprockets to turn freely without tearing the film perforations. Set the shutter at the T or B setting. If you use B, lock the shutter in its open position with a locking cable release. Turn off or block out any light except the stroboscope or flash.

Turn on the strobe and have the subject begin its motion. Observe it a few times to get a good idea of its path of travel. When you are ready to make the exposure, open the shutter with the T or B setting and start winding the film at a steady and even pace as the subject performs, illuminated only by the strobe. If you are using a camera strobe, an assistant can hold and fire it off-camera. The key factor in determining the outcome is the speed at which the film is wound past the open shutter, based on the length of film in the camera. There are three basic factors to consider in deciding how quickly to wind the film:

1. The speed at which the subject travels.
2. The frequency of the strobe illumination.
3. The amount of separation desired between images.

RESOURCE GUIDE

Collins, Douglas, and Joyce Bedi. *Seeing the Unseen: Dr. Harold E. Edgerton & the Wonders of Strobe Alley.* Cambridge, MA: MIT Press, 1994.

Davidhazy, Andrew. "Moving Film Stroboscopy." *Kodak Newsletter for Photo Educators*, vol. 21, no. 1, pp. 1–3, 1988.

UNDERWATER EQUIPMENT AND PROTECTION

Until recently, if you wanted to make pictures in or around water, you had only two options: get a Nikonos 35mm underwater camera or find a cumbersome watertight housing for the equipment. Today there are numerous options available.

From the 1960s until production ceased in 2001, the Nikonos was the underwater camera by which others were measured. The last production model, Nikonos V, has interchangeable lenses, is submersible to a depth of 160 feet, can be operated manually or by automatic aperture priority, comes with TTL flash metering, has a film speed range of ISO 25–1600 and is still commonly available.

Sea & Sea offers underwater digital camera systems and housing featuring the DX-1G camera set with a depth rating of 180 feet/55 meters. Their discontinued film cameras, some of which can be submerged to 150 feet, offer a wide array of professional features, including interchangeable lenses, electronic flashes, and other accessories, are still widely available.

RESOURCE GUIDE

Sea & Sea: www.seaandsea.com.

SeaLife: www.sealife-cameras.com (offers a line of underwater digital and film camera systems).

Weatherproof versus Waterproof

The development of the weatherproof/waterproof lens shutter, or compact camera, has provided a number of affordable alternatives for those wanting to make images under wet conditions. These cameras are essentially automatic point-and-shoot machines to which weather/water protection has been added. They are designed for people with an active lifestyle who do not want to risk ruining their expensive camera gear in a canoe or on a ski slope. Many different models of waterproof and weatherproof cameras are

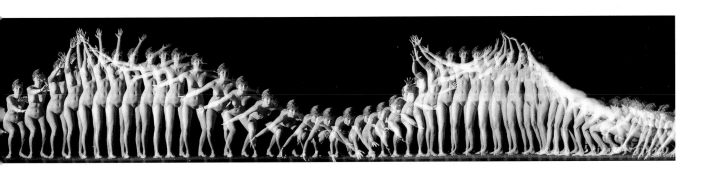

available. There is even a disposable waterproof camera. It is important to distinguish between a completely submersible camera (waterproof) and one that only resists water, dirt, dust, and sand but cannot be submersed (weatherproof). The manufacturer will usually state how many feet one can submerge a waterproof camera.

The latest generation of digital waterproof cameras brings electronic imaging to previously inhospitable situations. Nevertheless, numerous film cameras are also still available. Typically the models are lens shutter cameras and not SLRs. They have Galilean finders that provide only an approximation of the exact image size. They have a limited submersible depth, ISO range, and exposure control, but in exchange, a photographer gets a less expensive, lightweight, and durable camera capable of delivering good image quality in average lighting conditions.

Submersible Bags

Another option is the mechanically sealed, heavy-duty plastic bag, which enables photographers to keep their equipment dry and still operate the camera controls. High-quality bags such as EWA-Marine housing have optical glass lenses for distortion-free images and built-in gloves for easy operation. They also are large enough to handle flash units and motor drives and are tested to a depth of 100 feet/30 meters. These bags can be adapted to fit almost any camera, from a compact to a 6 × 7 cm unit. Bags are also available for camcorders.

For the general transporting of camera and electric equipment and in wet conditions, such as on a raft trip, try a product such as the Aquapac. Their camera bags have clear optical quality that permits exposures to be made through the case. Aquapac bags are guaranteed to float if dropped in the water and are water submersible to 15 feet/5 meters.

RESOURCE GUIDE

EWA-Marine: www.ewa-marine.com.
Aquapac: www.aquapac.net.

Hard Cases

To protect equipment when you are traveling or when doing fieldwork, consider purchasing a rugged, lightweight, shock-resistant, watertight case made of noncorrosive, light-reflecting material. Pelican equipment cases, which claim to be watertight, airtight, dust proof, and crush proof, are an excellent value. They come in numerous sizes and are made from high-impact ABS structural resin and have a neoprene O-ring seal with a purge valve that is watertight to 10 feet.

Hard Case Alternative

An inexpensive alternative to buying a hard case is using a large portable ice chest, such as those made by Coleman or Igloo. If watertight security is not important, an ice chest packed with foam offers excellent protection for photographic gear.

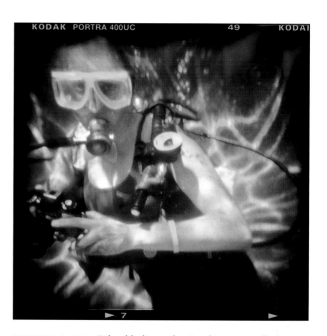

FIGURE 9.20 Orland believes that "making art is all about overcoming obstacles." To overcome the obstacle presented by the pool of water that threatened to damage his Holga, he wrapped it in a standard Ziploc bag. By removing as much of the air as possible from the bag, he retained his ability to operate the camera's controls. Though the bag slightly compromised the camera's ability to focus clearly, Orland rightly considered this inexpensive solution a success. He appreciates the Holga's plastic lens, which "filters out excessive sharpness so that realism doesn't get mistaken for reality."
© Ted Orland. *Robin Underwater*, 2004. 16 × 16 inches. Inkjet print. Courtesy of Ansel Adams Gallery, Yosemite, CA.

RESOURCE GUIDE

Pelican: www.pelican.com.

What to Do if Equipment Gets Wet

Should a piece of photographic equipment get wet, quick action is necessary to save it from total ruin. If salt water is the culprit, flush the item with fresh water. Then open the equipment up as much as possible and completely dry it with a hair dryer set on low. A drying oven also can be effective and is easy to construct. Place the wet equipment in a plastic bag with a zip-type closure. Place the nozzle of a hairdryer inside the bag and zip the bag closed. Secure any open spaces with tape. Then make a small hole at the opposite end of the bag so the air and moisture can escape. Turn the hair dryer on low and let it run until the gear is totally dry. When the equipment is dry, take it to a camera repair shop as soon as possible.

END NOTES

1. Nicholas Carr. "Is Google Making Us Stupid?" *The Atlantic*, July/August, 2008. www.theatlantic.com/doc/200807/google

HISTORIC AND ALTERNATIVE PROCESSES: BEAUTY, IMAGINATION AND INVENTIVENESS

hus far this book has primarily dealt with applications of traditional silver-based photography. There are numerous historic processes, often referred to as "alternative processes," that are no longer commercially profitable for large manufacturers, but offer distinctly different approaches for creating photographic images. Some were regarded as technical breakthroughs, while others were favored for a particular purpose, but all were displaced in favor of new processes that are more convenient, faster, and cheaper to use. Table 10.1 "Alternative Photographic Processes", prepared by Michael Ware, provides an overview of many of these methods.

Some of these processes come from other visual mediums, like drawing, painting, and printmaking. Other methods, such as the use of a copy machine and/or scanner, derive from commercial communications. These processes are often combined, blurring the boundary lines between the various visual arts media (see Chapter 11). Some can deliver, such as platinum, offer a longer tonal scale while others, such as gum, produce synthetic colors. If French writer Marcel Proust was correct when he said that art is a "translation" of life, then learning about these processes can expand your horizon of possibilities and promote further ways of expressing your ideas about the world.

The common factor among these diverse processes is that they do not produce an image that looks like a traditional gelatin silver photograph. The "straight" print is what most people expect to see when they look at a photograph. It is the cherished frozen instant, removed from the flow of linear time that has been preserved for contemplation and examination. The task of this predominant type of photograph is to accurately record and document the visible world in a manner that society has agreed is truthful.

The current interest in these *other* flexible ways of working can be traced back to the 1960s.[1] During this period many photographers actively began questioning the limitations of the straight photograph, particularly its spare range of working materials and the prescribed area in which a photographer was supposed to operate. The 1960s was an exciting time of explosive growth for the art of photography. Influential artists, such as Andy Warhol and Robert Rauschenberg, dynamically commingled photography with other media, inspiring both interest and experimentation across a wide range of photo-based imagemaking. In response to demand, photography programs sprung up in art departments where it cross-pollinated with other media, inspiring young artists to explore new perspectives. As these people entered the field, especially education, they in turn energetically taught their students to see things through multiple different prisms.

Imagemakers who followed this path of investigation wanted to make visible the hand of the creator. Some found machine-made, store-bought goods too homogeneous and derived great satisfaction from making unique materials themselves. The alternative processes discussed in this chapter allow imagemakers to explore and extend the relationship between the photographer, the event being photographed, the interpretation of subject, and the process of photography. In these distinct flexible processes, the camera image becomes a point of departure for transforming the entire relationship of making, viewing, and interpreting images. The resulting photographs challenge traditional "factory made" ideas about the camera image, and as facts become less important, beauty and imagination can step forward in importance. The nature and scope of photography have been redefined by a more flexible aesthetic that says a good photograph is not necessarily based on objectivity and scientific rationale. It dramatically demonstrates that there are multiple intelligences – ways of seeing – that can come into play when making photo-based images.

This chapter provides an introduction to key processes that have been widely used by contemporary photographers in recent years. It offers a technical starting point based on formulas and methods that have been proven successful. In most cases alternative printers mix their own sensitizer and processing chemicals from stock chemical compounds and coat their own paper, but some of the processes are available in kit form from specialized photographic suppliers. Most of the processes discussed are contact printing processes, not enlargement ones, and thus a negative equal to the final image size is required. (See Chapter 3 for one way of making enlarged negatives and for information on making negatives directly from slides.)

The discussion here is confined to coating paper stock with various emulsions, although it is possible to use these emulsions on almost any porous material, including ceramics and fabric. For more information on coating other materials, see "Resource Guide" at the end of the chapter. Be certain to follow all the safety rules

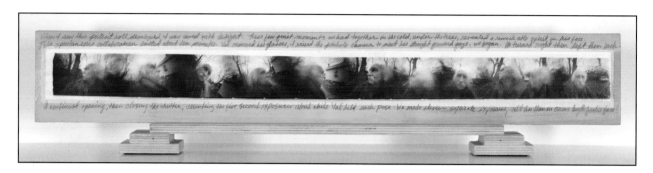

FIGURE 10.1 McKay fabricated this sequential portrait by contact printing an entire roll of film onto a single sheet of paper. She captured each of the 11 images that compose the portrait via 5 second exposures with her handmade pinhole camera, which uses 2¼ roll film. McKay produced the cyanotype prints in the sun using Photographers' Formulary cyanotype kit. Constructing a sculptural object, she pasted both the visual portrait of Surrealist-influenced photomontagist Val Telberg and a textual description of her relationship with the subject onto all sides of the wood (front text is reproduced below), which she protected by encasing it in Encaustic Medium. Front text: "When I saw this portrait roll developed, I was awed with delight. These few quiet moments we had together in the cold, under the trees, revealed a remarkable spirit in his face. This spontaneous collaboration lasted about ten minutes. Val removed his glasses, I raised the pinhole camera to meet his straightforward gaze, we began. He turned right then left then back. I continued opening, then closing the shutter, counting the five second exposures aloud while Val held each pose. We made eleven separate exposures, all less than an arms length from his face!"
© Elaine McKay. *Whole Roll Sculpture Portrait of Val Telberg*, 2004. 6 × 30 × 2 inches. Cyanotype with mixed media.

TABLE 10.1 Alternative Photographic Processes

Silver-based alternative photographic printing processes

Process	Sensitizer/binder	Image	Inventor	Year
Salt print	Silver chloride/none	Silver	Talbot	1834
Albumen	Silver chloride/albumen	Silver	Evrard	1850
Collodion	Silver chloride/collodion	Silver	Simpson	1865
Print-out	Silver chloride/gelatin	Silver	Abney	1882
Ozobrom	Silver bromide/gelatine contact diffusion	Pigments	Manly	1905
Bromoil	Silver bromide/gelatine dichromate bleach and harden	Litho ink	Piper and Wall	1907
Carbro	Silver bromide/gelatine contact diffusion	Pigment	Farmer	1919

Iron-based alternative photographic printing processes

Process Name	Sensitizer (Developer)	Image	Inventor	Year
Argentotype	Ammonium ferricitrate (dev: silver nitrate)	Silver	Herschel	1842
Vandyke Brownprint	Ammonium ferricitrate + silver nitrate	Silver	Arndt and Troost	1889
Sepiaprint	(dev: water)		Shawcrosss	1889
Kallitype	Ferric oxalate + silver nitrate (dev: borax or Rochelle salt)	Silver	Hunt Nicol	1844 1889
Argyrotype	Ammonium ferricitrate + silver sulfamate (dev: water)	Silver	Ware	1991
Cyanotype Blueprint Ferroprussiate	Ammonium ferricitrate + potassium ferricyanide (dev: water)	Prussian blue	Herschel	1842
New cyanotype	Ammonium ferrioxalate1 + ammonium ferricyanide (dev: dilute nitric acid)	Prussian blue	Ware	1992
Pellet print	Ammonium ferricitrate or ferritartrate (dev: ferrocyanide + gum)	Prussian blue	Herschel Pellet	1842 1878
Chrysotype	Ammonium ferricitrate (dev: sodium tetrachloroaurate (III))	Gold	Herschel	1842
New chrysotype	Ammonium ferrioxalate + gold (I) thio-complex (dev: carboxylic acids)	Gold	Ware	1987
Platinotype	Ferric oxalate + potassium chloroplatinite (dev: potassium oxalate)	Platinum	Willis	1873

(Continued)

TABLE 10.1 Continued

Iron-based alternative photographic printing processes

Process Name	Sensitizer (Developer)	Image	Inventor	Year
Sepia platinum	Ferric oxalate + potassium chloroplatinite + mercury (II) salts (dev: potassium oxalate)	Mercury + platinum	Willis	1890
POP platinum	Sodium ferrioxalate + sodium chloroplatinite	Platinum	Pizzighelli	1887
Satista	Ferric oxalate + silver chloride + potassium chloroplatinite	Silver + platinum	Willis	1913
Palladiotype	Ferric oxalate + sodium tetrachloropalladite (dev: potassium oxalate)	Palladium	Willis	1916
Amphitype Kelainotype	Ammonium ferricitrate or ferritartrate + mercury (II) salts	Mercury	Herschel	1842
Obernetter's Ferrocupric	Ferric chloride + cupric chloride (dev: thiocyanate/tone: ferricyanide)	Cupric ferrocyanide	Obernetter	1864
Phipson's	Ammonium ferrioxalate (dev: potassium permanganate)	Manganese dioxide	Phipson	1861
Ferrogallate	Ammonium ferritartrate (dev: gallic acid)	Ferric gallate	Colas	1859
Colas Blackline			Poitevin	1859
Heliographic Nakahara's	Ammonium ferritartrate (dev: tannic acid)	Ferric tannate	Nakahara	1894

Chromium-based alternative photographic printing processes

Process	Sensitizer/Colloid	Image	Inventor	Year
Gum bichromate	Ammonium or potassium Dichromate/gum arabic	Pigment	Poitevin	1855
Carbon (direct)	Dichromate/gelatine	Pigment	Poitevin	1855
Carbon transfer	Dichromate/gelatine	Pigment	Fargier	1860
			Swan	1864
Fresson	Dichromate/colloid	Pigment	Fresson	1899
Oil print	Dichromate/gelatine	Litho ink	Rawlins	1904
Ozotype	Dichromate/gelatine	Pigment	Manly	1899
Gum-ozotype	Dichromate/gum arabic	Pigment	Manly	1899

© Mike Ware, 2007. Courtesy of www.mikeware.co.uk.

outlined in Chapter 2. Regardless of which process you use, it is advisable to read the chapter in its entirety before experimenting with any of the processes, as specific methods from one technique often can be applied to another.

PAPER AND THE IMAGE VIEWING EXPERIENCE

The most important and often overlooked part of working with a historic process is the paper on which an image is printed. Being able to select the paper that best presents the image is an advantage of these alternative processes. The color and texture of the paper an image is printed on play a major role in determining what the final photograph looks like and the response it may generate. In gelatin silver, gum, and carbon prints the photochemistry is contained within a binder layer on top of the paper so that the image actually floats on the uppermost portion of the paper. In alternative processes based on iron salts, such as the cyanotype, platinum/palladium, and Vandyke, the emulsion/sensitizer is absorbed into the surface fibers of paper where they come into contact with various chemical substances, so the image is in fact part of the paper. This provides a different viewing experience because the image co-exists within the support material rather than being confined to a separate binder layer lying on top of the paper substrate. Lastly are inkjet prints when the image rests on the surface of the support material. The website www.digitalsamplebook.com allows one to visually compare the characteristics of numerous processes providing both surface and cross-section views of papers and are imaged at different magnifications and under various lighting conditions.

Paper is made from cellulose fibers derived from various plant sources, primarily cotton and wood pulp. Papers made from the wood of coniferous trees are known as sulfite pulp paper. In these papers wood chips are cooked in calcium bisulfate or sodium sulfite, and bleached, producing long, strong fibers. The highest quality of these papers is known as alpha cellulose papers. Papers made from this process are generally not suitable for alternative printing. Cotton rags or rag papers come from the part of the cotton plant that is used for textile

manufacture. Rag content describes the amount of cotton fiber relative to the total amount of material used in the pulp. These papers are the most suitable for the processes described in this chapter. Many papers designed for drawing, etching, and watercolor may have bleaches, buffers, clay fillers, dyes, optical brightening agents, sizing agents, and wet-strength resins incorporated into the fibers, which can affect the appearance of the print. Much current information can be found in online groups devoted to various alternative processes such as www.alternative-photography.com, which even conducted a survey about which papers worked well with various processes.

When choosing a paper, consider the following issues:

1. Is the paper chemically compatible with the sensitizer?
2. Does the paper have sufficient wet strength to withstand processing?
3. Will the paper fulfill your requirements for archival permanence?
4. Does the paper augment the aesthetic and conceptual foundation of the image?

Paper Wet Strength and Acid Content

Two primary concerns in choosing a paper for unconventional photographic processes are wet strength and acid content. Generally papers that are suitable for etching, lithography, or watercolor have sufficient wet strength to withstand the coating, processing, and washing of prints.

Acid-free paper is a must for most art applications. To produce their papers, archival manufacturers sometimes neutralize the acids in paper by adding an alkaline substance like calcium carbonate or magnesium carbonate into the pulp. Calcium carbonate reacts with iron-based sensitizer solutions used in many alternative processes, changing their pH, and producing unpredictable results. Therefore a nonbuffered acid-free paper is recommended.

Paper Surfaces

Paper can be divided into three categories according to its surface: cold-pressed, hot-pressed, and rough. Cold-pressed paper has a surface with slight texture, referred to as tooth, which is produced by pressing the finished sheet between cold cylinders. Cold-press papers tend to absorb more liquid than hot-pressed papers. Pressing a finished sheet through hot cylinders, much like ironing, produces hot-press paper. It has a smooth surface with almost no texture, making it idea for retaining fine detail. Rough surface paper has a strong texture or tooth, which is often described as a pebbly surface, a series of irregular rounded shapes like a pebble beach. Rough paper's indentations cannot capture the same level of fine detail as smooth surface papers; however, it is an outstanding choice for generating a grainy, impressionistic atmosphere.

Paper selection is a personal aesthetic choice, as artist/professor Brian Taylor explains: "I often prefer cold press paper for a more organic, toothier, hand made feel, and enjoy using rough surface papers for my gum prints. I have found hot press paper gives slightly more detail, and requires less coating solution, thus it saves money when using expensive emulsions such as platinum.

I am a girl, almost ten.

FIGURE 10.2 Kenny achieved the vivid color in this gum bichromate image by using six to seven coats of emulsion and subsequent exposures to produce each color or detail. Before performing the gum bichromate process, she first scanned several 35 mm negatives, digitally montaged them to produce a unified image, and inverted and printed inkjet contact negatives on Pictorico OHP transparency film. She used TH Saunders 140 lb. watercolor paper sized with gelatin to print the final gum bichromate image. Kenny finds this process has "the right mix of painterly surface and potential for manipulation" and is ideal for her *Dreamland* series, which reflects on a child's exploration of self and other.
© Kay Kenny. *I Am a Girl, Almost Ten, #2,* from the series *Dreamland Speaks When Shadows Walk,* 2004. 22 × 15 inches. Gum bichromate print.

However, there are times when the toothy surface of a cold press paper, which takes up more emulsion, can provide a more pleasing saturation and richness, and it also reveals brushstrokes less than hot press. Fortunately for the creative process, each photographer is free to choose the appropriate paper and surface which best portrays his or her aesthetic and technique."[2]

Applying Emulsion: Brushes, Coating Rods and Floating

The next essential decision is how to apply a light-sensitive emulsion. There are various techniques for applying liquids

to surfaces, including spraying with plant misters and air-brushes, and even spattering, splashing and dripping, but the most practical and popular method of applying emulsion is with a hand brush. The two most widely used coating brushes are black foam and Japanese hake brushes. The third most widely employed method utilizes a glass rod and the fourth is the technique of floating.

Black foam brushes are available at hardware stores, and many practitioners prefer the type with wooden handles because they seem to consistently be made from higher quality black foam than those with plastic handles. Some of the advantages of black foam brushes are that they are simple and easy to use, they deliver a flat coating edge, their cleanup is straightforward, and they are inexpensive. When carefully applied, no brushstrokes are visible in the final image. Foam brushes also have the benefit of being self-leveling, i.e. they soak up any excess pools of liquid that may have been laid down on the paper. They are an excellent choice for reasonably priced water-like emulsions such as cyanotype and Vandyke.

The major disadvantage of working with foam brushes is that when dry, they initially soak up and retain a significant amount of emulsion, which can deplete precious quantities of expensive emulsions such as platinum and palladium. Printers who use the foam brushes will counteract this initial tendency by prewetting the brush with water, squeezing it out so it is merely damp, and then proceed to dip it into the light sensitive emulsion. Foam brushes are also likely to retain a certain amount of emulsion even after cleaning in water, so it is a good idea to replace the brushes often to avoid contaminating fresh emulsions with old, residual chemicals.

Japanese hake brushes, which have a long flat handle, are the softest of all brushes. Hake brushes are made from rabbit or goat hair and were designed to apply ink and watercolor washes. They hold more emulsion than foam brushes and are often the preferred choice among gum printers for their ability to lay down a heavier coating of emulsion than foam brushes. There is no particular reason to use a hake brush for water-like emulsions, such as platinum, palladium, cyanotype, and Vandyke, because they retain a large quality of emulsion after coating.

The major disadvantage of the hake brush is their maddening loss of hairs during the coating process. When using a new hake brush their fine animal hairs inevitably come out one by one in the area you are coating. Some practitioners suggest applying a small bead of waterproof glue all around the entire base of the hairs, where they meet the wooden handle of the brush. Others pluck loose hairs before each coating. The good news is that if a hair or two comes loose on your paper, you can carefully lift it off with the brush and recoat that area to eliminate any blemishes. Another disadvantage of hake brushes is the difficulty of thoroughly cleaning them. As the hake brushes retain a large amount of emulsion they must be repeatedly rinsed and soaked overnight in a small bowl of water to thoroughly draw out the remaining emulsion, especially after gum printing.

Glass rods, often called "coating rods" and "puddle pushers," are long narrow glass rods with a handle attached, appearing much like a glass tube squeegee.

These are far more esoteric than foam or hake brushes and are only found in specialty sources (see "Material Resource Guide" at the end of this chapter). Available in various sizes from 4×5 to about 11×14 inches, these rods are the preferred coating method of platinum and palladium printers because they do not soak up or waste emulsion, allowing one to coat paper with approximately half the quantity required by a foam brush (hake brushes also retain an excessive amount of expensive emulsion). To use a glass coating rod, place it just outside the area of the print you wish to coat, then pour the required amount of light-sensitive emulsion along its inside edge and push the liquid across the print surface, squeegeeing back and forth until the area is coated. Some of the shortcomings of coating rods include that they are more difficult to purchase or replace as they are not widely available in local art or hardware stores, they are delicate and breakable, and they are more difficult to master at first, although the mechanics of the technique become familiar with practice.

In the floating method, the paper is simply allowed to float in a bath of emulsion (see "Salt Printing" section). Although it is very simple and straightforward method, it is not widely used because it requires a much greater quantity of often-expensive emulsion to be prepared.

Sizing

Sizing is the process by which gelatin rosin, starch, or another synthetic substance is added to paper to provide resistance to the absorption of moisture and to fill in the gaps between paper fibers. Sizing added to the pulp during manufacture is known as internal sizing. After the sheet is formed, it may be either surface-sized (painted or brushed on the surface) or tub-sized (immersed in a bath). Some processes require extra sizing. For details, see "Sizing" in "Gum Bichromate Process" section later in this chapter.

Experimentation is essential, because a paper that works well with the cyanotype process might not be chemically compatible with a platinum/palladium sensitizer. Be aware that papers with the same name, but made by different mills, may have undergone different chemical preparation during manufacture and therefore deliver dissimilar results. For that reason, obtaining enough of the exact same paper is a good policy to follow.

EXPOSURE

To make an exposure in the processes discussed in this chapter you will need:

1. Contact negative i.e. the same size as your final print (see Chapter 3).
2. Contact-printing frame with a tensioned split back is a major convenience in all nonsilver printing as it permits inspection without the risk of misaligning the paper and the negative.
3. UV light source such as the sun, unshielded black light, full-spectrum or plant-growth fluorescent lamps, a UVA suntan lamp, a carbon arc, or a mercury vapor lamp.

SALT PRINTS

According to specialist France Scully Osterman, the technique of making salted paper prints dates back to the early development of photography. In 1802 Thomas Wedgewood and Humphrey Davy used silver chloride to make printed-out images on paper. However, they did not discover a way to make these prints permanent. Several years later, Joseph Nicéphore Niépce also made prints on paper using the same process, before starting his investigations into the light sensitivity of asphaltum.

In the 1830s, William Henry Fox Talbot succeeded creating an effective combination of silver nitrate and chloride that he used to contact print images he made with a camera obscura. At this time Talbot discovered that an excess of chloride made the paper less sensitive to light and used this effect to stabilize his prints. In addition to chlorides, Talbot also used potassium bromide and potassium iodide to help stabilize the image.

After Sir John Hershel suggested the use of sodium hyposulfite (sodium thiosulfate, more commonly known as hypo) to more efficiently fix the image, the salted paper print "arrived." After the invention of the albumen print in 1850 by Blanquart-Evrard, the salted paper print was referred to as simply a "plain" print.

In 1850, John A. Whipple and William B. Jones, of Boston, obtained a patent for the "Crystalotype" – a particular type of albumen on glass process.[3] Later, "Crystalotype" was used by Whipple to describe salt prints produced from albumen negatives, and eventually, extended to salt prints from collodion negatives. The term is used here to differentiate an untoned salt print made from a glass negative, as opposed to one made from a calotype or waxed paper negative.

Salt Print Basics

Obtain a number of pieces of 100 per cent cotton paper (that can withstand washing) slightly larger than the negative being used, which will be carefully floated on, submerged in or brushed with a solution of ammonium or sodium chloride and water. This solution may also include a small amount of gelatin or one of many starches, such as arrowroot or tapioca. The gelatin or starch provides a light binder to prevent the silver chloride from going deep into the paper fibers. This not only enhances the detail of the image, but also alters the final image color. After this procedure the paper is hung up to dry.

FIGURE 10.3 *Printing Room.* Courtesy of the Scully & Osterman Archive.

Salting Formula

Salt solution

Gelatin (granular)	2 g
Ammonium chloride	2 g
Distilled water (68°F/20°C)	100 ml

To make the salt solution, put gelatin into cold water and let sit for 15 minutes until gelatin softens. Heat the softened gelatin over an alcohol lamp or on a hot plate and stir until dissolved. Then add the ammonium chloride to the warmed solution and stir until dissolved. Let the solution cool before using. The solution may be used slightly warm or cool, but not hot. If the solution gets cold, it will gel and will have to be rewarmed.

Applying the Emulsion: Brushing, Floating and Rolling

Brushing on the Emulsion

There are a number of ways in which emulsions can be applied to paper. The first is brushing and the second is by floating. Both the following procedures can be applied to other nonsilver processes as well. To brush on an emulsion you will need the following materials: (1) rolled

cotton, (2) large flat bread board, (3) blotting paper, and (4) tacks or removable drafting/masking tape.

Using tacks or removable tape, attach the entire perimeter of the blotting paper onto the board. Tape or pin the corners of the paper to clean blotting paper. After the blotting paper has been extensively used and is contaminated with silver, it can be replaced with a fresh piece.

Wearing protective gloves, ball up some rolled cotton by pulling the loose strands to the back (as illustrated) and soak with salt solution so that the cotton is wet, but not dripping. Apply in slightly overlapping lines, in one direction only. Allow an extra margin beyond what you will need for your print. After coating the whole sheet, turn the paper 90 degrees and go over the paper again with the same piece of cotton. Do not apply more solution. Turn the paper 90 degrees and apply a third time. These repeated steps are meant to help distribute the solution evenly, without puddles or streaking. The solution on the paper should be a slightly satin, even finish. Dry thoroughly with a hair dryer.

Floating on the Emulsion

The second common way in which emulsion is applied to paper is by floating. To accomplish this will need the following materials: (1) Pyrex, glass, or ceramic tray, (2) spring-type clothes pins, (3) hanging line, and (4) steamer or tea pot (optional).

Salt solution must be in a tray bigger than the paper (Scully Osterman uses Pyrex trays, but any glass or ceramic tray may be used; enamel trays are appropriate, too, unless they are chipped). Avoid bubbles when pouring salt solution into tray. Label or mark one side of the paper on a corner with a pencil so that you will know later which side is salted.

Fold two ends of the paper about 1 centimeter to use as handles (as illustrated in Figure 10.4) and allow the center of the paper to curve downwards.

Set the center of the curved paper onto bath so that only the very end of the curve nearest you makes contact with the solution. Then, gently lower the rest of the center section onto the solution. Now, lower one side of the paper onto the solution and then the other side until all the paper is floating upon the surface except for the handles on the ends.

Once the paper is floating, it may begin to curl upward on the ends. If so, gently hold down the ends with the tips of your fingers until the paper absorbs enough solution to make it lay flat. Make sure that the back of the paper does not get wet. At this time you should lift up one side of the paper and inspect for bubbles (see Figure 10.5). If discovered, they should be popped with a toothpick or piece of paper. Check the other side too.

Float the paper on the salting solution for a total of 2 minutes; counting from the time the paper lays flat. After 2 minutes, slowly pull the paper up from the solution by one corner (see Figure 10.6) and hang the paper by two corners with spring type clothespins on a line to dry (see Figure 10.7). Blot any droplets on the bottom edge of the paper with a disposable paper towel. The salting solution is not light sensitive so this can be done in daylight. Once the paper is dry it can be kept indefinitely. Flattening the paper in a book or dry-mounting press makes subsequent floating on the silver solution much easier.

FIGURE 10.4 *Floating Paper.* Courtesy of the Scully & Osterman Archive.

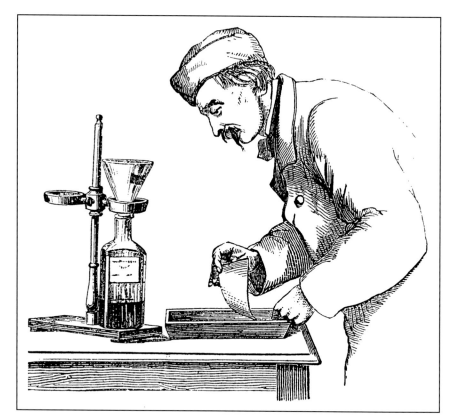

FIGURE 10.5 *Checking Paper Coating.* Courtesy of the Scully & Osterman Archive.

FIGURE 10.6 *Removing Paper from Bath.* Courtesy of the Scully & Osterman Archive.

Some workers will float the paper in a salt bath and then switch to brushing on the silver emulsion later because it is much more economical.

When needed, the "salted paper" is taken to a darkroom illuminated by red or yellow light. It is possible to use a 60 watt bulb 6 feet away from the coating area for sensitizing, though a yellow or red safelight is better. It is brushed with, or floated on the surface of silver nitrate solution and then removed and hung in the dark to dry. It should be used soon after it is dry.

Rolling on the Emulsion

A third way of applying emulsion is to use a glass rod to smoothly roll the emulsion across the surface of paper. This method is preferred by many practitioners, especially platinum printers (see platinum section for details), because it uses much less of the expensive sensitizing solution.

Sensitizing Solution

Silver solution

Silver nitrate	20 g
Distilled water (68°F/20°C)	100 ml
Granular citric acid or acetic acid (if needed)	
pH strips	

Dissolve silver nitrate in distilled water. Measure the acidity with pH strips. (If printing in hot weather, add acid to make the pH 2–3.) If granules of citric acid settle on bottom of bottle, use a filter or cotton in a funnel to pour the solution into a smaller container for dipping cotton and brushing. Floating requires a greater volume of solution. If you float the paper, be sure to filter the solution twice before using.

FIGURE 10.7 *Hanging Paper.* Courtesy of the Scully & Osterman Archive.

FIGURE 10.8 *Checking Exposure.* Courtesy of the Scully & Osterman Archive.

Method I: Brushing

To brush on the emulsion the following materials are needed: (1) rolled cotton, (2) large, flat board, (3) blotting paper, (4) tacks or removable masking tape, (5) glass or dedicated plastic funnel for silver nitrate, (6) small ceramic cup to hold silver nitrate, and (7) filters or cotton.

Instructions for brushing on the silver solution are the same as for applying salt, except that the procedure is done in subdued or safelight conditions. It is possible to use a 60 watt bulb 6 feet away from the coating area for sensitizing, though a yellow or red safelight is better.

Once coated with silver solution, the paper may be hung in a darkened room or dried quickly with a hair dryer.

Method II: Floating

To float on the emulsion the following materials are needed: (1) Pyrex, glass, or ceramic tray, (2) spring-loaded clothes pins, (3) hanging line, and (4) glass or dedicated plastic funnel for silver nitrate.

Floating the salted paper on the silver solution and drying the paper is the same as floating on the salt solution, except that the procedure is done under subdued or safelight conditions.

The emulsion may also be applied with a glass rod (see platinum section for details).

Exposure

To make an exposure you will need a contact printing frame and a UV light source.

Once dry, the sensitized paper and negative are placed sensitive sides facing each other, into a contact printing frame and placed in the sun (or a UV light box). These printing frames are fitted with a hinged back to allow inspection of the print, without changing the registration of the paper to the negative (see Figure 10.8).

After the frame has been exposed to light for a minute or two, take it to an area where the light is subdued and open one half of the printing frame to inspect the progress of printing out.

The print should look darker than what would be considered normal. If the image is too light or even looks perfect, close the back and continue to expose the print until the areas of maximum density are a shade or two darker than the desired finished print. The print will lighten when fixed.

Processing

The print is given an initial wash in tap water and then fixed in hypo, washed again, put into a sodium sulfite bath, and finally, a long water wash. Pyrex glass baking

dishes are perfect trays for all of the following treatments. They should be well cleaned with rottenstone (a polishing abrasive) and water, given a final rinse with distilled water and allowed to dry upside down.

The print is placed in a tray of clean tap water. Many public tap waters contain chlorine salts (sodium chloride). The excess silver will react with the chlorine in the water, precipitating silver chloride, which looks milky white. If using unchlorinated water, add a pinch of table salt. This water bath should be about 5 minutes with at least three changes of water. When there is no longer an appearance of milky white silver chloride, and the water remains clear, then wash the print with one more change of clean water before putting it into the fixer.

Fixing

Fixer Formula

Sodium thiosulfate	300 g
Sodium bicarbonate	4 g
Warm water (100°F/38°C)	2000 ml

Mix the chemicals until completely dissolved.

The print is placed in fixer for 5 minutes, agitating the tray continuously. During this fixing stage, the tones of the print will shift dramatically, depending on the sizing of the paper, the amount of gelatin or starch mixed with the chloride and how deeply the image was printed.

After fixing, wash the print for about 30 seconds with one change of water.

Hypo Clearing and Final Wash

Sodium Sulfite Bath Formula

Water (68°F/20°C)	3000 ml
Sodium sulfite	30 g

Next, the print is placed into a bath of sodium sulfite for 3 minutes, agitating continuously. Sodium sulfite acts as a hypo-clearing agent making the final water wash more effective.

Then, the print is washed for 30 minutes in running water, or instead, agitate and change water 4 times.

FIGURE 10.9 *Print Darkroom.* Courtesy of the Scully & Osterman Archive.

Image Tone

The print will dry a warm, reddish brown color unless toned with gold chloride before fixing. Gold toning is not included here because it was not generally adopted until after the introduction of albumen printing in 1850 (see Chapter 8 for gold toning formula).

One early method of safely modifying the final image color was to "heat tone." Traditionally this was done with a hot iron. Scully Osterman suggests blotting the print to remove the excess water and then using a hairdryer on high to dry the print. This will make the final print cooler in color.

Waxing: Protective Coatings

The metallic silver in printed out images is very fine and as such, susceptible to atmospheric conditions. Such prints are especially vulnerable to sulfides in the air that may cause deterioration, loss of density, and migration of silver particles. One way to slow this process is to coat the surface of the print with wax, thereby protecting the silver from harmful atmospheric effects. Waxing adds depth to the tonality and imparts a beautiful satin finish.

To wax a print you will need the following materials: (1) beeswax, (2) Oil of Lavender, (3) removable tape, and (4) glass, Corian, or marble worktop.

Tape the entire perimeter of the print onto a thick piece of glass, or marble slab. Warm the beeswax (microwave 20–30 seconds) and rub in drops of oil of lavender until wax is the consistency of lip balm. Apply the wax to the print with a clean piece of flannel wrapped around a ball of cotton. Rub it into the surface in long strokes, in one direction only. Apply a second coat from the opposite direction.

Allow the wax to rest on the print for a few minutes and then remove excess with a clean rolled, flannel cloth. Once the excess is removed, you may now buff the finish with a third piece of soft flannel to a satin sheen. Tape should be removed slowly. To avoid tearing, carefully pull tape away in a horizontal fashion, low and close to the table, while holding down the edge of print with clean fingertips.

RESOURCE GUIDE

The salt print history and process details have been kindly provided by France Scully Osterman. For additional information, see Scully & Osterman Studio: www.collodion.org

CYANOTYPE PROCESS

Cyanotype, Greek for "dark blue impression," is one of the easiest and least expensive ways of gaining hands-on experience with an alternative nonsilver process. Sir John Herschel invented the method in 1842 and used it as a proto-photocopy machine for making duplicates of his intricate notes.

The first aesthetic application of the cyanotype is credited to Anna Atkins, who worked with it in the 1840s

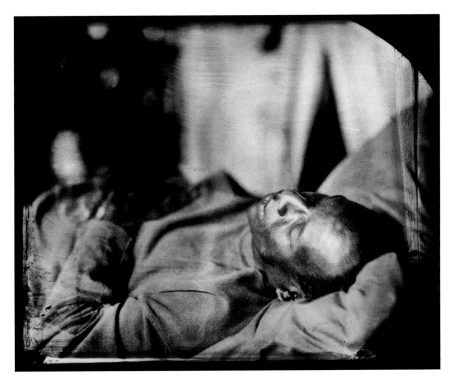

FIGURE 10.10 Scully Osterman tells us, "Guilherme was one of my subjects for the *Sleep* series who came from Brazil to visit the conservation lab at George Eastman House. When he arrived at my studio, he confided that he had been having difficulty sleeping, so I suggested, 'We would just see how it goes.' As I suspected, like many sleep-deprived people, he fell asleep soon after his head hit the pillow. But he was a bit restless and had terrible nightmares, which he told me about later. Several of my negatives of Guilherme seem to convey this feeling. While it may be simply serendipity, I prefer to think I recorded it."
© France Scully-Osterman. *Guilherme*, from the series *Sleep*, 2002. 8 × 10 inches. Waxed salt print. Courtesy of Howard Greenberg Gallery, New York.

and 1850s to illustrate her book *Photographs of British Algae: Cyanotype Impressions.* The heyday of the process was in the 1880s, when architects and shipbuilders used precoated cyanotype paper to make fast, inexpensive copies of line drawings.

The major disadvantage of the process, which kept it from becoming more widely adopted, is its bright blue color. In *Naturalistic Photography for Students of Art* (1889), Peter Henry Emerson said, "No one but a vandal would print a landscape in red or cyanotype." Yet the process remained popular for a time with professional and amateur photographers as an inexpensive and speedy method for proofing negatives.

The versatility of the cyanotype, like many nonsilver processes, can be seen in a workflow chart (Table 10.2) created by artist/photo educator Ginger Owen-Murakami, which shows the creation process for Figure 10.11.

How the Process Works

Herschel discovered that when light acts on certain ferric (iron) salts, they are reduced to a ferrous state. Many of these processes, including cyanotype, kallitype, Vandyke, platinum, and palladium, are sometimes referred to as iron-salt-sensitive processes or ferric processes, since they are all based on the reduction of iron and tend to be very stable.

In the cyanotype process, the light catalyzes the reduction of ferric ammonium citrate to a ferrous salt. The ferrous salt then acts as a reducer on the potassium ferricyanide. This produces a precipitate of insoluble blue pigment, ferric ferrocyanide, which is also known as Prussian blue. The areas that are not exposed to light remain in a ferric state. During development, washing removes these unreduced salts, leaving behind the insoluble ferric ferrocyanide. Heavy exposure causes some "reversal" of the image to colorless ferrous ferrocyanide. During drying, the ferrous ferrocyanide re-oxidizes to the distinctive deep blue.

TABLE 10.2 Creation Process for 3-D Cyanotypes

Image capture		Camera or scanner
Contact sheets	↔	Workflow software – Aperture/Bridge
		Organizing digital contact sheets
		↓
Image preparation	↔	Image adjustments – Photoshop
		↓
Contact printing negative	↔	Digital negative making: printer and copy machine
		↓
Nonsilver printmaking		Cyanotype process
		↓
3-D production Display		Creation of individual pieces Final mixed-media installation

FIGURE 10.11 Owen-Murakami scanned original family photographs and then used Photoshop to generate 8 × 10 inch negative transparencies. Using UV light, she contact printed these negatives onto pieces of white cotton that she had dipped in standard cyanotype solution. Owen-Murakami sewed the prints together to construct this sculptural kimono. She elaborates, "Like an archaeologist, collecting artifacts and theorizing historical stories, I use appropriated imagery to fabricate my ancestral story. The images reference concepts linked to the blueprint of identity." © Ginger Owen-Murakami. *History Kimono*, 2005. 60 × 48 × 2 inches. Cyanotype with mixed media.

Box 10.1 Chief Attractions of the Cyanotype Process

- The process is simple and inexpensive.
- It may be applied on a variety of materials and surfaces.
- High resolution and consistent tonal values can be maintained.
- Long printing times allow image inspection during printing.
- Excellent archival keeping properties, depending on the support base.
- The intense blue color can be altered with additional processing steps.
- Can be combined with other nonsilver processes.

It is possible to obtain different colors by changing the metallic salt applied to the ferrous image. Basically this is what happens in kallitype and platinum printing. It is also possible to alter the final blue image through a toning process.

Safety

In addition to the general safety guidelines provided in Chapter 2, be aware of these specific concerns when working with the cyanotype process:

1. Potassium ferricyanide should not be heated above 300°F (147°C) or allowed to come in contact with any concentrated acid, such as acetic acid in stop bath, as poisonous hydrogen cyanide gas can be produced.
2. Unused emulsion should be disposed of by absorbing it in kitty litter placed inside a plastic bag. This bag should be sealed and placed in a covered trash container outdoors.

Printing

Cyanotype emulsion has a long exposure scale. Negatives with a complete range of tonality work well, as do contrasty negatives. A full range of tones can be produced on a smooth paper from a negative that would normally require a Grade 2 paper in normal silver-based printing.

The cyanotype emulsion can be applied to any absorbent surface, including almost any paper, even colored stock (except those that have an alkaline buffer), fabric, bisque ware, and leather. The emulsion can be applied to other photographs or combined with other processes like Vandyke and with techniques such as hand-coloring and toning.

Choosing a Paper

A high-quality, cold-pressed, lightly-sized rag paper (100 per cent cotton), such as Arches or Fabriano Watercolor, offers good a starting point. Beautiful prints also can be made on unsized papers, such as Rives BFK. Any changes in the color of coated paper (when stored in the dark) from yellow to green or blue is a sign of paper/chemistry incompatibility. High humidity or letting the coated paper sit too long before exposure can also produce deleterious results. For optimum results, expose within a few hours of drying.

After you have mastered the technique, consider applying the emulsion to fabric or even chamois leather. The tighter the weave of the fabric, the deeper the blue tends to be.

Commercially made cyanotype paper is available at art and graphic supply stores. It is also sold as sun paper in museum and science stores. The quality of these materials varies widely and should be tested before buying in quantity.

Making the Sensitizer

The cyanotype emulsion is made by preparing the sensitizer from two stock solutions that are combined in equal parts at the time of use.

Cyanotype Formula

Stock solution A

Water (68°F/20°C)	250 ml
Ferric ammonium citrate (green)*	50 g

*The green variety provides an emulsion that is about twice as light sensitive as the brown ferric ammonium citrate, which is not recommended.

Stock solution B

Water (68°F/20°C)	250 ml
Potassium ferricyanide	35 g

Mix the solutions separately. Store them in tightly closed opaque containers. The separate solutions can last up to 6 months. Stock solution A can grow mold that appears to look like seaweed, which can be filtered out by pouring the solution through a coffee filter or cotton balls in a funnel, before using. This can be prevented by adding 1 gram of ammonium dichromate, just enough to create a poisonous atmosphere that will prohibit the growth of mold.

When you are ready to use them, combine equal amounts of stock solution A and stock solution B. For best possible results, coat and expose the paper the same day. Some workers have been able to store and use coated paper, with reduced light sensitivity, for as long as 2 weeks.

Modern Cyanotype: The Mike Ware Process

Photographer and chemist Michael Ware has developed an "improved" cyanotype formula. Ware has replaced ferric ammonium citrate with ferric ammonium oxalate to make a formula that is more light-sensitive, more readily penetrates paper fibers, and is less prone to mold than the traditional process. The results are cyanotype images that do not bleed, require shorter exposures, and have a dark (almost black) maximum density.

The preparation of this sensitizer solution calls for a little more experience in chemical manipulation than is required to make a traditional cyanotype sensitizer. This work should be carried out under tungsten light, not fluorescent or daylight. A hotplate will be found convenient for heating the solutions.

Ware Cyanotype Formula

Ammonium iron (III) oxalate	30 g
Potassium ferricyanide	10 g
Ammonium dichromate	0.1 g
Distilled water	100 cm^3

AR grade (99 per cent) chemicals are preferred.

1. Measure 20 cm^3 of distilled water from a measuring cylinder into a small Pyrex glass beaker, heat it to about 160°F (70°C), and completely dissolve 10 g of potassium ferricyanide in it, with stirring. Keep this solution hot.
2. Measure 30 cm^3 of distilled water likewise into another beaker, heat it to about 120°F (50°C) and dissolve in it 30 g ammonium iron (III) oxalate.
3. Add 0.1 g of solid ammonium dichromate to the ammonium iron (III) oxalate solution and dissolve it. Mix thoroughly.
4. Add the hot potassium ferricyanide solution to the ammonium iron (III) oxalate solution and stir well. Set the solution aside in a dark place to cool to room temperature and crystallize for about 1–2 hours.
5. Separate most of the liquid from the green crystals by filtration (Whatman No. 1 filter paper is recommended). The green solid (potassium iron (III) oxalate) is disposed of safely using the kitty litter method. The volume of solution should be about 60 cm^3.
6. Make up the yellow colored solution with distilled water to a final volume of 100 cm^3. The sensitizer can be made more dilute (up to 200 cm^3): it will be faster to print, but yield a less intense blue.

Filter the sensitizer solution and store it in a brown bottle kept in the dark; its shelf-life should be at least 1 year.

For more information, see: www.mikeware.co.uk.

Applying the Emulsion

When you are ready to work, combine equal parts of solution A and solution B. The emulsion from either formula can be applied to your support material under subdued tungsten light or in a darkened room. A 60 watt yellow insect bulb provides great illumination while screening out the blue and UV wavelengths of light. Avoid fluorescent lights because most of them produce UV light, which can affect the cyanotype emulsion, as well as all the other nonsilver processes discussed in this chapter. UV light raises the base fog level of the coated emulsion, reducing its overall sensitivity. This can reduce the contrast range and degrade the highlight and shadow details.

Spread newspapers on all working surfaces to protect them from cyanotype stains. After making the sensitizer, coat the paper with it. Two ounces of working solution should coat about eight to ten 8 × 10 inch prints, depending on application method.

There are two basic ways to coat paper. The first coating method involves using a polyfoam or a hake brush, an oriental-style wash brush on a long flat handle. Although more expensive, a hake brush can be useful for laying in large areas of sensitizer, for wetting the surface, and for absorbing excess media.

Tape or pin the paper to a smooth, nonporous surface. Dip a clean brush into the emulsion, squeeze out the excess, and brush evenly across the paper. The emulsion should be kept wet and not be overworked or reapplied during this process, or it will lose sensitivity.

The second coating method is called floating. Put the emulsion in a tray and float the paper on the solution for 2–5 minutes. Occasionally tap the backside of the paper gently to dispel any air bubbles, taking care not to get any of the sensitizer on the nonemulsion side.

Dry the paper in total darkness (a hair dryer, set on low, can be used to speed drying). To be on the safe side, look inside the tube of your hairdryer to see if it is casting a bright glow from the heating elements, which might fog your paper if held close over an extended period of time. The coated paper should appear yellow-green when it is dry.

Exposure

Cyanotypes are exposed by contact printing with a UV light. In a darkened room, put the negative on top of the sensitized paper (emulsion to emulsion) in a contact frame or under glass. Consistent sunlight is an excellent source of exposure. Sunlight exposure time may run from 5 to 20 minutes depending on the location, the time of day, the cloud conditions, and the season. Exposure times with sun lamps start at about 15 minutes. Keep the lamp about 24 inches from the print frame. If the frame gets too warm, a small fan can be used to dispel the heat. Wear appropriate eye protection when working with any sunlamp. The correct exposure time can be determined through inspection or by making a test strip. As the paper is exposed, it turns from yellow-green, to green, to dark green, to blue-green, and finally to blue-gray, at which time exposure should be complete.

It is necessary to overprint, as the highlight areas will lighten when the print is washed. Print until the highlights are considerably darker than desired. At this point, the shadow areas will begin to reverse. Check exposure by opening one side of the print frame back and carefully lifting the paper away from the negative, without disturbing the registration. If you are using glass, tape the paper and negative together on the support board on three sides, leaving the fourth free for inspection.

Processing

Process the print in subdued tungsten light by washing it in a tray of running water for 10–15 minutes at 68°F (20°C). Wash until the highlight areas are clear of stain (no yellow color should remain). Allow the print to dry in a darkened room. If intensifying or toning is planned, do it while the print is still wet. Washing in alkaline water (pH 8 or higher) will bleach the image. This can be corrected by increasing the exposure time and also by using the oxidization method described next.

Cyanotypes can fade slightly after processing, but they will return to their original color if left in the dark to re-oxidize. The final look of a cyanotype cannot be determined until it has had a chance to completely dry and oxidize.

Oxidation Solution

To see the final tone immediately, place the print in an oxidation solution directly after washing, and then follow with a 2 minute final wash to remove the hydrogen peroxide.

Cyanotype Oxidation Solution Formula

Water (68°F/20°C) 200 ml
Hydrogen peroxide (regular 3 per cent 20 ml
solution)

Quickly and evenly immerse the print in the oxidation solution for a couple of seconds. Remove, rinse, and dry it.

Cyanotype Toning

The color of a cyanotype can be altered to a certain extent through the use of chemical toners. Formulas that require the direct uses of ammonia or ferrous sulfate are not recommended because the colors obtained from them easily fade. It is possible to produce only local changes in color by brushing the toner on selected areas of the print. You can make more than one color change on a print.

Red-Brown Tones

The following formula produces a solid red tone, but the highlight areas turn yellow within about a week and will remain so.

Red-Brown Tones

Solution A

Water (68°F/20°C) 180 ml
Tannic acid* 6 g

*Always add the acid to the water.

Solution B

Water (68°F/20°C) 180 ml
Sodium carbonate 6 g

In a tray, immerse the print in solution A for 5 minutes. Then immerse the print in a separate tray of solution B for 5 minutes. Follow with a 10-minute wash in running water at 68°F (20°C).

Lilac to Purple-Brown Tones

Tannic acid* 70 g
Water (68°F/20°C) 1 liter
Pyrogallic acid* 2 drops

*Always add the acid to the water.

Mix the tannic acid and water. Heat the solution to 120°F (49°C) and add the pyrogallic acid. Rapidly and evenly immerse the print in the solution, or splotching may result. Allow the image to tone until it takes on a lilac color. Wash in running water at 68°F (20°C) for 15 minutes.

Deeper tones can be produced by putting the print in a solution of 15 g of caustic potash and 1 liter of water. After toning in this solution, wash for 15 minutes.

Violet-Black Tones

Immerse the print in solution A until it turns yellow, then wash for 2 minutes. Then take the yellow print from solution A and place it in solution B until the desired color appears. Follow with a 10-minute wash in running water. The gallic acid produces the violet tones. Increasing the pyrogallic acid results in a blacker tone.

FIGURE 10.12 McKay returned to this photograph several times over the years, ultimately producing this 3-D sculptural work, which serves as "a way to make the art accessible and allow a viewer to pick up the piece to look even closer. Making art is communication. Trying to stop a viewer in his or her tracks, to pause, to look, to ponder and wonder, is the 'how-to' trick." She began by capturing the portrait of Val Telberg with a 5 second exposure using her handmade pinhole camera. Two years later, she scanned the photograph and printed it onto acetate, and a decade later, she cyanotyped the acetate print. To complete the photographic sculpture, McKay hand-colored the cyanotype, pasted it onto a matt board mount, and protected it with Encaustic Medium.
© Elaine McKay. *Single Portrait of Val Telberg*, 2006.
7 × 6 × 2½ inches. Cyanotype with mixed media.

Violet-Black Tone Formula

Solution A

Sodium carbonate (washing soda)	50 g
Water (68°F/20°C)	1 liter

Solution B

Gallic acid*	8 g
Pyrogallic acid*	0.5 g
Water (68°F/20°C)	1 liter

*Always add the acid to the water.

Box 10.2 Ambrotype Process

1. Preparation of the glass plate – cutting, cleaning and polishing.
2. Coating the plate with iodized collodion.
3. Sensitizing the collodionized plate in silver nitrate.
4. Exposure in the camera or under an enlarger.
5. Development with acidified ferrous sulfate developer.
6. Fixing the image in either cyanide or hypo.
7. Drying and varnishing the plate.

AMBROTYPE PROCESS: WET-PLATE COLLODION POSITIVES ON GLASS

Invented in the mid-1850s the ambrotype is a direct positive variant of the collodion process on glass. An ambrotype can be made either by exposure in a camera or by projecting a positive transparency onto the sensitized plate using a conventional enlarger.

The term ambrotype comes from the Greek root *ambrotos*, meaning "imperishable." At the time the process was first patented in 1854 by James Ambrose Cutting, it included a finishing procedure of hermetically sealing the surface of the image with Canada balsam and a second sheet of glass (a "Cutting ambrotype"). The finishing technique fell from favor, but the name came to be used for all collodion direct positives on glass.

Ambrotypes, and its close relative, the ferrotype/tintype, rely on the characteristic of the collodion process to produce image particles of very fine reflective metallic silver. These light-colored particles establish the white parts of the image while the dark shadows are created by backing the clear glass plate with dark material or making the image on dark glass. The ferrotype technique is identical to that of the ambrotype, the only difference being the black enamel metal plates used for that process. A collodion negative is made by increasing both the exposure and development along with slightly different formulas for the collodion and developer. The basic process of making an ambrotype is outlined in Box 10.2

Making Photographic Collodion

To make an ambrotype one needs to prepare the collodion, silver sensitizing solution, developer, fixer and varnish following the well-tested procedures worked out by photographer/historian Mark Osterman.

Osterman's basic formula has a shelf-life of up to 1 year if the stock is kept in a cool place. If cadmium bromide is difficult to purchase one may substitute potassium bromide. However, if potassium bromide is used, the collodion will have a shorter shelf-life resulting in a faster shift of color from orange to deep red, an indicator of a gradual loss of sensitivity. The use of "Plain collodion" requires dilution with solvents and the addition of an iodide and bromide before it can be used as photographic (or salted) collodion.

Materials Required

1. Plain collodion (USP).
2. Ethyl ether (anhydrous, reagent grade).
3. 190 proof or 95 per cent grain alcohol (ethanol) (also known as "Everclear").
4. Cadmium (or potassium) bromide.
5. Potassium iodide.
6. Distilled water.
7. 300 ml clear glass bottle.
8. 100 ml beaker.
9. Glass, plastic or stainless stirring rod.
10. Small plastic syringe marked in milliliters.

Collodion Procedure

1. Pour 118 ml plain collodion into the bottle.
2. Add 77 ml ether and cap the bottle.
3. Add 2 ml heated distilled water into the 100 ml beaker with the syringe and add to this 1.5 g cadmium (or potassium) bromide. Stir until completely dissolved.
4. Add to this same beaker 2 g potassium iodide. Stir until dissolved and then add 77 ml of the alcohol.
5. Add the iodide/bromide alcohol solution to the collodion and agitate gently.

After the initial agitation, the bottle should be kept upright and not shaken. The collodion may be cloudy when first mixed, but eventually clear leaving a transparent yellowish liquid with some solids settling on the bottom. Placing the bottle in a pan of warm tap water and burping the cap from time to time can encourage this process. Once clear, the collodion is ready to use.

Sensitizing Solution: Silver Bath

Materials Needed

1. Silver nitrate crystals.
2. Glacial acetic acid *or* dilute nitric acid.
3. Distilled water.
4. pH test strips (in the acidic 3–6 range).
5. Dark brown glass storage bottle.
6. Latex gloves.
7. Eye protection.

The quantity of sensitizer needed is based on the size of plate you want to make and the means you choose to use it. Sensitizing can be done in a tray or a vertical tank. If the outside temperature is higher than 80°F (27°C) you may need to add more acid to prevent fogging of the plate, but this will reduce the plate's sensitivity.

Sensitizing Procedure

1. Pour 1065 ml distilled water into the dark brown storage bottle.
2. Add 84 g silver nitrate. Stir until dissolved.
3. Test pH and if the pH is higher than 5, add acid several drops at a time, until pH is less than 5.

This formula is for a 1065 ml bath. To adjust for a different quantity, allow 28 g of silver nitrate for every 355 ml of distilled water.

The Developer

Materials Needed

1. Iron (ferrous) sulfate.
2. Glacial acetic acid.
3. Alcohol.
4. Distilled water.
5. Plastic funnel with wide spout.
6. Cotton wadding for filtering.
7. 500 ml beaker.
8. 50 ml storage bottle.

Developer Procedure

1. Pour 355 ml distilled water into 500 ml beaker.
2. Add 15 g ferrous sulfate and stir vigorously.
3. Add 14 ml glacial acetic acid.
4. *Optional:* Add 18 ml of 190 proof "Everclear" alcohol.
5. Put loosely packed cotton in the neck of the funnel and filter the developer. Repeat this step at least two more times; cleaning the funnel, beaker, and bottle with clean water at every opportunity and packing the cotton tighter each time.

Alcohol is added *as needed* to prevent the developer from beading up on the surface of the collodion plate. This will be required as the silver bath is well used. Hot temperatures make chemical reactions occur faster. If the outdoor temperature is higher than 80°F (27°C) you may need to add more water or acetic acid than normal to restrain the action of the developer to allow a more manageable development.

The Fixing Solution

Potassium cyanide or hypo may be used. Cyanide is preferred as it leaves a brighter deposit of image silver than the hypo, but it is extremely poisonous and must be handled with the utmost care. Both fixing agents are simply mixed with water and should be replaced at the end of each session of fixing plates. Quantities needed are based on the size of the tank or tray used for fixing. Stock cyanide fixer should be mixed in a sturdy plastic bottle. In either case, make only what is needed for a day's needs.

Ambrotype Fixer Formulas

Potassium cyanide	14 g
Water (68°F/20°C)	946 ml
or	
Sodium thiosulfate	142 g
Water	887 ml

Safety Alert

Potassium cyanide is extremely poisonous and extra precautions must be taken when handling it including: (1) keeping it away from all living creatures, (2) wearing proper, protective gloves when mixing or using either fixer, (3) labeling all containers, and (4) keeping it from contact with any acid, as the mixture of the two will produce deadly cyanide gas.

The Protective Varnish

Plates should be varnished to protect their fragile surface from abrasion and darkening due to exposure to sulfurous atmosphere. The following is a typical "spirit" varnish that can be applied.

Varnish Formula

Gum sandarac tears	57 g
190 proof "Everclear" alcohol	414 ml
Oil of lavender	44 ml

Place alcohol, gum sandarac, and oil of lavender into a wide moth mixing jar with a lid. Agitate the solution

until the sandarac dissolves completely. This will take a considerable amount of time – 1–2 hours with continuous agitation. Alternatively, after the initial agitation the jar can be left undisturbed for a few days. Once the sandarac is dissolved completely, filter the varnish at least five times with progressively tighter cotton through a small funnel. The final varnish should be light yellow and completely clear, and can be placed in a storage bottle.

The Collodion Darkroom

Collodion is a "colorblind" process that is not sensitive to wavelengths of red, orange, yellow, brown, and warm green light. Your darkroom should be lighted using a deep orange or red filter, such as the Kodak 1A, which is used with orthochromatic materials. Deep-red glass, available from a stained glass supplier, can be fitted over an electric light or in a window for darkroom illumination.

The Camera

Any view camera will work as long as you can get the plate safely into the film back without exposing it to white light. While learning the process, use smaller plates to reduce expense. Standard sheet film holders for modern view cameras can be modified to take glass plates (see Figure 10.13). Additionally, images can be made from positive transparencies under the enlarger.

FIGURE 10.13 The septum divider of a *Lisco* Regal model sheet film holder is cut to the size of the plate. The size and proportion is not limited to historic formats. Front and back dark slides have been withdrawn in this detail to show one of four silver wire clips that hold the corners of the sensitized plate. Stiff silver wire is bent to the shape of staples and fitted into the two holes drilled on either side of each corner. The ends that protrude through to the other side are bent and hammered down to allow the dark slide free movement.
Scully & Osterman Conversion Holder Corner Detail. Courtesy of

Glass Preparation

Cut glass to the desired size using a metal straightedge and a high-quality glass cutter, available from a hardware store or have the glass professionally cut. Roughen the razor sharp edges on both sides with a sharpening stone.

Cleaning the Glass

Glass must be scrupulously clean before coating with collodion or the emulsion will peel during processing. Make a solution of glass cleaner by mixing equal parts water, alcohol and whiting, available from a stained glass supply. Rub a small amount of this solution on the glass and rub vigorously with a piece of cotton or clean, linen cloth until most of the solution is absorbed into the cloth. Pay special attention to the edges. Repeat this same operation on the other side.

Polishing the Glass

Using a clean piece of cloth wipe the outer edges free of any powder and polish both sides of the plate. Test the polish by breathing on the surface and observing the condensation. If there are any streaks or markings, the plate requires more polishing.

Coating the Plate

Under white light (daylight), hold the plate in the left hand by the lower left corner. Pour a large puddle of the prepared photographic collodion onto the center of the plate and then gently tilt the plate so the collodion goes to the lower left corner, the upper left corner, the upper right corner and finally the lower right corner.

Drain the excess off the lower right corner back into the bottle. While the collodion is draining, rock the plate from side to side to prevent lines from forming in the direction of the draining solution. Keep the drained corner of the plate slightly lower than the rest to prevent it from flowing back onto the plate. After the surface of collodion shows no more fluid movement (about 5 seconds) put the plate, collodion side up, immediately into the prepared silver nitrate solution. If the collodion begins to dry before it is put into the silver, the sensitizing will not be effective.

Safety Alert

Wear proper, protective gloves after the collodion is poured and until the plate is washed thoroughly after fixing.

Sensitizing the Plate

Sensitizing can be done in a tray or vertical tank under safelight conditions. Bring the plate into the darkroom

(or turn off the white lights) and place the plate into the silver solution. If you are using a tray, slide the plate collodion side up quickly under the surface. Any hesitation will leave a mark in the final image. If you are using a vertical tank, place the plate on the dipper and slide it into the silver solution in one easy motion.

The plate is ready to remove when the silver solution drains from surface of the collodion without lines or beads. Remove the plate by a gloved hand when using a try or with the dipper when using a tank. Allow the excess to drain and rest the edge of the plate on a piece of paper towel to draw of more of the excess silver.

Exposing the Plate

Place the sensitized plate in a light-tight film holder and expose with a view camera or under an enlarger. Exposure is determined by trial and error, judging over or underexposure of the developed plate by observing the degree of shadow detail. Collodion plates are about ISO 1 and become even less sensitive as the collodion ages. Light meters are not helpful due to the collodion's insensitively to red wavelengths of light.

Plate Development: Tray and In-Hand Methods

Under safelight conditions, a plate can be developed two ways, in a tray or in the hand. The tray method is easier, but the image's highlights and contrast range are usually more compressed than as those developed in hand.

Tray Method

Pour a little more developer than will be needed over the plate. Tilt the tray so all the developer is on one end and place the plate, collodion side up, on the upper end of the tray. In one quick motion, rock the tray to make the developer flow over the entire plate and continue rocking for a few more seconds.

In-Hand Method

Hold the plate in one hand with a slight incline to allow the developer to flow easily across the surface. Gently pour just enough developer to cover the plate along the edge so that it slowly flows across the surface; the less developer, the stronger the image. *Do not splash the developer onto the surface as this produces a faint image.* The image will actually darken at the point of impact because the excess silver needed to form the image during development will be pushed away. Rock the plate to distribute the developer and try to keep the solution on the surface without draining off the edges.

Development should be stopped before you see any of the deepest shadows of the image. Ideal development time is only 15 seconds. If the image is fully formed before 10 seconds, it was probably overexposed. If it took longer than 20 seconds, it was likely underexposed.

Development is stopped completely by gently flowing clean water over the surface and back of the plate. Tap water is fine as long as it does not contain iron particles, which will leave specks all over the image. This washing step should be done as long as it takes to observe the water flowing off the surface without streaks or beading.

Fixing and Washing the Plate

Fixing can be done in a tray or in a vertical tank under daylight conditions. Place the plate image side up into the fixing solution. This will remove the light colored silver iodide. If you choose to use hypo it will require a fixing time of four more minutes than it takes to clear the image and washing time of at least 5 minutes, although more is probably best.

Cyanide fixing on the other hand is based on observation. Fix until you see all the silver iodide removed and then leave the plate in the fixer for about two times more than it took to make the visual change. Cyanide will begin to dissolve the image bearing silver if this step is prolonged, though this effect may actually be used to increase the shadows of the image. While the washing step for cyanide fixed images can be shorter, as with the hypo, it is always better to wash as long as you can to remove residual chemicals.

Drying and Varnishing the Plate

The washed plate may remain in a tray of clean wash water until it is convenient to complete the process, which entails rinsing the collodion side of the plate with distilled water and either placing it on a drying rack or gently heating it from below with an alcohol lamp. Prevent the plate from getting too hot. Keep it constantly moving while drying with the lamp to avoid unequal heat, which can cause the plate to break.

When the water has evaporated from the surface, alcohol and ether in the collodion will begin to evaporate leaving the image a lighter color than when it was wet. Historic examples were often left in this state and carefully sealed in presentation cases. Unvarnished images will tarnish to a dark grey-blue if not properly sealed from the sulfurous atmosphere, therefore varnishing collodion plates is recommended using the method that follows.

Heat the prepared varnish by placing the pouring bottle in a cup of warm water. An inexpensive electric coffee cup warmer is ideal. Heat the plate to around the same temperature as the varnish. If the plate is too cold or too hot, the varnish will not flow evenly.

Pour the varnish the same way you poured the collodion *keeping the final draining corner lowermost* until the varnish has set. You may wick off some of the excess varnish by turning the plate vertically and resting the lower edge of the plate on a paper towel. Once set, the plate should be held over an alcohol lamp and warmed to drive off the excess the alcohol solvent. Once again, keep the plate moving and do not let the plate get to close to the flame or the varnish may catch fire.

Housing the Plate

Allow the varnish to out-gas on a rack for at least 3 days before framing. Do not try to remove dust, hairs, lint, or any other matter for several days and when you do, use compressed air. Never touch the surface of the plate or you will leave a mark.

Ambrotypes on clear glass will require a dark backing to make them appear as positives. Paint, black varnish, dark cloth or paper were all used during the collodion era. However, do not apply paint or black varnish to the collodion/varnished side of the plate. Over time, this may peel, taking the image with it. You may also creatively apply blacking selectively to certain areas and then place one image upon a second in a variant called the relievo ambrotype. An alternative is to use dark glass instead of clear glass, which requires a backing.

The image should be framed under glass and with a mat to prevent the collodion image from touching the cover glass. If the varnish was applied correctly, the image will live up to its Greek root as *immortal*. Ambrotypes from the 1850s, made according to the process described, are often found in an excellent state of preservation.

RESOURCE GUIDE

Osterman, Mark. *The Wet-Plate Process: A Working Guide*, available from Scully & Osterman Studio: www.collodion.org.

Albumen Photographs: History, Science and Preservation: www.albumen.stanford.edu

FIGURE 10.14 Osterman explains, "This image captures the spirit of a traveling medicine show that I used to perform from a stage built onto the back of a 1919 Model T Ford. This portrait of myself in the character of Dr. B. Barnabus Bumstead represents a foggy memory of the performance, like telling a story that becomes more embellished every time it's told. This ambrotype, a one-of-a-kind image on glass, is perfectly suited to the *Confidence* series. Being reversed, as are all primary camera images, it contributed to create distance from any truthful recollection of the performance or me. The actual ambrotype plate is a deep maroon colored glass that, with careful lighting, helped me to create the chiaroscuro of the piece. The main artifact in the image is a gaslight we used for evening performances. My lighting of the light for the purpose of extracting wasps from a nest is typical of the sort of nonsensical ballyhoo we would do to attract an audience prior to the performance."
© Mark Osterman. *Paper Wasp Extraction*, from the series *Confidence*, 2001. 10 × 8 inches. Hand-tinted ruby ambrotype. Courtesy of Nelson-Atkins Museum, Kansas City, MO.

KALLITYPE AND VANDYKE BROWNPRINT PROCESSES

Kallitype Characteristics

Dr. W. W. J. Nichol invented the kallitype in 1899. The process is based on Sir John Herschel's iron-silver reduction process called the chrysotype (the modern process is provided at the end of this section). This process is similar to platinum printing, except the kallitype image is made up of metallic silver instead of platinum.

The kallitype is a simple process consisting of silver nitrate and ferric salt. When the kallitype emulsion is exposed to light, some of the ferric salt is reduced to a ferrous state. The newly created ferrous salt reduces the silver nitrate to metallic silver. This metallic silver is not as stable as metallic platinum. Careful processing that removes all the ferric salt and nonimage silver greatly increases print stability.

The kallitype process was never commercially popular because it was introduced at the same time as gaslight papers, which were contact-printing, developing-out papers with a silver chloride emulsion that could be exposed by artificial light. Even more important, the kallitype had an initial reputation for impermanence. When Nichol first unveiled his process, he recommended the use of ammonia for a fix, which proved to be ineffective. However, when fixed in hypo, a kallitype can be as permanent as any other silver-based process.

The kallitype offers an excellent introduction to the more complex platinum printing. Although it is not as versatile as platinum, it offers a much less expensive way of achieving a platinum-like print quality. As in the platinum print, the kallitype works well with a continuous, long-tone negative. There are several formulas and variations of the kallitype process. The easiest one is known as Vandyke or Brownprint. After mastering it, you will be prepared to move on to the more complex general kallitype process.

Vandyke Brownprint Characteristics

The Vandyke Brownprint technique is named after the characteristic rich brown tones found in the paintings of seventeenth century Flemish master Anthony Van Dyck (or Vandyke). A Vandyke image produced from a long-tonal-range negative will have complete detail, from full shadows to full highlights. Shorter-tone negatives produce less-deep shadows. The color can range from medium brown to dark black-brown. Image contrast can be slightly controlled during development with the addition of potassium dichromate to the developer water. The emulsion has a shelf-life of a couple of months and improves with age. Ideally, the emulsion should be prepared and allowed to age 2–3 days before it is used.

Most acid-free rag papers, such as Arches Platine, Arches Cover, and Strathmore 500, offer good starting points. Rives BFK will work, but it should be sized first for consistent results (see the section on "Gum Bichromate Process" later in this chapter). As with cyanotypes, the emulsion may be applied in subdued tungsten light by brushing or floating (see "Applying the Emulsion" in the earlier "Salt Prints" section). No metal should come in contact with the silver nitrate, as it will cause a chemical reaction, so polyfoam brushes with all-wooden handles are recommended for coating. After the paper is coated, it should be dried in a darkened room. Paper may be heat- or fan-dried and should be printed on immediately, as the coated emulsion loses its sensitivity rapidly, producing flatter, grayer images. Be sure the coating is yellow before making any exposures. If it looks brown, it is not good, and should be discarded.

The Vandyke process works well on many fabrics because it contains no colloidal body such as gelatin or gum arabic. The emulsion soaks into the fabric, leaving it unaltered (it does not stiffen up). Natural fibers, such as close-weave cotton, produce the deepest brown tones. Do not use permanent-press materials as they repel the emulsion.

When combining a Vandyke with a cyanotype image it is necessary to print the cyanotype first, to prevent the Vandyke from bleaching.

Safety Alert

Do not mix Vandyke and cyanotype together chemicals as the Vandyke has tartaric acid, which could produce an almond smelling cyanide gas. (The cyanide gas used in an execution chambers is a slightly different cyanide compound.)

Vandyke Formula

Stock solution A

Ferric ammonium citrate	90 g
Distilled water (68°F/20°C)	250 ml

Stock solution B

Tartaric acid	15 g
Distilled water (68°F/20°C)	250 ml

Stock solution C

Silver nitrate*	30 g
Distilled water (68°F/20°C)	1 liter

*Wear gloves when handling silver nitrate because it will stain black anything it touches.

Mix each stock solution separately. With constant stirring, combine stock solutions A and B, then slowly add stock solution C. Store in a tightly closed opaque container in a cool, dry location. Allow to ripen (age)

2–3 days before using. Shake the emulsion before each use, including between brush dips, to ensure even distribution of the silver nitrate. Tightly sealed and refrigerated solutions can last for years.

Exposure

A Vandyke Brownprint is contact printed, using a print frame or heavy piece of glass and a smooth support board, under sunlight or an artificial UV light source until highlight detail becomes visible. Summer sunlight exposures can be as brief as 30 seconds but winter exposures can take 1 hour or more. The color of the emulsion will change from yellow to dark reddish brown during normal exposure. The exposure time for the Vandyke emulsion is about half that for cyanotypes. A typical trial exposure in full summer sun might be about 2 minutes. A comparable exposure with photofloods at about 24 inches from the print frame could be about 15 minutes. Underexposed (thin) negatives can be exposed until the emulsion turns a tan-brown color. Overexposed (dense) negatives should be exposed until the emulsion turns silvery brown.

Development and Contrast Control

The Vandyke is developed in a darkened room in running water at 68°F (20°C) for a couple of minutes, or until the water runs clear. The negative basically determines the contrast, but it may be increased slightly by adding a 10 per cent dichromate solution to the developer water. After the print has washed for 1 minute, transfer it to a tray containing 16 ounces (475 milliliters) of water and about 10 drops of the dichromate solution. Increasing the number of drops of dichromate solution produces more contrast. After the desired level of contrast is reached, transfer the print back into a tray of running water. This process may be repeated.

Fixer

To achieve the true Vandyke brown and ensure permanency, the image must be fixed in a 5 per cent bath of plain thiosulfate for 5 minutes at 68°F (20°C). Since it is a weak solution, it should be monitored with a hypo check and replaced often.

When the image enters the fix, it will darken and turn brown, and the highlights should become brighter. Fix, with agitation, for 5 minutes. If the image is allowed to remain in the fix longer than 5 minutes, it can begin to bleach. Extending the time in the fix can correct for overexposed prints.

Vandyke Fixer Formula

Sodium thiosulfate	25 g
Water (68°F/20°C)	500 ml

Washing and Drying

Wash the image in running water at 68°F (20°C) for 5 minutes. Then place it in a hypo-clearing bath for 2–3 minutes and give it a final wash of 30 minutes to ensure permanence. The image can be air- or heat-dried. Heat drying will darken the brown tone.

Basic Kallitype Process

The fundamental kallitype process is similar to the Vandyke, but it is more complex. The basic kallitype formula uses a mixture of ferric oxalate, oxalic acid, and silver nitrate as the sensitizer. When this emulsion is exposed to light, the ferric oxalate is changed to a ferrous state, which reduces the silver nitrate to metallic silver. During development, the ferrous oxalate is dissolved, leaving behind the metallic silver that forms the image. The advantages of kallitype over the Vandyke are that it offers superior control over image contrast and tone.

Kallitype Formula

Distilled water (100°F/38°C)	16 oz (473 ml)
Ferric oxalate	2¾ oz (78 g)
Oxalic acid*	80 grains (5.2 g)
Silver nitrate*	1 oz (31 g)

*Wear protective gloves when handling both oxalic acid and silver nitrate as they are poisonous and will stain anything they come in contact with.

Dissolve the ferric oxalate and oxalic acid in the water. Constantly stirring, add the silver nitrate. Pour the solution into an opaque bottle with a tightly sealed lid and allow it to ripen for at least 3 days before use.

After the emulsion has ripened, warm the container in a water bath at 100°F (38°C) to redissolve the crystalline silver oxalate precipitate. Apply the emulsion in a darkened room to paper or cloth at 100°F (38°C) by floating or coating with a polyfoam brush. The emulsion can be heat-dried. Printing should be carried out immediately because the sensitized coating will begin to deteriorate within 1 day.

Development and Contrast Control

The image color is determined by the selection of developer. Contrast can be controlled through the use of a 10 per cent potassium dichromate solution in any of the developers (see "Development and Contrast Control" in the "Vandyke Brownprint Characteristics" section). With a normal contrast negative, add 2 drops of the 10 per cent potassium dichromate solution to the developer. If the negative is flat (lacks contrast), add 6–10 or more drops to the developer. There is no need to add any dichromate with

FIGURE 10.15 Rayner constructed this mixed media work using images of skeletons taken in a museum in Strasbourg, France and of skulls taken in the Catacombs in Paris. She printed them on vellum using the Vandyke process. The resulting brown tint reminded her of dirt, which seemed to embody death, and the vellum provided further associations with fragility and decomposition. Rayner painted the backs of the prints with white gesso, which amplified the highlights and integrated the images into the folding panels onto which she adhered them. In this work, Rayner constructs an "archaic looking, sometimes humorous, pseudoscientific contraption that suggests what research in these fields might have looked like a century ago, an expansive time in science that seems nearly impotent to us now. I use this visual framework to point to our shortcomings, in spite of our current technological process. We are still a far from being in control in our search for knowledge."
© Beverly Rayner. *Relentless* (detail), 2006. 9½ × 19 × 7 inches. Vandyke print with mixed media.

contrasty negatives. Prints are processed for 5–10 minutes in any of the developer formulas. Best results are usually obtained when the developer is warm (100°F/38°C).

Kallitype Black-Tone Developer Formula

Distilled water (100°F/38°C)	500 ml
Borax	48 g
Sodium potassium tartrate (Rochelle salt)	36 g

Kallitype Brown-Tone Developer Formula

Distilled water (100°F/38°C)	500 ml
Borax	24 g
Sodium potassium tartrate (Rochelle salt)	48 g

Kallitype Sepia-Tone Developer Formula

Distilled water (100°F/38°C)	500 ml
Sodium potassium tartrate (Rochelle salt)	24 g

Kallitype Clearing Solution

After development is complete, rinse the print in running water and clear it for 5 minutes using the clearing solution.

Kallitype Clearing Solution Formula

Water (68°F/20°C)	1 liter
Potassium oxalate	120 g

Kallitype Fix

After the clearing bath, fix the print for 5 minutes in the fix solution. Be sure to check and replace this solution often.

Kallitype Fix Formula

Water (68°F/20°C)	1 liter
Sodium thiosulfate	50 g
Household ammonia (plain)	12 ml

Washing and Drying

Wash the print for several minutes, and then treat it with a hypo-clearing bath for 3 minutes. Give a final wash of 30 minutes to ensure permanence. Air-dry the print.

Combining Processes

The cyanotype and the kallitype processes contain chemicals that will attack one another when combined on the same surface. Unusual visual effects are possible, but do not expect the resulting image to be permanent. Changes can take place within 1 week. If you wish to preserve the effect, it is necessary to rephotograph the work in color. Again, not to mix the cyanotype and Vandyke chemicals together because of the potential for producing cyanide gas.

RESOURCE GUIDE

For a contemporary iron-based silver printing process that produces brown images on plain paper see Mike Ware's Argyrotype Process: www.mikeware.demon.co.uk/argy.html.

CHRYSOTYPE PROCESS

When Herschel described his cyanotype process, he also mentioned that gold could be used in a similar process. His instructions were limited to a statement in which he said the sensitizer was ferric ammonium citrate and the print was to be developed in a neutral solution of gold chloride. Working from this scant evidence, Robert W. Schramm and Liam Lawless devised the following chrysotype (gold print) process.

Chrysotype Formula

Gold chloride solution (10 per cent)*	8 drops (6.4 ml)
Distilled water (68°F/20°C)	12 drops (9.6 ml)
Ferric ammonium citrate (18 per cent)**	20 drops (16.0 ml)

*10 g per 100 cm³ of distilled water.
**18 g per 100 cm³ of distilled water.

Applying the Emulsion

Commence with a hot-press watercolor paper such as Cranes 7 cover stock. Apply an even coat of sensitizer under a 15–25 watt incandescent bulb using a foam or hake brush. One has about 20 minutes to coat the paper before the gold precipitates out of solution after you mix the sensitizer. Therefore, mix only what you will need to coat a few sheets of paper. The individual gold chloride and ferric ammonium citrate solutions will keep indefinitely, but the gold chloride solution needs to be stored in an amber bottle or in the dark. Air-dry the paper. Using heat, such as a hair dryer, will result in a loss in contrast.

Printing

Place the negative in contact with the dry, sensitized paper in a contact print frame. A contrasty negative will work best. A rule of thumb is to use a negative that would print best on Grade 0 or 1 gelatin silver paper.

Expose under a UV light source until a faint image appears. Use test strips to find the proper exposure with your UV source.

Chrysotype Developer

Slide the print face down into the developing bath and then turn it face up. Agitate the developer. The temperature of all solutions is about 68°F (20°C), but temperature control is not critical. Development should be complete in a minute or less.

Chrysotype Developer Formula

Potassium oxalate	2 teaspoon
Distilled water	8 oz

Clearing

Clear the print in a 10 per cent sodium sulfite solution or 3 teaspoons of HDTA in a liter of distilled water.

Wash

Wash for 30–60 minutes, depending on the paper.

The above process will result in unique, reddish-purple to bluish-red prints.

RESOURCE GUIDE

Ware, Mike. *The Chrysotype Manual: The Science and Practice of Photographic Printing in Gold*, available at: www.siderotype.com/publications.htm.

Ware, Mike. *Gold in Photography: The History and Art of Chrysotype*, available at: www.siderotype.com/publications.htm.

Schramm Studio: www.schrammstudio.com.

FIGURE 10.16 A year after William Henry Fox Talbot publicly announced his invention of silver-based photography in 1839, Sir John Herschel worked out a method for making photographic images in gold. Herschel's chrysotype formula, named after the Greek word for gold, had difficulties with contrast control and image fogging. (The modern formula eliminates those problems.) Depending on the size of the microscopic particles of gold, the type of paper, and the developer, chrysotypes can range in color from blacks and pinks, to blues, purple, violet, green, and in some cases a golden color.
© Robert Schramm. *La Lune*, 1999. 8 × 10 inches. Chrysotype print.

PLATINUM AND PALLADIUM PROCESSES

William Willis patented the platinum printing process in 1873 and began to market it in 1879 under the name Platinotype. Photographers such as P. H. Emerson and Frederick H. Evans favored the paper. It also became extremely popular with the Pictorialists, the Linked Ring Society, and the Photo-Secessionists.

Platinum is a contact-printing process in which the image is first partially printed out (becomes visible) in UV light. After exposure, the full image is chemically developed out to completion. Like all printing-out processes, it allows subtle highlight details to be retained without the deep shadow areas becoming buried. This is due to its self-masking ability. When a print is made using this process, the shadow areas are the first to appear on the paper, darkening the top layer of the print emulsion, which then acts as a mask. This mask holds back some of the light so the shadows do not get as dark as they would in a silver-based print that is developed out. Consequently, light is permitted to pass through the denser highlight areas of the negative without the shadows going black

and losing detail. Thus a soft print with a long tonal scale and luminous shadow detail can be produced.

All sensitizing and developing can be done under subdued tungsten light. Varying the proportions of the sensitizer solutions controls contrast. Platinum produces an image color from silvery gray to rosy brown. The print has a matte surface, so there is no reflected glare. Platinum is more stable than silver, so images can be as permanent as the paper on which they are printed.

The major disadvantage of platinum is its extremely high cost. For this reason, platinum papers have not been widely available since 1937. Palladium, which is somewhat less expensive, can be substituted for platinum and will deliver similar results, although it does not provide as much color variation. Palladium produces brown-tone prints. Platinum and palladium are often mixed in equal parts to produce a warmer tone than can be achieved with platinum alone.

Platinum Printing

Platinum is not light-sensitive enough to permit enlarging, so a large or enlarged negative is needed for contact printing. Due to the slowness of the material, burning and

FIGURE 10.17 Chamlee worked with an 8 × 10 inch Kodak Masterview camera to capture this view during the brief time that a surreal light filled this lagoon. She tray developed the Kodak Super XX film by visual inspection using ABC Pyro. Salto Platinum Atelier in Belgium, which oversaw the printing process, enlarged the 8 × 10 inch negative to 24 × 30 inches and printed it in five layers by exposing five negatives in register, four separations and one shadow mask. The print was then processed using standard platinum printing procedures. Chamlee explains, "I find the characteristics of the translucent, handmade Japanese Taizan paper printed in platinum are an exquisite match with the sensuous textures and forms in the picture."
© Paula Chamlee. *Jökulsárlón, Iceland,* 2004. 24 × 30 inches. Platinum print.

dodging are not generally done during printing but are carried out when the enlarged negative is made (see Chapter 3).

The platinum process is similar to other ferric, iron-sensitive processes such as the kallitype, except that platinum salts are used in place of silver salts. The paper is sensitized with ferric oxalate and potassium chloroplatinite. When exposed to UV light, the ferric salts are reduced to the ferrous state in proportion to the density of the negative. When the print is developed in a potassium oxalate developer, the newly formed ferrous salts are dissolved, and they, in turn, reduce the platinum to the metallic state. The image is then cleared in a bath of dilute hydrochloric acid, which eliminates the remaining ferric salts, leaving behind an image composed only of platinum.

Negatives

Platinum delivers a classic straight-line response, meaning that the print will reveal the full range of tonal values, from dark shadows to very subtle highlights, which have been recorded on the negative. For this reason, negatives possessing a long and full density range with good separation and shadow detail make excellent candidates for printing. Platinum is one of the few emulsions capable of successfully rendering such a wide contrast range. Generally, a contrasty and dense negative that will print well on a Grade 0 or 1 gelatin silver enlarging paper is a good starting place.

If the negatives being made are only for platinum printing, some printmakers increase the amount of

exposure given to the film by as much as quartering the standard ISO rating. For instance, an ISO 400 speed film would be exposed at ISO 100. T-MAX films are an exception. Try T-MAX 100 at ISO 75 and T-MAX 400 at ISO 200. In addition, some people increase the developing time by 30–50 per cent. D-23 is a favorite developer for negatives that will be used to print on platinum (see Chapter 4 for the formula). Thin negatives print looking dull, flat, and lacking in detail. On the other hand, printing negatives made on high-contrast film, such as litho film, is uncommon because their lack of tonal range does not take full advantage of the subtleties of the platinum process. Obviously, experimentation is in order. If the negatives being made are for both platinum/palladium and silver printing, expose T-MAX 400 at ISO 200 or T-MAX 100 at ISO 50 and process in D-23.

Paper

Arches Platine paper which is specially sized for platinum printing or other fine-textured, 100 per cent rag papers, like Crane's Kid Finish #64, are excellent starting points. Papers with too much texture cause the fine details of platinum to be lost. Rives BFK and similar papers are very absorbent and soak up copious amounts of expensive emulsion. Such papers can be sized to reduce their rate of absorption (see the section on "Gum Bichromate Process" later in this chapter). A paper's chemical makeup can have a noticeable effect on the color and tonal range of the print. Paper manufacturers are continually making changes in their operations. Test a variety of papers to determine the desired results.

Chemicals

The price of platinum and palladium salts varies greatly, so check a number of sources before ordering. Sometimes ferric oxalate can be hard to find. It is deliquescent (dissolves by absorbing moisture from the air) and should be stored in a tightly sealed opaque bottle. If prints appear to be fogged, test the ferric oxalate by dissolving some in water and adding a 5 per cent solution of potassium ferricyanide. If this mixture turns blue, the ferric oxalate has become ferrous. Discard it, as it will deliver poor results.

Platinum Emulsion

The emulsion is made up of three separate stock solutions, each stored in an opaque glass bottle with a medicine dropper. Do not interchange the droppers. Label the bottles and store them in a dark place. The platinum solution lasts indefinitely. The oxalates will keep for a couple of weeks or up to a few months if refrigerated. When the oxalate solution goes bad, the print highlights become uneven and start to fog. Follow all safety procedures as outlined in Chapter 2 when handling these chemicals.

Platinum Emulsion Formula

Stock solution 1

Distilled water (120°F/49°C)	55 ml
Oxalic acid	1 g
Ferric oxalate	15 g

Stock solution 2

Distilled water (120°F/49°C)	55 ml
Oxalic acid	1 g
Ferric oxalate	15 g
Potassium chlorate	0.3 g

Stock solution 3

Distilled water (100°F/38°C)	50 ml
Potassium chloroplatinite*	10 g

*Do not use chloroplatinate. If some of the platinum should precipitate out of the solution during storage, warm it in a water bath, prior to use, to redissolve the platinum.

All the solutions should be prepared 1–2 days beforehand and allowed to ripen. When you are ready to use the solutions, combine them to produce the desired contrast level (see the next section) in a clean glass bottle. Tighten the top and mix by shaking.

Contrast Control

Varying the proportions of solution 1 and solution 2 controls the image contrast with a normal negative (see Box 10.3).

Raising Contrast

In addition to increasing the amount of solution 2 in the emulsion, you can raise the contrast of a print by carrying one or more of the procedures listed in Box 10.4.

Lowering Contrast

Print contrast may be lowered by carrying out one or more of the procedures listed in Box 10.5.

Applying the Emulsion

The emulsion can be applied under subdued tungsten light. Practice coating on scrap paper. Use water to which a few drops of food coloring has been added to make it easier to see what is happening. Tape or pin the paper to a smooth, flat surface. Use a brush with no metal parts (about 2 inches wide) that has a thin row of bristles so a minimum amount of emulsion is used. If the brush has any metal, do not let the emulsion come in contact with

Box 10.3 Platinum Emulsion Contrast Control*

Very soft prints

Solution 1	22 drops
Solution 2	0 drops
Solution 3	24 drops

Soft prints

Solution 1	18 drops
Solution 2	4 drops
Solution 3	24 drops

Average-contrast prints

Solution 1	14 drops
Solution 2	8 drops
Solution 3	24 drops

Above-average-contrast prints

Solution 1	10 drops
Solution 2	12 drops
Solution 3	24 drops

High-contrast prints

Solution 1	0 drops
Solution 2	22 drops
Solution 3	24 drops

* For 8 × 10 inch print. Cut number of drops in half for 5 × 7 inch print, and half again for 4 × 5 inch print.

Box 10.4 Raising Contrast with Platinum Emulsion

1. Use a hard, smooth-surface (hot-pressed) paper.
2. Give the paper a second coat of emulsion after the first has dried.
3. Add 5–25 drops of a 10 percent solution of potassium dichromate to the developer.
4. Lower the temperature of the developer.
5. After the first exposure is processed and dried, recoat the paper and expose it again with the same negative.

Box 10.5 Lowering Contrast with Platinum Emulsion

1. Use a soft, rough-surface (cold-pressed) paper.
2. Reduce overall exposure time and process in a warm to hot developer.
3. Add a few drops of clearing bath to the developer.

it, as this will cause a chemical reaction that will contaminate the emulsion. Metal parts may be painted with rubber cement for protection.

Dip the brush into distilled water and squeeze it out so the brush is just damp. Doing this will reduce the amount of emulsion needed to coat the paper. Using a clean dropper put a line of emulsion along the top of the paper. With long, rapid, parallel strokes, brush the emulsion up and down and back and forth until the surface is dry. Coat an area larger than the negative so that the excess can be trimmed off to make test strips. Spread the emulsion as evenly as possible. Avoid puddles that may soak into the paper and produce uneven print density.

Wash the brush immediately after use, as exposure to light will cause ferrous salts to form in any remaining emulsion. If the brush is not properly washed, these salts can contaminate future prints during the coating process. Paper can also be coated by using a $^3/_8$ or ½ inch diameter acrylic or glass rod instead of a brush. Rods coat paper evenly and use less solution than other coating methods and can be purchased or made.

Coating Paper with a Rod Obtain solid glass rod stock or Pyrex glass rod and tubing from a supplier like Fisher Scientific (see "Resource Guide" at the end of the chapter) or from a glassblower supplier. The rod should be slightly longer than the width of the paper to be coated.

Using a clean dropper, put a line of emulsion along the top of the paper. Place the rod in the emulsion and pull the rod and emulsion across the paper. When you have reached the other side of the paper, lift the rod up and down slightly to redistribute the emulsion, and then drag the emulsion back to your original starting point. Repeat this procedure five or six times until the paper is evenly coated. Remove any excess emulsion with a paper towel.

Drying the Paper Once the paper is coated, hang the paper with plastic clips or clothespins with no metal in a darkened room, or use a hair dryer on low heat to speed drying. Platinum emulsion is hygroscopic and will absorb moisture from the air. If too much moisture is absorbed into the paper, the highlight areas can produce degraded and grainy results. Heating the paper as it dries helps reduce the likelihood of this occurring. When dry, the unexposed paper should be a pale yellow color.

Do not handle the emulsion surface, as it is easily contaminated before printing is completed. Sensitize only the paper needed for immediate use. Expose and process as soon as possible.

Printing

The emulsion is exposed by contact printing with UV light. Combine the negative and paper (emulsion to emulsion) in a printing frame or under glass with a smooth, firm support. A typical sunlight exposure can run 1–5 minutes depending on the season, the time of day, and cloud cover. Many workers prefer a UV exposure unit with a fluorescent, pulsed xenon, or quartz light source. They produce more constant exposures that can be easily

repeated (see "Resource Guide" at the end of this chapter). A home sunlamp also may be used. At a distance of about 24 inches from the printing frame, exposure times may run 15–30 minutes with a sunlamp. Since the platinum emulsion is expensive, making test strips or using a step wedge that show key highlight and shadow areas is highly recommended to keep costs to a minimum. Past experience, consistent use of light sources, plus trial and error will help establish good starting exposures.

The image will print out to a limited extent, appearing to be a lavender-gray against a yellowish ground. Correct exposure will have detail in the highlight areas, but this will be faint and is difficult to use as an accurate guide (another reason to make test strips or use a step wedge). The correct exposure cannot be determined until the print has been processed and at least surface dried.

Exposure time also depends on the amount of potassium chlorate (solution 2) in the emulsion. An increase in potassium chlorate cuts the printing speed and results in higher contrast. An emulsion for very soft prints, having no solution 2, may need 25 per cent less exposure than normal. An emulsion for high-contrast prints, having the maximum amount of solution 2, may need up to 75 per cent more exposure than usual.

Platinum Development

Due to the hygroscopic nature of platinum emulsion, the print should be processed immediately after exposure. Development can be carried out under subdued tungsten light in a saturated solution of potassium oxalate.

Platinum Developer Formula

Water (120°F/49°C)	48 oz (1,420 ml)
Potassium oxalate	1 pound (454 g)

Store the developer in an opaque bottle and use at 68°F (20°C). Do not discard the developer. It will last a long time without any replenishment and can actually improve with age as the platinum residuals build up. When a precipitate forms, decant the solution (gently pour off the solution without disturbing the sediment) into another container.

The developer acts very rapidly, so you must immerse the print, face up, with a quick, continuous motion. Hesitation may produce development lines or streaks that can sometimes be removed by rubbing the print while it is in the developer. Development time is 1–2 minutes, with gentle agitation. Development is automatic, meaning that the chemical reaction will continue until it is complete and then it will stop. Consequently, increasing the development time beyond about 2 minutes will not affect the final image.

The color of a platinum print becomes warmer as the temperature of the developer rises. A warmer temperature also increases the printing speed of the paper, so less exposure is required. Make sure the developer temperature remains constant between the test strip and the final print to ensure consistent results. Warm developer reduces the overall print contrast. You can compensate for this to a certain degree by increasing the amount of solution 2 in the emulsion.

Platinum Clearing Bath

After development, in normal room light, clear the print in three successive baths of dilute (1:60) hydrochloric acid (1 part hydrochloric acid to 60 parts water). This bath removes any remaining ferric salts by changing them into soluble ferric chloride. If this is not done, the print will remain light-sensitive and continue to darken. Some workers have found that citric acid, phosphoric acid, or Bostick & Sullivan's EDTA Tetra Sodium Clearing Agent (tetra-acetic acid tetrasodium) work well and are safer to use than hydrochloric acid.

Hydrochloric Acid Clearing Formula

Water (68°F/20°C)	420 ml
Hydrochloric acid (37 per cent)	7 ml

Always add acid to water. This solution may be re-used and lasts indefinitely.

EDTA Tetra Sodium Clearing Solution

Water (68°F/20°C)	420 ml
EDTA Tetra Sodium	15 g

Clear the print for 5 minutes in three separate trays of the clearing bath with occasional agitation. After a few prints have been cleared, dump the first bath, refill it with fresh solution, and move it to the end of the clearing trays so it becomes the third bath. Move the second bath up to the first position and the third to the second. This ensures the complete removal of the iron salts from the print. The third bath should remain clear after the print has gone through. If it is not clear, give the print a fourth bath in fresh clearing solution.

Washing and Drying

After clearing, wash the print for 30 minutes in running water at 68°F (20°C). Handle the print with care, as it is very delicate at this stage. Prints may be air-dried or dried with low heat from a hair dryer.

FIGURE 10.18 Modica spent 10 years photographing the lives of a family with fourteen children living in an isolated rural New York town using an 8 × 10 inch view camera and a single lens. The artist chose platinum printing for its extended and subtle tonal range and because the image is located in the paper itself, as opposed to sitting on top of the paper as in a gelatin silver print.
© Andrea Modica. *Treadwell, New York*, from the book *Treadwell*, 1986. 8 × 10 inches. Platinum/palladium print.

Spotting

Dried prints may be spotted with black India ink diluted with water. This often matches the neutral to warm black tones of a platinum print. Burnt umber and lampblack watercolors work well when mixed to the proper shade.

Combination Printing with Platinum

Platinum can be combined with palladium, gum, or cyanotype. When cyanotype is used with platinum the cyanotype should be printed last, as the potassium oxalate developer will bleach the cyanotype image.

Palladium Printing

When comparing palladium with platinum, remember that they act very much alike. Even experts can have difficulty seeing the difference between a platinum and a palladium print. Palladium is less expensive than platinum and produces a permanent brown-tone print that is warmer in tone than the image achieved with platinum. The working procedures are the same as those used with platinum, except for the following:

1. Palladium salts are not as sensitive as platinum salts to potassium chlorate, which controls the contrast. This can be corrected by doubling the amount of potassium chlorate in solution 2.

2. Palladium is more soluble in hydrochloric acid, so the clearing bath can be diluted 1:200 (1 part hydrochloric acid to 200 parts water). The contrast of palladium cannot be increased by adding potassium dichromate to the developer because the image will bleach out during the clearing baths.

3. Solution 3 of the emulsion sensitizer must be modified as described in the following formula.

Modified Palladium Emulsion Solution 3 Formula

Distilled water (100°F/38°C)	2 oz (60 ml)
Sodium chloropalladite	169 grains (9 g)

If sodium chloropalladite is unavailable, use the following formula.

Modified Palladium Emulsion Solution 3 A Formula

Distilled water (100°F/38°C)	1½ oz (40 ml)
Palladium chloride	77 grains (5 g)
Sodium chloride	54 grains (3.5 g)

RESOURCE GUIDE

Bostick & Sullivan offer their Ziatype process kit, which is user-friendly version of platinum/palladium: www.bostick-sullivan.com.

GUM BICHROMATE PROCESS

John Pouncy patented the first workable gum process in the late 1850s. The process was a favorite of the Pictorialists from the 1890s to about 1920, often under the name Photo-Aquatint. Gum printing experienced a revival in the late 1960s.

The gum bichromate process operates on the principle that colloids (gelatinous substances) become insoluble when they are mixed with certain light-sensitive chemicals and exposed to UV light. This effect is called hardening or tanning. The most frequently used colloids in photography are albumen, gelatin, and gum arabic. In the gum bichromate process, the support material is coated with a gum arabic that contains a pigment (watercolor or tempera) and with a light-sensitive chemical (ammonium or potassium dichromate) to produce a nonrealistic color image from a contact-size negative. Gum arabic, a water-soluble colloid, is hardened by exposure to UV light and thus made insoluble in direct proportion to the density of

Box 10.6 Gum Printing Attributes

- Inexpensive because it uses no metal salts.
- Permits extensive manipulation of the image.
- Versatile and can be combined with other processes.
- Permanent.
- Allows choice of color or multiple colors of the final image, as opposed to other processes with predetermined tones like cyanotype, kallitype, platinum, and Vandyke.

the negative. The areas that are not hardened remain water-soluble and are washed away with the unneeded pigment during development. The hardened areas are left intact and bond the pigment to the support. A great deal of control over the final image can be exercised through the following: choice of paper, pigment, localized development, recoating the paper with the same color or a different color, or using the same or different negatives for additional exposures. Box 10.6 lists gum print characteristics that attract artists to the process.

The disadvantages of gum printing stem from its versatile nature. It is a more difficult process to control than the nonsilver processes discussed earlier in this chapter. Multiple coats of emulsion and exposure are necessary to build up a deep, rich image. The support material (paper) must be presoaked (shrinking the paper) sized, or the registration of the different exposures will not line up, thus producing blurry images. Any subtle or fine detail will be lost in the process. Gum also does not deliver a realistic color balance, although some photographers will go to great lengths to produce digital color separation negatives in pursuit of creating full color gum prints (as described in Chapter 3 regarding making enlarged negatives).

This section offers a starting point for making gum prints on paper. There are countless formulas for gum printing, and the process can be used with almost any type of support material. Keep a record of your working methods and make adjustments. Feel free to modify the suggested working methods whenever necessary.

Paper

Start with a high-quality watercolor or etching paper that has a slight texture and the ability to withstand repeated soaking and drying. Some widely available papers include Arches Watercolor, Rives BFK, and Strathmore 500 Series (two- or three-ply). All paper should be presoaked and sized. Some papers, such as Strathmore 500, can be purchased presized. For exacting work, even these papers may have to be presoaked and resized.

Presoaking or Preshrinking

Presoak by placing the paper in hot water (100°F/38°C) for 15 minutes and then hang it up to dry. Without the

presoak, the paper will shrink after the first time it is processed, thus making accurate registration of the next exposure impossible.

Sizing

While presoaking/preshrinking achieves the desired effect of removing any shrinkage from the paper (for better registration later during multiple printings), this step unfortunately also removes the factory gelatin sizing from the paper. After the presoak, size the paper. There are two widely used methods of sizing. The quickest and easiest way is to use spray starch. Pin or tape the paper to a clean, smooth support board. At a distance of about 12 inches, start spraying the starch at the bottom of the paper in horizontal sweeps and work upward to the top of the paper. Do not overspray, as too much starch will prevent the emulsion from sticking to the paper. Use a soft, clean, damp sponge to wipe off any excess starch and to ensure an even coat. Apply a thin coat of starch between exposures to prevent the colors from bleeding into each other.

The gelatin method of sizing is more effective but also more time-consuming. Dissolve 28 grams of unflavored gelatin in 1 liter of cold water. Allow it to swell (sit) for about 10 minutes and then slowly heat the solution to 100°F (38°C) until it is completely dissolved. Pour the solution into a tray and soak each sheet of paper for 2 minutes. Lightly squeegee off the excess solution by dragging the printing/front side of the sheet of paper over the edge of a tray, and hang the paper up to dry (low heat may be used). Another popular squeegee method involves hanging the paper and using two Plexiglas rod dowels, placing one rod on the back of the paper, and one on the front horizontally, drawing them down the sheet together to force excess sizing down and off the paper.

Many workers give the paper a second coat of sizing after the first one has dried.

Hardening

The gelatin sizing must be hardened or else it will wash away during processing. In a well-ventilated area, harden the surface by floating the paper in a bath of 25 milliliters of 37 per cent formaldehyde and 500 milliliters of water for 2 minutes and then drying it. A 1 per cent glyoxal solution can also be used to harden gelatin sizing. In a well-ventilated area, add 25ml of glyoxal 40 per cent solution to 900 milliliters of water. Add water to bring the level up to 1 liter. Float the sized paper in the 1 per cent glyoxal solution for 5–10 minutes and then dry.

Emulsion

The emulsion is made of pigment, gum, sensitizer, and distilled water. Varying the amounts of these ingredients will result in noticeable changes in image characteristics. For this reason, experimentation is a must. A specific combination might deliver results that are pleasing to one imagemaker but unsatisfactory to another.

Pigments

The easiest way to add color to the emulsion is with good-quality tube-type watercolors such as Winsor & Newton and Grumbacher. Many workers find that the opaque gouache-style watercolors perform well. Tempera colors also may be used.

The following is presented as a basic color palette, which approximates the subtractive primaries of color photography (yellow, magenta, and cyan) plus black:

- Cadmium yellow (pale). Hansa yellow is a less expensive synthetic that can be substituted for cadmium.
- Alizarin crimson (close to magenta).
- Monastral or thalo blue. Prussian blue is not recommended because it is chemically incompatible with cadmiums and vermilions.
- Lamp black.

In addition to these three primary colors, there are earth colors such as burnt sienna (brownish brick red), raw sienna (yellower than burnt sienna), burnt umber (dark red-brown), and raw umber (yellowish brown). These colors, in conjunction with lamp black, are useful in making a wide variety of tones.

Note that the chrome colors, such as chrome yellow, can be chemically incompatible with the sensitizer and with other organic pigments. Emerald green, which is poisonous, should not be mixed with other colors, as it is not chemically compatible.

Gum Solution

The gum solution may be prepared from a formula, but it is advisable to purchase it in small premixed amounts. This bypasses the difficult process of dissolving the gum and prevents the handling of mercury chloride, which is a toxic chemical used to stop the growth of bacteria. Lithographer's gum (14°Baumé) solution is available from graphic arts or printing suppliers. Be sure it comes with a preservative, such as 1 per cent formaldehyde, as it does not keep well. To ensure its freshness, some practitioners buy it in small quantities and replace it often.

Sensitizer

The recommended sensitizer is ammonium dichromate (bichromate is the same thing) because it is more sensitive to light than potassium dichromate, thus making faster exposure times, although ammonium is more toxic than potassium dichromate. Store sensitizer in an opaque bottle. If precipitate forms during storage, reheat and dissolve the solution.

Ammonium Dichromate Formula

Distilled water (80°F/27°C)	100 ml
Ammonium dichromate*	25 g

*Wear protective gloves, as this may cause skin irritation.

Historic and Alternative Processes: Beauty, Imagination and Inventiveness

Preparing the Emulsion

The amount of pigment should be varied depending on the desired effect and the type of paper being used. The following is provided as a general guideline, but experimentation is in order.

Gum Dichromate Emulsion Formula

Gum arabic solution	40 ml
Pigment (tube-type watercolors) *	
Ammonium dichromate sensitizer	40 ml

*Pigment amounts vary greatly depending on the desired effect. The following is only a starting point:

- Alizarin crimson — 3 g
- Monastral or thalo blue** — 2 g
- Cadmium yellow — 3 g
- Burnt sienna — 3 g
- Burnt umber — 3 g
- Lamp black — 3 g

** Pure blues are difficult to achieve because the orange dichromate tends to shift the color balance to green.

Put the gum arabic and pigment in a clean baby food jar, secure the lid, and shake rapidly until the solution is completely mixed. Then add the dichromate and shake until the solution is uniform. Generally, the gum and dichromate are mixed in equal proportions, while the amount of pigment is varied. It is advisable to use the emulsion quickly, within one day or working session, as it does not keep well.

Visual Effects of Varying the Emulsion Ingredients

Varying the proportions of the gum, pigment, and sensitizer results in the following changes:

- Increasing the gum permits more pigment to be retained without staining. If there is too much gum, the emulsion will be too thick to be easily applied and may flake off during development.
- Decreasing the gum causes the emulsion to set up more slowly and also may cause staining.
- Increasing the pigment causes the emulsion to set up more rapidly and deepens the color in the shadow areas. This often requires forced development and may produce stains in the highlights. Too much pigment may cause the image to crumble off the paper during development.
- Decreasing the pigment allows the highlight areas to develop more readily but produces very low contrast, as there will be little shadow density.
- Increasing the sensitizer delivers less contrast, as it thins the emulsion; thus less pigment is deposited on the support surface.
- Decreasing the sensitizer results in a lack of light sensitivity, with only the shadow areas printing out.

Applying the Emulsion

The emulsion is not very sensitive to light while it is wet, so coating can be carried out under subdued tungsten

FIGURE 10.19 Taylor began constructing this image by first making a cyanotype exposure on Fabriano 140 lb watercolor paper. He then made three successive overlaying exposures with gum bichromate to add color, richness, and texture. Taylor completed the image by hand-painting animal figures with acrylic paint and sewing a parchment scroll depicting an ocean scene printed in cyanotype atop the multiply printed composition. The completed work represents an "imaginary ledger of animals found on Noah's Ark."
© Brian Taylor. *Noah's Ledger*, 2007. 20 × 24 inches. Hand-colored gum bichromate print over cyanotype with mixed media.

light. The paper should be pinned or taped to a smooth, flat board. Generally, the lightest color is applied first, as it may not print well over the darker colors. Some workers like to print a dark color first to make registration easier when additional coats are applied.

Pour the emulsion in a small nonporous bowl or jar. Dip a spreading brush at least two inches wide (polyfoam brushes work fine) into the emulsion. Squeeze out the excess on the side of the bowl. Coat the paper with long, smooth, horizontal strokes and then with vertical ones. Have enough emulsion on the brush to make one complete stroke without having to redip. The strokes should overlap slightly. Perform this operation as rapidly as possible (10–15 seconds for an 8 × 10 inch). Do not let the emulsion puddle or flood the paper.

Immediately take a dry blending brush and, holding it vertically to the paper, paint in long, gentle strokes, using only the tip of the brush to smooth out the emulsion. This step also should be done as quickly as possible. The coating must be even and thin, or the gum may flake off the print later.

Stop blending as soon as the emulsion becomes stiff or tacky. Many of the small brush strokes will smooth out as the paper dries.

Hang the paper to dry in a darkened room. A fan or hair dryer, set on low heat, can be used to speed drying. The paper should be exposed as soon as it is dry, as it will not keep for more than about 1 day. If it is sealed in a plastic bag and refrigerated, however, the paper can keep for up to 2 weeks. Try to avoid working in humid conditions, as the bichromate solution absorbs moisture from the air, making it less sensitive.

Exposure

Combine the negative and paper (emulsion to emulsion) in a contact-printing frame or under a clean piece of glass with a smooth support board. Expose this sandwich to UV light. Typical sunlight exposures can be 5–10 minutes. With photofloods, at a distance of 18–24 inches from the printing frame, exposures may be 20–60 minutes. Sunlamp exposures can range from 10–40 minutes. Different pigments require different exposures. Use an electric box fan to lengthen the life of the light source and keep the negative and print from getting too hot. Excessive heat may produce a pigment stain in the print.

Development

Immediately after exposure, the print should be developed in subdued tungsten light. Slide the print, emulsion side down, into a tray of water at 70–80°F (21–27°C). Allow it to float without agitation. Change the water after about 5 minutes, when it has become cloudy. Transfer the print to a tray of fresh water or remove the print and change the water in the tray, then return the print to the tray. For the full range of tones, development should be complete in about 30 minutes. You can tell it is complete when the highlight areas are clear. If development seems to be going

too slowly due to overexposure or the use of too much pigment, raise the temperature of the water to 100°F (38°C). If a print is underexposed, you can use additional layers of exposure to build up the image density. Overexposure or too much heat can harden the emulsion, making it impossible to wash off. The emulsion of an extremely underexposed image might float off the paper during development. If the emulsion flakes off, it was applied too thickly.

Forced Development

A soft brush and/or a directed stream of water (from a hose, graduate, or atomizer) can be used to manipulate the image. These forced development methods diminish subtle print detail but permit the use of more pigment in the emulsion, increasing the contrast and density of the image. The amount of pressure applied by the brush or stream of water determines the abrasive effect. The print may be removed from the tray of water, placed on a piece of Plexiglas for manipulation, and then returned to the tray to finish the development process. When development is complete, hang the print to dry.

Multiple Printing

After a single exposure, most gum images look flat and weak, lacking color saturation and a sense of visual depth. Multiple printing increases contrast of the shadow areas, can extend the overall tonal range, and give the appearance of greater depth. In basic multiple printing, the dried image is recoated and re-exposed with the same negative in register. This can be repeated numerous times. Gum printing can be successfully combined with cyanotypes for heightened color and contrast or with posterization negatives.

Registration Methods: Buttons, Crosshairs and Pins

If one is satisfied with the results of a single exposure gum print, registration (alignment of negative and print) is never an issue, since the negative is printed once, and need not be aligned a second time over the initial image. However, many gum printers specifically want the complexity of color and layering that is only possible with multiple printings, one on top of another. Variations in multiple printing include printing negatives with different densities, using color-separation negatives, and using entirely different negatives, printing out of registration, and changing the pigment.

When multiple exposures are required, a simple way to register the print is to mark all four corners of the negative on the paper with a soft lead pencil. For more accurate registration, tape a piece of heavy paper along one edge of the negative. Sandwich the negative and paper (emulsion to emulsion) together. Use a standard hole-punch to make a hole in two of the corner edges of the paper and the base sheet. Attach registration buttons, available at a graphic arts store, to the support board. Fit the negative and base

sheet into the registration buttons/pins. This will register the negative and paper each time it is recoated.

The drawback of this method is it biases the registration fully to the side of the print where the pins are located. The result is the inevitable shrinkage that occurs between runs will occur more noticeably on the opposite side of the image. To compensate, artist/educator Brian Taylor favors a method that spreads the shrinkage out and averages it across the entire image. Using a marking pen, Taylor makes opaque marks, such as crosshairs or dots, in the margin outside the image area, on one side of the image, and then again in the opposite margin. These opaque marks will leave a white photogram (shadow) of themselves during the first printing, which can be visually aligned once again with the crosshair marks on your negative during succeeding printings. Be sure to make these marks on your negative before your first exposure, so they can guide registration for all succeeding exposures. Photographers making enlarged negatives digitally can use Photoshop's specific tool for creating registration marks in the margins.

Brian Taylor also recommends another simple and invisible registration method of placing the negative on the coated and dried paper, then thrusting a pushpin through one side of the negative and the paper, then forcing a second pushpin through the opposing far side of the negative and paper. Next tape the negative in place and remove the pushpins. Now you have two small holes that can be used to register the negative with the print during succeeding printings by temporarily replacing the pushpins in the negative once again, and then using the points of the pins to relocate the holes they originally created in the print (of course, tape the negative to the print once again and remove the pushpins). This is a highly accurate registration method, which often reveals the slight shrinkage that unavoidably occurs between runs, but it gives a printer the ability of averaging out the shrinkage between the two holes.

Regardless of how much care is taken in initially presoaking/preshrinking the paper slight shrinkage often occurs between exposures. To compensate for shrinkage between multiple exposures Taylor turns the print over and wipes the back of the paper with a wet paper towel. This imparts a slight dampness to the paper, causing it to swell and enlarge during the next few minutes. This swelling lengthens the image and allows your registration marks to line up once again.

Clearing

After all the printing operations are finished, a yellow or orange stain may be visible. This may be cleared in a 5 per cent solution of potassium metabisulfite or sodium bisulfite. Immerse the print in the clearing bath for 2–5 minutes, wash it for 15 minutes, and dry it.

THE BROMOIL PROCESS

In the bromoil process a gelatin silver bromide print is bleached and then silver is replaced with ink. Introduced in 1907, bromoil offers the option of making an enlargement from a small negative and allows the color, tonal effects, and the diffusion of detail in the final print to be controlled by hand. Multiple impressions can be made with different colored inks. Bromoil's latitude, rich texture, and painterly appearance gave it a following among expressive printmakers through the 1940s.

Traditionally, bromoil prints are produced in either black or brown. The initial image is produced through the conventional black-and-white printing process. The image is then bleached, dried, resoaked, and finally ink is forced onto the emulsion to create the image. Inks cling only to areas on which the paper previously displayed the silver image. After one last drying, a bromoil print has been produced. This print is then archivally stable.

Bromoil Print Summary

The following introduction to the bromoil process is provided by Jill Skupin Burkholder, which is based on her extensive work and that of Gene Laughter with the process.

1. Select a negative possessing a full range of midtones and detail in both shadow and highlight areas.
2. Make a test strip or a test print on fiber photographic paper to determine optimum exposure and times for burning and dodging. The choice of photographic paper is critical with matte surfaces being preferred. This print will also serve as a guide when inking the matrix to determine the tonal values and details you wish to bring out in the inking process.
3. Make a guide print and process it normally at the exposure established in Step 2.
4. Make a print for bromoil by opening up one f-stop more than the exposure for the guide print if you are using super-coated paper (US) or 1/4 f-stop more if you are using nonsuper-coated paper (UK and Europe). Super coating is a hardened anti-abrasive layer applied by the manufacturer. The overexposure of the print allows the gelatin of the super-coated paper to sufficiently swell later in the bromoil process. For ease of handling, leave a white border, about 1 inch (2.5 cm), around the bromoil image.
5. Develop the print for 3 minutes in Kodak Dektol 1:9, Ethol LPD, or Rodinal film developer 1:30 with continuous agitation. Then put the print into a 28 per cent acid stop bath for 45 seconds or a water bath for 5 minutes. Next fix the print in a rapid fix without the hardener or in a 10 per cent solution of sodium hypothiosulfate.
6. Wash the print for a minimum of 30 minutes in an archival print washer or with a siphon washer in a tray. Gently blot off any surface water. Air dry for at least 6 hours. Then use a hair dryer on the hot setting 4 inches (10 cm) above the print until it is crisply dried. Now completely soak the print for 5 minutes in a tray of water at room temperature and then drain it.

7. Mix a tray of bleaching/tanning solution at working strength from the following:

10 per cent copper sulfate stock solution	$2\frac{1}{3}$ oz (70 cm^3)
10 per cent potassium bromide stock solution	$2\frac{1}{3}$ oz (70 cm^3)
Potassium bichromate stock solution	1 oz (30 cm^3)
Distilled water to make 1 quart (0.95 liter)	

This solution should treat about eight to ten prints with an image size of 6 × 8 inches (15 × 20 cm). Constantly agitate no more than three or four prints at a time while bleaching them for 8–10 minutes. Use tongs and gloves.

8. Wash these bleached prints, known as matrices, for 10 minutes to remove all the bichromate. Fix in a fresh bath rapid fix without hardener or a 10 per cent solution of sodium hypothiosulfate for 5 minutes. Wash prints in running water for at least 30 minutes. Gently blot off water. Air dry for at least 6 hours. Super dry (Step 6) again. On many papers a faint latent or a greenish tan image may be visible. Dark brown or black areas indicate you may have exhausted the bleach solution or printed too dark an image.

9. Place a pea-size dollop of lithographic ink on one corner of an inking tile (a 12 inch/30.5 cm smooth, white ceramic bath or floor tile) and spread it, like you are buttering toast, into a thin layer with the edge of a palette knife. Using a rubber ink brayer, spread the ink out into a perfectly smooth square patch on the tile. If you plan on applying ink with a roller, the square should be about 1 inch (2.5 cm) larger than the roller. If you plan on applying ink with a brush, roll the ink into a 2 inch (5 cm) square.

10. Soak the matrix in a tray of tap water at 68–110°F (20–43°C) for 10–20 minutes. The time and temperature of the soak can vary depending on the hardness of the water and the type of photographic paper. Soak only one matrix at a time, and keep it completely submerged by placing coins or pebbles on the white edges.

11. Place the matrix on blotting paper and remove all traces of surface water from both sides with a folded soft paper towel. Dry the back of the matrix by gently rubbing, and blot dry all of the water from the emulsion side of the bleached matrix.

12. Move the matrix, emulsion side up, to a plate glass support angled against a support to suit your comfort. Painters' tape can be used to hold down the edges during inking. Using your wrist as a fulcrum, apply the lithographic ink at the desired stiffness (consistency). Inking techniques vary widely among bromoilists and various brushing actions will deliver different results. Some use small sponges and foam rollers to aggressively clear the highlights of ink. Beginners can use a bristle pastry brush or round fitch brushes found in hardware stores.

TABLE 10.3 Common Bromoil Problems

Image is completely white; ink does not stick to the paper	Exposure time is too short
	Paper is too wet during ink application
	Paper has not been completely dried
Image is grey	Bleach is old
	Exposure time is too short
	Improper developer or fixer used
	Paper has not been completely dried after bleaching and fixing
	Inking method has not been mastered
Image is only black-and-white with no midtones	Image has been over-wiped at the end of inking
	Inking technique needs improvement – try a hot water soak to increase the amount of gelatin swelling and use ink thinned with a very small dot of oil
Image only has midtones; black is gray and white is dull	Bleach is old
	Improper developer or fix used
	Inking technique needs improvement – highlights should be cleared of ink with each inking and additional inking steps may be needed to build the shadows
Shadow areas do not bleach or show a red tone during bleaching	Print has been improperly fixed or rinsed before bleaching
	Bleach may be old or not correctly prepared

Resoak the partially inked matrix for a few minutes in room-temperature water. During the resoak, reroll the ink on your tile with a brayer to even the ink. Blot the matrix dry again. Continue inking and resoaking until the bromoil print reaches the desired state. See Table 10.3 "Common Bromoil Problems" for solving technical problems.

RESOURCE GUIDE

Laughter, Gene, *Bromoil 101: A Plain English Working Manual and User's Guide for Beginners in the Bromoil Process*, Sixth Edition. Self-published, 1999.

The Bromoil Circle: www.gryspeerdt.co.uk/index.html

GUMOIL

Gumoil printing is a recently invented process, which is different from bromoil. A positive (not negative) transparent image is contact printed to an unpigmented gum arabic surface coating sensitized with potassium bichromate.

FIGURE 10.20 Burkholder reflects, "Junk stores and warehouses are peculiar worlds full of forgotten stories. These collections of unrelated objects are fascinating pictures of what we leave behind and memories we can't quite recall." She captured the scene with a digital camera and wide-angle converter, and printed it as a digital negative on Pictorico OHP film from which she made a print with the painterly bromoil process. For Burkholder, "the bromoil process enhanced the dreamlike feel by adding the handcrafted texture from brushes and ink."
© Jill Skupin Burkholder. *Screaming Man,* 2004. 8 × 12 inches. Pigmented ink print from original bromoil.

It is developed in running water to wash the unhardened portion of the gum away. This leaves an unpigmented gum resist when dry and oil paint is then rubbed in over the whole image and the excess wiped off. The paint sinks into the open white spaces. The whole print is next etched in household bleach and another tonal region of the gum, now open, is available to a second oil color rubbed over the entire surface. Up to five or six layers of color, from dark to light, can be applied. Paper type and surface is selected by the print maker. The resulting image may be highly photographic (especially on hot-press cotton paper) or more impressionistic (when printed on cold-press paper).

RESOURCE GUIDE

For processing details, see: Koenig, Karl P. *Gumoil Photographic Printing.* Revised Edition. Focal Press, MA: Boston, 1999.

MORDANÇAGE

The mordançage process has historically been referred to as bleach-etch, etch-bleach, gelatin relief and reverse relief among others. In this process a caustic, acidified copper bleaching solution is utilized to bleach and dissolve away the silver image. This leaves a print in a reverse relief, whereby the dissolution occurs proportionately to the dark areas. With a little physical rubbing, the solubilized silver gelatin layer lifts off of the print and leaves behind whites in reverse relief where the darks formerly were. Completely rubbing produces a reversed or almost negative image, but often some positive remains because the original print highlights and midtones are not as affected. Large dark areas of the print can be left attached as veils. The print may be redeveloped, toned, or hand-colored after bleaching and rubbing to produce unique, colorful altered prints. Applying a clear, non-yellowing acrylic spray can protect the result. A print subjected to this chemical solution can

FIGURE 10.21 Koenig photographs for particular processes, and he made this bold image with his labor-intensive polychromatic gumoil process in mind. Koenig places his work in the Pictorialist tradition. "Like the Pictorialists I want my photographs to draw viewers into a scene, at least long enough to stimulate them to reflect upon the subject and its particular history. It is for this reason I seek to capture a moment in the descent into unrecognizable decay that all things must inevitably follow."
© Karl Koenig. *Rail Entrance, Birkenau (Auschwitz II)*, 2004. 11 × 15 inches. Gumoil print. Courtesy of Holocaust Museum, Houston, TX.

change in color and character over time, and should be taken into consideration as being part of the process's nature. If this is not desired, make a scan of the original to keep as a backup.

RESOURCE GUIDE

For processing details, see: Anderson, Christina Z. *Experimental Photography Workbook*, Fifth Edition. Bozeman, MT: Christina Z. Anderson, 2006. Opalenik, Elizabeth. *Poetic Grace*. Oakland, CA: OPA Editions, 2007.

LITH PRINTING

One can achieve remarkable effects by processing paper in nonrecommended developers. One of the most common examples is known as lith printing, which is really a misnomer, as it has nothing to do with printing from high contrast litho negatives. In this method one processes silver-based paper in an A & B lith developer (often in a diluted form) instead of a conventional paper developer to generate unusual tonal, color and grain effects with all the other processing steps remaining the same. The color of a finished image is largely determined by a combination of the printing paper, the length of the exposure, dilution of the developer, and the developing time and temperature. There is no conventional standard developing time in lith printing. The print is closely observed and pulled from the developer and quickly placed into the stop bath as soon as the desired color and density is achieved, resulting in colors from a subtle peach, through

a greenish brown to a warm black. Unlike conventional silver prints, the results are often unforeseen and problematical to duplicate, making each print unique.

Infectious Development

In lith printing black-and-white negatives are over-exposed onto conventional black-and-white paper. The paper is then developed in a lith A & B developer, which often is diluted at least 1:10 rather than the standard dilution of 1:3. A phenomenon known as *infectious development* takes over during the development cycle. In standard paper developing, the developing activity will slow down after about 2 minutes and eventually the developer will cease working in the shadow areas while continuing to work in the midtones and highlights at a much slower rate. However, in the infectious development process the darker tones to develop the fastest, until the darkest shadow areas become a solid black. Additionally this process increases the edge-sharpness or accutance in the higher contrast areas of the print and usually results in warm-toned images ranging from caramel to burnt ochre.

Image Color: Seizing the Print at the Decisive Moment

Image color depends largely on the grain size in the paper's emulsion and time and temperature of the developer. When the development is relatively short (90 seconds or less), the grains remain fine and produce a variety of warm tones. As the development is extended grains become larger and the image tone cooler until it reaches black.

Lith Printing Procedure

Lith printing is about experimentation, but the following offers a basic starting point.

Paper

Higher-contrast conventional papers of Grade 3 or 4, which do not utilize optical brighteners or "built-in" developers, work well. Papers with a high silver contrast work best. Try a variety of papers, as different ones will produce diverse results. For instance, warm tone paper will generate warmer color effects than a neutral or cold tone paper. Variable contrast paper also work well as long as you do not use any variable contrast filters. Regardless of paper, contrast is controlled by a combination of exposure and development.

Exposure

Expose for highlight or midtones and develop for shadow details. This is best determined by making a test strip, which has been removed from the developer when shadow detail reaches the desired point. Many practitioners intentionally overexpose the paper by two or more f-stops to ensure there is adequate highlight detail when the print is pulled from the developer. Long exposure times may be necessary to properly expose highlights. Experimentation is a necessity, as changes in exposure time will alter the look of the final print.

Lith Developer

The condition and dilution of the lith developer significantly affects the lith effect. Fresh developer does not always deliver the desired results. Often more intriguing outcomes occur after a few prints have been processed. Alternatively, adding used lith developer to the fresh solution at the starting rate of about 1:4 (old to new) can also be effective.

The A & B lith developers are designed to be mixed 1:1 to process lith film. When processing paper this dilution may be too strong. Many workers are able to produce a wider variety of effects by diluting the A & B solutions with water in ratios starting at 1:10 (developer to water) and going up to 1:30 (developer to water), which will also extend the processing time. Also, varying the ratio of A & B solutions can alter the visual outcome.

Depending on the paper, temperature, dilution, and exposure, lith developer typically has a useful development range of about 1½–5 minutes at 68°F (20°C). But since there are no standard development times, times can be as long as necessary. Image color can often be controlled through a combination of exposure and development time (long exposure with short development or short exposure with extended development). Print mottling, called *pepper fog*, can result from this technique, but some people find that this enhances the look. Clearly, experimentation is in order.

Constant agitation is necessary; otherwise different depths of developer caused by the tray's construction can

FIGURE 10.22 Anderson, whose work often centers on social deconstruction, fittingly used the mordançage process, which physically breaks down the photograph, along with it, the sanctity of the rules surrounding the pristine black-and-white print. She made this photograph in natural light with a Mamiya 6 × 7 cm camera, positioned on a tripod from the bottom of her basement steps. She developed the film in PMK and then exposed it onto Ilford Multigrade fiber paper. Before the final step of toning the photograph in selenium, Anderson explored the manipulative possibilities of the mordançage process.
© Christina Anderson. *Baby's First Steps*, 2003. 14 × 11 inches. Toned gelatin silver print.

Leaving a lith print in lith developer until the development is complete results in a densely overexposed, cold toned, dark print. The desired look is achieved by "seizing" the print from the developer precisely as the shadow areas arrive at the density you are looking for, and then quickly and smoothly sliding the print into the stop bath. This procedure gives new meaning to Henri Cartier-Bresson's "Decisive Moment" by acknowledging that such instances can occur any time in the creative process, not just at the moment of exposure. This modus operandi is what gives lith prints their characteristic black shadows juxtaposed against delicate, soft highlights that can vary from yellowish-beige to a peachy pink or olive-yellow, depending on the paper and your processing method. Alternatively, by modifying your technique, you can produce high-contrast, intensely grainy looking prints.

generate uneven development, producing unintended patterns on the print.

Under the glow of a red or amber safelight, watch for the emergence of detail in the key shadow areas. At the appropriate moment, swiftly slide the print into the stop bath. When it is getting close to the chosen point of completion, the print can be removed from the developer for observation and then immediately placed into the stop bath. Do not hold it up to drain or the critical moment will be missed. Some find it more effective to anticipate the "right" moment a few seconds in advance, pull the print from the developer then, allow it drain for a second, and then quickly slide the print into the stop bath. Use an indicator stop bath, which changes color so you will know when it is exhausted.

The capacity of developer is limited in this nonstandard application and thus can suddenly stop working. Discard the developer when time starts to extend beyond your established processing time. Keep some of the used developer to mix with the next batch. For consistent results, expect to do this often.

Contrast Control

Contrast is controlled by both exposure and development time. Timing depends on your chosen outcome and the state of the developer, which quickly exhausts. Forget about the timer and watch the critical shadow areas you want to control.

Print Assessment

Assessing a print with faint pink or sepia tones can be difficult under red or amber safelight. Therefore, fix the print in a rapid fixer for a minimum of 60 seconds with a constant agitation and then turn on the white light to make your evaluation. After making your assessment, complete the

fixing step and continue with your regular processing procedures. If scum marks appear on the print, soak it in a 3 per cent acetic acid and then thoroughly rewash it.

RESOURCE GUIDE

For detailed processing instructions and examples, see: Rudman, Tim. *The World of Lith Printing*, available at www.worldoflithprinting.com/

Fotospeed makes a lith processing kit: www.fotospeed.com

ELECTROSTATIC PROCESSES: COPY MACHINES

Copy machines provide the imagemaker with another opportunity to experiment with technological advances originally designed for business use. They enable one to combine electronic, manual, and mechanical processes in the creation of new images.

Black-and-White Copiers

Black-and-white copy machines are very accessible and less expensive to use than their color counterparts. They provide a good starting point for conducting experiments with copiers. You can apply many of the things you learn on these machines to work on a color copier. The quality of image reproduction varies widely depending on the type of system used. Generally, continuous-tone images lose a great amount of detail when copied. Some systems provide a special screen, which can be used to improve the copy

FIGURE 10.23 To create this humorous juxtaposition in a harsh landscape, the shape of a young woman was posed against an ancient volcano cone. To make a print capable of conveying this stark environment, conventional black-and-white paper was overexposed and processed in an A & B lith developer at the standard dilution. The print was "seized" from the developer as soon as the darkest shadow areas became a solid black, leaving the highlight areas underdeveloped. This produced a high-contrast warm-toned image, which was enforced with light selenium toning. © Robert Hirsch. *Identity Crisis*, from the series *Southwest Space Project*, 1978. 16 × 20 inches. Gelatin silver print.

delivered from a full-tone image. Graphic images tend to work well with most machines.

All the black-and-white copiers allow the image-maker to alter the density of the print. Some accept a variety of paper stocks, including different colors. Most machines make enlargements and reductions at fixed percentages of the original. Others permit you to make more than one copy on the same piece of paper; thus multiple exposure combinations are possible.

The black-and-white copiers rely on a number of different systems to form a completed copy print. The systems using an electrostatically charged toner that can form an image on any type of paper, including acid-free rag paper, provide the most stable print.

Color Copiers

Color copiers are widely available and artists are using them to explore their more complex imaging functions. Color copiers use the subtractive colors (magenta, yellow, and cyan). Each color is separated from the original through an internal filtering unit. The image is then reproduced with toners (pigments) made up of thermoplastic powders that are electronically fused onto the paper, making a permanent image. Copiers that use toners do not

require a specially treated paper and therefore can be fused onto a variety of artist's papers.

The original color copiers worked like a simple camera, using a lens to take a picture of the document to be copied. It produced a very flat and limited field of focus that extended only about ¼–½ inch above the copier glass. Current color copiers are digital (see next section). Color copiers provide many printmaking options, including the following:

- Rapid and consistent duplication and production.
- Ready conversion of 3-D objects into flat printouts.
- Manipulation of colors and contrast (many can produce a monochrome copy).
- Image enlargements and reductions.
- Printing on many different supports, such as archival artist's paper, acetate, and silicon transfer sheets (which can be ironed onto paper or fabric) An added virtue is that the pigments used to form the image are stable and provide a long print life. The rapid feedback of this process enables instant correction and further interaction of the printmaker with the materials and processes. Prints made on artist's paper can be hand-colored with pencils, dyes, inks, or watercolors. Individual prints can be connected with one another to form a larger mosaic of images.

FIGURE 10.24 Nettles printed this photographic book from digital photographs on a color copier. She explains, "This flag book illustrates the Three Norns of Norse mythology. These women, somewhat akin to the Greek fates, represent the past, present, and future. They were described in 1220 by Snorri Sturluson in his *Prose Edda* as weaving together the fates of mankind. The structure of this book allows each woman's page to be viewed front and back individually. When the covers are pulled, the flags overlap and interweave the three women's portraits and text about them, which emphasizes the complexity of their roles in this cosmology." © Bea Nettles. *Fate, Being, and Necessity*, 2007. 8 × 4 × ½ inches. Electrostatic prints with mixed media.

Digital Color Copiers and All-In-One Machines

Digital color copiers have a scanner (see Chapter 3) that reads the image to be copied and converts it into digital signals that are then sent to a raster image processor (RIP). The RIP converts color files into printing instructions that are transmitted to a laser printer capable of delivering color copies of up to 64 gradations per color. Like the original optical copier, digital color copiers use the subtractive color system, but in addition to magenta, yellow, and cyan, these copiers also use black. The black enables these machines to reproduce colors more accurately and to provide a greater sense of depth.

Digital color copiers have features that can be used with an image-editing unit, but typically do not offer noticeably higher quality than optical copiers. All-in-one multi-functional machines provide print/copy/scan capabilities in a single unit. All digital machines offer a wide range of features including:

- Excellent image resolution.
- Sharpness control to accentuate or soften detail.
- Programmable color balance memory.
- Enlargement or reduction feature that permits a subject to be stretched or squeezed to fit a specific space.
- Slanting control to set the horizontal and vertical copying ratios separately and position the original at a variety of angles.

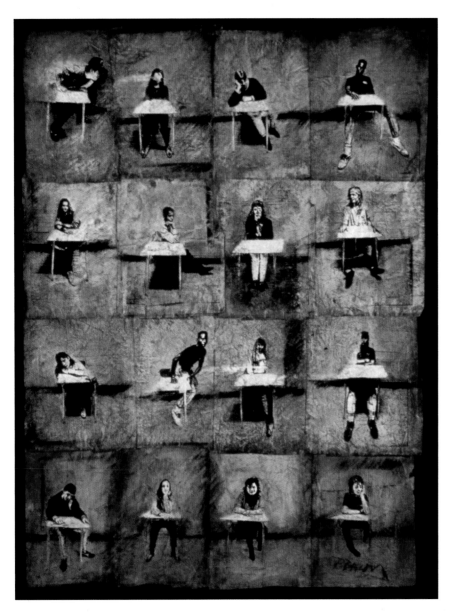

FIGURE 10.25 Artist and educator Pat Bacon utilized a photocopier to produce images to compensate for a less-than-ideal high school group darkroom. Bacon printed each of the students' images as a high-contrast 8 × 10 inch photograph. Then each photograph was copied, finished, and pieced together in the manner of making a quilt. Finishing involved coating the surface of the paper with a layer of Golden's Polymer Medium and allowing it to dry thoroughly. This top layer becomes a transparent workable surface that is flexible, durable, and easy to repair. Between layers of polymer medium and Golden's UV varnish Bacon applies paint, stains, and dyes. This method allows the work to be very portable between school, studio, and unorthodox installation sites. Bacon says, "The piece is a testament to my frustrations as an educator with the lack of educational response to social change."
© Pat Bacon. *Students and Desks* (detail), 1991. 50 × 48 inches; overall size 50 × 192 inches. Electrostatic print with mixed media.

- Multi-page enlarger that divides the image into multiple sections that can be printed in sequence and assembled into a single piece.
- Color conversion mode that lets you change the color of an original or a specified portion of the original.
- Image composition key that lets you combine original color materials with black-and-white text.
- Area designation that allows you frame, blank out, or segment the image.
- Shifting modes that let the image to be reduced and moved to any position on the page.
- Ability to make a color copy from a negative as well as a slide.
- Capability to connect the copier to a computer network.

RESOURCE GUIDE

Alternative Photography: www.alternativephotography.com

Barnier, John (Ed.). *Coming into Focus: A Step-by-Step Guide to Alternative Photographic Printing Processes.* San Francisco, CA: Chronicle Publishing Company, 2000.

Blacklow, Laura. *New Dimensions in Photo Imaging,* Fourth Edition, Boston, MA: Focal Press, 2007.

Crawford, William. *The Keepers of Light: A History and Working Guide to Early Photographic Processes.* Dobbs Ferry, NY: Morgan and Morgan, 1980.

Farber, Richard. *Historic Photographic Processes: A Guide to Creating Handmade Photographic Images.* New York: Allworth Press, 1998.

James, Christopher. *The Book of Alternative Photographic Processes,* Second Edition, Clifton Park, NY: Delmar Cengage Learning, 2009.

Nettles, Bea. *Breaking the Rules: A Photo Media Cookbook,* Third Edition, Urbana, IL: Prairie Book Arts Center, 1992.

Reeve, Catherine, and Marilyn Sward. *The New Photography: A Guide to New Images, Processes, and Display Techniques for Photographers.* Cambridge, MA: Da Capo Press, 1987.

Scopick, David. *The Gum Bichromate Book: Non-Silver Methods for Photographic Printmaking,* Second Edition, Boston, MA: Focal Press, 1991.

Material Resource Guide

Artcraft Chemicals: www.artcraftchemicals.com (photographic chemicals for a variety of photographic processes including wet-plate, platinum/palladium and other alternative processes).

Artist Paper: www.artpaper.com.

Bostick & Sullivan: www.bostick-sullivan.com (catalog of materials kits for platinum and alternative process printing).

Chicago Albumen Works: www.albumenworks.com (a line of products including a gelatin chloride printing-out paper).

Fisher Scientific: www.fishersci.com.

Photographers' Formulary: www.photoformulary.com.

Spectrum Chemical & Laboratory Products: www.spectrumchemical.com.

END NOTES

1. See Hirsch, Robert. "Flexible Images: Handmade American Photography, 1969–2002." *exposure,* vol. 36, no. 1, pp. 23–42, 2003.
2. Taylor, Brian. E-mail conversation with author, December 19, 2007.
3. Root, M. A. "The Camera and the Pencil," in *History of the Heliographic Art* [A Historic Extract from three 1862 issues of *Scientific American*]. San Mateo, CA: Café Press, 2003.

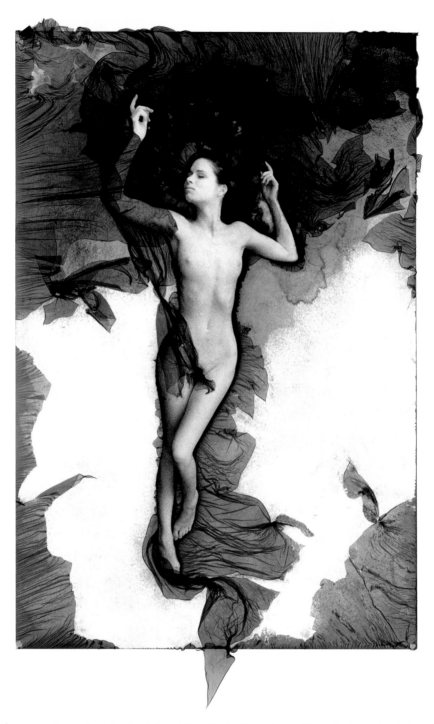

FIGURE 10.26 After processing and printing her infrared film, Opalenik transformed her print by putting it through a Mordançage solution composed of acetic acid, cupric chloride, hydrogen peroxide, and water. During this process "the silver gelatin was lifted in the dark pool areas, rearranged, and dried back down onto the print. With Mordançage each image is unique due to the lifting or removing of the silver gelatin. When trying to save this delicate veil, there is little control to the final image. Often I am rearranging the silver veils one drop of water at a time."

© Elizabeth Opalenik. *Changer la Femme #1, Santa Fe, NM*, 1999/2000. 14 × 11 inches. Gelatin silver print with Mordançage. Courtesy of John Teti Collection.

TRANSFORMING PHOTOGRAPHIC CONCEPTS: EXPANDING THE LEXICON

HAND-ALTERED WORK

The hand altering of photographic images began soon after the daguerreotype process was made public in 1839 to compensate for the latter's inability to record color. By the beginning of the twentieth century hand-altered work was popular with the foremost Pictorialists such as Edward Steichen, Frank Eugene, and Gertrude Käsebier whose images often resembled drawings, lithographs, and paintings. They used it to show that photography was more than an automatic mechanical process, and could be controlled and manipulated with the same expressive intent as traditional art forms. Today hand-altered processes are not done for compensation or imitation but to expand the boundaries of the photographic medium. Hand alteration enables photographers to bring into existence concepts, dreams, and feelings that cannot be achieved through standard photographic practice, thereby providing a bridge that can meaningfully unite ideas, materials, practice, and vision.

The Kitchen of Meaning

To grasp the ever-changing cultural dialogue, an image-maker has to be ready to seize time's wonders. Generally this does not come easy. Being an artist entails making a long-term commitment to aesthetic and technical training in what French writer and theoretician Roland Barthes dubbed "the kitchen of meaning," where one willingly toils to realize a bountiful visual roux. Hand-altered work allows photographers to prolong their interaction with the process and/or re-interpret past works, thereby redefining the temporal and/or technical architecture of the image. This shift in time enables the moment of exposure to act as a beginning rather than as an ending for imagemaking. This flexibility can expand the consciousness of a maker and give rise to an extended sense of reality that can articulate both an objective exterior and a subjective interior view of a subject. Hand-altered work can demonstrate how photography is an elastic process of discovery and invention and not just a fixed body of technical data that is permanently frozen at the moment of exposure. Hand-altered work may commingle at the juncture of what is real and what might be real, reminding us that the invisible and the intangible are as important as what we see in concrete reality. Such processes encourage an artistic and intellectual rethinking of the action between a matter-based and a mind-based interpretation of a subject, which can expand the interaction among the materials, the work, the maker, and the viewer.

Pushing Beyond the Familiar to an Enhanced Reality

Hand alteration is a way to expand the photographic lexicon and is not meant to replace traditional modes of working. When hand-altering work, take the freedom to push and pull the ideas and materials until resistance is felt. Push on the confines of familiarity, but learn to stop before resistance turns into chaos. When one hits resistance to new ideas and methods, it indicates you are entering uncharted waters. There are no guides, instructions, or maps to offer direction. You are on your own. This enables you to know how far you can stretch the medium and yourself. Maintain a record of your experiments so the results can be duplicated and your knowledge shared. Keep in mind what Picasso said: "The eyes of an artist are open to a superior reality."

Since there are fewer conventions in hand-altered practice than in regular methods, how does one find satisfaction? Your mind will quit circling and say YES to what has been created. During the act of making there may even be a dynamic haptic interchange between the artist and the materials, which physically culminates at completion. This is when you know it is time to cease working. Your own character is now intertwined with the piece. As the image is transformed, so are the maker and potential viewers.

Doing the Opposite: Creating a Doppelgänger

Much of this book has been devoted to providing known pathways for the expressive photographic imagemaker. As soon as you have gained control over the medium and tools and are able to express what you desire, it is time to avoid getting bogged down by too many rules. Pretend to have a *Doppelgänger*, an apparitional double or counterpart,

FIGURE 11.1 By gluing the book together, then digging through the pages, and carving out collages as intriguing images appeared during the process, Kline embraced chance happenings. He approached this work in an archeological context, treating the book as a dig site in which he "both destroyed and revealed images detached from their intended function. I sought to reveal the simple topographical structure of information contained within books by eliminating the text and showing the decontextualized images as they appeared. Absent from their intended use, the images can be seen as a cohesive whole released from their utilitarian duty and blended into a detached narrative, allowing the viewer to experience the image landscape of information."
© Kevin Kline. *American History,* from the series *Book Excavation,* 2007. 8½ × 4 × ¾ inches. Book carving.

The Anxiety of the New

When something new is created, it brings with it a sense of anxiety. This is because the new is not identifiable with our daily familiar world. Such anxious insecurity occurs when you are able to leave the beaten path and not yield to the comfort of habit, imitation, or trend. The new often produces much resentment because it entails throwing over a previous set of working conventions. Having blind faith in the ways of the past can lead to stagnate mediocrity that wallows in nostalgia. The *New* is dynamic and forces one to confront the past, discard its illusions, make corrections, and move forward in different directions.

Not all new images and working methods will take you to the destination you seek. Often the act of doing something for the first time helps to uncover what will ultimately bring new structure to a vision. Stay focused on the process of imagemaking itself, that vital interplay between alternative configurations and passions, rather than fixating on a particular form of closure. Each outcome can then be both a transitory hypothesis and a declaration of the will to know. One of the beauties of art is that it can relinquish a closed system in which there is only one right way to do something in favor of an open approach that allows multiple correct answers to a question. Hand-altering work animates the imagemaker to feel free to transform the ingredients of imagination and physical existence into a collection of previously unseen appearances and structures. In his story "The Legend of the Sleepers," Danilo Kis sums up this meditation about the past, present and future: "Oh, who can divide dreams from reality, day from night, night from dawn, memory from illusion."[1]

This chapter covers various key aspects of hand-altered work by dividing it into the following working methods: cameraless images, camera-based photographs, darkroom-generated pictures, and postdarkroom work.

RESOURCE GUIDE

Barrett, Terry. *Criticizing Photographs: An Introduction to Understanding Images.* Fourth Edition. New York: McGraw-Hill, 2005.

Hughes, Robert. *The Shock of the New.* Second Edition. New York: McGraw-Hill, 1991.

PHOTOGRAMS

A photogram is a cameraless, lensless image made by placing 2D or 3D objects directly on top of light-sensitive material and then exposing it. Conceptually, the photogram is entirely different from traditional camera images based on outer reality in which a photographer starts with everything and eliminates or subtracts anything that is not wanted in the frame (a process of subtractive composition). When making a photogram, an imagemaker begins with nothing except a blank piece of paper, like a painter approaching an empty canvas, and

who does the opposite of what you normally do. Too much knowledge can be as inhibiting as too little. Doing the opposite keeps one from being too complacent and judgmental. Reaching into the unknown is one way to grasp new possibilities. Keep a notebook of new ideas for future reference.

Try not to become smug with what you already know. Learning is a continuous process of waking up and focusing your attention on the subject at hand. It means giving in to possibilities and allowing yourself the opportunity to see what may not have been apparent or visible when you began the process.

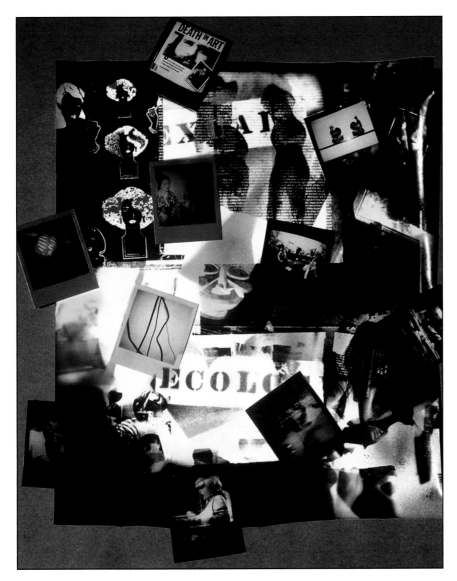

FIGURE 11.2 Barrow uses the Polaroid SX-70 for note taking when working on an idea that does not conform to conventional working practice. The visual notes, including images made off a video monitor, are scattered across the photogram to discover meaning that is simultaneously clearer and more ambiguous. When a satisfactory composition is achieved, the SX-70 prints are stapled in place. Color and text are added with spray lacquer paints.
© Thomas Barrow. *Sexual Ecology*, 1986. 26 × 25 inches. Gelatin silver print with stapled Polaroid SX-70 prints and spray lacquer paints.

adds the necessary ingredients to make the final piece (a process of additive composition). Cameraless images can also be produced digitally with a scanner (see Chapter 3).

The photogram plays with a viewer's expectations of what a photograph is supposed to look like. Although it appears on the surface to be a photograph, there is a sense of ambiguity and mystery, as a viewer attempts to understand the reality of the image.

The light source used to make the exposure can be straight-ahead, angled or even moving rather than perpendicular to and stationary with the light-sensitive material. When the image is developed, no exposure effects will be visible where an opaque object was completely covering the light-sensitive emulsion. What is created is a silhouette of the object when translucent or transparent objects are placed on the emulsion. Partial shadowing occurs under opaque objects that are not in complete contact with the

emulsion creating a wide assortment of tones. Any area left uncovered will get the maximum exposure and hence be opaque without any discernible detail.

The early pioneers in search of a practical photographic process were Johann Schulze in 1727, Thomas Wedgwood and Humphry Davy in 1799, and William Henry Fox Talbot from 1834 through the mid-1840s. All of them worked with cameraless images, establishing it as the earliest means of making light-sensitive pictures. The technique did not see much application until Christian Schad, a Dadaist painter, revived it in 1918 to create abstract images that he called Schadographs. Within a short time, Man Ray countered with his Rayographs. In Berlin during the 1920s, László Moholy-Nagy followed suit with what we now refer to as photograms. The contributions of these three image-makers helped to perfect and re-establish the photogram in the twentieth century.

What to Print On

Photograms can be made on any type of light-sensitive material. Black-and-white paper is a good place to begin experimentation. One can then move on to color paper and other materials such as cloth. Black-and-white paper is convenient and familiar, and it can be handled under normal safelight conditions. This makes it easier to arrange the objects in the composition.

Opaque, Translucent, and Transparent Materials

Careful consideration must be given to the choice of objects used in making a photogram. The selection of materials is limitless. Go beyond the hackneyed approach of taking some coins and keys out of your pocket or purse. Consider using natural objects such as feathers, flowers, grass, leaves, plants, rocks, and sand. Try putting raw eggs or oil in a zip-lock bag to make fluid compositions. Objects such as glass and stencils offer additional avenues to pursue. If you do not find what you need, make it yourself. Start simply, and as you master the working technique, increase the complexity of the arrangements. Ink applied on a thin piece of glass or acetate and then overlaid on the paper and exposed can widen your field of ideas. Also try combining natural, human-made, homemade, opaque, translucent, and transparent objects with ink to form a composition.

Exposure Methods

Although the easiest way to make an exposure is by using the enlarger or room light as a source, it also offers the least in terms of visual variety in the final print. To increase the range of visual effects, use another source of exposure, such as an electronic flash or a small desk light with a flexible neck. Using a fractional power setting on the flash or very low-wattage bulbs (15 watts) will produce longer exposure times and thus provide more opportunity for manipulation. Fluorescent tubes will deliver a more diffused and softer image than a reflector bulb or flash. Using a light source at different angles to the paper will produce a wide range of results. Varying the intensity of the light or the distance of the light from the paper during exposure will help to create a wider range of tonality in the final print.

Another method is to use a penlight. Wrap opaque paper around the penlight to act as a simple aperture-control device, thus enabling you to have more precise control over the intensity and direction of the light. The penlight can be used like a drawing instrument to emphasize specific areas of exposure. It also may be attached to a string and swung above and around the paper to produce unusual exposure effects.

Rather than making a single exposure from one source, try a series of brief exposures that combine different angles and light sources. Also try moving as well as stationary exposures.

FIGURE 11.3 Evans produced this cameraless image by attaching a portrait to a piece of thin cardboard and poking holes in the cardboard around the outline of the face. She then contact printed the cardboard negative onto fiber paper and then hand-altered the print by numbering each dot with a pen. This work comprises part of the imagemaker's conceptual series of cameraless images that reexamine the four major canons of photography: portrait, landscape, still life, and nude. She explains, "Thinking about both Minimalist and Conceptual art strategies, I wanted to make the 'objective' photograph 'subjective' by playing with gestalt, surface, process, and image."
© Susan Evans. *Dot to Dot Portrait*, from the series *Dot to Dot*, 1992. 10 × 8 inches. Gelatin silver print.

For repeatable results, without ruining the arrangement of objects, place a piece of glass on spacers above the printing surface. The glass should be slightly bigger than the paper being printed. Blocks of wood or film take-up reels can be used for spacers. Arrange the objects on the glass rather than directly on the paper. Define the exact printing area beneath the glass by using tape or a china marker to indicate where the corners of the paper should be positioned. After the objects are composed on the glass, turn off the white light and slide the photographic paper under the glass, lining it up with the corner marks. Before making the exposure, remove the spacers and carefully lower the glass on top of the paper. Be careful not to disturb any of the arranged items. Now expose the paper. If the exposure is made with the glass still up on spacers, the final image will be softer and less sharp. Box 11.1 provides the basic starting steps for making a photogram.

Box 11.1 Basic Photogram Steps

Under white light conditions

1. Put a piece of glass or clear Plexiglas, a little larger than the paper being printed on, up on spacers such as small toy building blocks.

2. Define the exact printing area under the glass by making marks with tape or a grease marker to indicate where the corners of the paper should be placed.

3. Using your collection of source materials, create a composition on the glass itself.

Under safelight conditions:

4. Place the light-sensitive material under the glass, lining it up with the previously marked corner positions.

5. Carefully lower the glass or Plexiglas from the spacers.

6. Expose the paper. A working exposure range can be determined by making a test strip. Place a piece of unexposed paper under the glass. Hold or place the light source at the distance it will be used to make the exposure. Make a series of three- to five-second exposures, just as you would when making a regular print. Process the paper and select the desired time and density combination.

7. Process following normal procedures. Adjust, and repeat until desired results are achieved.

Photogram Combinations

The color of the completed image can be changed through toning (see Chapter 8). After the print has dried, additional alterations are possible by drawing or painting on the image. Photograms can be also produced on color negative and positive materials. They also can be combined with other photographic methods. For instance, try combining a camera-made image with a cameraless one. Try rephotographing the photogram and combining it with another cameraless image. Magazine pictures also can be combined with other cameraless materials. Magazines are a print-through technique, and both sides of the page will be visible (see Robert Heineken's work in Chapter 1).

Experimentation with the choice of objects, sources of exposure, different types of light-sensitive materials, and postdarkroom techniques will be you to discover the possibilities photograms have to offer.

RESOURCE GUIDE

Neususs, Floris M., Thomas Barrow, and Charles Hagen (Eds). *Experimental Vision: The Evolution of the Photogram Since 1919*. Boulder, CO: Roberts Rinehart Publishers, 1994. www.photogram.org.

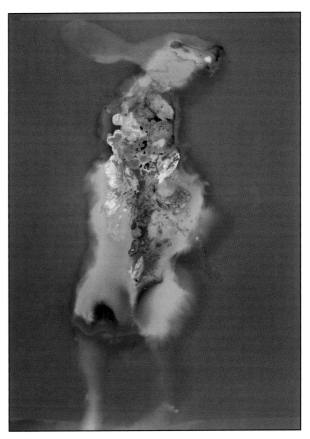

FIGURE 11.4 Burchfield chose an unusual subject to make this lumen print, which he produced using a similar method to that of Henry Fox Talbot, who made cameraless images of botanical specimens in the 1830s. Burchfield placed a rabbit corpse in contact with black-and-white photographic paper in midday sunlight, holding the object in place with masking tape and allowing its viscera to become integrated into the work. After a 3 hour exposure time, he fixed the print with a basic Kodak powdered fixer, which caused heat from the rabbit's body to create vivid tonalities on the paper where it had not been struck by light. Roadkill remains the artist's object of choice when creating lumen prints, as it functions as a "tribute to wildlife and an acknowledgement of its continued loss."
© Jerry Burchfield. *Rabbit Roadkill #1*, 2000. 14 × 10 inches. Gelatin silver lumen print.

CHEMIGRAM

The process of making chemical images on light-sensitive material can be traced back to the origins of photography, but it was Pierre Cordier who actively researched this area to make lenless, fine art photography. In 1958, Cordier named his process a chemigram (chimigramme), a combination of chemistry and the Greek "gramma," meaning writing, inferring it is a drawn or written chemical sign. A basic chemigram is constructed in full daylight by applying photographic chemicals, unusually developer

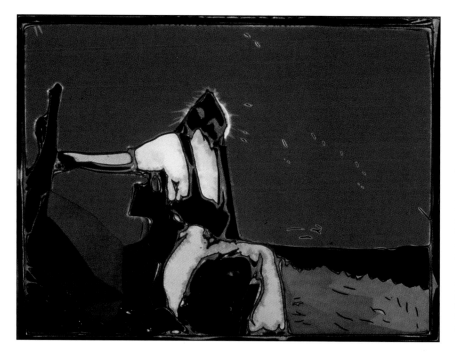

FIGURE 11.5 Cordier relates: "'Photo-graphy' [sic] means 'writing with light.' However, the chemigram is made in full light. The chemigram is not a 'writing of light,' but a 'writing of chemistry,' since the 'writers' are the developer and the fixer." He also thinks, "Practitioners of the chemigram are confronted with different sorts of chance (uncontrolled and uncontrollable), but chance is also something that can managed and programmed, and is often their best collaborator."
© Pierre Cordier. Chimigramme 6/3/81 III *Hommage à Robert Capa*, 1981. 12 × 14⅛ inches. Chemigram.

and fixer, without the use of a camera, enlarger or dark-room, sometimes to previously exposed photographic paper or film. The chemical reaction creates the image and the tone of the final print, or as Cordier puts it, "In the chemigram, chemistry writes; light does not." Cordier says, "The chemigram, which combines the physics of painting and chemistry of photography, is most likely the ultimate adventure of gelatin silver bromide." Many workers also employ "localizing" products, such as oil, varnish, and wax, to create more complex forms. Basically, any product found in your kitchen, bathroom, or paint store that can adhere to emulsion paper may be used to make a chemigram.

RESOURCE GUIDE

Pierre Cordier. *Le Chimigramme [The Chemigram].* Brussels: Racine Editions, 2007.

CLICHÉ-VERRE

Cliché-verre, drawing on glass, is another cameraless method used to produce a photographic image. Three English artists and engravers, John and William Havell and J. T. Wilmore, invented the technique. They displayed prints from their process in March 1839, making it one of the earliest supplemental methods to be derived from the invention of photography. In the original auto-graphic process, an opaque varnish was applied to a piece of glass and allowed to dry. Then a needle was used to etch an image through the varnish. The etched piece of

glass was used as a negative and contact printed onto light-sensitive paper to make a repeatable image.

In the early 1850s, Adalbert Cuvelier modified the process by etching on glass collodion plates that were intentionally fogged by light. Cuvelier introduced his method to artist Jean-Baptiste-Camille Corot, who used it as a means of producing fast and inexpensive editions of monochrome prints. Corot's success with cliché-verre caused many other artists of the French Barbizon School to follow suit. Thus the 1850s marked this process's high point in popularity.

There was only sporadic interest in cliché verre during the first six decades of the twentieth century. Man Ray, László Moholy-Nagy, Francis Bruggiere, Henry Holmes Smith, and Frederick Sommer carried out experiments. In the US, the process experienced a small revival during the late 1960s. Since then only a few imagemakers have used it, making it ripe for new exploration.

Making a Cliché-Verre

Obtain a piece of clean, clear glass that is a little larger than the size of the final print. 8 × 10 inches is a good minimum size; anything smaller makes it difficult to see what is being etched on the glass. Have the edges ground smooth to avoid glass cuts. Paint the glass with an opaque paint or varnish. Matte black spray paint also can be used. After the paint has dried, use a stylus (a sharp, pointed instrument such as an X-Acto knife, a heavy needle, a razor blade, or even a piece of rock or bone) to etch through the painted coating to the clear glass.

When the etching is finished, bring the glass into the darkroom. Under safelight conditions, lay it on top of a piece of unexposed black-and-white photographic paper. Make a print following normal working methods. As in photograms, try using different sources of light at a variety of angles to alter the look of the final image. The thickness of the glass will influence the clarity and sharpness of the final print. Thinner glass gives a sharper image. Generally, glass provides the smoothest and most concise line quality of any of the support materials.

Alternative Method 1: Color

Traditionally, cliché-verre was a black-and-white technique, but color paper may be used. By dialing in various color filter packs, one can produce a wide variety of color effects. Try multiple exposures using different filter packs and varying the type of light used for making the exposures.

Alternative Method 2: Paint Substitutes

Other media besides paint and varnish can be used to opaque the glass. One method is to "smoke" the glass by holding it over the chimney of a lighted kerosene lamp. Frederick Sommer used a smoked-glass technique very effectively in the 1960s. Henry Holmes Smith poured Karo corn syrup on glass, then photographed it and made dye-transfer color prints from the camera images. Opaque and translucent inks can be applied instead of paint, and printer's inks may be rolled onto the support surface.

Alternative Method 3: Glass Substitutes

Sheet film that has been exposed to white light and developed to its maximum density can be used in place of the opaque glass support. Film has the advantage of not being breakable and can also be put in the enlarger, so cliché-verre prints can be produced in various sizes. Generally, etching sheet film will produce a rougher and more ragged line quality than that achieved from a piece of etched painted glass. Acetate also can be used in place of glass or film. It can be purchased already opaque, or it may be painted or inked.

Alternative Method 4: Scanning

Draw an image on a ground-coated transparent material and scan it, which will allow one to manipulate and print digitally.

RESOURCE GUIDE

Glassman, Elizabeth, and Marilyn F. Symmes. *Cliché-verre: Hand-Drawn, Light-Painted, A Survey of the Medium from 1839 to the Present.* Detroit, MI: Detroit Institute of Arts, 1980.

Combination Methods

- Scratch directly into the emulsion of a camera-made negative and then make a print.
- Combine the cliché-verre with a camera-made negative.
- Use ink and scratching with a camera-made image.
- Coalesce scanned image with an analog technique.
- Do not opaque the glass or acetate completely. Etch only the opaque portion and use the remaining clear area to incorporate a camera image or photogram.
- Collect images from newspapers and magazines. Under safelight conditions, position them directly on top of the light-sensitive material, cover it with glass, and make an exposure. Remember, they will be reversed, and both sides of the image will print. Try opaquing and etching part of the glass in concert with this method.
- Use a liquid emulsion such as Liquid Light to produce a cliché-verre on other porous materials such as fabric or clay.

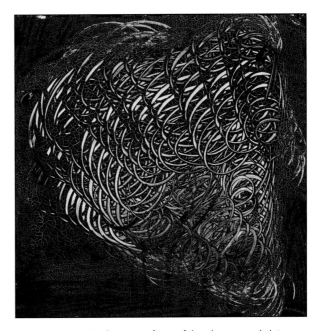

FIGURE 11.6 Making use of one of the alternative cliché-verre methods, Feldstein substituted sheet film in place of a glass support. He developed 4 × 5 inch film in Dektol under white light until it was completely black. Then he made images by scratching, etching, cutting, tearing, and sanding the film. When the work on the film was complete, he put it into an enlarger to make a large-scale photographic print.
© Peter Feldstein. *#527*, 1998. 42 × 42 inches. Gelatin silver print.

EXTENDED CAMERA EXPOSURES

When most people take-up photography, they have the "$1/_{125}$ second mentality." We have been conditioned to believe the photographer's job is to capture the subject by freezing it and removing it from the flow of time. By simply extending the amount of time the camera's shutter is open, however, an entirely new range of images can come into existence. This additional time also can provide an opportunity for a photographer to increase the interaction with the subject and in turn extend viewer involvement.

Equipment

You need a camera with a B (bulb) or T (time) setting to make extended time exposures. With the B setting, you hold the shutter in the open position for the entire exposure. With the T setting, you press the shutter release once to open the shutter and then press it again at the end of the exposure to close it. Some cameras have programmable time exposures. The camera is usually attached to a well-constructed tripod. The shutter can be fired by

FIGURE 11.7 Larson attached a handmade 4 × 5 inch pinhole camera to the front of his car and exposed the film for the duration of an eight-mile drive. He elaborates, "This image is primarily a function of distance and trajectory in concert with time. The camera, normally stationary, is in motion throughout the exposure, and the landscape organically compiles, averages, and mutates, while the film captures all light from point A to point B. With enough distance, the image would eventually overtake the film and leave it fully saturated with light and without any further ability to record change. This condition creates an ironic cancellation of the image by distance. The more of the landscape we experience, the less of it is retrievable from the film." © William Larson. *Untitled: 8 Mile Pinhole Exposure on Route 476, Philadelphia, Pennsylvania,* 2007. 30 × 40 inches. Inkjet print.

means of a cable release with a locking set screw, which permits hands-off exposures. This reduces the chances of blurred images due to camera movement and vibrations. A sensitive hand-held exposure meter can be useful because some built-in camera meters do not read available darkness with accuracy.

For maximum steadiness, use a sturdy tripod and do not raise the center column any more than is necessary. A heavy weight can be hung from the center column as ballast. Sandbagging the legs of the tripod also makes it less prone to movement. Close the shutter if the camera is shaken and resume the exposure after the disturbance has passed.

Cardboard Shutter

Hold a piece of black matte cardboard close to the front of the lens. When you are ready to end the exposure, place the cardboard in front of the lens and then close the shutter (using a cable release) to help reduce recording any camera jiggle. This is important when using any type of SLR or DSLR camera body whose mirror flips back down at the end of the exposure. This technique also can be used to permit changes in aperture and focus during the exposure. If the camera should be jarred during any of these procedures, allow it to settle down before removing the cardboard from in front of the lens and continuing the exposure.

Adjusting the Aperture

Varying the length of exposure time drastically affects the final outcome of the image. Opening the lens to a wide aperture diminishes the depth of field and delivers the shortest exposure time. Closing down the lens to a small aperture increases the depth of field and gives longer exposures. Closing down the lens also allows for changes in focus and aperture. The extended exposure time permits you to work with additional sources of light, such as a strobe or flashlight, during the course of a single exposure.

Where to Start

Begin with a negative film of ISO 100. Stop the lens down three f-stops from its maximum aperture. Bracket all the exposures (one f-stop under and up to three f-stops over in full f-stop increments). Keep a written record to compare with the results so more accurate exposures can be obtained with less bracketing in the future. Bracketing can always be useful, as the different lengths of time affect how the scene is recorded. Bracketing also is helpful in learning how to compensate for probable reciprocity failure, which is likely to accompany long exposures.

Reciprocity Failure

Reciprocity failure occurs with very brief or very long exposures. Each film has its own reciprocity failure characteristics, losing effective speed at different exposure levels and at different rates. A typical black-and-white negative film of ISO 100 might need one-third f-stop more

FIGURE 11.8 Persinger, founder of the f295 Symposium of Lenless, Alternative, and Adaptive Processes (www.f295.org), relies on the utter simplicity of the pinhole camera in his investigation of photographic time. "The act of making a longer exposure becomes a contemplative act, a meditation on light and form. During this time there is an opportunity to engage and fully encounter the subject in a meaningful way, to be immersed in the landscape of the image, to transcend the role of tourist, to become more than a passive observer. Photographs that utilize elongated exposures directly conflict with what many have come to expect from the craft. They are not as easy to view and not simply understood. These images show the world as a "continuity of moments." When left without a singular moment to hold we are challenged." © Tom Persinger. *Self-Portrait: Eating Lunch*, 2006. 7⅛ × 7¾ inches. Gelatin silver print.

exposure if the indicated exposure is 1 second, one-half f-stop more time at 10 seconds, and one full f-stop at 100 seconds. This correction can be made by using either the lens aperture or shutter speed control. With color film, reciprocity failure also produces a shift in the color balance. For exact times and filter corrections of specific films, consult the manufacturer's reciprocity failure guide.

The majority of cameras rely on battery power to operate their shutters. Shooting a 36-exposure roll with minute-long times can drain a battery's power (button cells are more susceptible than AA alkaline or 6 volt lithium cells). Some of these electronic cameras offer a mechanical B setting. If you are not sure whether your camera has this feature, set the shutter to B, remove the batteries, depress the shutter release, and see if the shutter opens. If the camera does not have a mechanical B setting, take a fresh set of backup batteries, just in case the ones in the camera fail during the session.

Using Neutral Density Filters

When we contemplate long exposures, we tend to think of low-light situations, such as early evening, night, or inclement weather. One way to extend the amount of exposure time in any situation is to use a ND filter. An ND filter blocks equal amounts of all the visible wavelengths of white light. Such filters are available in various strengths, which will reduce the amount of light reaching the film or sensor by one, two, or four f-stops. ND filters may be used in tandem (one attached to the other) to reduce the intensity of the light even further.

Flash and Flashlight Techniques

A flash can be used to illuminate parts of a scene. Large areas can be "painted" with multiple flash exposures. With the camera on a tripod and the lens open, a person dressed in dark clothes can walk within the scene and fire the flash to illuminate specific items or to light a large space. A flash also can be combined with other techniques. For instance, one can focus on one area of a scene and illuminate it with a flash, then shift the focus to another area in the composition and use the flash to light it. Colored gels can be used to alter the color relationships within a scene.

A flashlight also may be used to illuminate the subject. Start with a subject in a darkened room. Put the camera on a tripod and set the aperture to f-8 or f-11. Use the B or T setting to open the shutter. Begin painting the subject with the flashlight, using a broad, sweeping motion. Avoid pointing the light into the camera's lens. When you are done painting, close the shutter.

FIGURE 11.9 By taking advantage of camera vision, photographers can record subjects in a manner not visible to the human eye. To make this extended time exposure, Kenna used a 250 mm lens with his Hasselblad 500 C. The long lens compressed the pictorial space while the extended exposure introduced a sense of passing time and directional movement not seen in a conventional photograph. The print was toned with sepia to heighten a sense of mystery, create visual contrast, and intensify emotional impact. © Michael Kenna. *Ratcliffe Power Station, Study 68, Nottinghamshire*, England, 2003. 8 × 8 inches. Toned gelatin silver print.

FIGURE 11.10 Lebe used a small flashlight to outline his subject, Angelo, whom he posed on a rooftop at night. The light pattern on Angelo's shirt was caused by nearby lights in the nighttime sky when he changed position at the end of the 15 minute exposure, before the photographer closed the camera's shutter. Lebe considers this apparent misstep as a happy accident, believing that "the light drawing is a metaphor for the energy that we give off and sense in each other, which parallels the energy that the city gives off, letting us think of the city as a living thing itself."
© David Lebe. *Angelo on the Roof*, 1979. 16 × 20 inches. Gelatin silver print.

As you gain experience, you will be ready to tackle more complicated situations, such as working outside at night. When doing this, wear dark, nonreflective clothes so you may walk around within the scene without being recorded on film. Since it is impossible to know exactly what the final effect will be, make a series of exposures varying the intensity of the light and the type of hand gestures used in applying it. Some gestures may be smooth and continuous; others may be short and choppy. Have fun experimenting; try dancing around, running, hopping, jumping, or waving with the light.

POSTCAMERA TECHNIQUES: IN SEARCH IF TIME

The traditional photographic concepts of motion, space, and time can be altered in the studio and darkroom as well as in the camera to build additional spans of time (experiences) back into a photograph. The methods discussed allow for alternative potentialities to be amplified, embellished, expounded or revisited. Some techniques allow an imagemaker to mobilize and secure connections between formal artifice and disorder. Others permit the weaving of a simultaneous network of complex associations, a rich tangle of cross-stitching that can reveal an alternative temporality of a subject and demonstrate that the past, present, and future are a product synthesized by the memories of imagemakers and viewers. All these approaches can yield new insights into a subject and make the overall visual account richer and more thought provoking. Additionally, numerous photographers reinterpret their negatives over time as their concepts expand and new techniques, especially digital, allow them to visualize what was previously not possible. As artist Francisco de Goya observed, "Fantasy abandoned by reason produces impossible monsters; united with her, she is the mother of the arts and the origin of their marvels."

Painting the Print with Light

One can re-expose the light-sensitive printing material with a controlled source of light after the initial print is exposed or while it is developing. This can be achieved with a small penlight. Wrap a piece of opaque paper around the penlight so it extends a few inches beyond the body of the light source. Secure it to the penlight body with tape. This paper blinder will act as an aperture to control the amount of light. Pinch the open end of the paper together to control the intensity and shape of the light source. Fiber optics also can be attached to the end of the penlight for tighter control over the light.

Working Procedure

Correctly expose the image on black-and-white paper. Place a red filter beneath the enlarging lens. Since black-and-white paper is not sensitive to red light, the red filter enables you to turn on the enlarger and see the projected image without affecting the paper. Open the lens to its maximum aperture. Turn on the enlarger and project through the red filter. This allows you to see where to draw with the penlight. Begin drawing with the light. You can cover specific areas of the print with opaque materials to prevent re-exposure.

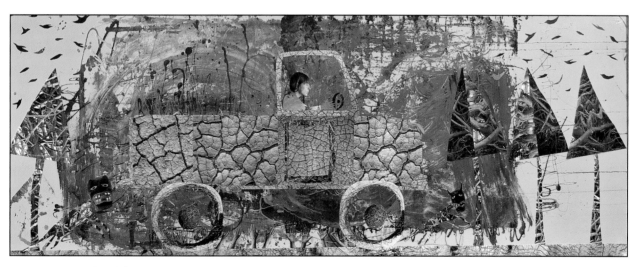

FIGURE 11.11 Though becoming well-versed in digital photography streamlined Roberts's working methods, it also posed a new challenge in how she unites such images into her extensive postcamera, hand-altered creation processes. This work originated as a painting in which the artist incorporated additional layers of mixed media and photocollage. The mud unifies the work, "both describing the body of the truck and also creating a surface that carries another meaning: dried, cracked clay that conveys a sense of the arid harshness of the world the truck comes from and continues to travel through."
© Holly Roberts. *Mud Truck*, 2006. 30 × 80 inches. Mixed media.

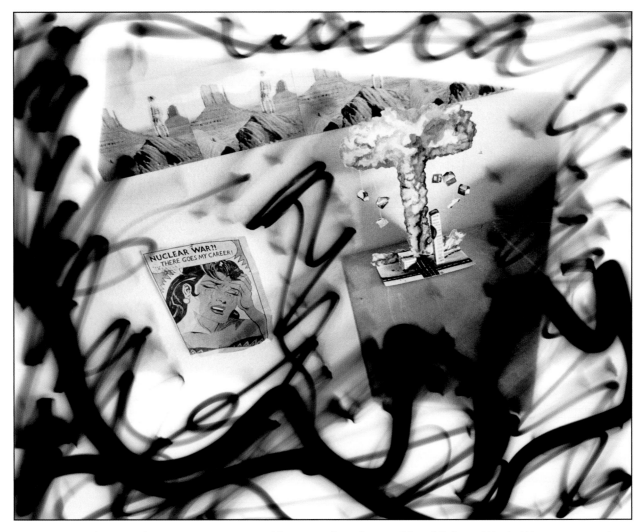

FIGURE 11.12 Starting with an image incorporating a 3-D paper sculpture by artist Edward Collier, a Wonder Woman comic, and a 3-D postcard of Monument Valley, AZ, Hirsch relied on postcamera darkroom methods to complete his theme. He expressionistically painted the photograph with light to add a strong sense of haptic emotion and volatility. This was done to convey the sense of the absurdity and fear one could experience growing up during the Cold War era when the US and Russian foreign policies pursued a course of mutually assured atomic destruction.
© Robert Hirsch. *Nuclear War?! … There Goes My Career!* 1983. 16 × 20 inches. Toned gelatin silver print.

It is also possible to draw with the light as the image begins to appear in the developer. This can produce a grayer line quality or a partial Sabattier effect.

Moving the Fine Focus

By moving the fine-focus control on the enlarger during the exposure, a maker can cause the projected image to expand and/or contract. Start by giving the print two-thirds of its correct exposure. Then begin to move the fine-focus control and give the print the remaining one-third of its time. For example, if the normal exposure time is 24 seconds, give the print its first exposure of 16 seconds and the remaining 8 seconds while moving the fine focus. It may be necessary to stop down the lens and increase the overall exposure so there is more time available to manipulate the fine-focus control. The final outcome is determined by the following:

- The ratio of the normal exposure to the moving exposure.
- The speed at which the fine focus is moved.
- How long the moving exposure is left at any one point.

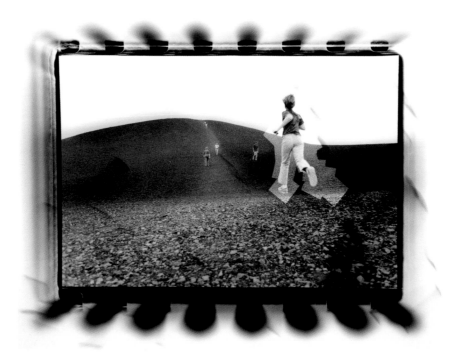

FIGURE 11.13 By moving the enlarger's fine focus knob during exposure, Hirsch amplified the main figure's sense of movement. Masking the central figure and subtly painting the area around him with light further enhanced this illusion. The overall effect disturbs traditional notions about landscape photography by visually deconstructing the concept of the classic "decisive moment." It also challenges conventional print values while expanding the image out of the normal boundaries of the photographic frame.
© Robert Hirsch. *Running on the Craters of the Moon*, 1985. 16 × 20 inches. Toned gelatin silver print. Courtesy of Dr. Philip Perryman Collection.

- Whether the fine focus is used to expand or contract the image.
- When the moving exposure is made. Different effects will be produced depending on whether the fine focus is moved before, in the middle of, or at the end of the normal exposure.

MULTIPLE-EXPOSURE METHODS

In-Camera Multiple Exposures

To make more than a single exposure in the camera on one single frame, begin with a controlled situation having a dark background. One must use a camera that has a double-exposure capability (see the camera's manual for specific instructions on how to carry out this procedure). Use one source of illumination to light the subject. Put the camera on a tripod, focus, and then figure the exposure for each frame based on the total number of exposures planned for that frame. Generally, the individual exposures are determined by dividing the overall exposure time by the total number of exposures. For instance, if the overall exposure for a scene is f-8 at $\frac{1}{60}$ second, the time for two exposures on one frame would be f-8 at $\frac{1}{125}$ second each. This tends to work well if the illuminated subject(s) overlap. If there is no overlap and a dark background is used, the correct exposure would be f-8 at $\frac{1}{60}$ second for each exposure. Be prepared to do some testing. Using a digital camera will speed up the testing process.

Variations

You can change the amount of time given to the separate exposures within each frame by altering the f-stop or shutter speed. This can produce images of varying intensities and degrees of motion within the composition. Changing the f-stop will introduce differences in the amount of depth of field from one exposure to the next. Altering the shutter speed can produce both blurred and sharp images in a single frame. Moving objects around within the composition can create a ghostly half-presence in the picture. Altering the position of the camera can help you avoid exposure build up, which will produce gross overexposure. Start simply, bracket your exposures, and work your way into more complex situations.

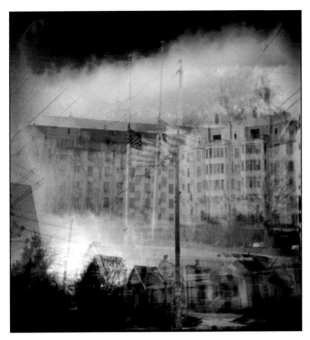

FIGURE 11.14 Little ran a roll of expired Fujicolor 120 film through her Holga 120S camera three times. She considered the light leaks, for which the Holga is notorious, a welcome ingredient, striving for leaks significant enough to substantially wipe out part of the image, which she viewed as meaningful content. The photographer states, "The content in this image becomes visible within its imperfections. This photograph has portions of the image obliterated that were left as a marker for rupture and potentially shifts the definition of boundary from the point at which something stops to that from which something begins."
© Adrianne Little. *End of Road #65*, 2007–08. 24 × 24 inches. Lightjet print.

Using a Masking Filter

A masking filter, which exposes only half the frame at a time, can be used to make a single image from two separate halves. One can buy this filter or make it by cutting a semicircular piece of opaque material to fit into a series-type filter holder designed for the size of the lens being used. An intriguing variation is to make a mask that has a number of doors, each of which can be opened for individual exposure. These doors may be of different shapes and sizes. The composition can be rearranged and relit for each exposure. The following is a basic guide for using a masking filter with an SLR camera.

Generally, allow each image to cross the centerline of the frame (mask) and come about one-third of the way into the blocked area. This can help make the blend line less noticeable. The major problem with this technique is that it is often easy to see the line where the two images meet. Extra care in dodging and burning when making the print can make this less noticeable.

1. Place the masking filter on the camera lens. Compose and normally expose half the frame.

2. Wind the shutter without advancing the film.

3. Rotate the masking filter so the first half of the image that was exposed is not masked off.

4. With the second half of the frame now in view, compose and expose the second half normally.

5. After this second exposure, advance the film to the next frame.

Darkroom Multiple Exposure

There are numerous methods for accomplishing multiple exposure in the darkroom. The simplest method of altering the perception of time and space within a composition involves exposing a single negative more than once on a piece of light-sensitive material. Box 11.2 lists some of the many variations on this procedure.

Combination Printing

Combination printing is when two or more negatives are printed on a single piece of light-sensitive material to make the final image. Combination printing is not a contemporary innovation, but was originally devised for use with the collodion wet-plate process in the mid-1850s to overcome the slowness of the film's emulsion and its inability to record certain parts of the spectrum. The technique was popularized in England by Oscar Gustave Rejlander and Henry Peach Robinson, and peaked by the 1880s. As technical improvements such as panchromatic emulsions and flexible roll film became available, combination printing was no longer necessary, and its practice rapidly declined. The process experienced a major rebirth in the 1960s with the images and teaching of Jerry Uelsmann. He used this precomputer technique in a surrealistic manner to juxtapose objects for which there was no correlation in the ordinary world.

Before the widespread use of digital imagemaking, combination printing was a way to make a composite of images by photographic means. Although the computer's ability to amalgamate images is unparalleled, not all imagemakers have abandoned combination printing. In an online exhibition of his work, Uelsmann addressed why he still creates certain images in the darkroom. "While I am interested in these computer options, I still have a basic love of the darkroom and the alchemy it embraces. In terms of the creative process, I find that the overwhelming number of options offered by the computer creates a decision-making quagmire."

Combination printing can be carried out by switching negatives in a single enlarger or by moving the light-sensitive material from one enlarger and easel to another, each having been set up to project a different image.

FIGURE 11.15 Northrup's in-camera multiple exposures were made with a homemade mask placed in front of the lens. The mask was made out of mat board cut into shapes and put up in front of the camera on a glass frame. Pieces were taken out one at a time, the viewable areas were exposed, and each piece was then put back in its place. Moving objects between exposures creates a cubistic sense of time and space.
© Michael Northrup. *Mad Donna*, 1995. 24 × 20 inches. Chromogenic color print. Courtesy of Strobophoto Studio, Baltimore, MD.

Box 11.2 Darkroom Multiple Exposure Practices

1. Enlarge or reduce the image with each new exposure.
2. Allow the exposures to overlap and intermingle.
3. Use different exposure times to create variety in image density.
4. Move the fine-focus control during some of the exposures.
5. Print only selected portions of the negative.
6. Combine this with other techniques such as cliché-verre or photograms.
7. Sandwich the negative with other negatives or with transparent materials.
8. Combine the negative with a positive (transparency) image.
9. Print from more than one negative.
10. Make masks that can be attached to the easel so that multiple negatives can be exposed with a single enlarger.

FIGURE 11.16 In this photograph, Zigmund employs darkness as a mask to combine different elements and exposures. Setting her ISO to 80, half the Fuji Pro 160C's rated film speed, she made her first exposure using a yellow plastic bag as a color flash filter aimed at the plant. She moved the camera for the second exposure and held the flash, pointing it at the clothesline. She placed the camera on the sidewalk for the third exposure and positioned one strobe behind the figure's head and another outside the frame to highlight the rest of the figure. This image functions as a performative self-portrait the artist intends viewers to identify with. "Despite incessant references to both body and experience, my identity marks its presence only from a distance. A sense of remoteness functions as a boundary and the viewer is impelled to appropriate insight from their own direct experience."
© Tricia Zigmund. *Self-Portrait with Ectoplasm*, 2006. 26 × 39 inches. Chromogenic color print. Courtesy of Kolok Gallery, North Adams, MA.

If more than one enlarger is available, most people find the second method easier to use.

Multi-Enlarger Combination Printing

A simple combination print can be made by blending two images, each of which is set up for projection in a different enlarger and easel. This can be accomplished by following the guidelines in Box 11.3

Opaque Printing Masks

Printing masks can be used to block exposure to different areas of the light-sensitive material. The masks must be carefully cut to avoid making an outline around each area where the exposure was blocked.

A multiple opaque mask can be used with a single negative. In this case, a mask is made the same size as the final print. The mask is cut into various shapes corresponding to those in the image. One section of the mask is removed, and an exposure is made. This section is then replaced, and another is removed and exposed. The process is continued until all the sections have received exposure. The amount of exposure can be varied from section to section to create different density effects. Numbering the sections can help you keep track of what you have done.

RESOURCE GUIDE

Uelsmann, Jerry N., with essay by John Ames. *Uelsmann: Process and Perception*. Gainesville, FL: University of Florida Press, 1985.

Box 11.3 Combination Printing Guidelines

1. Look through your contact sheets and find two images to combine. Select images that have a clear horizontal or vertical dividing line, as this will simplify the blending process.

2. Place each image in a different enlarger.

3. Size and focus the images. Allow them to slightly overlap.

4. Put a piece of plain white paper in the first easel. Use a marker to indicate the placement of the major objects and where the blending line will be.

5. Move this paper to the second easel and line up the second image and blending line with the indicated marks.

6. Make a test strip to determine the correct exposure for each enlarger.

7. Place the light-sensitive material in the first enlarger and make the exposure, using an opaque board to block the exposure around the blending line. Keep the board moving and allow some of the exposure to cross the blending line so there is no visible joining line.

8. Transfer the light-sensitive material to the second easel. Expose the second negative, using the opaque board in the same manner as in Step 7 to block the first exposure.

9. Expect to carry out this procedure a number of times until you master moving the board to get a seamless blend. Patience and craftsmanship are necessary to successfully create this illusion.

FIGURE 11.17 Uelsmann is the contemporary master of the multi-enlarger method for combination printing. Before entering the darkroom, he ponders his contact sheets, which make up his visual diary of things seen and experienced with the camera. This helps him to seek out fresh and innovative juxtapositions that expand the possibilities of the initial subject matter. He strives to synthesize and reconstruct images to challenge the inherent believability of the photograph. All the information is there, yet the mystery remains. Uelsmann says he finds "it exciting to challenge the limits, but others find it offensive because once you begin to alter the imagery, you are treading on the societal boundaries between perceived fact and fiction."
© Jerry Uelsmann. *Man on Desk*, from the book *Process and Perception*, 1976. 20 × 16 inches. Gelatin silver print.

FABRICATION: HAPPENINGS FOR THE CAMERA

Throughout most of photography's history, the majority of pictures were primarily of people, places, and things. Now many contemporary imagemakers want to explore ways to expand the photographic lexicon to comment on internal realities. One of the means photographers have used to express their inner concerns is fabrication. In the photographic sense, fabrication is the creation of a new reality, one that cannot be naturally found in the visible world. To accomplish this goal, a photographer constructs, devises, or invents an assemblage of subjects to be photographed. The techniques and methods used often investigate and question the nature of photography, photographic time, and how it is used. Such work propels the photographer and the viewer to become more aware of the artificiality of photographic reality by posing questions such as: What makes up reality? What is a photograph? Why is appearance constantly taken for truth? Where and how does a photograph obtain its meaning? Do our representations correspond to reality? Could the world be different from the way we represent it?

In *Connections to the World: The Basic Concepts of Philosophy*, philosopher/art critic Arthur Danto states, "Philosophy is the effort to understand the relationships between subjects, representations and reality." The techniques photographers use to probe these questions and relationships include the following:

- Constructing environments to reflect ambitions, dreams, fantasies, and social commentaries.
- Combining images and text by using typesetting, press type, rubber stamps, and handwritten messages that appear on or around the photograph.
- Creating 3-D photographic images by means such as painting emulsions on a variety of surfaces, cutting up images and hanging them from objects, sewing and stuffing cloth that has been treated with a photo-sensitive emulsion, or making freestanding floor screens based on classic Oriental models.
- Layering transparent images over one another, which are then rephotographed to create new pictorial meanings.

Sequences

Another aspect of fabrication involves departing from the traditional of only using a single image to convey a message.

FIGURE 11.18 People are afraid of what they cannot see. Collectively our subconscious is on alert for sudden and unexpected danger and death, which can take numerous and ever-changing shapes from AIDS to terrorism. The *Unseen Terrors* project evokes a dichotomous contrast between stability and fragility while offering an idiosyncratic micro and panoramic visual mini-history of 300 such invisible and innate cultural fears using the history of atomic theory and The Bomb as its focal point. Hirsch created this series by layering transparent images he made over one another and then rephotographing them on a light box to generate project specific content and meanings. These images were also used to produce decks of 52 *Atomic Playing Cards*.
© Robert Hirsch. *Bobby and the Terror*, from the installation *Unseen Terror: The Bomb, Other Bogeymen, and a Culture of Fear*, 2006. Variable dimensions. Digital file. Courtesy of Big Orbit Gallery, Buffalo, NY.

FIGURE 11.19 Previsualizing this work, Kellner first sketches and constructs a grid-like storyboard of his anticipated image. To produce this composite, he utilized an 800mm lens on his Pentax MZ-S, which immensely condensed the sense of depth and fragmented his subject into numerous frames. After developing the film, he positions each negative onto the contact sheet, following his original grid. He then scans and color corrects the collection of images to produce the final contact sheet, in this case a montage of seventy frames. The final work reveals the influences of early photomontage artists, such as Aleksandr Rodchenko, and early cubist artists, such as Robert Delaunay, in its methodical and inventive reconstruction of this frequently photographed building.

© Thomas Kellner. *Washington, Capitol I*, 2004. 13¾ × 10½ inches. Chromogenic color print. Courtesy of Schneider Gallery, Chicago, IL.

Box 11.4 Cinematic Imagemaking Methods

- A sequence is a group of images designed to function as a group rather than individually. Typically, sequences tell stories (although they do not have to be empirically narrative in nature), present numerous points of view, and provide information over an extended visual time period. Sequences can be made in the camera or put together using prints. They are often presented in a book format to encourage intimate viewing whereby meaning is built up page by page. A classic example of this strategy is Robert Frank's *The Americans* (1959).

- A grid format, an evenly spaced grating framework of crossing parallel lines (like a tick-tack-toe board), has been used both at the moment of exposure and during printmaking to enclose and analyze an image. The grid breaks down an image into separate units while still containing it as a unified form.

- A modified grid using a specially constructed easel that has individually hinged doors that may be opened and closed. This permits a single image to be broken down into separate quadrants, each of which can receive different exposure times. The overall effect in a single image can be fractured by light to create separate units within the whole.

- A contact sheet sequence combines aspects of the in-camera sequence and the grid. A scene is visualized in its entirety, but photographed as individual segments. When these separate frames are laid out and contact printed, they create a single unified picture.

- Using joiners, the practice of photographing a scene in individual parts and then fitting these together to form one image, was impeccably deployed by painter David Hockney during the 1980s. The images may be printed at the same size (as Hockney did) or cut into different sizes or shapes and arranged and attached in place.

FIGURE 11.20 To overcome his frustration with traditional, portraiture's limited point of view Levy constructed a photographic grid consisting of 15 individual images. Made with a 4 × 5 inch camera, these images examine the architecture, sense of time, and continuous overload present in photography collector Dr. Stanley Burns' living and working environment (see: www.burnsarchive.com). The prints are brought together to form the illusion of glancing through a window at an event that may actually consist of fragmented views made at different times. The images explore and challenge our perceptive process by testing the limits of discontinuity in space and time that our brains will accept in reading an image. The self-reflective elements attest to the collaborative relationship between the photographer and the subject.
© Stu Levy. *Sleeping Beauty (Stanley Burns, M.D.)*, 2002. 24 × 40 inches. Inkjet print. Courtesy of Verve Gallery, Santa Fe, NM.

Cinematic seeing presents a series of images in which each frame modifies the sense of photographic time and space of the frame before and after it. This interaction between frames delivers more data, thus enabling the audience to witness a different point of view or a new episode that can enhance their understanding of the subject. This technique can be accomplished directly in the camera using previsualization methods or created from prints using postdarkroom procedures. Box 11.4 lists methods to explore cinematic imagemaking.

RESOURCE GUIDE

Hoy, Anne H. *Fabrications: Staged, Altered and Appropriated Photographs.* New York: Abbeville Press, 1987.

COMPOSITE VARIATIONS

The Collage

A photographic collage is produced when cut and torn pieces from one or more photographs are combined on a common support material. A photographic collage may also include printed images from magazines, newspapers or the internet; a combination of colored paper, wallpaper, or fabric; natural materials such as sand, grass, flowers, and leaves; and 3-D objects. No attempt is made to deny that this complete image is an assemblage created from a variety of source materials. It is *not* rephotographed and is itself presented as the final product.

The Montage

A montage follows the same basic rules as those used in making a collage. However, the major difference is that the finished collection of materials is rephotographed. The making of this new photographic image allows the end product to be transformed back into a photographic print, from which additional copies may be produced. Sometimes the imagemaker attempts to hide the source of the various images and materials in an effort to present a new, seamless photographic, as opposed to digital, rendition that will make people ask, "How can that be?" Great fun, innovation, and provocation are possible by juxtaposing people, places, and things that would otherwise not be seen keeping company together.

Making a Collage or Montage

You will need the following materials to assemble a collage or montage.

FIGURE 11.21 Mills welcomes the technical challenge that collaging found photographs presents, in that he "takes all risks that present themselves, following where they may lead, even if it leads to the destruction of what is being created" in front of him. In surrealist fashion, the collages are formed by relinquishing previsualization, inviting chance and gaffes as the images revealed themselves. Mills' source materials are the black-and-white pages of *Life* magazine. He strives to create seamless images with a "coherent quality of light, without breaks in tonality or other qualities that would prohibit them from being read as straight photography."
© Joe Mills. *Untitled #291 (The Smoker)*, 2004/2007. 25 × 20 × 1 inches. Photomontage. Courtesy of Hemphill Fine Arts, Washington, DC.

- Large collection of source images and materials.
- Support print, board, or other material for a common backing base. This background material may be a piece of matte board or a photograph. Generally, photographs having open, uncluttered areas offer a good starting point. The support should be large enough to allow plenty of room within which you can maneuver – 16 × 20 inches is usually a good size to begin with.
- Sharp scissors.
- Sharp X-Acto knife (a #11 blade is good).
- Extra fine sandpaper (Grit 300).
- Adhesive glue or dry-mount tissue (if permanence is a concern, use an archival glue).
- Spotting colors.
- Fine sable brush (# 0).
- Fine-tip felt pens, in various shades of gray and black, which are lightfast and waterproof.
- Tacking iron and dry-mount press (if dry mounting is planned).

Below is a basic working guide for constructing a collage or montage.

1. Spread out all the source materials you are considering using. Be generous.

2. Try a variety of arrangements and juxtapositions on the background support.

3. After you have made a preliminary selection, trim the source materials down to their approximate final size. If you are using dry mounting, tack the dry-mount tissue to the back of each selection so it will adhere properly after final trimming.

4. Trim materials to their final size. For the smoothest finish, use sharp scissors to make long, continuous, beveled cuts. Use the X-Acto knife only when cuts cannot be made with scissors. Cutting with a blade tends to produce a more jagged edge. Smooth out rough edges with extra fine sandpaper.

5. Using the appropriate gray or black felt-tip pens, color the edges of the trimmed materials so they match each other and the support board. An edge that is too dark will be just as noticeable as one that is white.

6. Attach the trimmed, shaded pieces to the background support with glue or dry-mount tissue.

7. Add shadows with diluted spotting colors if desired.

Copying

If you are making a montage, the assembled work can be copied outside in clear, direct sunlight. Place the work on a clean, flat surface. The sunlight should be striking it at a 30–45 degree angle. Photograph the work with a 35 mm camera, ideally equipped with a macro lens to provide maximum flatness of field and sharpness. If you do not have access to a macro lens, you can use a 50 mm lens instead, which will easily fill the frame of for making standard sized prints. Make sure the camera is parallel to the work being copied. Stop the lens down to f-8 or f-11 to ensure good depth of field. For maximum detail and minimum grain, use a slow, fine-grain film or ISO 100 with a digital camera. Determine the proper exposure by reading an 18 per cent gray card in front of the work. Do not meter directly from the work, or you may get a faulty reading. Use a tripod or a shutter speed of at least $\frac{1}{125}$ second or higher to ensure sharp results.

The work may also be copied indoors using lights with daylight fluorescent bulbs set-up at 45 degree angles to the work, allowing the path of the lights to crossover each other. Be certain the color balance of your film (filter if necessary) or digital camera matches the color temperature of your light sources. The piece may be flat or tacked or taped to a wall. Using a gray card, measure the light falling on the work from each lamp, making sure each is casting even illumination across the work. Then place the gray card in front of the work and take a meter reading off it with both lights on. Polarizing filters can be attached to the lights and/or to the camera to control reflections and to adjust brightness, contrast, color balance, and color saturation. For the sharpest results, use a large-format camera to copy the work. Collages also may be scanned or copied on a black-and-white or color electronic copy machine.

RESOURCE GUIDE

Ades, Dawn. *Photomontage*. Revised Edition. New York: Thames & Hudson, 1986.

Golding, Stephen. *Photomontage: A Step-by-Step Guide to Building Pictures*. Rockport, MA: Rockport Publishers, 1997.

Teitelbaum, Matthew (Ed.). *Montage and Modern Life: 1919–1942*. Cambridge, MA: MIT Press, 1992.

Photo-Based Installations and Performance Art

Photo-based installations can comprise arrangements of images, objects, sound, and text that are designed to function as a single work. Installations provide viewers with the experience of being in and surrounded by the work, and often feature interactive digital components, including video and sound, to produce a more intense sensory realization. Precedents for installations can be found in the Pop Art era of the late 1950s and 1960s, such as Allan Kaprow's *18 Happenings in 6 Parts*, 1959 or Red Groom's "sculpto-pictoramas" such as *The City*

FIGURE 11.22 Angel uses collage to explore her experience as a cancer survivor and the process of healing both physically and emotionally. Angel tears photographs and collages them on eight-ply museum board using acrylic gel medium as an adhesive. "The tactile process of actually piecing together photographs is metaphorical as they represent the piecing together and layering of the experiences that comprise my life and how cancer defined it."
© Catherine Angel. *Lamentations*, 1995. 24 × 20 inches. Gelatin silver print with mixed media. Courtesy of Catherine Edelman Gallery, Chicago, IL.

FIGURE 11.23 Copy Stand and Lights. When copying work, two lights should be set up at equal distances on each side of the camera at 45 degree angles to the work being copied, allowing the paths of the light to overlap. For most accurate exposure, meter from a gray card, not off the surface of the work being copied. Make sure the color balance of your film (filter if necessary) or digital camera matches the color temperature of your light sources.

45° 45°

FIGURE 11.24 As a refugee from Vietnam and unable to speak English, Lê spent time during his childhood in the library looking at books about Western art. Lê combines the iconography of Eastern and Western cultures in a paper weaving style based on that of his aunt's traditional grassmat weavings. Depending on the content of the image being constructed, Lê adjusts his weaving process to bring forward certain aspects of the subject while keeping others veiled.
© Dinh Lê. *Untitled*, 2007. 53 × 76½ inches. Woven chromogenic prints and linen tape. Courtesy of PPOW Gallery, New York.

of Chicago, 1967. Most installations are not salable and generally are exhibited and dismantled, leaving only photographic documentation of their existence.

The conceptual artist Bruce Nauman utilized the supposed objectivity of the photograph to give a documentary look to his contrived situations, known as *performance art* (See Dennis DeHart's homage, Figure 9.14). This term has been retroactively applied to early live-art forms, such as body art and happenings. The progressive disintegration of conventional artist materials and presentation forms led artists to engage of the actual body as a forum for cultural critiques. Performance art is an open-ended classification for art activities that include elements of dance, music, poetry, theater, and video, presented before a live audience and usually "saved" by photographic methods and shown to larger audiences. One of its purposes is to provide a more interactive experience between artists and audiences.

Robert Smithson's constructed Earth Work projects, like *Spiral Jetty* (1970), a 1500 foot long spiral of earth and rock that jutted out into Great Salt Lake, and Christo's temporary projects, such as wrapping a building, or his *Running Fence* (1976), a 24½ mile fence of fabric, rely on photography to reach larger audiences. Initially, many conceptual artists resisted being documented, claiming that photographs would convert their art into marketable objects, violating their basic concept that such work was supposed to be experienced in person. But soon, Smithson was exhibiting his photographs and Christo was selling his. Artists like Smithson, who created transitory situations that he extracted from nature or left for nature to decompose, fixed his work with photography, stating: "Photography makes nature obsolete."[2] Such strategies helped to dissolve the boundaries that separated photography from other media.

FIGURE 11.25 *World in a Jar* curates and re-imagines key components from historical and original images to explore the workings of our collective societal memory involving loss, popular culture, religion, tragedy, and the nature of evil over the past four centuries. Using the Shoah as its point of departure, *World in a Jar* is a free-form sculptural montage that rethinks the customary linear narrative by offering an interchangeable supermarket of moveable images. The installation consists of 850 individual image jars, stacked on a 50 × 4 × 2 foot serpentine display pedestal, which is surrounded by 10 individually framed 40 × 60 inch prints. Each glass jar contains a different picture, a twin printed twice on a black field (akin to a nineteenth century stereo card), which lets them be seen from multiple points of view. © Robert Hirsch. *World in a Jar: War and Trauma*, 2004. 4 × 50 × 2 feet. Installation view. Courtesy of Burchfield-Penney Art Center, Buffalo, NY and Big Orbit Gallery, Buffalo, NY.

PROCESSING MANIPULATION: RETICULATION

Reticulation is the wrinkling of a film's emulsion into a spider web-like pattern or texture. Normally this is viewed as a processing mistake caused by differences in the temperature of the film's developing solutions. Until the 1950s, reticulation was not an unusual occurrence. Contemporary films do not suffer from this problem because of improvements in emulsion making, such as the use of improved hardeners. It can, however, be purposely induced for visual effect. Reticulation can literally dissolve the camera-based reality and replace it with a manipulated reality in which line, shape, and space are distorted and rearranged on the film's surface.

Reticulation can be accomplished through two basic methods. One way is to create extreme differences in temperature between the processing steps during film development. The other method is to induce it chemically after the film has been developed.

In the first method the film is developed at an elevated temperature (90°F/32°C or higher), then put in a very cold stop bath followed by a warm fixer. After this, the film is frozen before it is given a final hot wash. Even with these extremes, the hardener built into many modern films makes reticulation difficult if not impossible to accomplish.

With the second method, the film is reticulated by chemical means, which gives the advantage of working with normally processed film (even film that is a couple of years old can work). It also enables direct observation and interaction with the process, allowing you to stop the reticulation when you see fit. This chemical method works with many black-and-white films.

Sodium Carbonate Reticulation

Sodium carbonate can be used to produce simple random reticulation. No two films seem to react to it in the same way. Even negatives on the same strip of film can respond differently, making this process highly unpredictable. Kodak's TRI-X is one film that works well with this

technique. Using a medium- or large-format negative allows you to readily observe the process.

As mentioned earlier, previously processed film may be used, which can be useful for testing. The older the film is, the harder its emulsion surface tends to be, thus increasing the time it takes for reticulation to take place and also limiting its effects. Best results are achieved with freshly processed film (see Box 11.5).

Water Reticulation

Some films that have not been fixed with an acid hardener can be reticulated in water. Put the freshly processed film, fixed only with a nonhardening fixer, in plain water at 150°F (65°C) and allow it to sit until the water cools down to room temperature. This method will produce a much finer, softer pattern than that induced with sodium carbonate.

Masking

Specific areas of a negative can be masked with Fotospeed MK50 Fotomask or rubber cement to prevent reticulation (see Chapter 8). Use a fine brush to apply the mask directly on the emulsion (dull) side of the film and let it dry. Then immerse the film in the reticulating solution.

There may be some slight reticulation around the edges of the mask, depending on the length of time the film is in the solution. After the film has been washed and dried, the mask can be removed with masking tape or with your finger. Film may be masked, partially reticulated, washed and dried, remasked, and further reticulated to create a variety of patterns within a single image.

HAND-COLORING

Hand-coloring lets an imagemaker voyage beyond the conventional limitations of the photographic process to change the reality of a scene. Synthetic color can be applied to alter the mood, eliminate the unnecessary, and add space and time that were not present at the moment of exposure. This methodology can help bridge the gap between the inner/subjective and outer/objective realities by enabling imagemakers to control the color of the external world with their imaginations.

Materials for Adding Color

A wide array of materials and processes can be used to apply color to a photograph. Some widely used coloring materials include acrylic paint, colored pencils, dyes (both

Box 11.5 Chemical Reticulation Guidelines

1. Start with a completely processed and dried negative.

2. Prepare the reticulation solution by combining 30 g of sodium carbonate with 500 ml of water at 140–150°F (60–65°C). This solution has a useful temperature range of 105–160°F (40–71°C). As the temperature goes down, the action of the solution becomes slower. If the temperature gets too high, it will ruin the film's plastic base. You can maintain the temperature with the use of a hot plate.

3. Place the film directly in the hot solution, which is held in a clear glass jar or a small tray. For easy handling, attach a paper clip through a sprocket hole to individual frames of 35 mm film before placing them in a clean baby food jar filled with solution. Take care not to let the film come in contact with the walls of the jar or uneven reticulation will result. Some workers prefer the tray process. For tray processing tape the film, emulsion side up, to a slightly larger piece of thin Plexiglas or glass and place in a tray. This technique makes observation and manipulation easier, and it provides a solid horizontal support. The tray method also permits extending the time in the solution, which increases the effect and allows other visual distortion such as veiling effects to take

place. Veiling is caused by the physical breakdown of the emulsion as it begins to dissolve and fold up. Be careful not to leave the film in the solution too long, or the emulsion will completely slide off its base. One can push the loose emulsion around with a brush or a very weak stream of water to create other effects.

4. When the film is placed in the solution, the protective gelatin layer will dissolve and rise to the surface. Allow the film to remain in the solution for 5–20 minutes, with occasional agitation. Reticulation may begin within 45 seconds. The first stages will produce a fine-textured pattern. As time passes, the pattern should become larger and more exaggerated. The process may not take as long with 35 mm film as with a 6 × 7 cm format. This is because the pattern will be more evident when the 35 mm film is enlarged to the same size as the 6 × 7 cm film. If the process is allowed to go too far, the pattern will become more visually important than the original subject.

5. When the desired result is obtained, remove the film from the solution. A pair of tweezers can be helpful when dealing with unattached pieces of film. Wash it in cool running water for 10 minutes, treat with Photo-Flo, and then hang it up to dry.

FIGURE 11.26 Enfield hand-colored this photograph with oils and pencils "to better draw viewers into the image. Rather than faithfully reproducing the setting's chromatic structure, I want to discover the colors that evoke a similar emotional response to that felt at the actual site. The image is complete when I can look at it and feel as it I were back on location, smell the aromas, feel the same sun, the same atmosphere." She made this landscape on black-and-white infrared film using a wide-angle lens coupled with a Red No. 25A filter. Enfield developed the film in D-76 and printed it on a warm-tone, fiber-base paper, which was developed in a combination of Dektol with Selectol Soft developers to achieve the desired tones.
© Jill Enfield. *Fire Island Trees*, 1985/1990. 11 × 14 inches. Hand-colored gelatin silver print.

fabric and food), enamel paint, marking pens, Marshall's Photo-Oil Colors, oil paint, photographic retouching colors, photographic toners (see Chapter 8), and watercolors.

Solvent-Based Materials

These materials can be divided into four basic groups: lacquer based, oil based, water based, and miscellaneous.

- Lacquer-based paint is usually sprayed from a can or airbrush (see the section on "Airbrushing" later in this chapter).

- Oil-based materials are among the most common and easy-to-use coloring agents. Quality artist oil paints can be applied to almost any photographic surface. Before painting, a fine coat of turpentine is generally applied to the print surface with a cotton ball. Marshall Photo-Oils and Pencils are available in complete kits with directions for their application. Oil-based materials produce soft, subtle colors. Blending large areas of color is easy with oils. Since oils are slow drying, you can fix mistakes with cotton and turpentine.

- Water-based materials, such as acrylic paint, certain concentrated dye toners such as Edwal photographic retouching colors, and watercolors are considered additive coloring agents. They can be applied straight or mixed to form new colors on a palette. Overall coloring agents are considered to be toners and are covered in Chapter 8. Nonacrylic water-based coloring agents like watercolors affect the print surface in the same manner as conventional spotting. The color penetrates the surface and becomes a permanent part of the image. Mistakes cannot be erased as with oils but must be painted over. Consequently, more care, skill, and forethought are required.

- Intense and subtle color effects can be created with water-based materials, depending on how much water is used to dilute the coloring agent. Since these materials do not sit on the print surface, as do oil-based materials, colors tend to appear brighter, clearer, and more intense. When covering large areas, water-based materials must be applied rapidly and smoothly if you do not want brush strokes to be evident in the final image. Dipping a brush in diluted Photo-Flo or

lightly wetting the areas to be colored with a clean cotton ball and fresh water can reduce the likelihood of streaking.

■ Acrylics are somewhat different from other water-based materials. Acrylics reside on the surface of the print and so tend to appear brighter and more opaque. If these qualities are not problematic, it can be easier to work with acrylics than with watercolors because they are slower to dry. Thus, they can be removed while still wet using cotton and water.

■ Unconventional materials, including natural substances such as beets, coffee, or tea, may be used to add color.

Combining Coloring Agents

Coloring agents can be combined, as long as you keep in mind the old adage about oil and water not mixing. Remember that lacquer and oil do not adhere well to water-based materials and that water-based agents do not adhere well to lacquer and oil-based materials. Box 11.6 lists the factors affecting the permanence of additive coloring agents.

Box 11.7 provides starting points for applying additive colors to a photographic print. As experience is gained, begin to diverge from the given modes of application. Try hand-coloring on fabric and nonsilver emulsions or combining the procedure with toning and masking. Hand-coloring is a highly individualistic process, so be adventurous and experiment. Do not be afraid to make mistakes. The ability to make meaningful photographs often comes through an intellectual and/or spiritual

Box 11.6 Factors Affecting the Permanence of Additive Coloring Agents

■ Keeping properties of the specific coloring agents.
■ Combinations of coloring agents.
■ Type and condition of the surface being painted.
■ Levels of exposure to UV light.
■ Proper display and storage conditions, including moderate temperatures and medium to low relative humidity.

FIGURE 11.27 Orland hand-colored this photograph with oil color using both a cotton swab to produce a realistic effect and finger-painting to generate a more fantastical effect. With tongue-in-cheek, Orland declares that this image "was entirely pre-visualized in traditional "Adamsonian" fashion. The moment I came upon that sign out in the middle of the New Mexico desert; I knew that a meteor *had* to appear in the sky above the sign. This points to a much larger artistic truth: that for the artist, theory and practice are *always* intertwined. Only the artist can say what color the sky in his work needs to be, and only that sky, once created, can inform you of the subtle influence its light must exert upon the landscape below."
© Ted Orland. *Meteor!* 1998. 13 × 20 inches. Hand-colored gelatin silver print. Courtesy of Ansel Adams Gallery, Yosemite, CA.

Box 11.7 Hand-Coloring Guidelines: Applying Additive Colors to a Photographic Print

1. Begin with a dry, processed, well-washed print. Most workers prefer a matte surface, but a glossy surface also can be used.

2. Gather together all the needed materials, including the coloring agents and applicators. Colors can be applied with various sizes of good-quality brushes, Q-Tips, cotton balls, lintless cloth, or small sponges. A mixing palette, water or another solvent, and white paper on which you can test mixed colors are required. In addition, your work area should have an adjustable, high-quality, daylight work light.

3. Read all the manufacturer's instructions and follow all safety procedures as outlined in Chapter 2.

4. Practice the technique with throwaway prints.

5. The final results depend on a combination of application, print surface, type of coloring agent, temperature, and humidity.

6. Images made with water-soluble materials, including ink-jet prints, can be made water-resistant by spraying them with a fixing agent, such as Marshall's Image Guard, which also enhances UV light resistance and helps prevent fading.

FIGURE 11.28 Farber uses photography to manipulate information from the visible world to make viewers question what is being seen. Layering is used to build visual ambiguity, tension, and enigmatic surfaces. Babe Ruth's image was appropriated and rephotographed on 20 × 24 inch Polaroid material. The print was selectively masked and painted with a mixture of Rhoplex, gel, and acrylic paints. The masks were then removed, and these areas also were painted.
© Dennis Farber. *Baseball Abstract*, 1988. 24 × 20 inches. Polaroid with acrylic paint. Courtesy of Collection of Anne Roarke and Marshall Goldberg.

instinct that mastery of technique and hours of practice have liberated.

AIRBRUSHING

The airbrush, invented in 1882, is a small spray gun capable of delivering a precise combination of fluid (ink, dye, or paint) and air to a specific surface location. It is a versatile tool for those interested in photographic reworking of a completed image. To master airbrushing you must be willing to perform the task repeatedly. Opportunity abounds with the airbrush. See what you can do.

Types of Airbrushes

There are three general types of airbrushes: dual-action internal mix, single-action internal mix, and single-action external mix. Dual-action refers to the way the airbrush is triggered (push the trigger down for air and back for color). This procedure permits the operator to change the line width and alter the value of opaqueness of the fluid without having to stop and make adjustments. For all-around versatility, a dual-action airbrush is a good choice.

When the trigger is depressed on a single-action airbrush, a preset amount of fluid is sprayed. The only way to control the amount sprayed is by turning the needle adjustment screw when the airbrush is not in use. If uniformity of fluid application is critical, a single-action brush is a wise choice.

Internal mix means that the air and fluid are blended inside the head assembly. Internal mixing produces a very smooth and thoroughly atomized fine-dot spray offering the precision and detail usually required for smaller works such as photographs.

External mix means that the air and fluid are mixed outside the airbrush head or fluid assembly. It produces a coarser, larger-dot spray than does internal mixing.

External mix brushes are generally used for spraying larger areas.

Head Assemblies

Airbrushes also can have different head assemblies (for internal mix) or fluid assemblies (for external mix), which can be changed depending on the type of line quality desired and the viscosity (thickness) of the fluid being sprayed. There are three basic head types: fine, medium, and heavy. Internal-mix assemblies always provide finer line quality than external fluid assemblies, even when they are equipped with a similar-size head.

A fine head, which has the smallest opening, is used for extra-fine detail work. An internal mix can deliver line quality from the thickness of a pencil line to about 1 inch. An external mix is capable of making a line only as small as about $\frac{1}{8}$ inch wide. It is intended for use with fluids having a low viscosity, such as dyes, inks, gouaches, very thin acrylics, and watercolors.

A medium head is intended for detail work and can produce a line from $\frac{1}{16}$ inch for the internal mix or $\frac{1}{4}$ inch for the external mix to 1½ inches for both. A medium head will spray about twice the amount of fluid as the fine. It can handle more viscous materials, such as thinned acrylics, hobby-type enamels, and lacquers.

A heavy head has the biggest opening, delivering a spray line of $\frac{1}{8}$ inch for the internal, $\frac{1}{2}$ inch for the external, and 2 inches for both. Heavy heads spray about four times the amount of fluid as fine heads. They are designed for fluids having a high viscosity, such as acrylics, ceramic glazes, oil paints, and automotive paints.

Fluid Containers

Many airbrushes come equipped with a small cup, $\frac{1}{16}$–$\frac{1}{8}$ ounce, for holding the paint. These are too small for larger jobs, so specially designed jars with capacities of $\frac{3}{4}$–2 ounces can be attached to the airbrush. These extend the spraying range without the user's having to stop to remix the paint or refill the cup.

Selecting the Right Equipment

Select an airbrush based on its intended application. A dual-action, internal-mix, fine-line unit with optional bottle containers is appropriate for most photographic uses. This combination provides the precision and versatility required for most operations involving the airbrushing of photographs.

Air Brush Supply Sources and Accessories

The airbrush requires a steady, clean, and reliable source of dry, pressurized air. This can be obtained from canned air (propellant), such as Badger Propel, Paasche's air propellant, or from a compressor. Canned air, available at art supply stores, is convenient and initially less expensive, but it can run out unexpectedly at inopportune times.

If airbrushing is going to be more than an occasional activity, consider investing in a compressor. Air compressors are available from airbrush manufacturers or at discount hardware and home center stores. Get one with a regulator that permits adjustment of the air pressure in pounds per square inch (p.s.i.). A regulator offering a pressure range of 10–100 p.s.i. is excellent for airbrushing photographs. The regulator also allows additional control over the intensity of the spray and the pattern it produces.

The airbrush must have a flexible hose running from the source of air to the brush. A lightweight vinyl hose can be used with a canned propellant, but a heavy-duty braided hose should be used with a compressor. A 10 foot hose is recommended, as it provides greater flexibility of movement while spraying.

A filter/extractor can be attached to the compressor to remove moisture and impurities from the air delivered to the brush. This is especially useful in humid climates.

Work Area

A drafting table with an adjustable-angle top provides an effective work surface. The table and the entire work area, including walls and floor, need to be protected from the airbrush spray fallout. Newspapers, drop cloths, or plastic sheeting will do the job.

Prints can be pinned or taped at the corners to the work surface. They also may be attached with double-sided tape on the backside of the print.

Safety

Airbrushing should take place in a well-ventilated area. A work area with an exhaust fan is ideal. Since the spray is extremely fine, you should wear a double-cartridge respirator for protection. Bearded operators may not be completely protected because most respirators do not provide a tight fit over facial hair. Thin fabric masks do not offer adequate protection. Do not eat, drink, or smoke while airbrushing. Avoid putting your fingers in your mouth while working, and wash your hands and fingernails thoroughly when you are done. Follow all other safety guidelines provided in Chapter 2.

Airbrush Operation

Most airbrushes have the same basic operating procedures, but read the instruction book that comes with the airbrush for details. Box 11.8 lists basic airbrush procedures.

Mixing the Medium

A number of premixed, ready to use opaque airbrush colors are available from companies such as Badger and Paasche. These are convenient and easy to use but expensive. Mixing your own medium offers the greatest versatility and is more cost-effective. A good sable brush, number 4 to 7, to mix the medium is desirable. Inexpensive

Box 11.8 Basic Airbrush Operation

1. Attach the air hose to the air supply (compressor or canned propellant), then connect the air hose to the airbrush.

2. If the air supply is regulated, set it to a beginning operating pressure of 30 p.s.i. The normal working range is 15–50 p.s.i.

3. Put the medium (such as paint) into the airbrush jar. The medium needs to be thin, about as thick as you would use if you were applying it with a brush. Screw on the jar top with the airbrush adapter and attach the entire unit to the brush.

4. If you are using a compressor, turn it on. Hold the airbrush perpendicular to the work surface. Press the trigger while easing it slightly backward to spray the desired amount of medium. For close-up work, reduce the amount of air pressure. Increasing the air pressure or the distance between the brush and the work will provide a wider spray pattern.

5. For best results, use a constant, steady motion. Start the motion before pressing the trigger. Then press the trigger, keeping the motion steady. Release the trigger when done, continuing to follow through with the motion. Uneven airbrush motion, known as arching, will result in an uneven application of the medium.

6. The most common problem beginners have is runs and sags, which result from holding the airbrush too close to the work surface, holding the brush still or moving it too slowly, or forgetting to release the trigger at the end of the stroke.

FIGURE 11.29 Airbrushing allows the expressionistic application of synthetic colors to evoke mood and to eliminate unwanted detail in order to direct the viewer's attention to specific areas of the composition. Postmodern strategies of blurred media boundaries, irony, and satire prevail as artifice for commentary on American dilemmas including alienation, identity, popular myths, and social fictions. Unadorned text is provided to furnish clues for additional meaning.
© Robert Hirsch. *Anywhere I Hang Myself Is Home*, 1992. 16 × 20 inches. Toned gelatin silver print with mixed media. Courtesy of CEPA Gallery, Buffalo, NY.

brushes can lose their bristles and clog the airbrush. Most media must be thinned, or they will clog the airbrush. Mixing can be done in the spraying jar. The medium's consistency should tint the brush but not color it solidly. The medium should stick to the sides of the jar but should not thickly color its sides. Box 11.9 provides a beginning guide to thinning various media.

Note that acrylics dry very rapidly, so spraying needs to be almost continuous, or clogging will result. If you have to stop for a short time, dip the head assembly in a jar of clean water to prevent clogging.

As soon as you have finished with one color, spray clean water or solvent, depending on the medium used, through the airbrush until all the color is out.

Box 11.9 Airbrush Guide to Thinning Various Media

- 1 part nonclogging ink to 1 part water
- 1 part watercolor to 1 part water
- 1 part acrylic to 7 parts water
- 1 part enamel to 1 part enamel thinner

Practice

Before attempting to airbrush any completed work, practice operating the brush. Most airbrushes come with instructions containing basic exercises to get you acquainted with how the brush works. If the airbrush does not have these exercises, go to the library and get a book on basic airbrush technique. These exercises can be carried out on scrap paper or board. Once you have mastered these techniques, move on to practicing on unwanted prints. When you have built up your confidence, try your hand at a good print.

Masking

Masks made of paper, board, acetate, or commercial frisket material can be used to control the exact placement of the sprayed medium. Masks may be cut to any shape or pattern. Handmade masks are held in place with tape or a weight so the atomized medium does not get under the masked areas. Whenever you are using a mask, spray over the edge of it, not under it, to avoid underspray. Positive and reverse stencils can be used to repeat designs or letters.

Cleanup and Maintenance

When you have completed the work, clean the airbrush and paint jar thoroughly with water or solvent. The majority of airbrush problems are caused by failure to clean all the equipment properly. Follow the instruction guide for specific details on how to clean and maintain your airbrush.

Canned Spray Paint

A rough idea of what you can do with an airbrush can be learned by experimenting with different-colored canned spray paints. Follow all the general airbrush working and safety procedures. Canned spray paint provides a much wider field of spray and is not suggested for fine detail work. Canned spray paint and an airbrush can be combined. Just follow the guidelines provided in this section for combining media.

RESOURCE GUIDE

Badger Air-Brush Company (equipment, paint, supplies, educational aids): www.badgerairbrush.com.

Paasche Airbrush Company (equipment, paint, supplies, and educational material): www.paascheairbrush.com.

TRANSFERS AND STENCILS

A wide variety of transfer processes permit an image to be transferred to another receiving surface. Transfers offer a fast, inexpensive, and cool way to work with your images or those from other sources like magazines. Transfers will be reversed (like a mirror image) so all lettering will be backwards. There will also be a shift in color. One can transfer more than one image to a single receiving surface, creating a collage of images. Most methods are experimental and can be done without the use of a printing press.

Stencils can be used in place of images and the material used to form the new image is only limited by one's imagination. Stencils can be cut by hand using an X-Acto knife and a sharp blade, or commercially by a sign-making or graphic arts company. Paint, ink, or other materials can be applied to a variety of surfaces through the stencil's openings.

Transfer Materials

Materials needed for transfers vary, but there are some that are useful for all processes that include:

1. A burnishing tool. "Bone folders" are ideal; however, any blunt-edged tool such as a butter knife, a clay burnishing tool, a metal or wooden spoon, or a soft lead pencil can work.

2. A receiving surface. Ideally a smooth, absorbent material such as printmaking paper; however, cloth and other materials can be used if they have a fine, tight weave. Textured surfaces may also work but deliver less detail.

3. Large cotton balls and/or soft brush.

4. Appropriate solvent. Since solvents vary in their ability to dissolve inks one needs to experiment, starting with water, the least toxic solvent available. If this proves unsatisfactory use mineral spirits (paint thinner). If this does not work, move up to acetone, or "Goof-Off," available in hardware stores. These solvents evaporate rapidly. Transparent gels used for diluting oil-based silkscreen ink are generally very effective. Gels penetrate the paper, readily loosen the print image, and evaporate more slowly than liquid solvents. Silkscreen bases are available at art stores and commercial print supply companies. All these solvents contain volatile ingredients and can pose potential health hazards. Read the warning labels with each product. Work only in a well-ventilated area and follow all general safety rules (see Chapter 2).

FIGURE 11.30 Working with a 55 mm Micro Nikkor lens allowed Graham to closely rephotograph a found image of a Noh mask onto slide film. Using Daylab 25 printer, she made prints onto Polaroid 669 material. By interrupting the film's exposure after 10 seconds, the imagemaker was able to peel it apart and transfer it to damp paper. She manipulated the colors of the prints by hand-altering the emulsion dyes, hand-coloring selected areas, and dipping the prints in a vinegar bath to intensify the red hues before collaging the nine prints on a panel and coating the work with encaustic. "My vision and concept for this piece were punctuated by working with photographic practices as fragments, stages, layers, and conditions of transparency and opacity. This piece places the Noh mask as a layer of Japanese culture, truly embedded, somewhat transparent yet opaque, rich and dense."
© Shelby Graham. *Noh Mask: Rooted*, 2006. 12 × 12 × 3 inches. Polaroid transfer with mixed media.

Magazine Transfers: Petroleum Ink Bases

Images from freshly printed, clay-coated, slick magazines deliver the most contrast and color saturation. Test with water and if pigment dissolves, use water to make the transfer (see section on "Black-and-White Copier, Laser-Printed, and Inkjet Transfers").

Lay receiving material face up on a hard, smooth surface. Position the image to be transferred face down and use drafting tape (to avoid paper tears) to secure one edge only, so that the paper can be folded back to expose its image without shifting its position. Generously apply the solvent chosen with a cotton ball or brush to the face of the image. Quickly lay the coated magazine image back in contact with the receiving surface, and apply hard and even pressure with a burnishing tool to transfer the dissolved ink.

Each tool will yield a different result. Try a combination of tools for a variety of effects. Periodically check the results by lifting one corner of the magazine image up and inspecting the receiving base. When the magazine image dries and will not transfer any more ink, add more solvent to the image. Repeat this process until the image has been transferred. Be patient. This procedure can take up to 15 minutes. If you have access to a printing press it can be used instead of the hand burnishing.

Newspaper Transfers: Petroleum Ink Base

Newspapers transfer unpredictably, which is their charm if one wants a distorted image. If you want something more predictable, copy (Xerox) or scan and laser-print

the newspaper image (see next section). This also permits the image to be reversed so text will read correctly.

Lay receiving material face up on a hard, smooth surface. Trim (if desired) and position the image to be transferred face down. Tape in place if desired, or simply hold in place while working. Lightly saturate a cotton ball with solvent, then blot the cotton ball on paper towels until damp (if it is wet it will cause the ink to run). With hand pressure, apply the damp cotton ball to the back of the newspaper in circular motions until the paper becomes transparent. You can check the progress of your transfer by lifting a corner and peeking. Replenish solvent as needed. If too much of the newsprint comes off on the cotton ball, try using a thin slip sheet (blank piece of paper) between the cotton ball and the newspaper.

Black-and-White Copier, Laser-Printed, and Inkjet Transfers

A black-and-white image (made with a dry-toner copier or digital laser-printer) can be transferred onto another surface using a strong solvent. The method is identical to the newspaper transfer, previously mentioned, except that you will not need a slip sheet. A citrus-oil solvent may work on freshly printed images.

The advantage of the digital laser-print is that the image can be "flipped" prior to output and transfer, resulting in correct left-to-right orientation.

Inkjet printers can be used to make transferable images by using a waxy paper, such as computer label sheets or a release paper that is used as a protective overlay in dry-mount operations by using the procedure outlined in Box 11.10 that only requires plain water.

RESOURCE GUIDE

Enfield, Jill. *Photo-Imaging.* New York: Amphoto, 2002.

Color Copier or Laser-Printed Transfers

Color copiers used to have inks that readily transferred with solvents. This is now currently a rarity, but you may still find an old machine that will allow you to do this. One can experiment as the industry is always changing. Failing direct transfers, decal papers or Lazertran paper is an alternative.

Release Papers

Release paper, such as Acrylic Image Transfer Paper, is used for the so-called "paperless" transfer of photocopied

FIGURE 11.31 Abeles informs us "the Presidential Commemorative Smog Plates are portraits of U.S. Presidents from McKinley to Bush (senior) created from particulate matter (smog) in the polluted air. The stencil images are cut from transparent or opaque materials, and placed over dinner plates that were placed on a rooftop for varying lengths of time (from four to forty days), depending on the extent of their violation or apathy toward the distressed environment. Upon removal of the stencil, the Presidents' visages in smog are revealed, accompanied by their historical quotes about the environment and business. The darker the image, the worse their environmental record." The Roosevelt quote reads, "We must maintain for our civilization the adequate material basis without which that civilization cannot exist." 12/3/[19]07. The Reagan quote says, "A tree's a tree. How many more do you need to look at?" 3/12/66. Abeles created the process for the first Smog Collector in 1987.
© Kim Abeles. *Theodore Roosevelt* and *Ronald Reagan,* from the series *Presidential Commemorative Smog Plates,* 1992. 7¾ inch diameters. Smog on porcelain with gold enamel. Courtesy of a private collection.

Box 11.10 Inkjet Transfer Process

1. Put the transfer paper, shiny side up, into the printer. Be sure to remove any labels that might be on the paper.

2. Adjust the image settings to print about 20 per cent darker and 5 per cent higher in contrast than normal.

3. Select the highest quality printing mode and print the image. The image will look very dull.

4. Briefly soak a piece of blank receiving hot-press printmaking or watercolor paper in a tray of water, then remove, and blot excess moisture with a paper towel or cloth. If the paper is too wet, a dot pattern

will result. Cold-pressed papers will deliver a softer effect.

5. Place the inkjet print face down onto the damp receiving paper. Hold firmly in place and gently rub the back of the transfer paper and then carefully lift it off.

6. A soft or foam brush may be used to blend and manipulate the inks.

7. Watercolor paints or pencils can be applied on either a wet or dry print. Pastel chalks may be used on a dry print.

8. Dry the print with a hair dryer or air dry, face up on a plastic screen.

images, as this paper washes away with water much more easily and completely than standard copy paper. Designed to be used with laser printers and toner-based copiers, it can withstand the high fuser temperature of newer photocopiers. Note that the face of the image to be transferred must be coated with gloss acrylic medium.

Acrylic Image Transfer Paper for inkjet printers is specially designed to make "paperless" color acrylic image transfers with your inkjet printer. However, you will need an inkjet printer with waterproof ink in order to effectively use this product.

Also, color copies are subject to fading while black copies made with toner containing carbon are much more stable.

For process details, see Talbot, Jonathan. *Collage: A New Approach*, 5th Edition, available at: www. talbot1.com.

Water or Vegetable-Based Color Print Transfers

Common small- and large-format digital printers use inks or dyes that can be transferred using plain water, water-based transparent silkscreen gels, or even acrylic gels. The most archival results begin with pigment-based prints. Patience and experimentation will be required. Density of ink, variations between printer hardware, inkjet paper, and receiving paper will result in dramatically differing results.

Many people have success using a printing press to transfer the image because it can quickly apply a large amount of even and intense pressure. The procedure relies on devising a way to evenly dampen the inkjet print and/or receiving paper. Generally, printing paper (made for hand lithography or intaglio) is soaked for 20–30 minutes, then blotted between two large clean towels (and a rolling pin) until damp, not soaking wet. It is then quickly placed on the printing press, the color inkjet print is laid face-down on the damp paper, covered with a clean thin sheet of flexible plastic (such as Lexan or polycarbonate), and quickly run through the press. The transfer is then

checked; if the image needs more dampening to release, this can be applied by using a spray bottle, a dampened sponge, or damp blotting paper. The variables are many and experimentation is necessary.

Decal Papers

Most copiers and digital printers have manufacturer-recommended clear "decal" or transfer papers for use with their machines – be sure the decal paper is compatible or it could ruin the machine. These are often "ironed" on with heat and therefore application is limited. The results can be quite detailed; however, the clear plastic of the decal remains on the surface, even in areas where there is no image.

Lazertran Transfer Products

Lazertran Ltd makes transfer papers for color copiers and laser printers. After outputting the digital file or color copy onto Lazertran paper, the image is trimmed and soaked briefly in water. This releases the image from its backing paper, and it can be applied onto paper, canvas, ceramics, tiles, glass, metal, plaster, plastic, or wood. Unlike decals that are ironed on, Lazertran's makers of contact paper often used inside kitchen cabinets claim that it can be fused to bond permanently with a number of surfaces. They also make an iron-on transfer for silk and other sheer fabrics as well as one that allows you to cover curved surfaces and corners. For product details, see: www.lazertran.com.

Transparent Contact Paper Transfers

Clay-coated magazine pictures can be transferred by using transparent contact paper having an adhesive backing. This is the type of contact paper is often used inside kitchen cabinets. It is not photographic contact-printing paper.

FIGURE 11.32 Henderson playfully pairs different images against a background of male and female chromosomes to engage viewers in speculation about the nature of gender. The grid-like presentation of between 60 and 100 works recalls the authority of a natural history museum, while it explores and layers the role of science and culture in shaping self-knowledge of the body and visualization of its intricacies. © Adele Henderson. *#53*, from the series *Normal Male/Normal Female*, 1998. 7½ × 9½ inches. Print on paper, Plexiglas, wax, white shellac, wood frame, and one or more of the following: engraved and inked lines, litho ink transfers, hand painting in oil, asphaltum, or Lazertran transfer.

Select a clay-coated magazine picture. Remove the backing from the transparent contact paper and stick it onto the front of the magazine image. Burnish the clear contact paper well with a blunt edged tool. This will remove all bubbles and transfer the ink onto the adhesive layer of the contact paper.

Soak the adhered image and clear contact paper in hot water until the paper backing of the image dissolves enough to be removed with a small sponge or your finger. When this step is complete, only the ink transfer will remain on the contact paper. Hang the image up to dry. To protect the dry image and make it easier to handle, place a new piece of clear contact paper on the non-laminated side of the dried image and burnish it.

Aside from making a final piece with contact paper, you can use contact paper transfers for the following:

- Print them on light-sensitive material to get a negative image.
- Contact print them on a film to make a negative from which prints can be made.
- Put them in a slide mount and project them.
- Use them in a copy machine or scanner that can make prints from slides.

Flexible Transfers

A clay-coated casein paper image may be transferred to an acrylic medium to deliver a flexible transparent transfer. Acrylic matte mediums range in consistency from pourable to moldable with varying degrees of sheen and transparency and are used in a wide range of transfer processes. They can also be used to create glazes, extend paints, build texture, and change finishes plus many are excellent glues for collage work.

Select an image that has been printed on a clay-coated paper. Using a soft, wide brush, coat the front side of the printed image with acrylic gloss painting medium. Apply the acrylic medium quickly, in only one direction, and allow it to dry. Then apply it again in another direction and allow it to dry. Continue repeating this process until you have at least eight layers of medium.

Soak the coated image in hot water until the magazine picture dissolves and can be peeled off, leaving only the printer's ink in the acrylic medium. Hang the image up to dry. The acrylic medium will be white when it is wet, but it should become transparent after it dries.

The acrylic medium is flexible and can be shaped and stretched for many applications in which a regular transfer would not work. Warm the medium with a hair dryer before attempting to re-form it or it may break. Re-application of the acrylic may be needed if it begins to tear or get too thin. Place it face down on a piece of glass and begin working it from the edges to form a new shape. The flexible transfer can be stretched around 3-D objects or be stitched, stuffed, and attached to other support bases.

Blue Mitchell's Transfer Method

There are many ways to create acrylic lifts. Mitchell's method, applied to Baltic birch plywood, demonstrates the versatility of the transfer process (see Figure 11.33). This method can also be used to transfer other inkjet, magazine, and toner images. Note that Mitchell reverses his images in Photoshop before printing them with Epson permanent, pigmented ink on Epson Ultra Premium Presentation paper, which has a heavyweight stock with a flat matte surface that has a bright white base to accentuate highlights. Box 11.11 reviews the process.

Box 11.11 Mitchell Transfer Method
Phase 1

1. Using a wide foam brush, coat a thin layer of acrylic matte medium on the back of an image (printed in reverse); cover the image surface entirely. Let dry. Recoat the image but in the opposite direction of the previous coat. This creates a crisscross weave that strengthens the gel's surface.

2. Repeat 8–12 times and let it dry.

3. In between coats, apply a thin layer of gesso onto the birch plywood. Use just enough so that you can still see the wood grain.* For uniformity and stability use a high-quality birch plywood from an art supplier such as www.artmediaonline.com.

4. Once the gesso and gel have dried, recoat both surfaces once more with the acrylic gel. Flip and sandwich the image over onto the birch panel while the gel is still wet.

5. Burnish with the rolling pin or tools to flatten and adhere the paper and birch panel together.

6. Clamp or press the panel between the two pieces of plywood or MDF (medium-density fiber board – a human-made alternative to wood). Make sure the plywood overlaps the image. Let it dry overnight.

Optional: Personal preference dictates the look of the final image. Adding gesso will make the highlights in your image whiter while diminishing the wood color. Depending on the desired outcome, Blue sometimes fully coats to white and sometimes he does not gesso at all.

Phase 2

1. Unclamp.
2. With warm water and a clean sponge, moisten the surface of the upside-down paper.
3. Rub the paper in a circular motion with the sponge so the paper begins to ball up and deteriorate. Eventually the image will begin to show through. Be careful not to rub too hard or the gel with split or buckle – unless this is the desired effect. You can also use your figures to peel up the paper residue for a more controlled rub. However, be aware that your finger may become raw.
4. Once most of the paper has been removed, rinse off and let it dry. You should be able to make out your imagery in the wet state, but it may look somewhat hazy. For faster drying, place the panel in front of a space heater or use a blow dryer. When the panel is dry, you may want to remove more of the paper as it may reappear after it dries.
5. Repeat Steps 3 and 4 to achieve your desired results. Small bits of the paper can be left for atmospheric effects or you can remove all the paper. Dry.
6. Once the panel is completely finished and dried, apply a few coats of the UV varnish, such as Golden Archival Varnish. This will protect the image from light and add a final gloss to the image. This will bring out the blacks and saturate the image. The final image slightly reveals the wood grain or gesso white – mostly in the highlights of the image.

RESOURCE GUIDE

Golden Artist Colors: www.goldenpaints.com.

Polaroid Image Transfers

Images formed on Polaroid instant print film can be transferred to another receiving surface, such as artists' paper, 4 × 5 or 8 × 10 inch sheets of black-and-white or color film. These surfaces work well and provide an image large enough for viewing. To transfer an image from a piece of Polaroid print film to paper or another surface, follow the steps in Box 11.12.

RESOURCE GUIDE

Grey, Christopher. *Photographer's Guide to Polaroid Transfer: Step-By-Step.* Second Edition. Buffalo, NY: Amherst Media, 2001.

Thormod Carr, Kathleen. *Polaroid Transfers: A Complete Visual Guide to Creating Image and Emulsion Transfers.* New York: Amphoto Books, 1997.

Polaroid Emulsion Transfer

Emulsion transfer is a process for removing and transferring the top image layer of Polaroid ER films, such as Types 59, 88, or 669, or Polacolor 64 Tungsten, onto another support surface. Basically, an exposed sheet of Polaroid ER film is submerged in hot water until the emulsion can be separated from its paper support and then transferred onto another surface such as ceramics, fabric, glass, metal, and wood. Three-dimensional surfaces also can be used. The process removes the image from its normal context and destroys the traditional frame, while adding a sense of movement and elements of the third dimension into the image. The following steps are provided as a portal to this nontraditional process.

FIGURE 11.33 Employing his birch acrylic lift method allowed Mitchell to create a work that bears his indexical traces, evident in the paper residue and the brushstrokes from the gel and varnish. The artist first sculpted a "blanketscape," a blanket simulated to look like a landscape, which he captured with a Canon 20D. The mountains were separately recorded on T-MAX 400, processed, and scanned, after which he montaged the two images in Photoshop and printed the resulting composite in reverse. "Early moments in an experience illustrate the steps that allow us to see beyond the surface, where flashes of stillness, anxiety, wonder, and mystery present themselves through familiar and invented allegories. Those dreamlike fabrications bestow the dichotomies of good and evil, fantasy and reality, awake and dreaming, and the axis that connects them all."
© Blue Mitchell. *The Journey Begins,* 2006. 11 × 14 × 1½ inches. Acrylic lift on Baltic Birch panel.

FIGURE 11.34 Kulikauskas has found "only the transparency and flexibility of Polaroid emulsion allows me to join objects and images together the way I envision. It's a simple and poetic process." In constructing this 3-D sculptural object, he used the Polaroid emulsion transfer process to link a photograph of an eye with a pair of eyeglasses, thereby creating associations between the two forms of visual representation.
© Arunas Kulikauskas. *Eyeglasses,* 1995. 4½ × 2 × 2 inches. Mixed media. Courtesy of Polaroid Collection.

Box 11.12 Polaroid Image Transfer Steps

1. Normally expose a sheet of 4 × 5 inch Polaroid film.

2. Before pulling the print through the rollers, soak the receiving sheet in water (100°F/38°C) for about 1 minute. Remove the receiving sheet and use a hard roller or squeegee to eliminate the excess water. Quickly proceed to Step 3.

3. As soon as the film is pulled through the processing rollers, cut off the ends of the film packet with a pair of scissors. This prevents the receiving paper from getting brown stains that result from excess Polaroid developer.

4. Separate the positive and the negative images. This step should be done between 10 and 15 seconds after Step 3. Before 10 seconds the print may become fogged by light and after 15 seconds the dyes begin to migrate to the receiving sheet.

5. Immediately apply the negative image (face down) on the new receiving support material. Using a brayer, roll the negative, with medium pressure, four to six times in the same direction. The quality and look of a transfer depends on the porosity of the receiving material. The negative image may be transferred to artists' paper, a photographic print, another Polaroid print, or even back to the positive from which it was originally removed.

6. Keep the negative warm and allow it to stay in place for 2 minutes before removing it from the receiving base. Separate the negative and support base before they dry or you risk the likelihood of tearing the support base when you remove the negative.

The Emulsion Transfer Process

Emulsion transfers can be made onto any clean, smooth surface, including glass or sheet metal. Fabric support should be stretched and mounted because folds in the material can produce cracking when the emulsion dries.

The emulsion can be transferred in sections by tearing it with your nails or cutting it while it is soaking. The print can also be cut into pieces before its first submersion. All steps may be carried out under normal room light.

1. Expose and process Polaroid Type 59, 669, or 809 film and let it dry for 8–24 hours or force-dry with a hair dryer. Besides using a camera, exposures can be made onto positive transparency film and projected onto Polaroid ER. This can be done with a copystand, a colorhead enlarger, the Polaprinter, the Polaroid Daylab II, or the Vivitar slide printer.

2. Cover the backside of the print with plastic contact paper or with a coat of spray paint and allow it to dry. This will prevent the back coat of the print from dissolving during the submerging process. Trim the white borders of the print if you do not want them to transfer.

3. Fill one tray, larger than the print, with 160°F (71°C) water. Fill a second tray with cold water. Place a sheet of acetate or Mylar on the bottom of the cold water tray.

4. If transferring onto watercolor paper, use a foam brush to moisten (but do not soak) the paper with room temperature water. Put the paper on a clean, smooth piece of glass and squeegee it onto the surface, taking care to remove all bubbles and wrinkles.

5. Submerge the print face up in the tray of hot water for 4 minutes with agitation. The water should be

allowed to cool. Using tongs, remove the print from the hot water and place it in the tray of cold water.

6. While the print is under the cold water, lightly massage the emulsion with a pushing motion from the edges of the print toward the center. Slowly and carefully lift the emulsion and peel it away from its paper support base. Keep the emulsion that is being released from its support under the water. Now reverse the image (so it will not appear backwards when transferred) by bringing the emulsion back over itself (like turning down a bed sheet). Leave the emulsion floating in the water and dispose of the paper support. Hard water can make the emulsion difficult to remove. If this is a problem, try using bottled spring water.

7. Take hold of two corners of the floating emulsion with your fingers and clamp it on the bottom of the tray. Holding the emulsion, lift the acetate in and out of the water several times to stretch the image and remove the wrinkles. Repeat this on all four sides, always holding the top two corners. After it is stretched, you can dunk the image to purposely let the water curl and fold it. When you are satisfied with the image, remove it from the water and place it on your transfer surface, making sure the acetate or carrying material is on top.

8. Using your fingers to manipulate the image, carefully remove the acetate.

9. Smooth and straighten the image until it looks the way you want it to look. At this point the emulsion can also be resubmerged in and out of cold water to perform additional manipulations. When your manipulations are complete, roll the image with a soft rubber brayer from the middle outward. Begin using only the weight of the roller and gradually increase the pressure after all the air bubbles and excess water have been removed. Generally the operation is considered complete when all the folds appear to be pressed down. However, other rubbing tools and techniques may be used to achieve different effects.

10. Hang to dry. Transfer may be flattened in a warm dry-mount press. For added stability, protect from UV exposure.

FIGURE 11.35 Transfer printing is an easy, fast, and fun method of working with found images. Hock made this piece from Polaroid SX-70 images peeled apart during development. The backing was then adhered to a paper support. Appropriated images of monsters, inventors, and insects are juxtaposed to playfully reference hand-written and hand-illustrated medieval manuscript books. Visual contrast is created by combining cool- and warm-colored images within the composition. © Rick McKee Hock. *Codex (Frankenstein)*, 1986. 30 × 22 inches. Polacolor transfer. Courtesy of Red Dot Contemporary, West Palm Beach, FL.

CROSS-PROCESSING: SLIDES AS NEGATIVES

E-6 film, such as Fujichrome 200, can be cross-processed in C-41 chemistry to achieve an artificial, hyperenhanced color scheme with intense contrast. Expose at ISO 100 and develop in the C-41 process. Bracketing is recommended. Prints can then be made on conventional color paper or negatives can be scanned, adjusted, and digitally printed.

FIGURE 11.36 Roetter achieved this intensified color scheme by cross processing. She made the image by attaching a magnifying filter to a macro lens and then exposed onto Fujichrome 200, which she overexposed by one stop. She processed the transparency film in C-41 color print chemistry instead of the normal E-6 color transparency process. She then made a regular RA-4 chromogenic print. Lastly, Roetter applied a coat of reflective paint to the print to exaggerate its unreal appearance to further confront the issue: "Does the connection to the 'real' disappear when imaging or is there a way of connecting the essence through the act of perception? Can the brain compute essence visually and be altered energetically?" © Joyce Roetter. *Plantas de Peru*, 2004. 20 × 16 inches. Chromogenic color print with paint. Courtesy of Dr Bill Wright Collection.

RESOURCES GUIDE

Hirsch, Robert. *Exploring Color Photography: From the Darkroom to the Digital Studio.* Fourth Edition. New York: McGraw-Hill, 2005.

PICTURES FROM A SCREEN

Making pictures from a monitor or television screen offers a photographer the opportunity to become an active participant instead of being a passive spectator. The camera can be used to stop the action on the screen or extend the sense of time by allowing the images to blend and interact with one another. The literal distortion of photographing directly from the screen is both its strength and Achilles' heel. To make pictures from a television or monitor screen follow the steps in Box 11.13

Untraditional representations from the screen are possible using the following methods listed in Box 11.14:

Box 11.13 Making Images from a Screen

1. Clean the screen.
2. Place the camera on a tripod. Digital capture allows quick review and adjustments. A macro or telephoto lens can be used to fill the entire frame or to work with a small area of the screen and control the distortion produced, especially if the screen is curved.
3. Turn off the room lights and cover windows to avoid getting reflections on the screen. Place a black card in front of the camera, with a hole cut in it for the lens, to help eliminate reflections.
4. If available, use a "hood" device designed to capture images directly from a computer screen with a camera attachment to cover the screen area and block out ambient light.
5. Adjust the picture contrast to produce slightly darker (flatter) than normal for an accurate, straightforward rendition.
6. Adjust the color to your personal preferences.
7. Most monitors generate a new frame every $1/30$ second. If the shutter speed is higher than $1/30$ second, the leading edge of the scanning beam will appear on the picture as a dark, slightly curved line. If you do not want this line, a shutter speed of $1/30$ second or slower should be used. Experiment with shutter speeds of $1/15$ and $1/8$ second. If the image being photographed is static or can be "frozen" on the screen, try using the slower speeds to ensure the frame line is not visible. Cameras with a leaf-type shutter may synchronize better with the monitor's raster lines.
8. Once the correct shutter speed is determined, make all exposure adjusts by using the lens aperture.

FIGURE 11.37 Bush actively participates in rethinking the reality on her television by manually distressing images that she captured from a screen. Utilizing a 55 mm Macro Nikkor lens, she positioned it close to her television screen at an extreme angle and exposed the color negative film. After making the chromogenic print, she splashed its darkest areas with household bleach, which she immediately washed off before the color began to present itself. In doing this, the imagemaker investigates the ideas of violence that the newscasters on her television tend to avoid. This distressed photograph serves as her reaction to the coverage of the 1991 Gulf War, which prompted her to realize that "infotainment had replaced journalism. Free speech was controlled and laundered. This is what I felt needed to be addressed, while those of us who still remembered free journalism could protest its demise and inspire a new generation to demand its reinstatement."
© Diane Bush. *Warhead #23*, 2005. 17 × 23 inches. Chromogenic color print. Courtesy of George Eastman House, Rochester, NY and Rutgers University, New Brunswick, NJ.

Box 11.14 Unusual Screen Representations

- Vary the shutter speed from the ¹⁄₃₀ second standard.
- Adjust the screen's color balance from its normal position.
- Vary the horizontal and vertical hold positions.
- Make a series of multiple exposures from the screen onto one frame.
- Place a transparent overlay of an image or color in front of the screen.

- Project an image onto a scene and rephotograph the entire situation.
- Fabricate a situation to be photographed that includes a screen image.
- Use a magnet to distort the picture. Use an old set, as it will likely put the unit out of adjustment, requiring a repairperson to fix it.
- Photograph images on a movie theater screen (for noncommercial use).

With daylight balanced color film, the resulting image will probably have a blue-green cast. This may be partially corrected by using a No. CC30R, No. CC40R, or No. 85B filter, with appropriate exposure compensation, at the time of initial exposure.

Different films deliver a variety in color renditions due to the film's spectral sensitivity and dye-image formation system. If color film is used to photograph a black-and-white monitor, the resulting image may have a blue cast.

If no screen lines are wanted, the image will have to be captured by using a film recorder that makes its image based on electronic signals rather than from a screen.

A Blue-Ray, DVD player or videocassette recorder gives a photographer the chance to be selective about the images on the screen and also provides the ability to repeat the image on the screen until it can be photographed in the manner that is desired.

END NOTES

1. Kis, Danilo. *Encyclopedia of the Dead*. New York, Farrar, Straus and Giroux, 1989.
2. Bargellesi-Severi, Guglielmo (Ed.), *Robert Smithson Slideworks*. Verona: Carlo Frua, 1997, p. 13.

FIGURE 11.38 Working on many different levels, Roberts combines her hand and digital skills to explore the mutability of reality in the broadest sense. Holly Roberts lived in the Zuni Pueblo during the 1980s where she found that the Zuni belief in multiple realities—such that a person might be transposed into an animal—reinforced her own intuitive beliefs. Roberts paints her photographs in her quest to open a path that treads a line between mystery and realism. This method gives her the option to use the authenticity of the photographic rendition of reality or to oppose or parallel it with her painting. Roberts says, "My unconscious intelligence directs my hands to tell the materials where to go. It allows the emotional/spiritual channels to open up. This does not happen because we think about, explain it, or conceptualize it. It occurs because we put our hands in it and that act takes us somewhere else."
© Holly Roberts. *Being Saved*, 2005. 24 x 24 inches. Mixed media.

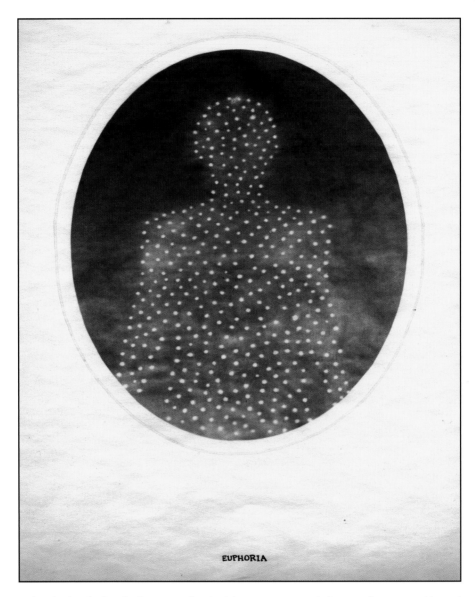

EUPHORIA

FIGURE 11.39 Estabrook's hand-colored salt prints explore both human science and photographic science. He explains, "Just one hundred years ago, science could still claim palmistry, phrenology, and physiognomy among its disciplines, and even today we tend to believe that written on the body are the keys to decipher the secret language of the everyday. There is science, too, in photography— mixing salt and silver to represent the otherwise unseen details of the natural world. This series incorporates nineteenth-century printing techniques and focuses on the body and illness, evoking early medical photographs to suggest the flush of first love or the depths of its absence."

© Dan Estabrook. *Euphoria*, from the series *Nine Symptoms*, 2004. 14 × 11 inches. Salt print with ink and watercolor. Courtesy of Catherine Edelman Gallery, Chicago, IL.

Index

#53 1998 (Adele Henderson), 266
#527 1998 (Peter Feldstein), 237
07_00_01 2000 (Timothy Tracz), 7
8 Mile Pinhole Exposure on Route 476,
 Philadelphia, Pennsylvania 2007
 (William Larson), 238
16mm movie cameras, 178–9
35mm cameras:
 conversion to pinhole, 170
 disposables, 173
 panoramic effects, 177
 stereoscopic photography, 181, 183
 see also Single lens reflex cameras
110 format cameras, 181
360 degree cameras, 176, 177
782. Apple Advancing 1975 (Marion Faller
 and Hollis Frampton), 178
Abeles, Kim, xiv, 49, 264
Abundance 2006 (Christina Anderson), 74
Accelerators, 83, 130, 133
Acetic acid, 76
Acid-free paper, 190
Acids, 75–6
 developers, 101, 130
 disposal, 38
 papers, 190
 platinum process, 215
 stop baths, 45, 79, 148–9
 toners, 155
Acrylics, 258, 261, 264–8
Acutance, 80
Adams, Ansel, 15, 18, 20, 105, 107, 117,
 170
Additive coloring agents, 136, 256–9
Advanced Photo System (APS) cameras,
 181
Ag-Plus liquid emulsion, 126, 127
Agfa:
 14 formula, 93
 108 formula, 140–1
 120 formula, 141
 123 formula, 142
Agitation patterns, 45, 132
Air-drying prints, 121, 149
Airbrushing, 259–62
Albumen prints, 192
Alcohol solvents, 84
Alkalis, 75–6, 83, 87, 130, 133
All-in-one copy machines, 228–9
Allegory, 3
Allergic reactions, 38–9, 76
 see also Sensitivities to chemicals
Alternative processes, 187–229
 ambrotypes, 201–6
 bromoil, 221–2
 chrysotypes, 210

copy machines, 226–9, 264–5
cyanotypes, 188, 197–201, 207, 210, 219
gum bichromate, 12, 217–21
gumoil, 222–3, 224
kallitype/Vandyke, 207–10
lith printing, 224–6
mordançage, 223–4
palladium, 211, 216–17
platinum, 63–4, 211–16
salt prints, 192–7
Alternative spaces, 23–6
Amateur photography, 6–7
Ambrotype process, 201–6
American Flag, Santa Clara, CA 2004
 (Renee Billingslea), 10
American History 2007 (Kevin Kline), 232
Amidol developer, 91–2, 129–30, 142
Ammonium dichromate formula, 218
Analog cameras, 43
 see also Cameras
Analog notebooks, 32
Analog printing, 105–27
Analytical Reagent (AR) grade chemicals, 74
Ancestor Portrait #15 2001–2004 (Donna
 Hamil Talman), 162
Anderson, Christina, 74, 225
Andres Serrano & Sister Agnes 2006
 (Nicolai Klimaszewski), 31
Andromeda 2005 (Greg Erf), 138
Angel, Catherine, 164, 253
Angelo on the Roof 1979 (David Lebe),
 240
Angle of view changes, 173–6
AnOther Western 1998 (Pipo Nguyen-duy),
 156
Ansco:
 120 formula, 137
 130 formula, 130, 142
Ansel Adams Coffee Can 1994 (Jo
 Babcock), 170
Antifog see Restrainers
Antihalation backing, 47
Antistatic devices, 116
Anxiety, 232
Anywhere I Hang Myself Is Home 1992
 (Robert Hirsch), 261
Apertures, 166, 170, 238
APO (apochromatic) lenses, 112
Appraisal phase, thinking model, 35
APS (Advanced Photo System) cameras, 181
AR (Analytical Reagent) grade chemicals, 74
Archaic cameras, 179
Archival methods, 61, 62, 127
Are You Rea #1 1966 (Robert Heinecken),
 20
Armstrong, Bill, 36

Around Toroweap Point, Just Before and
 After Sundown 1986 (Mark Klett),
 114–5
Ascorbic acid, 101
Aspect ratio, 176
Assassination Site President John F.
 Kennedy 1970s, 8
Atkins, Anna, 197–8
Attracted to the Light H 1997–99 (Doug
 and Mike Starn), 23
Audiences, 29, 35
Audubon, John James, 12
Aura concept, 11–12
Autochrome color process, 12–13
Auxiliary matched focusing lenses, 183
Azo paper, 130

B setting, extended exposures, 238, 239
Babcock, Jo, 170, 171
Baby's First Steps 2003 (Christina
 Anderson), 225
Backdrops, 5
Bacon, Pat, 228
Baden, Karl, 11
Bailey, Jonathan, 161–3
Balance scales, 72
Barber, Craig, xiii
Barrel distortion, 174
Barrow, Thomas, 157, 233
Barthes, Roland, 231
Bas-relief prints, 55
Baseball Abstract 1988 (Dennis Farber), 259
Base-plus-fog density, 81
Bates, Michelle, 172
Battery power, 239
Bauer, Amanda, 110, 175
Bauhaus, 16–17
Beard, Peter, xi, 19
Beauty, 187
Bee 2008 (Molly Jarboe), 42
Beers, Dr. Roland, 138, 144–5
Being Saved 2005 (Holly Roberts), 273
Belcher, Alyson, 166
Belger, Wayne Martin, 182
Benjamin, Walter, 11–12
Benzotriazole, 131
Berra, Yogi, 3
Bias in photography, 4–5
Billingslea, Renee, 10, 121
The Birds of America (John James
 Audubon), 12
Black printer inks, 66
Black tones:
 cyanotypes, 201
 kallitypes, 209
Black-and-white copiers, 226–7, 264–5

Black-and-white film:
 developers, 79–103, 129–45
 high-speed, 50–3
 infrared, 46–9
 processing for permanence, 61–2
 reversing, 59–61
 toning, 163–4
 ultra-fine grain, 55
Black-and-white from color, 123
"Blanketscapes", 5
Blanquart-Evrard, Louis-Désiré, 123
Bleaching prints, 153, 161, 221–2
Blot out the Sun 1 1998–2000 (Doug and Mike Starn), 124
Blue Dream 2007 (Melissa Zexter), 136
Blue toners, 158
Bobby and the Terror 2006 (Robert Hirsch), 248
the Body, 27, 122, 143, 160
Bosque 1992 (Ellen Garvens), 100
Borax, 83
Bosworth, Michael, 47, 183
Boy with Bull, Santa Clara, CA 2006 (Renee Billingslea), 121
Bracketing, 238, 271
Brahma 2006 (Wayne Martin Belger), 182
Brent, Robert, 37, 71
Bromide developers, 84, 99, 131
Bromide emulsions, 117
Bromide papers, 131, 142
 see also Cold-tone papers
Bromoil process, 221–2
Bromophen developer (Ilford), 135
Brown toners, 151–8, 201, 209
Brownprint process, 207–10
Brush application:
 developers, 140
 emulsions, 191–3, 195, 200, 220
Brush, Gloria DeFilipps, 180
"Bullshit" detection, 30–1, 34
Bunnell, Peter C., 21
Burchfield, Jerry, xvi, 235
Burkholder, Dan, 62, 64–6
Burkholder, Jill Skupin, 223
Burning tools, 116, 132
Burnishing tools, 262–3
Bush, Diane, 272
Button registration process, 220–1
Byrd, Jeffery, 150, 160

Callier effect, 109
The Calling 2005 (Blue Mitchell), 5
Calotypes, 5, 58–9
Cameraless images, 16, 55, 141, 162, 232–7
Camera Desiros 1987 (Kim Abeles), xiv
Cameras, 43, 165–86
 ambrotype process, 204
 cases, 186
 classic types, 61
 compensating developers, 100
 copying montages, 252
 custom-built, 171
 disposable cameras, 173
 extended exposures, 238–41
 filters, 47–50
 focusing, 47, 50, 111, 166
 hand-altered work, 238–51, 271–3

multiple-exposure methods, 243–4
 panoramic cameras, 174, 176–7
 pinhole cameras, 161, 165–70, 238–9
 plastic cameras, 171–3, 179, 186
 purpose, 165–6
 sequence cameras, 178–9
 see also Films; ISO settings; Lenses
Campbell, Kathleen, 67, 102
Canned air, 116, 260
Canned spray paints, 260, 262
Capa, Robert, 35
Cardboard shutters, 238
Carey, Ellen, 16
Carnochan, Brigitte, 6, 153
Carr, Christine, x
Cartes, 7
Cartier-Bresson, Henri, 3, 225
Casanave, Martha, v, 161
Cases, cameras, 186
Catechol developer, 98–9, 143–5
CCD (Charge-coupled device), 67
Chamlee, Paula, 97, 212
Chance, 34, 232
Changer la Femme #1, Sante Fe, NM 1999/2000 (Elizabeth Opalenik), 230
Changing bags, 47
Charge-coupled device (CCD), 67
Chart 1994 (J. Seeley), 56
Chemicals, 73–4
 classifications/grades, 73–4
 disposal, 38, 39, 74
 fiber papers, 127
 fog levels, 81
 formula creation, 71–7
 litho films, 56
 mixing, 38, 56, 71–3, 75, 85, 148, 260–1
 platinum process, 213
 reticulation, 255–6
 safety guidelines, 37–9, 71, 74
 sensitivities to, 38–9, 129
 toners, 147–8
 see also Developers *Individual chemicals*
Chemigram process, 77, 235–6
Chevreul, Michel-Eugene, 10
Chiarenza, Carl, 61
Chloride papers, 131, 136
Chlorobromide papers, 131, 142, 162
 see also Warm-tone papers
Chlorophyll, 49–50
Christo's installations, 254
Chromium:
 alternative processes, 189
 intensification, 89–90
Chromogenic film, 79
Chrysotype process, 210
"Cigar" effect, 177
Cinematic imagemaking, 250–1
Circles of confusion, 167
Citric acid, 130
Classic cameras, 61
Clatworthy, Fred, 13
Cleaning procedures:
 airbrushing, 262
 glass for ambrotypes, 204
 negatives, 116
Clearing solutions:
 chrysotype process, 210
 gum bichromate process, 221

kallitype process, 209
 platinum process, 215
 salt prints, 196
Cliché-verre, 236–7
Close-up photography, 176
Coated papers *see* Emulsions
Coating rods, 191, 214
Codex (Frankenstein) 1986 (Rick McKee Hock), 270
Cold light, 109–10
Cold-pressed papers, 190
Cold-tone papers, 134–6, 147, 162
 brown toners, 152–3, 155–6
 developers, 139, 140, 142
 red toners, 158
Collages, 7, 15–17, 19, 251–3
 "defocusing" technique, 36
 postcards, 123
 toners, 151
 see also Montages
Collective Bargaining 2007 (Heather Wetzel), 75
Collimated beams, 109
Collodion printing, 5–8, 75, 201–6
Color:
 amateur photography, 6
 Autochrome process, 12–13
 black-and-white from, 123
 cliché-verre, 237
 copy machines, 227–9, 264
 daguerreotypes, 5
 dyes, 161
 enlargers, 120
 gum bichromate process, 218, 219
 hand-coloring prints, 136, 256–9
 lith printing, 224–5
 paper colors, 118
 Photoshop, 66
 scanner settings, 67, 68
 transfers, 265
 see also Toners
Combination printing, 5–6, 22, 244–7
 cliché-verre, 237
 hand-coloring, 258
 photograms, 235
 platinum process, 216
Commercial grade chemicals, 74
Comparison prints, 151
Compensating developers, 98–101
Composite variations, 251–4
Compressors, 260
Concepts:
 content/process and, 3
 printmaking, 3–20
 transforming/expanding, 231–73
Condenser enlargers, 84, 108–10
Connor, Linda, 83
Contact allergies, 39
 see also Allergic reactions
Contact papers, 117, 136
 alternative processes, 187
 litho films, 59
 safelights, 113
 sequences, 249–50
 transfers, 265–6
 see also Warm-tone papers
Contamination, developers, 84, 87
Content/concept/process relationship, 3

Continuous tone litho films, 57–8
Contrast:
 controlling, 133–4, 208–9, 213–14, 226
 digital negatives, 63
 grain, 80
 heightening, 54–5
 Kodak T-MAX 100 film, 60
 liquid emulsions, 127
 lowering, 213–14
 papers, 118–21
 raising, 213–14
 variable-contrast development, 138–9,
 144–5
Conversation, photography as, 1
Copy machines, 226–9, 264–5
Copying montages, 252–3
Copyright laws, 3
Cordier, Pierre, 235–6
Corot, Jean-Baptiste-Camille, 236
Cosine law, 174
Cotton rags, 190
Creativity, 2–3, 29
Critical thinking, 30
Cropping negatives, 107
Cross-processing, 271
Crosshair registration process, 220–1
Crystalotype prints, 192
Cultural bias, 5
Curled negatives, 110–11
Curves, Photoshop, 63–6
Custom cameras, 171
Customary weights, 76
Cutting, James Ambrose, 201
Cutting reducers, 90
Cuvelier, Adalbert, 236
Cyanide fixers, 203
Cyanotypes, 188, 197–201, 207, 210,
 219

D-23 developer, 85–6, 93
da Vinci's Wings 1998 (Robert and Shana
 ParkeHarrison), 107
Dadaism, 9, 15–16, 172, 233
Daguerreotypes, 3–5
Danse Ardente #11 2003–06
 (Donna Hamil Talman), 122
Darkroom environment:
 high-speed films, 50
 infrared films, 47
 miscellaneous equipment, 116
 multiple-exposure methods, 244–7
 revisualization, 21–2
 ventilation, 37, 39, 116
 wet-plate collodion, 204
Davidhazy, Andrew, 184–5
Davy, Humphrey, 192, 233
Dawson, Robert, 13, 40
Day #16 – National Portrait Gallery 1995
 (Gerald Mead), 123
De Swaan, Sylvia, 43
Death, Hemis Monastery, Ladakh 2006
 (Linda Connor), 83
Decal papers, 265
"Decisive Moment" concept, 3, 225
DeFilipps Brush, Gloria, 180
Defining creation process, 29
"Defocusing" technique, 36
DeHart, Dennis, 125, 152

Dektol, 54, 135, 138, 143
Delta 3200 film (Ilford), 50–3
Demachy, Robert, 12
Density, 80–1, 118
Depth of field, 174
Detail control, 59
Developers/developing agents, 79–103
 acutance, 80
 ambrotypes, 203, 205
 applications, 91–102, 135–40
 characteristics, 81–5, 135–40
 chrysotype process, 210
 components, 81–5, 129–31
 D-23, 85–6, 93
 high-speed films, 51–3
 Ilford PAN F PLUS film, 55
 kallitype process, 208–9
 keeping qualities, 84
 lith printing, 224–6
 paper, 118, 129–45, 162
 platinum process, 213–15
 procedures for use, 44–5
 replenishment, 87–8
 selection, 34–5, 84
 temperatures, 52–3
 toner combination, 147, 150, 162
 types, 85–7
 Vandyke process, 208
 see also Development times
Developing-out paper, 129
Development times:
 Bromophen, 135
 condenser enlargers, 109
 gum bichromate process, 220
 high-contrast litho films, 57
 high-speed films, 50, 52–3
 IR black-and-white film, 49
 Kodak TRI-X in Dektol, 54
 paper factors, 131–2
 Selectol, 136
 toners, 147–9, 151–2
 see also Developers/developing agents
Diafine, 87
Diana cameras, 171
Dichroic color enlargers, 120
Diffusion enlargers, 84, 108–10
Digital equipment:
 cameras, 1, 43, 69, 166
 color copiers, 228–9
 enlargers, 111
 notebooks, 32
 scales, 72
 timers, 115
Digital images, 26–7, 31, 44
 paper, 124
 scanning, 67
 sequential images, 179
 stereoscopic photography, 183
Digital negatives, 59, 62–6
Dilution ventilation, 39
Diopters, 176
Dioramas, 5
Diptych – Forli 1998 (Steve Harp), 180
Dirt on lenses, 112
Disney, Walt, 3
Disposable cameras, 173
Disposal of chemicals, 38, 39, 74
Distilled water, 40, 76, 84, 131

Distortion, 173–4
Distressed images, 272
Dodging tools, 116
Door County, Wisconsin 1970
 (Joseph Jachna), 120
Doppelgängers, 231–2
Dot to Dot Portrait 1992 (Susan Evans),
 234
Double-density effect, 118
Double exposures, 5
Doubt 15 1994 (Misha Gordin), 33
Dr. Beers developer, 138, 144–5
Dreamland Speaks When Shadows Walk #2
 2004 (Kay Kenny), 190
Drum scanners, 67
Dry-down effect, 132–3
Drying procedures:
 ambrotypes, 205
 film processing, 45
 kallitype process, 210
 platinum process, 214, 215
 prints, 121, 149
 Vandyke process, 208
Dual-action airbrushes, 259
Dual-purpose negatives, 97
Dutch Landscape #12 (Peter Eide), 26
Dye toners, 147–9, 161, 163–4

Easels, 114
Eastman, George, 8
Eastman House, Rochester, NY 1989
 (Jo Babcock), 171
Edge burning, 132
Edgerton, Harold, 184
EDTA tetra sodium clearing solution,
 215
Edwal TST developer, 138–9
Efflorescent chemicals, 73
Eide, Peter, 26
Einstein's Theory of Relativity, 1
Ektaflo Type 2 (Kodak), 137
Electronic images, 26–7
 see also Digital images
Electronic scales, 72, 74
Electronic timers, 115
Electrostatic processes, 226–9
Elon see Metol developers
Embodied #14 1996–1997 (Martha
 Madigan), 146
Emergency procedures, 37
Emerson, Peter Henry, 13–14, 198
Emulsions, 116–17, 187
 application, 191–5, 200, 210, 213–14,
 219–20
 chrysotype process, 210
 cyanotype process, 199, 200
 gum bichromate process, 218–20
 liquid, 124–7
 palladium process, 217
 platinum process, 213–14
 tonal range, 134
 transfer techniques, 267–70
 variable-contrast papers, 118
Encyclopedic images, 7
End of Road #65 2007–8 (Adriane Little),
 250
Endothermic chemicals, 75
Enfield, Jill, 257

Enlargements:
 focusing devices, 114–15
 negatives, 56–8, 60–1, 107–8, 211–12
 snapshot photography, 9
Enlargers, 84, 108–12, 120, 133–4, 241–7
Enlarging lenses, 111–12
Enlarging meters, 116
Enlarging papers, 117
 see also Cold-tone papers
Enmeshed Man 1966 (Naomi Savage), 21
Eno, Brian, 34
Environmental safety, 37–40
Epson printer curve, 63–5
Erf, Greg, 138
Eshbaugh, Mark, 73
Estabrook, Dan, 274
Etching techniques, 236, 237
Ethol LPD developer, 135, 150
Euphoria 2004 (Dan Estabrook), 274
Evans, Susan, 234
Experimental photography, 18, 31
 see also Alternative processes
Exposure, 191–2
 ambrotypes, 205
 cyanotypes, 200
 extended, 238–41
 gum bichromate process, 220
 high-speed black-and-white films, 50–1
 IR black-and-white film, 48
 Kodak T-MAX 100 film, 60
 Kodak TRI-X film, 54
 lith printing, 225
 multiple-exposure methods, 243–7
 photograms, 234–5
 pinhole cameras, 170
 salt prints, 195
 silver-based films, 79
 Vandyke process, 208
Extended camera exposures, 238–41
Extended red sensitivity film, 49–50
External mix airbrushes, 259–60
Eyeglasses 1995 (Arunas Kulikauskas), 268

Fabrication, 248–51
"Failure" acceptance, 106
The Fall 1999 (Robert Hirsch), 112
Faller, Marion, 178
Fallis, S.W., 9
Familiarity, 231
Fans, 39
Farber, Dennis, 259
Farmer's Reducer, 90–1
Fate, Being, and Necessity 2007 (Bea
 Nettles), 227
Fear avoidance, 34
Feldstein, Peter, 237
Feresten, Peter Helms, 88
Ferguson, Jesseca, 78
Ferrotypes, 4, 121, 201–2
Ferrous ferrocyanide, 198
Fiber-based papers, 117, 127, 170
Field:
 depth, 174
 flatness, 111
Figure 6 1999 (Bill Armstrong), 36
Filmer, Lady, 7
Films, 43–69
 camera operation, 166

classic cameras, 61
cliché-verre, 237
disposable cameras, 173
image characteristics, 79–81
moving film stroboscopy, 184–5
plastic cameras, 172
scanning, 67
screen pictures, 273
selecting, 34–5, 44
transfer techniques, 267–70
 see also Developers; Development times;
 Processing films
Filters, 167
 extended exposures, 239
 extended red sensitivity film, 49–50
 focusing devices, 114
 high-speed films, 50
 IR black-and-white film, 47–8
 masking methods, 244
 safelights, 113
 scanners, 67
 variable-contrast papers, 119
FIN 1989 (Robert Hirsch), 179
Fine focus, 242–3
Fine-grain developers, 80–1, 84–7, 91–3
Fine printmaking, 105–27
Finishing prints, 121–2
Fire in the Nest 1997 (Amanda Bauer), 110
Fire Island Trees 1985/1990 (Jill Enfield),
 257
Fish, Alida, 143
Fish-eye lenses, 174–5
Fixers, 79
 ambrotypes, 203, 205
 disposal of, 39
 high-speed films, 51
 hypo check, 45, 46
 kallitype process, 210
 pyro developers, 98
 salt prints, 196
 toning prints, 149, 163
 Vandyke process, 208
Flare, lenses, 112
Flash photography, 48–9, 133–4, 239–41
Flash point, wax, 122
Flashlights, 239–41
Flatbed scanners, 67
Flatness of field, 111
Flexible transfers, 266–7
Floating emulsion application, 191, 193–5,
 200
Floating panoramas, 178
*Flooded Salt Air Pavilion, Great Salt Lake,
 Utah* 1985 (Robert Dawson), 40
Fluid containers, 260
Foam brushes, 191
Focal length of lenses, 111–12
Focus shift, 112
Focusing, 166
 devices, 114–15
 enlarging lenses, 111–12
 extended red sensitivity film, 50
 field flatness, 111
 IR black-and-white film, 47
 postcamera techniques, 242–3
 stereoscopic photography, 183
Fog levels, 81, 87, 95, 113, 131
Foltz, M.K., 173

Forced development methods, 220
Form creation, 33–4
Formulas, 187
 ambrotypes, 203
 creating own, 71–7
 cyanotypes, 199–201
 developers, 79, 81–5, 90–102, 134,
 135–45
 gum bichromate, 217–19
 kallitype/Vandyke process, 207–10
 platinum process, 213, 215
 preparing, 74–6
 salt prints, 192, 196
 toners, 151, 154–9, 162–4
Fotomask, 160
Fotoplastik montage, 16
Frame grabbers, 69
Frames for salt printing, 195
Frampton, Hollis, 178
*Frank Ross's Barber Shop, Lebanon Jct.,
 Kentucky* 1985 (Frank Hunter), 72
Frey, Mary, 117
Friedman, James, 103, 108
Friskets, 159–60, 161
*Frozen Jacket, Bloomington, Indiana,
 Winter 1999* 1998–2001 (Osamu
 James Nakagawa), 111
Full-frame fish-eye lenses, 174

Garden Series #2 1979 (David Lebe), 141
Garvens, Ellen, 100
Gaz, Stan, 159
Gelatin silver curve, 63–4
Gels, 48
Generative Systems Department, Chicago,
 26
Glass:
 ambrotypes, 201–6
 chemigrams, 236–7
 photograms, 234
Glass rods, 191, 214
Glassless carriers, 110
Gloves, 38, 116
Glycin developer, 91, 130, 141, 142
Goblin Valley, Utah 2002 (Dennis DeHart),
 152
Going Home 1994 (Catharine Angel), 164
Gold Protective Solution GP-1, 157–8
Gold Toner T-21, 156–7
Gordin, Misha, 33, 81
GP-1 split-tone formula, 163
Graded papers, 113, 118–19
 see also Papers
Graham, Shelby, 263
The Great Picture 2006 (Jerry Burchfield),
 xvi
Grain:
 developers, 79–80, 84, 86–7
 focusing devices, 114
 heightening, 54–5
 high-speed films, 51
 image color, 224–5
 papers, 134–5
Gray cards, 167, 252
Grayscale settings, 68
Green toners, 159
Greene, Myra, 27
Grid format, sequences, 250

Grosz, George, 15
Group f/64, 15
GT-15 Red Toner, 158–9
GT-16 Green Toner, 159
Guilherme 2002 (France Scully-Osterman), 197
Gum bichromate process, 12, 217–21
Gumoil, 222–3, 224

Hake brushes, 191, 200
Half-frame cameras, 179–80
Halftone process, 10, 55
Hand-altered work, 231–73
 airbrushing, 259–62
 camera-based techniques, 238–51, 271–3
 cameraless images, 232–7
 coloring by hand, 136, 256–9
 composite variations, 251–4
 cross-processing, 271
 postcamera techniques, 241–3
 transfers/stencils, 262–70
Hand-coloring prints, 136, 256–9
Hand-held cameras, 8–9
Handling film, 46–7, 48
Handmade photography, 23–6
Hard camera cases, 186
Hard water, 131
Hardeners:
 gum bichromate, 217, 218
 toners, 149, 155, 156
Harp, Steve, 180
Havell, John and William, 236
Head assemblies, airbrushes, 260
Health and safety, 37–40, 129
 see also Safety guidelines
Heartfield, John, 15–16
"Heat tone" method, 197
Heinecken, Robert, 20
Henderson, Adele, 266
Herschel, Sir John, 192, 197–8, 210–11
High-contrast:
 developers, 140–1
 litho films, 55–8
 papers, 118
High-energy developers, 87
High-speed black-and-white films, 50–3
Highlights:
 dry-down effect, 133
 Gold Toner T-21, 156
 high-speed films, 53
 Rodinal developers, 101
Hinton, Alfred Horsley, 12
Hirsch, Robert, 54, 104, 112, 139, 179, 226, 242–3, 248, 255, 261
Historic processes, 27, 187–229
 See also Individual processes
History Kimono 2005 (Ginger Owen-Murakami), 198
Höch, Hannah, 16
Hock, Rick McKee, 270
Hockney, David, 250
Hofkin, Ann Ginsburgh, 46
Holding My Breath: 1:27 2003 (Elizabeth Raymer Griffin), 70
Hole 2005 (Bea Nettles), 119
Holga camera, 171–2, 186
Hommage á Robert Capa 1981 (Pierre Cordier), 236

Homage to Bruce Nauman 2005 (Dennis DeHart), 125
Hot-pressed papers, 190
Hot water development method, 133
Hulcher cameras, 178
Hunter, Frank, 72, 99
Hydrangea 1999 (Brigitte Carnochan), 6
Hydrochloric acid, 215
Hydroquinone developers, 81–2, 129–30
 applications, 92, 93–4
 components, 129–30
 contrast control, 134
 temperature, 131
 warm-tone papers, 141
Hygroscopic chemicals, 73
Hypersensitization, 113
Hypo:
 Alum Sepia Toner T-1a, 154–5
 check formula, 45, 46
 clearing solutions, 196
 see also Fixers

Iceberg #11 2004 (Jonathan Bailey), 164
Ideas:
 getting, 32
 visualizing, 33
 see also Concepts; Imaginative thinking
Identity Crisis 1978 (Robert Hirsch), 226
Ilford:
 Bromophen developer, 135
 Delta 3200 film, 50–3
 ID-9 formula, 91
 ID-13 formula, 92
 ID-60 formula, 91–2
 ID-62/ID-86/ID-72 formulas, 96
 ID-78 formula, 142–3
 Microphen formula, 95–6
 PAN F PLUS film, 55
 SFX film, 49–50
Illumination *see* Light
Images:
 capturing, 43–69
 characteristics, 79–81
 cinematic, 250–1
 color in lith printing, 224–5
 distressed images, 272
 encyclopedic, 7
 modifications, 5
 photographic image concept, 2
 viewing experience, 189–91
 see also Cameraless images; Digital images
Imaginative thinking, 29–37, 187–229
Imperial measures, 76
In-hand method, plate development, 205
Infectious development, 224
Infrared Coast 2007 (Kim Abeles), 49
Infrared (IR) film, 46–9
Ink:
 halftone process, 10
 transfer techniques, 263–4
Inkjet printers, 63, 65–6, 264–5
Installations, 252–4
Instant film, 61, 267–70
Intensification, 89–90
Interleafing prints, 162
Internal mix airbrushes, 259–60
Internet selection, films, 44
Inventiveness, 187–229

Inverting images, 63
IR (Infrared) film, 46–9
Iron-based alternative processes, 188–9, 198–9
Iron-on transfers, 265
ISO settings:
 high-speed films, 50, 53
 infrared film, 48
 Kodak T-MAX 100 film, 60

Jachna, Joseph, 120
Japanese Bridge and Geothermal Plant, Iceland 2004 (Robert Dawson), 14
Jarboe, Molly, 42
Javier Garcia Wake, Fort Worth, Texas 1987 (Peter Helms Feresten), 88
Joe Kemp 1976 (Milton Rogovin), 85
Johnson, Keith, 126
Jökulsárlón, Iceland 2004 (Paula Chamlee), 212
Jones, William B., 192
The Journey Begins 2006 (Blue Mitchell), 268

Kallitype process, 207–10
Keiley, Joseph T., 91
Kellner, Thomas, 249
Kenna, Michael, 240
Kennedy, John F., 8
Kenny, Kay, 190
Kirsch, Russell A., 26
Kis, Danilo, 232
"Kitchen of meaning", 231
Klett, Mark, 114
Klimaszewski, Nicolai, 31
Kline, Kevin, 165, 232
Kodak:
 D-1/Pyro ABC formula, 98
 D-19 formula, 93–4
 D-23 formula, 85–6, 93
 D-25 formula, 93
 D-52 formula, 136
 D-72 formula, 135
 D-76/D-82 formula, 94
 D-85 litho developer, 93
 Blue Toner T-26, 158
 Brown Toner, 152–3
 cameras, 8–9
 Dektol developer, 135, 138
 Direct Positive Film Developing Outfit, 60–1
 DK-50 formula, 94
 Ektaflo Type, 2, 137
 Gold Protective Solution GP-1, 157–8
 Gold Toner T-21, 156–7
 hand-held camera, 8–9
 Hardener F-5a, 155
 Hypo Alum Sepia Toner T-1a, 154–5
 MAX Water & Sport camera, 173
 Polymax T, 135
 Polysulfide Toner T-8, 155–6
 R-4a formula, 90–1
 R-4b formula, 91
 Rapid Selenium Toner, 152
 Selectol developer, 136
 Selectol-Soft developer, 137–8
 Sepia Toner, 153–5
 Sulfide Sepia Toner T-7a, 155

Kodak (*continued*)
 T-20 Dye Toner, 163–4
 T-MAX
 100 film, 60–1
 P3200 film, 50–3
 RS Developer, 88
 TRI-X film, 54–5
 XTOL developers, 101
Koenig, Karl, 224
Kokoro 2004 (Norman Sarachek), 77
Kulikauskas, Arunas, 268
Kwik Print process, 18

Lacquer-based materials, 257
Lamentations 1995 (Catherine Angel), 253
Landscape combination printing, 5–6
Language of photography, 1–3
Lantern slides, 59
Larson, Sally Grizzell, 68
Larson, William, 238
Laser-printed transfers, 264–5
Latensification, 113
Lava Flow 1928 (Fred Clatworthy), 13
Lawless, Liam, 210
Lazarus, Harry, 37, 71
Lazertran transfer products, 265
Lê, Dinh, 25, 254
Le Gray, Gustave, 5–6
Lebe, David, 141, 240
Lensbaby, 176
Lenses, 166
 angle of view changes, 173–6
 copying montages, 252
 enlarging lenses, 111–12
 panoramic cameras, 176–7
 plastic cameras, 172
 stereoscopic photography, 183
 zoom lenses, 120, 176
Lenticular screen cameras, 181
Levy, Stu, 250
Liepke, Peter, 59
*Life Is Splendid and Obscure and Broken
 and Long Enough* 1989 (Jeffery
 Byrd), 150
Life magazine, 22
Light:
 collimated beams, 109
 copying work, 252–3
 development controls, 133
 double-density effect, 118
 enlargers, 108–10
 extended exposures, 239–41
 leaks, 172
 metering, 48, 116, 166–7
 photograms, 233, 234–5
 postcamera techniques, 241–2
 safelights, 113–14, 119, 132
 see also Exposure
Lilac tones, 201
Linked Ring group, 12
Liquid Light, 124–7
Liquids:
 developers, 85
 disposal, 74
 emulsions, 124–7
 measures, 76
Listening for Falling Debris 1991 (Jeffery
 Byrd), 160

Lith/litho:
 developers, 140
 films, 55–8, 93, 113
 printing, 224–6
Lithopanes, 31
Little, Adriane, 244
Local controls:
 development, 133–4
 poisons, 39
Lounging Woman (Martha Rosler), 16
Low-contrast papers, 118
LPD developer, 135, 150
Lullin, Théodore, 10
La Lune 1999 (Robert Schramm), 211

Mach, Ernst, 9–10
Machiavelli 1936 (William Mortensen), 15
McCloud River Elephant Ear 2007 (John
 Rickard), 125
McKay, Elaine, 188, 202
Macro lenses, 176, 252
Mad Donna 1995 (Michael Northrup), 245
Madigan, Martha, 146
Magazines, 10–11, 22, 263, 265–6
Maintenance of airbrushes, 262
Maio, Mark, 86
Man on Desk 1976 (Jerry Uelsmann), 247
Man Ray, 1, 24, 233, 236
Man with Blindfold 2007 (Kathleen
 Campbell), 67
Map Camera 2007 (Kevin Kline), 165
Marc, Stephen, 95
Marey, Etienne-Jules, 10, 166
Market forces: bias, 4
Maskell, Alfred, 12
Masking methods, 5
 airbrushing, 262
 filters, 244
 friskets, 159–60, 161
 multiple-exposures, 244, 245
 reticulation, 256
Masks (safety), 38
Material Safety Data Sheets (MSDS), 37–8
Matte papers, 118
Mead, Gerald, 123
Meaning, 11–12, 231
Means, Amanda, 109
Mechanical scales, 72
Mechanical timers, 115
Melainotype method, 4
Melville, Herman, 35
Memory, 23–4, 54, 119
Memory Experiment #1 1999 (Beverly
 Rayner), 24
Meteor! 1998 (Ted Orland), 258
Metering systems, 48, 116, 166–7
Methodist Church, Mexico, New York
 1985 (Frank Hunter), 99
Metol developers, 95, 129
 Ansco, 120, 137
 contrast control, 134
 MQ formula, 81–2, 92–4
 pyro formula, 98
 temperature, 131
Metric measures, 76
Mia's Room, Mason, Ohio 1998 (Paula
 Chamlee), 97
Microphen formula, 95–6

Mills, Joe, 251
Miss Channel, Limelight 1992 (John
 Valentino), 132
Mitchell, Blue, 5, 266–8
Mixed dyeing, 161
Mixing chemicals, 71, 75
 airbrushing, 260–1
 equipment, 72–3
 liquid developers, 85
 litho films, 56
 safety, 38
 toners, 148
Modernity, 15–16
Modica, Andrea, 216
Modifications to images, 5
Moholy-Nagy, László, 16–17, 233, 236
MoMA (Museum of Modern Art,
 New York), 21
Monitor screens, 271–3
Montages, 15–17, 95, 249, 251–3
 see also Collages
Mordançage process, 223–4
Mordant dye toners, 147, 149
Mortar and pestle sets, 72
Mortensen, William, 15, 17–18
Motor drives, cameras, 178
Movie cameras, 178–9
Moving film stroboscopy, 184–5
MQ developers, 81–2, 86, 92–4, 129
 cold-tone papers, 135
 glycin, 142
 temperature, 131
MSDS (Material Safety Data Sheets), 37–8
Mud Truck 2006 (Holly Roberts), 241
Multi-contrast papers, 118–21
Multi-cycle D-23 development, 87
Multi-enlarger combination printing, 246–7
Multi-toned prints, 160–1
Multiple-exposure methods, 243–7
Multiple printing process, 220–1
Mumler, William H., 8
Mural paper, 120–1
Museum of Modern Art (MoMA),
 New York, 21
Muybridge, Eadweard, 10, 178
MYTOL formula, 101

Nadar's photography, 10
Nakagawa, Osamu James, 111
Nankin, Harry, 137
Narcissa 2006 (Brigitte Carnochan), 153
National Aeronautics and Space Adminis-
 tration (NASA), 26
Naturalistic photography, 13–14
Nauman, Bruce, 254
ND (neutral density) filters, 50, 239
Near San Quirico, D'Orcia, Tuscany 2000
 (Michael Smith), 130
Needles, 167–9
Negatives, 105
 alternative processes, 187, 211–13
 carriers, 110–11
 cleaning devices, 116
 color to black-and-white, 123
 digital, 59, 62–6
 dual-purpose, 97
 enlargements, 56–8, 60–1, 107–8, 211–12
 instant film, 61

litho films, 55–6, 57–8
paper, 58–9
pinhole cameras, 170
platinum process, 211, 212–13
scanner settings, 68
slides as, 271
see also Developers/developing agents
Nelson Gold Toner, 156–7
Nettles, Bea, 18, 119, 227
Neutral density (ND) filters, 50, 239
Neutral-tone papers, 152
see also Papers
New creation anxiety, 232
New Media, 26
Newspapers, 10–11, 263–4
Newton rings, 110
Nguyen-duy, Pipo, 156
Niagara Winter No.1 2004 (Michael Bosworth), 183
Nichol, W.W.J., 207
Niépce, Joseph Nicéphore, 192
Nietzsche, Friedrich, 165
Nixon and Agnew (Pop Goes the Weasel) 1960s (John Wood), 17
No. 1 (43° N, 3° S) 1999 (Sally Grizzell Larson), 68
Noah's Ledger 2007 (Brian Taylor), 219
Noh Mask: Rooted 2006 (Shelby Graham), 263
Normal developers, 85–6
Northrup, Michael, 245
Notebooks, 32, 116
November and April 2004 (Heather Wetzel), 13
Nuclear War?!...There Goes My Career! 1983 (Robert Hirsch), 242

Oblique Strategies, 34
Obsolete special-use cameras, 179–81
Occupational Safety and Health Administration (OSHA), 37–8
OHP (overhead projection) films, 65
Oil-based coloring materials, 257
On the News 1992/2003/2007 (Sylvia de Swaan), 43
One-and-a-Half Domes, Yosemite National Park 1976 (Ted Orland), 175
One-shot developers, 88
One-step enlarged negatives, 60–1
Opalenik, Elizabeth, 224, 230
Opaquing:
 litho films, 58
 multiple-exposures, 246
 photograms, 234
Opposites, 231–2
Optical scanning recognition (OSR), 67
Originality, 2–3
Orland, Ted, 175, 186, 258
Orthazite, 139
Orthochromatic materials, 55–8, 113
OSHA (Occupational Safety and Health Administration), 37–8
OSR (optical scanning recognition), 67
Osterman, Mark, 202, 206
Overhead projection (OHP) films, 65
Overlapping prints, 177
Owen-Murakami, Ginger, 198
Owens, Bill, 82

Oxidation:
 cyanotypes, 200–1
 developers, 83–4, 97–8

Paints, 236–7, 262
Palladium process, 211, 216–17
see also Platinum process
Palmer, Scott, 100, 174
PAN F PLUS film (Ilford), 55
Panchromatic materials:
 film, 46, 48, 50–3
 papers, 113, 123
Panoramic cameras, 174, 176–7
Panoramic mosaic technique, 177–8
Papageorge, Tod, 35
Papers, 117–21, 123–5, 187
 acid content, 190
 archival methods, 127
 colors, 118
 cyanotypes, 199–200
 developers, 118, 129–45, 162
 gum bichromate process, 217–18, 220
 image-viewing experience, 189–91
 lith printing, 225
 negatives, 58–9
 photograms, 234
 pinhole cameras, 170
 platinum process, 213, 214
 positives, 58–9
 safelights, 113–14
 salt prints, 192–5
 sequences, 249–50
 sizing, 191, 218
 surfaces, 118, 190
 texture, 118
 tonal range, 134–5
 toner combination, 147, 151–3, 155–6, 158, 162
 transfers, 264–7
 types, 117–18
 variable/multi-contrast, 118–21
 wet strength, 190
 see also Emulsions
Paper Wasp Extraction 2001 (Mark Osterman), 206
Paraminophenol developers, 99–101
ParkeHarrison, Robert and Shana, 107
Parts, formulas in, 75
PC cards, 167
Pen half-frame cameras, 179–80
Penlights, 234, 241
Pepper fog, 225
Percentage solutions, 75, 82
Performance art, 252–4
Permanence:
 additive coloring, 258
 black-and-white film, 61–2
 printing for, 127
Persinger, Tom, 239
Petroleum ink bases, 263–4
PH scale, 75–6
 accelerators, 83, 130
 water, 131
 see also Acids; Alkalis
Phantasmagoria, 24
Pharmaceutical grade chemicals, 74
Phenidone developers, 81–2, 92, 95–7, 101, 129

Photo-based installations, 252–4
Photo-essays, 10
Photo magazines, 10–11
Photo-Secessionists, 12
Photograms, 16, 55, 141, 162, 232–5
Photographic image concept, 2
Photographist concept, 20
Photography:
 origins, 29
 purposes, 35–7
Photography clubs, 12
Photography as Printmaking exhibition, 21
Photomechanical reproduction, 11–12
Photomontages, 15–17, 95, 249
 see also Collages
Photoshop program, 62–6, 69
Picasso, Pablo, 1, 3
Pictol *see* Metol developers
Pictorialists, 12–13, 217, 224, 231
Picture and Wallpaper 2006 (Keith Sharp), 148
Pigments, 218, 219
 see also Color
Pillsbury "A" Mill 2005 (Keith Taylor), 80
Pin registration process, 220–1
Pinhole cameras, 161, 165–70, 238–9
Place de la Bastille 1997 (Ilan Wolff), 169
Plantas de Peru 204 (Joyce Roetter), 271
Plastic cameras, 171–3, 179, 186
Plates:
 coating, 204
 exposing, 205
 housing, 206
 sensitizing, 204–5
 see also Wet-plate collodion printing
Plating process (silver), 88
Platinum process, 63–4, 211–16
PMK developer, 98, 100
Point of view bias, 5
Poison control, 39
Polaroid film, 61, 267–70
Polishing glass, 204
Polymax T (Kodak), 135
Polysulfide Toner T-8 (Kodak), 155–6
Pop, negatives, 111
Porett, Thomas, 36
Positives:
 ambrotypes, 201–6
 instant film, 61
 litho films, 55–7
 paper positives, 58–9
 scanner settings, 68
Possibility Scale, 33–4
Postcamera techniques, 241–3
Postcard papers, 120–1
Postcards, 7–8, 123
Postdevelopment procedures, 87–91
Posterizations, 55
Postmodernism, 26
Postmortem photography, 3
Postvisualization, 13, 17–18, 34
POTA developer, 96–7
Potassium bromide restrainers, 84, 131
Potassium cyanide *see* Hypo
Pouncy, John, 217
Powder developers, 85
Power winders, 178
PQ developers, 81–2, 92, 95, 135

Practical grade chemicals, 74
Practice exercises, airbrushing, 262
Pre-exposure procedures, 34, 113
Pregnancy safety, 38
Prepared formulas, 71
Prepared toners, 148
Preservatives, developers, 83–4, 130
Preshrinking paper, 217–18
Presoaking materials, 44, 217–18
Previsualization, 13–15, 34
Princeton, New Jersey 1985 (Michael Smith), 92
Print flashing, 133
Print washers, 116
Printers:
 digital negatives, 63, 65–6
 paper negatives, 59
 transfer techniques, 264–5
Printing-out paper, 123–5
Printmaking, 1–28
 ambrotypes, 201–6
 analog fine printing, 105–27
 bromoil process, 221–2
 chrysotype process, 210
 cliché-verre, 236–7
 concepts, 3–20
 contrast control, 133
 cyanotypes, 199
 digital negatives, 63–6
 equipment, 108–16
 extending boundaries, 21–6
 finishing prints, 121–2
 gum bichromate process, 12, 220–1
 hand-coloring, 136, 256–9
 materials, 116–21, 123–7
 multiple-exposure methods, 244–7
 panoramic effects, 177–8
 photograms, 234–5
 platinum process, 214–15
 postcamera techniques, 241–2
 salt prints, 192–7
 scanning resolutions, 68
 special materials, 123–7
 standard materials, 116–21
 styles, 105
 technology, 3–20
 thinking model, 35
 toners, 148–9, 151, 153–4, 160–3
 transfers, 265–70
 washing prints, 116
 see also Lith/lithoProcessing films
Problem solving, 29–31, 34, 35
Process:
 alternative processes, 187–229
 analog printing, 105–8
 concept/content relationship, 3
 understanding, 29
Processing films, 44–6, 131–3
 alternative processes, 195–6, 200
 color control, 147
 continuous tone litho films, 57–8
 cross-processing, 271
 fiber papers, 127
 high-speed black-and-white, 50, 51
 IR black-and-white, 48
 Kodak T-MAX 100 , 60
 Liquid Light, 126
 permanence, 61–2, 127

printing-out paper, 124
reticulation, 255–6
silver-based, 63–4, 79
toning prints, 148–9, 162
ultra-fine grain black-and-white, 55
 see also DevelopersPrintmaking
"Production-Reproduction" (Moholy), 16–17
Proofs, 65
Proportional reducers, 90
Protective equipment, 38, 71
Protective treatments:
 toning, 157–8
 varnishing, 203–4
 waxing, 197
Proust, Marcel, 23, 187
Purple-brown tones, 201
Push Pin Photogram (B/Y/R/G) 2002 (Ellen Carey), 16
PVC pipes, 120
Pyro developers, 97–9, 130
Pyrocatechin developer, 98–9, 143–5

Quicksilver developer, 136

Rabbit Roadkill #1 2000 (Jerry Burchfield), 235
The Raft of George W. Bush 2006 (Joel Peter Witkin), 2
Rag papers, 190
Rail Entrance, Birkenau, Auschwitz II 2004 (Karl Koenig), 224
The Rain/Quadrat 5 2005 (Harry Nankin), 137
Ratcliffe Power Station, Study 68, Nottingham-shire, England 2003 (Michael Kenna), 240
Rational Being 1996 (Kathleen Campbell), 102
Rauschenberg, Robert, 18, 187
Raymer Griffin, Elizabeth, 70
Rayner, Beverly, 24, 209
RC (resin-coated) papers, 57–8, 117–18
Real Estate History 2006 (Brian Taylor), 134
Reality:
 enhancement, 231
 fabrication, 248
 see also Meaning
Reciprocity failure, 238–9
Reconstructed, Caulked, Interstice 1977–79 (Thomas Barrow), 157
Recording ideas, 32
Rectilinear wide-angle lenses, 174
Red sensitivity film, 49–50
Red toners, 158–9, 201
Redford-Range, June, 144
Reduction formulas, 90–1
Reduction potential, developers, 130
Reflections in Natural History 1965/2004 (Peter Beard), 19
Registration methods, gum bichromate, 220–1
Release papers, 264–5
Relentless 2006 (Beverly Rayner), 209
Rembrandt Heads 1989 (Doug and Mike Starn), 154
Removal of stains, 159

Renner, Eric, 168
Replacement toners, 147
Replenishment, developers, 87–8
Reproduction concept, 11–12, 16–17
Researching projects, 29–30
Resin-coated (RC) papers, 57–8, 117–18
Resolution:
 grain, 80–1
 scanners, 67–8
Resource guide compilation, 44–5
Respirators, 38
Restrainers, 81, 84, 130–1, 135
Reticulation, 88–9, 255–6
Retired Farmer and His Wife 1988 (June Redford-Range), 144
Retoning prints, 153–4
Retouching litho films, 58
Reusing toners, 151
Reversing black-and-white film, 59–61
Revisualization, 21–3
Rickard, John, 126
RIT dyes, 161
Roberts, Holly, 241, 273
Robin Underwater 2004 (Ted Orland), 186
Robinson, Henry Peach, 6
Robinson Renude #185 2002 (Timothy Tracz), 6
Rock Faces 1995–2004 (Laurie Tümer), 125
Rockland:
 Ag-Plus, 126, 127
 Liquid Light, 124–7
Rodinal developers, 99–101
Roetter, Joyce, 271
Rogovin, Milton, 85
Roll cameras, 176, 177
Roller Coasters 2006 (Brian Taylor), 151
Rolling method, emulsions, 194
Rorty, Richard, 35
Rosler, Martha, 16
Rough surface papers, 190
RS Developer, 88
Rubber cement, 160, 161
Ruby lamps, 113
Running on the Craters of the Moon 1985 (Robert Hirsch), 243

Sabattier effect, 139–40
Sabrina Raaf 2007 (Lincoln Schatz), 30
Safelights, 113–14, 119, 132, 235
Safety guidelines, 37–40, 71, 74
 airbrushing, 260
 ambrotypes, 203, 204
 cyanotypes, 199
 developers, 129
 toners, 150
 Vandyke process, 207
Saloonatics – B-16 2003 (Scott Palmer), 174
Saloonatics – R-74 2003 (Scott Palmer), 100
Salt prints, 192–7
Sarachek, Norman, 77
Savage, Naomi, 21
Scale Model Camera, 179, 180
Scales, 72, 74
Scaling for scanners, 67–8
Scanning, 43, 45, 66–9, 237

Schad, Christian, 233
Schatz, Lincoln, 30
Schmidt, Peter, 34
Schramm, Robert, 210–11
Schulze, Johann, 233
Scratches, hiding, 116
Screaming Man 2004 (Jill Skupin Burkholder), 223
Screen 2002 (Christine Carr), x
Screen pictures, 271–3
Scully Osterman, France, 192–7, 204
Secession movement, 12
Seeley, J., 56
"Seizing" prints, 224–5, 226
Selective focusing, 13–14
Selective toning, 159–61
Selectol developer, 136
Selectol-Soft developer, 137–8
Selenium:
 intensification, 89
 toners, 151–2, 157, 163
Self-Portrait #2B 2002 (Alyson Belcher), 166
Self-Portrait with Ectoplasm 2006 (Tricia Zigmund), 246
Self-Portrait: Eating Lunch 2006 (Tom Persinger), 239
Sensitivities to chemicals, 38–9, 129
 see also Allergic reactions
Sensitizing solutions:
 ambrotypes, 203, 204–5
 cyanotypes, 199–200
 emulsion application, 194
 gum bichromate, 218, 219
Sepia toners, 150, 152–5, 209
Septic systems, 39
Sequence cameras, 178–9
Sequences, 248–51
Serengeti Lion 1984/2006 (Peter Beard), xi
Serrano, Andres, 31
Sewing needles, 167–9
Sexton, John, 106
Sexual Ecology 1986 (Thomas Barrow), 233
SFX film (Ilford), 49–50
Shadowgrams, 137
Shadows:
 dry-down effect, 133
 Gold Toner T-21, 156
Sharp, Keith, 148
Sharpness of grain, 80–1
Shashin concept, 23, 35
Sheridan, Sonia Landy, 26
Shifting focus, 112
Ships at Sea 1975 (Robert Hirsch), 139
Short-stops see Stop baths
Shout 30 1985 (Misha Gordin), 81
Shutter mechanism, 166
 extended exposures, 238–41
 pinhole cameras, 169–70
 plastic cameras, 171–2
 see also Exposure
Sicily_05_2 2005 (Ann Ginsburgh Hofkin), 46
Silver-based materials, 187
 alternative processes, 188, 194–5, 203
 developers, 89–90, 129–45
 film processing, 63–4, 79

printmaking, 105–27
 toners, 147, 155
Silver chloride emulsion, 116–17
Silver gelatin curve, 63–4
Silver intensification, 89, 90
Silver nitrate, 155
Silver recovery systems, 39
Silver sensitizing solutions, 194–5, 203
Single-action airbrushes, 259
Single-cycle D-23 development, 87
Single-image sequence cameras, 178–9
Single lens reflex (SLR) cameras, 48, 166
 see also 35mm cameras
Single Portrait of Val Telberg 2006 (Elaine McKay), 201
Sizing paper, 191, 218
Sketches, 33
Sleeping Beauty 2002 (Stu Levy), 244
Slides as negatives, 271
SLR see Single lens reflex cameras
Small Woods Where I Met Myself 1967 (Jerry Uelsmann), 22–3
Smith, Hamilton L., 4
Smith, Michael, 92, 130
Smithson, Robert, 254
Smoked-glass cliché-verre technique, 237
Snapshots, 8–10, vi
Snyder, Marc, vi
Sodium carbonate:
 accelerators, 83
 Kodak TRI-X film, 54–5
 reticulation, 255–6
Sodium hydroxide, 83
Sodium sulfite, 86, 130, 196
Softened water, 40, 131
Solarizing/Solarol developers, 139–40
Solid chemicals, 74, 76
Solvent-based materials, 257–8, 262, 264
Sommer, Frederick, 236–7
Spagnoli, Jerry, 4
Spanish Harlem Girl 2003 (Peter Liepke), 59
Spark exposures, 9–10
Special-purpose developers, 87
Special-use cameras, 165–86
Special-use films, 43–69
Spencer, Nancy, 168
Spiral of Rocks 1998 (Amanda Bauer), 175
Spirit Photograph Supposedly Taken During a Séance 1901 (S.W. Fallis), 9
Spirit photography, 8, 9
Split-toning, 161–3, 175
Spoons, 72
Spotting prints, 121, 216
Spray bottle developer application, 140
Spray paints, 260, 262
Sprint Quicksilver developer, 136
Stains:
 developers, 97–8, 130
 removal, 159
Stan 2006 (Stan Gaz), 159
Starn, Doug and Mike, 23, 124, 154
Static problems, 47, 116
"Stealing" information, 3
Steamboat Willie (Disney), 3
Stencils, 262–70
"Stenograms", 169
Step tablets, 63

Stereo cameras, 181
Stereo cards, 7–8, 181
Stereoscopic photography, 7–8, 9, 181–4
Stieglitz, Alfred, 12, 13–14, 91, 107
Stock solutions:
 cyanotypes, 199
 developers, 90–1, 96, 140, 145
 toners, 156–9, 163
 Vandyke process, 207
Stop baths, 45, 79, 148–9
Storage considerations, 45, 73, 74, 84
Students and Desks 1991 (Pat Bacon), 228
Straight dye toners, 148
Straight photographic aesthetic, 14–15, 187
Strand, Paul, 13–14, 105
Stroboscopic photography, 184–5
Submersible bags, 186
Subtractive reducers, 90
Suburbia (Owens), 82
"Success", 106
Sudek, Josef, 106
Sulfate developers, 84
Sulfide Sepia Toner T-7a, 155
Sulfite pulp papers, 189–90
Sunlight exposure, 200
Super-proportional reducers, 90
Superadditivity, 82, 93
Surrealism, 9
Survivors' Reunion, Majdanek Concentration Camp, Near Lublin, Poland #42 1983 (James Friedman), 103
Swing-lens cameras, 176–7
Systematic thinking, 30–5
Szarkowski, John, 21

T setting, extended exposures, 238
T-MAX (Kodak):
 100 film, 60–1
 P3200 film, 50–3
 RS Developer, 88
Tabular silver grains, 51
Talbot, William Henry Fox, 5, 9–10, 58, 184, 192, 233
Talman, Donna Hamil, 122, 162
Tanning effect, 97–8
Tap water see Water
Tare weights, 72
Taylor, Brian, 57–8, 134, 151, 190, 219, 221
Taylor, Keith, 80
Teacher role, photographers, 35
Technical grade chemicals, 74
Technology of printmaking, 3–20
Television screens, 271–3
Temperature:
 developing film, 52–3, 131
 formulas, 74–5
Testing:
 exposures, 51
 safelights, 113–14
 washing procedures, 116
Tetra sodium clearing solution, 215
Texture:
 litho films, 59
 papers, 118
Theodore Roosevelt and *Ronald Reagan* 1992 (Kim Abeles), 264
"Thing in itself" concept, 35

Thinking model, 30–5
Thinning materials, airbrushing, 262
Thiosulfate, 79
Three 1983–1986 (M.K. Foltz), 173
Three Deer 1978 (Bea Nettles), 18
Three-dimensional work, 21, 122, 181–3, 198
Tice, George, 14
Time in photography, 9–11, 23, 26, 241–3
 see also Development times
Time Warp – Philadelphia 1967 (Thomas Porett), 36
Timers, 114–15
Tintypes, 4, 5, 126, 201
Tonal range:
 high-speed films, 53
 papers, 134–5
Toners, 147–64
 angle of view changes, 175
 black-and-white film, 163–4
 cyanotypes, 201
 equipment, 150–1
 kallitype process, 209
 reuse, 151
 salt prints, 197
 types, 147–8
 variations, 159–64
Tourists at monument designed by sculptor Witkor Tolkin #7 1983 (James Friedman), 108
Towery, Terry, 89
Toy cameras, 179
 see also Plastic cameras
Tracz, Timothy, 6–7
Trade names, chemicals, 73
Transcendental thinking, 34
Transfers, 262–70
Translucent materials, 234
Transparency, 58
 contact paper transfers, 265–6
 double-density effect, 118
 materials, 65, 102, 234, 265–6
 see also Positives
Trays/tray methods, 115–16, 150–1, 205, 256
Treadwell, New York 1986 (Andrea Modica), 216
Trees, Blowing Snow, Yosemite Valley, California 1982 (John Sexton), 106
TRI-X film (Kodak), 54–5
Triple-beam scales, 72, 74
Tripods, 176–7, 238
Troubleshooting digital negatives, 65–6
Truth, nature of, 3
TST developer (Edwal), 138–9
Tucson 1983 (Robert Hirsch), 54
Tümer, Laurie, 125
Tupperware Party 1970 (Bill Owens), 82
Twenty-One Faces 1987–2008 (Karl Baden), 11
Two Horses/Book 1998 (Jesseca Ferguson), 78
Two-solution development, 87, 133, 144–5
Two-step enlarged negatives, 57

Uelsmann, Jerry, 18, 21–3, 244, 247
Ultra-fine grain black-and-white film, 55
Ultra-wide-angle lenses, 174

Underexposed film development, 97
Underwater photography, 173, 185–6
US customary weights, 76
Unidentified Baby 1870s, 4
Untitled 1995 (Andrew Davidhazy), 184
Untitled 1997 (Stephen Marc), 95
Untitled 2001 (Jerry Spagnoli), 4
Untitled 2002 (Martha Casanave), v
Untitled 2003 (Martha Casanave), 161
Untitled 2006 (Myra Greene), 27
Untitled 2007 (Dinh Lê), 25
Untitled 2007 (Dinh Lê), 254
Untitled #276 2000 (Mark Eshbaugh), 73
Untitled #291 (The Smoker) 2004/2007 (Joe Mills), 251
Untitled (7450) 2000 (Gloria DeFilipps Brush), 180
Untitled 6 2001 (Terry Towery), 89
Untitled 253 1994 (Carl Chiarenza), 61

Valentino, John, 132
Vandyke process, 207–10
Variable-contrast:
 development, 138–9, 144–5
 liquid emulsion, 127
 papers, 113, 118–20
Varnishes, 203–4, 205
Varying Hare 2007–8 (Mary Frey), 117
Vegetable-based transfers, 265
Ventilation, 37, 39, 116
Vietnamese art, 25
Viewfinders, plastic cameras, 172
Viewing images, 189–91
Vignetting:
 daguerreotypes, 5
 enlargers, 108
 wide-angle lenses, 174
Violet tones, 201
Visualization, 29, 33–4, 106
Vivaria series (Bosworth), 47

Walking with Pygmalion #8 1998 (Alida Fish), 143
Wall Street 1990 (Mark Maio), 86
Wall, Alfred H., 6
Ware, Michael, 187, 199–200
Warhead #23 2005 (Diane Bush), 272
Warhol, Andy, 18, 187
Warm-tone papers, 117, 135
 brown toners, 151–3, 156
 developers, 118, 134–7, 139, 141–2, 162
 red toners, 158
 toning effect, 147
Washing procedures, 116
 ambrotypes, 205
 chrysotype process, 210
 film washers, 45
 kallitype process, 210
 platinum process, 215
 salt prints, 196
 toning, 149, 160
 Vandyke process, 208
Washington, Capitol I 2004 (Thomas Kellner), 249
Water, 40
 chemical formulas, 75–6
 developers, 79, 84, 87, 131, 133, 149
 processing films, 79, 195–6

reticulation, 256
Water-based materials, 257–8, 265
Water-bath development, 87, 149
Water Glass #10 2004 (Amanda Means), 109
Waterproof cameras, 173, 185–6
Waxing prints, 5, 59, 122, 197
Weatherproof cameras, 185–6
Wedgwood, Thomas, 192, 233
Weighing chemicals, 72, 74, 76
West 48th 1990 (Craig Barber), xiii
Weston, Edward, 14–15, 97–8, 105, 117, 129
Wet-plate collodion printing, 5–8, 75, 201–6
Wet strength, paper, 190
Wet-toned prints, 160–1
Wetzel, Heather, 13, 75
"What if" questions, 34
Wheatstone, Sir Charles, 9
Whewell, William, 107
Whipple, John A., 5, 192
White Castle, Route #1, Rahway, New Jersey 1973 (George Tice), 14
White Hand 2001 (Nancy Spencer and Eric Renner), 168
White House, East Gate 2006 (Michael Bosworth), 47
White light conditions, 235
Whole Roll Sculpture Portrait of Val Telberg 2004 (Elaine McKay), 188
Wide-angle lenses, 111–12, 174
Widelux camera, 177
Wild Horses: Grandfather Cuts Loose the Ponies, Vantage, WA 1994 (Michelle Bates), 172
Wilde, Oscar, 1, 27
Willis, William, 211
Wilmore, J.T., 236
Windmills, Spain 2002 (Dan Burkholder), 62
Witkin, Joel-Peter, 2
Wolff, Ilan, 169
Wood, John, 17
Workshop movement, 24
World in a Jar: War and Trauma 2004 (Robert Hirsch), 255
World in a Jar: World & Trauma Montage 2005 (Robert Hirsch), 104
World War I, 15
Worthington, A.M., 10
Wratten filters, 48, 49

X-rays, 81
XTOL developers, 101

Yama 2006 (Wayne Martin Belger), 182
Yama camera, 182
Yellow stain removal, 159
Yuma Rocks 2008 (Keith Johnson), 128

Zerostat Antistatic Gun, 116
Zexter, Melissa, 136
Zigmund, Tricia, 246
Zone System, 15, 105
Zoom lenses, 120, 176